Master Drawings

FROM THE WORCESTER ART MUSEUM

Master Drawings

FROM THE WORCESTER ART MUSEUM

David Acton

Hudson Hills Press, New York
In Association with the Worcester Art Museum

Master Drawings from the Worcester Art Museum is published in conjunction with an exhibition held at the Museum from April 18 to June 21, 1998, on the occasion of its one-hundredth anniversary. It will also be seen at the University of Michigan Museum of Art, Ann Arbor, November 7, 1998, to January 17, 1999; at the Davenport Museum of Art, Iowa, February 7 to April 11, 1999; and at the Michael C. Carlos Museum, Emory University, Atlanta, May 8 to July 11, 1999.

Published with the assistance of the Getty Grant Program.

First Edition

Published in the United States by Hudson Hills Press, Inc., Suite 1308, 230 Fifth Avenue, New York, NY 10001-7704.

Distributed in the United States, its territories and possessions, and Canada by National Book Network.
Distributed in the United Kingdom, Eire, and Europe by Art Books International Ltd.

Editor and Publisher: Paul Anbinder

Assistant Editor: Faye Chiu

Copy Editor: Virginia Wageman

Proofreader: Lydia Edwards

Indexer: Karla Knight

Design: Sisco & Evans, New York

Composition: Angela Taormina

Manufactured in Japan by Toppan Printing Company.

Library of Congress Cataloguing-in-Publication Data

Worcester Art Museum.
 Master drawings from the Worcester Art Museum / David Acton. — 1st ed.
 p. cm.
 Published on the occasion of an exhibition held at the Worcester Art Museum, Apr. 18–June 21, 1998, on the occasion of its one hundredth anniversary; University of Michigan Museum of Art, Ann Arbor, Nov. 7, 1998–Jan. 17, 1999; Davenport Museum of Art, Iowa, Feb. 7–Apr. 11, 1999.
 Includes bibliographical references and index.
 ISBN: 1-55595-146-5 (cloth : alk. paper).
 1. Drawing—Massachusetts—Worcester—Catalogues.
2. Worcester Art Museum—Catalogues. I. Acton, David.
II. University of Michigan. Museum of Art. III. Davenport Museum of Art (Davenport, Iowa). IV. Title
NC25.W67W678 1998
741.9'074'7443—DC21 97-48740
 CIP

Contents

Foreword

James A. Welu
Director, Worcester Art Museum

On the occasion of the Worcester Art Museum's centennial, we are pleased to celebrate the Museum's outstanding collection of drawings. The graphic arts have formed an important part of the Museum's collection throughout its history and represent a large part of its holdings. As the simplest and most direct products of the artist's creativity, drawings have been valued as a supplement to the Museum's collection of paintings and sculpture. Because these works of art cannot be on permanent view, however, they are not widely known and have received little attention from scholars. Although some segments of the collection—such as the American watercolors—have been more thoroughly studied and exhibited, the collection as a whole has received only sporadic attention.

The most important foregoing study of the drawings at Worcester was undertaken in 1958 by Horst Vey, who has recently retired from his post as director of the Staatliche Kunsthalle in Karlsruhe, Germany. At the time he was a visiting scholar, serving as a curatorial assistant at the Museum and also teaching at Clark University in Worcester. Vey conducted research on a selection of works and organized the exhibition *European Drawings from the Museum Collection.* He published his findings on twenty-eight works in the *Worcester Art Museum Annual* and also produced a mimeographed survey of all the European drawings. Some of the illuminated manuscript paintings in the collection, watercolors, pastels, and other drawings were featured in Museum handbooks in 1922, 1967, 1974, and 1994. The Museum's watercolors were featured in the exhibition and catalogue of 1987, *American Traditions in Watercolor,* which brought deserved attention to that excellent collection. All along, new works have been acquired, and the collection has continued to broaden in its scope.

This book is just one component of a comprehensive project which began in 1990 with the support of the Andrew W. Mellon Foundation. Over a period of five years, David Acton, the Museum's Curator of Prints, Drawings, and Photographs, evaluated, researched, and catalogued all of the Museum's drawings, reorganizing their storage and coordinating the conservation treatment of many works. This catalogue and exhibition reflect the exciting results of his efforts. He has been able to clarify issues of attribution and subject for many of the Museum's holdings. The collection was found to have nearly twice the number of drawings anticipated, nearly 1600 sheets, many of which were not previously described in Museum records. These drawings constitute a survey of style and technique throughout the history of Western art from about 1300 to the present. All of the drawings were documented, their data added to the Museum records, and curatorial files were organized and updated. A conservation survey was prepared to evaluate the state of preservation of all the drawings, and conservation treatments were undertaken for those works most in need. Some of these studies and discoveries are reflected in the essay "With Pen and Ink," written by Dr. Acton and Joan Wright, the Museum's paper conservator, which presents a chronological survey of artists' use of ink through the discussion of examples in the Museum's collection.

Here, in the first comprehensive survey of the Worcester Art Museum drawings collection, many works acquired since 1958 will be seen for the first time, including examples by François Boucher, Jean-François Millet, Lyonel Feininger, Oskar Kokoschka, and Alberto Giacometti. During the period of this project, the Museum has also undertaken an active program of acquisition, acquiring many exciting works that supplement its holdings and serve to provide a more complete survey of the development of European and American drawing. Several of these recent acquisitions—including works by Jusepe Ribera, Jacques Louis David, and Adolf Menzel—are featured here. Some of the most intriguing additions are drawings that relate directly to other works in the collection. For example, the *Study of a Male Nude* is a preparatory sketch by Jean-Baptiste Joseph Wicar for his *Electra Receiving the Ashes of Her Brother, Orestes,* a major neoclassical painting acquired by the Museum in 1991. Similarly, the *Sketch of Contadini* is a study for *The Chapel of the Virgin at Subiaco* by Samuel F. B. Morse, a painting bequeathed to the Museum in 1907 by its founder, Stephen Salisbury III.

The publication of this catalogue was supported by an additional grant from the Andrew W. Mellon Foundation, a generous gift from the Getty Foundation, and a grant from the National Endowment for the Arts. We are extremely grateful for these funds, which have enabled us to share more effectively this important part of the Museum's one-hundred-year-old collection.

Acknowledgments

David Acton

Many people have helped me in the research and writing of this book and the organization of its accompanying exhibition. Over many years all of my colleagues at the Worcester Art Museum have been helpful and encouraging, including the Director, James A. Welu, and successive Directors of Curatorial Affairs, Susan E. Strickler and Elizabeth de Sabato Swinton. My colleagues in the Department of Prints, Drawings, and Photographs have worked with diligence and patience on every phase of this ambitious project: Stephen B. Jareckie, Annette Dixon, and Michael Herrmann were supportive colleagues, constructive critics, occasional research assistants and translators. I am very grateful to Joan Wright for her important contribution to the catalogue's introductory essay, for her sensitive and skillful conservation of the works of art, for her acute eye, intellectual generosity, and enduring friendship. Stephen Briggs did the photography for the catalogue at the Worcester Art Museum. Arrangements for photography and reproductions benefitted from the efforts of curatorial assistant Bethany Taylor. The monumental tasks of organizing study and documentary photography, producing and refining typescript, managing extensive corre-

spondence and curatorial files, were ably undertaken by department assistants Jill Burns and Margaret Avery, whose faithful efforts over many years can hardly be overestimated. The editors Margaret Jupe and Virginia Wageman worked diligently and patiently to make an enormous amount of information readable and engaging. I am also grateful to publisher Paul Anbinder, whose scrupulous attention to detail and visual sensitivy made this book much more accurate and beautiful.

I also thankfully acknowledge the advice and assistance of my colleagues Clifford S. Ackley, Larry Clark, Anne Havinga, Shelly Langdale, and Miriam Stewart. Perhaps most of all I am grateful to Margaret Morgan Graselli of the National Gallery of Art and William Robinson of the Fogg Art Museum; these two colleagues initiated me in the discipline of drawings connoisseurship, introduced me to scholars and experts, guided me to obscure references, and provided advice on methodology. Literally scores of other scholars, curators, dealers, and collectors unselfishly provided their time and expertise. Some are noted throughout the book, but there are a great many others, too numerous to name, and to all of them I owe an enormous debt.

With Pen and Brush—Ink as a Drawing Medium

The collection of drawings at the Worcester Art Museum presents an astounding spectrum of stylistic development throughout the history of Western art. It represents the breadth of drawing media and technique as well. Ink is both the most common and the most varied of all drawing media, and this collection offers an ideal opportunity to study the evolution of ink and its variety of uses.

Throughout recorded history ink has been the primary medium in both writing and drawing. Like a barometer of cultural development, its use has, in phases, changed mercurially or settled into staid tradition. Despite many subtle technical developments, the enduring simplicity of ink and its limitless possibilities have assured constant use. Documents and images rendered in ink survive from about 2000 B.C., when the medium was used in ancient Egyptian and Chinese civilizations. Literary descriptions and images in painting and sculpture reflect the traditions of ink writing and drawing in ancient Mediterranean cultures. In the Middle Ages, when books were copied by hand, scribes working in monastery writing workshops refined, codified, and broadened the use of pen and ink. Then, with the advent of paper manufacture in Europe in the fourteenth century, the use of ink surged, not only for writing and drawing, but soon thereafter for printing as well.

Ink is simple to use but unforgiving, for it cannot be erased and mistakes are not easily concealed. Cenino Cennini, the Florentine author of an influential artists' handbook in the early Renaissance, recommended that students practice in chalk or charcoal, progressing to ink only after achieving mastery of these erasable materials.[1] Similar respect for ink was advanced in the seventeenth century by John Evelyn, the English author of *The Excellency of Pen and Pencil,* who cautioned the acolyte: "You must be exact here, for there is no altering what you do with the pen."[2]

Ink drawings can be made on almost any surface, including papyrus, plaster, vellum (nos. 23, 29), and fabric (no. 5). However, paper is the most common support for working in ink. This plentiful, relatively inexpensive material is made all over the world from a variety of natural fibrous substances. In the basic European method of papermaking, universally employed from the fourteenth through the eighteenth centuries, paper was formed in sheets from cotton or linen.[3] The material was recycled from old rags that were shredded, soaked, and macerated until the fibers were reduced to their shortest length. The pulp was then suspended in water and placed in a vat. Sheets were formed by dipping a mold of wire mesh stretched on a wooden frame into the slurry. Excess water drained through the sievelike mold, the leaves were turned out, and the remaining moisture was squeezed from them in a mechanical press. Then the sheets were hung over a cord to dry. Finally, papers were usually treated with sizing—a glutinous liquid preparation of glue, flour, or resin—to control the absorption of the sheet. Sheets made in this way were called laid papers. They can be identified by microscopic variations in the thickness of the paper caused by the interlaced wires of papermaking molds. A pattern of "laid lines" from the individual wires and "chain lines" where these filaments were sewn to the mold's supporting slats gave the paper its distinctive gridded pattern in transmitted light. When mechanically woven, fine wire mesh was developed in the eighteenth century, this metal cloth was used for papermaking molds. Known as wove papers, sheets made by this process are uniform in thickness and texture and lack an overall watermark pattern. Since the nineteenth century wove papers have usually been made by machine, but they are still the product of the basic pulp-casting process. Throughout eastern Asia papers were traditionally hand manufactured by a similar method, not from cotton or flax but of bast fibers from the inner bark of several varieties of mulberry trees. Those relatively long filaments are soft, tough, and supple, with either a natural cream or bleached white color.

Over the centuries many different tools have been used to draw with ink, but just a handful of the simplest of them have been dominant. The brush was most common of all; even when artists came to favor pens for drawing, brushes were still used to apply washes of ink. From ancient times these simple tools were made from a wide variety of common materials, determined by their purpose. In the Renaissance, brushes for broad wall painting were fashioned of hog bristles lashed to wooden handles,[4] while more delicate instruments for calligraphy and drawing were made of fur mounted in the tapered ends of quills.[5] Squirrel hair was frequently used for this purpose, although more refined brushes for oil painting were made of the silky winter fur of rabbit, otter, or mink. The best brushes were made of tail hairs from several species of Asiatic red

sable.[6] By the mid–eighteenth century, brushmaking had become a specialized craft pursued by artisan-merchants throughout Europe. The mass-produced brush that we know today, with its bristles secured to the end of a wooden handle by a metal ferrule, was developed in the nineteenth century.[7]

Pens also have been used for writing and drawing in ink since antiquity. The earliest of them were made of hollow grasses, canes, and even bamboo, and are generically called reed pens. The capillary pressure of these stiff tubes naturally held a small amount of fluid ink, which ran down inside the shaft to be spread in a line when the pen was dragged across the drawing surface. The reed was prepared with an angled cut through its tubular shaft trimmed obliquely into a V-shaped tip. A final slice bifurcating the point allowed it to spread under downward pressure from the artist's hand and thus trace a wider line. To increase and control the size and shape of the drawn line, the tip of the pen could be cut square to the desired width. When its end was trimmed to a slanted chisel point, the artist could also vary the width of the drawn lines by rotating the pen. Although the reed was predominant for writing in ancient times, it was seldom used again for drawing in Europe until the Renaissance.

The reed pen produced a broad, variable, blunt line. Its distinctive character can be seen in a detail from the drawing *The Beheading of Saint John the Baptist,* made by an artist in the circle of Rembrandt (fig. 1). The reed's relatively inflexible splines quickly discharged a large amount of ink, requiring the artist to work in short strokes and to dip the pen often. The resultant lines are rich, fairly short, and blunt at their ends. They can vary in width along their length. With extended use the reed fibers could become permeated with fluid and produce only imprecise, feathery lines. Therefore, if an artist wanted sharply defined lines, it was necessary to trim the implement frequently.

Around the sixth century reed pens were superseded by quills, pens made from birds' feathers. By the twelfth century these pens had become the most popular of all writing implements, and they remained predominant for over seven hundred years.[8] The success of the quill pen was due to the tool's simplicity and scope, as well as to the universal availability of feathers. Cennini described how to cut a feather for drawing: "get a very nice sharp penknife, and make a horizontal cut one finger along the quill . . . then put the knife back on one of the edges . . . and taper if off toward the point. And cut the other side to the same curve, and bring it down to the same point. Then turn the pen around the other side up, and lay it over your left thumb nail;

and carefully, bit by bit, pare and cut that little tip; and make the shape broad or fine, whichever you want, either for drawing or for writing."[9] To harden the quill, the shaft was placed in a pot of hot sand to extract moisture and oils. As a quill was dried and cured, it became stiffer and more brittle, clearer and more translucent. Thus pens were available commercially in a range of renitence, generally differentiated by their color.[10] The strong, supple quill tip could be trimmed to a sharp point or squared to produce wider lines. By the eighteenth century the Dutch had refined the hardening processes and other improvements to enhance the quality, longevity, and commercial demand for their pens.[11]

The wing feathers of the goose, swan, raven, and crow were most often used for pens. American penmen favored the quills of the wild turkey.[12] Their size and availability made goose quills most popular of all, while crow feathers were preferred for writing or drawing fine lines. It was such common practice to use feathers from certain species to achieve particular qualities of line that when metal pens came into use in the nineteenth century, they were named for the feathers they emulated. Thus "crow quills" referred to small points for fine work and details, and "goose quills" referred to larger pens for thick, broad strokes. Calligraphers' pens retain these common names today.

The distinctive line of the quill, and the finesse that it allowed the artist, can be seen in a detail of a landscape drawn by Giovanni Francesco Grimaldi (fig. 2). The thin, pliant quill point glided effortlessly across the paper, responding to the draftsman's hand in quick calligraphic flourishes. As Grimaldi pulled the pen toward him, he pressed down to gently spread its splines to create a thickening line, or he eased the downward pressure for a thinning line. In the horizontal branches of the tree one can see how easily the pen flexed to produce expressive squiggles and curlicues.

The industrial revolution brought minor refinements to quill pens and methods for their mass production. In 1809, for instance, the Englishman Joseph Brahmah patented a machine that cut feather shafts into uniform nibs and set them into separate holders. Yet despite other improvements and advanced curing methods, quills remained susceptible to changing humidity that could make them warp or splinter. Thus artists and draftsmen always sought permanent pens, and the strength and pliability of metal made it the logical material for their experiments. Metal pens survive from antiquity, and literary references to bronze, brass, silver, and gold pens occur throughout European history. However, before the development of refined alloys, metal-

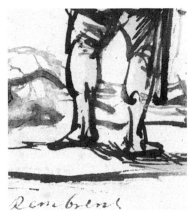

Fig. 1. Circle of Rembrandt, *The Beheading of Saint John the Baptist,* detail, see no. 22.

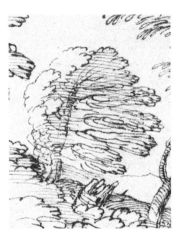

Fig. 2. Giovanni Francesco Grimaldi, *A Riverside Landscape,* detail, see no. 25.

Fig. 3. A selection of steel pen nibs, from the trade catalogue of Henry Cohen, Importer and Wholesale Stationer, Philadelphia, 1859.

smiths found it difficult to make nibs that could hold a sufficient amount of ink or that would be as thin and responsive as the quill.

Pens were first made from steel late in the eighteenth century. In 1780 the English metalsmith Samuel Harrison fabricated special alloy pens for the scientist and author Joseph Priestley. In 1809 the American inventor Peregrine White won a patent for slitted handmade steel pens. John Mitchell of Birmingham began mass producing pen points stamped from steel foil in 1828. Two years later James Perry patented the design for a point with a hole at the top of its central cleft to hold more ink, having two short, diagonal slits in the nib shoulders to increase the flexibility of its splines. Within a decade the hardened quill had become obsolete.[13] The first American company to manufacture steel pens was founded in Camden, New Jersey, by Richard Estabrook, Jr., in 1858. That factory became the world's largest producer of writing implements, especially during the World War I era. Since most ink contained acids corrosive to steel, manufacturers often plated their pens and constantly searched for resistant alloys. The finest nibs were made from gold alloyed with copper and silver. Since this metal was relatively soft, the pens were tipped with iridium, a hard element of the platinum group that was resistant to chemical attack.[14]

Steel nibs were strong, uniform, and available in a wide variety of sizes and points (fig. 3). Yet, despite their advantages, their practical shortcomings frus-

trated some purists. The English illustrator Walter Crane wrote: "Though one occasionally meets with a good steel pen, I have found it too often fails when it is sufficiently worn to the right degree of flexibility."[15] Crane's drawing *The Great Lord Sol* (fig. 4) may exemplify the stiffness of steel, but it also demonstrates how the implement could perform in the hand of a master. Since the perforated nib could hold quite a lot of fluid, the artist was able to draw long, continuous strokes without recharging his pen. Here Crane preferred to use a single point rather than several pens of different gauges. Thus, to create contours of varied width, he traced over lines to thicken them or placed them side by side. This image was conceived for photomechanical reproduction, and so the artist favored sharp, discrete lines and dots that were clearly legible. Lyonel Feininger achieved much different effects with a steel pen in his drawing *The Viaduct, Meudon* (fig. 5). Rather than serpentine contours, he used quick, short strokes. After most of the ink had drained from the nib, Feininger continued to hatch with its sharp point, creating pale, soft lines, scratching the paper and even breaking its surface. After re-inking he applied yet more fluid to the fractured, absorbent paper fibers to create dark, feathery passages such as in the trousers of the man reading the paper.

Fig. 4. Walter Crane, *The Great Lord Sol,* 1875, pen and brown ink on cream paperboard, 19.1 × 30.3 cm. Worcester Art Museum, 1965.705.

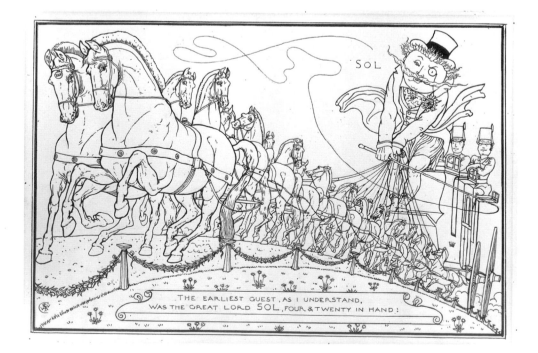

Brushes and pens can be used with a wide range of inks, but those most common and enduring have been media that are uniform and workable. Artists prefer saturated inks that flow easily without blotting or bleeding. Soluble inks that can mix in even washes greatly increase the expressive potential of the medium. Some ancient inks evolved from dyes that were used for tinting fabric. In the West, from about the thirteenth through the nineteenth centuries, three basic types of ink were predominant for writing and drawing: iron gall, carbon, and bistre. Each was the product of different ingredients and processes. Until the late eighteenth century, artists generally made their own inks. Thus ingredients and preparations were seldom duplicated exactly, and like any recipe, each formulation of old ink was essentially unique. Moreover, it was common to add other materials such as umber or chalk, and even to mix inks together to achieve additional depth, tonal variety, and color.[16] Today it is difficult to ascertain precisely the makeup of ink in old drawings, but from their recipes we know how they were made and used.[17]

European artists most frequently used iron gall, or gallotannin, ink, which often is called "common ink" in early books on technique. The majority of the old master drawings in the Worcester Art Museum collection, drawn in ink that now appears brown, were executed in inks that were probably once blue-black in color. The sustained prevalence of the medium stemmed from its superb handling properties and the ease with which large quantities could be made. Its basic ingredients were the gallic and tannic acids that are highly concentrated in oak galls, tumorlike scars formed by an oak tree after attacks by insects, fungi, or other irritants. To make this type of ink artists crushed the woody tissue and soaked or boiled it for several days in water or wine. The extract was then strained, and ferrous sulfate was added, along with glue or gum arabic, the sticky sap exuded by acacia trees.[18] The fresh preparation was usually pale violet-gray in hue, and its color deepened as the ink was aired and periodically stirred over the course of several days. In the late eighteenth century the final curing was eliminated when tinctures such as indigo or brazilwood were added, later to be replaced by aniline dyes.

The workability of iron gall ink can be seen in a detail from the drawing *A Striding Philosopher* by Jusepe de Ribera (fig. 6). The light brown color is barely visible when examined by infrared reflectography.[19] This indicates an absence of carbon, confirming the ink's identification as iron gall. In the quill this fluid ink responded well to the artist's hand. Its flow is apparent in its liquid appearance,

in the line's color variation, and in the occasional pooling on the paper. Even when the medium was thick and saturated, as in the philosopher's right hand, it could still be transparent. As it aged, iron gall ink would turn brown and granulize, and its acidic content would degrade the paper to which it was applied. Such disintegration can be seen in the passage delineating the philosopher's left shoulder, where a heavy deposit of ink has literally eaten away the support beneath.[20]

Carbon, or lampblack, was probably the pigment first used to make ink, although it was seldom used in Europe before the Renaissance. The ancient Egyptians and Chinese made this ink from the soot of burned oil. It was their custom to dry the medium into cakes or sticks for storage, later to be reconstituted in water by rubbing on a smooth, hard surface.[21] This method of preparing and keeping ink is still used today in Asia by traditional calligraphers. Pliny and Dioscorides described the traditional writing inks used by the Greeks and Romans of their time, which were also basic carbon inks.[22] However, compared with iron gall ink, the carbon ink used in Europe in the sixteenth century was crude and difficult to handle.[23] Renaissance recipes called for the artist to collect candle soot, or the residue from burned sheep's wool, resinous woods, twigs, or bones and blend the pigment in water with a plant gum binder.

Carbon ink was used in the drawing *Allegorical Figures of Rivers and Mountains,* executed in the studio of Giorgio Vasari around 1542 (fig. 7). Applied with a pen to blue paper, this ink still appears black and opaque, for unlike iron gall ink, carbon ink does not change color over time. This work also shows how readily the medium could be thinned with water to create even, translucent washes for application with a brush. Two distinct washes were used in this drawing, probably made from the same carbon ink in different dilutions. Both were thin and homogeneous enough to be readily absorbed by the lightly sized paper, causing little pooling on the surface of the sheet.

The most ancient type of carbon ink is still prevalent today. Used for centuries throughout Asia, India ink probably received its common name in the West from products imported from the Indian subcontinent in the eighteenth century during British colonization. An ancient basic recipe called for "the soot produced by the smoke of pines and the oil in lamps, mixed with the isinglass [gelatin] of asses' skin, and musk to correct the odour of the oil."[24] However, the common binder for both Asian and European preparations was gum arabic. Imported Asian ink was long held as the standard against

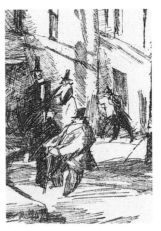

Fig. 5. Lyonel Feininger, *The Viaduct, Meudon,* detail, see no. 78.

Fig. 6. Jusepe de Ribera, *A Striding Philosopher,* detail, see no. 20.

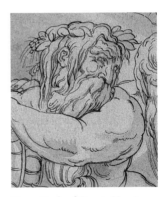

Fig. 7. Circle of Giorgio Vasari, *Allegorical Figures of Rivers and Mountains,* detail, see no. 7.

Fig. 8. India ink sticks, from the trade catalogue of Henry Cohen, Importer and Wholesale Stationer, Philadelphia, 1859.

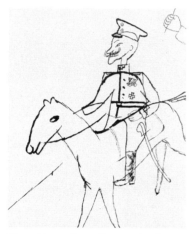

Fig. 9. George Grosz, *Vorwärts,* detail, see no. 84.

which the quality of European black inks was judged. In his *Elements of Drawing,* published in 1812, the English artist George Hamilton described the medium: ". . . brought from China, where it is used for ordinary writing, which the Chinese perform with a brush instead of a pen. It is a solid substance, of a brownish-black colour. . . . The best is always stamped with Chinese characters, breaks with glossy fracture, and feels smooth, and not gritty, when rubbed against the teeth. An inferior kind, made in this country, may easily be known by its grittiness."[25] Traditional ink sticks were imported to the West in Hamilton's time (fig. 8), as they are today.

The character of India ink is well illustrated by a detail from the drawing *Vorwärts* by George Grosz (fig. 9). Rich and opaque in color, the medium has an impermeable, slightly glossy surface. Here its sheen is apparent in the eye of the horse and the torso of the soldier. Because of its gummy binder, the India ink remained mostly on the surface of the paper. It retained the qualities of line determined by the artist's tools, in this case the fine, scratchy line of a steel pen and the coarse, broad strokes of a reed pen. Grosz used a modern, commercial formulation, which contained shellac or other resinlike additives, to make the medium waterproof. This ensured that the ink would not spread into overlays of water or wash after drying.

Carbon was also used to color early printing inks. However, since the requirements of printing are quite different from those of drawing, these media developed differently. Until late in the eighteenth century, printing ink was generally made of burned linseed oil, mixed with resin and sometimes soap.[26] The result was an adhesive compound, more densely saturated with color than were drawing inks and with the consistency of petroleum jelly. This thick, sticky medium was meant to adhere to printing surfaces, to be transferred from them by pressure, and to lie on top of the paper rather than soaking into it. Compared with drawing inks, printing inks dried hard and opaque.

Another sooty drawing ink commonly used by the old masters was bistre. This thin, fluid medium was usually made from tarry deposits scraped from fireplaces in which hardwoods such as beech had been burned.[27] Usually pale gray or brown in color, bistre ink was seldom used for writing because it included particulate carbon and solubilized tars that did not flow readily in a pen. Yet because the medium provided washes of soft hue and variable tone, it was widely used in brush drawings from the fourteenth through the nineteenth centuries.[28] Since the pitchy

soot in bistre had its own binding properties, it was not necessary to mix an adhesive ingredient into the ink. To limit its absorption into lightly sized paper, however, and make it easier to use, some authorities suggested adding gum, or "Spanish juice," the viscous extract of licorice root.[29] Bistre could be prepared either as black- or brown-colored ink, and as it aged it would darken and develop a tawny cast.[30]

Domenico Tiepolo was an expert in the use of bistre for brilliant tonal washes, ranging from transparent golden browns to grainy, flickering grays.[31] His use of the medium can be seen in a detail from the drawing *Fame and Putti in the Clouds* (fig. 10). Supplementing his carbon-ink pen lines, the artist used bistre wash to emphasize dimension and plasticity of form. The wash included heavy particulate matter, which sank to the bottom of the inkwell, so the artist could get different densities of wash depending on where in the pot he dipped his brush. Tiepolo skillfully exploited this variable quality of the medium. For example, in the puddle of wash under the chin of the figure of Fame, the artist placed a deposit of soot to emphasize the jaw line. The putto facing downward at the viewer, in the lower right, is modeled in softer, golden washes. For this figure the draftsman loaded his brush with transparent wash from the top of the inkwell. The bistre infiltrated the paper, and while the grainy soot was deposited on the surface, its thin, fluid medium was deeply absorbed, and the wash can be seen in corresponding golden passages on the verso of the sheet.

Yet another drawing ink described by early authors is sepia, the dark brown pigment naturally produced by the cuttlefish and excreted into the sea as a watery smoke screen when the creature is threatened. The natural efficacy of sepia depends on its being extremely and immediately diffusible. This ink seems to have been used for writing in antiquity, but afterward it was rare.[32] The extraction and refinement of sepia was a difficult process.[33] In the late eighteenth century the medium was revived for use in wash drawings, and around 1778 a Professor Seydelmann in Dresden developed an efficient process for preparing sepia drawing ink.[34] Its manufacture continued in the nineteenth century, when the ink was produced commercially.[35] Sepia seems to have appealed to amateur artists on the grand tour and may have been fashionable for its romantic associations.

During the nineteenth century advances in chemistry and increased research profoundly affected the formulation and manufacture of ink. Such additives as alizarin (in 1856), aniline dyes (1860), and methyl violet and nigrosin blue (1879) were used to color or

Fig. 10. Domenico Tiepolo, *Fame and Putti in the Clouds,* detail, see no. 40.

enhance writing and drawing inks. However, over time many of these materials proved unstable. Excessively acidic alizarin ink caused the degradation of paper, while aniline dyes were subject to fading when exposed to light and air. In 1879 a Professor Kloster of Bonn alerted the government to such problems, and in 1888 Germany imposed the first standards on the formulation and manufacture of ink.[36] Since that time ink manufacture in industrialized countries has been regulated by governments in order to maintain the quality and safety of these products.[37]

The use of ink underwent a revolution late in the nineteenth century when the pen was provided with its own portable ink supply. Tools like the fountain pen, ballpoint pen, and porous-tip pen are so common today that we forget they are relatively new and that schoolchildren in the 1910s dipped their pens in inkwells. In the twentieth century the development of new inks has resulted chiefly from the demands of these self-contained implements. When the first fountain pens became available around 1870, they seemed almost miraculous. These tools with which "a hundred to a thousand words can be written without filling . . . were much in demand."[38] In 1884 the L. E. Waterman Company of New York marketed the first affordable fountain pens, and millions were sold each year thereafter. The fountain pen carried ink inside its handle in a tiny rubber sack or metal capsule. The fluid was fed through a capillary tube to a metal point, which was tightly covered when not in use to keep it from drying out. Because the tip was often left wet with ink, corrosion-resistant metal nibs were required. At first these points were made of steel plated with silver or gold, and later stainless

steel was used. The first fountain pens were refilled with an eyedropper; later a tiny rubber balloon was used as the ink reservoir, with a built-in lever to deflate the sack pneumatically and to draw in the fluid when it was released. A later design carried ink in a rigid tube that was filled by means of a syringe-like piston, retracted with a screw. In the 1950s disposable plastic ink-filled cartridges came into use. Because of their capillary feed system, fountain pens required thin ink. Usually these were solvent-based media, sometimes water soluble, colored with iron, tannin, or aniline dyes. They could be unstable and prone to fading.

The concept of rolling ink onto paper with a ball bearing was also developed in the late nineteenth century. Patents were filed, and the first crude ballpoint pens appeared on the American market in 1895. However, it was Laszlo Josef Biró, a Hungarian inventor living in Argentina, who perfected a viable ballpoint pen, for which he received a patent in 1937. This implement became popular in Great Britain in the late 1930s. During World War II the United States Army required a lasting pen with quick-drying ink that would be effective in a broad range of climatic conditions and leak-proof at high altitudes.[39] The army adopted the ballpoint, and its activities carried the pen around the world, so that by about 1945 the implement was employed universally. It consisted of an open-ended capillary tube filled with solvent- or oil-based ink. This reservoir fed fluid to a tiny ball bearing, the bottom half of which protruded from a metal retaining socket. The viscous ink adhered to the top of the bearing, which was rolled across the paper, transferring a thin line of fluid. Early ballpoints contained a replaceable writ-

13

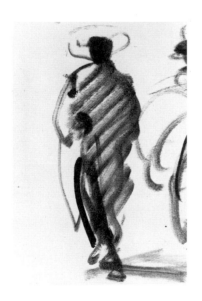

ing unit, consisting of an ink tube and tip, that could be retracted with a spring to protect the point when not in use. Later, disposable models were made almost entirely of inexpensive polymer plastics. The first balls were made of steel, to be replaced by synthetic sapphire bearings, then by tungsten carbide and hard plastic.

Sol LeWitt used a ballpoint pen for his *Documentation Drawing* (fig. 11), one from a series of planning sketches for a minimalist sculpture (see no. 98). The density of his ballpoint line was determined by pressure. To plot out his rectilinear outlines, the artist used strong, deliberate strokes, but he shaded in quick, light scribbles. The hardness of the ball and the pressure of the artist's hand can indent the paper. However, LeWitt drew lightly and sometimes his ballpoint pen skipped. In order to adhere to the applicator ball, ballpoint ink is viscid and syrupy, so that it tends to lie on top of the paper rather than soaking in. Furthermore, if the bearing does not roll evenly, the ink can congeal when exposed to the air, gelling into sticky blobs on the surface of the paper. When dry the ink is resistant to erasure and impervious to wash or watercolor.

Porous-tip pens have become the most common ink instruments in use today, and they are often employed for drawing. The earliest of these mass-produced implements were developed from warehouse marking tools of the 1940s that consisted of a brushlike felt pad used to paint a wide line of solvent-based ink. In the succeeding decade a wedge-shaped, hard felt point was mounted to an airtight metal canister that enclosed an ink-saturated sponge. That design evolved into a finer felt-tip pen with a

barrel made of disposable plastic, housing a sponge permeated with ink and a tiny conical point of porous felt. The synthetic fiber pen is a similar writing tool developed in Japan in the 1960s, modeled after a traditional bamboo brush. Instead of permeable fabric, its tip is composed of a wicklike bundle of acrylic nylon fibers. Porous-tip pens use thin petroleum-based inks, often containing such aromatic solvents as benzene or naphtha. Often these inks are water soluble, and they can fade quickly when exposed to light.

In his drawing *Mexico,* made in 1959, Luciano Guarnieri probably used two felt-tip marking pens that carried inks of different saturations. A detail of the sketch—a walking figure dressed in a serape and sombrero (fig. 12)—shows that the artist favored a wide marker with a wedge-shaped writing pad. The angle allowed Guarnieri to vary the width of his drawn line by twisting the pen. Varied tones within the striated lines also suggest that in cross-section the pad was triangular or teardrop-shaped. Most of the pen strokes are thicker and darker at one side, where the felt was wider and more saturated with ink, while the narrower, drier edge of the tip produced lighter, intermittent marks. Streaks and tonal variations within the lines, which have the appearance of brushstrokes, were caused by the texture of the felt itself. The pen seems to have been old and worn, for most of the drawing consists of transparent, brushlike lines that have a soft, chalky appearance. The soft tip could be moved freely in any direction while continuously delivering ink to the paper, so that the draftsman could create unbroken lines without lifting the marker from the sheet.

Guarnieri exploited the idiosyncrasies of his pen; his rapid diagonal hatching with these variegated lines achieved a pattern that suggests the figure is enveloped in a decorated or wrapped drapery.

Since ink partially evaporates from a porous-tip pen when it is not in use, the drawn line usually begins as a thin, transparent mark and then darkens along its length. If the draftsman leaves the point in contact with the paper for any amount of time, ink continues to flow. As the paper absorbs the ink, a dark, blunt mark is produced that broadens as the ink continues to seep into the fibers. By pressing down on the tool the artist can transfer more ink to the paper and create a darker line. Guarnieri also created a darker passage by superimposing layers of drawing, as along the shadowed left shoulder of the figure. To complete the drawing it seems that he used another, fresh marker to draw accents of comparatively dark, saturated lines. One of these is apparent along the leading edge of the figure's right leg. This line is relatively uniform in its width, and its edges appear wet, soft, and feathery, an effect caused by the ink soaking into the paper fibers. The thin, flowing inks used in these felt-tip markers were solvent-based dyes. In the most saturated areas of the drawing the ink soaked well into the paper and is visible on the verso of the sheet. The dye was relatively fugitive, however, and its color has already begun to fade from Guarnieri's drawing.

In 1954 the Koh-I-Noor Corporation, an old German pencil manufacturer, developed a technical fountain pen, the Rapidograph No. 3060, specially for the use of engineers and architects. This implement is designed to work effectively with drawing templates and to draw solid, saturated lines, uniform in their width. It does not have a flat bifurcated nib, but meters ink to the paper through a cylindrical tube that houses a concentric metal pin of smaller diameter. This pin floats like a piston and is attached to a counterweight that falls into place to stop the ink flow when the pen is lifted from the paper. The simple valve regulates ink flow, while its barrel-like point produces a drawn line of its own diameter. The smoothly rounded sides of the tube tip enable the draftsman to draw lines against a straightedge or French curve. The cylindrical point can also move in any direction, unlike a traditional steel nib that can scuff the paper fibers if pushed against the sheet. Technical pens are available in a range of sizes, with the gauge of the tubular tip determining the width of the drawn line. The first of these tools used India ink; however, as smaller and more precise models evolved in the 1960s, specialized inks were developed. Generally these are water-based media carrying fine particulate diazo pigments that have been precipitated from gases. Technical drafting inks usually contain shellac to make them waterproof when dry. Although they are also formulated to adhere to cloth and film, the colors of technical drafting inks are not light fast, and some are unstable when exposed to solvent.[40] Technical fountain pens have appealed to artists because of their precision and the ease with which they can be controlled. Carol N. Luick used a technical pen to achieve the meticulously ruled lines of her untitled drawing of 1973 (fig. 13). Because the pen was continuously supplied with ink, the length of the line was limited only by the artist's straightedge and arm span. The slight variation in some of the lines resulted from her variation of pressure or the angle at which she held the pen.

In this century science and industry have hastened the development of a wide range of mass-produced inks, suited to many specialized uses. Writing implements also have continued to evolve, generally advancing toward greater utility and economy. Artists have been quick to take advantage of these materials and tools, exploring their capabilities and limitations, and molding them to their own purposes. Scientific technology has made it possible to develop methods for the identification of ink constituents in old master drawings. Ultraviolet and infrared examination, reflectography, and spectrometry are currently being used to help analyze artists' materials. Although such procedures can now identify only broad categories of ink composition, the information they provide helps us to understand artists' practices with increasing clarity. These studies have shown that the passage of time and the effects of light, oxygen, and humidity can alter the appearance of both ink and paper. The images we perceive in drawings reflect the history of the objects and are continually changing. Seldom do they remain precisely as the draftsman intended. Scientific analyses have also demonstrated that throughout history artists have used their own peculiar recipes and admixtures of media, concocted and adapted to suit their immediate needs. Understanding these dynamics of execution and deterioration, along with a basic knowledge of artists' materials and practices, can enhance our experience of the art and our appreciation of the remarkable achievement of the artists who, throughout history, have felt compelled to draw.

Fig. 13. Carol N. Luick, *Untitled,* detail, 1973, technical fountain pen and black ink on white wove paper, 48.4 × 48.4 cm. Worcester Art Museum, 1973.67.

Notes

1. Cennini 1960, p. 30.

2. Evelyn 1688, p. 11.

3. On the history and technique of paper-making, see Hunter 1947.

4. Cennini 1960, pp. 40–41.

5. Salmon 1685, vol. 2, p. 855.

6. Gettens/Stout 1947, p. 279.

7. Ayers 1985, p. 124.

8. Meder 1978, vol. 1, pp. 42–43.

9. Cennini 1960, p. 23.

10. The American penman Adam Rapp (1832, p. 25) commented on commercial quill pens: "of those manufactured I prefer the opake, except in some few instances, when the full clarified can be procured but not too brittle, in the process of too much heat having been applied in the process of clarification."

11. Watrous 1967, p. 48.

12. Rapp 1832, p. 25.

13. Howard 1985, pp. 785–86.

14. The iridium, or "diamond tip," pen was developed in the 1850s by John Isaac Hawkins, an English immigrant to America. The manufacture of these durable but expensive pens is described by John Foley (1875, pp. 41–79).

15. Crane 1914, p. 71.

16. Meder 1978, vol. 1, pp. 46, 48.

17. See Burandt 1994.

18. Watrous 1967, p. 72.

19. Fletcher 1984, p. 26.

20. Recent analyses of iron gall inks have suggested that the ratio of its three component compounds—gallic acid, iron sulfate, and gum arabic—determined the black or brown tint of the medium and its acidic corrosion of paper. See Sistach/Espadaler 1993.

21. In Italy carbon inks were sometimes dried into cakes during the seventeenth century. See Meder 1978, vol. 1, p. 44.

22. According to Carvalho (1904, p. 34), Pliny recorded a recipe containing soot, charcoal, and a gum binder. Although he did not state their medium, these ingredients were probably mixed in water. Dioscorides was more specific, supplying the proportions of ingredients for carbon inks, including one formula containing copperas, ox glue, and soot from burned resin.

23. Watrous presents some early European recipes for black carbon ink (1967, p. 67) and suggests that they were intended as quick substitutes for iron gall ink.

24. Quoted in Carvalho 1904, p. 2.

25. Hamilton 1812, p. 11.

26. Lehrer 1892, pp. 160–61; Pasko 1894, pp. 461–63.

27. Surprisingly, bistre was rarely used in England, though it was quite common on the Continent. In the eighteenth century Robert Dossie (1764, pp. 125–26) observed this fact and speculated that the reason was that beech was seldom used in English fireplaces and stoves. When it was, the wood was often burned green and thus yielded soot unsatisfactory for ink. Dossie recorded a traditional method for making bistre from the soot of hardwood that had been dried before it was burned. His recipe stressed the need to decant the solution and separate its silty solids from the clear liquid.

28. Mayer 1969, p. 37.

29. Ostell 1807, p. 87; Hamilton 1812, p. 71.

30. Baker 1985.

31. Cohn 1970, p. 215.

32. According to David Carvalho (1904, p. 5), the ancient Egyptians used sepia to color inscriptions carved in stone. The Spartans were perhaps the first to use cuttlefish ink in cooking, for it was the principal ingredient of their black broth.

33. Wehelte 1975, p. 118.

34. Meder 1978, vol. 1, pp. 47–48.

35. The manufacture of commercial sepia began by grinding into fine powder the dried ink sacs of fish. A process of removing impurities began by boiling the powder in caustic lye or potash. After filtering, hydrochloric acid was added to the solution and the natural pigment, or melanin, was precipitated as a fine powder. The sepia was then formed into cakes, mixed with oil in paint, or suspended in water for ink. See Mitchell 1937, pp. 18–26.

36. See De Pas/Flieder 1976, p. 195.

37. C. E. Waters (1940) outlines the history of writing inks in the United States and describes federal government specifications for these products and the methods used for their testing. The author also discusses the manufacture of gallotannin writing ink, its freezing for shipment and storage, its aging, the effect of inks on paper, and the restoration of faded documents.

38. Pasko 1894, p. 431.

39. King/Haden 1972.

40. We wish to thank Colleen R. Page of Anthes Universal Ltd. for providing information on the chemical components of Pelikan drawing inks.

Master Drawings

FROM THE WORCESTER ART MUSEUM

Tuscan

EARLY 14TH CENTURY

1. *The Martyrdom of Saint Lawrence, a Bifolium from a Gradual,*
about 1290–1310

Black ink, tempera, and gold leaf on vellum, 55.7 × 38.7 cm

EXHIBITION: *An Exhibition of Italian Panels and Manuscripts from the Thirteenth and Fourteenth Centuries in Honor of Richard Offner,* Hartford, Connecticut, Wadsworth Atheneum, 1965.

REFERENCES: Wagstaff 1965, pp. 52–53, cat. no. 96; Benedictis 1978, p. 65 n. 20.

Museum purchase, 1989.175

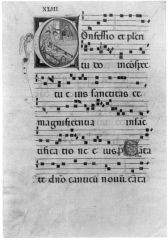

Fig. 1

The earliest works of European graphic art in the Worcester Art Museum are fragments from illuminated manuscripts. Written by hand before the advent of the printing press, these books often are lavishly ornamented with painted miniatures. In the medieval period most books of this kind were made by teams of artisans working together in writing workshops, or scriptoria, attached to churches or monasteries. Scribes copied the text in elegant calligraphic pen work, while others concentrated on ornamental borders and initials, illusionistic miniature paintings, and bookbinding.

This bifolium is one of seven separate pieces in the museum's collection from the same gradual, or choir book.[1] In a set that may have consisted of six or eight volumes, it contained the words and music sung by the priest and choir during the celebration of the daily Mass, as well as the *Sanctorale,* or the Mass for the saints' days in the Catholic calendar. Carl Nordenfalk was the first to recognize the quality of these manuscript illuminations, and in 1954 he speculated that they may have come from a Tuscan gradual made in the early fourteenth century.[2] Mirella d'Ancona and Samuel Wagstaff supported this date and proposed that the present leaf came from a Sienese manuscript.[3] More recently, Miklos Boskovits suggested that the book might have been produced in Florence a generation earlier, perhaps as early as 1280.[4] Stephen Fliegel recognized that another bifolium from the same choir book is now in the Cleveland Museum of Art.[5] All four pages of the present fragment carry music, text, and highlighted and ornamented initials, drawn in ink and tempera colors and accented with gold leaf (see fig. 1). The one historiated initial is the letter *C,* beginning the daily offices for 10 August, the feast of Saint Lawrence, which carries an image of the best-known event in the saint's legend, his martyrdom by fire.[6]

According to the medieval hagiographer Jacobus de Voragine, the Spanish-born Lawrence was a Levite, or a layman who assisted priests in the temple.[7] His remarkable piety caused him to rise quickly in the hierarchy of the early church, and eventually Lawrence became a close adviser to Pope Sixtus II in Rome. At that time the church was persecuted by Emperor Gaius Messius Decius, who in the years 249–51 dominated a realm still officially dedicated to the worship of pagan gods and the deified emperor. When Lawrence defied the emperor's order to surrender the assets of the church, Decius commanded that he be tied to a gridiron and burned to death. Lawrence accepted his sentence with righteous dignity and was miraculously able to endure the agony of his martyrdom.

In the present miniature the martyrdom of Saint Lawrence takes place just outside the towering city wall of Rome. Although the artist did not understand the principles of linear perspective, he suggested space by overlapping geometric elements in his composition and by intuitively situating planes on opposing angles. Thus we seem to look directly down on the metal grill that stands over the fire on four legs, but we perceive Saint Lawrence from the side as he lies on the gridiron. The artist emphasized the grate with dark, heavy outlines that are unlike the other delicate contours of the design. A sense of depth is subtly enhanced by one corner of the grill and Lawrence's right foot, which overlap the framing initial and project off the page into the viewer's space. Two executioners stand on the high wall, which is decorated by a carved acanthus frieze and topped by a battlemented parapet. They use long-handled tridents to stir the fire and hold their victim over the flames. As he gazes into the saint's face, one of the executioners wears an expression of sorrow and sympathy, alluding to the persuasive powers of Lawrence's serenity and to Voragine's account of his ordeal. Behind the ramparts rise two magnificent buildings, one of which is made of the multicolored stone characteristic of late medieval Tuscan architecture. From a lofty turret the emperor himself supervises the execution. Decius stands in an ornamentally framed window; a decorated cloth over the ledge before him helps give his niche the appearance of a throne. He wears a long-sleeved tunic under a toga fastened at his right shoulder, and on his head sits an Oriental-style crown with earflaps. Holding a long scepter in his left hand, the emperor raises his open right hand to command the soldiers. He looks incredulously into Lawrence's face, where he sees no agony. The eyes of the two men meet as the saint lifts his tonsured head and raises his hands in prayer, peaceful in the realization of his martyrdom. This miracle is symbolized by an angel holding a mantle to receive the saint's body; hovering outside the fictive space of the initial, the angel is in the less substantial area of the verse and music.

The present miniature is the work of a highly skilled craftsman, and although he has not been identified he was certainly an important artist in his time. A contemporary of Cimabue and Gaddo Gaddi, he worked in a style that combined the tradition of Byzantine painting with the more current advances of Roman artists who strove for greater naturalism. Boskovits suggests that he may have been a member of the artistic circle of the Master of San Gaggio, a painter whose oeuvre is based on a famous panel depicting the Madonna and Child with saints, now in the Accademia in Florence.[8]

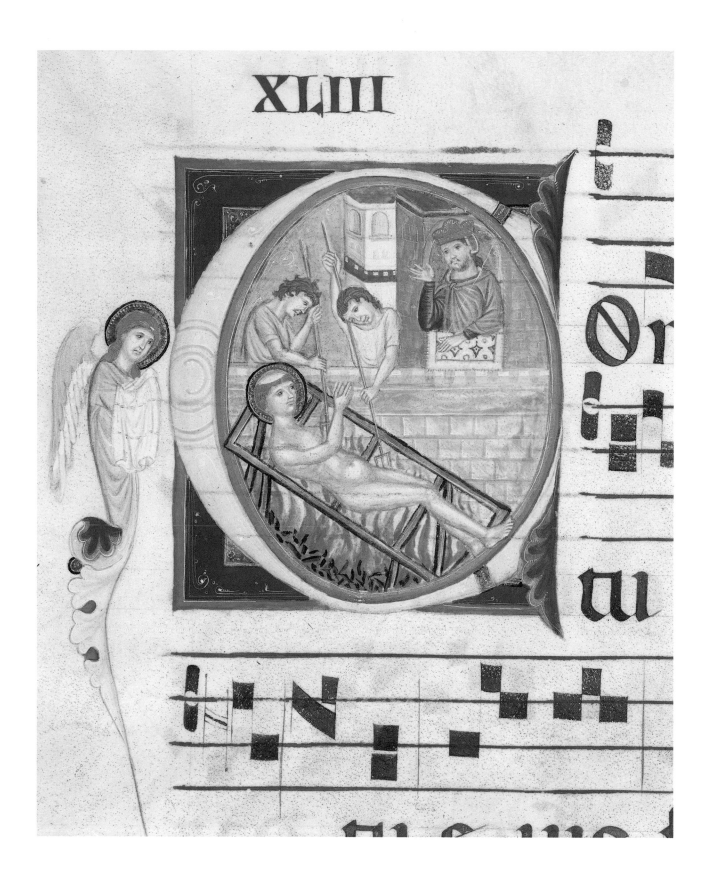

Among the other works attributed to this master are scenes from the life of Christ that flank a *Virgin and Child,* painted by the Magdalen Master, on a dossal now in the Timken Art Gallery in San Diego, and *The Madonna Surrounded by Scenes from the Passion,* a panel now at the Gemäldegalerie in Berlin.[9]

Recently it has been suggested that this master may be identified with the Florentine painter Grifo di Tancredi.[10]

Fig. 1. Tuscan, *The Martyrdom of Saint Lawrence, a Bifolium from a Gradual,* full sheet.

South German

LATE 15TH CENTURY

2. *Saint George,* 1460–80

Metalpoint on prepared cream laid paper, 26.5 × 16.7 cm

WATERMARK: Three crossed arrows (not in Briquet)

INSCRIBED: In pen and black ink, lower left: *Martin Schön;* unidentified paraph

PROVENANCE: Private collection, Vienna; private collection, Paris; purchased from Michael Miller/ Lucy Vivante Fine Arts, New York.

REFERENCES: Winzinger 1980; Andersson/Talbot 1983, pp. 149–51; *Apollo,* vol. 138, May 1994, suppl. p. 12.

Stoddard Acquisition Fund, 1994.249

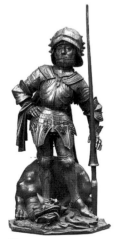

Fig. 1

This remarkable work, which exemplifies the European international style of the late Middle Ages, was found and published by Franz Winzinger, who hypothesized that its creator may have been an armorer.[1] However, Walter Karcheski, Jr., recently discovered that the metalpoint was copied after a limewood statuette made in Swabia or Bavaria during the second half of the fifteenth century, which is now in the Metropolitan Museum of Art in New York (fig. 1).[2] The sculpture depicts a knight standing with his right foot on the neck of a slain dragon, clearly identifying the subject as Saint George.

The most popular knightly saint in Christendom, George was thought to have lived in Cappadocia at the end of the third century. He was venerated in the early Greek church but did not become popular in Europe until the Middle Ages. The saint's legend centers around the conquest of a terrible dragon, a story similar to the ancient myth of Perseus.[3] Once the itinerant warrior came upon a young princess bound in chains on a lake shore, placed there as a sacrifice to the dragon that lived in its deep waters. When it appeared, George killed the monster and restored the maiden to her father the king, seeking not her hand but the conversion of his subjects to Christianity.

In the New York statuette the victorious saint holds his lance in his left hand and props his right hand on his hip. His fine suit of armor is so carefully depicted that it can be identified and dated with some precision. It is a type of battle dress made between 1450 and 1475 in the workshops of Milan, or produced slightly later in the forges of Innsbruck, then in lower Germany. When Milan was the center of the European armor industry in the early fifteenth century, a large segment of its output was meant for export to Germany and the Netherlands. To alter this situation the Holy Roman Emperor Maximilian I established three royal armories at Innsbruck to provide defenses and weapons for himself, his court, and his imperial forces.[4] Managed by the Seusenhofer family of Augsburg, these workshops employed many skilled craftsmen from Milan. One distinguishing feature of Innsbruck armor is the short helmet, or sallet, with its large spiral rivets.[5] Another characteristic is the distinctively shaped plackart, or lower breastplate, with its sculpted fluting that resembles the prow of a ship.

Although in the present drawing the draftsman did not depict the slain dragon, the contour of the beast's curly ear covering George's right foot confirms this association. The artist omitted the lance, which would have obscured important details of the figure from the chosen viewpoint. He carefully observed the suit of armor, methodically representing details of how it was constructed and worn. He detailed the many rivets of varying sizes connecting the component lames and the unseen straps that hold these pieces together. The artist even included a row of interlaced circles under the front of the breastplate, indicating the bottom of the chain-mail doublet worn under the armor. The drawing differs from the sculpture in some of its details. On the right side of the breastplate the draftsman correctly depicted a crescent-shaped lance rest, a feature that may once have been on the sculpture. Other elements of the armor are depicted cursorily or not at all. These small inconsistencies suggest that the artist may have abandoned this sheet before its completion or that he observed his model for a limited time. By reducing the size of George's head in proportion to his body, the artist created a slimmer figure that seems more agile. He also slightly exaggerated the S-curve of the figure's dancelike posture. He chose a viewpoint that positioned the saint as if he were gazing at an object to his right, a pose that would be appropriate for a patron saint in a devotional image.

The drawing was done in metalpoint, a technique commonly used by medieval illuminators for the underdrawings of their manuscript paintings. This was a challenging medium because, as he worked, the artist could not see the image completely. It took time for the metal to tarnish and impart the soft, tawny hue that we now perceive. At the lower left corner of this sheet is a hatched metalpoint grid where the draftsman apparently tested his stylus. Also in the bottom left of the sheet is a paraph, or stylized monogram, written in pen and ink and partially smudged. Although this monogram has not yet been identified, it is probably the mark of a former owner, perhaps the collector who erroneously ascribed the drawing to Martin Schongauer, the painter and engraver of Colmar.

The creator of this drawing may have been a contemporary of Schongauer, but his style seems closer to artists working in the upper Rhine valley in the mid–fifteenth century, such as the Master E.S., who also was known chiefly through his activity as a printmaker.[6] The style is also comparable to the work of contemporary Swabian painters such as Hans Schüchlin or Friedrich Herlin, who depicted Saint George, in a strikingly similar suit of armor, in his famous altarpiece in the Georgskirche at Nördlingen.[7] It seems unlikely that the creator of this drawing could have been an armorer, since surviving working drawings for armor are more schematic and technical. This stylish, elegantly proportioned figure and the sensitively depicted face elevate the sheet above a technical drawing. However, the partially finished character of the drawing

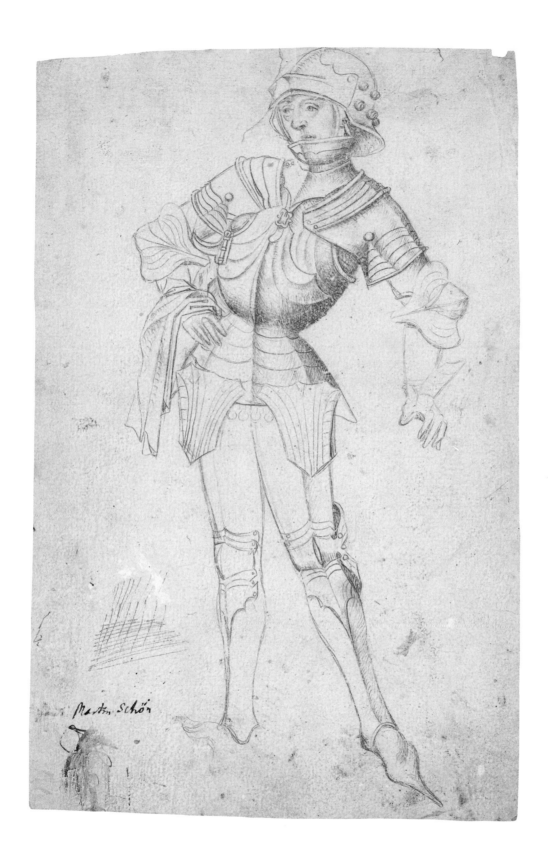

suggests that it may have been created as a record of
the sculpture's posture and costume. The prepara-
tion of this sheet is so refined and the draftsmanship
so skillful that we can assume the artist was practiced
in the technique of metalpoint. Such qualities reveal
the hand of an accomplished master, who may well
have been a painter.

Fig. 1. South German, *Saint George and the Dragon,*
ca. 1450–75, limewood with gilding and polychrome,
76.2 cm high. New York, Metropolitan Museum of Art,
gift of George Blumenthal, 41.100.213.

Attributed to Giapeco Caporali

DIED IN PERUGIA 1478

3. *The Prayer of King David, a Bifolium from an Antiphonary,* about 1473

Black ink, tempera, and gold leaf on vellum, 58.6 × 43.0 cm

PROVENANCE: Purchased from Durlacher Brothers, London.

EXHIBITIONS: *The Eye Listens: Music in the Visual Arts,* South Hadley, Massachusetts, Dwight Memorial Art Gallery, Mount Holyoke College, 1950; *Of Music and Art,* Milwaukee Art Institute, 1954.

REFERENCES: Worcester Art Museum *Bulletin,* vol. 12, October 1921, p. 37; Rox 1950, cat. no. 17; Milwaukee 1954, no. 245.

Museum purchase, 1921.157

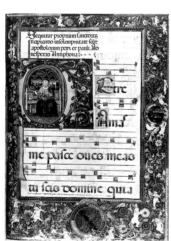

Fig. 1

This superb example of Renaissance miniature painting comes from an antiphonary, the large liturgical choir book containing music for the cycle of daily devotions throughout the year. The two parts used for alternate, or responsive singing by two divisions of a choir are distinguished by color. The phrases for the first choral part of the introduction, or *Invitatorium,* on the present page are written in black and end with the word *Evouae;* they are followed by responses, or the second choral part, inscribed in red ink.

The style of the decorations suggests that this bifolium is from an antiphonary made in the north Italian town of Perugia during the mid-1470s and that the lavish historiated initial on the present leaf was painted by Giapeco (or Giacomo) Caporali. He was probably born in Perugia in the first quarter of the fifteenth century, the son of Segnolo Caporali.[1] Although nothing is known of Giapeco's training or early activity, his name first appears in the roll of the guild of Perugian manuscript painters in 1461, when he was among the many artists who lived near the city's Porta Eburnea. Giapeco and his younger brother, Bartolomeo, also a painter, worked together on several illuminated manuscripts, among them a *Missale Fratrum Minorum* made in 1469 for the abbey of San Francesco in Perugia. The following year the two brothers purchased a house in the parish of San Fortunato, and in 1471 Giapeco married Maddelena Rossi, whose dowry contract is still in the Perugia archives. Notable among the handful of manuscripts to which the artist contributed during the 1470s is a missal now in the Capitulary Library at Perugia (MS 10). In 1474 he held the position of prior of the city of Perugia.[2] Giapeco Caporali was apparently a fairly young man when he died in Perugia in 1478. At the time of his death he was treasurer of the Perugia guild of miniaturists, a position his younger brother took over. Bartolomeo Caporali enjoyed a longer and more distinguished artistic career.[3] Educated as an apprentice in the workshop of the Florentine painter Benozzo Gozzoli, he was admitted to the painters' guild of Perugia in 1442. He was also a panel painter and executed several prestigious commissions. The style of these works reflects the influence of Giovanni Boccati, Piero della Francesca, and Alesso Baldovinetti and is comparable to that of the present miniature.

The three staves of musical notation on the present illuminated page are fully framed with decorative borders of acanthus spirals, flowers, and leaves. This ornate foliage is inhabited by a group of lively putti who play with animals, perform on musical instruments, tussle together, and face each other in mock knightly battle. Three figural roundels punctuate this border along the bottom of the page, containing the mourning Virgin and Saint John the Evangelist flanking the Dead Christ. The half-length figure of Saint Francis appears in another tondo at the upper left, and in a smaller roundel in the right border is a youth with long hair bound by a fillet, perhaps John the Baptist. In a smaller frame at the top of the folio is the bust portrait of a bearded monk, with rays of light emanating from his bald head, who may be Saint Benedict.

The text on this page comes from the first Psalm, and the illuminated initial *B,* the first letter of its first word, *Beatus,* depicts David, king of Judaea, traditionally believed to have been the composer of the Psalms.[4] Sitting in a field of flowers before a range of receding hills, David has laid down his harp to direct his attention heavenward. He looks up, lifting both his hands in the ancient attitude of prayer. The arrowlike poplar trees flanking the musician and the tall towers surmounting distant blue hills accentuate the upward movement of the king's gaze. There God the Father hovers on a flight of fiery orange cherubim and looks directly into David's eyes, affirming their close relationship. In legend the king's humanity is reflected in his bouts of melancholia, which he alleviated with his music and hymns to the Lord. According to the Evangelist Matthew, David was a direct ancestor of Christ, so he often appears as a prefiguration of the Savior. Here it would seem that the artist meant to establish a parallel between David's personal anguish, and his surrender to God as expressed in the Psalms, and the worldly suffering of Christ himself, who appears in the border below.

This painting was first attributed to Giapeco Caporali by Stephen Fliegel of the Cleveland Museum of Art.[5] This attribution was tentatively supported by Elvio Lunghi, who noted the similarity of this page to another by Giapeco in the multivolume antiphonary of the Benedictine monastery of San Pietro in Perugia, executed over a period of five years, beginning in 1471 (fig. 1).[6] These two pages indeed compare very closely, not only in their size and in the style and technique of their illumination, but also in the calligraphy of their text and their fine ornamental pen work. It would seem that the present bifolium came from another dismembered volume of the antiphonary of San Pietro in Perugia. Records in the San Pietro archives record payments to several artists, including Giapeco Caporali, who was paid for his work on the choir book in 1472, 1473, and 1476.[7] The abbey ledgers also mention the scribe Don Alvige, who may have produced the book's fine calligraphy, as well as Tommaso de Mascio and his companion Archolano,

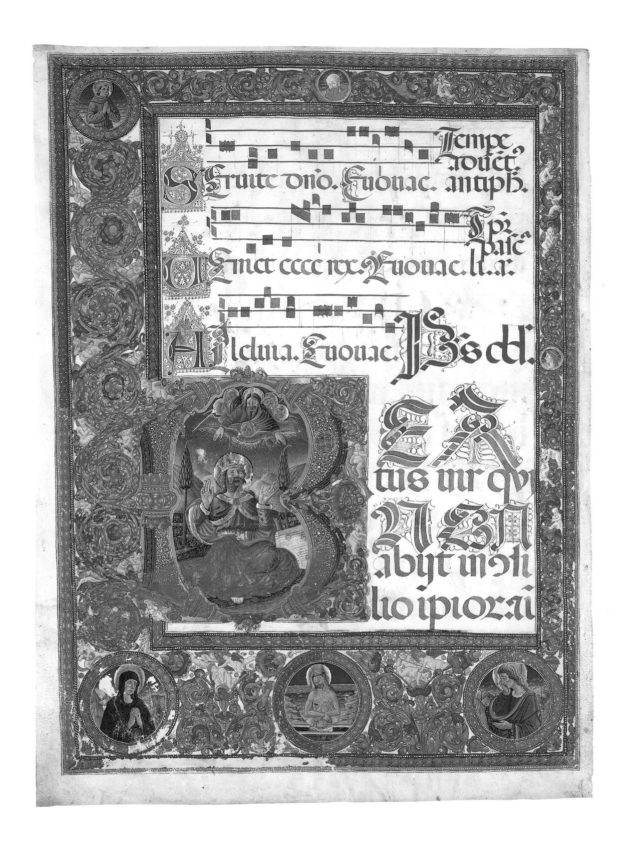

who may have executed the lavishly ornamented pen-work initials. Today only four volumes of the antiphonary of San Pietro remain in the abbey in Perugia, their covers prominently marked with the letters *I, J, L,* and *M* to indicate their place in the abbey library. Another intact volume of the choir book is now at Columbia University in New York, and it contains similar pages painted by Caporali.[8]

Fig. 1. Giapeco Caporali, *Saint Peter,* p. 1, recto, from the antiphonary of San Pietro, Perugia, vol. M, 1473.

Danube School

GERMANY, FIRST QUARTER OF THE 16TH CENTURY

4. *Christ and the Woman of Samaria,* about 1515

Pen and black ink heightened with white gouache on dark cream laid paper, 20.8 × 14.8 cm

INSCRIBED: In pen and black ink, lower left: *Hans Schaufele von Nerlingen;* in graphite on verso, lower center: *Hans Schaufele von Nerlingen*

PROVENANCE: A. Beurdeley, Paris; Galerie Georges Petit, Paris, 1920; sold at Hôtel Drouot, Paris, 1987; Ian Woodner; purchased from Christie's, London.

REFERENCES: Lenormand/Dayen 1987, lot 100; Mielke 1988, no. 173; Christie's 1991, p. 154.

Stoddard Acquisition Fund, 1991.99

Fig. 1

During the first quarter of the sixteenth century a distinctive style was practiced by artists who lived and worked along the Danube River from Vienna to Regensburg.[1] The most active and influential artists to work in this manner were Lucas Cranach the Elder, Albrecht Altdorfer, and Wolfgang Huber, who each made paintings, drawings, and prints. These artists of the Danube School deeply identified with nature and delighted in landscapes with sweeping fjords and vast forests. All the artists used a similar agitated line, which manifested the spirit and energy of nature, to depict craggy mountain peaks and tall pine trees. Their images often utilize the broad vistas that are visible only from the high vantage of mountains, giving their works an all-encompassing, almost cosmic view of nature and the world. They often preferred stepped compositions with trees and rocky outcroppings stacked in layers before rolling wooded foothills and distant valleys and peaks.

Spectacular effects of light were also characteristic of their work. To achieve these coloristic effects in their drawings, the Danube School artists adopted and further developed the chiaroscuro drawing technique, which had been used in Italy and northern Europe for more than a century. Between 1511 and 1513 Albrecht Altdorfer produced many drawings of this kind, which were conceived and sold as finished works of art. His chiaroscuro drawings depict imaginary landscapes, eerie realms given extra resonance by the shifting effects of illumination. In the present piece a sandy-colored gouache is thickly painted onto a sheet of thin laid paper. The artist drew over this neutral field with a pen and black ink and then applied highlights in thick white gouache with a brush. Handling the pen deftly, the draftsman used quick, vertical scribbles to represent distant pine forests clinging to the mountainsides and the towers and turrets of faraway cities and castles. The white heightening not only accented highlights and modeled form but also was used to surround passages of black pen, enhancing an illusion of protrusion of these areas.

The drawing represents a story from the life of Christ, told in the Gospel of Saint John.[2] Once, while on a journey from Judea to Galilee, Christ stopped in Samaria to take rest and refreshment at a roadside well. A local woman came to draw water, but when she saw Christ she hesitated and demurely waited at a distance. The Jews of Galilee considered the Samaritan people to be barbaric and unclean and avoided any contact with them. However, when he saw her, Jesus bade the woman to come to the well and asked her for a drink, speaking to her respectfully and without prejudice. A kindly conversation followed, which demonstrated the woman's human-

ity and the incompatibility of racial prejudice in Christ's teaching. She recognized him as the Messiah.

The artist situated this biblical story not in the arid Holy Land, but in the lush, forested mountains of the Danube River valley. The rocky, vertical landscape is covered with protruding roots, clinging clumps of bushes, and towering windswept firs. A wall of rock descends to a river that meanders away into the distance at the left. Nestled on the distant riverbank is a medieval city with soaring church spires and castellated towers. A turreted castle atop the tall cliffs overlooks the city and river gorge. Christ and the Samaritan woman meet at a fresh spring where cold alpine melt flows from a spout set into the rock and into a small brook. Although the stream separates the two figures, a stone bridge across the water symbolizes the connection between them. They look directly at one another as the woman points invitingly to her home. Both figures wear heavy garments appropriate to sixteenth-century Germany, rather than to the ancient Near East. Christ huddles in a heavy cloak that seems to have a fur collar. His companion wears a skirt and short jacket, with billowing—perhaps slashed—gathers at her waist and elbows, and a short cape covering her shoulders. A veil protrudes from beneath her puffed headpiece, which was fashionable in the artist's day.

At this time it is not possible to identify precisely the creator of this drawing. Its style and technique do not correspond to that of Hans Schäuffelein von Nerlingen—a follower of Albrecht Dürer—whose name was inscribed on the sheet by a later collector. Rather, the drawing was made in the Danube valley, under the influence of Albrecht Altdorfer and Wolfgang Huber. The distinctive scribbly, imprecise pen work is characteristic of both these artists. Another drawing by the same hand, now in the Albertina in Vienna, represents *Two Foot Soldiers,* who are conversing in an expansive setting with a distant village (fig. 1). The Albertina drawing also bears Schäuffelein's name, written in the same hand, which suggests that the drawings were once together in the same collection. The rapid, sketchy execution in both drawings is comparable, with willowy pen lines combined with brushed white heightening. The artist favored parallel hatching to model form and to create shaded passages, and his lines are often curved, terminating in small hooks. His loopy, sketchy lines give both images an almost buzzing energy. The figure styles are also comparable in these two drawings. Like Christ and the Samaritan woman, the foot soldiers are stocky, heavyset figures who stand on firmly planted feet. All the figures seem to wear the broad-toed "cow's-nose" shoes

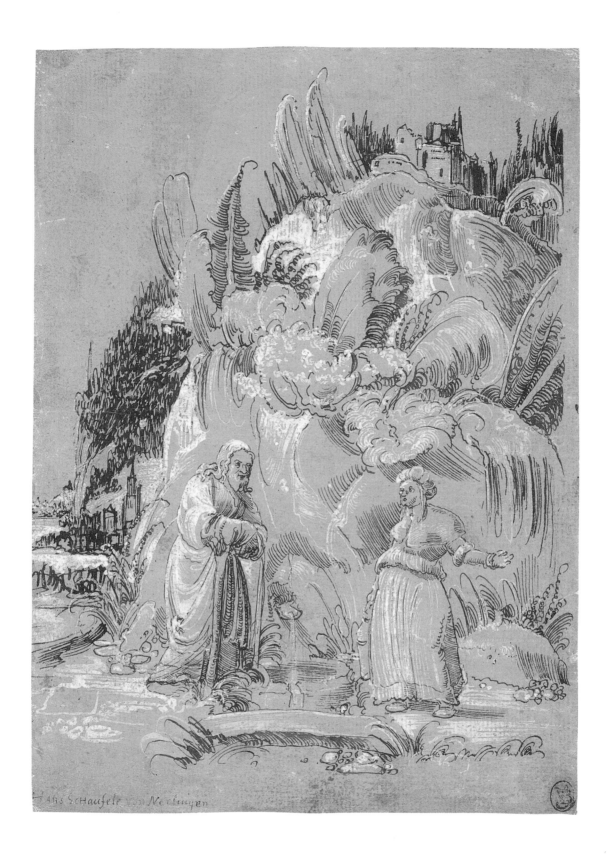

fashionable in Germany in the first quarter of the sixteenth century. Although the soldiers' tiny heads rotate expressively, their necks are not visible. The artist abbreviated their hands as rounded, loopy mitts. However, the facial gestures that are visible are precise and expressive. In both drawings the conversants look at their companions, establishing direct and meaningful contact. It is this sense of humanity and the spark of energy that distinguish these drawings as the work of an eccentric master.

Fig. 1. German, *Two Foot Soldiers,* ca. 1520, pen and black ink heightened with white gouache on prepared paper, 20.4 × 15.5 cm. Vienna, Graphische Sammlung Albertina, 3244.

Circle of Jan de Beer

ANTWERP ABOUT 1475–ABOUT 1528 ANTWERP

5. *The Supper at Emmaus,* about 1520

Pen and brown ink, gouache with white heightening on prepared light brown linen, 22.6 × 41.0 cm

INSCRIBED: In pen and gray ink, in image, right center: indistinct monogram /1433

PROVENANCE: G. Vallardi (Lugt 1223); unidentified collector's mark, lower right; private collection, Munich; purchased from H. M. Calmann, London.

EXHIBITION: *European Drawings from the Museum Collection,* Worcester Art Museum, 1958.

REFERENCES: Friedländer 1915, p. 76; Bock/Rosenberg 1931, vol. 1, p. 61; Worcester Art Museum *Annual Report,* 1957, p. 15; Vey 1958, pp. 8–11; Vey *Catalogue,* pp. 20–22; Worcester Art Museum *News Bulletin and Calendar,* vol. 27, December 1961, n.p.; Friedländer 1974, p. 19; Ewing 1978, pp. 301–2, 305–7.

Museum purchase, 1956.29

Fig. 1

The identity of the artist who created this drawing remains uncertain, but his style indicates that he worked during the early sixteenth century in Antwerp. This thriving commercial and cultural center gave rise to a painting style that incorporated effects of form and composition from Italian art. Because their style was highly artificial and often derived from precedent works, the early scholars who studied these masters dubbed them the Antwerp Mannerists.[1] These artists favored bright, clashing colors and often set their imagery in grandiose architectural settings. Their figures were exaggerated in their proportions and graceful in their poses. This sophisticated art preserved medieval iconography, a complex language of symbols that was understood by contemporary viewers.

One of the few Antwerp Mannerists who has emerged as an individual personality is Jan de Beer.[2] His name first appears in archival records dated 1490, when he was listed as an apprentice to the painter Gillis van Everen. He built a successful career; in 1504 de Beer became a free master in the Antwerp painters' guild, and in the coming years he achieved some authority in this organization and presumably in the community. In 1509 de Beer was elected a guild alderman, and in 1515 he was made a dean. Relatively early in his career, the master enrolled his own apprentices in the guild. His only son, Aert, was also an artist and probably his father's student.[3] In 1515 Jan de Beer collaborated on decorations erected for the entry of the archduke—the future Emperor Charles V—into Antwerp. Also in that year he worked on the decorated parade car that the Antwerp rhetoricians' guild, *die Violieren,* took to the Mecheln Land Jubilee festival.[4] Records of de Beer's lawsuit against the widow of a former colleague and his use of the court system suggest his elevated social status. A recently discovered document shows that the artist had died before 10 November 1528.[5]

In the British Museum in London there is a sketch sheet by de Beer representing nine heads, signed by the artist and dated 1520.[6] This drawing has been used to attribute a number of stylistically related paintings to the artist, chief among them *The Adoration of the Magi* at the Brera Gallery in Milan. A similar stylistic affinity has long prompted scholars to associate the present drawing with Jan de Beer, although it is not by the same hand as the London sheet. In that drawing the combination of free, confident hatching and heightening creates dimension and establishes delicate linear patterns absent from this sheet, which has a lighter, less exacting touch.

The Supper at Emmaus was one of the occasions on which Christ appeared to his followers after the Resurrection.[7] One day Jesus' disciple Cleophas and a companion, traditionally assumed to have been Saint Peter, were on the way to the village of Emmaus near Jerusalem. On the road they were joined by a stranger, and as they walked they told him about Christ's life, teachings, recent death, and resurrection. It was evening when they reached Emmaus, and the apostles invited their companion to dine with them. At the table the stranger broke the bread and pronounced a blessing, and at that moment, just as they recognized him as the Resurrected Savior, he vanished.

The present drawing represents the gospel story quite literally. On the right, in the distance, the three travelers cross a footbridge into the village. In the principal scene they are seated at the dining table in a cozy interior. Evening light streams through the leaded windows, and details like the Gothic woodwork, convex mirror, and well-laid table suggest an almost aristocratic opulence. The companions are clothed in pilgrim's garb, with hooded robes and large brimmed hats. A walking staff is propped in the corner, where there sits a pet monkey, the symbol of sin controlled. A plump dog, greedily enjoying a bone under the table, may stand for the complacent confidence of the disciples' faith. Christ is represented full face, with a cruciform halo, directly in the center of the composition. It is the moment when the miracle is revealed, and the disciples' astonishment is conveyed by their gaping expressions and arrested actions.

In many ways this image is similar to de Beer's drawing *The Road to Emmaus,* now in the Rijksmuseum in Amsterdam.[8] The figures have similar characters and costumes, and they stand before a city surrounded by a bridged moat. In a background vignette in that image the supper is represented. These affinities suggest that the creator of the present drawing may have known and been inspired by the Amsterdam sheet.

The present work is one of several related drawings from the circle of Jan de Beer.[9] There are nine in the group, all comparable in style, size, technique, and format. Most seem to be components of a Passion cycle. All drawn on linen, they once may have formed an integral suite of images, perhaps conceived as preparatory designs for stained glass or some other decorative work of art. Their unusual fictive framing elements suggest that the designs originally may have been contiguous, perhaps in a large compartmentalized object like a banner or even an altar frontal. Horst Vey suggests that the series might

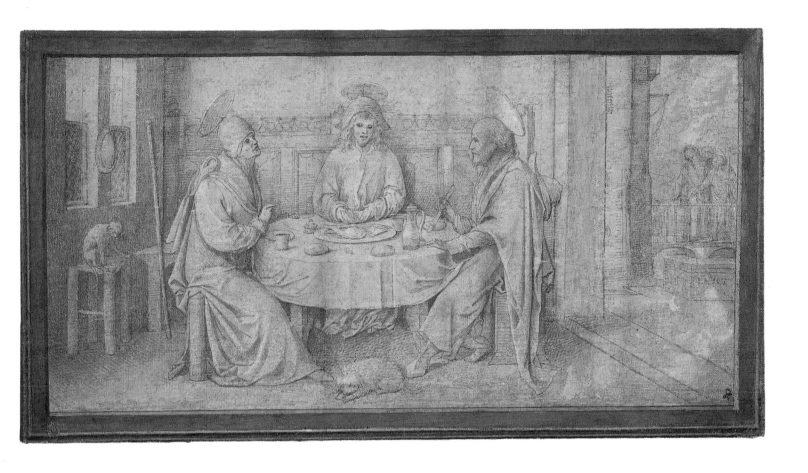

also have been studies for larger temporary decorative paintings, a notion that seems plausible since documents show that de Beer, and presumably the guild members in his workshop, created temporary festival decorations in 1515.[10] The present drawing relates most closely to the other unusual subject in this group, a sheet representing *Saint Jerome in His Study* (fig. 1), which is now in the Museum Boymans-van Beuningen in Rotterdam. Both works are by the same hand and also are comparable in their media, size, and provenance.

Fig. 1. Circle of Jan de Beer, *Saint Jerome in His Study*, ca. 1525, pen and brown ink with white heightening on linen, 20.1 × 40.0 cm. Rotterdam, Museum Boymans-van Beuningen, J.W.d.C.1.

Girolamo Francesco Maria Mazzola, called Parmigianino

PARMA 1503–1540 CASALMAGGIORE

6. *Three Old Men,* about 1532

Red chalk and stylus on cream laid paper, 15.8 × 14.9 cm

WATERMARK: Indistinct

INSCRIBED: In pen and brown ink, lower right: *-parmesan fe.;* sketched in red chalk on verso: a cow seen from behind

PROVENANCE: Purchased from Galerie Henri Baderou, Paris.

EXHIBITIONS: *The Practice of Drawing,* Worcester Art Museum, 1951–52; *European Drawings from the Museum Collection,* Worcester Art Museum, 1958; *The Figure in Mannerist and Baroque Drawings,* Storrs, University of Connecticut, 1967.

REFERENCES: Worcester Art Museum *News Bulletin,* vol. 17, December 1951, p. 5; Worcester Art Museum *Annual Report,* 1952, p. xiii; Vey *Catalogue,* no. 103; Pouncey 1976, p. 176, fig. 44; Worcester 1994, p. 108.

Museum purchase, 1951.49

One of the most influential masters of the late Renaissance in Italy, Parmigianino became famous for his distinctive, strikingly elegant figure style. He was born in Parma on 11 January 1503 into an extended family of artists.[1] The provincial family style is reflected in his earliest known painting, *The Baptism of Christ,* made when he was about sixteen years old, which is now in Berlin.

In about 1520 Parmigianino worked on the interior decoration of the church of San Giovanni Evangelista, where the most important painter of the region, Antonio Correggio, was at work on his own frescoes, and the young artist adapted and synthesized Correggio's style. Rather than striving for balanced compositions, or ideally proportioned and naturalistically posed figures, Parmigianino attenuated and exaggerated proportions. Late in 1523 the artist went to Rome, where he learned about the latest trends in painting. He admired Raphael and his students, particularly Perino del Vaga, and also was influenced by Rosso Fiorentino. Parmigianino was granted an audience with Pope Clement VII, and he presented his own paintings to the pontiff, including his *Self-Portrait in a Convex Mirror,* now in the Kunsthistorisches Museum in Vienna.

When the French sacked Rome in 1527, Parmigianino fled to Bologna. During the productive period that followed, he executed several of his most important paintings, including the *Saint Roch* altarpiece for the church of San Petronio. In 1530 the artist received the prestigious commission for altarpieces and apse fresco murals at the church of Santa Maria della Steccata in Parma. Late in 1534 he executed his most famous work, the remarkable *Madonna of the Long Neck,* for a chapel in Santa Maria dei Servi in Parma, which is now at the Uffizi in Florence. In this painting he pushed his stylized manner to new extremes, creating an exaggerated elegance that seems to deny the spirit of the ostensible subject. In the last decade of his life the artist became eccentric and troubled. According to Vasari (no. 7), an obsession with alchemy turned him away from painting. Failure to complete the Steccata project in twice the contracted time landed him briefly in jail for breach of contract. After his release in 1539, he fled to Casalmaggiore to escape further prosecution. He died there on 24 August 1540, just thirty-seven years of age.

Even during his lifetime Parmigianino was noted for his skill as a draftsman. He drew constantly throughout his career, and more than eight hundred of his surviving drawings have been catalogued.[2] He preferred fine detail and worked with pen, metalpoint, or sharpened flakes of chalk. Occasionally in conjunction with chalk he used the stylus, first pressing a few succinct lines into the pliant surface of the paper with the sharp point. When subsequently he drew over these passages, the debossed stylus lines were reserved from the chalk to read as white accents, apparent here in the locks and across the shoulder of the old man in the center. In his definitive study of Parmigianino's drawings, A. E. Popham overlooked the present sheet. However, the drawing was later recognized by Philip Pouncey, who confirmed its attribution and praised its quality.[3] Pouncey described it as a presentation drawing, even though there is no setting, the figures do not interrelate, and their extremities overlap incongruously. These features, as well as the fragmentary but fluent sketch on the verso, suggest instead that the drawing was an informal exercise.

Parmigianino made many studies of old men, who appear as prophets, apostles, and ascetic saints in his paintings. Many of them wear rags and carry books, implying that their attention is focused on their intellectual and spiritual lives, not on the material world. They seem to symbolize the wisdom of age and experience, and perhaps the knowledge of magic and alchemy. Each man in the present drawing wears a thin, capelike garment that falls from his shoulders to leave the sides of his nude body exposed. As these tattered fabrics blow or ruffle aside, their long, flowing lines emphasize stringy sinews. The old men have long, tangled beards; their matted locks fall in fringes from their bald pates; and their fingernails are overgrown into fearsome claws.

The middle figure, who raises his skull-like face as he plods forward with his staff, wears an expression of deep longing. As Pouncey observed, this figure is similar to *Diogenes* in Parmigianino's more finished drawing now at the Galleria Nazionale in Parma.[4] The figure on the left, who looks beyond the man he faces and extends his hand behind him, is similar to the graybeard in Parmigianino's drawing now in the Rijksmuseum in Amsterdam, which is also in red chalk over stylus.[5] On the verso of that drawing is a sketch of a youth swathed in draperies that billow behind him like a sail; the same draperies once swirled around the figure on the left in the present drawing, but the loop of fabric was cut away when the sheet was trimmed. The old man on the right props his left foot on a rock or hillock in order to spread across his thigh what appears to be a scroll. This figure relates to the varied sketches of reading philosophers by Parmigianino, including drawings at the British Museum, the Ashmolean, and Chatsworth.[6] They all appear to be studies connected with the philosopher in the background of *The Madonna of the Long Neck,* a composition that Parmigianino worked on for some time in the 1530s

before receiving the formal commission for the altarpiece in 1534.[7]

The sheet has been trimmed on both sides, and drawn passages have been lost. Red chalk borderlines were added by a later hand, perhaps that of the collector who inscribed the artist's name in the lower right corner. A similar inscription appears on Parmigianino's drawing of an artist's studio now in the Morgan Library,[8] and the two drawings may have been together in a former collection.

Circle of Giorgio Vasari

AREZZO 1511–1574 FLORENCE

7. *Allegorical Figures of Rivers and Mountains,* about 1542

Pen and black ink with gray washes over black chalk on blue laid paper, 23.8 × 33.2 cm

WATERMARK: Angel, with monogram, with countermark (similar to Briquet 613)

INSCRIBED: In pen and black ink, top center: *Apenino · M·;* in the image: *Arno/Tevero*

PROVENANCE: H. Beckman (Lugt 256a); Leipzig (Lugt 2731); H. W. Campe (Lugt 1391); B. Funcke; purchased from Jeffrey Wortman, New York.

REFERENCES: Frey 1923, vol. 1, pp. 115–16; Schulz 1961; Cecchi 1978, pp. 53–54, 60 nn. 16, 17.

Trustee Fund in honor of Richard Stuart Teitz, and Eliza S. Paine Fund, 1991.14

Fig. 1

Fig. 2

Giorgio Vasari is best known as the author of the collection of artists' biographies, *The Lives of the Most Excellent Painters, Sculptors, and Architects,* published in Florence in 1550.[1] It was this pioneering anthology that first suggested the notion of an Italian Renaissance, and it remains the single most important source of information about Tuscan artists of the period.

Vasari was also an important artist in his own right. In his hometown of Arezzo he studied with Luca Signorelli, and in Florence he served apprenticeships with Andrea del Sarto and Baccio Bandinelli. From 1555—when he became court painter to Cosimo I de' Medici, Grand Duke of Tuscany—until his death in 1574, Vasari was the arbiter of style and taste in Florence. His large workshop produced architectural designs, painted altarpieces, and interior fresco cycles in Florence, Rome, and the Vatican. Vasari even acted as impresario for extravagant court festivals.

In 1541 the famed poet and raconteur Pietro Aretino, also an Arezzo native, lured Vasari to Venice with a handsome commission and the opportunity to collaborate on an exciting project.[2] A newly formed social fraternity of young nobles called the *Sempiterni* had engaged Aretino to write and stage an original comedic play. It was customary for Venetian gentlemen to form such fraternities, which were called *compagnie della calza,* or "stocking clubs," because their members wore distinctively colored and patterned hose. Every year at carnival time each club would stage a festival, and the grandest fraternities commissioned music and elaborately staged plays for the occasion. In 1541 the *Sempiterni* hired Aretino to produce *La Talanta,* a bawdy play about the misadventures of a Roman prostitute.[3] According to Vasari's diary, Ottaviano de' Medici, Aretino contracted the artist to produce the stage sets and decorations for this extravaganza. Our information about the artist's work on the project comes from his diary and a letter to his patron, Ottaviano de' Medici.[4] To complete this demanding commission Vasari brought along three of his best assistants from Florence: Bastiano Flori of Arezzo and Doceno and Battista Cungi of Borgo San Sepolcro.

La Talanta was staged in an unfinished building in the Canal Regio district of Venice. The temporary theater decorations were elaborate, combining painting, sculpture, trompe l'oeil architecture, and special lighting effects. The ceiling and walls were covered with paintings, probably done on canvas and fitted into grids of wooden framing. On the ceiling there were four large allegories of the times of day, surrounded by twenty-three smaller canvases representing the hours. A drawing by Vasari, now in the

Rijksprentenkabinet in Amsterdam, records the decorative scheme for the side walls (fig. 1). Fictive architecture provided a structure for illusionistic vignettes, with trompe l'oeil urns, swags, and terms alternating with niches that held carved wood or plaster figures of classical deities. Four large paintings dominated the scheme, representing the geographical possessions of the Venetian state, personifications of rivers, lakes, islands, and mountains.

The present drawing depicts the central design for a decorative panel for one of the auditorium walls. It depicts two personifications of Italy's great rivers, the Arno and the Tevero (Tiber). They are traditionally represented as bearded old men with an oar or rudder, leaning back on an elaborate amphora that spills forth the river waters. The Tiber is accompanied by the she wolf suckling the infants Romulus and Remus, mythological heroes who grew up to be the founders of ancient Rome. The figure of the Arno cradles a brimming cornucopia, symbol of the fertility nurtured by the river. Behind them is another graybeard who stretches out a hand to caress the shoulder of each river-god. He is the hoary personification of the Appenine Mountains, whose melting snows and glaciers give rise to mountain streams that flow together into the great rivers.

Vasari and his contemporaries believed that their elegant and intellectual art should contain visual quotations from the greatest masterpieces of earlier epochs. Thus, these river-gods were based on a host of precedents, including the famous Hellenistic sculptural groups representing the Nile and Tiber rivers, which Vasari knew in the papal collection at the Vatican.[5] The figure of the Arno in the present drawing is also close to that of the saint in Michelangelo's *Conversion of Saul* fresco in the Pauline Chapel at the Vatican.[6] Its ultimate model was an ancient Roman sculpture of the reclining Hercules, also in the papal collection at the Vatican.[7]

Although the present drawing embodies Vasari's design, its style and technique demonstrate that it is not by the painter's hand. A related autograph sketch, now at the Staatliche Kupferstichkabinett in Berlin, which represents the river-gods Livenza and Timavo, has a finer, more delicate line (fig. 2). Though the figures are quite similar, the brawny arms, matted beards, and thin waists seem even more exaggerated in the present drawing. Many other details relate these two works. For example, the urns held by the river-gods are analogous in form, in their gadrooned bodies and decorative detail, and the gushes of water they disgorge. However, in the Berlin drawing the white heightening and chiaroscuro shading are more delicate, implying a more dramatically lighted scene in a darkened grotto.

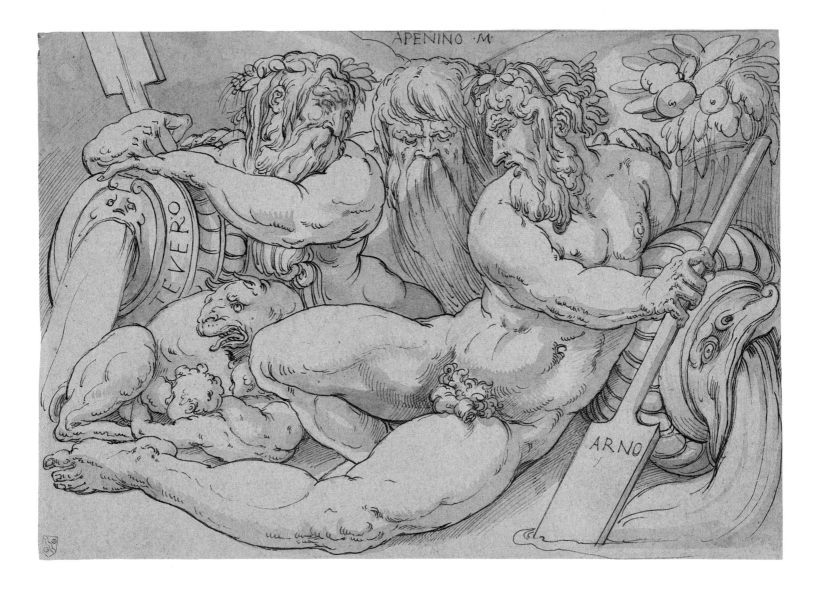

These relationships show that the present sheet is a finished preparatory drawing for Vasari's Venetian project, perhaps based on the master's own slight sketches and other finished designs for this series.[8] It may have been made by one of his assistants for the purpose of visualizing and refining the composition before transfer to a full-scale decorative cartoon or to the theater wall.[9] It is likely that the creator of the drawing was Doceno or Battista Cungi, or Bastiano Flori. However, since these artists have not received

systematic study and their drawing styles are not well understood, a more precise attribution cannot be made at this time.

Fig. 1. Giorgio Vasari, *Study for Festival Decorations for the Sempiterni,* 1541, pen and ink with wash, 10.8 × 15.9 cm. Amsterdam, Rijksprentenkabinet, 1958.42.

Fig. 2. Giorgio Vasari, *The River-Gods Livenza and Timavo,* ca. 1542, pen and wash on blue paper with white heightening, 25.4 × 32.4 cm. Berlin, Kupferstichkabinett, Staatliche Museen zu Berlin, Preussischer Kulturbesitz, KdZ 15.260.

Giulio Campi

CREMONA ABOUT 1502–1572 CREMONA

8. *Susanna and the Elders,* about 1549

Pen and brown ink on gray-brown laid paper, 26.0 × 41.5 cm

INSCRIBED: In pen and brown ink, lower left: *Titiano*

PROVENANCE: Karl Eduard von Liphart (Lugt 1687); private collection, Paris; purchased from H. M. Calmann, London.

EXHIBITIONS: *Exhibition of Renaissance Art,* Amherst, Massachusetts, Amherst College, 1956; *European Drawings from the Museum Collection,* Worcester Art Museum, 1958; *Master Drawings of the Italian Renaissance,* Detroit Institute of Arts, 1960; *The Figure in Mannerist and Baroque Drawings,* Storrs, University of Connecticut, 1967; *Visions and Revisions,* Providence, Rhode Island School of Design, Museum of Art, 1968; *Sixteenth-Century Italian Drawings: Late Renaissance Studios and Styles,* Cleveland Museum of Art, 1979; *The Draftsman's Eye: Late Italian Renaissance Schools and Styles,* Cleveland Museum of Art, 1981.

REFERENCES: Tietze-Conrat 1939; Worcester Art Museum *Annual Report,* 1957, p. 15; Vey 1958, p. 18; Vey *Catalogue,* p. 87; Snow 1960, pp. 20–37; Ostrow 1968, p. 20; Bailey 1977, pp. 114–17; Olszewski 1981, pp. 138–39.

Museum purchase, 1956.32

Fig. 1

The leading painter in Cremona during the sixteenth century was Giulio, the eldest of the three sons of the painter Galeazzo Campi.[1] There is little reliable information about his education or early career, but his father presumably was his first teacher. His earliest works seem Brescian and Venetian in character, but the painter's style soon reflected the influence of the Parmesan masters Correggio and Parmigianino (no. 6).

Giulio's professional status was well established by 1537, when he painted a fresco cycle representing the life of Saint Agatha in the church dedicated to her in Cremona. These paintings reflect the influence of Pordenone, as does Giulio's high altar for the church of Saint Sigismund executed three years later. When the Holy Roman emperor Charles V visited Cremona in 1541, Giulio led the family workshop in the execution of lavish temporary decorations commissioned by the city.[2] Afterward, he and his younger brothers, Antonio and Vincenzo, returned to the decoration of the transept of Saint Sigismund, where they painted frescoes of the four doctors of the church and other biblical subjects in an eclectic style that incorporated influences of Giulio Romano and Michelangelo. During the late 1540s the artist produced an extensive fresco series of the lives of Christ and the Virgin in the church of Santa Margherita. Then he returned to the decoration of the nave vault of Saint Sigismund in 1557. During the 1560s Giulio Campi and his shop produced several altarpieces for chapels in the cathedral at Cremona. The style of the later paintings was influenced by the return during the Counter Reformation to straightforward, comprehensible religious painting and away from Mannerist artificiality and exaggerated elegance. This style was perpetuated in the work of Giulio's sons, Galeazzo, Curzio, and Annibale.

The present drawing is a study for a painting depicting the biblical heroine Susanna. This canvas is one from a series of eight scenes of justice, executed by the Campi family workshop around 1549 for the Chamber of the Judges in the Palazzo Municipale of Brescia.[3] Still in Brescia, the canvas now hangs in the Pinacoteca Tosio-Martinengo (fig. 1). The biblical heroine Susanna was the wife of a prosperous merchant who lived during the Babylonian exile of the Jews.[4] Her beauty captivated two old men, who knew that she bathed alone every day in the garden of her elegant home; they often hid there to spy on her. One day the two elders approached the bathing Susanna and attempted to seduce her. After she had rebuffed them, they falsely accused her of adultery with another man. Susanna was tried, convicted, and sentenced to death. However, the young prophet Daniel recognized her virtue and came to her

defense. Separating the two men to cross-examine them, he found that their stories conflicted and exposed their true motives. Susanna's innocence was proved, and the wretched elders were condemned instead. Since this legend was considered apocryphal by Protestants, it was embraced by the Roman Catholic Church of the Counter Reformation. Moreover, since the moral of the story involves the triumph of virtue over lust and deceit, for Catholics it came to symbolize the falsehood of Protestantism.

Campi's drawing includes the essentials of his finished composition. The heroine sits on the edge of an ornamented stone cistern and dips her foot in the water. Jets of water pour into the pool from a fountain sculpture above, which takes the form of a goddess in a pose adapted from one of Michelangelo's sculptures in the Medici Chapel. The carved lions on the fountain may refer to Daniel, the prophet and just judge who saved Susanna, and who also had survived the trial of the lions' den. The elders wear elegant robes, befitting their stature, but they seem to bow before the beauty. At their approach Susanna has summoned her maid, who dashes from the house with a shift to cover her mistress. On the left a vista into the distance shows a garden with fenced plots and an orchard, details changed in the final painting.

Since the Brescia painting has traditionally been attributed to Antonio Campi, Giulio's younger brother and assistant, Erika Tietze-Conrat and Horst Vey attributed the present drawing to him.[5] However, Philip Pouncey suggested that Giulio created the drawing, and his opinion has since been supported by Stephen Ostrow, Edward Olszewski, and Giulio Bora.[6] The Campi family workshop collaborated on the extensive Palazzo Municipale project, but there are other drawings related to the cycle, now in the Uffizi in Florence, bearing inscriptions referring to Giulio.[7] He may have designed the entire cycle.

Although the drawing includes the essentials of the final painting, several details of pose and costume were changed. In sketches in the right margin of the present sheet, the artist gave form to his plan to alter the figure of the elder on the left. He replaced the contrapposto posture with a more beseeching pose, for the man in the painting raises both of his hands toward Susanna. The curly hair and full jowls of this figure are reminiscent of the antique portrait type associated with the Roman emperor Vitellius.[8] Giulio may even have modeled it after the ancient sculpture known as the "Grimani Vitellius," which was brought from Rome to Venice in 1523 by Cardinal Domenico Grimani and is now in that city's Museo Archeologico Nazionale. Many Renaissance artists in Venice, including Titian,

Tintoretto, and Veronese, utilized the sculpture's distinctive features in their work, cherishing it as a paradigm of ancient art. There are several red chalk drawings of the Grimani Vitellius attributed to Antonio Campi; one is in the British Museum in London, another is in the Ambrosiana in Milan, and a third recently appeared on the market.[9] These would seem to have been made directly from the sculpture and were probably not related to the Brescia painting of Susanna and the Elders. They do reflect, however, the importance of the sculpture for the Campi family.

Fig. 1. Antonio Campi, *Susanna and the Elders,* 1549, tempera on canvas, 204.0 × 295.0 cm. Brescia, Pinacoteca Tosio-Martinengo, 14.

Lambert Lombard

LIÈGE 1506–1566 LIÈGE

9. *Constantinopolis,* about 1550

Pen and brown ink on cream laid paper, 11.6 × 10.1 cm

PROVENANCE: Leonard Baskin; purchased from Hill-Stone, New York.

Sarah C. Garver Fund, 1991.101

Lambert Lombard was one of the first Flemish artists to bring the Italian Renaissance north to the Low Countries.[1] This talented and versatile artist worked as a painter, draftsman, engraver, and architect. Also an erudite scholar and author, he developed a remarkably thorough knowledge of ancient history, art, and literature. Lombard was influenced by two Netherlandish artists who had visited Italy. He was probably a pupil of Jan Gossaert, and he also was familiar with the work of Jan van Scorel. By 1532 Lombard was court painter to the bishop of Liège, Erard de la Marck. To learn about the history of art, during the 1530s he studied provincial Roman antiquities and Romanesque fresco painting.[2] When the English cardinal Reginald Pole passed through this city on his way to Rome in 1537, Lombard joined his entourage, intending to purchase paintings, sculpture, and furniture in Italy to decorate the bishop's palace in Liège. The artist stayed in Rome for about two years to study and to buy antiquities, which were sent back to Flanders.

After his return to Liège, Lombard devoted himself to writing and teaching. The Italian author Giorgio Vasari (no. 7) used Lombard's collection of biographies of northern artists as a primary source for the second edition of his own *Lives of the Artists,* and later in the century the Netherlandish biographer Carel Van Mander praised Lombard as an erudite scholar and teacher.[3] His admiring collaborator and biographer Domenique Lampson wrote that Lombard, seeking to share his knowledge of Italy, established a school in Liège where he taught literature and aesthetics, as well as drawing and engraving.[4] Outstanding among his many pupils were Frans Floris, Hubert Goltzius, and Willem Key. Apparently this academy incorporated a printmaking workshop organized like that of Raphael's engraver, Marcantonio Raimondi.[5] There Lombard's drawings were reproduced in prints and thus disseminated throughout northern Europe as models for Italianate imagery. Several of the artist's most important designs survive in these engravings.[6]

Lambert Lombard's distinctive personal style survives in several paintings and in a sizable body of drawings. In its subject, style, and execution, the present sheet is typical of Lombard's studies made in Rome. Executed with great confidence and facility, this small line drawing isolates figures from any setting and employs little modeling. However, its details of pose, costume, and allegorical paraphernalia are precise. Compared with scores of quick thumbnail sketches in which the artist recorded an encyclopedic repertoire of antique motifs, the image is quite resolved. Lombard found models for these repertorial drawings in ancient coins, gems, and cameos, as well as antique paintings, architectural and sculptural fragments, and even Renaissance classicizing facade paintings and prints. All these study drawings are complete in their details and do not show any deterioration caused by age. They are not finished, illusionistic compositions, but are precise, efficient notations of motif, sometimes crowded together several to a sheet. The largest group of Lombard's drawings is assembled in the d'Arenberg album, now in the Musée de l'Art Wallon at Liège. This scrapbook contains hundreds of sketches, ranging from relatively large resolved sheets like the present drawing to tiny snippets with their margins clipped away, glued side-by-side on the album page.

Like most of Lombard's Roman sketches, the Worcester drawing seems to record the design of an older work of art, precisely documenting its iconographical details. Dressed in a long tunic and a mantle ornamented with a boss at her right shoulder, this goddess is bedecked with bracelets and a jeweled necklace, her hair bound up in a fillet. She wears a crown fashioned in the form of town walls, identifying her as the allegorical personification of a city. In her right hand she holds a laurel wreath, and a staff or scepter is in her left hand. A group of young winged Victories crowns her with laurels and illuminates her fame with torches. Beside her on the ground, a full moneybag is inscribed with the symbol for infinity, representing the city's unlimited riches. All of these attributes identify the figure as the personification of Constantinopolis, the great city in Asia Minor conquered by the Romans in the fourth century and made the capital of the Eastern Roman Empire.

In 324, when the Roman emperor Constantine converted to Christianity, he forbade veneration of pagan images in Rome. At that time the city's ancient temples dedicated to the goddesses Tyche and Rhea were converted into shrines commemorating the twin capitals of Rome and Constantinople. The image of Rhea was adapted to represent Constantinople, with the lions she held replaced by symbols of sovereignty. Rhea also inherited the attributes of riches and good fortune from her sister, Tyche, who now came to signify the city's prosperity. In sculpture, painting, and works of decorative art, the personifications of Rome and Constantinople— now ostensibly Christian and deprived of any divinity—often appeared together during the era of the Eastern Empire. Lombard probably made this drawing of Constantinopolis after a painting made in Italy in the eighth or ninth century. One famous set of four paintings from this period represents the allegorical figures of Rome, Alexandria, Trier, and Constantinople.[7] In seventeenth-century

copies of them, which survive in the Vatican, Constantinopolis is represented with the very attributes and attendant *erotes* represented here.

Although the pose, costume, and allegorical details of this image are accurate according to Roman tradition, the figure style is Lambert Lombard's own. Constantinopolis and her attendants are tall and lanky. The goddess's head is very small, while her lower body seems relatively large. She is dressed in fabrics that appear thin and sheer, clinging to the body in tight accordion folds reminiscent of the "wet drapery style" of ancient sculpture. This vision of the antique was an elegant, affected pastiche influenced by the Netherlandish Romanism of the 1530s–50s.

Tommaso d'Antonio Manzuoli, called Maso da San Friano

SAN FRIANO 1531–1571 FLORENCE

10. *Two Men in Conversation,* about 1567

Red chalk on cream laid paper, squared for transfer, 34.2 × 19.7 cm

INSCRIBED: In graphite on verso, lower right: *72/A 19280/H/CX.*

PROVENANCE: P. and D. Colnaghi and Company, London; David Richardson, Washington, D.C.

Gift of David Richardson, 1992.64

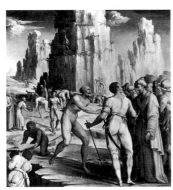

Fig. 1

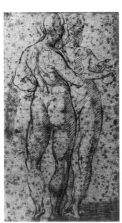

Fig. 2

Once attributed to Cavaliere d'Arpino, this drawing seems instead to have been executed by the Florentine painter Maso da San Friano in conjunction with his best-known project. Working in the circle of Giorgio Vasari (no. 7), he was one of several artists who during the 1560s sought to revive the styles of Andrea del Sarto and Jacopo Pontormo, local masters of the previous generation.[1] Vasari wrote that Maso was the student of Pier Francesco Foschi in Florence.[2] Foschi's influence is apparent in Maso's earliest surviving work, *Portrait of Two Architects* of 1556, now at the Palazzo Venezia in Rome. The artist's first important commission seems to have been for the altarpiece for the De' Pesci chapel at San Pier Maggiore in Florence. He executed several other altarpieces for the convent of the Trinity in Cortona. His paintings made for the De' Pesci family around 1560 reveal Maso's fascination with the style of Florentine painters working at the beginning of the century, such as Fra Bartolommeo, Sarto, and Pontormo. As a member of Vasari's workshop, Maso worked on decorations for the funeral of Michelangelo in Florence in 1564, and for the wedding of Joanna of Austria to Francesco I de' Medici in 1565. Then he executed paintings for the Studiolo in the Palazzo Vecchio. This was the high point of Maso's career, for he died shortly thereafter, at the age of forty, when he was just beginning to establish a career and a distinctive artistic personality.

Soon after becoming prince regent of Tuscany, Francesco I de' Medici engaged Vasari, his court artist, to remodel a small room in the Palazzo Vecchio in Florence.[3] This unusual Studiolo was a study, a treasure room, and perhaps a secret chamber for amorous adventures. Hidden passages led directly to the street and to the prince's bedroom nearby. The Studiolo housed Francesco's collection of minerals, natural wonders, and precious works of decorative art, kept in wall cupboards behind painted doors. The room's ornamentation follows an arcane program invented by the court scholar and intellectual Vincenzo Borghini. In the center of the ceiling is the image of the earth goddess Gaia and Prometheus, the mythical adventurer who created man and gave him fire. They are surrounded by allegorical figures of the four elements: earth, water, fire, and air. On each of the four walls below are several representations of how these components of the physical world have affected the lives of gods and men.

Vasari organized the forty-six works of art for the Studiolo, made by twenty-two artists of the Medici court, including Agnolo Bronzino, Alessandro Allori, Giovanni Stradanus, and Vasari himself. Two paintings on slate panels by Maso da San Friano were included, *The Fall of Icarus* and *Diamond Mining.* The latter is an intriguing fantasy in which the artist imagined the exotic process of diamond mining as being similar to the familiar quarrying of marble (fig. 1). In the background, mountains of solid crystal loom like icebergs, studded with scaffolding and machinery to move tools and the extracted gems. The work is done by an army of nude slaves, most of whom have one hand tied behind their backs to stop them from pilfering. A mine overseer stands in the foreground with a sword and staff, bargaining with Oriental merchants clad in flowing robes and fanciful turbans. It seems that their purchases fill the casket, the weight of which is emphasized by the lower placement of the servants who heft the box.

The present red chalk drawing is an early study related to this foreground group. A tall bearded man turns his back to the viewer as he steps away; he raises his right hand to point at something out of the frame. His feet, knees, hips, shoulders, and head each plot different horizontal planes, in the characteristically twisting Mannerist posture. His tiny feet, represented in midstride, seem too small to support this dancelike twist for more than the briefest moment. The draped figure speaks to another man, whose nude body is sketchily defined. Just a few telling strokes suggest his bearded face. The artist's continuing creative process is apparent in the pentimenti, for he redrew the left foot of this figure, searching for the correct position. Although Maso only sketched out the background figure, he focused on the poised, graceful positions of the hands. With his right thumb the second man seems to count on the fingers of his open left hand. This expressive gesture gives the conversation the quality of a reasoned argument.

This preparatory study was probably made during Maso's planning of his panel *Diamond Mining.* It is similar to another red chalk drawing attributed to the artist, now in the Biblioteca Reale in Turin (fig. 2).[4] Slightly smaller than the present sheet, that drawing represents the two men, both nude, in exactly the same poses. Together these two drawings demonstrate the artist's process as he moved from the conception of an image to its realization. The Turin drawing shows how the artist first sketched the two primary figures of the group, facing one another as they do business. The present study, with the foreground figure dressed as an Oriental merchant, would seem to have followed. The artist squared the design and transferred it to subsequent studies. Eventually the roles were reversed, and this figure became the overseer whose back is turned to the viewer.

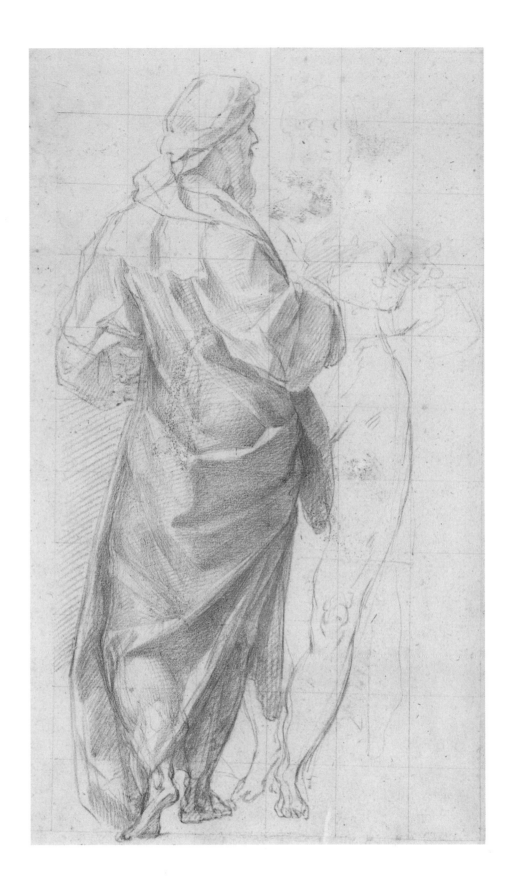

In style and manner of execution the present work is comparable to another chalk drawing by Maso made for the same painting. This is a drawing of the man, seen from the back in the painting, pushing the laden jewel box, which is now in the Louvre.[5] The figure style of this image is similar to Vasari's in its undulating contour lines and in such proportions as the bulging, muscular calves above slender ankles. This was the style favored by Maso da San Friano later in his career.

Fig. 1. Maso da San Friano, *Diamond Mining,* ca. 1567, oil on slate, 127.0 × 120.0 cm. Florence, Palazzo Vecchio.

Fig. 2. Maso da San Friano, *Two Nude Men,* ca. 1567, red chalk on cream wove paper, 23.0 × 12.0 cm. Turin, Biblioteca Reale.

Bernardino Lanino

VERCELLI ABOUT 1515–ABOUT 1582 VERCELLI

11. *The Madonna and Child with Saints and the Mystic Marriage of Saint Catherine,* about 1578

Brown ink and gouache over black chalk on cream laid paper, 47.9 × 34.7 cm

WATERMARK: Sun (similar to Briquet 13951)

INSCRIBED: In graphite, lower left: *95*

PROVENANCE: Giuseppe Vallardi (Lugt 1223); purchased from H. M. Callman, London.

EXHIBITION: Worcester Art Museum, *European Drawings from the Museum Collection,* 1958.

REFERENCES: Sadik 1956; Worcester Art Museum *Annual Report,* 1957, p. 15; Vey 1958, pp. 14–15; Vey *Catalogue,* no. 95; Worcester Art Museum *News Bulletin and Calendar,* vol. 27, December 1961, pp. ii–iii; Romano 1970, p. 66, n. 1; Romano 1986, p. 289.

Museum purchase, 1956.36

Fig. 1

Bernardino Lanino shared the provincial Piedmontese style of his master, Gaudenzio Ferrari, as well as his unusual chiaroscuro drawing technique. The son of a weaver, Lanino was born about 1515 in the village of Vercelli, about thirty-five miles southwest of Milan.[1] As a young boy he served as an apprentice to the painter Baldassare de Cadighi; then around 1530 he became an assistant to Gaudenzio, the leading painter in Vercelli. In 1534 Lanino received his first major commission to paint an altarpiece for the church of Ternengo.

In the early 1540s Lanino executed several independent commissions, including an altarpiece with *The Ascension of the Virgin* for the church of Santi Girolamo e Sebastiano in Biella. Several of his paintings in this village and nearby suggest that Lanino had opened his own workshop after leaving Ferrari's studio. In October 1543 Lanino married Dorothea, the daughter of another of Gaudenzio's assistants, Girolamo Giovenone. That year he also purchased a house in Vercelli from his new father-in-law. The artist traveled to Milan in 1546 to undertake a major project in the chapel of Saint Catherine at the church of San Nazzaro. Many frescoes and altarpieces were carefully dated and provide the framework for Lanino's long and methodical career, and that of his workshop, which included his sons Cesare, Gerolomo, and Pietro Francesco. The date of the artist's death has been interpolated from a document of 1583 that records a commission for the sons of the late Bernardino Lanino.

When it came to the Worcester Art Museum in 1956, the present work was attributed to Gaudenzio Ferrari;[2] it was Horst Vey who recognized it as the work of Lanino.[3] The drawing was executed in preparation for an altarpiece for the church of the Annunziata in the parish of Motta de' Conti, a commission granted in 1578 and completed two years later (fig. 1).[4] Its technique and formal composition are similar to other projects that occupied Lanino and his workshop around 1575.[5] Though the panel, still at Motta de' Conti, appears to have been extensively painted by Lanino's workshop or in later restoration, this sheet has the master's distinctive touch.

The drawing represents a traditional *sacra conversazione,* an imaginary gathering of saints from different times and places, paying homage to the Virgin and Child. Saint John the Baptist carrying a lamb, a bishop saint in cope and miter, and Saint Anthony Abbot in monastic habit flank the enthroned Madonna. This gathering also includes the mystic marriage of Saint Catherine of Alexandria. During the fourth century Catherine was a princess in a small country in north Africa who devoted herself to religious study as a young girl under the tutelage

of a desert ascetic.[6] To focus her meditation he gave her an icon depicting the Virgin and Child. As she fervently prayed, Catherine realized that the baby in the painting slowly turned to face her. Her faith grew ever stronger, and she experienced the infant reaching out to place a ring on her finger, symbolizing their spiritual marriage and Catherine's redemption. In nearby Alexandria, the Emperor Maxentius brutally persecuted the Christians. To his displeasure, Catherine gave them comfort and support. Maxentius ordered that she be tortured by a machine consisting of a spinning wagon wheel that bristled with knife blades, designed to rend its victim like a circular saw, but an angel appeared to destroy the apparatus before it could harm her. Catherine was finally beheaded and received a glorious martyrdom. In Lanino's drawing she kneels, holding a spiked wheel and palm of martyrdom, reaching out her right hand to receive the ring from Christ. As this composition evolved into the painting at Motta de' Conti, the figure of Saint Joseph was added behind the Virgin's right shoulder, and other refinements were introduced.

This work exemplifies Lanino's unusual grisaille drawing technique. Gaudenzio Ferrari may have learned this method from Bramantino, also incorporating the influences of such transalpine artists as Albrecht Altdorfer and Niklaus Manuel Deutsch. Reserving this chiaroscuro technique for finished modelli and presentation drawings, Gaudenzio and Lanino created images of form and dimension. Lanino's grisaille drawings possess remarkable qualities of depth and plasticity.

Time has altered the relationships between the pigment layers in the present drawing, which once appeared more unified. However, this appearance helps us to understand how the drawing was made, in translucent layers like an oil painting. Lanino plotted his symmetrical design with a vertical plumb line in black chalk down the middle of the sheet; then he used the chalk to sketch the figures. To block out the spatial scheme of the composition, the artist rubbed dark, dry pigment into the paper in background areas and then overpainted these receding passages with thin layers of brown wash. Using a fine brush and brown ink, he then detailed the standing figures. Tiny paper losses along these drawn lines suggest that he used iron gall ink, an acidic medium that later degraded the support.

Lanino drew the Virgin and Child in white so that they would seem to project forward. He used several layers of translucent white wash, in varied admixtures, to further model and highlight form throughout the image. The underlayers of liquid pigment seem to have saturated the paper, so that

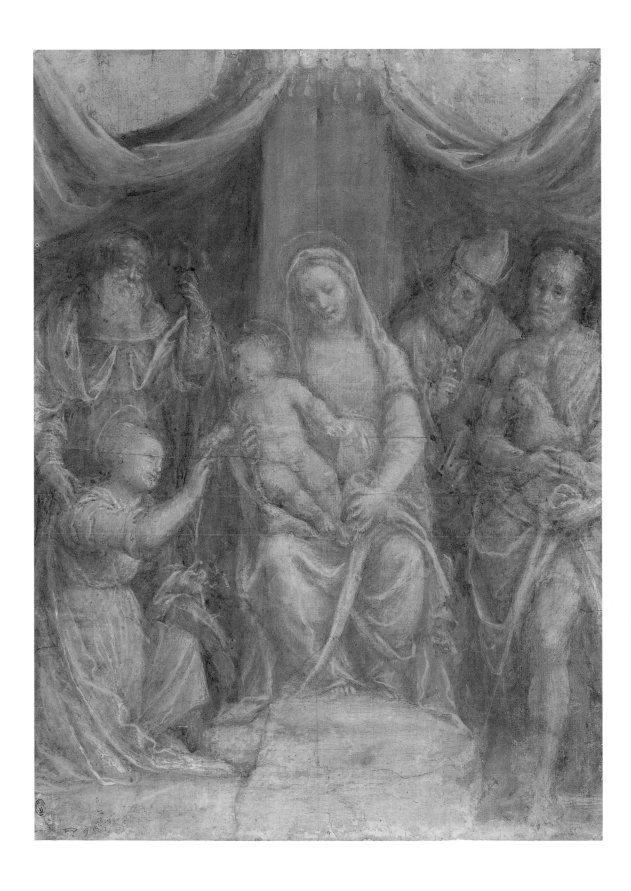

the overlaid washes could not be absorbed and dried by evaporation, leaving a soft, liquid appearance. Lead white was the colorant of the white body color, with animal glue as a binder, which shrank as it dried, causing a microscopic web of traction crackle. Lanino used concentrated white pigment for the final drawn layer, which lies on the surface of the drawing and captures raking light, showing the artist's painterly hand.

Fig. 1. Bernardino Lanino, *The Mystic Marriage of Saint Catherine,* 1580, oil on panel, 210.0 × 145.0 cm. Motta de' Conti, Sant'Annunziata.

Federico Zuccaro

SANT' ANGELO IN VADO 1543–1609 ANCONA

12. *David with the Head of Goliath,* about 1580

Pen and brown ink with wash on blue laid paper, 22.6 × 28.7 cm

PROVENANCE: Purchased from H. M. Calmann, London.

EXHIBITION: *Renaissance into Baroque: Italian Master Drawings by the Zuccari, 1500–1600,* Milwaukee Art Museum/New York, National Academy of Design, 1989–90.

REFERENCES: Calmann 1953, no. 13; Vey *Catalogue,* no. 117; McTavish 1985, p. 56; Mundy 1989, pp. 298–99.

Museum purchase, 1956.34

Fig. 1

The Zuccaro brothers, Taddeo and Federico, dominated painting in Rome in the later sixteenth century.[1] Their style combined the intellectual artificiality of Mannerism with the pictorial idealism of Raphael and the heroic expressiveness of Michelangelo. In 1550 Federico followed his older brother to Rome from the family home near Urbino, and through the succeeding decade he served as Taddeo's assistant. By 1560 Federico had begun to attract his own prestigious commissions, including a contract to decorate apartments in the Vatican in preparation for the visit of the grand duke and duchess of Tuscany, Cosimo de' Medici and Eleonora of Toledo.

In 1563 Federico was called to Venice where he painted murals in the Doge's palace. Afterward he worked in the Veneto and Lombardy before returning to Rome. When Taddeo died in 1566, Federico inherited his studio and commissions. He completed decorations in the Sala Regia in the Vatican and continued painting projects at the Palazzo Farnese at Caprarola. By 1573, when the artist traveled through Lorraine and the Netherlands on his way to England, Federico had attained wealth, fame, and the status of international courtier. In London he is said to have painted portraits of Queen Elizabeth I and members of her court, though none of these survives. Then the artist proceeded to Florence, where he painted *The Last Judgment* in the dome of the cathedral, one of the most important commissions of his career. In the mid-1580s King Philip II of Spain invited him to work at the palace of the Escorial, where he painted several altarpieces.

Back in Rome after 1588, Federico was instrumental in the reorganization of the Accademia di San Luca, the city's professional artists' guild, which incorporated an art school. He was elected its first president, and later he donated his house to serve as headquarters for the institution. His aesthetic theories were set out in his treatise *Le idea de' pittori, scultori ed architetti,* published in Turin in 1607.[2] Through this book Federico influenced succeeding generations of Italian and northern artists. Both Zuccaro brothers were prolific draftsmen, and large numbers of their drawings survive.[3]

The epic story of David and Goliath is one of only a few Old Testament subjects that Federico Zuccaro depicted. Many legends surround the shepherd boy who united ancient Israel, became its king, and made Jerusalem its capital. A wise and sensitive leader, David also was an accomplished musician and poet and is credited with composing the Psalms (no. 3). However, his most famous story is that of his boyhood encounter with Goliath, related in the Old Testament.[4] Once during a battle between the

Philistines and Israelites, each army called for a champion to fight on its behalf. The Philistines' finest warrior was Goliath of Gath; over eight feet tall, he fought in a suit of gleaming brass armor and wielded a spear "like a weaver's beam." David, a shepherd boy, bravely volunteered to oppose the giant, armed only with the leather sling he used to protect his flocks. He took one rock from his bag and hurled it from a distance, striking Goliath squarely on the forehead and killing him instantly. Then he decapitated the giant with his own sword, signaling the Israelites to attack. After the ensuing victory, David carried his opponent's head through the streets of Jerusalem. He was met by the Israelite women, who sang and danced in celebration of the young hero's courage and wisdom.[5] According to the Gospel of Matthew, Christ was David's direct descendant, and so the monarch was often represented in Christian art.

There is another drawing of David and Goliath by Federico Zuccaro, formerly in the collection of Duke Roberto Ferretti in Montreal, apparently a later and more refined conception of the present image (fig. 1).[6] In that vertical composition, the hero straddles the body of his vanquished enemy, rising to his feet after severing Goliath's head, which he holds squarely in the center of the composition. David McTavish suggested that the later drawing shows the influence of Michelangelo's Sistine Chapel paintings and also that both it and the Worcester sketch should be considered together as works made in preparation for one project.[7] Generally, the later sheet is the more carefully executed of the two, more detailed and more faithful to the biblical account. The artist changed the setting from a rocky landscape in the present sketch, with soldiers cowering behind distant trees, to a field before an army camp below a citadel. Many more foot soldiers are represented, foreshadowing the battle that will follow. Although the lower part of the later drawing with Goliath's body has been squared for transfer, no related painting has been identified. The style of the later drawing seems to indicate a date of about 1580.

Although the later sheet is more compact and resolved in its composition, the drawings share several motifs, such as the huge sword, Goliath's lifeless head, and David's peculiar topknot coiffure. In both images the hero's leather sling lies discarded on the ground, symbolizing the shepherd's life that David will now forsake to fulfill his royal destiny. In the later sheet David's arm positions and the angle of his glance are changed, and like the rest of the design, the face and costume are more carefully rendered. However, the pose and proportions of the figure are the same. Although its position has shifted, Goliath's

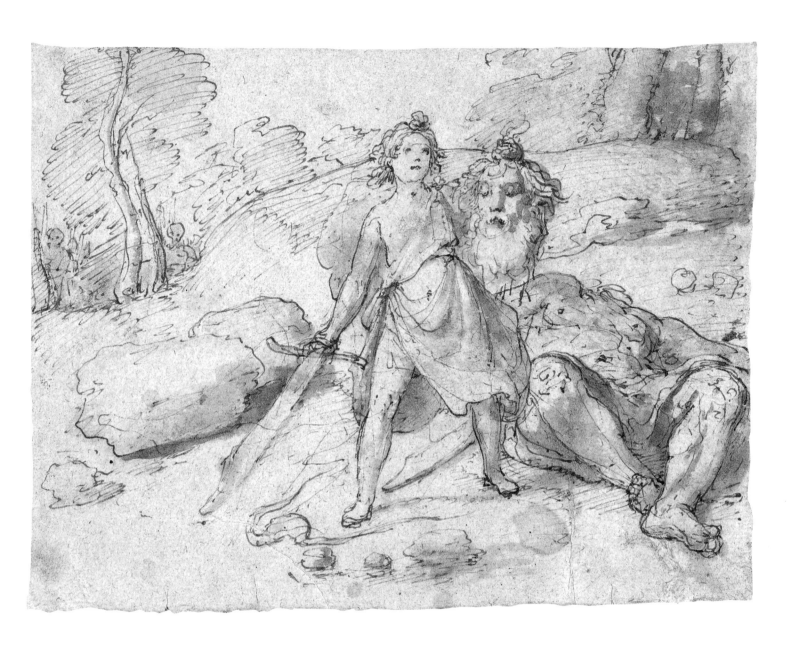

foreshortened, lifeless body is also similar in both images. Several pentimenti are visible in the present drawing, as in the positions of Goliath's legs and David's feet, but there are no such changes to the principal figures in the later drawing. All these refinements would be consistent with the progression from a rapid, interrogatory, inventive sketch to a more

considered preparatory drawing for a project that Federico Zuccaro seems never to have carried further.

Fig. 1. Federico Zuccaro, *David and Goliath,* ca. 1580, pen and brown ink with wash over red chalk on cream laid paper, partially squared for transfer in black chalk, 30.4 × 25.2 cm. Formerly Montreal, Collection of Duke Roberto Ferretti.

Hans Bol

MALINES 1534–1593 AMSTERDAM

13. *The Spies Returning from Canaan,* about 1588
A Summer Fête in a Fantastic Town, about 1593

The Spies Returning from Canaan

Gouache on vellum, laid down on paperboard, 14.2 × 20.9 cm

A Summer Fête in a Fantastic Town

Gouache on vellum, laid down on oak panel, 13.3 × 20.3 cm

PROVENANCE: Purchased from P. De Boer, Amsterdam.

REFERENCES: De Boer 1956; Worcester Art Museum *Annual Report,* 1957, p. 15; Merkel 1958, p. C7; Vey 1959, pp. 63–70; Dresser 1974, vol. 1, pp. 161–63.

Eliza S. Paine Fund in memory of William R. and Frances T. C. Paine, 1956.87, 1956.86

Fig. 1

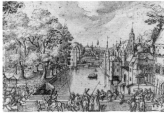

Fig. 2

One of the most influential Netherlandish landscape artists of the sixteenth century, Hans Bol was born in Malines on 16 December 1534. According to the contemporary Flemish biographer Carel Van Mander, he was fourteen years old when he began an apprenticeship with his two uncles Jacob and Jan Bol, who taught him the local specialty of painting in watercolors on canvas.[1] He was admitted to the painters' guild in 1560 and built a successful career.

When the Spanish forces of King Philip II occupied the city in 1572, Bol was completely dispossessed. He fled to Antwerp, where the hospitality and support of his admirer the collector Anthonie Couvreur enabled the artist to regenerate his career. He joined the Antwerp painters' guild in 1574 and obtained municipal citizenship in the following year. Because his watercolors were widely copied and sold as originals, Bol began to paint miniatures so small and detailed that they were beyond the forgers' abilities to reproduce. His reputation was also spread by his original genre and landscape etchings.[2] More than 350 prints after Bol's designs were produced by the most important Netherlandish engravers of the period. In 1584 the continuing wars with Spain drove the artist from Antwerp to the northern Netherlands, and eventually he settled in the prosperous city of Amsterdam, where he found a ready market for his landscape miniatures. He developed an international clientele, which included such prestigious patrons as the Elector of Saxony. In 1591 the artist received Amsterdam citizenship, and he died there two years later.

Although these two miniatures are similar in scale and style, their incongruous subjects show that they were not conceived as a pair. One depicts an expansive view of the Flemish countryside as the most bountiful region of the biblical Holy Land. This miniature illustrates a story from the Old Testament of how, during the Israelites' forty years in the wilderness, God promised that one day they would inhabit the land of Canaan, and he commanded Moses to send spies to explore the region.[3] They found a rich, abundant country, inhabited by strong people living in large, fortified cities. In the Valley of Eschol the Israelites cut down one enormous cluster of grapes and carried it back to Moses on a pole between two of them, to prove the bounty of the land.

This miniature is based on a landscape drawing by Bol, now at the Staatliche Kunsthalle in Karlsruhe, which is dated 1588, clarifying the miniature's illegible date (fig. 1).[4] To transform the contemporary view of his homeland into a biblical scene, Bol simply added the vignette of the Israelite couriers with their gigan-

tic grapes. Horst Vey recognized that the artist copied this motif from a woodcut illustration by Tobias Stimmer from Johann Fischart's book *Neue Künstliche Figuren Biblischer Historien* of 1576.[5] In conception, style, and technique, this miniature is comparable to several others Bol made in the late 1580s.

The companion miniature in the Worcester Art Museum collection represents a summer festival in an imaginary town, where tall, castlelike structures line long canals. Hundreds of townspeople have turned out, including many amorous couples. On a bridge spanning the immediate foreground several armored knights with lances prepare to meet each other in jousting tournaments. Two mounted trumpeters sound a fanfare to begin a contest, as from each corner a knight lowers his lance and spurs his horse toward his opponent. At this moment, however, much attention is given to another competition on the canal, where two warriors with swords and shields approach one another, each teetering on the prow of a boat and intent on knocking his opponent into the water. By directing attention from all sides of the composition to this central event, Bol made it seem as if we are part of the audience watching the festivities; we identify particularly with the embracing couple in the center of the composition, standing on the bridge parapet. Just behind the lovers the artist placed another man, who stumbles tipsily to the ground while looking directly up at us to wave.

Two extant drawings by Bol relate to this composition, one in the Musées Royaux des Beaux-Arts in Brussels and the other at the Kunsthalle in Hamburg (fig. 2).[6] The Hamburg sheet is without the competitors in the boats and their spectators, concentrating the activity on the equestrian tournament. The architecture, the trees, and many other details differ between the drawing and the present gouache. The Brussels drawing is inscribed 1593, suggesting a date for the present miniature. Several other studies and miniatures that Bol created around that time incorporate similar towering buildings clustered around a park, court, or canal.[7] The artist may have been prompted to depict such scenes by the Vijverberg and its surroundings in The Hague, an area with which he was certainly familiar.[8] He also may have derived these images from the designs of Hans Vredeman de Vries, whose illustrated treatises on perspective and garden design include several plates depicting imaginary castles, parks, and canals in strict one-point linear perspective.[9]

The medieval, aristocratic mode of this work recalls the works of the Limbourg brothers and other French and Burgundian book painters of the four-

teenth and fifteenth centuries. With its castle spires, courtly tournaments, and romancing couples, the miniature also reflects a nostalgic, romantic view of the Middle Ages fashionable in Bol's day. Henrik Bramsen suggested that Bol understood and purposely utilized the iconography of the "castle of love,"[10] a common theme in miniature paintings and ivory carvings of the fourteenth century in France.[11] The lovers and chivalric contests in Bol's miniatures are often close to the images on the ivories, where attacks on castles defended by women symbolize suitors' assaults on the hearts of their beloved.[12]

Fig. 1. Hans Bol, *Landscape,* 1588, pen and wash, 14.7 × 21.3 cm. Karlsruhe, Staatliche Kunsthalle, 1950/II.

Fig. 2. Hans Bol, *A Tournament,* ca. 1593, pen and wash, 14.5 × 21.5 cm. Hamburg, Kunsthalle, 35803.

Francesco Vanni
SIENA 1563–1610 SIENA

14. *Saint Ansano Baptizing the Sienese,* about 1593

Black and red chalks on cream wove paper, 42.3 × 27.7 cm

INSCRIBED: In graphite on verso, lower center: *Collection P. J. Mariette;* in pen and brown ink on verso, bottom of sheet: *Io Fran.co Vanni pittore mi sobligo a esequire il seguente disegnio in pittura/a tela a olio per servitio della Altare de S. Ansano in Duomo secondo sobligo fatto da me [?]/sopra sotto el 14 della presente mese di Giugnio 1593 come giurnale dell'opera C[?]/E[?] lo giugunta di Span.a Tomaso operais accetto il seguente disegnio da esquire . . .* [illegible].

PROVENANCE: Crozat Collection; Pierre-Jean Mariette (Lugt 1852); purchased from Galerie Henri Baderou, Paris.

EXHIBITIONS: *The Practice of Drawing,* Worcester Art Museum, 1952; *Pontormo to Greco: The Age of Mannerism,* Indianapolis, John Herron Art Institute, 1954; *European Drawings from the Museum Collection,* Worcester Art Museum, 1958; *Le Cabinet d'un grand amateur P.-J. Mariette, 1694–1774: Dessins du XVe siècle au XVIIIe siècle,* Paris, Cabinet des Estampes, Musée du Louvre, 1967; *Visions and Revisions,* Providence, Rhode Island School of Design, Museum of Art, 1968.

REFERENCES: Worcester Art Museum *News Bulletin and Calendar,* vol. 17, December 1951, p. 6; Worcester Art Museum *Annual Report,* 1952, p. xiii; Herron 1954, cat. no. 43; Vey *Catalogue,* no. 115; Vey 1958, pp. 20–21; Riedl 1960, pp. 163–67; Worcester Art Museum *News Bulletin and Calendar,* vol. 27, December 1961, n.p.; Louvre 1967, pp. 100–101; Ostrow 1968, p. 25; Riedl 1976, p. 24.

Museum purchase, 1951.54

Fig. 1

The most important painter of the late Renaissance in Siena, Francesco Vanni made mostly devotional pictures.[1] His stepfather, Archangelo Salimbeni, was his first teacher, and he probably studied alongside his half brother, Ventura Salimbeni. During the late 1560s Vanni may have been the pupil of Bartolommeo Passarotti in Bologna. He developed a personal late Mannerist style related to the styles of Jacopo Pontormo and Francesco Salviati in Florence and to the Zuccari (no. 12) in Rome, where he may have visited. Vanni probably returned to Siena shortly after his stepfather's death in 1580, and he lived there for the rest of his life. During the 1590s the artist experimented with etching, perhaps with the encouragement of his half-brother, and under the influence of the prints of Federico Barocci. Although he produced just a few plates, Vanni later provided designs to other printmakers whose works helped to disseminate his style and reputation.

This sensitive and powerful image illustrates an episode in the life of the patron saint of Siena, who lived in the fourth century, when the city was part of the Roman Empire. Ansano, the scion of a noble Sienese family, became a Christian at the age of twelve. Soon he was preaching, converting his neighbors, and baptizing them into his new faith. His own father denounced him to the emperor Diocletian who, according to legend, had Ansano tortured in boiling oil before executing him in the year 303, when the saint was twenty years of age.

The present sheet is a drawing for Vanni's major altarpiece for the Siena cathedral, executed from 1593 to 1596 (fig. 1). A contract preserved in the cathedral archives describes Vanni's commission for the painting and approves the project "in accordance with the drawing by his hand which he has submitted to the office of works."[2] On the verso of the present drawing is an inscription that may be translated: "I Francesco Vanni painter pledge to execute this design as a painting on linen in oils to serve as the altar of Saint Ansano in the cathedral according to the promise which I made completely on the 14th of the present month of June 1593, as [recorded] in the journal of the office of works." This notation in the artist's hand demonstrates that the present sheet is the very presentation drawing Vanni used to communicate his conception for the altarpiece to the cathedral trustees.[3]

The young Ansano, with his halo and flowing robes, stands in the center of the composition, near a monumental colonnade that suggests the porch of a pagan temple. However, anachronistically, the medieval bell tower of Siena's Palazzo Pubblico can be seen in the background, a detail deleted from the finished painting. Townspeople gather around him

as the saint pours water from a cup to sanctify the ritual of baptism. At Ansano's feet a humble mother presents her son, who looks out at the viewer, inviting us to enter the miraculous scene. Other devotees hurry to the ritual, bringing their children or removing clothing in preparation for baptism. At the left two elders speak conspiratorially, pointing to the saint; they may be the temple's priests or Ansano's pagan father denouncing him. The saint's martyrdom is depicted in the drawing in the middle distance at the right. Christ looks down from his throne in the heavens above, surrounded by angels; before him kneels the Virgin, interceding for Ansano and the Sienese. Proof of her advocacy and of Christ's mercy is the dove of the Holy Spirit, which descends to the saint.

There are at least nine extant drawings by Vanni related to this important commission, now in the Uffizi in Florence, the Biblioteca Comunale in Siena, and the Princeton University Art Museum.[4] Although several of these are studies for various figures, the sheets in Florence and Princeton represent fairly complete and slightly different versions of the altarpiece. This extensive group of drawings reveals something of the painter's methods. Vanni clearly developed his ideas in rapid experimental drawings, and his motifs were afterward carefully combined in the working compositional drawings. Their basic composition is the same, with the saint standing on a platform and raising the baptismal cup to anoint a woman who kneels before him. However, in the painting the artist shifted the positions of the figures on the steps below. At the base of the steps the disrobing figure is on the left, and an old man in voluminous robes stands at the right. Above, the Virgin intercedes not with Christ but with God the Father, whose poses are nevertheless similar. In the Princeton sketch nearly all of the major figures have assumed the positions they hold in the final painting, and indeed that drawing is squared for transfer. However, the final painting shows that Vanni continued to develop and refine his design.

Highly detailed drawings, such as the present sheet, are not uncommon in Vanni's oeuvre. In its finish and soft modeling the Worcester sheet reflects the influence of Federico Barocci, which began to appear in Vanni's work in the late 1580s. The basic composition of the *Saint Ansano* altarpiece was modeled after Barocci's *Madonna del Popolo* of about 1575, which had been executed for a chapel in Arezzo.[5] Vanni's graceful red chalk drawings also reflect Barocci's faceted drapery style and his facial types with their round, full cheeks, and heavy-lidded eyes. Barocci often made preparatory drawings with two colors of chalk and even used colored pastels. In

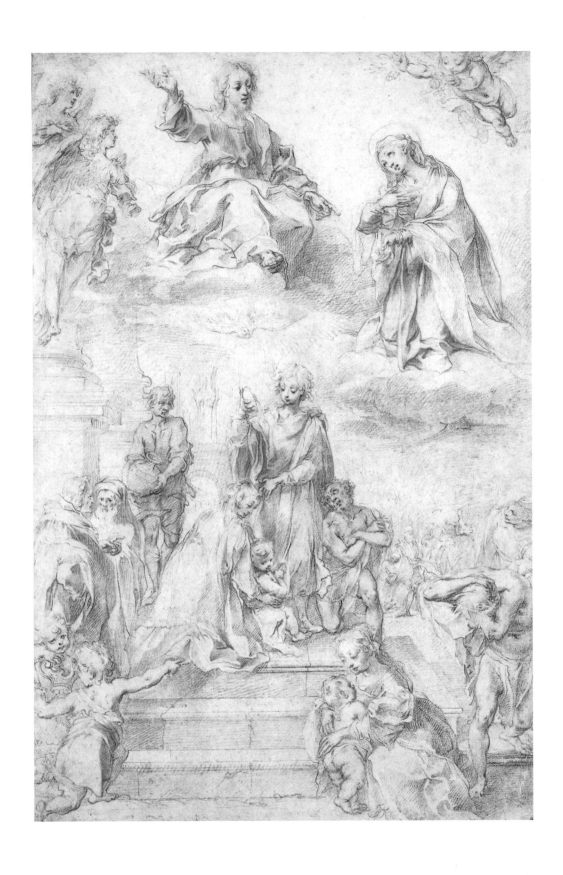

the present drawing Vanni lavished special attention on the faces of the primary figures, whose expressions convey the mood of the image, a feature that the artist particularly wished to convey to his sponsors.

Fig. 1. Francesco Vanni, *Saint Ansano Baptizing the Sienese,* 1593–96, oil on canvas. Siena cathedral.

Jacob Matham

HAARLEM 1571–1628 AMSTERDAM

15. *Ruins of the Palace of Septimus Severus on the Palatine,* about 1595–97

Pen and brown ink with brown wash and watercolor on cream laid paper, 42.0 × 29.5 cm

INSCRIBED: In pen and brown ink, lower center: *Roma.;* above: *HG* [effaced]

PROVENANCE: Purchased from H. M. Calmann, London.

EXHIBITIONS: *European Drawings from the Museum Collection,* Worcester Art Museum, 1958; *Rome,* Northampton, Massachusetts, Smith College Museum of Art, 1963; *Dutch Mannerism: Apogee and Epilogue,* Poughkeepsie, New York, Vassar College Art Gallery, 1970; *Northern Travelers to Sixteenth-Century Italy: Drawings from New England Collections,* Amherst, Massachusetts, Mead Art Museum, Amherst College, 1990.

REFERENCES: Vey *Catalogue,* 40; Vey 1958, pp. 22–24; Stechow 1970, p. 55; Boon 1980, p. 158; Courtright 1990, p. 26.

Museum purchase, 1956.22

Fig. 1

In 1579, when his widowed mother remarried, Jacob Matham became the stepson of Hendrik Goltzius, the leading engraver of the northern Netherlands in the late Renaissance.[1] Under this master's tutelage, Matham became a professional engraver and during his long career produced some three hundred prints after the designs of more than forty artists. During the late 1580s the youth became the Haarlem workshop's most consistent and prolific assistant, executing over fifty engravings after his stepfather's designs. In 1590–91 Goltzius made a journey to Italy that profoundly affected his art.[2] Matham himself left for Italy in 1593, and he stayed in Rome for about four years. He probably associated there with resident Netherlandish artists, including Paul Bril, Jan Bruegel the Elder, and Aegidius Sadeler. Like his mentor, Matham made drawings of the landscapes and works of art he saw. He also collected prints and drawings by Italian artists, and after his return to Haarlem he began to work on a long, albeit sporadic, succession of engravings after the works of such artists as Michelangelo, Raphael, and the Zuccari (no. 12).

Matham seems to have taken over responsibility for much of the thriving family print shop and publishing house in 1600, when Goltzius turned away from printmaking to concentrate on painting. In that year Matham was elected to the Haarlem painters' guild, and he became a deacon in that organization in 1605. During his maturity the artist made prints after the designs of Abraham Bloemaert, Sebastian Vrancx (no. 19), and at least twenty-six other Netherlandish and German artists. Under his direction the company shifted its specialty from virtuosic Mannerist engravings to prints after many painters of the golden age of Netherlandish painting. Two of Matham's three sons—Adriaen and Theodor—became engravers and worked in the shop.

Matham probably executed the present drawing during his time in Rome; it represents the ruins on the Palatine Hill in Rome as they appeared at the end of the sixteenth century. The ruins are those of the palace built by the Roman emperor Septimus Severus in an ambitious building campaign at the end of the first century A.D. The floors of what were once interior spaces are covered with rubble and soil several feet deep, judging from the arches spanning doors, which are near the ground in this drawing. Brickwork has been exposed, as the concrete skin of the building has fallen away in random fractures. Vegetation grows on top of the ruins and hangs down into the darkened chambers in leafy, picturesque swags. Bushes also have sprouted inside the building in areas exposed to sunlight. Shifting light and long shadows across the ground are evocatively rendered, not only emphasizing the interior space but also, for a northern viewer, evoking the bright Mediterranean sunshine.

The drawing's vertical composition emphasizes the vast scale of the ruins. A similar illusion of depth is achieved by the receding architectural spaces, measured by distant archways of diminishing scale and by a glimpse of the sky above. Matham also suggested the scale of the building by placing two figures in the lower left corner of the drawing. These are not detailed enough so that they or their activities can be identified, but their reclining positions vaguely evoke the traditional poses of ancient river-gods. The foreground figure seems to concentrate on something cradled in both arms before him; perhaps he is reading.

This sheet was formerly ascribed to Goltzius, whose monogram once appeared above the legend *Roma.* The drawing entered the museum collection with an attribution to Paul Bril and was published as such by Horst Vey.[3] Wolfgang Stechow suggested an attribution to Matham in 1970.[4] It has long been recognized that a sheet now at the Institut Néerlandais in Paris is comparable in subject, style, and technique and is certainly by the same hand (fig. 1).[5] This hypothesis has been convincingly supported by Karel G. Boon.[6] Both drawings are modeled with scribbled zigzag hatching to quickly fill up and shade the carefully drafted architecture. The artist included figures in the foreground of the Paris drawing. They are more carefully rendered than those in the present drawing and hold pencil and paper, clearly identifying them as artists sketching in the ruins. They are balanced by another figure who stands high atop the ruins. Posed like an ancient sculpture, he points to some unseen feature of the ruins, almost as if to direct the attention of his companions and the viewer. The curved parallel hatching, seen in the foreground hillocks and rocks, is rendered in the swelling pen lines used by Goltzius and Matham. The arbitrary passages of colored wash on the Worcester drawing are similar to those found in the drawings of Carel Van Mander, the Haarlem painter who was Goltzius's closest friend. It is reasonable to speculate that Matham adopted Van Mander's technique. In 1603 Matham sketched *The Ruins of Brederode Castle* near Haarlem, a drawing that also has stylistic affinities to the present sheet.[7] Their imagery and style suggest that Matham executed both the Worcester and Paris drawings during his sojourn in Rome, when he was inspired by the work of Jan Bruegel the Elder and Paul Bril, and inevitably incorporated the strong influences of his stepfather, Hendrik Goltzius.

Fig. 1. Attributed to Jacob Matham, *Artists in the Ruins on the Palatine Hill*, ca. 1595, pen and brown ink with wash, 42.0 × 30.1 cm. Paris, Fondation Custodia Collection Frits Lugt, Institut Néerlandais.

Attributed to Peter Paul Rubens

SIEGEN 1577–1640 ANTWERP

16. *The Council of the Gods,* 1601

Brush and brown ink with ink washes and gouache on cream laid paper, 20.2 × 28.0 cm

PROVENANCE: Prosper Henry Lankrink (Lugt 2090); Philip Hofer, Boston.

EXHIBITIONS: Northampton, Massachusetts, Smith College, 1939; Cambridge, Fogg Art Museum, Harvard University, 1944; *European Drawings from the Museum Collection,* Worcester Art Museum, 1958.

REFERENCES: Worcester Art Museum *Annual Report,* 1950, p. xii; Worcester Art Museum *News Bulletin and Calendar,* vol. 15, May 1950, p. 32; Vey *Catalogue,* pp. 25–26.

Gift of Philip Hofer in honor of the Presidency of Frank C. Smith, Jr., 1950.247

Fig. 1

The preeminent Flemish painter of the Baroque age, Peter Paul Rubens was also a skillful and prolific draftsman. He was the sixth child of Jan Rubens, an Antwerp magistrate who was denounced as a Calvinist and forced into exile.[1] The family moved to Siegen in Westphalia, where Peter Paul was born. Two years after Jan Rubens's death, his widow returned to Antwerp and raised her children as Catholics. Peter Paul began his artistic training in 1591 as an apprentice to the landscape painter Tobias Verhaecht, and during the succeeding decade he also worked in the studios of Adam van Noort and Otto van Veen.

In 1600 Rubens journeyed to Italy, where he worked for Duke Vincenzo Gonzaga in Mantua. He made extended visits to Rome, and his style was transformed by studies of antique art and such masters as Raphael, Michelangelo, and Titian. Rubens executed major painting commissions at this time, for churches in Rome, Genoa, and Fermo. He also began a diplomatic career with a mission to the Spanish royal court in 1603. When his mother died in 1608 Rubens returned to Antwerp, where he soon became court painter to Archduke Albert of Austria and his wife, the Infanta Isabella Clara Eugenia, viceroys for the king of Spain. Rubens married Isabella Brandt in 1611 and began a family. A period of great productivity followed, and the artist's many commissions included portraits, triptychs for the Antwerp cathedral, as well as altarpieces and designs for thirty-nine ceiling paintings at the Jesuit church at Antwerp. From 1622 to 1627 he was in Paris, at work on a series of paintings representing the life of Marie de Médicis, conceived to decorate the Luxembourg palace.

Rubens's life changed profoundly after the deaths of his eldest daughter in 1623 and his wife three years later. He dedicated more time to diplomatic activities, traveling to Madrid to negotiate a treaty with Spain in 1628. The artist charmed King Philip IV, who ordered paintings from him and appointed him secretary to the privy council of the Netherlands. Another important mission followed in 1629–30, to England, where Rubens received a knighthood from Charles I and painted the ceiling of the banqueting hall at Whitehall palace. Late in 1630 the artist married Hélène Fourment, a young beauty who was often his model. Late in his career, with the aid of a large and prolific workshop, Rubens produced decorations for the Torre de la Parada, a royal hunting lodge near Madrid. The artist died on 30 May 1640 and was buried in the church of Saint Jacques in Antwerp.

Drawing copies of other works of art was a rudimentary part of Rubens's education, and he contin-

ued the practice throughout his career.[2] The artist made many such copies when he was in Italy to keep as a personal library of composition and motif for later reference. He also collected drawings by other artists, sometimes reworking them in pen and ink and body color. He even engaged other artists to make copy drawings, studies that he often furbished and amended.

The present drawing is a copy of a fresco painted by Raphael and his workshop in the Loggia de Psiche of the Villa Farnesina in Rome around 1513 (fig. 1). This long, narrow arcade is decorated in trompe l'oeil to appear as a leafy bower, hung with tapestries that depict the myth of Cupid and Psyche.[3] The drawing shows part of the ceiling, where the pagan gods are assembled to meet the mortal Psyche, newly betrothed to Cupid, the god of love. In the fresco the deities are identifiable by their attributes, but most of these details are absent from the drawing, and the focus shifts to the figures themselves. Rubens successfully imparted distinctive personalities to these figures, and each has an emotional and psychological identity. On the left is the two-faced Janus, Roman god of beginnings, who in Raphael's ceiling converses with Mercury, looking with his other, older face, toward Psyche at the right. Hercules, recognizable by his club and lion skin mantle, sits with his back to Janus. The prominent figure of Hercules was adapted from the fragmentary Hellenistic sculpture known as the Belvedere torso, and Raphael's reconstruction of the antique figure may well have been the focus of Rubens's interest in this particular passage from the fresco. At the center of the drawing, a bearded figure in a turban carries long metal tongs, identifying him as Vulcan, the god of fire and blacksmith to the Olympians. On the extreme right is the youthful Bacchus, now without the grapevine wreath he wears in the fresco. In the foreground recline two river-gods, each leaning on a great urn, the source of fluvial waters. A swag of fruits and foliage suggests the rivers' fertility in Raphael's mural; in the drawing this motif has become an ambiguous grassy tussock from which one old man's face emerges. Other such incongruities confirm that the present drawing was meant as an exercise, not a purposeful working sketch.

Scholars agree that Rubens's hand is apparent here, but opinions vary about the degree of his involvement. Julius Held suggested that the drawing was principally the work of another artist, retouched by Rubens.[4] He noted that the master seldom excerpted whole groups from larger compositions. Michael Jaffé, however, suggested that Rubens may have executed the drawing himself.[5] He observed that its style and technique are comparable to those of other

sketches made during the artist's first visit to Rome in 1601. In its seamless integration of drawing media, and its touches of pink, cream, gray, and pale green gouache, the sheet is very close to other drawings made at this time. Rubens was deeply interested in Raphael, and it is reasonable that he should visit the Villa Farnesina, with its famous frescoes.[6] Another drawing by Rubens after the Villa Farnesina frescoes is now at the Pierpont Morgan Library in New York.[7] Executed in red chalk and touched with

chalk wash and oil paint, it depicts Venus from one of the loggia pendentives; on its verso is a sketch of the two river deities from *The Council of the Gods*. Universally accepted as by Rubens's hand, this drawing supports the notion that the artist visited the Villa Farnesina and had the opportunity to execute the present drawing.

Fig. 1. Raphael, *The Council of the Gods,* ca. 1513, fresco. Rome, Villa Farnesina.

Hans Heinrich Wägmann
ZURICH 1557–ABOUT 1628 LUCERNE

17. *Prudence,* about 1610

Pen and black ink with gray wash on cream laid paper, squared in black chalk, 24.1 × 18.0 cm

INSCRIBED: In graphite on verso, lower right: *Werner Kubler/Schaffener*

PROVENANCE: Unidentified collector's mark, lower right; purchased from C. G. Boerner, New York.

REFERENCES: Boerner 1987, no. 6; *Simiolus,* vol. 21, 1992, p. 221.

Sarah C. Garver Fund, 1994.226

The style and technique of this drawing are characteristic of Swiss seventeenth-century designs for stained glass; thus the sheet was once ascribed to the Schaffhausen glass painter Werner Kübler the Elder. However, both Tilman Falk and Eckart von Borries correctly identified the hand as that of Hans Heinrich Wägmann.[1] The most versatile artist of the late Renaissance in Lucerne, Wägmann was a muralist and panel painter who produced topographical views and miniatures, as well as designs for prints, heraldic decorations, and glass engravings.

The artist was baptized in Zurich on 12 October 1557.[2] Although his father was a merchant, on his mother's side Wägmann belonged to a large, extended family of artisans. His maternal grandfather was the Zurich medalist Jakob Stampfer; the goldsmith Hans Heinrich Stampfer and the glass painter Ulrich Jakob Funke were also among his relatives. Nothing is known of Wägmann's training; by April 1580 he had attained professional stature when he was admitted to the Vintners' Guild, the professional organization in Zurich to which painters belonged. From that year there are records of payments to him for two paintings in the city tower *(Oberdorftor),* works on which he collaborated with Heinrich Bau.

On 17 October 1582 Wägmann immigrated to Lucerne. It may have been religious persecution that prompted young Wägmann's move or his relationship with Margarethe Geilinger, whom he married within the year. They raised four sons who all became artists. Wägmann was readily accepted in Catholic Lucerne and, beginning in 1582, consistently received important local commissions. In 1584 he painted the choir screen for the chapel of the Virgin in Eigenthal. Five years later he won the prestigious municipal commission to represent the local legend of the Giant of Rheiden in murals on the exterior of the town hall tower. For this accomplishment Wägmann and his sons were granted full citizenship by the city of Lucerne. In 1590 the artist began three altarpieces for the new Jesuit church of Saint Michael. He also painted the high altarpiece for the Lucerne cathedral; its designs were derived largely from prints, showing how Wägmann studied German masters of earlier generations, especially Albrecht Dürer and Hans Holbein the Younger.

Wägmann's best-known works were his paintings for the Kapellbrücke, or chapel bridge, a fourteenth-century structure spanning the Reuss River in central Lucerne. In 1599 the city fathers commissioned the thematic program from Lucerne's poet laureate Renward Cysat, but not until January 1611 was it decreed that the bridge should be decorated with painted panels. A document records Wägmann's pay-

ment for four paintings in 1614. The paintings represented the history of the Helvetian Brotherhood *(Eidgenossenschaft)* and scenes from the lives of Saints Leodegar and Mauritius, the patrons of Lucerne. Most of them were multifigured narrative scenes in expansive landscape settings and derived extensively from earlier German and Swiss prints. The paintings were periodically restored because they were out of doors and exposed to the elements for 350 years. When the span collapsed in 1741, some of the panels fell into the river; the bridge was soon rebuilt. In 1991 the bridge was devastated by fire, and forty of Wägmann's panels were destroyed. Today the ninety surviving paintings are kept at the Historisches Museum in Lucerne, and the bridge is decorated with photographic reproductions.

Although the exact date of the artist's death is not known, his son Hans Ulrich presided over the division of his estate on 11 November 1628. Only about forty drawings by Wägmann are known today, a small number for an artist who had such a long and successful career.

This piece represents the personification of Prudence, one of the four cardinal virtues, identified by her traditional attributes, the looking glass and snake. The mirror symbolizes that she is cautious enough to be aware of what is behind her and capable of seeing herself as she really is. The Evangelist Matthew's exhortation "Be wise *(prudentes)* as serpents" may have led to the snake's becoming another attribute for Prudence in the Middle Ages.[3] Here the woman grasps the serpent carefully by the neck; its writhing coils echo the shape of her furling drapery beneath. In her pose and proportions the elegant figure reflects Wägmann's understanding of anatomy gained by artists in the Italian Renaissance. However, the drawing style is linear, and the artist delighted in the flat, calligraphic patterns on the surface of the sheet. This exaggeration of the drapery, in both volume and movement, was characteristic of Swiss art of the time and can be found as well in the works of such artists as Hans Bock the Elder and Tobias Stimmer.

Although no other works by Wägmann have been identified that include this figure, it is likely that Prudence was meant to accompany her sisters in a wall painting or stained-glass cycle. Such allegorical figures probably appeared in the artist's decoration of the council chamber of the Lucerne town hall. Surviving records of Wägmann's payment for this project do not include a description of his subjects. Although the council chamber was repainted in the eighteenth century, the Virtues remain a part of its decorative program. The present drawing is squared, or superimposed by a grid drawn in black chalk, a

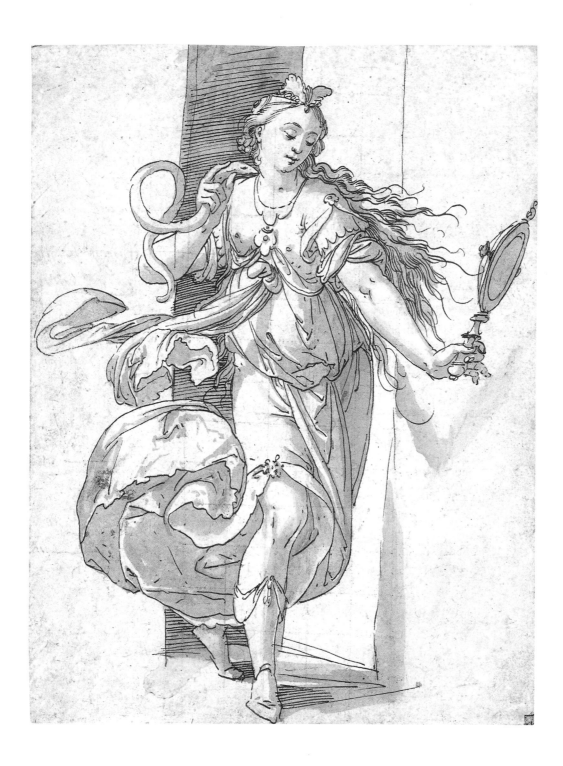

device used to transfer the design to another surface or alter its scale. This would seem to support Heinz Horat's speculation that the present sheet may have been a preparatory design executed in conjunction with that project.[4]

Wägmann may have derived the subject and style of this figure from earlier works by Hans Holbein the Younger. In the Basel Kupferstichkabinett there are sixteenth-century drawings that copy Holbein's designs for the allegorical figures of Wisdom and Temperance.[5] They are believed to relate to Holbein's unfinished mural cycle of the 1520s in the great council chamber of the Basel town hall, paintings that

certainly would have been familiar to Wägmann.[6] The drawings represent long-tressed maidens who stand in shallow niches, carry similar attributes, and are dressed in voluminous, blowing draperies. A harsh light falls across each from the side, casting deep shadows that serve to emphasize the illusion of dimension. In its pose and proportions the present figure is very close to a chiaroscuro drawing in Holbein's hand dating from the 1530s, *Young Woman Throwing a Stone*.[7] That sheet, now in the Basel Kupferstichkabinett, depicts a figure that was itself probably derived from engravings of the school of Raphael.

Giovanni Francesco Barbieri, called il Guercino

CENTO 1591–1666 BOLOGNA

18. *Domestic Conflict,* about 1621

Pen and brown ink on cream laid paper, 28.8 × 26.4 cm

WATERMARK: Bird in a circle under a six-pointed star (similar to Briquet 12210)

INSCRIBED: In graphite, lower left: *Guerchin*

PROVENANCE: Sir Peter Lely (Lugt 2092); Jean-Denis Lempereur (Lugt 1740); Lionel Lucas (Lugt 1733a); Claude Lucas; purchased from H. M. Calmann, London.

EXHIBITIONS: *Six Centuries of Master Drawings,* Iowa City, State University of Iowa, 1951; *The Practice of Drawing,* Worcester Art Museum, 1951–52; *European Drawings from the Museum Collection,* Worcester Art Museum, 1958; *Art in Italy, 1600–1700,* Detroit Institute of Arts, 1965; *The Figure in Mannerist and Baroque Drawings,* Storrs, University of Connecticut, 1967; *Drawings by Guercino and His Circle,* South Hadley, Massachusetts, Mount Holyoke College Museum of Art, 1974; *Guercino, Master Draftsman: Works from North American Collections,* Cambridge, Arthur M. Sackler Museum, Harvard University/Ottawa, National Gallery of Canada/Cleveland Museum of Art, 1991.

REFERENCES: Christie's 1949, lot 49; Heckscher 1951, cat. no. 65; Worcester Art Museum *News Bulletin and Calendar,* vol. 17, December 1951, p. 3, no. 28, ill. p. 5; Stout 1951; Vey *Catalogue,* p. 93; Vey 1958, p. 25; Worcester Art Museum *News Bulletin and Calendar,* vol. 27, December 1961, n.p.; Cummings 1965, p. 102, fig. 106; Stone 1991, pp. 190–91.

Museum purchase, 1951.21

Fig. 1

Guercino was the most prolific and influential draftsman of the Italian Baroque. He got his unusual nickname, which means "the squinter," from his crossed eyes, said to result from a childhood accident.[1] He was born and baptized in the village of Cento. His natural talent as a draftsman was recognized when he was very young and led to his first apprenticeship with Paolo Zagoni in nearby Bologna. By 1607 Guercino had become an assistant in the studio of the painter Benedetto Gennari the Elder, and soon he and the master were full partners.

The artist attracted the attention of Antonio Mirandola, canon of San Salvatore in Bologna, who provided Guercino with his first independent commission for an altarpiece in 1613 and became a close friend and patron. In 1616 the artist set up a drawing academy in the house of Bartolommeo Fabri, one of his Centese patrons, and quickly attracted students and assistants. In letters written in 1617 Ludovico Carracci mentioned that Guercino was in Bologna and at work on a commission for Cardinal Alessandro Ludovisi, archbishop of Bologna. In 1619 an engraved book of his anatomical drawings brought Guercino to the attention of Ferdinando Gonzaga, the duke of Mantua. He executed a painting for the duke and personally delivered it to him in 1620 at Ferrara, where the artist was rewarded with a knighthood. A similar award of nobility followed from one of his major patrons, Cardinal Jacopo Serra, the papal legate of Ferrara.

When the Bolognese cardinal Alessandro Ludovisi became Pope Gregory XV in 1621, Guercino was called to the Vatican. His experiences in Rome brought him lasting prestige. The crowning achievement of his activity there was his *Saint Petronilla* altarpiece, which was installed in Saint Peter's in 1623. Among his most important secular works were the decorations of the Casino Ludovisi, with its famous *Aurora* ceiling fresco.

After the death of Pope Gregory in 1623, Guercino returned to his hometown to preside over a large workshop. Although he never married, the artist became the breadwinner for the family of his late partner, Gennari. His assistants included the master's sons Bartolommeo and Ercole Gennari. The latter married Guercino's sister Lucia in 1628, and their two sons also grew up to be Guercino's assistants. In the village of Cento this workshop produced paintings and drawings that were sent across Italy and beyond.

In 1642 Guercino and his entourage moved to Bologna. Soon, after the death of Guido Reni, he became the city's preeminent painter. Under Reni's lingering influence, Guercino's style became more staid. He executed commissions for the principal

Bolognese churches and many other prestigious religious and secular contracts, including notable paintings for members of the French court and for Emperor Ferdinand III. Guercino died on 22 December 1666 and was buried in the church of San Salvatore in Bologna.

Guercino produced a remarkably broad and diverse body of drawings, which number in the thousands.[2] His paintings were always preceded by copious preliminary studies, ranging from quick sketches of fleeting ideas to methodical refining studies. A different side of his artistic personality is found in the drawings that Guercino made for his own pleasure, including landscapes, genre studies, caricatures, and capricci. In the catalogue for the sale of the Lucas collection in 1949, the present drawing was called *The Enraged Husband,* and its title at the Worcester Art Museum has always been *Domestic Conflict.* However, rather than a genre scene, it probably depicts an episode from popular theater.[3] The well-dressed assailant in this vehement quarrel wears a sheathed saber at his belt and a bandoleer with wooden gunpowder cartridges for his flintlock pistol, weapons that seem to identify him as a cavalier. His victim screams hysterically, while trying to push away the muzzle of his gun. She wears decorated shoes and an elegant dress with frills at the neckline, suggesting that she may be a gentlewoman or a prostitute. The violence of this scene is emphasized by the terrified, naked boy and by the chair overturned on the floor. The rush-seated chair, of the sort to be found in a tavern, provides the only clue to the setting. One of the most striking features of this drawing is the cavalier's gaze, directed at the viewer as if to elicit consent, thus implying a relationship between an actor and his audience.

This sheet relates to several of Guercino's drawings depicting theatrical subjects, probably dating from around the time of his move to Rome in 1621. One drawing from this period, now in the British Museum in London, depicts a theater filled with eager spectators;[4] another, now in the Ashmolean Museum at Oxford, represents a performance in a tavern.[5] The actors are surrounded by a group of accompanying musicians and an audience that includes well-dressed gentlefolk and several carnival-like masqueraders. In the immediate foreground is an overturned chair, which may have indicated the kind of play that was being performed.

Yet another of Guercino's drawings at Oxford seems close to the present work (fig. 1).[6] It represents a woman whose distaff and keys identify her as a tavern mistress or head cook, who violently scolds a kitchen maid at her cooking fire. The positions of the figures in this sheet, and their relationship

of domination and threat, are parallel to those in the present drawing. Indeed, this confrontation appears very serious, for the descending movement of the aggressor and the angle of her spindle suggest that she might push her victim into the fire. The technique of the sketch, in which form is suggested by means of contoured parallel hatching, is also similar to that in *Domestic Conflict*. In both of these drawings the toppled chair is a prominent feature. Perhaps this motif was common in a type of popular play characterized by slapstick violence, immediately recognizable in the artist's time but lost to us today.

Fig. 1. Guercino, *A Kitchen Quarrel*, ca. 1621, pen and brown ink on cream laid paper, 23.8 × 27.7 cm. Oxford, Ashmolean Museum.

Sebastian Vrancx

ANTWERP 1573–1647 ANTWERP

19. *Studies of Carriages and Carts,* 1620s

Pen and brown ink over graphite
with wash on cream laid paper,
19.3 × 30.5 cm

INSCRIBED: In pen and brown ink,
lower right: *brugel.*

PROVENANCE: Purchased from
Richard Day, London.

EXHIBITION: New York, E. J.
Landrigan, 1985.

REFERENCE: Worcester Art Museum
Journal, vol. 8, 1984–86, pp. 63, 70.

Mr. and Mrs. Henry H. Sherman
Fund in honor of Timothy A. Riggs,
1985.20

Sebastian Vrancx was long remembered mainly as a battle painter, and some of his most accomplished pictures represent cavalry skirmishes or the raids of highwaymen during the Eighty Years' War. However, he also painted bucolic landscapes and genre scenes and had diverse interests and creative activities. Vrancx was born in Antwerp and baptized there in the Sint-Jacobskerk on 22 January 1573.[1] He probably began his studies around 1590 as an apprentice to the painter Adam van Noort. In 1594 the artist became a member of the Antwerp Chamber of Rhetoric, *de Violieren.*[2] He was deeply involved with this social and literary confraternity and authored many poems and plays, both comic and tragic, that were performed during his lifetime by members of his chamber, but are now lost. Around 1595 the artist embarked on a study trip to Italy, which was customary for Flemish artists at this time. His paintings executed there and classicizing imagery in works he made after his return to Antwerp attest to his experiences in the south.[3] Vrancx also was influenced by Paul Bril, a Flemish painter who spent most of his career in Rome. The artist was back in Antwerp by 1600, when he was listed as a master on the roll of Saint Luke's Guild, for which he served as assistant dean in 1611 and as head dean in the following year. In 1610 Vrancx was admitted to the Society of Romanists, a club of Netherlandish artists who had been to Italy and visited the relics of Saints Peter and Paul in Rome. This group, which included Jan Bruegel the Elder, Hendrick van Balen, and Otto van Veen, met yearly to honor the Roman saints and to reminisce about their time in Italy. Vrancx served as dean of that fraternity in 1617.

By this time Vrancx was quite a successful painter, and his work was much in demand. He painted Italianate landscapes with classical ruins, religious and mythological scenes, allegories of the months and the seasons, illustrations of Netherlandish proverbs, and carnival scenes, as well as battle pictures. Although most of his military paintings seem to represent unidentified, generic engagements, occasionally Vrancx depicted actual events, with some historical accuracy. In 1612 the artist married Maria Pamphili, the daughter of an art dealer and sister-in-law of the painter Tobias ver Haecht. He became a prominent figure in Antwerp artistic and social circles; he was a member of the fencers' guild and the civic guard, in which he served in the prestigious position of captain from 1621 to 1631. Many of Vrancx's designs were reproduced in prints. His activities as a designer for prints are attested by at least sixty-five drawings illustrating Virgil's *Aeneid,* which were never engraved but were conceived in mirror image to compensate for the reversal of the

intaglio process.[4] He collaborated in paintings with Hendrick van Balen, Jost and David Vinckboons, and his friend Jan Bruegel the Elder. Vrancx died on 19 April 1647 and was buried at the church of the Carmelites in Antwerp.

In this drawing of a diverse collection of horse-drawn carts, the scale and lighting of each vehicle are similar, and the foreground wagons occasionally overlap those behind. There is no setting, however, and the carts do not seem to occupy a continuous space but instead are crowded in efficient stacks on the sheet. Most of the vehicles are common working drays with wattle sides and roofs of cloth stretched over arched wooden staves, the type of cart the artist might well have observed on the streets. Among them are freight or farm wagons carrying barrels or hay. At the lower right a tethered pig naps in the shade under a van, and a cockerel surmounts the cart at the upper left. Some of the wagons are pulled by teams of horses driven by outriders so that the entire cart could be given to cargo. One vehicle, in the middle distance, stands out among the others as an elegant passenger carriage. This large wagon has paneled walls, a wide side door, and trunks riding in front and behind. It is drawn by a team of six horses with a pair of liveried drivers. Inside sits a fashionably dressed couple wearing capes, ruffs, and wide-brimmed plumed hats. On all the carts Vrancx depicted the harness with accuracy and detail that show his knowledge of its function; he also gave careful attention to the construction of the wagons and their suspension. Particularly well observed are the trapezoidal casks that swing from the backs of some carts, vessels that may have carried axle grease.

The detail and variety of the carts, and the fact that the vehicles are shown from several different viewpoints, suggest that Vrancx made this drawing as a repertorial study to be used as a model for later works. Another study by his hand recently appeared on the art market; representing a group of cannons and military wagons crowded together on a sheet, it is comparable to the present drawing in its scale, style, and technique.[5] Yet another similar sheet in Russia suggests that these drawings may all have once been bound together in a sketchbook. Vrancx's mature drawing style is economical, sure, and distinctive. The style of the present study is comparable to that of the drawing of a battle scene now at the Institut Néerlandais in Paris, to which it is close in date.[6] In earlier drawings, like those of the *Aeneid* series, Vrancx employed short, looping pen lines and a more extensive use of wash, in a manner akin to that of Bril. By comparison the artist's later drawings also utilize straight lines and more angular pen strokes that are full of energy and character. These

fluent, calligraphic lines, and the way that Vrancx
supplemented them with layers of wash, are reminis-
cent of the etchings of Jacques Callot, where
remarkably fluid and expressive *échoppe* lines are sup-
plemented by modeling networks of crosshatching.

Jusepe de Ribera, called il Spagnoletto

JÁTIBA, SPAIN ABOUT 1591–1652 NAPLES

20. *A Striding Philosopher,* late 1620s

Pen and brown ink on cream laid paper, 13.9 × 11.2 cm

PROVENANCE: Hans Beckmann (Lugt 2756a); purchased from W. M. Brady and Company, New York.

EXHIBITION: *Jusepe de Ribera, 1591–1652,* New York, Metropolitan Museum of Art, 1992.

Charlotte E. W. Buffington Fund, 1993.25

Fig. 1

One of the most eloquent painters of seventeenth-century Italy, Jusepe de Ribera became famous for his unflinching realism. Whether representing religious, historical, or mythological subjects, the artist strove to envision how such distant events might really have been. Born at Játiba, near Valencia, Ribera was the son of a shoemaker.[1] Little is known about his childhood or training. He was an accomplished professional by 1611, when he was recorded in Italy at work on a painting for the confraternity of San Martino for the church of San Prospero in Parma. Two years later he was in Rome, where along with his brother Juan he lived and worked among a small community of Spanish artists. The artist became acquainted with the work of Caravaggio, whose influence is apparent in Ribera's interest in dark, dramatically lighted images.

In 1616 Ribera went to Naples, then a possession of Spain, and he remained there for the rest of his life. He married the daughter of a Neapolitan painter and established a successful career. The artist stood out among Spanish and Italian painters of his time for his scenes from ancient mythology, which portrayed the Olympian gods with physical and character flaws that were very human. During the 1620s Ribera also executed several paintings depicting ancient philosophers as elderly, craggy peasants.[2] His religious paintings became so famous that in January 1626 Ribera was decorated with the Cross of the Order of Christ in a ceremony at Saint Peter's in Rome.

Since the artist attracted the patronage of the viceroys of Naples, many of his works were destined for Spain. In the mid-1630s he executed paintings for the Alcázar palace and the palace of the Buen Retiro in Madrid. He also received commissions from the Duke of Alcalá, who was the viceroy of Sicily, and the Count of Monterey, the viceroy of Naples.

In 1637 Ribera painted a *Pietà* for the sacristy of the church of the Convent of San Martino in Naples. In the following year Giovan Battista Pisante, the convent's prior, engaged him to paint a series of fourteen canvases for the church, representing patriarchs and prophets, a project completed in 1643. In April 1641 Ribera was engaged to report on the works left unfinished at the death of Domenichino in the Capella del Tesoro di San Gennaro at the convent of San Martino, and he was commissioned to complete the artist's altarpiece *Saint Gennaro Emerging from the Furnace.* At that time he also painted the famous *Clubfooted Boy,* now in the Louvre.

During the violent anti-Spanish uprising in Naples in the summer of 1647, Ribera and his family lived in the Palazzo Reale. When Don Juan of Austria, the illegitimate son of King Philip IV of Spain, came to Naples to repress the revolt, Ribera painted a large equestrian portrait of him, which is now in the Palacio Real in Madrid. After the revolt, when he returned to his house in Santo Spirito di Palazzo, Ribera was beset by ill health and financial problems. The artist's death was registered in parish records on 3 November 1652, and he was buried in the church of Santa Maria del Parto in Mergellina.

Ribera was unusual among the Neapolitan painters in his attention to drawing, generally a practice more common to the artists of Rome.[3] His paintings took shape only after a long process of drawing. The fluid rhythm and calligraphic line in this little sketch mark it unmistakably as the creation of Ribera's hand. Several of his drawings represent a similar figure of a bald, wizened old man, a character that seems to have fascinated the artist.[4] One of these figures, dressed in a toga, appears in Ribera's drawing now at the Achenbach Foundation for Graphic Arts in San Francisco (fig. 1).[5] In a few lines Ribera reflects his awareness of ancient art and classical culture, which he must have studied in both Rome and Naples.[6] The man in the present drawing is dressed in clothing of the artist's own time, but his pose and demeanor link him to antique representations of orators or philosophers. It is probable that this figure ultimately derives from ancient Roman portrait sculpture of the late Republic. The realistic, unflattering depiction of this philosopher, like the portraits of Roman patriarchs, enhances rather than tarnishes the intellectuality and moral rectitude of the subject. Although it is uncertain whether Ribera could have known the Republican *Portrait of an Old Man* from near Otricoli, which represents a wizened old man with a bald head, staring eyes, protruding lower lip, and high cheekbones, the man in the present drawing is particularly reminiscent of that famous sculpture.[7] The pose of Ribera's striding philosopher may also have been inspired by that in the well-known portrait of the emperor Augustus from Primaporta, now in the Vatican.[8] With his right hand raised and the index finger extended, Augustus is often presumed to be making an address; Ribera's philosopher projects an air of noble probity similar to the emperor's.

The style of the present drawing suggests that it was executed in the late 1620s, the same period as the Achenbach study and several of Ribera's other simple, expressive pen-and-ink line drawings. Moreover, both these works express the artist's own personality in their combination of historical allusion, truth, and caricature. Like Guercino (no. 18), Ribera executed many satirical sketches, including caricatures of contemporary figures, some of which were influenced by the commedia dell'arte.[9] The "punch line"

of the present image is the pair of tumbling, giggling
nude children who mock the pompous orator.

Fig. 1. Jusepe de Ribera, *Study of an Orator,* late 1620s, pen and
brown ink with red chalk on white laid paper, 19.5 × 14.0 cm.
San Francisco, Achenbach Foundation for Graphic Arts,
California Palace of the Legion of Honor, 1963.24.165.

Giovanni Benedetto Castiglione, called il Grecchetto

GENOA ABOUT 1609–ABOUT 1664 MANTUA

21. *A Satyr Family among Animals,* about 1635

Oil paint and gouache over red chalk on cream laid paper, 29.4 × 44.6 cm

PROVENANCE: Purchased from H. M. Calmann, London.

EXHIBITION: *European Drawings from the Museum Collection,* Worcester Art Museum, 1958.

REFERENCES: Worcester Art Museum *Annual Report,* 1957, p. 15; Vey *Catalogue,* no. 89; Worcester 1994, p. 123.

Museum purchase, 1956.38

One of the most innovative and influential Genoese artists of the Baroque period, Castiglione was active as a painter, draftsman, and printmaker. In his youth he studied in his hometown with Giovanni Battista Paggi, Giovanni Andrea de Ferrari, and Sinibaldo Scorza; from the last he may have derived his life-long interest in painting animals.[1] In his rich, naturalistic figure style, Castiglione also shows the influence of the Bassano family of Venice, who flourished in the sixteenth century. Castiglione was probably associated with Anthony van Dyck, who was in Genoa between 1621 and 1627. From that painter, who often developed his pictorial ideas in small oil sketches, Castiglione may have adopted the unusual practice of drawing in oil paints on paper.

Castiglione first visited Rome about 1632, and after a period of activity in northern Italy he returned there by 1647. His association in Rome in the orbit of Nicholas Poussin drew the artist to neoclassicizing themes of ancient history and mythology. In 1651 he settled in Mantua, where he became court painter for the ducal family, the Gonzaga. From 1659 to 1663, the final, productive years of his life, he lived in Venice and Genoa. Castiglione's mature, large-scale animal paintings were important to succeeding generations of artists because of their integration of figures and settings.

The earliest of Castiglione's brush drawings in oil on paper seem to date from the early 1630s, and most represent pastoral and Old Testament scenes. Their compositions are often organized like the present drawing, with animals and objects in a jumbled accumulation at one corner in the immediate foreground, before a broad leap of space to the distant background, where mountains rise beneath clouded skies. Castiglione's early oil sketches also are characterized by a tight, dense handling of paint and the use of many different colors.[2] As time progressed the artist's execution became more spontaneous, and he used fewer colors. The later drawings were executed in neutral hues, such as gray-green or ocher, and shaded in gray or heightened in white. During his maturity his style became spare, and his distinctive line became nervous and often angular. It would seem, therefore, that the present drawing was produced early in Castiglione's career. Indeed, it has been suggested that this precisely drawn and intricately colored oil sketch may be one of the artist's earliest surviving works in the medium.[3]

Castiglione was fascinated by the notion of all kinds of animals, wild and tame, coming together in an instinctive, peaceable stampede. Throughout his career he frequently returned to images of mythological or biblical subjects that feature gatherings of animals, in such paintings as *The Entrance of the*

Beasts onto the Ark (1654, Genoa), *God Creating the Animals* (ca. 1655, Genoa), and *Jupiter and the Birds* (before 1658, Genoa). At the National Gallery in Washington there is a later drawing in oil colors on paper, *Noah Leading the Animals into the Ark,* which is similar to the present work in its imagery.

The present drawing depicts the mythological realm of Arcadia, where a satyr family is at rest, surrounded by animals. They lie beneath a monumental decorated urn that emits billows of smoke, suggesting that their exhaustion may be the aftermath of the rites of Dionysus, the god of wine. This notion is supported by what seems to be the crown of grape leaves worn by the old satyr. At the right in the immediate foreground is a still-life vignette with luxurious draperies, crisp white linens, a feathered cap, and an unusual decorated vessel, perhaps meant to be an Asian blue-and-white glazed pot. This unusual compilation, which would seem to have its source in Netherlandish still-life painting, emphasizes the exotic quality of the image. Several of the animals, including ostriches, flying cranes, goats, dogs, and cats, are paired, and some of them seem to be engaged in mating rituals. Thus, the image also involves associations with the mysterious, instinctive aspects of mating and procreation, and evokes another of the artist's favorite themes, the story of Noah's ark. A canvas by Castiglione now in the Galleria Saubada at Turin is quite similar in imagery and mood to the present drawing. A staid and peaceful image, it seems to represent the sequel to a Dionysian celebration. Satyr families and nymphs huddle around sculptural herms and gigantic urns dotting the Arcadian landscape. However, most of the animals seem to be game rather than beasts that coexist peacefully with the satyrs. Glowing with the effects of wine, some of the satyrs sing, while others listen quietly and drowse.[4]

Frequently Castiglione depicted primordial and primitive subjects, and he was equally fascinated with both the pagan and biblical accounts of the early social development of mankind. Satyrs were another favorite subject, and they often appear in his paintings, drawings, and prints.[5] The ancient Greeks and Romans believed that these mythical beasts lived deep in the forests and mountains. They were hybrid creatures, half man and half goat, said to have sprung from the mingling of species during the orgiastic rites dedicated to Dionysus. The bestial side of the satyrs' makeup dominated their humanity. They were thought to be lazy, lecherous, and totally devoted to personal pleasure, in their daily lives and in the worship of their god. Thus they became symbols of hedonistic living. Castiglione often represented a lounging, besotted creature like

the old satyr in this drawing, leaning back on one straightened arm. His legs are spread to signify his immodesty, and a baby is perched there to indicate the creature's generative profligacy. His mate, with pointed ears that mark her race, is seen in only half-length, coddling her infant. The artist placed her in close proximity to a nanny goat to emphasize further her bestiality. The instinctive behavior of animals, the mythical, bestial lives of the satyrs, and perhaps even a suggestion of the intellectual and moral superiority of humans are all present in this intriguing image.

Circle of Rembrandt Harmensz. van Rijn

LEIDEN 1606–1669 AMSTERDAM

22. *The Beheading of Saint John the Baptist,* about 1640

Pen and brown ink with wash on cream laid paper, 21.6 × 19.6 cm

INSCRIBED: In pen and brown ink, lower left: *Rembrandt*

PROVENANCE: Bernard Houthakker, Amsterdam; purchased from Gutekunst and Klipstein, Bern.

EXHIBITIONS: *European Drawings from the Museum Collection,* Worcester Art Museum, 1958; *Exhibition of Drawings and Prints by Rembrandt,* Middletown, Connecticut, Davison Art Center, Wesleyan University, 1959; *Dutch Prints and Drawings of the Seventeenth Century,* Worcester Art Museum, 1979.

REFERENCES: Benesch 1954–57, vol. 3, no. 480a, fig. 599; Göpel 1956; *European Art This Month,* vol. 1, December 1956, p. 14; Gutekunst and Klipstein 1956, p. 36; *American Artist,* vol. 21, May 1957, cover, p. 6; *Art and Auctions,* vol. 1, 1957, p. 25, no. 253; *Art Quarterly,* vol. 20, Spring 1957, pp. 96, 98; *Arts,* vol. 31, May 1957, pp. 27, 29; Comstock 1957; *Pictures on Exhibit,* vol. 20, January 1957, p. 28; Worcester Art Museum *Annual Report,* 1957, p. 15; Worcester Art Museum *News Bulletin and Calendar,* vol. 22, February 1957, pp. 25–26; Vey *Catalogue,* no. 32; Vey 1958, pp. 27–29; Haverkamp-Begemann 1961, p. 51; Worcester Art Museum *News Bulletin and Calendar,* vol. 27, December 1961, p. 3; Sumowski 1963, p. 207, no. 31; Hennessey 1973, p. 179.

Museum purchase, 1956.99

For many years this drawing was given to Rembrandt, following the ascription written on the sheet by a former collector.[1] Egbert Haverkamp-Begemann was among the first to challenge the traditional attribution, and now most scholars agree that the sheet was probably drawn by a member of the master's workshop.[2] Werner Sumowski suggested that it may have been made by Ferdinand Bol.[3] Although there are affinities to drawings given to Bol, too few documented works by the artist are known to allow a confident attribution.[4] William Robinson noted that there are also similarities between the present sheet and drawings attributed to Gebrand van de Eeckhout, but that these too are not close enough to make a firm attribution.[5] This confusion stems from the intimacy of the artists gathered around Rembrandt in Amsterdam during the 1630s and 1640s. In an age when the quality of a work of art was more important than the identity of its creator, paintings and drawings by these artists apparently were conceived as products of the workshop at large. These works were made in an aspiring spirit of imitation and were not considered plagiary. Their attribution is further complicated by the fact that the students and assistants used the same materials and procedures as Rembrandt, who may even have collaborated in the creative process.

Regardless of its authorship, this is a masterful drawing. It uses composition and psychological relationships to tell a biblical story in human terms, making the tale enticingly accessible.[6] John the Baptist was a charismatic prophet who wandered through Judaea preaching the word of God, describing the coming of Christ the Messiah, and performing a ritual of spiritual cleansing by immersing his followers in water. When he publicly criticized the Roman governor Herod Antipas for marrying his sister-in-law, Herodias, John was arrested and imprisoned. A decadent banquet took place at Herod's court, and his proud stepdaughter, Salome, danced for the guests. So entranced was the governor by her performance that he rashly promised to grant her any request. Herodias told her daughter to ask for John's head on a silver plate. Though horrified by this demand, Herod had no choice but to honor the oath uttered before his guests. John was summarily executed and his head given to the evil Salome, who delivered it to her mother on the salver.

This drawing represents a moment just after John's execution, when the headsman presents Salome with her ghoulish trophy. The artist organized his design on a symmetrical framework around the motif of John's severed head, suspended just under the empty geometric center of the composition. This dreadful object is bracketed by the strong vertical figures of Salome and the executioner, who together form a stable H shape, fixing the action. The countenance of the dead saint seems pure and innocent, sharply contrasting with Salome's masklike glower. In just a few lines the artist skillfully delineated her face, expressing cruelty and determination as she gazes unafraid at her prize. A crowd of onlookers on the right beholds the event with both shock and morbid interest. Elegant costumes mark them as courtiers, visitors to Herod's banquet, and an array of varied poses and facial expressions suggests their different personalities. This variety is comparable to Rembrandt's own contemporaneous depictions of the execution of John the Baptist.[7] The architectural setting, with its diagonal wall opposite an open arch, is similar to compositions that Rembrandt created around 1640, such as in the etching *The Triumph of Mordecai.*[8] Symbolically this design also implies the theological significance of the moment depicted. Through the archway on the left, above and beyond the executioner's chopping block, is an intensely illuminated void. The strong geometry of the receding barrel vault guides the viewer's eye toward that fateful future. All the people ignore this light, yet John's prone corpse and the executioner's sword point to the bright expanse, away from the experience of the Baptist's time and toward the new Christian era.

Though this drawing was thoughtfully conceived, its execution was quick and instinctive, like that of many of Rembrandt's own drawings. The draftsman used a pen cut from a natural pipe of reed or bamboo, with its point trimmed at an angle so that by twisting the implement he could produce lines of variable width. However, the splines of the reed pen were fairly stiff and inflexible, causing the pen to discharge its ink quickly and requiring the artist to work in deft strokes. Generally his drawn lines are dark, fairly short, and blunt at their ends. Usually when the artist executed an inaccurate line or passage, he confidently corrected the image by overdrawing. In two passages, however, he felt the need to hide his mistakes. For the figure of the old man leaning on the parapet in the right foreground, and in the area of John's decapitated corpse, the artist covered the mistaken passages and redrew his corrections. He overpainted his mistakes with a brush and white wash. This watery paint soaked into the paper and partially dissolved the pentimenti drawn in iron gall ink underneath. Then, apparently before the paint had completely dried, the draftsman made his corrections again, using a wide reed pen. To some extent the superimposed ink bled into the wet areas and created soft, blurry lines. Finally, using a brush, the draftsman applied just a few areas of diluted ink to help to define the figures, and to clarify and add

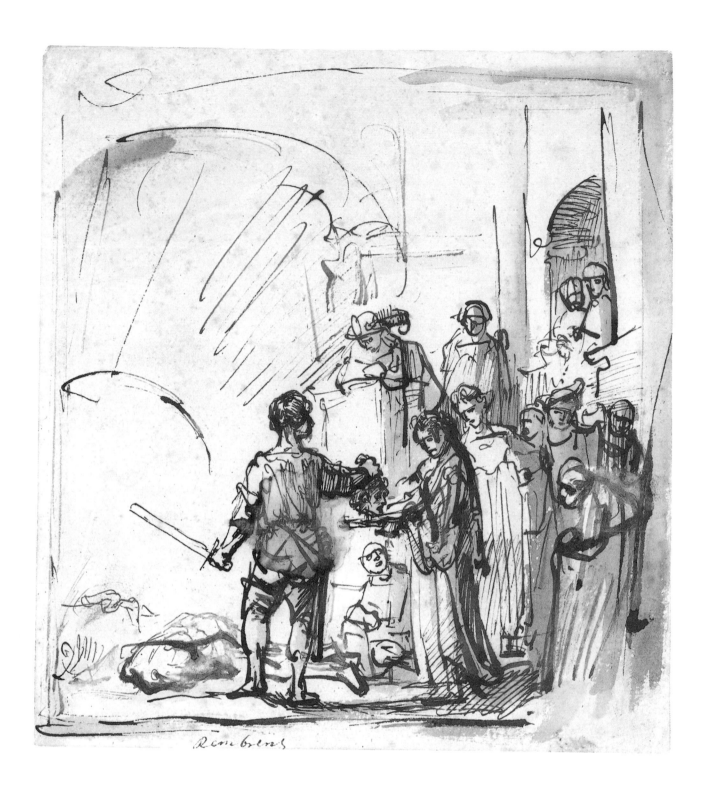

depth to the spatially complex setting. He layered light wash on the right side of the composition, darkening the lower corner, isolating by juxtaposition and drawing attention into the bright space opposite. Perhaps it was during this final stage that the draftsman splashed one blemishing drip from a wash-laden brush in the middle of the sheet and the figure of the executioner. Despite this stain, the drawing retains its sense of immediacy and emotional drama, combined with a mood of underlying gravity.

Stefano della Bella
FLORENCE 1610–1664 FLORENCE

23. *An Ostrich Hunt,* about 1654

Pen and brown ink on vellum, with later additions in black and brown inks over metal leaf, 20.2 × 40.4 cm

PROVENANCE: Hippolyte Destailleur (Lugt 740); purchased from H. M. Calmann, London.

EXHIBITION: *European Drawings from the Museum Collection,* Worcester Art Museum, 1958.

REFERENCES: Worcester Art Museum *Annual Report,* 1957, p. 15; Vey *Catalogue,* 86; Vey 1958, pp. 29–30; Worcester Art Museum *News Bulletin and Calendar,* vol. 27, December 1961, n.p.

Museum purchase, 1956.33

Fig. 1

The most influential Italian printmaker of his generation, Stefano della Bella produced more than one thousand etchings.[1] Several times this number of his drawings survive, reflecting his remarkable energy, broad interests, and distinctive artistic personality.[2] The son of a sculptor, he served an early apprenticeship with a goldsmith. Della Bella studied drawing and painting with Giovanni Battista Vanni, Cesare Dandini, and Giulio Parigi in Florence. The strongest influence on della Bella's early printmaking was Jacques Callot, the dashing master from Lorraine who was court etcher to the Medici, the grand ducal family of Tuscany. It seems that from Callot's prints della Bella learned to use the *échoppe,* a shaped etching needle that produces a fluid, calligraphic printed line. In 1627, at the age of seventeen, della Bella dedicated a print to the Medici. Soon he was accepted into the artistic entourage of the court, and in 1633 he was sent to complete his education in Rome, where he lived and worked in the Medici palace. During this period he produced many etchings representing important events in the life of the Medici family, the stock-in-trade of a court artist.

In 1639 della Bella was sent to Paris in the retinue of the Tuscan ambassador to the court of Louis XIII. He established a successful independent career there, working for French print publishers. He also executed commissions for the court and aristocracy, which included such eminent figures as the cardinals Richelieu and Mazarin. After returning to Florence in 1650, della Bella produced influential plates representing the Medici villas in Tuscany and the celebrations of the grand ducal court. He served as the drawing tutor for the future grand duke of Tuscany, Cosimo III de' Medici, and accompanied him to Rome in 1654–55. In 1661 a stroke abruptly ended della Bella's artistic activity, and he died three years later.

Hunting scenes are common among Italian prints of the seventeenth century. They appear frequently in della Bella's oeuvre, with such accurate details that we may assume the artist's extensive knowledge and experience of hunting. The style and imagery of the present drawing reflect della Bella's manner after his return to Florence from Paris in 1650. It relates to a suite of nine etchings that he issued about 1654, representing the hunting of different birds and animals.[3] The artist may have been inspired to create this series by the work of Jan Stradanus, a prominent artist at the Medici court in the mid–sixteenth century.[4] Many of Stradanus's designs were translated into works of decorative art in the Florentine workshops. Among them was a series of over one hundred images executed around 1568, representing the hunting of many kinds of game all over the world,

designed for a tapestry cycle that decorated the Medici villa at Poggio a Caiano.[5]

The present drawing is quite accurate in its representation of the ostrich, even in such details as the way the bird holds its head erect as it runs and extends its short wings. This precision suggests that the artist had closely observed an ostrich, perhaps in a courtly menagerie in Florence or Paris. However, the image represents a peculiar combination of game in a setting that appears to be European. Mountains rise in the background, delicately rendered with the light touch of a quill of the finest point. It seems a lush, bosky landscape; on the right, wooded hills rise before the peaks with trees that seem to be leafy and full. On the left, one of the hunters, who turns from the viewer, appears to have dismounted to restrain his hound and watch the chase, while a servant holds his horse. The hunter wears a large hat and sword and carries a spear that is reminiscent of the weapons used by Stradanus's equestrian ostrich hunters.

Horst Vey recognized that this drawing conflates details from two different etchings by della Bella: one representing the hunting of ostriches (fig. 1), and the other the chasing of deer with hunting hounds.[6] In the background of the former print, the hounds pursue another ostrich to the right and down a receding hill or riverbank. In the present drawing, however, this position is occupied by an antlerless deer, whose forequarters seem to have sunk into a river or beyond the brow of a hillock, while a hound snaps at its haunches. Thus it would seem that della Bella executed this drawing not in preparation for the prints but after them, perhaps as a presentation drawing. This notion is supported by the fact that the drawing was done on vellum rather than on paper, which was the more economical and conventional material for the artist.

The prints were made with more than one fine etching needle to produce delicately etched lines that were often varied by staged biting. These gossamer lines were subordinate to an overall, painterly cohesion. Della Bella used a very fine pen and similar thin lines in the present drawing. His touch was light and sure, and rather than unbroken contours he used a multitude of short hatchings to both outline and model form. It is the drawing style of a printmaker.

The decorative border on this drawing was added later by another hand, and it cannot be considered as part of the artist's original conception. Its ornamentation seems to be a pastiche, executed in unplanned stages. The acanthus cartouche surrounding and squeezing the central scene was drawn with pen and black ink over gold leaf. In comparison with that of della Bella, the drawing manner is awkward and

heavy handed. This element would seem to have
been done after the corner putti and female sphinxes,
which are uncomfortably cramped into the corners
and are overdrawn by the borderlines of the acan-
thus cartouche.

Fig. 1. Stefano della Bella, *The Ostrich Hunt,* ca. 1654, etching,
15.6 × 21.4 cm. Vienna, Albertina.

Luca Giordano

NAPLES 1634–1705 NAPLES

24. *Christ and the Woman Taken in Adultery,* about 1657

Pen and brown ink with wash over red chalk on cream laid paper, 20.7 × 34.4 cm

WATERMARK: The letters *O* above *M*

INSCRIBED: In pen and brown ink, upper left: *Amo;* lower left: *Adultera*

PROVENANCE: Purchased from Galerie de la Scala, Paris.

REFERENCE: Hoffmeister/Kreul 1995, pp. 15, 16, 19.

Eliza S. Paine Fund, 1995.40

One of the most prolific and cosmopolitan Italian artists of his time, Luca Giordano enjoyed a long and influential career. His great energy and effortless fluency gave him the nickname "Luca fa presto" ("Luca works fast" or "Luca the fast worker"). The son of the Neapolitan painter Antonio Giordano, he demonstrated such prodigious talent as a boy that the viceroy of Naples arranged a place for him in the workshop of Jusepe de Ribera (no. 20).[1] He became a trusted assistant and assimilated the master's style so completely that his early works have often been mistaken for Ribera's own.

Sometime between 1650 and 1654 Giordano traveled to Rome, Parma, and Venice. After he returned to Naples in 1655, Giordano's paintings became lighter and more decorative. He then began an independent career, gained membership in the painters' guild, and married Margherita d' Ardi. Giordano executed altarpieces for many of the churches of Naples and quickly became the city's leading painter. In Venice in 1667 he painted the *Assumption* altarpiece for Santa Maria della Salute and undertook several other ecclesiastical commissions.[2] By 1680 the artist had established an international reputation, and the most important patrons of Europe provided his commissions. He was invited by Grand Duke Cosimo III to Florence in 1682–83, when he painted the magnificent ceiling of the hall in the Palazzo Medici-Riccardi. In 1692 King Charles II called the artist to Spain, where he was named court painter. Giordano stayed in Spain for ten years, working chiefly for noble patrons, decorating chapels, churches, and palaces in Madrid, Toledo, and at the Escorial. The painter returned to Naples in 1702 and continued working at a hectic pace. When he died in 1705, his shop was engaged in ceiling frescoes in the Treasury of San Martino. The artist was buried in the church of Santa Brigida, which he had decorated fifty years earlier.

Giordano depicted the biblical story of Christ and the woman taken in adultery several times. The Pharisees brought this sinful woman to Jesus, for according to Hebrew law she should have been stoned to death, but the occupying Romans had deprived the Jews of the power to impose such a penalty.[3] Thus, the priests hoped to prompt Christ to offend one of these opposing authorities. In response he silently bent down to write with his finger in the dust on the ground, and then said, "Let him who is without sin among you cast the first stone at her." The woman's accusers fell silent and withdrew, and Christ forgave the woman and sent her away. Although the biblical account does not reveal what Christ wrote on the ground, medieval tradition suggested that he listed the Pharisees' sins,

Fig. 1

thus demonstrating his divine omniscience.

The present drawing probably documents Giordano's original conception for a project that culminated in two paintings, one now in a private collection in Naples,[4] and the other in the Kunsthalle in Bremen (fig. 1).[5] This is a first sketch in which the artist gave form to his developing concepts of how to tell this story visually. His first thoughts may have been noted on the verso of this sheet, where with just a few quick lines of red chalk he drew one stooping figure and the face of another turned up and to the side. On the recto Giordano redrew the locations and poses of the main figures in red chalk, then he swiftly detailed these figures and tested others with a fine reed pen and iron gall ink. Finally, using a brush, the artist applied washes of ink, modeling form, indicating setting, and emphasizing the main formal elements of his composition.

In Giordano's original conception, Christ stoops down, concentrating his gaze and attention before him, as he reaches out his finger to write in the dust.[6] The Pharisees react with annoyed wonder, bowing, scratching their heads, and one even using an eyeglass to see the legend in the dust. Christ and the accused woman are highlighted to set them apart from the background and surrounding figures. Even though she is restrained and threatened, the woman in the drawing stands erect, with head held high. Christ's arm and the gazes of the Pharisees and soldiers direct the viewer's attention down to the legend on the ground, the dominant theme of this image. Despite all Giordano's changes and refinements, this strong, vertical structure dominates the finished Bremen painting. Although the latter shows the scene in half-length, the drawing's general composition is preserved, as are the placement and attitudes of most of the figures. The painting depicts a later moment, however, for Christ is standing and about to pronounce his challenge to the Pharisees. As he points, all eyes are cast down to his inscription on the ground. Even the woman in the Bremen painting bends her head and glances downward, now presenting a less defiant attitude.

A highly finished presentation drawing in red chalk by Giordano, now at the Museo Nazionale di San Martino in Naples, and an oil sketch at the Museo Nazionale in Reggio Calabria represent intermediate stages of the development of this composition.[7] Differences between them suggest that the artist made several other preliminary sketches in a long process of experimentation and refinement that produced the final, elegant solution of the Bremen painting.

Two Latin words are prominently inscribed on the drawing: *Amo* (I love) and *Adultera* (adulteress).

Although it is difficult to ascertain whether the notations are by Giordano's hand, these two opposing themes are here interwoven.[8] He depicted the *Adultera* as attractive and confident, a personification of the transgression that provoked wrath and the threat of violence within the Hebrew community. By contrast, *Amo* characterizes Christ's attitude of protection and forgiveness of the sinner. In all

Giordano's drawings and paintings of this subject, love is expressed by Christ's calm diversion of the Jews' anger away from the woman.

Fig. 1. Luca Giordano, *Christ and the Woman Taken in Adultery*, ca. 1657–60, oil on canvas, 176.0 × 255.5 cm. Bremen, Kunsthalle.

Giovanni Francesco Grimaldi

BOLOGNA ABOUT 1605–1680 ROME

25. *A Riverside Landscape*, 1660s

Pen and brown ink on cream laid paper, 12.2 × 25.5 cm

INSCRIBED: In pen and brown ink on old mount, lower center: *Le Titien;* on verso of old mount: *Titiano/mea no. 22.55;* in pen and brown ink, lower right: *167*

PROVENANCE: *ARD* (Lugt 172); purchased from P. and D. Colnaghi and Company, London.

EXHIBITIONS: *Six Centuries of Master Drawings,* Iowa City, State University of Iowa, 1951; *The Practice of Drawing,* Worcester Art Museum, 1951–52; *European Drawings from the Museum Collection,* Worcester Art Museum, 1958.

REFERENCES: Heckscher 1951, cat. no. 63B; Worcester Art Museum *News Bulletin and Calendar,* vol. 17, December 1951, p. 3, no. 27; *Worcester Daily Telegram,* 1951, p. 2; Vey *Catalogue,* no. 92.

Museum purchase, 1951.11

Best known and most influential as a landscape painter, the versatile Giovanni Francesco Grimaldi worked as an architect, printmaker, and designer of book illustrations and stage sets in Rome during much of the seventeenth century. He was born in 1605 or 1606 in Bologna and is said to have been educated there in the Carracci Academy.[1] When he went to Rome in 1625, Grimaldi might have been a qualified professional, or he could have pursued studies at an academy of Bolognese artists at the Quattro Fontane near San Dionisio. He also may have been an apprentice to the Bolognese painter and etcher Baldassare Aliosi, called il Galanino; in 1637, a year before Aliosi's death, Grimaldi married his daughter Elena. In 1635 Grimaldi joined the Accademia di San Luca, the painters' guild of Rome, and he remained a member of that organization throughout his career, serving two terms as its principal.

During the 1630s Grimaldi was a prominent member of the Bolognese colony in Rome. He produced the scenographic sets for a theatrical performance at the French Embassy in Rome celebrating the birth of the future King Louis XIV in 1638. The artist often collaborated with the Bolognese sculptor and architect Alessandro Algardi; Grimaldi was superintendent for the construction of the Villa Doria Pamphili, which Algardi designed, and the artists also worked together on frescoes in Roman churches. Grimaldi was also influenced by Antonio Tassi, alongside whom he worked in the *salone* of the Villa Doria Pamphili. Several of the most prominent Roman families numbered among Grimaldi's patrons, and he received the direct support of at least three popes. In about 1648 Cardinal Mazarin called the artist to Paris, where he spent nearly three years decorating the cardinal's palace, now the Bibliothèque Nationale. He also painted frescoes in the queen's rooms of the Louvre and in the Jesuit Church of Paris, and he seems to have been employed by the duc d'Orléans as well.

Grimaldi's landscape paintings were eagerly purchased by collectors and helped to disseminate the Carracci landscape tradition. He also was a printmaker and made nearly sixty landscape etchings.[2] In 1660 Grimaldi designed sets at the church of the Gesù for the *quarant ore,* or "Forty Hours of Devotion," an annual ritual of carnival when the monstrance containing the Sacrament remained on the altar for forty hours.[3] Another commission of notable prestige came to him in 1668 when Cardinal Giulio Rospigliosi—later Pope Clement IX—engaged the artist to decorate rooms in the Quirinal palace.[4] During the 1670s the artist worked extensively in the Palazzo Borghese, serving as super-intendent of the villa decorations from 1674 to 1678. Grimaldi died in the Roman parish of San Lorenzo in Lucina on 28 November 1680.

The present drawing depicts an imaginary summer idyll, based on views that Grimaldi observed in the Roman Campagna, the sort of image he represented scores of times in other drawings, prints, and paintings. The sketch exemplifies his skill as a draftsman, his aptitude for composition, and his personal, calligraphic style. The body of water and the gentle breeze that stirs the trees in this peaceful view are characteristic of Grimaldi's landscapes. The artist imposed a regularizing control on nature, basing his compositions on simple systems of planes, arranged along strong horizontal and vertical axes. He depicted a concordant natural environment in which weather works in an integral system with the mountains and rivers, fields and forests. Only the thatched buildings at the right suggest the presence of man, who seems to live simply and harmoniously with nature, without dominating this realm. This small sketch has a logical and well-balanced composition that effectively controls the movement of the viewer's eye. An illusion of expansive space is created by overlapping hills and mountains that become less detailed farther in the distance. A sense of depth is also enhanced by the slight darkening of the sky near the horizon in the most distant part of the view. Undulating topography gives the image a sense of movement. This motion is enhanced by the foliage of trees and bushes that seem to cascade down from left to right. The static erect and fallen trees on the brow of the hill create a visual breve note, from which a cadent, falling march to the left proceeds, plotted by a series of slanting tree trunks and stumps. This effect is enhanced by the bushy foliage that rustles in the wind as it blows with increasing movement to the right. Most of the branches on the tall, scrawny tree on the right grow from one side, and the billowing clouds behind it that echo the shapes of more richly leafed boughs seem to pull the tree, and the viewer's attention, off to the right and into the distance.

Grimaldi's graceful drawing style also gives this image its fresh vitality. The artist masterfully controlled the pliant point of the pen in quick, effortless calligraphic flourishes. Pulling the pen toward him and pressing down gently to spread its splines, he created flowing, thickening lines. After laying out the image in this chirographic manner, the artist enhanced its effects of dimension and depth by superimposing passages of tone rendered in hatched lines. Sometimes these shading pen strokes follow the contours of form and help to define shape. Elsewhere Grimaldi created softer passages of tone by

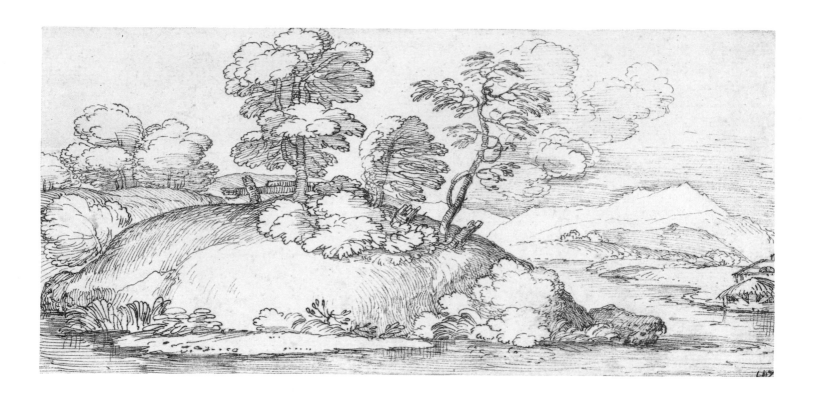

lightly drawing parallel hatching with a nib that was
nearly dry. Although the imagery of this drawing is
similar to that in many of the artist's etchings, it does
not correspond closely to any of them. Its faultless,
polished execution suggests that the sketch was
made in the studio and may be the copy of another,
fully resolved image. The small size, degree of resolu-
tion, and virtuosic execution suggest that this was a
presentation drawing made by Grimaldi to give to
a friend or patron. We know that the artist engaged
in the common practice of making presents of his
drawings.[5]

Attributed to Giovanni Battista Pace

ACTIVE IN ROME 1650S–60S

26. *A Bathing Party,* about 1665

Brown ink, applied with pen and brush, and wash on cream laid paper, 14.6 × 25.8 cm

WATERMARK: Six-pointed star in a circle

INSCRIBED: In pen and brown ink, lower center: *39/Trenta nove;* in pen and brown ink on verso, lower center: *Pellinoro;* in pen and black ink on verso, lower left: *AS*

PROVENANCE: The "double number" collector; Agnew's, London; purchased from Richard Day, London.

Sarah C. Garver Fund, 1982.5

Little is known of the life of this Baroque painter and draftsman, who was active in Rome during the 1660s.[1] A close follower of Pier Francesco Mola, he probably was a member of that master's workshop and perhaps his student. In recent years a handful of paintings and drawings traditionally attributed to Mola and other members of his circle have been reassigned to Pace. Stylistically and technically the present sheet fits comfortably into that group.

Pace probably was born in Rome in the early 1640s, the son of the still-life painter Michele Pace. The scant documentary evidence of the son's career links him to the Chigi, a prominent Roman banking family, for whom he worked in the mid-1660s. In 1664 he was commissioned to paint copies of frescoes that decorate the Palazzo dei Conservatori in Rome at the Palazzo Chigi at Arricia.[2] In the following year Michele Pace was contracted to execute four landscape views of country properties owned by the Chigi. These murals, which survive in the family palazzo at Arricia, reveal how old-fashioned the father's style was at this time. The paintings have led to the conclusion that Giovanni Battista could not have studied with his father but must have been Mola's pupil instead.

The most revealing archival evidence concerning Giovanni Battista Pace is the document, dated 9 December 1665, of his receipt of 140 scudi for two paintings made for Cardinal Flavio Chigi. These small canvases, *The Dream of Joseph* and *The Flight into Egypt,* survive today in private collections in Rome.[3] For many years they remained the artist's only known works. However, recently a painting long attributed to Mola, the *Saint Jerome* at Buscot Park in England, has been identified with Pace's canvas described in the inventory made at the death of Prince Maffeo Barberini in 1686. On stylistic grounds, scholars have attributed other easel pictures to Pace, including two pairs depicting *The Flight into Egypt* and *The Rest on the Flight into Egypt.* These works reveal an eclectic style with a greater interest in chiaroscuro and a freer handling of paint than Mola's.

Giovanni-Battista Passeri, the Baroque painter and biographer, wrote that toward the end of his career Mola relied increasingly on assistants to finish his commissions, implying that this practice was detrimental to the master's business. Shop members painted replicas of Mola's existing designs and executed the bulk of some of his large-scale commissions. Richard Cocke hypothesized that Pace was among the assistants in this entourage and that he was trained by copying Mola's drawings, later producing variant versions of the master's paintings.[4]

Taking Mola's manner as a point of departure, Pace's drawing style seems to have gradually evolved toward greater spontaneity. The influence of Carlo Maratta is also apparent, and Pace also may have made copies of that master's works as learning exercises. Many of Pace's drawings are vigorous and spontaneous, and often they have quick exploratory sketches on the back, indicating that the artist used drawing to work out his visual ideas. Pace sought to capture the expression of motion and pleasing surface design rather than plastic form. This energetic draftsmanship is apparent in two known etchings by the artist, *Assault on a Walled City,*[5] and a *Saint Luke Painting the Madonna.*

Among the drawings attributed to Pace, this previously unpublished sheet is unusual in the ambiguity of its subject matter. The drawing seems to represent a playful scene, with frenetic energy stemming from the draftsman's vigorous style. Several figures are tussling on the shore and cavorting in the water of a pond or river set in a lush, expansive landscape. In the right foreground the head of one man breaks the surface as he paddles along, still wearing his hat! He swims toward another figure, submerged to the shoulders, who holds a baby aloft, apparently a mother playfully dipping and elevating a child. Other figures seem to chase one another along the water's edge and dive in showily. A rollicking couple in the water appear to scream and tauntingly poke at the divers, three of whom leap from a boat at the left, steadied by oarsmen. These figures, frozen in different stages of their dive, evidently embody the artist's search for the most expressive kinesthetic pose. Richard Cocke observed that this sprawling posture, with one leg lifted and arms outstretched, suggests that Pace had no experience on which to base his sketch of diving into water.[6] Such a freely observed genre scene would be most unusual in Pace's supposed oeuvre of drawings, which consists chiefly of religious and mythological images. Bruce Davis has suggested that the drawing might depict rescue attempts during the biblical flood and that what seem to be expressions of carefree gaiety might actually signify terror.[7] Since the style and technique of the present drawing are similar to another Old Testament drawing by Pace, *The Crossing of the Red Sea,* this suggestion has merit.[8]

Trenta nove.

Anthonie Palamedesz.

DELFT 1601–1673 AMSTERDAM

27. *A Young Footman,* 1660s

Brush and brown ink with wash on cream laid paper, 18.8 × 14.8 cm

INSCRIBED: In graphite on verso, upper center: *100/8.;* lower right: *net—66;* traced in graphite on verso

PROVENANCE: Thomas Banks (Lugt 2423); William Pitcairn Knowles (Lugt 2643); Carol Emil Dytes (Lugt 533a); purchased from Succi, London.

REFERENCES: Sotheby Mak van Waay 1984, lot 83; Worcester Art Museum *Journal,* vol. 8, 1984–86, pp. 100, 103.

Gift of the Board of Trustees in honor of Anne M. Morgan and Deaccessioned Paintings Fund, 1986.1

Anthonie Palamedesz., called Stevers, enjoyed a successful career in Amsterdam in the mid–seventeenth century as a painter of small genre pictures. Little is known about the life of the artist. He was born in Delft in 1601, the son of a gem cutter who was in the service of King James I of England.[1] His younger brother, the battle painter Palamedes Palamedesz., may have been born in London. Although the details of his education are uncertain, Anthonie may have been an apprentice to Michiel Jansz. van Mierevelt or perhaps to Hendrick Gerritsz. Pot in Delft. Palamedesz. was an independent master by 1621, when he became a member of the Amsterdam painters' guild, and he served as dean of that organization for four intermittent terms beginning in the 1630s.

The artist married Anna Joosten van Hoorendijk in 1630, and together they raised three children. He must have run an active and productive workshop in Delft, for several artists served him as apprentices, including his brother Palamedes, his eldest son of the same name, and the Rotterdam painter Ludolf de Jongh. A versatile painter, Palamedesz. produced portraits,[2] still lifes, landscapes, and occasionally subsidiary details in architectural views. He also collaborated from time to time with other painters, including Anthonie de Lorme and Dirck van Delen.

Palamedesz.'s most popular works, however, were panel paintings representing the affluent Dutch merchant classes at social gatherings. Made to be bought by the people they depicted, most of these pictures represent soldiers at leisure in guard rooms or taverns or parties of fashionable men and women socializing in their homes. These merry companies were made up of handsome, young, well-dressed partygoers gathered in comfortable interiors appointed with elegant yet properly restrained Dutch taste. Often the paintings contain subtle relationships between the merrymakers, who interact physically or psychologically.[3] In seventeenth-century Holland such images of men and women gaming and celebrating together were often viewed as moralizing allegories. These admonitions, however, are seldom central or compelling messages in Palamedesz.'s art. Works of this kind seem to have provided the artist with a long and successful career. In about 1660 Palamedesz. was married, for a second time, to Aagje Woedewart, and they had a son in the following year. The artist seems to have been living with his eldest son in Amsterdam when he died on 27 November 1673.

The present drawing represents a youthful servant holding a gentleman's cloak, hat, and sword, as if he were waiting patiently for the departure of an unseen guest. Many of Palamedesz.'s paintings feature youthful servants who pour wine or wait at the table. These attendants are nearly always young men, dressed in neat, well-tailored costumes of seemly, drab colors. The drawing has not been identified with a specific figure in any of Palamedesz.'s known paintings, and despite its finished state, it may have been an impromptu study made from a posed model. The young man looks directly at the viewer—and the artist—a feature that rarely occurs in Palamedesz.'s paintings, which suggests that this is a preliminary study. Though this is very likely an informal, extemporary sketch, it has implications of social class and style. The footman holds a broad-brimmed hat adorned with a huge feather and a heavy overcoat lined with spotted fur, suggesting that he waits upon a gentleman of wealth and taste. Similarly, the sword that the youth carries in his left hand, seemingly an expensive weapon, with its large, shaped pommel and broad, decorated hand guard, could imply aristocratic status. Not only do the people in Palamedesz.'s paintings wear such elegant costumes, but the clothing often appears piled on tables and chairs to symbolize affluence, excess, and social rank. However, from the bored, rather forlorn look on the young man's face, his slouch, and the angle of his head, the viewer may infer that his job is more tedious than glamorous.

Palamedesz. used simple means to execute this quick study. The entire drawing was made with bistre ink applied with a brush, using washes of various dilutions. The artist used a thin, translucent ink to block in the figure quickly. Then, with progressively thicker, darker mixtures of ink, he superimposed more precise modeling and linear details.[4] Palamedsz. may have taken these varied ink solutions from a single pot, obtaining the thin wash from the top and the thick, more saturated infusion from the bottom of the inkwell, where the sediment had settled. The artist sensitively charged his brush, occasionally applying a heavy, wet layer of ink that spread as it soaked into the paper and at other times using a relatively dry brush that skimmed across the sheet, leaving pigment lying on the paper surface. This sensitivity to his materials, the deft precision of his hand, and the energy and spontaneity of the drawing show that Palamedesz. was a more expert draftsman than his reputation conveys.

Willem van de Velde the Elder

LEIDEN 1611–1693 LONDON

28. *The French Man-o-War "Royale Thérèse,"* 1673

Black chalk with gray wash on cream laid paper, 32.0 × 69.9 cm

WATERMARK: Arms of Amsterdam

INSCRIBED: In black chalk, lower left: *den Konig was hier voor opt halff deck/in dit schip genaemt des werelts wonder was/geloff ick de seconde 4kante schout bij nacht der franse/opt het welcke dito Konig 3 mael met het boe schudt liet (schieten) om dattet soo vere drog*

PROVENANCE: J. MacGowan (Lugt 1496); Philip J. Gentner, Florence.

EXHIBITIONS: *European Drawings from the Museum Collection,* Worcester Art Museum, 1958; *Dutch Prints and Drawings of the Seventeenth Century,* Worcester Art Museum, 1979.

REFERENCES: Worcester Art Museum *Annual Report,* 1920, no. 80; Henniker-Heaton 1922, p. 208; Cannenburg 1950, p. 197; Vey *Catalogue,* pp. 16–18; Vey 1958, pp. 31–33; Boymans-van Beuningen 1979, vol. 1, pp. 61, 65; Fox 1980, p. 122, fig. 144.

Museum purchase, 1919.214

Fig. 1

Willem van de Velde knew ships, sailing, and warfare so well that he could draw naval actions quickly and efficiently in the midst of battle, recording not only events but much of the ships' details as well.[1] This ability kept the unusual specialist much in demand. He was born in maritime Flanders, the son of a barge captain. There is no record of his training, but it seems likely that van de Velde was a pupil of the landscape painter Cornelis Liefrinck. He seems to have developed his specialization in marine painting during his early career in Leiden. By 1636, when his third child was christened, van de Velde was in Amsterdam. During the 1640s he sketched the Dutch fleet in the Texel at Den Helder and near Terschelling. The artist sailed with the Netherlandish fleet in the first Anglo-Dutch War of 1652–54. He also accompanied the navy in 1658 when it sailed to Copenhagen to defend the sound from the aggressions of Charles X of Sweden. On 8 November van de Velde sketched the battle when the Dutch joined forces with the Danes to defeat the Swedish navy. Later the artist recorded several major naval battles during the second Anglo-Dutch War. He was present, by command of the Dutch admiral, to sketch the defeat of the English at the Four Days' Battle in 1666.

Van de Velde was still employed by the admiralty at the outbreak of the third Anglo-Dutch War, which became difficult when the French occupied parts of Holland and painting commissions became scarce. In 1672 the artist moved to England, and his career again prospered. He established a studio at the Queen's House in Greenwich, together with his sons Willem and Adrian. They executed many royal commissions, including the designs for a suite of tapestries representing the Battle of Solebay. The elder van de Velde sailed with the English fleet during the third Anglo-Dutch War, recording some of its battles. The king granted him an annual salary of one hundred pounds, and the Duke of York pledged an additional fifty pounds per year. Most of his later works depict naval pageants, royal arrivals, and embarkations; van de Velde remained active until his death in December 1693.

Van de Velde's surviving drawings range from quick, descriptive sketches to large friezelike panoramas of astonishing detail. Produced during his activity in Holland, these expansive works were drawn with pen and ink on canvas prepared with a white ground. The bulk of van de Velde's activity as a draftsman, however, was dedicated to rapid studies made in the harbor or at sea. Literally hundreds of these sketches are extant, most now divided between the National Maritime Museum in Greenwich and the Museum Boymans-van Beuningen in Rotterdam.[2]

The identification of the ship of the line in the present drawing was long debated by scholars. However, Frank L. Fox has persuasively argued that it represents the French man-o-war *Royale Thérèse.*[3] In July 1673 van de Velde sketched this vessel several times at the English port of Sheerness. Originally christened *Paris* when she was built at Toulon in 1670, the ship featured exterior decoration designed by Pierre Puget, whose original drawing is now in Marseilles.[4] That design differs from van de Velde's drawing, suggesting that French shipwrights did not fully carry out Puget's impractical plans. The ship's decoration also may have been altered in 1671, when she was renamed the *Royale Thérèse.*[5] Carrying seventy to eighty guns, she was one of three French ships from the Mediterranean under the Marquis de Martel that reached Dover on 18 June 1673. In June she became second-in-command of the French squadron, as indicated by the square flag flying at her mizzen. Sometime in the ensuing days the ship was completely dismasted in a gale, and she arrived at the Medway on 26 June under jury rig. She was refitted in time to take part in the Battle of Texel on 11 August 1673 as Martel's flagship.

In June and July of 1673, in the midst of the third Anglo-Dutch War, King Charles II of England visited the Nore in Kent. Van de Velde's notes, written in Dutch on the present drawing, make reference to King Charles, which suggests that the drawing was made at that time. The inscription may be translated: "The King was here forward on the half deck in the ship called the World's Wonder. She was, I believe, the second square, rear admiral of the French squadron. On board of her, the said King caused her forward guns to be fired three times because they had such a good range."

In his inscription on this sheet van de Velde refers to the ship as "the World's Wonder." Frank L. Fox speculated that this may have been a sarcastic nickname invented by English seamen to ridicule this major French flagship, which arrived at Dover dismasted and crippled.[6] Although van de Velde did not speak the king's language in 1673, he used this English term in the Dutch inscriptions on two other drawings of the ship. He may have heard this derisive name and used a phonetic spelling. Even though it was an English name for a French ship, the artist might even have assumed it was the ship's proper name.

M. S. Robinson identified another study by van de Velde that depicts the ship seen from the stern and dismantled (fig. 1).[7] Now at Greenwich, that sheet is similar in its unfinished, sketchy character and shows how the artist intended to record the details of the vessel, not to create a finished portrait.

On the stern there is a feminine portrait surrounded by fleurs-de-lis, and in 1673 the *Royale Thérèse* was the only French two-decker in the allied fleet with a name appropriate to such a patron. In both drawings the same figures, with their broad hats and shouldered rifles, are gathered on the quarter- and foredecks.

Fig. 1. Willem van de Velde the Elder, *The French Man-o-War "Royale Thérèse,"* 1673, black chalk and gray wash on cream laid paper, 35.5 × 68.6 cm. Greenwich, National Maritime Museum.

Liévin Cruyl

GHENT ABOUT 1640–1720 GHENT

29. *View of Venice,* about 1676

Pen and black and brown inks over graphite with wash on prepared vellum, 15.8 × 21.9 cm

INSCRIBED: In pen and brown ink, lower left: *Liévin Cruyl*

PROVENANCE: Purchased from H. M. Calmann, London.

EXHIBITION: *European Drawings from the Museum Collection,* Worcester Art Museum, 1958.

REFERENCES: Worcester Art Museum *Annual Report,* 1957, p. 15; Adlow 1958, p. 8; Vey *Catalogue,* no. 41; Vey 1958, pp. 33–34; Langedijk 1963, p. 86; Eisler 1988, p. 36; Jatta 1992, no. 91.

Museum purchase, 1956.25

The master draftsman Liévin Cruyl specialized in soaring bird's-eye city views and landscapes of meticulous detail. His achievements brought him an international reputation in his day, but the details of his career are only now slowly being rediscovered.[1] He was probably born in Ghent and seems to have been trained as an architect, for an early drawing by Cruyl represents an architectural project for the city's church of Saint Michael.[2] An inscription on this sheet, drawn in 1662, describes Cruyl as vicar at Wettern, a small town east of the city, but it is not clear whether he was a lay priest or a member of a monastic order.

From 1664 until about 1670, the artist was in Rome where he produced many drawings representing contemporary views of the city.[3] Some of these designs were engraved and appeared in 1666 in the book *Prospectus locorum urbis Romai insignium.* Fifteen other drawings of Roman views, engraved for the book *Thesaurus Antiquarium Romanorum* of 1697, probably were also made during this period.[4] Along with their precise recording of architecture and topography, these images include vignettes of everyday Roman life.

In 1668, while still living in Rome, Cruyl won the important commission to design the high altar for the church of Saint Bavo in Ghent. An impressive presentation drawing for this project, now in the Ghent municipal archive, reflects a style combining contemporary classicizing Roman Baroque with conservative sixteenth-century elements. During the 1670s Cruyl made an enormous bird's-eye view of Ghent, probably from memory while he was resident in Italy or France. A lengthy inscription states that it was sent to King Louis XIV to demonstrate the artist's capabilities as a draftsman. The image depicted the important architectural, cultural, and commercial monuments of Ghent for the French king, who had recently conquered the city. Cruyl's petition was successful, for in 1681 he was at Versailles, collecting a handsome salary for panoramic drawings of the palace and grounds. These were probably meant to be engraved and to spread the news of Louis XIV's grand building projects.[5] While in royal service Cruyl also made drawings with narrative and symbolic themes.[6] It is assumed that his years at the French royal court were the apogee of his artistic career. Little is known of the last decades of his life, however, and he is thought to have died in Ghent about 1720.

The present drawing represents the Piazza San Marco, the principal public square of Venice, in a bird's-eye view from the southwest. The composition is organized around the central vertical element of the bell tower, which draws the viewer's eye up from the foreground lagoon to the mainland and the distant Alps. With amazing accuracy Cruyl depicted not only the most famous buildings around the piazza, but also the smaller town palaces and churches in the distance. People fill the square in small groups, as if conversing or promenading on a sunny afternoon. In the foreground many gondolas, laden with passengers, travel back and forth before the quay. The larger merchant galleys and the anchored galleon all seem to be Venetian ships, emphasizing the wealth and distinctive style of this prosperous city-state. Cruyl probably based this drawing on his aspect of the city from a lofty viewpoint at the top of the church of San Giorgio Maggiore, which lies opposite this scene across the mouth of the Grand Canal. To envision an even higher point of perception, Cruyl certainly would have made use of Jacopo da Barbari's famous panoramic woodcut of the city, of about 1500.

Like many other works of Cruyl's Italian period, this piece was drawn in two different inks on grounded vellum. Since the character of line in both inks is comparable, the original visual effect of these drawings depended on variation of color between the two media. However, this relationship changed over time. The black lines were drawn in stable carbon ink, while for the softer lines and hatchings the artist used a brown-hued ink, probably made of iron gall, which has dissipated and seemingly attacked the parchment's ground. As it aged the drawing changed in appearance, and details like the human figures and the ships' rigging took on a diffuse, washlike quality. Cruyl used a combination of tools for this drawing. The straight, ruled lines that plot the geometric structure of composition terminate in blunt ends and seem to have been made with a pen. Their threadlike delicacy suggests a metal-nibbed implement of the sort sometimes used for writing during this period. However, for most of the drawing Cruyl used a brush for soft hatchings and shadings in gray and brown wash. This unusual technique and the artist's preferred materials derive from the traditions of the scribe and manuscript illuminators rather than those of the painter's studio.

This drawing is one of four known Venetian views by Cruyl.[7] Two represent the Ponte Rialto and one, similar to the present sheet, depicts the Piazza San Marco. It seems that this group originally made up two pairs; one of the sets, close to the present drawing in size, style, and technique, appeared on the art market in 1987.[8] All three of the other drawings carry identifying inscriptions on their versos.[9] They are comparable to nearly twenty other drawings by Cruyl of the mid-1670s that represent views of other Italian sites, including Naples and the Gardens at

Tivoli, and it is possible that all were made for a
planned series of Italian views. Karla Langedijk has
suggested that Cruyl made the present drawing
while on his way back to Ghent and the final phase
of his career.[10]

Giacinto Calandrucci

PALERMO 1646–1707 PALERMO

30. *Venus at the Forge of Vulcan,* about 1685

Pen and brown ink over black chalk on cream laid paper, 20.5 × 39.6 cm

INSCRIBED: In pen and brown ink, lower left: *Caland^{ci};* in pen and brown ink, lower right: *13* [scribbled over]

PROVENANCE: Pierre Crozat, Paris (Lugt 2952); Sloane Gallery, London; purchased from Paul Drey Gallery, New York.

REFERENCE: Graf 1986, vol. 1, p. 54, no. 116–21; vol. 2, pl. A42.

Mary G. Ellis Fund, 1971.87

Fig. 1

A favorite student of Carlo Maratta, Calandrucci became one of the leading painters in Rome in the late seventeenth century and remained a faithful exponent of his master's style throughout his life.[1] He was an apprentice in the workshop of the Sicilian painter and engraver Pietro del Po. This artist was in Rome by 1649, where his professional status is documented by his membership in the Accademia di San Luca. Thus it is possible that Calandrucci's parents sent him to Rome, to the workshop of his fellow Sicilian, to enter him into the profession of painting.

Next the artist joined the workshop of Carlo Maratta.[2] His ability to mimic his master's style made him a valuable member of Maratta's studio and may explain the fact that no early works by Calandrucci are known. His first independent works are those of a mature painter, essentially following Maratta's manner of the 1670s. He probably remained in the workshop until the master's death in 1713 and may even have inherited his unfinished commissions.

Calandrucci executed several major ecclesiastical commissions in Rome, including frescoes in the church of Santa Bonaventura, the ceiling decoration of Santa Anna dei Palafrenieri, and facade paintings at Santa Maria del Suffragio. He also produced decorative frescoes in some of the great Roman town palaces, including the Palazzo Lanti. It is likely that he was recommended for this commission by Maratta, who often passed unwanted projects to his assistant. Calandrucci's paintings were reproduced in prints by Jean Charles Allet, Jacques Blondeau, Aquila Thibout, and other etchers. This dissemination of his designs helped to spread the artist's fame in Italy and France. The Spanish ambassador in Rome promised the artist a position at the Madrid court, but to his frustration Calandrucci was never summoned by the Spanish king. In 1700 he returned to Palermo, where he executed a notable altarpiece for the church of San Salvatore representing *The Madonna with Saint Basil.* At his death the artist was at work on frescoes in the church of San Lorenzo in Palermo. He bequeathed his house in the Via del Greci to his sisters, whose sons Giambattista and Domenico both assisted in Calandrucci's workshop.

Calandrucci's most important work was considered to have been his decoration of the Palazzo Besso in Rome, a grand house originally erected by the Strozzi family. In 1882 the palazzo was razed to make room for the Corso Vittorio Emanuelle. Calandrucci's destroyed paintings there are known today from written descriptions and from the artist's surviving drawings. There are many single-figure studies and several sketches of entire compositions, but no complete plan of the decorative scheme, so

an accurate reconstruction of this rich fresco cycle is impossible.

The present sketch is the first of a series of at least six drawings that Calandrucci made in preparation for a ceiling mural in the Palazzo Besso. Pascoli specifically describes the decor of the Salone Rosso where mythological subjects were depicted.[3] Throughout the grand galleries, the vaulted ceilings were organized into oval compositions that fit together in a manner similar to those in Calandrucci's decorations of the Palazzo Muti-Papazzurri in Rome. Immediately beneath the vaulted ceilings were painted friezes.[4] Dieter Graf speculated that the three large, elliptical narrative compositions in the Salone Rosso represented *Paris Receiving the Golden Apple from Mercury, The Judgment of Paris,* and *The Forge of Vulcan,* the fresco for which the present sketch was executed.[5]

This image represents a story from Virgil's *Aeneid* in which Venus, the goddess of love, visits the forge of Vulcan, her husband and the blacksmith of the gods.[6] By another lover, a mortal from Troy named Anchises, Venus had given birth to Aeneas. He had grown up to be a great warrior and would distinguish himself as a hero in the war between the Trojans and the Greeks. Anxious to protect and promote Aeneas in the war, Venus asked Vulcan to forge a magic sword and an invulnerable suit of armor for her son. In the drawing the goddess visits the Olympian smithy to meet Vulcan and accept this magic armor. She arrives in her chariot drawn by doves and is attended by flitting *amorini* who help to convey to her the helmet and sword. In the background on the right, three workmen labor at the anvil, forging some other enchanted metalwork, as billows of smoke and steam rise from their cavern foundry. The brawny Vulcan sits in the foreground conversing with Venus, as he passes the armor to her piece by piece for her inspection. Leaning on his mighty hammer, the blacksmith points to a gleaming cuirass and greaves beside him on the ground, while the shield, bow case, and quiver lie in front of him. With the help of this armor and Venus's other support, Aeneas endured his epic adventures and led his band of companions to their eventual settlement in Italy, where they became the legendary ancestors of the ancient Romans. Thus the great city-state and its empire were built by a race descended from the ancient Trojans and from the gods themselves. Such a heroic image of the divine origins of Rome was an appropriate subject for the decoration of a Roman town palace.

Both the style and technique of this drawing reveal the influence of Carlo Maratta. After lightly blocking

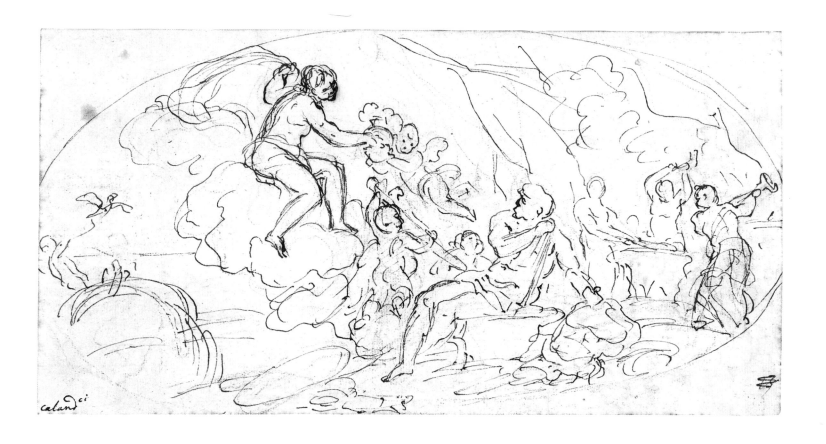

out the composition in black chalk, Calandrucci
began to delineate his figures in quick, tentative pen
lines, which he sometimes sketched over in searching
for the proper contour. In subsequent drawings the
artist replaced this interrogative manner with a con-
fident, fluid style in which he defined more carefully
the forms and details that are only implied in
this sheet. Other drawings, usually done in chalk,

defined these figures even further. Several of these
drawings are now in Düsseldorf, including another,
more refined study of the entire composition (fig. 1).

Fig. 1. Giacinto Calandrucci, *Venus at the Forge of Vulcan*,
ca. 1685, pen and brown ink with wash over black chalk,
20.0 × 40.2 cm. Düsseldorf, Grafische Sammlung,
Kunstmuseum, FP 2056.

François Boitard

THE HAGUE ABOUT 1670–ABOUT 1715 THE HAGUE

31. *The Crucifixion,* 1690s

Pen and black ink with gray wash on cream laid paper, 40.2 × 26.8 cm

INSCRIBED: In red crayon on verso, upper center: *Lot One Hundred;* in graphite on verso, center: *Lot 5*

PROVENANCE: Purchased from Sotheby's, London.

REFERENCES: Sotheby's 1975, lot 66; Worcester Art Museum *Annual Report,* 1975, p. 18.

Sarah C. Garver Fund, 1975.128

Relatively little is known of this unusual artist who seems to have enjoyed a successful career at the end of the seventeenth century, working in France, Holland, and England.[1] As his oeuvre slowly comes to light, Boitard's reputation progressively improves. Although the drawings attributed to him seem to include designs for decorative murals, no paintings have been attributed to him, and his entire oeuvre consists of drawings. Significant groups of his works are now to be found in Paris, Moscow, and Stockholm.

Boitard was the student of Raymond Lafage, an eccentric artist who worked exclusively as a draftsman.[2] Lafage traveled widely and became known for his artistic performances during which he created drawings by request. The Dutch historian Arnold Houbraken wrote that he saw a similar demonstration by Boitard.[3] Some of Boitard's drawings, such as *Saint Michael Fighting Satan,* or the pendant images of Venus and Bacchus in decorative cartouches, seem to represent designs for wall paintings. Duke Anton Ulrich collected several of his drawings, among them the design for a ceiling at the ducal residence in Brunswick representing *Apollo in the Chariot of the Sun,* which was later painted by another artist. Some of his other works, which now appear quite tame, were pronounced obscene by the Duke's librarian.[4] Boitard also made large drawings of mythological and classical subjects, which are similar to Lafage's finished presentation drawings.[5] Two of these are now at the Pushkin Museum in Moscow,[6] and there are four elaborate mythological images at the Nationalmuseum in Stockholm.[7] Some of the works attributed to Boitard depict theatrical images and the Italian commedia dell'arte, favorite subjects of Lafage. The artist also designed a suite of erotic prints that were crudely etched and published in the Netherlands.[8] Others of his designs were engraved by Mathias Oesterreich and Michael G. Prestel.

Few religious images have been described among the works of François Boitard. The present drawing seems a bold, stylized illustration meant for contemplation. The artist concentrated on the balance of its design and on literary accuracy rather than expressive content. Systematically organized in registers, the image has overlapping layers of figures logically measuring space from bottom to top and from foreground to distance. Strong geometry, plotted by the three crosses, divides the composition visually and conceptually. The gospels relate how darkness fell at noon on the day of the Crucifixion, demonstrating the cosmic implications of these human events. Boitard combined suggestions of the eclipse with the medieval convention of bracketing the cross with the sun and moon to symbolize

Christ's universal divinity. At his right hand appear the elements of good and the evidence of God. Beneath the overshadowed sun, the repentant thief peers at the Savior with a redeemed countenance, while Christ's followers are gathered below him. These elements are contrasted by darkness on Christ's left. There, under the partially obscured crescent moon, the unrepentant thief writhes in agony, and a military banner and standard symbolize the evil Roman empire. This divided composition foreshadows Christ's Last Judgment, in which the Savior raises his right hand to resurrect and draw to heaven the souls of the good, while with his left he condemns the damned to hell.

As Christ expires on the cross a cold wind blows through the scene, stirring his drapery and a soldier's cape. Christ's lips are parted and his brow furrowed in concern, as he gazes down at the swooning Virgin. She is supported by the young Saint John and accompanied by the three Marys. Opposite Christ's followers is a group symbolizing the greed of his enemies. Oblivious to the suffering of their victims, four helmeted foot soldiers gamble for possession of Christ's seamless cloak. Their armor, weapons, gestures, and wrathful faces emphasize their iniquity. Behind the base of the cross, a group of mounted soldiers bears a forest of lances, which surround Christ and emphasize the might of his oppressors. Most of the soldiers are helmeted, and those few who wear turbans may represent the condemning judges or officials.

Executed primarily in pen and black ink with no underdrawing, this sheet suggests Boitard's skill and confidence as a draftsman. The principal figures are outlined with controlled, thick pen lines. Subsidiary contour lines, modeling drapery, and other details of the setting were added in spontaneous, lightly touched strokes. Over his pen work the artist applied a soft gray ink wash, creating darker passages by layering. Boitard shaded the right contours of forms with wash, reserving the darkest tones in the foreground, to create the illusion that a dramatic light falls across the scene from the right.

Another drawing of *The Crucifixion* by Boitard is now in Stockholm (fig. 1).[9] Slightly smaller than the present sheet, it is nevertheless more detailed. Both designs share their general organization, many motifs, and details. However, the Stockholm composition is not as orderly in its organization, though its setting is more carefully executed and it has a more explicit vista into the deeper landscape. That image places the Virgin and her entourage behind the base of the cross, diminishing their importance, while a multitude of soldiers in the foreground is emphasized. In the Stockholm drawing the artist

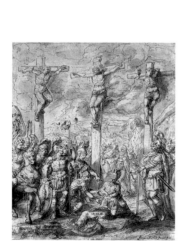

Fig. 1

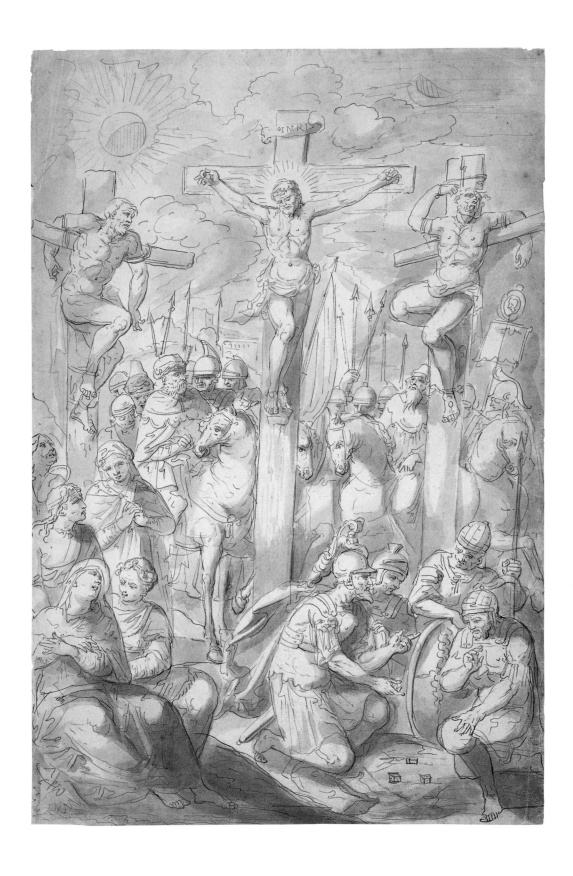

lavished more attention on the classicizing details of costume and narrative than on the principal subject. The sheet bears the artist's name in an ornamental pen inscription; it is a formalized address of the sort that might appear on a print, but no engravings of the composition are known. Although the Stockholm *Crucifixion* sheet seems more resolved

and refined by comparison, both drawings are straightforward, fluent, and intelligible and seem to be finished presentation drawings.

Fig. 1. François Boitard, *The Crucifixion,* 1690s, pen and black ink with gray wash, 23.4 × 19.1 cm. Stockholm, Nationalmuseum, NM Anck. 58.

Willem Fransz. van Mieris

LEIDEN 1662–1747 LEIDEN

32. *The Judgment of Solomon,* about 1706

Black chalk with white heightening
on blue laid paper, 36.9 × 29.4 cm

PROVENANCE: J. Schepens,
Amsterdam; purchased from
Sotheby's, London.

EXHIBITION: *Dutch Prints and
Drawings of the Seventeenth Century,*
Worcester Art Museum, 1979.

REFERENCES: Worcester Art Museum
Annual Report, 1974, p. 18; Welu 1977,
pp. 15–17; Naumann 1981, vol. 1, p. 36
n. 9.

Sarah C. Garver Fund, 1974.250

A leading painter in Leiden in the early eighteenth
century, Willem van Mieris brought a Rococo
elegance and classicizing sophistication to
Netherlandish art. Born on 3 June 1662, he was
the fourth child of Cunera van der Cock and Frans
van Mieris, who was a prominent figure in the
Leiden school of *fijnschilders,* or "fine painters."[1]
This unorganized group of artists specialized in
small, meticulously detailed genre paintings. Willem
served as his father's student and assistant, until
Frans died suddenly in 1681. At that time the artist
probably took over his father's studio and continued
to work in the *fijnschilder* tradition.

In 1683 van Mieris became a member of the
Leiden painters' guild, an organization in which he
achieved prominence, serving as a deacon in 1697,
1698, 1704, and 1708. On 24 April 1684 the artist
married Agneta Chapman, and their family eventu-
ally included two daughters and a son. His continu-
ing professional success is reflected by his purchase
of a succession of different homes and country
retreats, culminating in his residence on the elegant
Breestraat, which he acquired in 1705.

By the late 1680s van Mieris had begun to concen-
trate on subjects from ancient mythology, using a
classicizing style that reflected the influence of the
French Academy. Together with the painters Jacob
Toorenvliet and Carel de Moor, he founded a draw-
ing academy in Leiden, which opened shortly before
1694. That year van Mieris made a single etching,
the production of which may have been related to
the academy. Depicting the myth of Ocyroë, the
plate reflects the artist's brilliant draftsmanship; its
technical sophistication suggests that the etching
was made in conjunction with a professional print-
maker.[2]

Van Mieris attracted commissioners from The
Hague and Amsterdam as well as Leiden. Perhaps
his best-known patron was the wealthy Leiden cloth
merchant Pieter de la Court van der Voort, who
owned several paintings. For his son Allard de la
Court, van Mieris made copies of other works in
Pieter's collection. Shortly after 1700 the artist began
to produce sculpture, chiefly decorative reliefs and
vessels that he modeled in terra cotta and in wax
to be cast in bronze.[3] In 1702–4 van Mieris made
four bronze vases for the garden of Pieter de la
Court's palatial home. Based on urns at the garden
of Versailles, they are decorated with continuous
friezes depicting mythological subjects. All four are
now in the English Royal Collection and decorate
the gardens at Windsor Castle. After de Moor's
death in 1736, van Mieris became director of the
Leiden drawing academy and taught many students
there. His son Frans and Hieronymus van de Mij

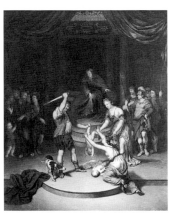

Fig. 1

are thought to have been his only painting appren-
tices. The master became blind in his old age, and
his late paintings may have been completed by these
assistants. Van Mieris died on 26 January 1747 and
was buried in a plot at the Pieterskerk in Leiden that
he had purchased in 1731.

The present drawing depicts the famous Old
Testament story of two women who came before
Solomon, king of Israel, seeking judgment in their
dispute.[4] They carried two infants, one dead and
one alive, and each woman claimed that the living
child was her own. After consideration, the king
ordered his guard to divide the disputed child in two
with his sword and to give half to each woman. One
mother tearfully begged Solomon to give the child
to the other woman, and that demonstration of love
proved to him that she was the true mother.

James Welu recognized that the present drawing
relates to van Mieris's painting of 1706, now in the
Historical Museum in Amsterdam (fig. 1).[5] The
refinement of its composition and the fact that this
finished drawing is on blue paper suggest that it may
have been a presentation piece, perhaps made for the
approval of a patron. Several improvements were
made between this drawing and the finished work.
In the painting the figures are smaller, and the point
of view is slightly higher. Solomon sits in the center,
and his judgment is translated into action along the
dominant vertical axis of the composition. While
the false woman holds open her skirt in satisfied
expectation, the true mother reacts violently, falling
to her knees, screaming, and throwing up her hands.
In the painting the king's scepter is more vertical
and points directly at the child, held upside down by
one leg. The gruesome aspect of the executioner is
emphasized by his dog, which lowers its head and
gazes with hungry interest at the dead child. In the
painting a sheet of drapery appears on the ground
beneath this figure, further accentuating the central
axis of the composition and helping to link the dead
child with the living infant. Close to Solomon's
throne in both the drawing and the painting are
groups that include soldiers and townspeople. In
the painting minor changes were made in the posi-
tions and gestures of the men standing at the king's
side, and a child was added at the left. Solomon sits
beneath a shell carved into the wall, an ancient motif
revived in the Renaissance used to designate figures
of inspiration or authority. The king is flanked by
carved lions, symbols of royalty, whose tails curl up
the pilasters. Tall niches hold sculpture on each side
of the throne. While in the drawing these carved
figures are partially concealed, both niches are
exposed in the painting, revealing Athena, goddess
of wisdom, on the left and on the right the blind-

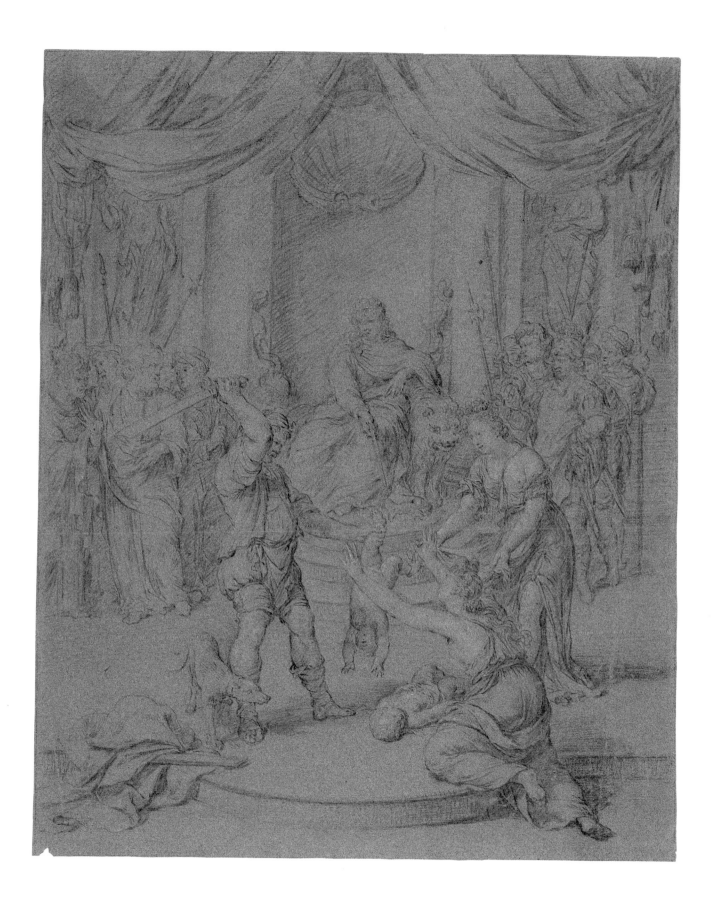

folded figure of Justice holding a sword and scales. The Judgment of Solomon was a popular subject in Netherlandish art of the Baroque period, and its depiction was often chosen to decorate town halls and municipal courts. It would seem that van Mieris's small painting was made for a special commission, and one can imagine that it would have been an appropriate picture for a judge or lawyer.

Fig. 1. Willem Fransz. van Mieris, *The Judgment of Solomon,* 1706, oil on panel, 67.0 × 55.0 cm. Amsterdam, Historical Museum, A24844.

Charles Parrocel

PARIS 1688–1752 PARIS

33. *Studies of a Soldier,* about 1735–40

Red chalk on cream laid paper,
29.6 × 37.8 cm

WATERMARK: *C ♡PIGNION BULE/
AUVERGNE*

INSCRIBED: In graphite on verso,
lower left: *J.F. Parrocel XVIII
B.R.E./1704–1781;* lower right: *425*

PROVENANCE: Purchased from H. M.
Calmann, London.

EXHIBITIONS: *Six Centuries of Master
Drawings,* Iowa City, State University
of Iowa, 1951; *The Practice of Drawing,*
Worcester Art Museum 1951;
*European Drawings from the Museum
Collection,* Worcester Art Museum,
1958.

REFERENCES: Matthiesen 1950, p. 20,
cat. no. 60; Heckscher 1951, cat.
no. 70B; Worcester Art Museum
Annual Report, 1951, p. xii; Worcester
Art Museum *News Bulletin and
Calendar,* vol. 17, December 1951,
p. 5, no. 58; Vey *Catalogue,* no. 63;
Vey 1958, pp. 35–36; Schuman 1979,
p. 135, cat. no. D44.

Museum purchase, 1951.22

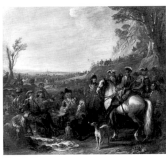

Fig. 1

An eminent art professor and painter of battle scenes, history subjects, and portraits, Charles Parrocel came from an extended Provençal family active in the arts from the sixteenth century. He was born in Paris on 6 May 1688, the eldest son of Joseph Parrocel, a painter who specialized in battle scenes.[1] As his student and assistant Charles inherited this enthusiasm for the military. After his father died in 1704, he lived and studied with his godfather, Charles de la Fosse, and studied with Bon de Boullogne the Elder. In 1705 Parrocel joined the French cavalry, and during his year in service he drew many studies that were later used in his paintings. In 1712 Charles went to Rome to study at the French Academy, where his education was supported by the duc d'Antin. He spent the years 1716 to 1720 in Malta and Venice, studying and painting.

The artist was back in Paris by 1721, when he was appointed a member of the Académie Royale and won a royal commission to paint *The Arrival of the Turkish Ambassador at the Tuileries Palace* for Versailles. This monumental canvas won accolades for its lush color and carefully observed detail. In 1723, in collaboration with Jean-Baptiste van Loo, Parrocel painted an equestrian portrait of King Louis XV for the duc d'Antin. During this project Parrocel was given lodgings and a studio at the Tuileries.

In 1728 the artist took up residence at the Gobelins, where he lived for the rest of his life, working as a painter, a designer of tapestries, and an academy teacher. His comprehensive knowledge of military costumes and equipment gave his works a lifelike accuracy. He also was expert in painting horses and conducted analytical, almost scientific studies of their anatomy and movement. This expertise is apparent in Parrocel's designs for the illustrations of *Ecole de cavalerie* by François Robichon de la Guérinière, a manual of horsemanship and cavalry tactics first published in 1733.[2] Many of the artist's paintings were reproduced in prints, and he also made his own original etchings.[3]

In July 1735 Parrocel was elected Conseiller de l'Académie, and in 1744 he became an assistant professor at the academy. That autumn the king ordered him to follow the army into Flanders to record the victories of the French, and two of the resultant paintings were destined for the Dauphin's apartments at Versailles. The artist was constantly engaged in battle paintings and equestrian portraits under the commission of royal or aristocratic patrons. In the late 1740s Parrocel frequently took leaves of absence from the academy to undertake projects for the king, or because of a chronic illness that caused him periodic attacks of apoplexy. Because of this illness, his

promotion to the rank of full professor seems to have been largely honorific. The artist died on 24 May 1752 at his lodgings at the Gobelins, and he was buried in the parish of Saint-Hippolyte.

The present drawing was once ascribed to Charles's cousin Joseph François Parrocel (1707–1781), but it had acquired the correct attribution by 1950.[4] The subject, style, and technique of the drawing are characteristic of Charles Parrocel, as are the many visible changes that reflect the artist's process. The drawing represents two different views of a single subject. In each, the soldier has the same prominent, angular nose and down-turned mouth, and he wears his hat low on his brow. His long hair is gathered in a plait in back, and a kerchief is tied tightly around his neck. Curls and wisps of hair stick out above his ears to echo the shape of his hat brim, suggesting that the soldier was to be depicted in activity, not primped and posed for a formal portrait. In both sketches the man gazes attentively at something or someone, a representation appropriate to the interpersonal situations of Parrocel's group portraits. At first glance the drawing appears resolved, but there are many corrections, revealing that it was an active working sketch. Such searches for the correct contour are particularly apparent around the brim of the soldier's hat and along the contours of his jaw and chin. Despite its many pentimenti, the rapid sketch of the open left hand seems anatomically incorrect.

This drawing would seem to have been made in preparation for one of Parrocel's military group portraits of the late 1730s, but it has not yet been associated with a particular painting. Its subject is similar to those of paintings like *The Halt of the Grenadiers* of 1737, now in the Louvre (fig. 1). Made for a new dining room in the palace of Fontainebleau, that painting reflects Parrocel's style at the height of his career.[5] Some of the extant preparatory drawings for *The Halt of the Grenadiers* were executed in black, red, and white chalks on gray paper, in a freer, more spontaneous manner than that of the Worcester sketch.[6] However, the present drawing is comparable in its degree of finish to Parrocel's preparatory chalk sketches in Rouen, Stockholm, and Frankfurt.[7] A red chalk drawing in Frankfurt representing a Greek infantryman and another in Stockholm that depicts a crowd of soldiers both include a foreshortened, unfolding hand with a pointing, fleshy index finger extended, details that are similar to the hand in the present drawing.[8] Jack C. Schuman recognized the similarity between this drawing and another in the Musée Atger at Montpellier.[9] Also executed in red chalk, the latter depicts a man in a tricorn hat with a large, aquiline nose, angular jaw line, and thin, down-turned mouth. He may be the same subject

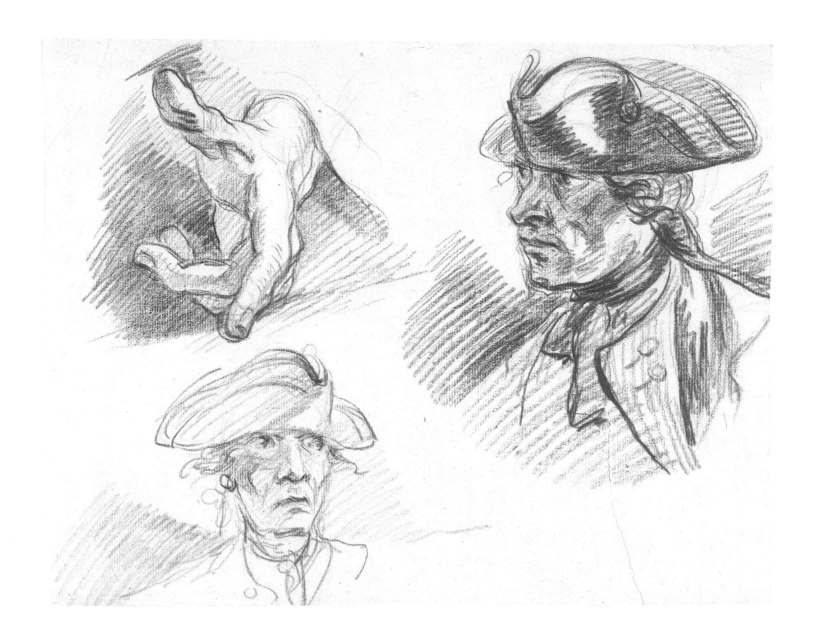

as that of the Worcester drawing. In both sheets
the soldier appears active and attentive, with wispy
backswept curls that stick out over his ears. For the
Montpellier drawing, which is signed, Schuman
suggested a date of around 1740.[10]

Fig. 1. Charles Parrocel, *The Halt of the Grenadiers,* 1737, oil on
canvas, 210.0 × 249.0 cm. Paris, Musée du Louvre, 7123.

Charles Coypel

PARIS 1694–1752 PARIS

34. *Portrait of Charlotte Philippine de Châtre de Cangé, Marquise de Lamure,* about 1735

Pastel on blue wove paper, laid down on linen, 75.5 × 61.9 cm

INSCRIBED: In pen and brown ink on label affixed to verso: *Charlotte philippine de châtre de Cangé, veuve en première noce de Mʳ de Boze [Mariée] veuve en seconde du marquis de Lamure. Morte 1ʳ Avril 1789. Cousine germaine de madame du Can, née Charlotte Rosalie de châtre. Etiquetée ce 24 Avril 1846.*

PROVENANCE: M. De la Rue, Château des Caites, Caen; Baron de Reuter; Christie's, London; Duveen Brothers, London; Theodore T. Ellis, Worcester, Massachusetts.

REFERENCES: *Magazine of Art,* vol. 24, 1899, p. 29; Mireur 1911, vol. 4, p. 198; P. B. Cott in Worcester Art Museum *Annual,* vol. 4, 1941, pp. 23–24, 28, 33 nn. 53–54; *Film und Frau,* vol. 7, 1955, pp. 26, 98; Dresser 1974, vol. 1, pp. 233–35, 585; Ribeiro 1983, cover; Gutwirth 1992, pp. 87–88; Lefrançois 1994, pp. 147, 266–68.

Bequeathed by Mary G. Ellis as part of the Theodore T. and Mary G. Ellis Collection, 1940.61

Formerly attributed to Maurice Quentin de Latour and to Antoine Coypel, this portrait was ascribed to Charles-Antoine Coypel by Perry B. Cott and Daniel Catton Rich.[1] Charles Coypel was one in an extended family of distinguished artists.[2] His grandfather Noël Coypel (1628–1707) was director of the French Academy in Paris and in Rome, and his father, Antoine Coypel (1661–1722), had a successful career as a decorative painter and portraitist. Even in this rarefied context, Charles was a prodigy. His first dated work is a self-portrait made when he was ten years old in which the precocious artist depicted himself sketching an antique bust. He was admitted to the academy as a painter in 1715, a remarkable honor at that time for a twenty-one-year-old artist.

In 1719 Coypel was named curator of the royal art collection, and three years later he became chief painter to the duc d'Orléans. He first exhibited at the Salon in 1725, and five years later he became a professor at the academy. In 1746 Coypel was named first painter to the king of France, and in the following year he was appointed director of the academy. The master was at ease among the most distinguished people of his time. He was also a playwright, and several of his comedies and tragedies were performed at the royal court. Coypel established his reputation as a painter of grand narrative paintings, but they often were stodgy, academic images, peopled with stock figures chiefly developed in the studio. By contrast Coypel's portraits are among his most carefully observed and sensitive works.

An old label on the linen mount identifies the subject of this pastel as Charlotte Philippine de Châtre de Cangé.[3] She was the daughter of Jean Baptiste Pierre Gilbert de Chastres, equerry, Seigneur de Cangé. Known in society as Jean Pierre Imbert, her father was an intellectual, a great bibliophile and manuscript collector.[4] In 1733 Louis XV purchased a library from Imbert, and he acquired another part of his holdings, an important collection of books on the military, in 1751. Two days after her birth on 1 April 1713, Charlotte Philippine was taken to her baptism at the cathedral of Saint-Louis de Versailles by Philippe d'Orléans, the future regent of Louis XV, and Elisabeth Charlotte, the dowager duchess of Orléans.[5] At age nineteen she married Claude Gros de Boze, an archaeologist and numismatist from Lyons who was thirty-three years her senior. During his career he held many important positions, including president treasurer of France and councilor to the king. In 1753 de Boze died, and five years later Charlotte Philippine wed Seigneur Jean-Joseph de Bourguignon-Bussière, the marquis de Lamure, aide-de-camp to the maréchal duc de Richelieu. When she died in 1789, the marquise de Lamure

named as her sole legatee "Madame Charlotte Rosalie Chastre, widow of M. Ducan," her cousin and her mother's goddaughter. It was Mme Ducan who inherited this pastel and probably glued the descriptive label on its back.

Although Cott and Rich dated the pastel to the 1740s, Thierry Lefrançois argued that the sitter appears to be about twenty years old and that the portrait was more likely to have been done around the time of her marriage to Claude Gros de Boze.[6] The style of the marquise's elegant costume seems to support this assumption. It was common in portrait engravings of the period to frame a figure with a stone parapet or window, which often carried an identifying inscription and coat of arms.[7] Coypel, who executed his own portrait engravings, was well aware of these conventions. In this pastel the artist cleverly transformed this convention by framing the subject in the gilded wooden sill of a coach window.[8] This is confirmed by the lady's traveling costume, the elegance of which reflects her social status.

With the red velvet cushion from inside the carriage propped on the window's edge, the marquise leans forward as if she has stopped for a friendly chat. Her gloves and stole, or *palatine,* show that she is dressed for the out-of-doors, perhaps even for winter.[9] She wears a pink silk gown with wide cuffs over lace *engageantes,* which suggests that her dress dates from the 1740s or earlier. With its floral designs and bluish cast, this luxurious material matches her lace cap. The hat has two lappets, or "streamers," meant to hang down at the back. According to fashion, however, the lady wears them looped up and pinned on top of her head.[10] The lace complements the delicate curls of the powdered wig, which enframe her youthful face with its porcelain complexion. To protect her forearms she wears unusual blue, fur-lined cuffs, snugly secured by a row of jeweled buttons. The front edge of the dress is trimmed with a strip of fabric called "robing," which appears to be ruched, or pleated horizontally. The front of the gown, or stomacher, was pinned or stitched in place under the robe and topped by a tucked-in strip of lace known as a "modesty." It appears to be decorated with two symmetrical, vertical rows of tassels. Two jeweled buttons or ornaments are apparent down the center, made up of pink cabochon gems surrounded by pearls. The marquise wears a fine, cream-colored kidskin glove on her left hand and holds its mate. She carries a fan made of paper or vellum in her right hand, partially unfolded to reveal a floral chinoiserie design painted on its leaf. Dangling from each of the lady's ears is a pair of magnificent pear-shaped baroque pearls. This jewelry balances and stabilizes the marquise's face and her piercing,

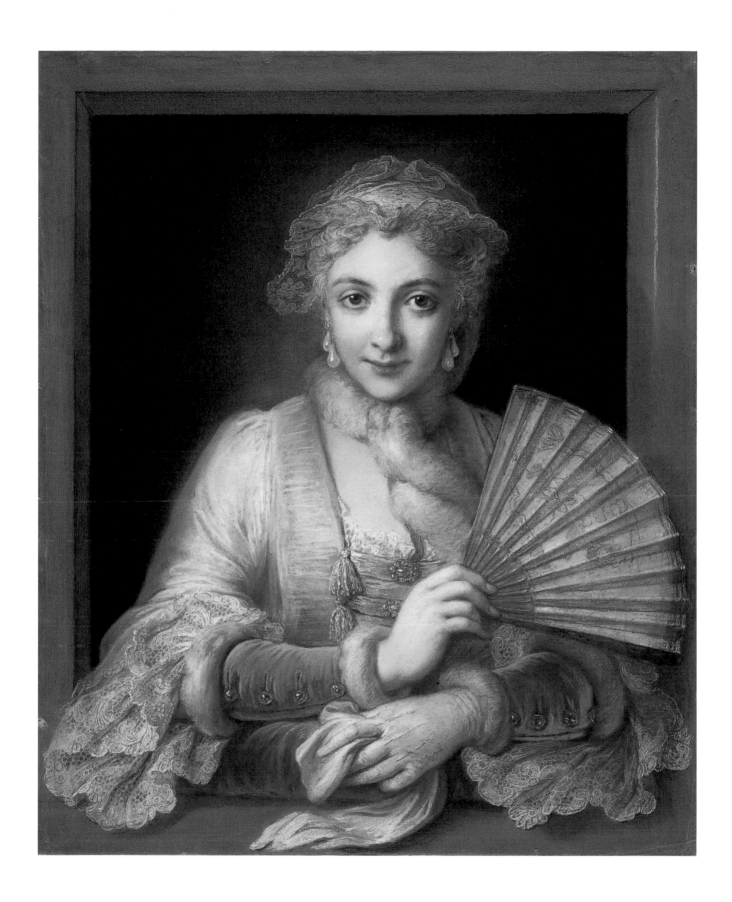

unblinking brown eyes. With her bemused half-smile and the gesture of moving the fan aside, the lady seems to be giving a friendly greeting. The likeness has a direct and flattering quality, which implies that it may have been made as a family memento.

Giambattista Tiepolo

VENICE 1696–1770 MADRID

35. *The Miracle of Intercession,* about 1740–45

Pen and brown ink with wash over
black chalk on cream laid paper,
44.9 × 32.0 cm

WATERMARK: Crossbow

INSCRIBED: In pen and brown ink on
verso, upper left: *l.;* upper center: *910
5/Giambattista Tiepolo/1692–1769/vue
du passepartout 43 —30–1/2*

PROVENANCE: Paul J. Sachs,
Cambridge, Massachusetts.

EXHIBITIONS: *The Practice of
Drawing,* Worcester Art Museum,
1951–52; *European Drawings in the
Museum Collection,* Worcester Art
Museum, 1958.

REFERENCES: Henniker-Heaton 1922,
pp. 74–75, 207; Worcester Art
Museum *Annual Report,* 1922, p. 16,
no. 20; Taylor 1933, p. 71; Worcester
Art Museum *News Bulletin and
Calendar,* vol. 17, December 1951,
p. 6, no. 72; Vey *Catalogue,* no. 109.

Gift of Paul J. Sachs, 1922.13

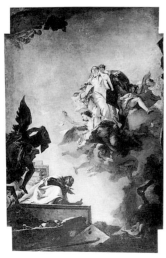

Fig. 1

The most influential Venetian painter of his time,
Giambattista Tiepolo developed fresco painting to
new levels of stylistic and technical sophistication
and in doing so defined the style of Italian Rococo.
The artist was born on 6 March 1696, the son of
a Venetian sea captain who died when he was an
infant.[1] As a boy he was apprenticed to the painter
Gregorio Lazzarini. The prodigious youth also
found inspiration in the more dramatic works of
Giovanni Battista Piazzetta, Sebastiano Ricci, and
Federico Bencovich. Tiepolo entered the painters'
guild in Venice in 1717. Two years later he married
Cecilia Guardi, sister of the painters Gianantonio,
Francesco, and Niccolo Guardi. Giambattista was the
father of nine children, three of whom, Giovanni,
Lorenzo, and Domenico (no. 40), became painters.

During the 1720s Tiepolo painted decorative fres-
coes and canvases in churches, palaces, and villas in
Venice and the surrounding region. His early work
was replaced by bright, spacious imagery and a clear,
sunny palette. Tiepolo accomplished major projects
in the church of the Gesuati in 1739, as well as at
the Scuola dei Carmini and at Santa Maria degli
Scalzi in 1743. His decoration of the Palazzo Labia
in Venice, representing the story of Anthony and
Cleopatra, was a tour de force of illusion. In 1750
the artist was called to Würzburg, where he executed
frescoes in the residence of the prince-bishop Karl
Philipp von Greiffenklau. In this famous High
Rococo cycle, Tiepolo designed the illusionistic
images to integrate seamlessly into architectural
settings.

After Tiepolo's triumphant return to Venice in
1753, it took him nearly a decade to fulfill the com-
missions awaiting him. He became the first presi-
dent of the city's new Academy of Painters and
Sculptors in 1756. Notable among his projects of
the period were his frescoes in the Villa Valmarna
at Vicenza of 1757 and those in the Oratorio della
Purità at Udine of 1759. In 1762 King Charles III of
Spain called Tiepolo to Madrid, where he decorated
the ceiling of the throne room and several rooms of
the royal palace. The artist died suddenly in Madrid
on 27 March 1770.

Drawing was Giambattista Tiepolo's primary
creative activity, and he used the graphic media
throughout his long career to test new visual ideas,
record motifs, and plan the imagery for his paint-
ings. The present sheet was probably a study related
to a decorative painting project. For many years its
subject was incorrectly identified as the Holy Family,
until George Knox recognized that it represents the
vision of a mystic saint.[2] A bald, elderly man dressed
in flowing robes sits solidly on a rock before a distant
mountain peak. Looking out at the viewer with

piercing eyes, he points to the ethereal vision above,
where seraphim flutter in and out of billowing
clouds. The Virgin sits high on a vaporous throne,
holding a small cross in her right hand and glancing
down at the old man. In the space between them
angels carry the body of an infant. The pudgy baby's
eyes are closed, and its arms and legs dangle lifelessly.
This figure represents a human soul, and the elderly
saint has interceded on its behalf with the Virgin,
who now accepts the spirit into heaven. Since it was
customary for artists to represent a disembodied soul
as an infant, it remains unclear whether this is the
spirit of a child or an adult.

One of the most enduring concepts in Christian
theology, the principle of intercession was at the
foundation of Catholic reverence for the saints and
the proliferation of their images.[3] This tradition
holds that the saints and the Virgin in heaven can
appeal to God on a worshipper's behalf. Catholic
doctrine teaches that prayers directed to Christ or to
God the Father should beseech for mercy and spiri-
tual salvation; however, a worshipper can appeal to
the mediating saints for specific personal needs and
help on the road to heaven. Here the intercessor is
Elijah, a sainted prophet of the Old Testament, who
lived a strict ascetic life on Mount Carmel, miracu-
lously sustained by God.[4] The mountain appears in
the background as his attribute. When the prophet
ascended into heaven in a fiery chariot, he dropped
his cloak to his disciple Elisha, figuratively passing
on his succession.[5]

Elijah was revered as the founder of the monastic
order of the Carmelites, for whom Tiepolo often
worked in Venice. In his altarpiece *The Madonna of
Mount Carmel,* painted about 1720 for San Aponal,
Carmelite monks, nuns, and saints intercede with
the Virgin and Child on behalf of souls in purga-
tory.[6] In the dark background is the hooded figure
of Elijah with Mount Carmel looming behind him.
The style and technique of the present drawing sug-
gest that it was made in the early 1740s, a time when
Tiepolo was engaged upon several extensive projects
for the Carmelites. In 1740 he was commissioned
by the leading Carmelite lay society, the Scuola dei
Carmini, to provide paintings for their lavish Venice
headquarters. They requested a series of canvases
to surround the Baroque *Assumption of the Virgin,*
by Alessandro Varotari, il Padovanino, on the ceil-
ing of the main assembly hall. In a letter dated
21 December 1739, Tiepolo declined the commission
because he found the subject of the central painting
inappropriate to the Scuola, also declaring that he
himself lived "in devotion to the Virgin of Carmel."[7]
Within the next few weeks the Scuola decided to
move Padovanino's canvas and engaged Tiepolo to

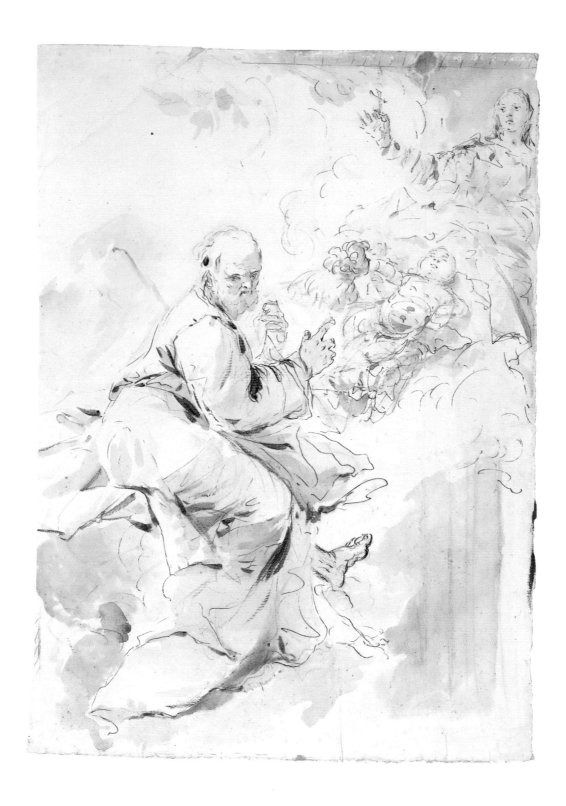

produce an entirely new decorative cycle for the ceiling of the *gran salone*.[8] The central panel was to depict the Virgin descending from Heaven to pass the scapular to Simon Stock, the medieval general who founded the Carmelite lay fraternity (fig. 1).[9]

Tiepolo produced eight more canvases to surround the central ceiling panel at the Scuola dei Carmini, and although various subjects were considered, the finished compartments depict four Carmelite miracles and the allegorical images of four virtues. The figures of Elijah and Elisha are both mentioned in the 1740 contract but are absent from the ceiling painting in the Scuola dei Carmini. It is possible that Tiepolo once considered depicting them independently in the lateral compartments and among the Carmelite miracles. If so, the present drawing could have been executed at one stage in the artist's deliberation.

Fig. 1. Giambattista Tiepolo, *The Vision of Saint Simon Stock*, 1740–49, oil on canvas, 553.0 × 342.0 cm. Venice, Scuola Grande dei Carmini.

Circle of Jean-Baptiste Oudry
PARIS 1686–1755 BEAUVAIS

36. *The Two Goats,* 1740s

Charcoal and black, white, and brown chalks on blue laid paper, 62.1 × 47.9 cm

INSCRIBED: In black chalk, lower right: *J. B. Oudry*

PROVENANCE: Unidentified collector's mark; comte de la Monneray, Chateau de Foullaux; Schaeffer Galleries, New York; purchased from R. M. Light and Company, Boston.

EXHIBITION: *Art Treasures for Worcester: The Legacy of Daniel Catton Rich,* Worcester Art Museum, 1970.

REFERENCES: Worcester Art Museum *Annual Report,* 1963, cover, p. xiii; *Art Quarterly,* vol. 26, Summer 1963, p. 265; "La Chronique des arts," *Gazette des Beaux-Arts,* vol. 63, February 1964, p. 110; Hennessy 1973, p. 177; Opperman 1977, vol. 2, p. 712.

Mary G. Ellis Fund, 1963.59

Fig. 1

The favorite animal painter of King Louis XV, Jean-Baptiste Oudry was a distinguished professor at the French Academy.[1] After studying briefly with painter Michel Serre in 1704, he served for five years as an apprentice to the portraitist Nicholas de Largillierre. Oudry became a student at the Academy of Saint Luke in 1708. Six years later he was teaching there as an assistant professor, and in 1717 he became a full professor and was elected to the French Academy. From 1724 the artist received many painting commissions from the king, and he regularly exhibited his works at the Salon between 1727 and 1753.

Beginning in the mid-twenties Oudry also was active as a designer of decorative arts. In 1726 he became designer for the tapestry factory at Beauvais, where he was named director in 1734. The artist also produced designs for the Gobelins tapestry works, where he was supervisor in 1738 and achieved the position of inspector a decade later. Oudry was also a printmaker, and he executed sixty-six original engravings and etchings, most of them depicting animals.[2]

The present drawing illustrates a proverb from Aesop's *Fables,* the Greek compendium written in the sixth century B.C., which was updated and popularized in Oudry's time by Jean de la Fontaine. This drawing represents the tale of two goats, an ancient aphorism on the folly of stubbornness. La Fontaine describes the nanny goats as if they were two proud and obstinate matrons. Meeting one day on a narrow bridge, each refused to yield passage to the other. After a restive argument they both ended up in the icy stream. Oudry's vision of this tale places the goats' heads and determined expressions in the center of the composition. The elegant arcs of their horns and curly beards give a sense of potential movement, which is locked in place by sturdy bodies and braced legs. A pair of trees in the background swaying in the wind echoes the focal confrontation. As the breeze stirs the leaves and the brook babbles underneath, the goats stand immobile, staring eye to eye. The verse tells what will come, and the spectacle is left to the viewer's imagination.

Oudry began his illustrations for la Fontaine's *Fables Choisies* about 1729.[3] He designed 275 images in his spare time over a period of about five years, while working as a painter for the Beauvais tapestry works. The drawings were consistent in style and format. In 1751 the complete set of drawings was acquired by the wealthy and influential financier Montenault, who conceived the idea of reproducing them in engraving and publishing them along with la Fontaine's text. To undertake this huge project, Montenault engaged Charles-Nicholas Cochin *fils*

to rework and consolidate the designs, and assembled a team of forty-two engravers. Many of Oudry's human figures benefited from Cochin's intervention, but the liveliness of his animals suffered. The first engravings were exhibited in the Salon of 1753, and the first three volumes were published in 1755 and 1756. Financial difficulties delayed the project until 1759, when the publishers were aided by a royal grant, which enabled them to release the final volume. Oudry's illustrated volumes of la Fontaine are among the biggest and most lavish of any illustrated books of this period.

Oudry often made supplementary drawings of the fables, sometimes designing as many as four versions of each tale. Some of these seem to be experiments, created in the planning stages of the project, while others are variations that adapt resolved compositions to new purposes. The Worcester drawing is certainly based on Oudry's design, judging from the engraving that appeared in the book (fig. 1). It is one of a pair owned for many years by the comte de La Monneray and kept in his Château de Fouillaux near Le Mans. The pendant image represented the tale of *The Wolf and the Swan.*[4] The drawings were larger than most by Oudry and unusual in their oval format. Pierre Rosenberg first suggested that their size and shape indicate that they were designs for tapestry or needlework chair backs.[5] Because Oudry was employed as a designer for the Beauvais royal tapestry factory between 1729 and 1734, when he was at work on his drawings of la Fontaine's fables, it is reasonable to assume that he might have adapted two of these designs to ornament the elliptical backs of a pair of matching side chairs.

Most scholars feel that the greater part of the drawing is not by Oudry's own hand. Opperman speculated that the artist might have originally sketched the composition, which was later overdrawn and strengthened by another hand.[6] It would seem that the master created a quick sketch of the subject, derived from his image of the fable in la Fontaine, and then a member of his workshop reworked the design, clarifying and defining form to make it easier for a craftsman at the tapestry factory to execute the design in that medium. Hints of Oudry's style are visible in the underdrawing, particularly in the background. The buildings especially are quite characteristic, but rather than the straight, angular, choppy lines that characterize the artist's touch, this drawing has been traced over by the hand of a draftsman who favors a softer, deliberate, more sinuous line. However, as Opperman observed, the underdrawing of the trees and buildings in the background may suggest Oudry's touch.

Fig. 1. Claude-Olivier Galimard, after Jean-Baptiste Oudry,
The Two Goats, etching, 32.4 × 25.0 cm, from Jean de la
Fontaine, *Fables choisies mises en vers,* vol. 4, 1759, p. 81.
Boston, Museum of Fine Arts, bequest of Mrs. Arthur Croft,
1901, 1289.

Pompeo Batoni

LUCCA 1708–1787 ROME

37. *Study for the Figure of Chronos,* about 1745

Red chalk on cream laid paper,
28.1 × 21.8 cm

PROVENANCE: Galippe; Haussman;
Finkenstein; Benjamin Sonnenberg;
F. Kleinberger and Company, New
York; purchased from Sotheby Parke
Bernet, New York.

EXHIBITIONS: *Yvonne French at the
Alpine Club,* London, 1960; *Italian
Eighteenth-Century Artists,* Paris, Petit
Palais, 1961.

REFERENCES: Worcester Art Museum
Journal, vol. 2, 1978–79, pp. 48, 50;
Sotheby Parke Bernet 1979, no. 73;
Clark 1985, p. 388, no. D290.

Jerome A. Wheelock Fund, 1979.18

Fig. 1

After establishing himself as an academic history painter, Pompeo Batoni became the leading portraitist of the eighteenth century in Italy. While the style of his grand narrative pictures exemplified an international academic manner ultimately based on the art of Raphael, his portraits had all the swagger and stylishness of the high French Rococo.

Pompeo was the son of the distinguished goldsmith Paolino Batoni of Lucca.[1] His mother died after his birth by cesarean section, and it was expected that the infant would also perish. For many years he seems to have suffered the effects of this traumatic birth with a neural disorder that affected his speech and motor skills. Despite these handicaps the boy was put to work in his father's shop and developed prodigious skill in ornamenting metalwork with delicate engraving. In 1720, when Pope Benedict XIII established a new bishopric in Lucca, the governors of the Republic expressed their gratitude with a gold chalice commissioned from Paolino Batoni. Pompeo designed and decorated this cup, and his mastery was honored when the youth was sent to deliver it himself. Once in Rome, with the support of his godfather and seven other Lucchese noblemen, he studied painting. After about three years Batoni attracted his first commissions for portraits and grand history paintings. He also began a family, fathering two sons and three daughters before the death of his wife in 1742. Five years later he remarried, and this union produced more than ten more children. While his second son, Paolo, entered holy orders, all of Batoni's other sons became painters.

For twenty years, beginning in the 1750s, Batoni flourished as the most important portraitist in Rome. His subjects included Italian nobles and prelates and many distinguished visitors to Rome on the Grand Tour. He established himself in a large house in the via Boca di Leone, which also included exhibition galleries and studios where evening drawing classes were offered. The Prussian painter Johann Gottlieb Puhlmann joined this household in 1774 when he became Batoni's pupil and eventually his chief assistant. The artist's salon attracted the best of Roman society; three different popes visited the studio. Batoni's daughters were accomplished singers and musicians, and they often performed for visitors. The artist was knighted by Pope Benedict XIV and ennobled by the Archduchess Maria Theresa.

Batoni was elected to the Accademia di San Lucca in 1741, and over the course of his career he held many administrative offices in that organization. However, he never allowed teaching, administration, or social duties to detract from his painting. He was a tough businessman, for the financial demands of

his large family and studio were considerable. Privately Batoni was a devout Catholic who worshipped and liberally gave alms to the poor every day. During the 1780s, when the flow of tourists to Rome abated, the artist's activity subsided. His work ceased in October 1786 when he suffered an incapacitating stroke, and he died five months later.

This preparatory sketch represents the figure of Chronos, or Father Time, for Batoni's allegorical painting *Time Orders Old Age to Destroy Beauty,* now in the National Gallery in London (fig. 1).[2] Begun in July 1745, the picture is one of a pair created for the Lucchese collector Bartolommeo Talenti. Its pendant, an *Allegory of Lasciviousness,* now in the Hermitage in Leningrad, was completed in 1747. In a letter to his patron in 1744, Batoni wrote that these two pictures would come from his imagination. He described the subjects of these paintings and the progress of their creation in other correspondence.

In the allegory of impermanence for which this drawing was executed, Chronos, the Titan who came to be identified as the personification of Time, is winged to indicate his swiftness. He is identifiable by his hourglass and by the scythe that he uses to cut life short. These attributes are not included in the drawing, which is an early figure study. The deity is not represented as a doddering, infirm graybeard, as is common, but as a muscular, effective man in the prime of life. Paradoxically, his maturity would seem to place him of an age between his two daughters. With a pointing gesture Chronos orders one of them, Old Age, symbolized by a wizened crone in peasant garb, to accost her sister, Beauty, personified by a youthful maiden. Waving her hand over her victim's face, the hag exposes the maid to the disfiguring ravages of time.

While he may have invented the allegory himself, Batoni derived the figures for *Time Orders Old Age to Destroy Beauty* from several sources. For the figure of Beauty he adapted François Duquesnoy's sculpture of *Saint Susanna.*[3] For the figure of Chronos he adapted the pose of the prince from the famous Renaissance engraving *The Judgment of Paris* by Marcantonio Raimondi after Raphael.[4] The present sketch is one of only two preparatory drawings for the London painting that are known to survive. The other is a study in black chalk on yellow prepared paper representing the head of a woman for the figure of Old Age, now in the Rijksmuseum in Amsterdam.[5]

The nude represented in the Worcester sheet may have been sketched from the model in the studio, posed in precisely the position retained in the finished painting. This is suggested by the carefully rendered vignettes of head, hands, and foot, which

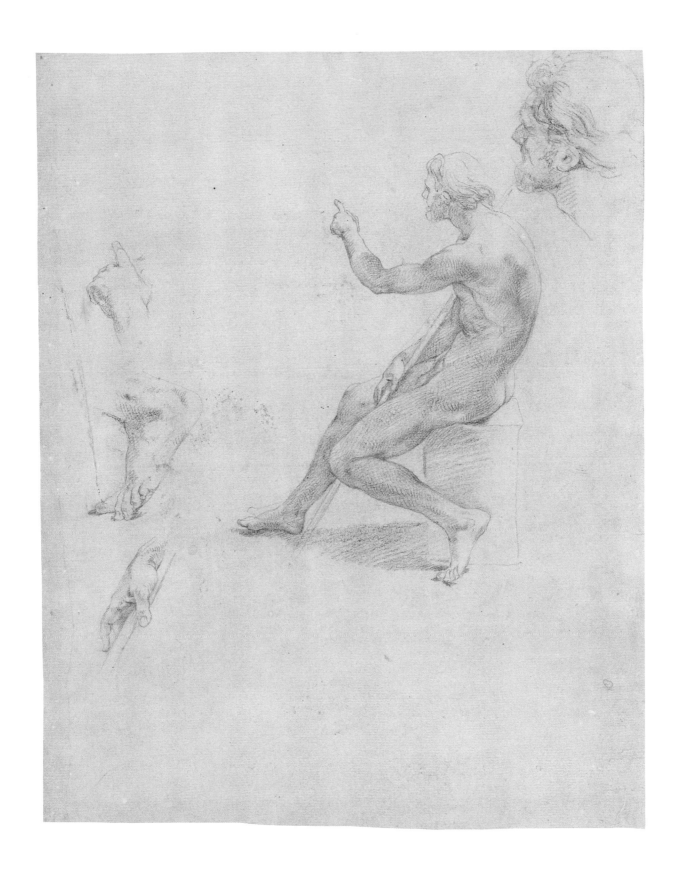

refine and resolve awkward details in the figure study. Moreover, the model for this sheet seems younger than the figure of Chronos in the painting. The right hand, carefully observed as it holds the staff in this sheet, was altered to hold the hourglass in the final composition. Several pentimenti—like

those of the figure's right arm and foot—further demonstrate that this was a working drawing.

Fig. 1. Pompeo Batoni, *Time Orders Old Age to Destroy Beauty,* 1745–46, oil on canvas, 135.3 × 96.5 cm. London, National Gallery, 6316.

Jacob de Wit

AMSTERDAM 1695–1754 AMSTERDAM

38. *A Children's Bacchanal,* about 1748

Pen and black ink and wash over charcoal with white heightening on cream laid paper, 29.1 × 18.3 cm

WATERMARK: *LA*

INSCRIBED: In pen and brown ink, lower right: *7/2.;* in pen and brown ink on verso, lower right: *Voor de herr Jan Jeronimis Bormel 17.2/graeuw Schoor steen Stukke;* in pen and brown ink on tab affixed to sheet: *deWit c p inv.*

PROVENANCE: Rudolf Philip Goldschmidt (Lugt 2926); purchased from Schaeffer Galleries, New York.

REFERENCES: "Accessions of American and Canadian Museums," *Art Quarterly,* vol. 32, 1969, p. 332; Worcester Art Museum *Annual Report,* 1969, p. xii.

Museum purchase, 1969.25

Fig. 1

The leading decorative painter in Amsterdam during the eighteenth century, Jacob de Wit gained an international reputation for his paintings, custom designed for elegant homes. Baptized in Amsterdam on 19 December 1695, at age nine he became an apprentice in the workshop of Albert van Spiers, an academic painter who favored a neoclassical style.[1] In 1708 de Wit was adopted by his wealthy, aesthetically inclined uncle, who called himself Jacomo de Wit. A successful merchant in Antwerp, he dealt in wine and works of art and owned an impressive collection of Italian, Flemish, and Dutch pictures. In Antwerp the young Jacob de Wit entered the studio of Jacob van Hall, and through his teacher and uncle he met other artists and patrons who made it possible for him to attend life drawing classes at the Antwerp Academy and to copy paintings in churches and exclusive private collections.

In 1713 de Wit was admitted to the Antwerp painters' guild, but sometime in the next four years he returned to Amsterdam. De Wit developed a specialty in decorative paintings for private homes, mostly canvases designed to be set into ceilings and walls and integrated into ornamental *boiseries.*[2] These were chiefly mythological or allegorical images executed in a light style. Many were painted in grisaille or in tones of white and gray meant to imitate carved marble or plaster sculpture. As a pun on the painter's name, these were called *witjes,* or "little white paintings." In addition to the patricians of Amsterdam and collectors elsewhere in the Netherlands, the prolific artist had a clientele as far away as Paris and London.

De Wit became a full citizen of Amsterdam in 1720, and four years later he married Leonora van Neck. His only important history painting is the monumental mural *Moses and the Seventy Elders Receiving Divine Inspiration,* commissioned in 1735 for the council chamber of the Amsterdam Town Hall. The artist also executed many important ecclesiastical commissions, including altarpieces for the most important new chapels in Amsterdam, the Moses and Aaronkerk and the Fransche Kerk. By 1741, when he purchased a house on the Leizersgracht, de Wit had become one of the most highly paid painters in Amsterdam. The artist died on 12 November 1754. The catalogue of the estate shows that he owned paintings by Peter Paul Rubens (see no. 16) and Anthony van Dyck as well as other Netherlandish artists, and a number of Italian drawings.

De Wit was a prolific draftsman and seems to have easily sold all the drawings that he released. His drawings are better understood than his paintings, since many of the latter were privately owned and integral to the homes they decorated. The Worcester Art Museum owns two drawings by de Wit, one a sheet of studies of hands, which seems to date from the period of the artist's tuition in Antwerp (fig. 1).[3] These sketches apparently were made from several paintings by various artists. The crossed hands at the top of the leaf, with their wrists bracketed in pearls, appear to reflect the style of Rubens, whose works exerted an important influence on de Wit's early career.[4]

The present drawing seems to have been de Wit's record of one of his private commissions. The artist's notation on the verso of the drawing may be translated: "for Mr. Jan Jeronimis Bormel, . . . [a] grisaille overmantel." The patron was undoubtedly Jan Jeronimus Boreel, an important Amsterdam notary.[5] Beginning in 1707 he lived on the Herengracht, east of the Konigsplein, and served as secretary of the Amsterdam orphans' court. Boreel married Anna Maria Peels in 1709; in 1722 he purchased a house called Hartenlust, south of Bloemendael. In 1735 Boreel became secretary of the public notaries in Amsterdam.

Executed with speed and confidence, the composition of this drawing is sensitive, fresh, and spontaneous. Like those of most of de Wit's interior decorations, the design represents children whose activities mimic those of adults. Gathered in a sylvan grove, these figures are devotees of Bacchus, engaged in rites that involved achieving a state of ecstasy by drinking wine. Their joyful frolics suggest that they may be inebriated, a notion supported by an overturned drinking cup and a basket of grapes in the foreground, as well as the prominent decorated urn. While one child seems to sing, beating time on a tambourine, another holds aloft a thyrsus, the staff entwined with vines and tipped with a pine cone that Bacchus wielded as his scepter. Four of the children wrestle with a billy goat, the lusty animal sacred to Bacchus, steadying the animal for another bacchant to mount. The activity of the composition swirls from right to left, up through the tree trunk to where one putto has climbed a branch high above his friends. His pose, which suggests an imminent fall, brings the viewer's eye down again to the main action.

It does not seem possible to determine whether the overmantel painting represented by this drawing was made for Boreel's Herengracht home or for his house Hartenlust. Although the subject, style, and format of the drawing are consistent with some of the artist's *witjes* designs, the setting seems deeper and more expansive than the grisaille paintings. No such painting is recorded at the Rijksbureau voor Kunsthistorische Dokumentatie in The Hague.[6]

At the Hermitage in Saint Petersburg a painting by de Wit represents a similar children's bacchanal and includes several of the same motifs and figures as the present drawing.[7] The setting of that painting, several of its figures, and especially the central motif of a child mounting the goat's back are identical to the present drawing. However, this painting is horizontal in format and more expansive in its illusionistic space. It is conceivable that the present drawing was made as a record of one of de Wit's *witjes,* in a vertical format, and that the full-color painting in Saint Petersburg was a related but separate project.

Fig. 1. Jacob de Wit, *Studies of Hands,* ca. 1715, red chalk with white heightening on prepared cream laid paper, 19.9 × 15.4 cm. Worcester Art Museum, museum purchase, 1964.83.1.

Johann Wolfgang Baumgartner

KUFSTEIN 1709–1761 AUGSBURG

39. *Revelers in a Park before a Fountain,* early 1750s

Pen and black ink with gray wash heightened with white on blue laid paper, 24.3 × 36.7 cm

INSCRIBED: In pen and brown ink on old mount, lower right: *J: Holzer fecit;* in red ink on old mount, lower right: *N:13. 2.St.*

PROVENANCE: Purchased from Galerie Siegfried Billesberger, Munich.

EXHIBITION: International Fine Art Fair, New York, 1995.

REFERENCE: Billesberger 1995, pp. 27, 29.

Stoddard Acquisition Fund, 1995.51

One of the leading painters in Augsburg during the Rococo period, Johann Wolfgang Baumgartner was also a prolific draftsman and designer. He was born in 1709 in the village of Kufstein in the Tyrol.[1] His father was a blacksmith who taught his own trade to his son. However, the multitalented youth was drawn to Salzburg, where he worked as an assistant to a musician, who also taught him to paint. His early works were small reverse paintings on glass representing landscapes and architectural views.[2] He developed his own technique, using pigments suspended in a turpentine medium, and executing linear details by scraping the dry paint away with a stylus and backing the glass with black paper. Practicing this specialty, the artist traveled widely in eastern Europe.

By 1733, when he settled in Augsburg, Baumgartner had married Anna Katharina Mayr. The scale and subject of Baumgartner's glass paintings made them suitable for engraving, and during the 1730s the artist sold his designs to Augsburg printmakers and publishers, then among the most productive in Europe. Christian and Martin Engelbrecht, Christian Gustav Kilian, Joseph and Johann Klauber, Melchior Küssel, and others produced etchings and engravings after his designs. Baumgartner became the prolific designer of a wide variety of prints, including religious and political broadsides, calendars, devotional images of saints, mythological narratives and allegories, and miscellaneous book illustrations. Most of the nearly 250 drawings attributed to Baumgartner are preparatory designs for prints. About 50 of them can be associated with the 126 illustrations for the Bible published by the Engelbrecht brothers about 1743. In the late 1740s the artist began the enormous project of providing 287 oil sketches to be engraved as illustrations for Joseph Giulini's *Daily Devotions of a True Christian,* a four-volume book of devotional prayers, published in 1753–55.[3]

Baumgartner became prosperous and raised a large family. During the mid-1740s he studied at the Reichsstädtische Akademie, where he was a pupil of Johann Georg Bergmüller. The work of the South German painters Johann Evangelist Holzer and Gottfried Bernhard Götz prompted Baumgartner to develop a lighter style, freer execution, and pastel palette. The artist also was influenced by the French Rococo, which he probably knew through prints. Baumgartner was admitted to the painters' guild on 16 August 1746, when he also became a citizen of Augsburg. His first important paintings were done in 1754–55 for the church of Saint Jacob at Gersthofen near Augsburg. Among his most famous projects was his decoration of the monastic church

at Bergen, near Neuberg, on the Danube, a commission that occupied him from 1756 through 1759.[4] In 1760 Baumgartner was engaged by the Augsburg prince-bishop Franz Konrad von Rodt to paint frescoes in the small pilgrimage church at Baitenhausen, directly across the lake from the city of Constance. Afterward von Rodt commissioned him to paint murals in the small summer pavilion beneath the new castle of Meersburg. Next the artist was to work inside the castle itself, a handsome project announced in the Augsburg newspapers. However, when Baumgartner returned to the city after working late into the fall, he was very sick; he died of consumption on 7 September 1761.

The present sheet is one from a group of nearly thirty drawings by Baumgartner that were for many generations in the possession of a South German family. They are all designs for prints. Sixteen sheets among them are comparable in size and format, the models for four series of four prints. One of these suites depicts elegant gardens with groups of picnicking figures; another represents similar groups in Italianate port settings. The images of both series were tied together by the theme of the times of day. While the parties in the chateau gardens are based on the popular prints of Antoine Watteau and Hubert Gravelot, the portside caprices derive from etchings by Antonio Canaletto and Bernardo Bellotto. Just one print reproducing a design from these series has been identified: a mezzotint of one of the Venetian scenes published by Johann Philipp Koch; however, it proves that all the drawings in this group were intended as print designs.[5] All four drawings of courtly garden parties, including the present sheet, were used in a printmaker's workshop. Their versos were smeared with red chalk and a waxy substance, then the main contours of the composition were scribed with a sharp stylus when the designs were transferred to the copper plates.

In its spacious composition, organized around architectural elements, the present drawing is similar to many of Baumgartner's earlier reverse paintings on glass. All of the three pendant drawings represent informal social gatherings in the gardens of affluent, up-to-date palaces; they feature elegant parterres and plazas, niches, intersecting paths, and vistas for the viewer to explore visually and in the imagination.[6] In Baumgartner's day, suites of prints representing court life were quite common, intended not only for library albums but also for the walls of domestic interiors. Although the fashion originated in France, such garden scenes often appeared in German prints of the mid–eighteenth century. Baumgartner designed many of these caprices, published by both Johann Philipp Koch and Martin Engelbrecht, com-

bining courtly elegance with Christian and pagan themes and melding observed realism with imagined allegory. The figures and situations in the present drawing do not suggest any of the common themes of such suites, like the seasons, the senses, the ages of man, or the times of day. Yet the design features many motifs and situations to which more specific allegorical details could easily be added. It is possible that Baumgartner meant to provide options to the printmaker or publisher when he planned and executed these drawings without thematic details. It would have been simple for the etcher to add or subtract figures or to introduce other details of activity or interaction to specify such a unifying allegorical theme.

Domenico Tiepolo
VENICE 1727–1805 VENICE

40. *Fame and Putti in the Clouds,* about 1755

Pen and black ink with wash over black chalk on cream laid paper, 20.2 × 28.3 cm

WATERMARK: Indistinct coat of arms

INSCRIBED: In pen and gray ink, lower right: *Dom. Tiepolo f;* in graphite on verso, lower right: *D29573*

PROVENANCE: Horace Walpole; William Lygron, eighth Earl of Beauchamp; Christie's, London; Barrett; purchased from P. and D. Colnaghi and Company, London.

EXHIBITION: *Art Treasures for Worcester: The Legacy of Daniel Catton Rich,* Worcester Art Museum, 1970.

REFERENCES: Christie's 1965, lot 58; Worcester Art Museum *Annual Report,* 1969, p. xii; *Art Quarterly,* vol. 32, 1969, p. 215; Hennessey 1973, p. 182.

Mary G. Ellis Fund, 1968.67

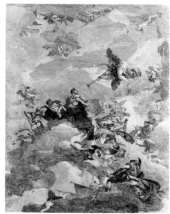

Fig. 1

Although Domenico Tiepolo spent most of his career in the shadow of his father, Giambattista (no. 35), he was himself an accomplished master with an individual artistic personality. He was born on 27 August 1727 and grew up in the large workshop of his extended family, for his maternal uncles and cousins were also painters.[1] By the early 1740s he had begun to assist significantly in the decorative painting projects executed by his father's busy workshop.

Domenico's first important independent project was a commission for fourteen paintings representing the Stations of the Cross, executed in 1747 for the church of San Paolo in Venice. Later he reproduced these images in etchings that he published himself.[2] From late in 1750 until 1753 the artist was in Würzburg, employed as his father's chief assistant on the decoration of the palace of the prince-bishop. Several of the Würzburg frescoes are documented as Domenico's own work. He also produced some independent projects in Germany, including paintings for the royal residence at Veitshöchheim. Back in the Veneto about 1755, he painted the cupola of Santissima Giovita e Faustina in Brescia. Two years later the artist decorated the guest house of the Villa Valmarana in Vicenza, and he had many other religious and secular commissions in the region.

In 1762 Domenico accompanied his father to Madrid, where he worked in the service of King Charles III. It is assumed that by this time Giambattista, who was in his late sixties, depended largely on his son to carry through his ambitious plans for the ceiling paintings in the royal palace, as well as for the seven famous canvases painted for the monastery church at Aranjuez. Two important works from this period are documented as Domenico's own, the ceiling fresco representing the Glorification of Spain near the queen's chambers in the royal palace, and eight paintings of the Passion for the church of San Filipo Neri in Madrid. After his father died in Spain in 1770, Domenico returned to Venice. Six years later, at the age of forty-nine, he married Margherita Moscheni in a ceremony witnessed by two Venetian aristocrats. Over the next decade the artist flourished chiefly as a decorative painter in Venice, finally enjoying the stature he had earned through his own artistic accomplishments. He painted in the Doge's palace and in major churches. He was one of the founders of the Venetian Academy in 1756, and from 1780 to 1783 he served as president of that institution. Toward the end of his career, in the mid-1780s, Domenico executed a series of frescoes in the family villa at Zianigo, seemingly for his own pleasure. Seven years after the fall of the Venetian Republic, the artist died at the age of seventy-seven.

During his long career Domenico worked in a variety of drawing styles and techniques. Among the artist's most original drawings are his caricatures, many representing the daily lives of wealthy Venetians or the misadventures of Punchinello and his society of clowns and mountebanks. Many of his extant drawings are repertorial, depicting figures and motifs that appear frequently in the decorative paintings executed by the family workshop. The present drawing is such a design, representing figures viewed from below for an illusionistic ceiling decoration. It represents the allegorical figure of Fame as a winged demigoddess bearing a trumpet to proclaim the glory of a personage or event. In her left hand she carries a laurel wreath, an award of victory and honor. She is accompanied by a cloud of attendant putti, who also carry horns and diadems. Fame often appears in paintings by the Tiepolo workshop. The figure in the present drawing resembles that of the goddess, depicted carrying two trumpets, in *The Apotheosis of Francesco Morosini,* a ceiling painting executed by Giambattista's atelier in the Palazzo Morosini in Venice around 1750–53. She is even closer to another hovering figure that appeared in *The Apotheosis of Hercules,* a lost painting known through an extant oil sketch and an etching of the design (fig. 1).[3] These figures are comparable not only in their poses and attributes but also in the relationship of each to a bank of clouds on which a putto plays.[4]

Domenico's expertise as a draftsman is apparent in this sheet, which combines rapid sketching with a pen and carbon ink, with delicate, golden washes of bistre ink that emphasize dimension and plasticity of form. The bistre wash included heavy particulate matter, which sank to the bottom of the inkwell; the draftsman obtained washes of varied densities by dipping his brush into various depths of his ink pot. When he spread the wash across the sheet, the grainy soot was deposited on the surface while the thin, tinted medium soaked into the paper, forming a corresponding golden halo on the verso. In the puddle of wash under the chin of the figure of Fame, for example, Domenico placed a deposit of soot to emphasize the jaw line. The putto facing downward at the viewer, in the lower right, is modeled in softer, transparent washes that the artist took from the top of the inkwell.

The present drawing was once included in the noted Beauchamp Album, a large collection of drawings by Domenico Tiepolo, apparently bound together sometime between 1783 and 1793.[5] Inside its back cover the album had an inscription in the same hand as that on the Gatteri Album of Tiepolo drawings now at the Museo Correr in Venice. Both

albums may once have been owned by the painter Francesco Guardi, Domenico's uncle. The album containing the present drawing was then acquired by Horace Walpole, the English author and dilettante, who affixed his bookplate to the folio. A French inscription on the title page suggests that the album was in France during the nineteenth century, before its acquisition by the Beauchamp family.[6] The folio was dismembered at the time of the Beauchamp sale at Christie's in 1965.

Fig. 1. Domenico Tiepolo, after Giambattista Tiepolo, *The Triumph of Hercules,* ca. 1755, etching, 66.8 × 50.8 cm. New York, Metropolitan Museum of Art, Rogers Fund, 22.81.94.

Attributed to Charles-François Pierre La Traverse

PARIS 1726–ABOUT 1780 PARIS

41. *The Bodies of Saints Peter and Paul in the Catacombs,* about 1755

Pen and black ink with brown wash over black chalk on cream laid paper, 52.9 × 39.0 cm

WATERMARK: Fleur-de-lis in a circle

INSCRIBED: In graphite, lower center: *216;* in graphite on verso, lower left: *fragonard Ca Menpuieil*

PROVENANCE: Purchased from Lucien Goldschmidt, New York.

EXHIBITIONS: *Art Treasures for Worcester: The Legacy of Daniel Catton Rich,* Worcester Art Museum, 1970; *French Drawings of the Seventeenth and Eighteenth Centuries in North American Collections,* Ottawa, National Gallery of Canada/ Toronto, Art Gallery of Ontario/ San Francisco, California Palace of the Legion of Honor/New York, Cultural Center, 1972–73.

REFERENCES: Worcester Art Museum *Annual,* vol. 9, 1961, p. xiii; Worcester Art Museum *News Bulletin and Calendar,* vol. 27, December 1961, n.p.; "La Chronique des arts," *Gazette des Beaux-Arts,* vol. 59, January 1962, p. 68; Rosenberg 1972, p. 229, cat. no. 157; Aaron 1985, pp. 52–53.

Museum purchase, 1961.12

Once ascribed to Jean Honoré Fragonard, this fascinating, rather macabre drawing entered the collection with an attribution to Pierre Subleyras, a French academic master who worked chiefly in Rome.[1] Its style is indeed similar to that of Subleyras, who sometimes depicted enshrouded, recumbent figures in his paintings.[2] However, that artist had a more angular manner of drawing and preferred to work in a combination of chalk and light wash. The present drawing certainly seems to have been executed in Rome by a French artist connected with the academy, and Pierre Rosenberg suggested that he may have been Charles La Traverse.[3]

Born in Paris in 1726, La Traverse was a student of François Boucher (no. 43) at the Académie Royale, where he won second prize in the annual school competition of 1748. Boucher helped to arrange a grant from the court that enabled the young artist to go to Rome in the following year. La Traverse sent his paintings from Rome to the Paris Salon: *The Death of Hippolytus* in 1750 and *The Portrayal of Alexander's Mistress* in 1751. He remained in Italy until 1755, visiting Naples and exploring the ancient ruins at Pompeii and Herculaneum. In 1756 La Traverse traveled with the French consul the Duc d'Osemar to Spain, where he worked for the rest of his career. He was profoundly influenced by Spanish painting and also by the Flemish masters who had worked there in the sixteenth and seventeenth centuries.[4] In Spain his small landscapes and floral paintings were more appreciated than his portraits and history paintings. La Traverse became an active teacher in Madrid. Perhaps his best-known painting there was an allegory of the birth of a Spanish infanta, which was engraved by Manuel Salvador Carmona. The artist seems to have fallen ill in the late 1770s; a letter he sent from Granja in San Ildefonso in 1779 to d'Angiviller at Versailles describes a slight improvement in his health. Shortly thereafter the artist returned to Paris, where he died.

The style and technique of this work are similar to drawings by La Traverse now in Besançon.[5] The black ink pen lines are precisely and seamlessly integrated with the superimposed brown ink washes. The intriguing, disconcerting subject is parallel to that of a sheet in Besançon representing *An Exhumation at the Foot of a Tree.*[6]

Regardless of its authorship, the present drawing prompts in the viewer a combination of morbid fascination, pathos, and optimism. It represents the bodies of two of Christ's most important apostles, Peter and Paul, in an underground chamber. According to tradition, the two apostles were executed in Rome on the same day, and their bodies were hidden together in the catacombs until pious Greeks could

establish churches in the city for each martyr. The treatment of the corpses was haphazard, for it was illegal to remove the bodies from their place of execution, and the Christians risked great peril in doing so. Yet even though they were left unprotected, the bodies remained undisturbed and miraculously preserved, eventually to receive honored burials. Because of their importance for Rome, the story of these two saints was often represented there in religious art. During the seventeenth century the subject was interpreted by several artists in Rome, including Giovanni Lanfranco and Giovanni Benedetto Castiglione (no. 21). It would, therefore, be logical that a Frenchman working in Rome, like La Traverse, should represent this subject.

In this meticulously crafted drawing, the two corpses lie on beds of fabric or fur, shrouded and respectfully separated. Yet the winding sheets are rolled up to reveal sinewy legs and cocked knees, implying the power of movement now absent from the bodies and a hasty interment. It is unusual that the artist chose to obscure the faces of the saints. Although this concealment suggests respect for the dead, it also denies the personalities, and to some extent the humanity, of the saints. The artist masterfully created a mood of somber silence. The glowing lantern casts a harsh illumination and long shadows over the scene. The lighting emphasizes the figures, and an illusion of space is achieved through their foreshortening. It is made more dramatic by the placement of the lamp behind the rafter. Descending shafts of light are echoed by the dangling rope and tufts of straw hanging from the beam. The composition is organized as a series of centralized, superimposed triangles that echo and accent the beams of light from the lantern. This stagy tenebrist lighting is characteristic of Roman art and ultimately reflects the lingering influence of the seventeenth-century master Caravaggio.

Thomas Frye

EDENDERRY, IRELAND 1710–1762 LONDON

42. *Portrait of a Young Woman,* about 1760

Black, brown, and white chalks on cream laid paper, 48.6 × 39.9 cm

PROVENANCE: Daniel Dupuy, Philadelphia; by descent to Mrs. Vernon Bobbitt, Albion, Michigan; purchased from R. M. Light and Company, Santa Barbara, California.

EXHIBITION: *Rococo to Regency: British Prints and Drawings of the Eighteenth Century,* Worcester Art Museum, 1987.

REFERENCE: Worcester Art Museum *Biennial Report,* 1986–88, pp. 7, 20.

Anonymous Fund, 1986.71

In the course of his career the versatile Thomas Frye worked as a painter, draftsman, ceramist, decorative arts designer, and printmaker.[1] He was born in a village near Dublin, and though little is known of his early years, it is assumed that he studied or served an apprenticeship in Ireland, perhaps with a portrait painter. Around 1734 Frye moved to London, where he won a commission from the Saddlers' Company in 1738 to paint a full-length portrait of their patron, Frederick, the Prince of Wales. The artist may have obtained this project through his acquaintance with Henry Heylyn, a copper merchant who was then joint master of the guild. In 1741 Frye himself made a mezzotint after his portrait of the prince, which is his earliest signed print.[2] The impressive technical quality of the plate demonstrates the artist's professional skill as a printmaker and suggests that he was associated with the "Dublin Group" of Irish mezzotint artists who lived and worked in proximity in London during the mid–eighteenth century.[3] However, while most of those craftsmen specialized in reproductive prints, Frye's mezzotints were based on his own original designs.

By December 1744 the artist was living in the village of West Ham in Essex. There he, along with Edward Heylyn—Harry's younger brother—established the Bow Porcelain Factory near the village of Stratford-le-Bow.[4] From relatively inexpensive white clay imported from North America they produced high quality porcelain and the world's first "bone china," formulated from bone ash. The factory produced distinctive tablewares but established a lucrative specialty in painted figurines. Soon Frye was at the head of the thriving workshop, which employed ninety china painters by 1750. Overwork forced him to retire in 1759, however, and his married daughter Sarah Wilcox, a skilled porcelain painter, took over the business.

Frye returned to London and settled in the neighborhood of Hatton Garden, resuming work as a portraitist and mezzotint scraper. Aside from his commissioned portraits, he concentrated on salable prints of beauties and celebrities at this time. According to John Chaloner Smith, Frye frequented the theater to see King George III and Queen Charlotte Sophia, so that later, working from memory, he could execute their portraits in mezzotint.[5] In 1760 a newspaper advertisement announced an exhibition at the artist's chambers of portrait drawings. Subscriptions were taken for mezzotints of the most popular images among them. Eventually twelve engravings comprised a series, representing fanciful portraits of men and women. A second suite of six mezzotints followed in 1761 and 1762. This suite was more thematic, representing fashionably coiffed and costumed young women. Supposedly the artist attempted to find models for these prints, but the beauties he approached were wary of the company in which their likenesses might appear.[6] Thus, the mezzotints probably represent imaginary portraits, based loosely on the artist's combinations of studies from life and his own fancy.

The present work relates closely to prints in Frye's second suite of life-size mezzotints. It represents an elegantly dressed, confident young woman who turns her head slightly to her right, fixing her gaze boldly on the viewer. A white cotton shift protrudes from the top of her low-necked gown, which is secured with laces down the front of its bodice. A mantle of fabric woven with delicate parallel stripes is draped over her left shoulder.[7] Her hair is drawn up in plaits atop her head, and a long coiled lock falls over her right shoulder. A veil of sheer material is fixed over the coiffure by a dark, diamond-shaped jewel, and the transparent fabric falls over the right shoulder. Two rows of pearls encircle her throat, and a large teardrop baroque pearl dangles from her left ear. Although this drawing was not made into a print, its style and subject are closely comparable to *A Young Woman Holding a String of Pearls,* a mezzotint from Frye's first series (fig. 1).[8] The overall compositions are quite similar, as are the shape and angle of the two heads and the illumination of figure and background. There are many other corresponding details, including the coiffures and veils, the treatment of the eyes and mouths, even the shading and highlighting of the pearls.

The artist handled the dry pigments masterfully, achieving a broad tonal range and subtle textural effects. After establishing a neutral gray-brown foundation over the entire sheet, he drew in black, brown, and white chalks, creating a monochromatic image that was essentially tonal, and thus parallel to mezzotint. In both, forms are lightly outlined in black chalk and hatching is the chief method of modeling. These tonal effects translated logically to the mezzotint plate. To delineate sensitively the contours of the face, the artist smeared and blended chalk with a stump, but most of the modeling and shading effects were achieved by hatching. In some areas Frye also scraped pigment away from the paper in parallel strokes. These technical means are similar to a drawing by Frye now at the Seattle Art Museum representing *A Man in a Turban.*[9] Even though it is oriented in the same direction as the finished print, that sheet was probably the preparatory study for a mezzotint from Frye's first series.[10] Rendered in the same charcoal and chalks on a neutrally hued paper, its size and format are comparable to the Worcester drawing.

Fig. 1

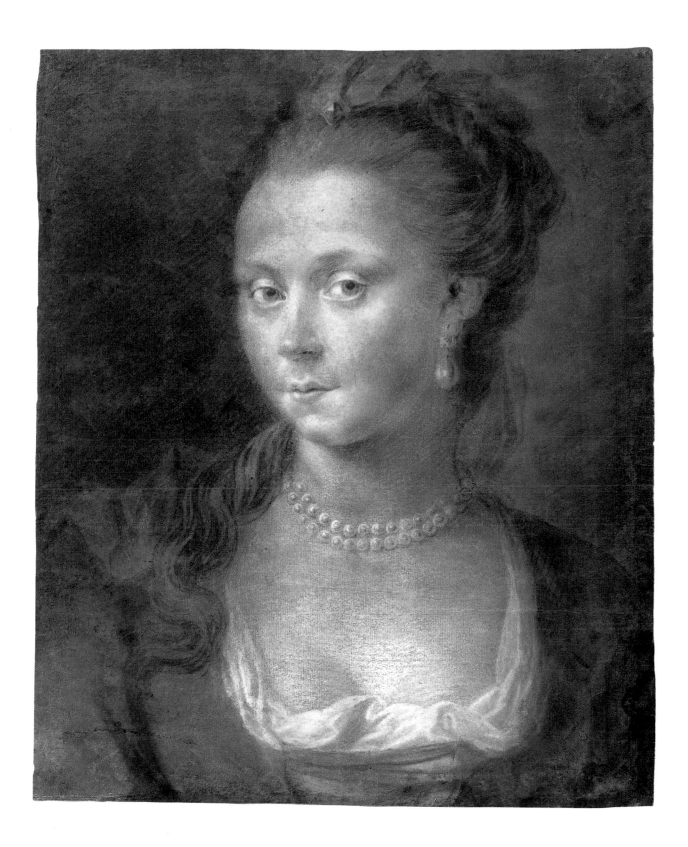

The present drawing is laid down on an old backing sheet. Linear abrasions around its circumference show that it was once mounted on a wooden stretcher for framing, a practice common in the eighteenth century. The location of these scars on the verso of the drawing shows that the sheet has been trimmed at the top. Examination under transmitted infrared light also reveals that the artist altered his design, covering his changes with final layers of chalk. Originally the young woman had narrower eyes. She also once had a higher, more chaste neckline, quite like that in Frye's contemporaneous mezzotint portrait of *Queen Charlotte Sophia.*[11]

Fig. 1. Thomas Frye, *A Young Woman Holding a String of Pearls,* 1760, mezzotint on cream laid paper, 50.3 × 35.2 cm (plate). Worcester Art Museum, Stoddard Acquisition Fund, 1988.161.

François Boucher

PARIS 1703–1770 PARIS

43. *The Annunciation,* 1765–70

Black chalk on cream laid paper,
34.4. × 20.7 cm

INSCRIBED: In black chalk, lower left:
Boucher; embossed on mount, lower
right corner: *G*

PROVENANCE: Jan Baptist de Graaf
(Lugt 1120); purchased from H.
Shickman Gallery, New York.

REFERENCES: *Gazette des Beaux-Arts,*
vol. 89, March 1977, p. 52; Heim
1977, no. 12.

Eliza S. Paine Fund, 1976.3

The works of François Boucher embody the Rococo elegance, sophistication, and frivolity of the age of Louis XV. As a painter, designer, and decorator, this prolific artist gave form to the blithe superficiality with which the French court, then the wealthiest and most powerful in Europe, chose to surround itself.

Boucher was the son of a painter who was his first teacher and who afterward apprenticed him to the workshop of François Lemoine.[1] Early in his professional career he fell under the influence of Jean-Antoine Watteau. In 1723 Boucher won the French Academy's Prix de Rome, which provided for a study trip to Italy. However, he was not able to claim his prize until 1727, when he accompanied the painter Carle van Loo to Rome. There, Boucher was most influenced by the decorative paintings of Giambattista Tiepolo (no. 35) and Francesco Albani. After his return to Paris he continued his association with the academy, where he was made an associate in 1731. Three years later he became a full Academician. Boucher became a favorite artist of Parisian society, led by the king's mistress, Madame de Pompadour.

During the 1730s Boucher distinguished himself as one of the leading decorative painters of the Rococo, and he was in great demand for both his easel pictures and extensive decorative mural projects. The artist worked in the grandest residences in France, including the royal palaces of Versailles, Fontainebleau, Marly, and Choisy. Most of his paintings represented mythological, pastoral, or genre subjects as lighthearted caprices. In 1751 Boucher became Madame de Pompadour's drawing teacher. Soon he was named chief painter to the king, and in 1765 he became director of the French Academy. He regularly provided decorative designs to the royal porcelain factories at Vincennes and Sèvres and to the tapestry works at Beauvais and at the Gobelins, where he was appointed director in 1755. He also created images for illustrated books and designed sets and costumes for the theater.[2]

Boucher turned his attention to religious subjects late in his career, perhaps as much at the behest of his aging clients as from personal inclination. Several times in drawings and prints he depicted the Annunciation, the appearance of God's angel Gabriel announcing the birth of Jesus to his mother Mary. Boucher perhaps first represented this episode in a drawing now in the Musées d'Angers (fig. 1). Its arched top suggests that this design was conceived for an altarpiece, but no such painting seems to have ever been made. A colonnade in the background and the perspectively rendered paving stones seem to place the studying Virgin in a temple or classical building. Tall and slim, Mary strikes a graceful pose more fitting to a courtly minuet than to a serious

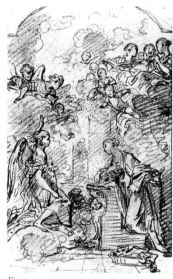

Fig. 1

moment of study and contemplation. Pierre Rosenberg noted stylistic similarities between the Angers drawing and the works of Pierre Charles Tremolières, which would seem to suggest a date in the 1740s.[3]

When working on the present drawing it seems that Boucher looked back to the drawing now at Angers, made some twenty years earlier, for inspiration, subject, format, and composition. This Annunciation takes place in a garden, beneath the boughs of tall, shady trees. Visible in the background is a tall decorative plinth topped by an urn, a grand classicizing garden decoration. The Virgin sits on a chair surrounded by symbols of her maidenly occupations. A draped table at her right holds scrolls, the religious texts that were the subject of her studies; on her left are a distaff and a basket filled with twisted skeins and balls of yarn. At this miraculous moment, a cat playing with a ball of yarn at the Virgin's feet pauses to gaze up at her. Mary's eyes are downcast, and her hands are crossed at her breast in an attitude of humility traditional to the Annunciation. She is elegant and feminine, clad in luxurious draperies and mantle, but seems more modest than the balletic Virgin of Boucher's Angers drawing. The figure of Gabriel appears hovering on a bank of clouds with open wings. As he gazes down at the Virgin he greets her and proffers a white lily, symbol of Mary's purity. With his right hand the Archangel points to the heavens above where God the Father reclines in the clouds surrounded by a glory of angels. The kindly human expression of this figure, with his flowing beard and triangular halo, belies his omnipotence. Crossing his hands in a gesture echoing Mary's, he releases the Dove of the Holy Spirit to descend on a shaft of light down to the demure Virgin below.

While its compositional scheme derives from Boucher's earlier Angers drawing, the Worcester sheet has at its focal center a radiant void, the path of the Holy Spirit, indicating the exact moment when the miraculous incarnation of Christ occurred. This blazing beam of heavenly light illuminates the figure of the Virgin and casts shadows on the objects surrounding her. The glory of seraphim and billowing clouds in the heavens above seem to glow with comparable radiance. The artist rendered the upper quadrant of the drawing with thinner, sparser lines and less shading to suggest this brilliance. Boucher also made clever use of the composition's arched top, which provides a halo of space and light around the head of God the father.

The Worcester drawing seems to have been executed as an independent work of art, not as the preparation for a painting or print.[4] This notion

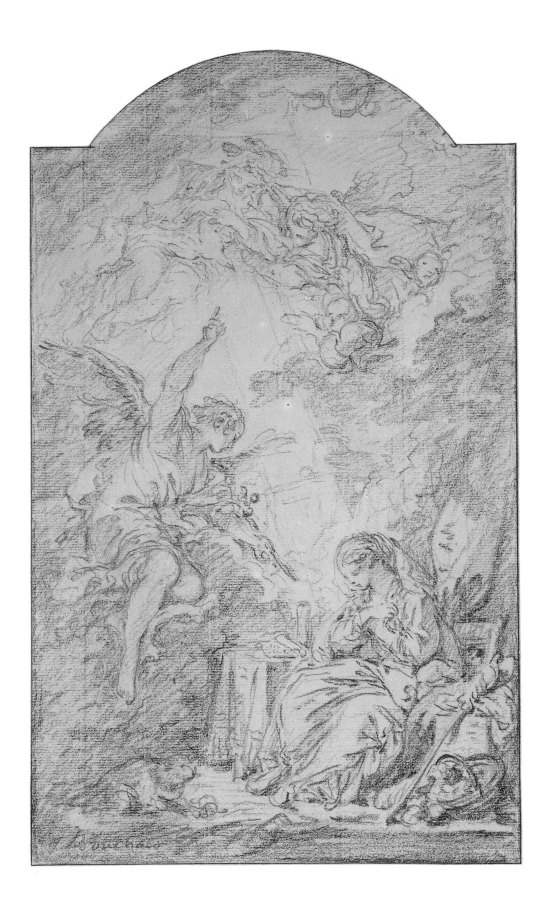

is supported by the way in which the signature is integrated into the image and not added as an afterthought. The nature of the subject, the facial and figure type, and the active, quavering line are all typical of a work from Boucher's old age, probably of the later 1760s. The wonderful combination of dramatic grandeur with human emotion and accessible domestic details characterizes the artist's vision near the end of his career.

Fig. 1 François Boucher, *The Annunciation,* 1740s, black chalk on white laid paper, 29.8 × 18.1 cm. Angers, Musées, M.T.C. 4814.

John Singleton Copley

BOSTON 1738–1815 LONDON

44. *Portrait of Joseph Barrell,* about 1767

Pastel on cream laid paper, 59.4 ×
46.0 cm

PROVENANCE: Joseph Barrell, the sit-
ter; by descent to Henry F. Barrell,
New Providence, New Jersey; pur-
chased from Copley Gallery, Boston.

EXHIBITIONS: Boston, Copley
Gallery, 1915; *Exhibition Showing
the Development of American
Painting,* Worcester Art Museum,
1927; *American Art in the Age of
Independence, 1750–1800,* New Haven,
Yale University Art Gallery, 1975;
The Colonial Epoch in America,
Worcester Art Museum, 1975–76.

REFERENCES: Bayley 1915, p. 52;
Worcester Art Museum *Bulletin,*
vol. 6, October 1915, pp. 1, 13, 16;
Coburn 1915; Worcester Art Museum
Annual Report, 1916, p. 15; Henniker-
Heaton 1922, p. 170; Worcester Art
Museum *Annual Report,* 1922, p. 170;
Bolton 1923, p. 18; Bayley 1929, p. 163;
Lee 1929, p. 76; Parker/Wheeler 1938,
pl. 126; Historical Records Survey
1939, vol. 2, p. 27, no. 142; Taylor
1948, p. 17; Prown 1966, vol. 1,
pp. 66–68, 82, 208, pl. 230; Rich/
Dresser 1966, p. 648; Little 1968;
Sherrill 1975, p. 32; Strickler 1981–82,
p. 37; Schofield 1993, p. 36; Rebora
1995, p. 268.

Museum purchase, 1915.81

John Singleton Copley's remarkable evolution from colonial portraitist to cosmopolitan history painter makes him one of the most interesting American artists of the eighteenth century. Born in Boston, he was initially trained by his stepfather, the English mezzotint engraver Peter Pelham, who settled in the colonies in 1726.[1] Copley learned the techniques of painting and printmaking, as well as the funda-mentals of portraiture, from Pelham. He also learned as much as he could from the works of American painters such as John Smibert and John Greenwood and from artists visiting Boston like the Englishman Joseph Blackburn. However, Copley ultimately developed his mature style from careful observation of the world around him.

In his portraits of the late 1750s the artist incorpo-rated settings of his subject's daily lives. The wealthy New England merchants who were his patrons appreciated his combination of elegance, naturalism, and unpretentious dignity. Thus Copley was in con-stant demand as a portraitist, and such prominent Bostonians as the merchant John Hancock and the silversmith Paul Revere sat for him. The artist became financially successful, married well, and built a fine home for himself on Beacon Hill.

Despite his success, Copley became dissatisfied with the limitations of provincial life. He longed to travel in Europe, to study the works of the old mas-ters, and to create grand history paintings. In the summer of 1774, shortly after the Boston Tea Party signaled the advent of revolution, Copley sailed for Europe. After a year of study in Italy he settled in London, where his family joined him, and he remained there the rest of his life. As he struggled to establish himself as a portraitist, Copley found that the straightforward realism that succeeded in Boston was unacceptable. His style gradually became more ostentatious, and he replaced his tight, meticulous handling of oil glazes with a more painterly manner. Copley also pursued his aspirations to become a nar-rative painter, depicting contemporary events and investing them with all the grandeur and heroism of ancient epics. His most famous history pictures were *Watson and the Shark* of 1778, now in the Museum of Fine Arts in Boston; *The Death of the Earl of Chatham,* 1779, now in the Tate Gallery, London; and *The Death of Major Pierson,* painted in 1783, also in the Tate Gallery. In 1785 the artist won the presti-gious commission to portray the children of King George III; that canvas is still in the royal collection.[2] Gradually Copley gained recognition in the London art world, and the mark of his final acceptance came in 1793 when he was elected to the Royal Academy.

This pastel, one of four Copley portraits in the Worcester Art Museum,[3] represents the fifth-generation colonial Joseph Barrell (1739–1804).[4] His family owned and operated a fleet of American-built cargo ships that plied the Atlantic. In 1769, when his father, John Barrell III, moved to England to manage the company's British operations, Joseph became its chief colonial agent. His trading ventures included expeditions to Madeira for wine and to the West Indies for sugar, and he even sent American-grown ginseng root to China to be traded for tea. He was married three times, widowed twice, and he fathered twenty children. In the 1760s Barrell and his large family lived on Summer Street in the South End of Boston, in a mansion surrounded by exten-sive gardens. However, when he felt overtaxed by the town fathers, he built Pleasant Hill, a larger house in Charlestown. It was designed by the twenty-nine-year-old Charles Bulfinch, the son of a close friend and neighbor, who was once employed in Barrell's company. The house became an architectural and cultural showplace.[5]

During the Revolution Joseph Barrell sided against the British. He financed six privateers, including ships from his own fleet, that opposed British cargo and war vessels. Said to have been acquainted with George Washington, Barrell was among a group of local patriots who arranged the president's visit to Boston in 1789. His most impor-tant contribution to the revolutionary cause, how-ever, was as the organizer of exploratory merchant expeditions. In 1787 Barrell and a small group of Boston investors realized a venture conceived by the British captain James Cook. They sent two ships on the first American voyage to the northwest coast of the continent. The *Columbia Rediviva,* captained by John Kendrick, and the *Lady Washington,* com-manded by Robert Gray, sailed around Cape Horn and up the western coast to present-day Oregon, Washington, and British Columbia.[6] There the Yankees traded hardware goods with Native Americans for sea otter pelts and crossed the Pacific to the Chinese ports of Macao and Canton, where they traded the furs for tea and fine china to bring back to Boston. On her second voyage, in May 1792, the *Columbia Rediviva* entered the mouth of the Columbia River, which they named for their vessel, landed, and raised the American flag. This expedi-tion gave first title of the northwest region to the United States, a claim later conceded by England.

This pastel portrait represents Barrell twenty years before the voyages of the *Columbia,* as a dash-ing young sophisticate. The pastel medium, the small size of the work, and the sitter's comparatively informal mien mark this as an economical product by comparison with Copley's formal canvases. The piece may have been ordered together with a similar

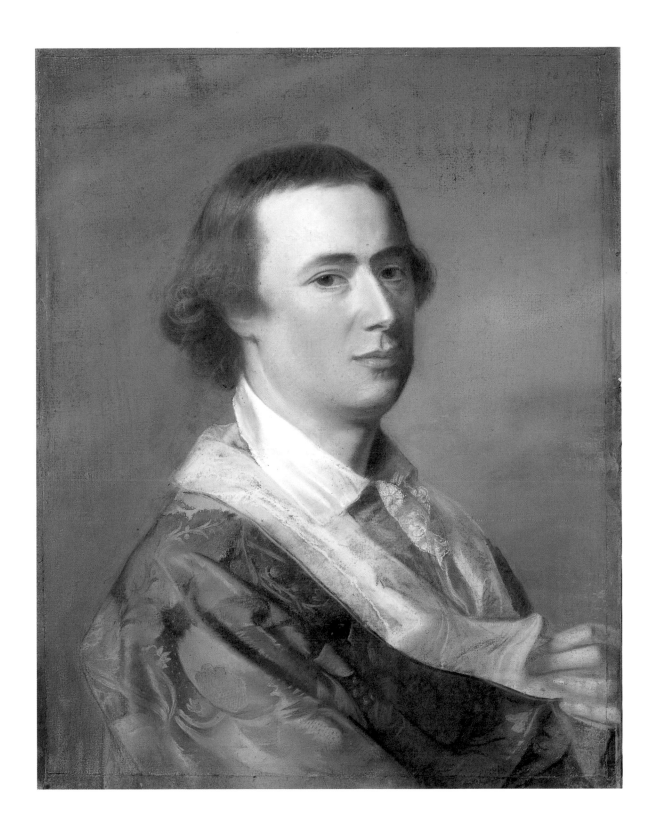

portrait of Anna Pierce Barrell, the merchant's first wife.[7] For the present drawing Copley used a formula that occurs in his other contemporary portraits. The colorful silk damask jacket with its satin lapels gives an air of arrogance to the image, which is emphasized by the sitter's gracefully posed hand.[8]

That the artist employed the same costume and pose for his contemporaneous pastel portrait of another young Boston merchant, Jonathan Jackson,[9] indicates how pragmatic and entrepreneurial Copley was at the time.

Pierre-Paul Prud'hon

CLUNY 1758–1823 PARIS

45. *Study of Drapery,* about 1778

Red chalk on cream laid paper,
16.4 × 21.0 cm

WATERMARK: *1768 D'ANNONAY*

INSCRIBED: In pen and brown ink,
lower left: *Ptrus Plus Prudhon delin.*

PROVENANCE: Baron de Joursanvault;
E. Desperet (Lugt 721); Durlacher
Brothers, New York; Mrs. Frank C.
Smith, Jr., Worcester, Mass.

EXHIBITION: *European Drawings from
the Museum Collection,* Worcester Art
Museum, 1958.

REFERENCES: Worcester Art Museum
Annual Report, vol. 17, 1952, p. xiii;
Vey *Catalogue,* pp. 38–40; Worcester
Art Museum *News Bulletin and
Calendar,* vol. 27, December 1961, n.p.

Gift of Mrs. Frank C. Smith, Jr.,
in memory of her husband, 1952.3

An official French painter of the Revolution and the Empire that followed, Pierre-Paul Prud'hon worked in a style more lyrical and romantic than that of Jacques-Louis David (no. 46), Napoleon's premier artist. His history and decorative paintings retained much of the delicacy of French art of the mid–eighteenth century, a style that appealed to Napoleon's empresses.

Prud'hon was born in Cluny, the son of a stonecutter.[1] When he was a teenager his talents were recognized by the Baron de Joursanvault, who financed his studies at the Dijon Academy operated by François Devosge. In 1778 he won the Prix de Rome awarded by the Burgundian state. Prud'hon spent three years in Italy, where he developed his personal style combining the influences of Antonio Allegri da Correggio and Leonardo da Vinci. He also gravitated to a more delicate version of neoclassicism, as practiced by the contemporary Italian sculptor Antonio Canova and the German painter Anton Raphael Mengs.

After returning to Paris around 1788, Prud'hon became a supporter of the French Revolution, and he attended the meetings of the Club of the Jacobins. He made a living at that time by painting portraits and selling his drawings. The artist left Paris after the fall of Robespierre, not to return until 1796, when he earned a living as an illustrator of novels. Prud'hon was introduced into high society by his friend Frochot, Napoleon's future prefect of the Seine. He came to the attention of Josephine, the wife of General Bonaparte, who engaged the artist to paint the salon ceiling of her house in the rue Chantereine in 1799.

Prud'hon exhibited his neoclassical allegory *The Triumph of Bonaparte* at the Salon of 1801, and its notoriety initiated a succession of official commissions. In 1803 Dominique-Vivant Denon, the emperor's minister of art, engaged Prud'hon to decorate the ceiling of the Greek sculpture gallery at the Louvre. Prud'hon was at his most popular and influential during the period of about 1808 to 1815, when he created his greatest paintings, including imperial allegories, grand mythological pictures, and portraits. The artist designed interior decorations, furniture, and *objets de vertu* for the imperial family and court. He also planned and produced many official celebrations and ceremonies, from the coronation of Napoleon to the emperor's wedding to Marie-Louise. That empress was especially fond of Prud'hon. He painted her bridal suite and later served as her drawing tutor. Because of his friendship with Talleyrand, Prud'hon remained in favor after the fall of Napoleon, but his life ended on a note of romantic tragedy. In 1821 Prud'hon's student

Constance Meyer, who was infatuated with the artist and wished to marry him, committed suicide. Afterward the artist became melancholy and both his life and his work began to deteriorate. Sick and lonely, he spent his final days oppressed by his desires and unfulfilled ambitions.

The present sheet is an unusual early work in Prud'hon's extensive oeuvre of drawings. Most of his drawings are "academies," figure studies done from the model in pen or pastels on colored papers. The handful of drapery studies catalogued by Guiffrey are such works, produced later in Prud'hon's career, several of which represent the clothing of figures.[2] This drawing represents a swag of heavy silk or satin of the sort that might cover a window or hang from the canopy of a bed. One corner of the drape is pulled up and appears to be fastened with a tasseled silk cord. The artist carefully rendered the crinkly folds in the surface of the fabric, suggesting its crisp stiffness. The weight of the material is also conveyed by the large folds and the manner in which it sags. Delicate hatching with sharpened chalk even suggests the weave and texture of the fabric. Especially naturalistic and evocative are the effects of illumination and reflection from the surface of the lustrous material. The artist depicted a wide tonal range, from the shaded crevices of folds in the underside of the swag to the bright highlights at the crest of its topmost folds. This preference for bright illumination and high contrast would characterize Prud'hon's work as a draftsman throughout his career.

This drawing has a distinguished provenance. Before its possession by Desperet, according to a note on an old mount, its owner was the Baron de Joursanvault, Prud'hon's first benefactor.[3] The young artist probably met the aristocrat in 1776, and two years later he took up residence in the baron's house. Sylvain Laveissière suggested that Prud'hon may have copied this drapery from the background of a fashionable painting or print, such as a portrait by Hyacinthe Rigaud.[4] Another inscription on the drawing's old mount identifies it as a "sketch of a drapery in the background of a painting executed in miniature in oil in 1778."[5] No model has been identified in a painting by Prud'hon or any other artist. It would be likely that Prud'hon would use the medium of red chalk in 1778, for it was popular among the foregoing generation of artists and may have been a technique taught to him by François Devosge.[6]

A date of 1778 would seem consistent with the form of the artist's name inscribed on the sheet. In a letter dated 27 September 1777 he signed himself "Pierre Paul Prud'hon."[7] It is known that Prud'hon sold his drawings early in his career and that it was

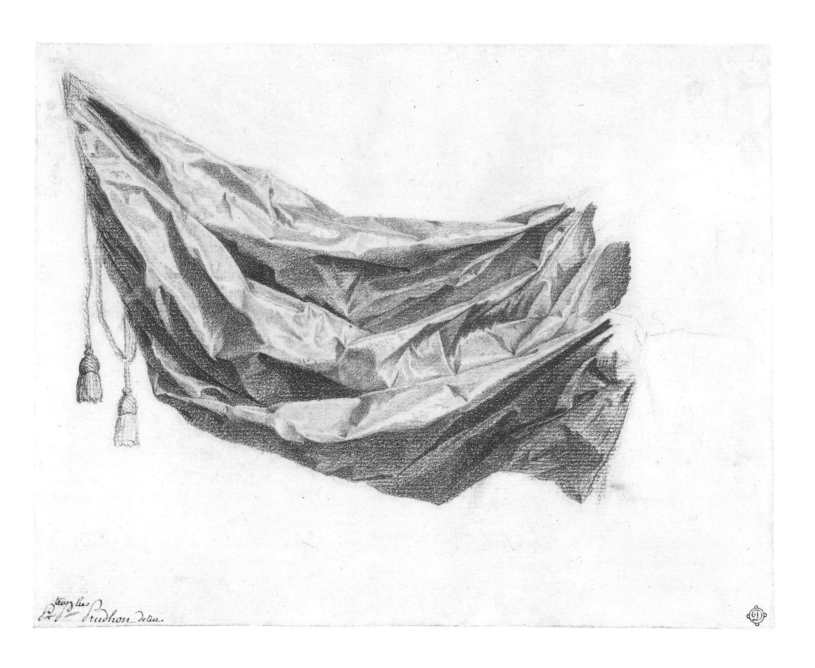

the habit of his dealer Constantin to add inscriptions
in elegant calligraphy, identifying the artist in the
manner of a print.[8] The legend on this sheet is just
such a Latinized address that could have been added
by the dealer and thus may also support the dating.

Jacques-Louis David

PARIS 1748–1825 BRUSSELS

46. *Apollo with a Cithara,* about 1784

Black conté crayon on white laid paper, 17.4 × 8.7 cm

WATERMARK: *VAN DER LEY*

INSCRIBED: In black crayon, lower right: *David*

PROVENANCE: Louis-Antoine Prat, Paris; purchased from Paul Prouté, Paris.

REFERENCE: Prouté 1993, p. 20.

Stoddard Acquisition Fund, 1993.57

During the French Revolution and Napoleonic empire, the painter Jacques-Louis David became the ultimate arbiter of French taste. His creative achievements were closely linked to his moral convictions and his political activities. David grew up in Paris among a family of artisans and shopkeepers.[1] After his father's death in 1757, he became the ward of his uncles, an architect and a master mason, who arranged for studies with the elderly François Boucher (no. 43) and for an apprenticeship with the painter Joseph-Marie Vien. In 1774 David won the Prix de Rome for his painting *Antiochus and Stratonice,* now in the Ecole des Beaux-Arts in Paris. In the following year, when Vien left to take the post of director of the French Academy at Rome, David accompanied his master to Italy. He stayed for nearly five years, studying ancient art and culture and developing a personal heroic style, also influenced by Raphael and Nicolas Poussin.

After his return to Paris in 1780, David married and began a family. He was elected to the French Academy in 1783, and in the following years he established himself as a portraitist and history painter specializing in the severe style of neoclassicism. His most important paintings of this period represented classicizing themes of uncompromising morality and were conceived to ignite revolutionary passions. During his second visit to Rome in 1784–85, David painted *Oath of the Horatii,* now in the Louvre, which caused a sensation when it was shown at the Salon in Paris. It was followed in 1787 by *The Death of Socrates,* now at the Metropolitan Museum of Art in New York, and two years later by *Brutus Receiving the Bodies of His Sons,* now in the Louvre.

This period was also marked by David's deepening involvement in politics. In 1789 he became a member of the Club of the Jacobins. During the Revolution he became a deputy and voted in favor of the execution of Louis XIV. In 1790 the Jacobins commissioned David to depict *The Oath of the Tennis Court,* the historic meeting at Versailles where the third estate pledged to establish a new constitution to replace the monarchy. His grandiose plans for the painting were never realized, but other political works established David as the artistic voice of the Revolution. One of these, *The Death of Marat,* painted in 1793 and now in the Musées Royaux des Beaux-Arts in Brussels, remains the most famous picture of the Revolution. After the fall of Robespierre, the artist was imprisoned for five months in 1794 and 1795. The pleas of his wife, who was estranged from David because of his revolutionary zeal, helped to secure his release and amnesty.

David painted his first portrait of General Bonaparte in 1797, and soon he was an avid supporter of Napoleon, who readily accepted the painter's attentions and capabilities. Although he was appointed First Painter to the Emperor in 1804, he never accepted that honor. However, this association soon reinstated David to the dominant social and artistic position he had held during the Revolution. In the first decade of the century, the artist executed a series of paintings glorifying Bonaparte's exploits. In contrast to the cool, contemplative reserve of David's Republican pictures, these paintings are bright, heroic, and inspirational. David was banished from France after the fall of Napoleon, and he lived in exile at Brussels. He never pursued a pardon from his homeland and declined a court appointment from the king of Prussia. During his final period of activity the artist created some remarkable portraits and history paintings that reflect themes and styles of the first flush of neoclassicism.

The subject, style, and technique of the present drawing show that it was made in the early 1780s, when David was forging his own neoclassical vocabulary.[2] The sheet represents Apollo, the ancient Greek god who embodied the rational, civilized, creative side of human nature. He wears a crown of laurel leaves and strums a cithara, a stringed musical instrument of ancient Greece. The form of the cithara in this drawing and the position in which the musician holds it suggest that David found his model in ancient Greek vase painting. The pose and proportions of David's god are also reminiscent of the *Apoxyomenos,* an ancient sculptural type representing an idealized athlete, thought to have been invented by the Greek sculptor Lysippos.[3] The god's short curls are also characteristic of early classical Greek prototypes rather than Hellenistic or Roman depictions in which he is usually long haired.

Apollo's solid, two-footed pose is reminiscent of those of the young men in David's *Oath of the Horatii.* The medium and manner of execution of this sketch are also similar to a contemporaneous study of a male nude that David made in preparation for the painting of *Belisarius* executed on his return from Italy in 1785 (fig. 1).[4] The simple, linear economy with which he delineated the contours of the body and its musculature are closely comparable. Apollo is slimmer, however, and closer to the figure of the prince in David's painting *Paris and Helen,* executed in 1788 and now in the Louvre. The meticulous archaeological details in that canvas again reveal the artist's careful study of the antique. The artist meant to characterize Apollo and Paris as romantic and inspired, while his young Republican heroes of the period embodied strength and virility. David expressed these distinctions

Fig. 1

through the slightest variations of proportion and characterization.

The present drawing seems to have been the initial visualization of an idea rather than a working preparatory study. The inscription seems to be genuine, but it is unusual that a sketch of this sort should bear the artist's signature. Its presence may suggest that the artist gave this drawing as a gift to an acquaintance or a collector, thus separating it from the hundreds of studies and sketchbook leaves that David quickly marked with his initials.

Fig. 1. Jacques-Louis David, *Study of a Male Nude Lifting His Arms,* ca. 1785, black crayon, 22.0 × 16.0 cm. Lille, Musée des Beaux-Arts, 1193.

Thomas Rowlandson

LONDON 1756–1827 LONDON

47. *Nymph and Satyr,* about 1790

Pen and ink with watercolor over graphite on cream laid paper, 19.0 × 25.6 cm

WATERMARK: *W[HATMAN]*

PROVENANCE: Christopher Powney Gallery, London.

REFERENCES: "La Chronique des arts," *Gazette des Beaux-Arts,* vol. 77, February 1971, p. 84; Worcester Art Museum *Annual Report,* 1971, p. xxiii.

Mary G. Ellis Fund, 1970.114

Fig. 1

One of the most influential English artists of the eighteenth century, Thomas Rowlandson worked chiefly as a draftsman. A spendthrift and bon vivant by all accounts, Rowlandson made a reputation as a ladies' man, a hard drinker, and a gambler. Nevertheless, he produced an enormous body of work and was a shrewd and practical businessman.

Rowlandson was two years old when his father, a textile merchant, declared bankruptcy, and the boy was given to the care of his uncle, a prosperous silk weaver.[1] After his uncle's death in 1764, he was brought up and well educated by his aunt in the London borough of Soho. In 1772 he entered the Royal Academy school. His earliest dated drawings reflect the style of the Romantic painter John Hamilton Mortimer and the satirists William Hogarth and Pier Leone Ghezzi. During the 1770s Rowlandson set himself up as a portraitist in London. Soon, however, he concentrated on watercolored drawings, which were attractive and accessible to customers from the middle and upper classes of English society. At the Royal Academy in 1784 the artist exhibited his watercolor representing *Vauxhall Gardens,* a large gossipy caricature of the upper crust at leisure. Later translated into a large and immediately popular print, this image established Rowlandson's reputation.[2] When his aunt died in 1789 Rowlandson inherited a fortune and embarked on a life of pleasure. He traveled widely and enjoyed himself in gaming houses, ballrooms, racetracks, and the hunt field, recording his adventures in clever, humorous pen drawings finished with watercolor.

In 1797 Rowlandson received his first commission from Rudolph Ackermann. For nearly a quarter of a century afterward this eminent London print and book publisher kept him at work providing designs for satirical book illustrations and intaglio prints. Rowlandson's most famous book illustration project was for William Coombe's *Tours of Doctor Syntax,* which appeared in three volumes between 1812 and 1821. These satirical novels followed the picaresque adventures of a boastful impostor who was always in trouble but managed to extricate himself by quick thinking and preposterous lies.

Rowlandson died in 1827, after two years of illness. Despite his hedonistic life-style, he left a sizable estate. His output was truly prodigious, for over the course of his career he may have produced more than ten thousand drawings. Most were sold directly through book and print sellers and provided the artist with a steady income. He often made several copies of his most popular drawings, sometimes facilitating the process with the technique of counterproofing. The artist placed a dampened sheet of

paper on the face of a finished ink drawing and passed both through a printing press to offset a ghostly mirror image on the fresh sheet. He would then trace over with a pen and wash with watercolors, sometimes varying colors or details. These works lack the pencil underdrawing that the artist habitually used when executing primary images.[3]

The present drawing represents not a satire of Georgian England, but a scene from ancient mythology. In a loosely suggested landscape, beneath the glowing dawn sky, a voluptuous nymph is awakening. Plump and rosy cheeked, she is reminiscent of Rowlandson's many other dimpled milkmaids and bewigged society beauties. Stretching as she rises from a reclining position, she draws back the covers to reveal her nudity. At this vulnerable moment the nymph is startled by a lecherous satyr leering down from the rocks above. Rowlandson depicted the satyr with quickly scribbled lines, the nubs of horns and his goatee beard emphasizing his devilish character. Even in this moment of surprise, the beauty seems knowing and capable, and the faun appears more foolish and lecherous than truly threatening. This scene is one of bawdy comedy, not one fraught with ancient literary meaning.

Rowlandson adapted these figures, their interaction and poses, from old master prints. During his career the artist amassed a collection of thousands of prints, including old originals and contemporary reproductive plates, from which he often adapted compositions and figures into contemporary subjects. At the Whitworth Art Gallery at the University of Manchester there are three sketch sheets by Rowlandson, each representing several female nudes derived from a different printed source. Although their poses accurately reflect the model engravings, Rowlandson translated the figures into his own style. In the upper left quadrant of one sheet (fig. 1),[4] Rowlandson depicted a beauty surprised by a lecherous old man approaching from above, in a vignette depicting the myth of Danäe from a print after Hans Rottenhammer. That print was probably the model for the present drawing.

A satyr spying on a sleeping nymph was a subject from ancient mythology and art that was often repeated in paintings and prints of the Italian Renaissance. The image probably had its source in the ancient myths of Antiope or Amyone.[5] The reclining woman usually throws one arm over her head in these images, in a traditional posture symbolizing sleep ultimately derived from ancient art.[6] Titian represented such encounters in his painting *The Pardo Venus* in the Louvre and in the design of a popular woodcut attributed to him.[7] The many other Renaissance and Baroque prints depicting this

theme are usually scenes of erotic anticipation in which the lecher watches silently, or lifts bedclothes to reveal his victim. Seldom does he accost the nymph, and the viewer is left to anticipate the encounter. Rowlandson slightly altered this common image by depicting a later moment in the encounter, when the nymph discovers her observer.

The theme of unequal lovers, or futile lechery, was a favorite of Rowlandson and seems to have been certain to provoke amusement in his viewers. The artist adapted the subject to many different anecdotal contemporary situations. For example, a drawing of an *Old Roué and Sleeping Girl,* now in the Fitzwilliam Museum in Cambridge, presents this comic, titillating theme as a Georgian anecdote that might have come from the pages of Henry Fielding's ribald novel *Tom Jones.*

Fig. 1. Thomas Rowlandson, *Studies of Female Nudes* (detail), ca. 1800–1810, pen and gray ink with gray wash, 36.5 × 46.2 cm. Manchester, Whitworth Art Gallery, University of Manchester, D.6.1988.

Felice Giani

SAN SEBASTIANO CURONE 1758–1823 ROME

48. *Herod Desecrating the Tombs of the Kings,* about 1795–1800

Pen and brown ink with wash over black chalk on cream wove paper, 56.1 × 39.6 cm

INSCRIBED: In graphite on verso, lower left: *1255*

PROVENANCE: Mrs. Kingsmill Marrs, Boston.

EXHIBITION: *European Drawings from the Museum Collection,* Worcester Art Museum, 1958.

REFERENCES: Vey *Catalogue,* no. 91; Vey 1958, pp. 37–39.

Bequest of Mrs. Kingsmill Marrs, 1926.953

Felice Giani was the leading decorative painter of the late neoclassical period in Italy. He was born in a small village near Genoa and began his studies at Pavia in the workshops of Carlo Antonio Bianchi and Antonio Galli Bibiena.[1] Around 1778 Giani moved to Bologna, where he studied with Domenico Pedrini and Ubaldo Gandolfi. The artist was in Rome by 1780, and there, over the next six years, he developed his bold, unusual manner. At the Accademia di San Luca he studied with the decorative painter Cristoforo Unterberger and Pompeo Batoni (no. 37). Giani's works of this period reveal that he also studied the art of the ancients, Raphael, and Michelangelo, and that he was directly influenced by such contemporaries as Giuseppe Cades.

In the late 1780s Giani began to specialize in the decoration of domestic interiors. He became the leader of a new trend in ornamental fresco, typified by his paintings in the Palazzo Alteri in Rome. The classicizing murals consisted of candelabra motifs that divided the walls and ceilings into enframed panels; antique figures, allegories, and even narrative images derived from ancient Roman wall painting punctuated the ornamental scheme. Giani employed this style when he executed prestigious commissions in the Villa Borghese and the Palazzo Chigi in Rome. Some of his projects incorporated both fresco and tempera painted on plaster with ornate stucco work. In 1792 the artist visited the Roman ruins at Pompeii and Herculaneum where he filled sketchbooks with studies of ancient art and wall ornamentation, repertorial motifs that he later adapted into his neoclassical decorations. During the 1790s Giani worked extensively in Faenza, where he decorated more than a dozen town palaces in a concentration of activity that gave him the nickname "Il faentino."

When Napoleon and his armies occupied Italy, Giani accepted commissions from the elite French governors who remodeled Roman town palaces for themselves. After 1800 the artist even went to Paris to execute decorations for Napoleon himself at the Tuileries palace and Malmaison. Returning to northern Italy, he continued his work in private homes, especially in Faenza. Later in the decade Giani's workshop executed decorations in the Palazzo Chigi at Ariccia and in the Palazzo di Spagna in Rome. In 1811 the painter and Napoleonic functionary Jean-Baptiste Wicar (no. 55) helped to arrange a position for Giani in the prestigious Accademia di San Luca of Rome.[2] The following year the artist undertook a prestigious Napoleonic commission for decorative frescoes in the Palazzo Quirinale, then a residence for the French viceroy. When Giani died in 1823 he left his house in Rome, the Villa Gabriana, and its contents to his friend the artist Michele Köck.

Giani was a productive draftsman, and his surviving drawings number in the thousands. These include repertorial sketches, preparatory studies for paintings, and finished pen drawings and watercolors.[3] The present work is typical of the large, virtuosic pen and wash drawings that the artist made in his maturity; some were transformed into engravings, while others seem to have been conceived as finished works of art. Like many of the narrative vignettes integrated into Giani's decorative wall paintings, these works often represent obscure, heroic subjects.

This drawing depicts a tale from ancient Hebrew legend symbolizing the power of tradition, but Giani probably chose the subject for its spectacular imagery.[4] This is a story of the evil of Herod the Great, the son of Antipater, who in 37 B.C. seized the throne of Judaea with the support of Roman troops. He was a cruel tyrant who maintained power by murdering his political rivals, including many of his own relatives. Herod's power came from Rome, not from the traditional birthright as ethnarch; indeed, he demoted the priests at his court, filling their positions with Jews from the Diaspora. Despised by the Jews of Judaea, he is reviled in the Talmud as a greedy despot who undertook extravagant building programs for his own glory. Once the avaricious king determined to rob the sacred precinct of Jerusalem where David, Solomon, and all the kings of Israel were buried in treasure-laden tombs, planning to enjoy their riches himself. Under the cover of night he brought a troop to the necropolis and ordered his men to tear open the tombs. When the looting began there was a miraculous explosion that consumed the soldiers and much of the treasure. Although Herod survived, he was reminded of the power of God and the sanctity of an honored tradition that he could never join.

The organization of the present image, like that of many of Giani's large-scale drawings, is rather formulaic and similar to Mannerist compositions. The action takes place in a crowded foreground, made all the more claustrophobic by a coffered Roman arch decorated with pseudo-Egyptian hieroglyphs. The background is an imaginary pastiche resembling a stage set, meant to evoke an antique environment. Both the architecture and the soldiers' costumes combine Greek and Roman elements in a theatrical manner.

The style of this drawing reflects Giani's interest in the work of the Mannerist artists of the late sixteenth century, such as Giorgio Vasari (see no. 7) and Luca Cambiaso, and the progenitor of their style, Michelangelo. The proportions of the stylized figures are exaggerated, with stocky, muscular

physiques, oversize limbs, and tiny heads. Horst Vey noted how the positions of the foreground soldiers in Giani's drawing were quoted from the spandrel representing the Brazen Serpent in Michelangelo's Sistine chapel ceiling fresco.[5] The figure of Herod was similarly adapted from that of Christ in Michelangelo's *Last Judgment*. Giani's style also reveals his association with the group of eccentric artists gathered around Henry Fuseli in Rome in the 1790s.[6] Most of these artists were visitors to Italy from England or northern Europe, dilettantes and intellectuals who preferred obscure subjects from ancient or biblical literature or the writings of Dante, Shakespeare, and Milton.

James Sharples

LANCASHIRE, ENGLAND 1761–1811 NEW YORK

49. *Portrait of Charles Brockden Brown,* about 1798

Pastel and charcoal over graphite on blue wove paper, 23.8 × 18.6 cm

PROVENANCE: Purchased from William MacBeth Gallery, New York.

EXHIBITION: *The Early Republic: Consolidation of Revolutionary Goals,* Worcester Art Museum, 1976.

REFERENCES: Henniker-Heaton 1922, p. 203; Knox 1930, p. 95; Jareckie 1976, pp. 31–32; Axelrod 1983, reproduced on jacket.

Museum purchase, 1916.71

Charles Brockden Brown (1771–1810) is considered to have been the first professional author in the United States.[1] Raised a Quaker and well educated in his native Philadelphia, Brown abandoned a law career at the age of twenty-two to devote himself full time to writing. His stories are notable for their full, careful delineation of characters, and his fascination with psychology and the bizarre anticipated the writing of Edgar Allan Poe. In 1789 he published a series of essays on Romanticism in *Columbian Magazine,* and in 1798 he published two novels, *Arthur Mervyn* and *Wieland,* that reflect the influence of English Gothic and German Romantic writers. Brown first introduced Native American characters into fiction. Living in New York, he met many of the leading intellectuals, authors, and artists of the day and was a member of the Friendly Club, along with his friend and roommate, William Dunlap, the painter and historian. During the 1790s James Sharples and his family maintained a close friendship with Dunlap, and frequent social calls to their home are mentioned in his diary.[2]

Sharples was a highly successful professional portraitist. He had studied with George Romney and first exhibited at the Royal Academy in London in 1779. He lived briefly in Cambridge, and over the next six years he moved to Bath, Bristol, and London. Already twice widowed, Sharples married his student Ellen Wallace of Bath in about 1783. A talented artist herself, Ellen worked alongside her husband, often producing copies of his works. Their two children, James Jr. and Rolinda—as well as son Felix by Sharples's second wife—all became artists. Sharples supported this family through the years of their childhood by making pastel portraits for customers in Liverpool and Bath. In 1793 Sharples brought his family to America, where he worked in Philadelphia and New York before returning to Bath in 1801. Five years later the two sons returned to the United States. Their parents soon followed, and the family established themselves as professional portraitists in New York, where they lived until Sharples's death on 26 February 1811, when Ellen Sharples and her children returned to England.

In the New World Sharples concentrated on pastels, perhaps not wishing to compete with the established American portraitists working in oil, or in an attempt to find more customers by working in the less costly medium. His simple, unostentatious style appealed to American Puritans, merchants, and socialites alike. Typically Sharples made small pictures on paper that were uncomplicated and uncluttered in their composition and affordable for middle-class patrons. He usually depicted his sitters in stark profile, before featureless backgrounds

and close to the picture plane. This formulaic composition and his delicate, stipplelike technique linked Sharples to the traditions of British miniaturists (see no. 51) and itinerant silhouette portraitists (see no. 50), rather than to the grand manner school of portraiture headed by Sir Joshua Reynolds and Thomas Gainsborough.

In his catalogue of portraits compiled in 1802, James Sharples listed "C. B. Brown, esq., Author." Today two versions of this work are known, the present drawing and a similar pastel at Independence Hall in Philadelphia (fig. 1).[3] They are comparable in size, style, and technique. It is known that Ellen made a copy of the portrait of Brown, for in May 1810 she noted in her diary that she had made a copy of her husband's portrait of "Mr. Charles Brown."[4] The author's death early in that year might have provided her with the impetus to make the copy.[5]

The portrait depicts the author as quite a young man, with a confident, intelligent demeanor. In the Worcester portrait the figure is smaller than the Philadelphia version, with rough scumbling to provide a shadowy background. The modeling is tighter, Brown's face is slightly fuller, his head is slightly more erect, and the highlighting of the pupils creates a more direct gaze. Although the Worcester portrait may not be as balanced in its composition as the Philadelphia version, its expressive qualities seem more animated. These minor differences suggest that the Philadelphia drawing is Ellen Sharples's copy and that this pastel is the original.

Fig. 1. Ellen Sharples, *Portrait of Charles Brockden Brown,* 1810, pastel, 23.8 × 19.1 cm. Philadelphia, Independence National Historical Park, 11893.

Fig. 1

Charles Févret de Saint-Mémin

DIJON 1770–1852 DIJON

50. *Portrait of Thomas Jefferson,* 1804

Charcoal and black, white, and gray chalks on cream wove paper, prepared with pink gouache, 60.7 × 42.9 cm

INSCRIBED: In graphite, lower right: *Ths. Jefferson*

PROVENANCE: Wilder D. Bancroft, Ithaca, New York.

EXHIBITIONS: *The Thomas Jefferson Bicentennial Exhibition, 1743–1943,* Washington, D.C., National Gallery of Art, 1943; *The Life Portraits of Thomas Jefferson,* Charlottesville, University of Virginia Museum of Fine Arts, 1962; *The Early Republic: Consolidation of Revolutionary Goals,* Worcester Art Museum, 1976.

REFERENCES: Bowen 1892, pp. 486–87; Hart 1898, pp. 52–53; Bolton 1923, pp. 66–67; Norfleet 1942, pp. 30–31, 176–77; Washington 1943, cat. no. 7; Kimball 1944, pp. 523–24; Dresser 1951; Rice 1959; Bush 1962, pp. 65–67; Ramsay 1962; Dijon 1965; Betts/Bear 1966, pp. 253, 256–57, 371, 388; Adams 1976a, pp. 67–70; Adams 1976b, pp. 75, 361; Jareckie 1976, pp. 28–29; Foley/ Rice 1979; Teitz 1979, pp. 64–65; Cunningham 1981, pp. 79–86; Stein 1993, pp. 198–99; Miles 1994, pp. 130–33, 326–27.

Museum purchase, 1954.82

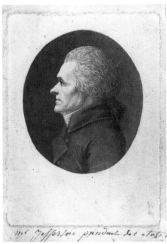

Fig. 1

In the century preceding the invention of photography, artists and scientists sometimes used mechanical devices to capture visual images precisely and transfer them to paper or canvas. The oldest of these was the camera obscura, a darkened box with a pinhole to admit light and a mirror inside to cast the image onto a sheet of paper, where it could be traced. This apparatus would one day provide the basis for the development of photography. The Frenchman Gilles-Louis Chrétien invented a similar mechanism, which he perfected and sold as a parlor game or an artist's aid.[1] This device was called the *physiognotrace,* and the most famous artist to use it regularly was Charles Févret de Saint-Mémin.

Born into a noble family, Saint-Mémin was educated at exclusive private and military schools, where he was instructed in all aspects of learning and behavior appropriate to an aristocrat, including the fundamentals of drawing and painting. He received a respectable commission in the French army at the age of eighteen. However, his military career was abruptly curtailed in 1789 when the storming of the Bastille heralded the French Revolution. Like many French aristocrats, Saint-Mémin and his family fled their homeland. They traveled first to Switzerland, planning to go on to Santo Domingo, the birthplace of the youth's mother; however, the political instability erupting in that French colony also made it a dangerous place. So when the family landed in the United States in 1793, they settled here. After his father's death in 1802, Saint-Mémin carried on as a portraitist until 1814, when he returned to France with his mother and sister. He regained French citizenship and no longer needed to depend upon his work as an artist. Instead, Saint-Mémin became director of the city museum in Dijon, a position he held until his death in 1852.[2]

In the United States the young Saint-Mémin began to work as a painter, and his former gentleman's pastime became a profession. Following Chrétien's plans he constructed a large *physiognotrace.* After using the machine to trace a life-size outline of his subject's head and shoulders onto paper, he modeled the likeness in charcoal, chalks, and ink washes, usually over a prepared pastel-hued ground. Mechanically assisted portrait drawings and cut-paper silhouettes were the stock in trade of itinerant artists of the era, but Saint-Mémin added an innovation that ensured his success. He miniaturized and multiplied his images, so that his customers could share their portraits with family and friends. Using another mechanical device, the pantograph, the artist reduced his images to the scale of vest-pocket miniatures, less than two inches in diameter. He then etched the design on a little copper plate,

painstakingly finishing the likeness with burin and roulette and printing the facsimiles. Saint-Mémin offered a package to his customers, including the life-size drawn portrait, twelve miniature impressions on paper, and the printing plate so that they could later have more impressions made.

Saint-Mémin's society connections, the cachet of his aristocratic background, and his exquisite manners seem to have contributed to his success as an itinerant portraitist. He portrayed some of the most prominent and influential members of American society as he traveled from New York to Philadelphia and through the South. More than seven hundred and fifty of his portraits have been identified, including the likenesses of such famous historical figures as Paul Revere.[3]

When Saint-Mémin portrayed him in 1804, Thomas Jefferson was nearing the end of his first term in office as third president of the United States. This was not the first time he had sat before such a machine, for Edme Quenedey made a *physiognotrace* portrait during Jefferson's visit to France in 1789 (fig. 1). By comparison, Saint-Mémin's portrait seems to represent a bright and self-assured intellectual whose features seem softer and more sympathetic. Although his presidency had been quite successful, particularly for the Louisiana Purchase of 1803, Jefferson's personal life at this time was marked by tragedy. He had lost his second daughter, twenty-five-year-old Maria Jefferson Eppes, in April 1803.

Fiske Kimball first noticed the record in Jefferson's pocket account book of the payment to Saint-Mémin of $29.50 on 27 November 1804.[4] According to the artist's customary charges, this sum would have paid for the original drawing, the execution of the miniature etched and engraved plate, along with the first twelve prints and an additional thirty-six impressions of the portrait prints. However, it seems that Saint-Mémin made another print after his *physiognotrace* portrait of Jefferson, one of his most prominent subjects. The second version was larger and elliptical in format, rather than the customary size and round shape. Presumably the artist had permission to engrave after the variant proofs from the original plate that he retained. There are only the tiniest differences between the images. On 25 February 1805 Saint-Mémin declared in a newspaper advertisement that he had for sale "a few likenesses of the President of the United States, engraved by himself."[5] It is likely that these were the larger, oval prints. Portrait prints like these, produced for the open market rather than the commissioner, are quite rare in Saint-Mémin's oeuvre. The president's fame and popularity would have guaranteed their appeal and salability.

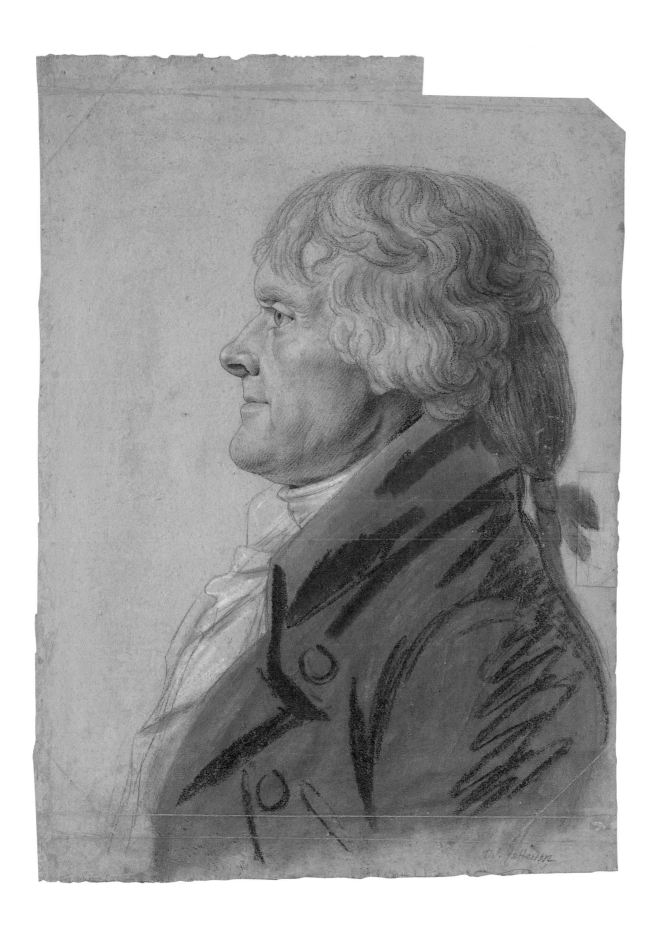

Fig. 1. Edme Quenedey, *Portrait of Thomas Jefferson,* 1789, etch-
ing and aquatint, 13.0 × 9.5 cm. New Haven, Yale University
Art Gallery, Mabel Brady Garvan Collection, 1946.9.785.

Richard Cosway

TIVERTON, DEVONSHIRE 1740–1821 LONDON

51. *Self-Portrait,* about 1805

Watercolor on cream wove paper,
11.0 × 7.9 cm

INSCRIBED: In pen and brown ink on
verso, top: *28*

PROVENANCE: Maria Cosway, London
and Lodi, Italy; Varese Collection,
sold at Christie's, London, 1 June
1896; E. M. Hodgkins, London and
Paris; purchased from Eugene Bolton,
London.

EXHIBITIONS: George Stanley's
Auction House, London, 1822;
Lodi Museum, 1820s; *Richard and
Maria Cosway, Regency Artists of Taste
and Fashion,* Edinburgh, Scottish
National Portrait Gallery, 1995.

REFERENCES: Williamson 1897,
frontispiece, p. ix; Henniker-Heaton
1922, p. 171; Lloyd 1995, p. 127,
cat. no. 160.

Museum purchase 1921.57

The most fashionable English miniaturist of his day, Richard Cosway was celebrated for his ability to imbue his subjects with presence and elegance. He was born in a small country town, the son of a schoolmaster. At the age of thirteen he went to London as an apprentice to the painter Thomas Hudson.[1] Afterward he was a pupil at William Shipley's Drawing School and studied at the Duke of Richmond's gallery. Cosway was also a student of the painter Giovanni Battista Cipriani, a prominent figure at the Royal Academy. Soon he began to specialize in miniature portraits in a style that reflected an interest in grand portraiture and emphasized the individuality and elegance of the sitter.

Small of stature and bombastic, Cosway was fastidious in his appearance. A contemporary account describes his arrival at Christie's auction house, "full-dressed, in sword and bag, with a small three-cornered hat on the top of his powdered toupée, and a mulberry silk crote profusely embroidered with strawberries."[2] In August 1769 Cosway began studies at the Royal Academy, and in the two succeeding years he was appointed Associate and then Academician. The artist's refined tastes and society friends fostered aspirations to wealth, and in 1768 he purchased a house on Berkeley Street, which was luxuriously furnished.

On 18 January 1781 Cosway married Maria Hadfield, the daughter of an Englishman who ran a hotel in Florence. Her noted beauty and accomplishments made her the perfect partner to share Cosway's intertwined professional and social aspirations. She too was a skilled miniaturist who exhibited her portraits at the Royal Academy. In 1785 the couple moved to Schomberg House, a fashionable residence in Pall Mall. Sumptuously decorated with an extensive collection of old master paintings and drawings, this house became the setting for musical soirées attended by London society.

By the late 1780s Cosway was the preeminent miniaturist in London, and about 1785 the artist became principal painter to the Prince of Wales. In the following year the Cosways visited Paris, where the artist made portraits of several French aristocrats. The couple gained notoriety in Parisian intellectual and artistic circles, where Maria Cosway was surrounded by admirers, including the painter Jacques-Louis David (no. 46) and the statesman Tadeusz Kosciusko. The American painter John Trumbull introduced the Cosways to the circle of Thomas Jefferson.

Around 1790 the Cosways had a daughter, Louisa Paolina Angelica. However, by this time the marriage had faltered, and soon Maria took a position as the superior of a seminary for young ladies in Lyons.

When Louisa Cosway died in 1796, Maria briefly visited England. In 1812 she opened her own school for young ladies, the Collegio delle Grazie, at Lodi in Italy.

Although his portraits remained popular, in his later years Cosway withdrew from London society and became unsociable, introspective, and preoccupied with mysticism. Around 1814 he seems to have suffered an incapacitating stroke. Maria Cosway returned to London to care for him before his death on 4 July 1821. When she returned to her school the widow took Cosway's library, paintings, and at least five hundred of his drawings.

Judging from the costume and hair style, the present drawing would seem to date from about 1805. Although Cosway was about sixty-five years old, his well-known vanity prompted him to depict himself as youthful and handsome. This dating is supported by Cosway's characterization of himself as a philosopher. With his gaze fixed firmly on the viewer, the artist points to an open book where the Seal of David appears on the page, along with a circle with a point in the center. These simple geometric forms are mystical symbols whose significance is discussed in the writings of Jacob Boehme, to whose philosophy Cosway was devoted.[3] He sits before two distinctly different columns, probably meant to represent the pillars of Boaz and Joachim, relics of the ancient Temple of Jerusalem that were important in the Jewish and Masonic traditions. By placing himself in this holy space, and including the volume with its recondite symbols, Cosway implied that he possessed this spiritual knowledge. The distant horizon is lighted by the soft glow of a rising sun, another symbol of inner illumination. A similar full-length *Self-Portrait* miniature of 1806, now in the Uffizi in Florence, includes comparable iconography.[4]

The technique of the present piece is typical of Cosway's watercolors from the turn of the century. After sketching an outline of the composition with the facial features more carefully detailed, he modeled the figure with careful watercolor stippling. At this stage of his career Cosway favored a blue-gray palette and painted nearly monochromatic images with the faces accented in pale tints of pink. In his later miniatures, such as the present sheet, he left the paper completely untouched by paint in the background. Cosway skillfully used the transparent qualities of watercolor to achieve effects of luminosity, which are so appropriate to this self-portrait.

Because this painting is on paper rather than the customary, more expensive ivory, Cosway may have intended it as a personal keepsake. It is probably the same *Self-Portrait* that was exhibited at George Stanley's auction house in Old Bond Street

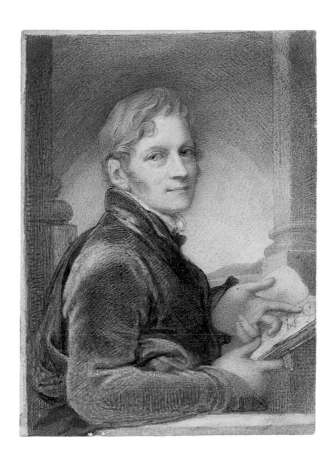

in London, prior to the sale of the artist's estate held in April 1822.[5] That sheet was described again in 1896, among a number of the finest drawings and paintings in the artist's estate that were extricated from the college at Lodi by an Italian dealer, whom Williamson called "Varese," to be sold at Christie's in London.[6] It seems to have been an image that was so personal and accurate that it was valued by the artist and, at least for a time, by his widow. It was also prized by Cosway's biographer, George C. Williamson, who used the *Self-Portrait* as the frontispiece of his monograph on the artist.

William Young Ottley

NEAR THATCHAM, BERKSHIRE 1771–1836 LONDON

52. *Rhea Delivering the Infant Zeus to Her Parents,* about 1810

Pen and brown ink with gray wash and watercolor on cream laid paper, 12.1 × 20.9 cm

PROVENANCE: P. and D. Colnaghi and Company, London; David Richardson, Washington, D.C.

Gift of David Richardson, 1992.66

Aside from his artistic activities, William Young Ottley was a historian, writer, and pioneer in the study of Italian early Renaissance art. He was born into a wealthy and privileged family at the country house Dunstan Park in Berkshire, the son of a captain in the Coldstream Guards.[1] Ottley first studied art with George Cuitt, a local drawing master in Richmond, Yorkshire, where the boy was at boarding school. Afterward he was at Winchester School, and his next teacher was probably John Brown, a follower of Henry Fuseli. Ottley entered the Royal Academy Schools in London in 1778.

In 1791 the young artist went to Italy, where he remained for eight years. There he became a close friend of John Flaxman, the English designer and sculptor.[2] Ottley also met the Dutch painter David Pierre Giottino Humbert and the Roman printmaker Tommaso Piroli.[3] That artist engraved two suites of prints after Ottley's designs, and during the 1790s he probably taught the techniques of printmaking to the artist. During his residence in Italy, Ottley built his own collection, which eventually included paintings by Rembrandt, Titian, Correggio, and Botticelli and very extensive holdings of drawings. In the chaos of the French invasion of Italy in 1797, he found unusual opportunities to enrich his collection.[4] At that time Ottley also began working as a drawings dealer.

After his return to England in 1799, Ottley's artistic activities waned as he concentrated more on research, writing, and commercial activities. He became a counselor and friend to the painter Sir Thomas Lawrence, the era's most passionate English collector of drawings, who purchased the bulk of Ottley's collection in 1823. Ottley's reputation as an expert was confirmed by the series of finely illustrated books he produced in the 1810s and 1820s. In 1833 he became keeper of prints and drawings at the British Museum in London. Financial need may have prompted him to take this post. His family income had come from estates in the West Indies, but Ottley refused government compensation for losses incurred when an act abolished slavery throughout the British Empire.[5]

The bulk of Ottley's artistic activity took place in Rome during the 1790s and in the first years of the nineteenth century. At that time he was one of a remarkable group of artists gathered around Henry Fuseli.[6] Most were visitors from northern Europe who came to Rome to study the ancient and Renaissance art and in search of the sublime and the romantic.[7] The interactions of this group led them to seek inspiration in literature, and they represented themes from ancient authors as well as Dante, Shakespeare, and Milton. Most of the works

by Ottley now in the British Museum represent fantastic scenes from literature.[8]

The subject of the present drawing comes from Hesiod's *Theogony,* an ancient epic poem that presents the origin and genealogy of the pagan gods.[9] It begins with the story of creation, when out of primordial chaos the goddess Gaia (Earth) took form. In turn she produced her own mate, Uranos (Heaven), and together they begot the Titans, a race of earth giants who possessed great physical strength, but were without intellect or morality. Gaia persuaded the twelfth Titan, Kronos, to depose his father. Then Kronos and his sister Rhea gave birth to the next generation, the Olympians, the gods of the Greek pantheon. It was fated that one of his children would overthrow Kronos, so, to Rhea's dismay, he devoured each of his offspring as they were born. Eventually the goddess deceived her mate by substituting a swaddled rock for the newborn Zeus, who was raised by his grandparents, Gaia and Uranos. Later, Gaia contrived to make Kronos regurgitate all of his children, and after a desperate struggle they conquered him. Thus the Olympian gods came to power, to rule the universe with Zeus as their king.

The present drawing shows Rhea bringing Zeus, the child she had saved, to live in safety with his grandparents. The gods are represented as human figures of heroic proportions, clad only in the simplest draperies. They live in a featureless void, where only light marks the boundaries between terrain and firmament. Uranos looks up from his book to glance benignly at the child, his burly physique signifying his former strength. Rhea's attenuated proportions and exaggerated elegance signify her continuing allure and fecundity. The impossibly elongated child also faces away from the viewer as he scrambles toward Gaia. The matriarch is the dominant figure in this scene. She holds out her arms to receive the baby with all the human emotions of a doting grandmother.

Once attributed to Fuseli, the present drawing was identified as the work of Ottley by Christopher Powney.[10] He compared the sheet with John Flaxman's images from Hesiod, in a series engraved by William Blake, published in London in 1817.[11] Three extant drawings by Flaxman also depict episodes from the tale of Gaia, Rhea, and the infant Zeus. In Flaxman's drawing of *Rhea Delivering the Infant Zeus to Gaia* (fig. 1), Rhea and her child have normative, even idealized proportions. Gaia is depicted as a giantess, wearing a mural crown, a diadem made of city walls.[12]

Ottley's drawing reflects Fuseli's influence in its elegant artificiality, dramatic illumination, and exaggerated mood. The artist also found inspiration in

Fig. 1

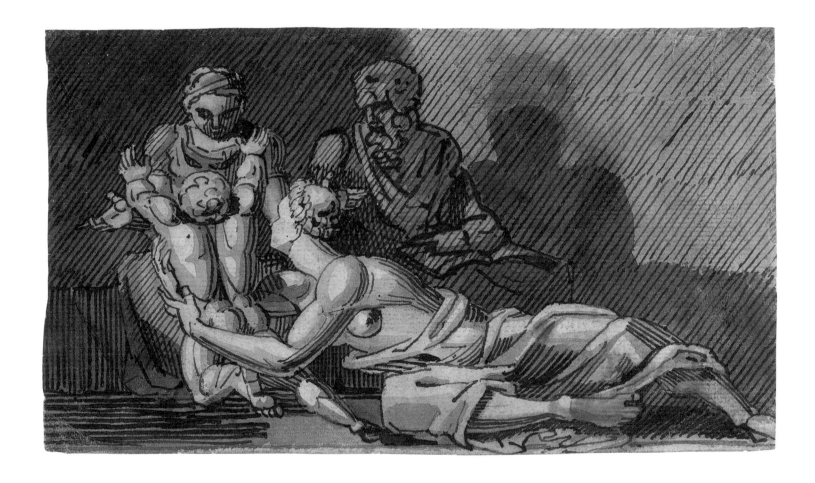

Italian Mannerist art of the late sixteenth century, particularly that of Luca Cambiaso.[13] Like that virtuosic draftsman, Ottley usually employed a reed pen and iron gall ink to draw broad, calligraphic lines, which were often superimposed with quick washes that added the illusion of dimension and depth. Here he used a broad-nibbed pen to draw wide, uniform lines with iron gall ink. Then with a brush he applied liquid inks to shade his figures and create effects of illumination. To achieve subtler lighting effects and to give the drawing a more striking appearance, he used washes of both gray bistre ink and watercolor.

Fig. 1. John Flaxman, *Rhea Delivering the Infant Zeus to Gaia,* ca. 1810, ink and wash, 11.2 × 12.6 cm. Collection of Robert N. Essick.

Jean-Pierre Norblin de la Gourdaine

MISY-FAULT-YONNE 1745–1830 PARIS

53. *The Folksinger,* 1810s

Brush and India ink with gray wash over graphite on cream laid paper, 8.8 × 11.7 cm

PROVENANCE: Purchased from Galerie de la Scala, Paris.

Stoddard Charitable Trust Fund, 1987.7

A painter and printmaker whose career began in Paris during the ancien régime, Jean-Pierre Norblin worked well into the Napoleonic era. He was born in a small town near Paris about a decade before the beginning of the Seven Years War.[1] Norblin seems to have begun his artistic training when he was about fifteen years old, as an apprentice in an engraving workshop in the capital. Afterward he was the pupil of Francesco Casanova, and later he studied at the Académie Royale and the Ecole Royale des Elèves Protégés in Paris. He worked intensively as an etcher in the 1770s and 1780s, in a style profoundly influenced by Rembrandt.[2]

Norblin met Prince Adam Czartorski, a cousin of the king of Poland, who became a close friend and his most important and faithful patron. In 1774 the artist went to Poland where he became one of the country's most eminent painters of history, portraits, and genre. He worked at Czartorski's court in Warsaw and at Pulawy, and he executed several murals at the prince's country house Powazi near Warsaw. Many of these decorative paintings are Rococo caprices in the manner of Antoine Watteau. Soon Norblin had gained such stature that he was able to open his own academy of painting in Warsaw. Best known among his students were Michel Plonski and Alexander Orlowski.[3]

In 1785 Norblin was named official painter to the court of King Stanislaus-Augustus and was granted a title of nobility. He was present in Warsaw on 3 May 1791, when the *Grossen Reichstag* established the new constitution for the Polish monarchical republic, marking the cooperation of a democratic government with the royal houses of Sachsen-Wettin. However, the political reforms were superseded when Poland was invaded by Russia and Prussia. Soon the abdication of Stanislaus-Augustus represented the end of the old rule and the beginning of a foreign monarchy. Through this turbulent period Norblin represented these momentous events in both drawings and paintings.[4]

The artist returned to France in 1804, the year of Napoleon's coronation. During the last decades of his life he ceased to paint, concentrating instead on drawings of life in Paris. Norblin's reputation in France finally became established when Philippe Debucourt published the portfolio *Costumes polonais (Zbior Rozmaitych Stroiow Polskich)* in 1817. This album of fifty color prints after Norblin's designs represents the regional and ethnic costumes of Poles, Samoyeds, and Lithuanians.[5] Shortly before he was to leave on a trip to Rome, Norblin died in Paris, on 23 February 1830.

Throughout his career Norblin delighted in recording the life he saw around him. Many of these

drawings survive, depicting the activities of life in Polish villages and on the streets of Warsaw and Paris. These fascinating sketches provide accurate images of the topography, architecture, and details of daily life. The present drawing is a tiny, quickly rendered sketch executed after the artist settled in Paris in 1804. A female singer entertains a crowd in an impromptu street concert. Standing on a chair to project her voice over the crowd, she gestures expressively with her right hand. A candle held in her left hand casts its illumination on her face. A large crowd has gathered around the folksinger, listening intently. Behind her is what seems to be a shelved display case balanced on a post, perhaps filled with books, pamphlets, or popular prints, suggesting that the folksinger is also a street merchant.

There is another drawing of this subject by Norblin in the Musée Carnavalet in Paris (fig. 1). That sheet is larger and more precise in its setting and details of the figures. Although her dress and pose are similar to the woman in the Worcester sketch, that singer performs before an open door from which light pours out onto the crowd. She seems to read from a paper held in her right hand, and the bright lamp in her left hand provides a searing focal point for the composition.

Two foreground figures, silhouetted by candlelight in the present sketch, seem to wear military uniforms. With his back to the viewer one man wears a frock coat, breeches, and a tricorn hat with a feathered plume. His companion, in similar garb, carries a half-laden backpack. In the Paris drawing, these figures were repositioned, and although their poses were retained, the military character of their costumes was eliminated. Because of its small size and its sketchy manner, the present drawing would seem to be an immediate sketch, made on site in the street in a few moments. It would seem that the artist used the little drawing as a model when he worked up a larger and more refined version of the composition later in his studio. This seems to have been Norblin's practice in planning and refining the composition of a painting; however, no canvas of this subject has been identified.

The nocturnal setting and dramatic illumination of this piece are shared by many of Norblin's street drawings. The artist was drawn to this effect by Netherlandish prints from the seventeenth century, particularly the works of Hendrik Goudt and Rembrandt, and he became quite masterful at depicting night scenes. He also probably took his practice of sketching in the street from these master printmakers, along with the German etcher Christian W. E. Dietrich, all of whom depicted beggars, street performers, and country fairs.[6]

Fig. 1

The subject of this drawing places it among the works that occupied Norblin in the final phase of his career. During the second decade of the nineteenth century he made large, complex, finished drawings of life on the Parisian streets, where all classes of society came together, images of wandering merchants, entertainers, preachers, and children at play. These works generally depict pleasant views of life, and they are often amusing but never cross into caricature.

Fig. 1. Jean-Pierre Norblin de la Gourdaine, *The Folksinger*, 1810s, pen and brown ink and wash with gouache heightened with Chinese white, 26.7 × 23.7 cm. Paris, Musée Carnavalet, 7025.

George Cruikshank

LONDON 1792–1878 LONDON

54. *An Iron Forge,* 1812

Pen and black ink with watercolor on cream wove paper, 47.2 × 62.5 cm

INSCRIBED: In pen and brown ink on mount, above sheet: *An Iron Forge – a few miles from Denbigh – North Wales –*; below sheet: *G Cruikshank. 1812. Sketched by me G C. when between 19 & 20 years of age. Now 60 years back –*

PROVENANCE: John B. Gough; Mary G. Whitcomb; Mrs. Harriet Merrifield Forbes; by descent to her daughter, Mrs. Esther Forbes Hoskins, Worcester.

EXHIBITIONS: *The Works of George Cruikshank . . . Collected by John B. Gough,* Boston, Club of Odd Volumes, 1890; *Monstrosities and Inconveniences: Works by George Cruikshank from the Worcester Art Museum,* Worcester Art Museum, 1986/Bank of Boston 1987.

REFERENCES: Gough 1890, pl. iv; Libbie 1892, lot 185; Worcester Art Museum *Annual Report,* 1962, pp. x–xiii; Dresser 1974, vol. 1, pp. 19, 538; Steinberg 1987, cat. no. 5.

Gift of Mrs. Esther Forbes Hoskins, 1962.17

Fig. 1

The leading English illustrator of the nineteenth century, George Cruikshank evolved from a caricaturist in the tradition of William Hogarth into a serious graphic artist of Dickensian social conscience. The artist was born in 1792, the son of the caricaturist and etcher Isaac Cruikshank.[1] He dreamed of going to sea like his older brother, Robert, but after just a few years at school George became his father's assistant. He was tutored in the techniques of printmaking, but taught himself to draw. When just a teenager he was producing single-leaf satirical etchings that were watercolored by hand and inexpensively sold on street corners throughout Britain. The style of these early prints was influenced by Thomas Rowlandson (no. 47) and James Gillray, the leading satirist of the foregoing generation. When dissipation and illness caused Gillray to stop working in about 1811, the young Cruikshank was hired to complete his unfinished plates. George's father had retired by this time, and he and his brother, back from sea, ran the family business. Their lampoons of the private life of the prince regent and of the recently defeated Napoleon were enormously popular. Two of Cruikshank's drawings for satirical prints are now in the Worcester Art Museum, *The Death of Boney* (fig. 1) and *The Eclipse of the Sun.*[2] Quickly scribbled in graphite or pen, both works have extensive, corrected inscriptions, plays on words that show how the artist often conceived his caricatures simultaneously as verbal and visual puns.

During the 1820s Cruikshank began to focus more attention on book illustration. He produced satirical images for humor magazines as well as illustrations for more serious novelists, including Walter Scott, W. Harrison Ainsworth, and Charles Dickens. The focus of his activity gradually shifted from original etchings to designs meant to be reproduced by professionals in wood engraving and other reproductive processes. In 1841 the artist even started his own magazine, *Omnibus,* which was a failure despite the contributions of Frederick Marryat and William Makepeace Thackeray. Its successor, *Cruikshank's Magazine,* first appeared in 1854 and survived only for two numbers. Despite these disappointments, the artist remained busy, popular, and influential.

In 1847 Cruikshank produced *The Bottle,* shortly followed by *The Drunkard's Children,* illustrated booklets of fiction describing the moral descent of alcoholics and the resulting ruin of their families. These inexpensive, extremely popular pamphlets were reprinted in several editions and were even dramatized for the stage. Cruikshank was a celebrity by the time he married Eliza Widdison in 1850. After his marriage he became progressively more strait-laced and even gave up smoking after forty years.

The moralizing content of his works became stronger and their humor diminished. Cruikshank believed that his health and longevity resulted from this abstemious life-style, and indeed he continued working into his mid-eighties.[3]

At the height of his career Cruikshank became an important figure in the Temperance Society and an effective and esteemed lecturer at society rallies. In 1853 he was present at the London docks to greet John B. Gough, Worcester's charismatic leader of the American temperance movement, who was arriving for his first British lecture tour. During the following weeks the two men socialized often and became close friends, sharing their dedication to the cause of temperance as well as their interest in the book arts.[4] In May 1854 Cruikshank introduced Gough at a rally at the Sadlers Wells Theater in London. That evening the orator was so inspiring that after his talk the audience descended onto the stage, across a plank laid over the orchestra pit, and many signed pledges of abstinence.[5]

Gough once owned the present drawing, which he probably brought to Worcester in 1854. As a favor to his friend, it seems that Cruikshank prepared the unusual mounting and annotations in order to establish the early date of the drawing, clarifying its importance in the artist's oeuvre and in Gough's collection.[6] The inscriptions indicate that as a young man Cruikshank sketched this iron forge in North Wales. The style and technique of the drawing are reminiscent of the works of Rowlandson, recalling the colored satirical sketches made by that artist on his frequent tours of the British countryside. Like him, Cruikshank began his drawing with a loose, impromptu sketch in graphite. Then he drew over the image with pen and ink and superimposed layers of colored washes, progressively refining and tightening his composition. The finished image has a tattered, energetic quality appropriate to the ramshackle buildings and untidy yard. The dirtiness of this scene pokes fun at the English tradition of picturesque landscape, which had been considered the height of aesthetic sophistication two generations before Cruikshank. English poets and painters of the eighteenth century had found inspiration in the grandeur and harmony of nature, and their reverence for its beauty was reflected in works as diverse as Thomas Gainsborough's romantic landscapes of rural England, Capability Brown's bucolic garden designs, and William Gilpin's thoughtful treatise on the picturesque in taste.[7] At the same time a similar romanticized view of the Industrial Revolution appeared in art. Such painters as Joseph Wright of Derby and Joseph M. W. Turner depicted forges and factories as dark, menacing places where muscular

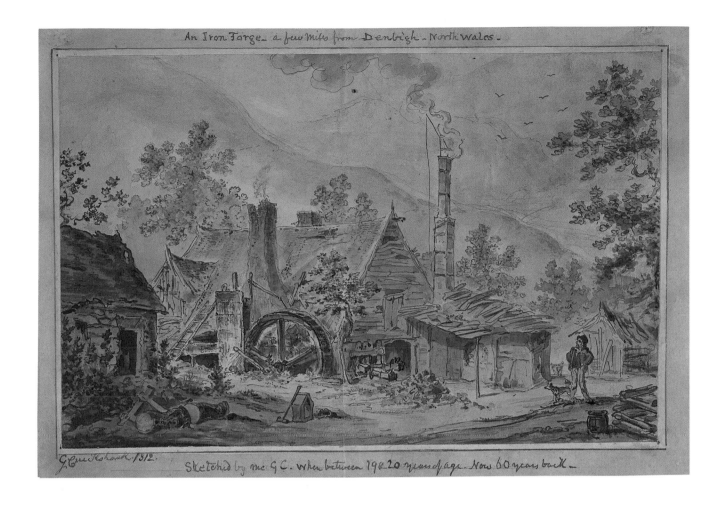

heyes in leather aprons fashioned works of utility and elegance, their labors often observed by admiring beauties. Cruikshank's dirty and dilapidated forge, occupying an old mill, is probably closer to reality. It stands in a deforested glen, which, like the ax and chopping block that provide fuel for the forge, symbolizes the destruction of the picturesque countryside. Puffs of smoke rising from the chimneys, heaps of slag, and tools left lying about symbolize the haphazard activities of labor and life. Nevertheless, the noisy, smelly factory seems to inspire the awe of a countryman who stands knock-kneed, with hands on his hips. Dressed in layers of tattered woolens and accompanied by his scrawny, ill-bred dog, this bumpkin represented the true soldiers of British industry.

Fig. 1. George Cruikshank, *The Death of Boney,* ca. 1805, graphite with pen and brown ink on cream wove paper, 27.5 × 34.4 cm. Worcester Art Museum, Samuel B. Woodward Collection, 1934.245.

Jean-Baptiste Joseph Wicar

LILLE 1762–1834 ROME

55. *Study of a Male Nude,* about 1826

Black chalk over graphite with white chalk on brown laid paper, 23.1 × 17.9 cm

PROVENANCE: Antonio Bianchi, Rome; by descent through his family; purchased from Margot Gordon, New York.

Stoddard Acquisition Fund, 1994.236

Although the French painter Jean-Baptiste Wicar spent most of his career in Rome, he practiced the official neoclassicism of the Napoleonic court and passed it on to a new generation of artists. He was born into a large family in Lille, the son of a cabinet-maker.[1] His childhood talent enabled him to attend drawing classes with Louis Jean Guéret and to win a drawing prize that took him to Paris. There, in 1779, Wicar became an apprentice to the engraver Jean-Jacques Phillipe le Bas. Three years later he joined the atelier of Jacques-Louis David (no. 46), who became Wicar's most important teacher as well as his social and philosophical mentor, a lifelong friend and supporter.

In 1784 Wicar completed his first major painting, *Joseph Explaining His Dreams,* which he dedicated to the magistrates of Lille, who had helped to finance his Parisian studies. In that year he accompanied David on a visit to Rome. Wicar was back in Italy in 1786, engaged on the *Galerie de Florence,* a compendium of reproductive prints illustrating famous works of art in the collection of the grand duke of Tuscany. David's continuing influence on his student is reflected in Wicar's painting *Brutus Vowing to Expel the Tarquinians* of 1789 now at the Musée Wicar in Lille.

Wicar's political activities also followed David's example, and in Italy he produced several paintings with revolutionary themes. Back in Paris in 1793, Wicar became actively involved with Republican extremists, and after the fall of Robespierre he served a short prison term. Upon release the artist returned to Florence, and he remained in Italy for the rest of his life. During Napoleon's regime he was appointed a commissar of art on David's recommendation. In 1797 he became involved with the imperial commission for the removal of works of art and science from Italian states vanquished by Napoleon's forces. Wicar selected this booty and arranged its shipment to Paris, where it eventually filled the Musée Napoleon. This position, combined with the political chaos in Italy at the time, made it possible for him to amass remarkable collections of his own, particularly in his favorite field of drawings.[2] Wicar settled in Rome around 1801. He became a professor at the Accademia di San Luca and remained a prominent figure in the Roman art world in the epoch of the Empire and the Restoration. He now devoted more attention to portraiture, painting such important figures as Pope Pius VII, Joseph Napoleon, and Joachim Murat, the king of Naples.

In 1826 the French ambassador to Rome, Duke Adrien de Montmorency-Laval, commissioned Wicar to paint a scene from Sophocles' *Electra,* a canvas that was to be his last major history painting.[3]

The Greek legend of the house of Atreus had long fascinated the artist. In 1794 Jacques Louis Pérée made an engraving, *Electra Carrying the Ashes of Orestes,* after Wicar's design.[4] Soon thereafter, perhaps even during his brief political imprisonment at the old Collège du Plessis in Paris in 1795, the artist executed a pair of small, round paintings of Electra and Orestes.[5] In 1801 he completed yet another canvas depicting the reunion of the siblings.[6]

The painting depicts a key moment in Sophocles' complex story when King Agamemnon was murdered by his adulterous wife, Clytemnestra, and her lover Aegisthus.[7] Fearing for the life of Agamemnon's heir, his daughter Electra sent her infant brother Orestes into exile in a foreign land. Years later, emissaries arrived from that country with an urn containing the ashes of her deceased brother, which Electra received with great sorrow. She soon discovered, however, that the courier was really Orestes, who had returned in disguise to avenge his father's death. Later, with the aid of his companion Pylades, the prince accomplished this deed. Wicar's painting, now in the Worcester Art Museum, represents the complex interactions of the moment when brother and sister meet before Agamemnon's tomb (fig. 1).[8] The prince reveals himself to Electra, who sheds tears of relief while still clutching the cinerary urn. Pylades lifts a finger to his lips to warn her not to reveal their identity. Clytemnestra and Aegisthus are seen approaching in the background, foreshadowing the next episode in this legend.

The present drawing is an early study for the figure of Orestes made in preparation for the painting.[9] It is one sheet from an album compiled by Wicar and bequeathed to his student Antonio Bianchi.[10] Like David, Wicar made nude studies for each figure in a painting to understand accurately the pose and proportions of a figure, which would eventually be concealed by draperies. By the time he had executed this sketch, the artist had settled on the relationship between the painting's two primary characters. The figure of Electra clutching the marble urn came from his tondo painting of 1795. The figure of Orestes in this drawing leans toward his sister while gazing into her face. Wicar based the figure's proportions on those of the sculpture of ancient Greece and Rome. The fig leaf was added by a later hand. In this sheet the artist tried different positions for Orestes' legs and feet and also experimented with the placement and character of Pylades. It seems that at this stage of his conception, Wicar considered placing Orestes behind his companion, for the sketchy outline of a draped man facing into the composition partially obscures the main figure.

Fig. 1

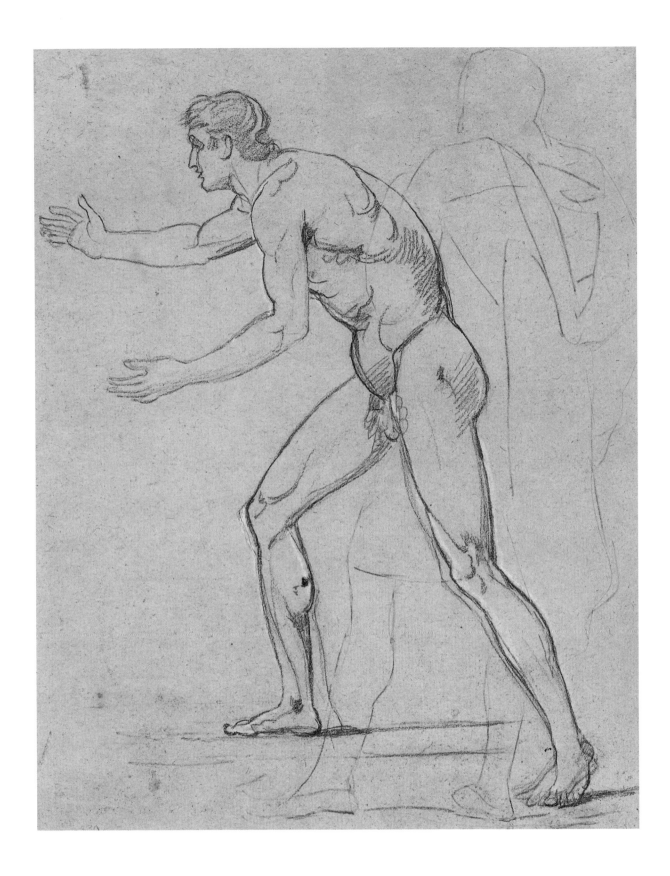

To transfer the present design to another sheet of paper so that he could further refine it, the artist covered the back of the sheet with black chalk. Then, when he traced the outlines of this figure, the image was offset as if from carbon paper. Wicar seems to have first traced the drawing with white chalk; this may not have been hard enough, for he also used a hard stylus, which incised the paper. The pose and attitude of Orestes represented in this drawing remain in the final painting.

Fig. 1. Jean-Baptiste Joseph Wicar, *Electra Receiving the Ashes of Her Brother, Orestes,* 1826–27, oil on canvas, 100.8 × 136.5 cm. Worcester Art Museum, Stoddard Acquisition Fund, 1991.47.

Rembrandt Peale

NEAR RICHBORO, PENNSYLVANIA 1778–1860 PHILADELPHIA

56. *Portrait of Timothy Pickering,* 1827

Black and white chalks over graphite on tan wove paper, 20.9 × 17.6 cm

INSCRIBED: In black chalk, bottom center: *Timothy Pickering – from Life./ Rembrandt Peale.*

PROVENANCE: F. J. Dreer, Philadelphia; Henry T. Tuckerman, New York; purchased from Charles E. Goodspeed, Boston.

Museum purchase, 1916.125.36

Fig. 1

Perhaps the most successful of the four artist sons of Charles Willson Peale, Rembrandt Peale painted allegories and history pictures but is best known as a portraitist. He was born near Richboro in Bucks County, Pennsylvania, on 22 February 1778.[1] In his father's Philadelphia studio Rembrandt learned the fundamentals of his craft and became a trusted assistant.[2] In 1795 Rembrandt was at his father's side when George Washington sat for his portrait, and the youth was allowed to paint his own likeness of the president. He also worked in his father's famous museum of art, history, and natural wonders and helped to build the display of its most famous attraction, the skeletons of two prehistoric mastodons. In 1802 Rembrandt and his brother Rubens took one of the skeletons for exhibition in London. There the young artist studied with Benjamin West, who had been his father's teacher thirty-five years before.

After returning to Philadelphia, Rembrandt established himself as a portraitist. He traveled up and down the East Coast, executing private commissions and painting celebrities for the "collection of great men" exhibit in the Peale Museum. Rembrandt Peale made two visits to Paris, in 1808 and 1810, and his style was influenced by the cool palette and severe linearity of French neoclassicism, then dominated by Jacques-Louis David (no. 46).

In 1814 the artist moved to Baltimore to open a branch of Peale's museum. In 1820 he painted *The Court of Death,* an enormous panoramic moral allegory, now in the Detroit Institute of Arts. The painting toured around the country for decades, spreading the artist's reputation. Peale also became famous for his archetypal portrait of George Washington. He made several versions of this heroic image on canvas and one in a widely disseminated lithograph.[3] Later in New York, Peale succeeded John Trumbull as president of the American Academy of Fine Arts, and in 1826 he helped to found the National Academy of Design. After traveling in Europe in 1828–30 and in England in 1832–34, the artist settled permanently in Philadelphia.

Made during Rembrandt Peale's maturity, the present drawing reflects his powers as a portraitist and his lingering impulse to portray the most famous men of his time. Its subject, Timothy Pickering, was an important officer in the Revolutionary War and an influential politician during the first years of American independence. Born in Salem, Massachusetts, on 17 July 1745, Pickering studied at Harvard College to become a lawyer.[4] In 1766, while practicing law and serving as registrar of deeds for Essex County, he joined the militia. Elected colonel in 1775, Pickering wrote *An Easy Plan of Discipline for the Militia,* a treatise used by the command of the

Massachusetts minutemen and by the Continental army. He led his regiment south in February 1777 to join Washington's army at Morristown, New Jersey; the general was impressed with the Yankee colonel and appointed him adjutant. Pickering fought in the battles of Brandywine and Germantown, but for much of the war he served as quartermaster general for the American armies. He was present at the surrender of Cornwallis at Yorktown.

After the war Pickering lived in Pennsylvania. He was a member of the Pennsylvania constitutional convention and later held the position of postmaster general for the nation.[5] Pickering also served as advisor to the president on Indian affairs, and he concluded a treaty with the Six Nations in 1793. For much of 1795 he was secretary of war and afterward became secretary of state, holding that office under Presidents Washington and Adams until May 1800. Then Pickering returned to Massachusetts, where he was elected to the Senate in 1803. He continued to serve in the Massachusetts state government almost until the time of his death, in Salem on 29 January 1829.

In the spring of 1792, when Pickering was in Philadelphia to supervise the convention of the fifty Native American chiefs, Charles Willson Peale painted his portrait (fig. 1).[6] The present drawing depicts the patriot near the end of his life and was probably made when Rembrandt Peale was in Boston in 1827. The draftsman portrayed a flinty, obdurate politician so extreme in his views that at times he even advocated the secession of New England. By directing Pickering's confrontational glare at the viewer, Rembrandt suggested a sterner personality than in the painting. Whether this daunting likeness reflects the public persona of the sitter or the artist's reaction to him is not known.

Peale used only quick, confident lines in this drawing, which are never scribbled or smeared. He achieved darker passages of tone by superimposing short, straight hatched marks to shade and model form. These lines are shortest and most precise in the detailed area of the face. By accenting the areas of the cravat and face with lines of white chalk, the artist exploited the tan hue of the paper itself to enhance the tonal effect of the drawing. Peale seems never to have made another version of this drawing or an oil painting from it.

Lillian B. Miller suggested that Peale wrote the identifying inscription when he made the sketch, but that he did not sign his name to the drawing until much later.[7] The signature reflects the labored hand of the artist at the end of his life. Miller also proposed that this might be the drawing that Peale sent to the Philadelphia autograph and art collector

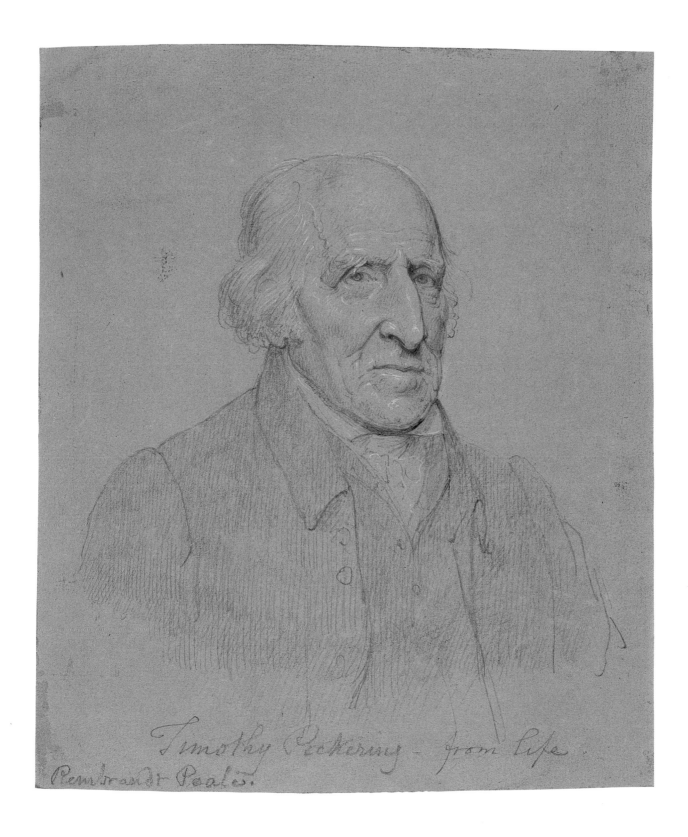

Timothy Pickering — from life.
Rembrandt Peale.

F. J. Dreer on 17 April 1860.[8] The artist might well have kept the sketch in his possession until 1860, when in response to Dreer's request, he signed it and sent it off. The drawing was subsequently owned by Henry T. Tuckerman and bound into a special illustrated edition of his *American Artist Life,* a rare deluxe version of the book featuring photographs, prints, and drawings from the author's personal collection. Later it was in the library of Charles E. Goodspeed, the distinguished Boston dealer of American books and prints.

Fig. 1. Charles Willson Peale, *Portrait of Timothy Pickering,* 1792, oil on canvas, 57.2 × 48.4 cm. Philadelphia, Independence National Historical Park.

Samuel F. B. Morse

CHARLESTOWN, MASSACHUSETTS 1791–1872 NEW YORK

57. *Sketch of Contadini,* 1830

Oil paint and colored crayons on prepared cream wove paper, 24.9 × 19.0 cm

INSCRIBED: In pen and black ink, upper right: *Sketch of Contadini/made in Subiaco in the Sabine hills/40 miles East of Rome Italy, by/Samuel F. B. Morse.* [erased] *in the year 1830/presented to John R. Chapin Eq/from his friend/Sam. F. B. Morse./Nov. 1856.*

PROVENANCE: John R. Chapin; by descent to his grandson, Charles P. Chapin; Hirschl and Adler Galleries, New York; E. Maurice Bloch, Los Angeles; Christie's, New York; purchased from Marvin Sadik, Falmouth, Maine.

EXHIBITIONS: *American Drawings and Watercolors,* New York, Hirschl and Adler Galleries, 1979; *American Art from the Colonial and Federal Periods,* New York, Hirschl and Adler Galleries, 1982; *Samuel F. B. Morse,* Grey Art Gallery, New York University, 1982; *Faces and Figures in American Drawings,* San Marino, California, Huntington Library and Art Gallery, 1989; New York, Christie's, 1990.

REFERENCES: Chapin 1895, p. 10; Staiti/Reynolds 1982, pp. 67, 89; Bloch 1989, pp. 52–53; Staiti 1989, pp. 181, 183; Christie's 1990, lot 45; Stebbins 1992, p. 284.

Sarah C. Garver Fund, 1991.15

Fig. 1

Samuel Finley Breese Morse is best remembered as the inventor of the electromagnetic telegraph and the Morse code, but first and foremost he was a painter.[1] His aspirations as an artist developed when Morse was a student at Yale, where he met the painter Washington Allston. In 1811 he accompanied Allston to England, and in London he studied under Benjamin West at the Royal Academy. When Morse returned to Boston in 1815, he intended a career as a history painter, but found only portrait commissions. He traveled up and down the East Coast, executing portraits in New Hampshire, Massachusetts, Connecticut, Pennsylvania, and as far distant as South Carolina. In 1823 Morse settled in New York and built a business successful enough to finance a house on Canal Street. In 1826 he founded the New York Drawing Association, which evolved into the National Academy of Design.

The artist returned to Europe in 1829 to resume his study of the old masters. He hoped to win the prestigious commission to paint murals in the rotunda of the Capitol in Washington, D.C., and believed that this experience might improve his prospects. Morse financed his journey with about twenty-eight orders for copies of famous paintings. Among these was a commission from Stephen Salisbury II, of Worcester, for copies of works by Guercino (no. 18) and Bartolomé Esteban Murillo.[2] After visiting England and France, Morse arrived in Rome in late February of 1830. He explored the city in the company of American friends, including James Fenimore Cooper, John Gadsby Chapman, and Horatio Greenough. In the spring the artist was at work on a commissioned copy of Raphael's *School of Athens* at the Vatican.

On 8 April 1830, Holy Thursday, Morse attended ceremonies at the Sistine chapel along with Cooper, Chapman, and Salisbury.[3] Then, in the midst of a grand tour of Europe, Salisbury commissioned an original landscape from Morse. He later wrote to his mother: "I ordered a picture . . . desirous to have some such memorial of Rome, and I could not feel sufficiently satisfied with any picture I saw there, to select a copy."[4] Salisbury gave the artist an advance of two hundred dollars, and Morse originally intended to paint for him a view of the ancient Fountain of Egeria. Later, perhaps in consideration of the handsome commission, he decided to send Salisbury his painting of the chapel of the Virgin at Subiaco (fig. 1).

In early May Morse set out with his friend Chapman and some English artists on a month-long sketching trip in the Sabine mountains. They visited the villages of Ariccia, Tivoli, Subiaco, Vico, and Vara. At the village of Subiaco, Morse and his

companions visited the picturesque medieval convent of San Benedetto. Below the cloister on the mountain road to the east, they paused to work at a wayside shrine dedicated to the Madonna, where travelers and shepherds stopped to pray.[5] On 22 May 1830 the artist wrote in his journal that he began a sketch at the shrine, which may well be the present drawing. It represents the Italian peasants, or *contadini,* that Morse observed minding their flocks along the mountain track. Many details of pose, spatial relationships between figures, and effects of illumination were retained in the final painting, showing that Morse executed the sketch with thoughtful consideration.[6] He carefully recorded unusual details of the peasants' costumes, such as the tall, conical hat of the shepherd at the left and his companion's soft Phrygian cap. One shepherd carries a long walking stick to balance his way over precipitous trails and wears tall, strapped gaiters to protect his lower legs from the brush. Removing his hat and gazing beyond the frame, he takes an attitude of respect for the wayside altar depicted in the painting. The diminishing scale of the other figures and their positions on different levels imply the steep terrain along the mountain road. Their concentration in various directions reveals how they minded their flocks on the rocky slopes. With blue and red crayon the artist outlined several sheep ambling away from the viewer and shepherd boy. In the final painting the artist retained the dramatic illumination and long shadows of this drawing. Morse also made a subtle artistic allusion to the nationality and timelessness of his subject, for the right hand of his bearded shepherd is in the same position as that of God the Father in Michelangelo's famous *Creation of Adam* on the ceiling of the Sistine Chapel.

There is another oil sketch by Morse in the collection of the Worcester Art Museum, made in preparation for the final canvas, that represents a view of the mountain shrine at Subiaco with different contadini figures but without the shepherds.[7] While that small sketch, perhaps also made on site, depicts the scene in full daylight, the finished canvas has the long shadows and dramatic evening glow of the present drawing. Later, in the studio, the artist expanded his composition on all four sides, diminishing the scale and importance of the shrine in the expansive landscape. For the finished painting he also introduced the two main figures from the present drawing in exactly the same postures.

On 19 January 1831 Morse wrote to Salisbury from Rome describing the painting that he had just completed: "This chapel . . . is a good example of those shrines before which the Contadini bow the knee, and worship the Virgin, in the distance is the town

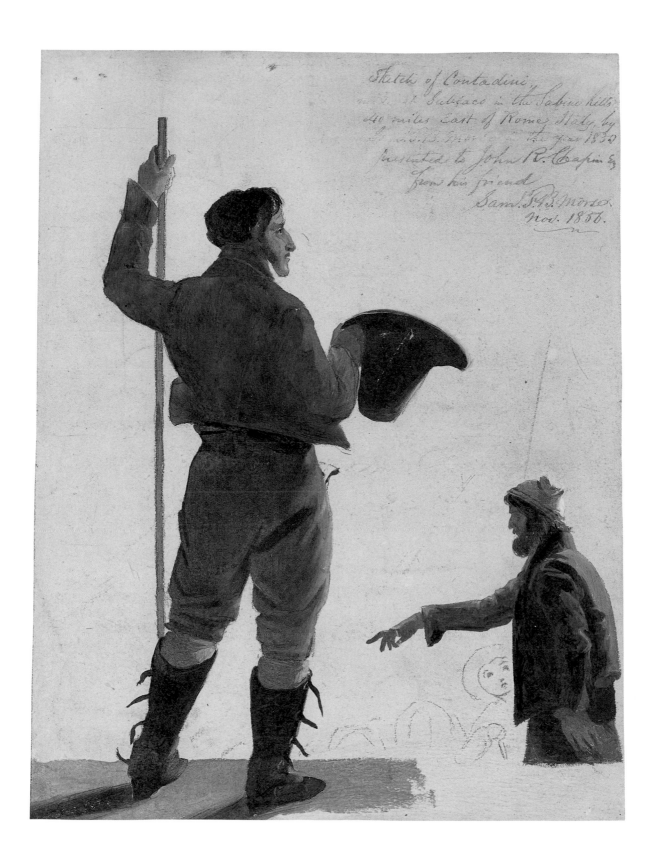

Fig. 1. Samuel F. B. Morse, *The Chapel of the Virgin at Subiaco,*
1830, oil on canvas, 76.0 × 93.9 cm. Worcester Art Museum,
bequest of Stephen Salisbury III, 1907.35.

of Subiaco; before the shrine is a female kneeling
and other figures in the road; the time is a little be-
fore sunset. . . . I can truly say, I have painted it *con
amore,* and that I esteem it myself as the best land-
scape I ever painted."[8] The picture was exhibited on
the Campidoglio in Rome in March 1831 and after-
ward shipped to Worcester, to hang in the Salisbury
home. It was bequeathed to the Worcester Art

Museum in 1907 by Stephen Salisbury III, the institu-
tion's founder and son of the painting's commissioner.

Ruth Henshaw Bascom

LEICESTER, MASSACHUSETTS 1772–1848 ASHBY, MASSACHUSETTS

58. *Portrait of Mary Davis Denny,* 1839
Portrait of Joseph Addison Denny, 1839

Portrait of Mary Davis Denny

Pastel, charcoal, and colored wove paper collage, 50.8 × 38.4 cm

INSCRIBED: In graphite and pen and black ink on verso, lower center: *Mary Davis (of Rutland) / painted by "Aunt Bascom" (Ruth Henshaw) / July 12 1839*

Portrait of Joseph Addison Denny

Pastel, charcoal, and colored wove paper collage, 50.5 × 38.2 cm

INSCRIBED: In pen and black ink on verso, lower center: *Joseph Addison Denny / 1839 / made by Ruth (Henshaw) Bascom / dau of Col. William Henshaw*

PROVENANCE: By descent in the sitters' family to Mary Davis Thurston, Leicester, Massachusetts.

EXHIBITIONS: *Art in America, 1830–1950,* Worcester Art Museum, 1969; *The Second Fifty Years: American Art, 1826–1876,* Worcester Art Museum, 1976.

REFERENCES: Peirce 1953; Worcester 1969, p. 2; Peirce 1970; Riggs 1976, pp. 51–53; Bank 1979.

Gifts of Miss Mary Davis Thurston, 1965.406, 1965.407

A talented self-taught artist, Ruth Henshaw Bascom developed silhouette portraiture from a hobby into a profession later in her life. She worked in a provincial, unaffected style, and the primary goal of her art was to please the friends and neighbors who were her sitters. She was eldest of the ten children of Colonel William and Phebe (née Swan) Henshaw.[1] The primary source of information about the artist is her diaries, begun in 1789 when she was sixteen years old and continued faithfully for fifty-seven years.[2] This account describes her interest in many other crafts; she sewed her family's clothes, wove carpets, pieced quilts, created watercolors, and stenciled theorem paintings.

Henshaw attended the summer terms at local schools for young children and older girls, and in 1791 she took part in a six-week session at Leicester Academy, which seems to have qualified her as a teacher. Over the next decade Henshaw had at least nine temporary teaching engagements. In 1804 she married Dr. Asa Miles, a professor at Dartmouth College, who died within a year. Then, in 1806, she became the third wife of the Reverend Ezekiel Lysander Bascom, pastor of the First Congregational church in Gerry (later Phillipston), Massachusetts.

Bascom first mentioned her hobby of making portraits in her journal in 1801. By 1819 she was producing about one likeness a month. Her subjects were relatives and neighbors. She usually worked directly from her models, in brief sittings in her hosts' drawing rooms during evening visits. Although several of her profiles were drawn in charcoal or pastel, most of Bascom's profile portraits combined drawing with cut-paper silhouette. She would tack a sheet of paper on the wall, pose her sitter before it, and trace the shadow in profile. Later she would draw details based on notes she had taken at the sitting, cut out the paper elements, attach them to a background sheet, and frame the portrait.

In 1821 the Reverend Bascom became pastor of the Unitarian church in Ashby, Massachusetts, and the family moved to this small village. For a time the artist's activity subsided, and it may be that since her patrons came primarily from social contacts, it took time to build up a circle of social acquaintances in her new home. In 1828 Bascom's attitude toward her work seemed to change. In that year she produced between seventy and eighty portraits, lavishing more attention on each piece. At that time she first wrote in her journal of being paid for a portrait and referred to contacts with other craftspeople who built frames for her.[3] Bascom's activity expanded as she portrayed sitters in different towns. In 1828

she worked in Cambridgeport, Athol, and Boston, as well as in Ashby. As her reputation spread, it seems that the artist began to organize trips around her artistic activities. She probably charged between one and four dollars, perhaps reflecting the sitter's ability to pay. Her diary notes that she occasionally accepted payment in kind and sometimes did portraits for free. Bascom often made wedding and engagement portraits as well as memorials of deceased subjects, often children.

This pair of silhouettes is from a group of five family portraits given to the museum by Miss Mary Davis Thurston, the artist's great-niece. The group also includes the portrait of Mrs. Denny's mother, Mary Smith Davis, and the couple's children, three-year-old Mary Elizabeth Denny (fig. 1) and Charles Addison Denny, aged sixteen months.[4] Their frequent appearance in her journal shows that the artist was close to the Denny family. Bascom mentioned one of the drawings in her diary: "Friday—fair, but sudden shower at 1 p.m. and thunder 62, . . . at Addison Dennys finishing the sketch till 2&c. Addison Denny and his mother Davis, Ken Bartody & Martha Scott. . . ."[5] This excerpt confirms the date inscribed on the portrait's verso and demonstrates that the artist would trace several different portraits in a session. A week later she noted: "—finished Joseph's sketch. Went to brother's for tea and framed his likeness, then J.A.D.'s and ditto."[6] This and similar entries show that Bascom delivered her portraits mounted, and it is likely that the frames of the present works are original.

The Denny portraits exemplify Bascom's mature style. In each the bust, the head itself, hair, and headgear were often cut from separate colored sheets and affixed with pins. Occasionally Bascom used printed wallpaper for the backgrounds of her portraits or drew her own generic landscape settings in pastel. However, more often—as here—she used broadly separated diagonal crayon lines to suggest a curtain background. Although the background sheets of both of these drawings have faded to an umber hue, originally they were deep blue in color. The artist applied a knowing seamstress's eye to her sitters' costumes. She represented collars and cravats, bonnets and frills with such accuracy that it is often possible to date her portraits by the clothing styles. To differentiate between fabrics she used different papers, drawing media, and methods of representation. Bascom even represented necklaces, barrettes, glasses, and earrings in cut gold or silver foil paper. The artist was not afraid to change her earlier works, and her diary shows that she adjusted hair

styles or added such details as spectacles to update the portraits.

It seems clear from the range of Bascom's portraits that she was skilled at accurately depicting the physical features of her subjects. Moreover, their fashionable coiffures and clothing suggest something of their social status. However, the wide-eyed stares and expressionless faces of most of the portraits reflect little of their subjects' character. It is mostly in her portraits of the elderly, in faces wrinkled with wisdom and experience, that these images seem to reveal personalities.

Fig. 1. Ruth Henshaw Bascom, *Portrait of Mary Elizabeth Denny*, 1837, pastel over graphite on cream wove paper, 40.1 × 30.7 cm. Worcester Art Museum, gift of Miss Mary Davis Thurston, 1965.408.

Horatio Greenough

BOSTON 1805–1852 SOMERVILLE, MASSACHUSETTS

59. *Study of a Young Woman,* about 1840

Crayon heightened with white chalk over graphite on cream wove paper, 28.5 × 21.4 cm

PROVENANCE: Henry T. Tuckerman, Boston; purchased from Charles E. Goodspeed, Boston.

Museum purchase, 1916.128.185

The first American sculptor to gain international recognition, Horatio Greenough spent many years studying and working in Italy in order to bring neoclassicism to American art.[1] Born on 6 September 1805, he was the son of a prominent Boston merchant and grew up in comfort and privilege. Even in childhood Greenough set his sights on becoming a sculptor; he made drawings and carvings for his friends, and once he carved a plaster copy of a Roman portrait head using a coin as his model. He sought out craftsmen to teach him to use tools and doctors to lend him books on anatomy. In Boston the French-born sculptor J. B. Binon was his first teacher.

Greenough was a voracious reader and an outstanding student. He attended Harvard College for two years, and while in school he designed the obelisk that still stands in Charlestown as a monument to the Battle of Bunker Hill. At Harvard Greenough became close friends with the painter Washington Allston, who encouraged his interest in sculpture and persuaded him to go to Italy in 1824 to study ancient and Renaissance art. After spending two years in Rome, Greenough returned to Boston to begin his career as a professional sculptor, attracting commissions for private and public monuments and for portrait busts of Washington statesmen such as President John Adams and Chief Justice John Marshall.

The artist returned to Italy in 1828 to continue his studies of marble carving at the quarries of Carrara. Later he settled in Florence, where he lived and worked for twenty years, gaining prominence in the international artists' community there. Throughout his years in Italy many of Greenough's patrons were Americans. Among them was the author James Fenimore Cooper, who in 1830 engaged the artist to carve *Chanting Cherubs,* a sculpture based on figures in a painting by Raphael. This piece won critical acclaim when it was shown in the United States and attracted new commissions for Greenough. The artist continued to work as a portraitist, sculpting the marble likenesses of such prominent Americans as Henry Clay, Josiah Quincy, and John Jacob Astor. He also was an author, and his essays on art and aesthetics published in American magazines made him familiar to a wide audience who never saw his work. Greenough built a reputation as a critic who could translate the mysteries of highbrow culture into accessible terms of Yankee practicality.[2]

In 1832 the United States Congress commissioned Greenough's most famous sculpture, a monumental portrait of George Washington, intended for the Capitol rotunda. The intellectual sculptor chose his models carefully. He depicted the first president as

the enthroned Zeus, king of the gods, in order to represent American democracy as the reincarnation of ancient values. He derived Washington's facial features from Jean-Antoine Houdon's marble portrait from life, and in the spirit of neoclassicism he based his design on the most famous sculpture of antiquity, Phidias's colossal ivory and gold monument to Zeus that in the fifth century B.C. stood in the sanctuary at Olympia. Greenough represented Washington garbed in classical draperies and sandals, seated in a severe pose, holding out a sword in his left hand and raising his right, gestures meant to convey the offering of peace. After working on the piece for a decade, Greenough delivered the sculpture to Washington and saw it installed in the Capitol. However, its symbolism baffled most Americans at a time when Washington was a cult hero, and they condemned the monument as foreign and indecent. In response to persistent criticism, it was eventually placed outside on the Capitol grounds and is now in the Smithsonian Institution.

Greenough returned to America in 1851, intending to set up a studio in Newport, Rhode Island. However, he was stricken with a fever and died on 18 December 1852, a few months before he had expected to resume his work there. The sculptor's status as a celebrity and his authority on matters of taste were reflected by the popularity of his letters, published after his death.[3]

The present drawing was once owned by the art critic Henry T. Tuckerman, a friend of the artist.[4] He assembled and edited some of Greenough's writings, along with epitaphs composed by several of the sculptor's prominent admirers, in a book published in the year after his death.[5] This thoughtful, delicate sketch seems to record the features of a distinctive individual, and it may be a study for a portrait. However, the focus of the artist's attention is not on the sitter's physiognomy or character, but on the shape and proportions of her head and neck and the details of her hair style, important elements of a portrait in the round. The young woman's coiffure—in which her long locks have been parted laterally across the head and divided into a chignon at the back, with plaited forelocks in front of the ears—was fashionable throughout Europe in the early 1840s and helps to date the drawing. Greenough observed the hair and styling with great care, striving to capture its soft, reflective sheen and detailing the loose wisps at the back of her neck.

The pentimenti showing where the artist searched for the right contour around the woman's neck distinguish this as a preparatory study. So does the drapery, lowered to reveal her shoulders, which is certainly not a typical garment for a young woman

in that era of propriety. When executing the drawing the artist plotted the outlines of his subject in graphite and then modeled the figure with a softer, darker crayon. With a sculptor's sensibility, Greenough used delicate linear hatchings that follow the contours of form to define precisely the way that light falls over the subject. He may have used a stump to smear the crayon in the area of the woman's shoulders, creating broader, more generalized modeling.

Jean-Auguste-Dominique Ingres

MONTAUBAN 1780–1867 PARIS

60. *Study for the Portrait of Madame Moitessier,* about 1845–50

Black and red chalks on white wove
paper, 35.5 × 30.9 cm

PROVENANCE: Ingres atelier sale (Lugt
1477); purchased from Wildenstein
and Company, New York.

EXHIBITIONS: Caracas, Venezuela,
1957; *Ingres, Centennial Exhibition,
1867–1967,* Cambridge, Fogg Art
Museum, Harvard University, 1967;
*Art Treasures for Worcester: The Legacy
of Daniel Catton Rich,* Worcester Art
Museum, 1970; *Old Master Drawings,*
Austin, University of Texas, 1977.

REFERENCES: Moskowitz 1962, vol. 3,
no. 724; *Art Quarterly,* vol. 28, 1965,
pp. 109, 118; Mongan 1965a; Mongan
1965b; Mongan 1967, no. 95.

Museum purchase in memory of
Mary Alexander Riley with funds
given by her friends, 1964.82

Fig. 1

The leading French classicist of his generation,
J.-A.-D. Ingres is often considered to have been the
champion of drawing in the first half of the nine-
teenth century, in conceptual opposition to the
advocate of painterly expression, Eugène Delacroix.
After early academic training at the Toulouse
Academy, Ingres went to Paris in 1796 to join the
workshop of Jacques-Louis David (no. 46). He
turned instead to a style based on ancient Greek
vase painting. In 1801 Ingres won the Prix de Rome
with a neoclassical history painting, *The Envoys of
Agamemnon,* now at the Ecole des Beaux-Arts in
Paris. However, the artist did not go to Italy until
1806, but once there he stayed for eighteen years.

In Italy Ingres was influenced by the idealism
of Raphael and the classicism of Nicolas Poussin.
After his four-year scholarship had run out, he
earned a living chiefly by his pencil portraits. He
won major commissions for two decorative paint-
ings for Napoleon's palace in Rome. After the fall
of the emperor in 1814, Ingres produced a consider-
able number of small paintings with medieval and
Renaissance subjects. In 1820 the artist moved to
Florence, where he worked primarily on *The Vow
of Louis XIII,* a monumental canvas commissioned
for the cathedral in his home town of Montauban,
which was acclaimed when it was shown at the Paris
Salon of 1824, establishing Ingres as the new leader
of the conservative academic style. In 1834 the artist
became director of the French School in Rome, a
post he retained for seven years. He returned to
France in 1842 and became an influential professor
and director at the Ecole des Beaux-Arts. When a
retrospective exhibition of his works was mounted
at the Exposition Universelle in 1855 he became a
grand officer of the Legion of Honor. Seven years
later he was named a senator of that order.

Most of Ingres's portrait drawings were produced
during the first half of his career, and over 450 of
them are known today.[1] Most of these, precisely ren-
dered in graphite, and sometimes lightly touched
with watercolor, were meant to be finished works.
By contrast, the present drawing from late in Ingres's
career was a preparatory sketch for the well-known
painting of Madame Moitessier, now in the National
Gallery in London (fig. 1). When Sigisbert Moitessier
first asked Ingres to paint a portrait of his wife, the
artist declined. She was the former Marie Clothilde
Inès de Foucauld, daughter of an important execu-
tive in the Administration of Water and Forests,
an agency of which the painter's friend Monsieur
Marcotte was the director. Sometime later at the
Marcotte home Ingres met Madame Moitessier
and was much impressed by her beauty. In 1844 he
offered to accept the commission after all, and the

sitter posed for several sessions. However, as time
progressed the artist could not complete a painting
to his own satisfaction.[2] Perhaps he was intimidated
by his sitter's beauty or his vision of it. Sketches
show that his early conceptions of the portrait de-
picted Madame Moitessier seated on a sofa with her
daughter Catherine leaning against her knee. Ingres
began one version in 1845 and another in 1847, aban-
doning both in frustration. After many sittings and
seven years of patient expectation, Moitessier and
his wife began to insist upon a finished portrait.
In 1851, to appease his clients, Ingres produced an-
other painting in just a few months. This canvas,
which represents the subject standing, is now in the
National Gallery of Art in Washington.[3] The first
portrait remained in the studio unresolved.

Ingres apparently began work on the portrait,
using the pose shown in the present drawing, at
about the time of his completion of the Washington
painting. The pose is similar to one in the famous
ancient Roman fresco of *Herakles and Telephus* at
Herculaneum, a mural the artist may have seen dur-
ing his years in Italy. The distinctive position of the
hand, with its elegant, snaky fingers, and the sitter's
piercing dark eyes are quite close to those features
in the antique fresco. The Worcester drawing is one
from a series of working sketches made in prepara-
tion for the London portrait.[4] In the final painting,
the artist reversed the composition of the present
drawing, but retained the expressive hand, the shape
and position of the head, and the confident gaze.

Ingres probably made the present sketch soon
after he had decided to cast his sitter with the dig-
nity of a classical goddess. The drawing is striking
for its liveliness and its perceptive characterization
of Madame Moitessier's optimistic self-confidence.
The sitter's youthful appearance is moderated in the
portrait, finally completed in 1856; she seems slightly
older and staid in her exquisite gown and elegant sur-
roundings. In June 1857 Ingres described Madame
Moitessier to his friend Marcotte as possessing a
"terrible and beautiful head," adding his hope that
since he had last met her "nothing has altered the
beautiful eyes and divine face."[5]

It is unusual that the Ingres estate stamp appears
on the Worcester drawing, for it was not affixed to
any of the four thousand sheets that the artist be-
queathed to his home town of Montauban, now pre-
served in the Musée Ingres. In 1876 the artist's heirs
contracted the Parisian art auctioneer Monsieur
Féral to sell works in Ingres's estate. Before the sale,
Féral offered a preparatory sketch of the London
portrait to Sigisbert Moitessier, who brought suit
contending that as commissioner of the two por-
traits the drawings were actually his property. Féral

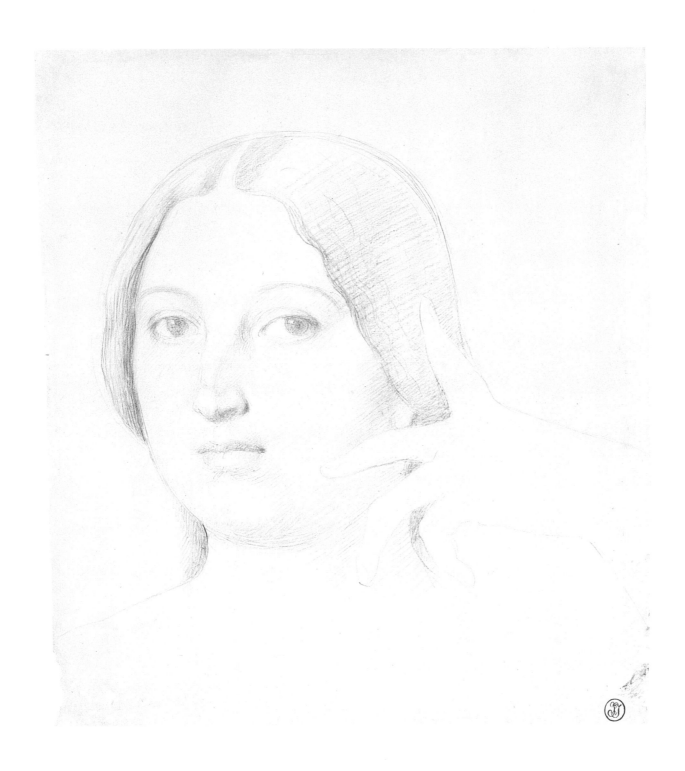

won the court battle, but it was ruled that he could not sell these drawings, which were returned to Ingres's heirs. Marked as possessions of the estate, the drawings were eventually released to the New York art market. This sequence of events may explain why the estate stamp appears on two drawings that coincidentally made their way to Massachusetts museums.

Fig. 1. Jean-Auguste-Dominique Ingres, *Portrait of Madame Moitessier*, 1847–56, oil on canvas, 120.0 × 92.0 cm. London, National Gallery.

George Loring Brown

BOSTON 1814–1889 MALDEN, MASSACHUSETTS

61. *View of Rocca di Papa*, 1855

Graphite with watercolor and white heightening on cream wove paper, 46.7 × 70.3 cm

INSCRIBED: In graphite, lower left: *G. L. Brown/Rocca di Papa. 1855*

Anonymous gift, 1990.165

George Loring Brown specialized in paintings of the Italian countryside destined for the drawing rooms of wealthy Americans. He grew up in Boston, the son of a carpenter. At the age of eleven he was apprenticed to Alonzo Hartwell to learn the craft of wood engraving.[1] His drawings and paintings attracted minor commissions and the support of a wealthy Boston merchant, enabling Brown to travel to Europe in 1832. In England he met John Cheney, a Boston engraver then living in London, who provided financial support and guidance to Brown, even taking him to Paris where he learned much by copying old master paintings in the Louvre. He stayed in Paris to live and study with the miniature painter Savinien-Edme Dubourjal. At this time Brown was also the pupil of the landscapist Eugène Gabriel Isabey.

By 1834 Brown was back in Boston, where he once again took up commercial design and printing to support himself. He married Harriet Pease of Shrewsbury, Massachusetts, and took her to Europe when he returned in 1840. Settling in Rome, Brown struggled to find work as a copyist and to attract commissions for his original landscapes. The following summer the Browns moved to Florence, where the artist concentrated on original landscape paintings. These were featured in an exhibition in New York for which the artist returned to the United States in 1846. This show was a great success and finally established Brown's reputation and brought several lucrative commissions.

In November 1846 the artist again returned to Italy. Two years later he established a temporary studio at Albano, a small town southwest of Rome. This rural retreat gave him access to the Sabine Hills and the Roman Campagna and became headquarters for his sketching forays into the picturesque countryside. He still maintained his primary studio in Rome, where he was a member of a community of American artists. The chief purchasers of Brown's paintings were wealthy Americans, many of whom traveled to Italy and ordered landscapes that were sent home as mementos. During the 1850s Brown made trips to Naples, Capri, Sicily, Paris, England, and Switzerland. At this time the artist also executed a series of etchings meant for the American and British markets, picturesque landscape prints that are comparable in imagery and pictorial means to the present drawing.[2] Brown returned to America in 1859 and settled in South Boston. For the rest of his career he continued to concentrate on Italian views. Apart from a final trip to Europe in 1879, he stayed in the Boston area for the rest of his life.

Brown's account book from the late 1800s—now in the Museum of Fine Arts in Boston—reveals that from mid-July to mid-October 1855 the artist lived at Frascati, another village in the Sabine Mountains southwest of Rome. It must have been sometime during those months that Brown made the present drawing near Rocca di Papa, a small village some four miles from Frascati near the Lake of Albano. Situated in the rocky Alban Mountains, for centuries this location was a favorite summer retreat from the discomforts of the city heat. There the garrison of Rome had summer quarters, and many holiday villas were built on the cool, forested slopes of the volcanic crater.

The present drawing is similar to Brown's Italian landscape paintings in its combination of a recognizable site with anecdotal details of the lives of the local inhabitants. It is a view of Monte Cavo, which rises above the village. The Via Triumphalis, an ancient road paved with basalt, runs from the village to the mountain, with its summit temple of Jupiter; in the epoch of the Roman Empire, victorious generals traveled this route in triumphal procession. In Brown's day the mountain was a popular destination for tourists, for from its summit one could see the seacoast, the Volscian and Sabine Mountains, Rome and the Campagna, and the surrounding Alban Mountains.[3]

In Brown's image of the river gorge near Monte Cavo, the waters widen into slow shallows before descending to a lower level on the right. The water has been directed into broad stone tanks. Village women lean over the edges of these vats to do their laundry and perhaps soak, bleach, and dye fabrics. Water flows from sluices in the sides of these pools, and the viewer imagines their torrents emptying into the lush grotto beneath. These cisterns are a meeting place, for other villagers and herders with their walking staffs have gathered. A man in a hat, with a bag slung over his shoulder and a long walking staff in the middle ground at the left, would seem to be a shepherd. This figure provides scale to the composition and a point of view for the spectator. On the brow of the distant hill at the right a farmer plows with a team of oxen. These figures diminishing progressively in size are found throughout the drawing, enhancing the illusion of depth.

Brown probably executed this drawing on site. He drew with pieces of graphite in varied size, sharpness, and perhaps hardness. Generally, the elements of the drawing that are closest to the viewer are darkest, enhancing the visual effect of depth with atmospheric perspective. The wispy grasses of the foreground foliage taper along their length and were certainly drawn with a soft, wide pencil. However, in the sky he used minute hatchings in a harder material to suggest soft clouds and soaring birds. Occasion-

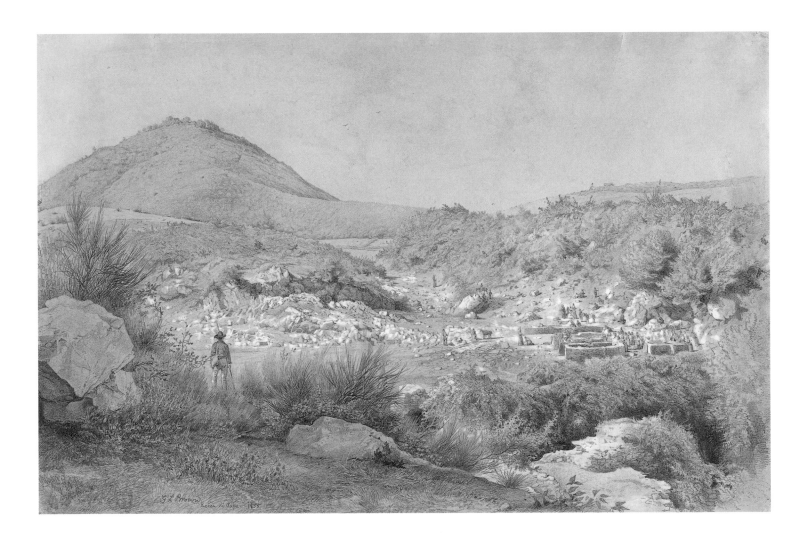

ally the artist used a stump to soften and blur passages of tone, but he usually superimposed hatching on this smoky modeling. The bright peasant clothing of some of the women is picked out in watercolor. The artist also highlighted many other areas with Chinese white, especially where the bright sunshine reflected off the rocks. Although the pigment is lost from these places, it protected the paper from discoloration and now seems to represent an approximation of the artist's original intent.

Jean-François Millet
GRUCHY 1814–1875 BARBIZON

62. *Bringing Home the Newborn Calf,* about 1857

Charcoal with white heightening on cream wove paper, 27.0 × 32.3 cm

INSCRIBED: In charcoal, lower right: *J. F. Millet;* in graphite on verso of old mount, lower right: *no 184*

PROVENANCE: J. S. Forbes; Vose Galleries, Boston; Dr. Loring Holmes Dodd, Worcester, Massachusetts; Mrs. Howard W. Preston, Cranston, Rhode Island.

REFERENCES: Bénédite 1906, p. 28, pl. 28; Herbert 1966, p. 61; Herbert 1975, p. 206; Worcester Art Museum *Annual Report* 1975, p. 16; Herbert 1976, p. 144; Worcester 1994, p. 143.

Gift of Mrs. Howard W. Preston, 1974.329

Fig. 1

The son of respected and prosperous peasants, Millet was born in the seaside hamlet of Gruchy, near the village of Gréville in Normandy.[1] He began his artistic studies in Cherbourg from 1833 to 1836 with the painters Bon Dumoucel and Jean-Charles Langlois. A scholarship from the city of Cherbourg made it possible for Millet to go to Paris in 1837 to attend the Ecole des Beaux-Arts, where he was a pupil of Paul Delaroche. During the 1840s Millet exhibited regularly at the Paris Salon, and his works included portraits, pastoral landscapes in a style reminiscent of the eighteenth century, and statuesque nudes. By 1847 Millet had begun to produce the genre scenes that made him famous.

Although most of Millet's friends were republicans, his activities during the Paris Revolution of 1848 are unknown. He did receive a commission from the new government for the painting *Hagar and Ishmael,* now at the Mesdag Museum in the Netherlands. His palette grew darker during this turbulent period, and his imagery became more severe. Millet moved with his family to the village of Barbizon, about twenty-five miles southwest of Paris, where a colony of artists had gathered who generally devoted themselves to rural subjects. There the artist concentrated on drawings and paintings of simple, poor country folk. For many authors and artists after the Revolution, the French peasantry became the symbol of a simple, preindustrial life and the uncorrupted political ethics that then seemed lost. Millet strove to depict not only the harshness and brutality of the peasants' lives but also their spirit and dignity. His romanticized, essentially noble vision of country life contrasted with the stark, politically charged realism of Gustave Courbet and his followers. However, this romantic quality enhanced the popularity of Millet's art.

In 1850 Millet made an agreement with Alfred Sensier, a Parisian civil servant and friend to many artists, who became his sole agent. Sensier provided the painter with materials and placed his finished works with dealers and in exhibitions. The outbreak of war in 1870 prompted a brief return to Cherbourg, but Millet spent the rest of his life in Barbizon, working through his Parisian agent. In 1871 he was elected to the newly founded Fédération des Artistes. In his later years, perhaps in response to the achievements of the early Impressionists, the artist gradually turned away from genre to concentrate more on landscape. He also experimented with etching and made prints that reproduced some of his most famous compositions for distribution to a wider audience.

Millet was a powerful draftsman whose drawing style eliminated the inessential and stressed the solid modeling of sculptural form. His many surviving drawings include slight *pensées,* working and prepara-

tory sketches for his paintings. He also executed finished pastels in color for the lucrative Parisian market that were often variants of his resolved canvases.[2] The present drawing represents a scene that Millet witnessed on one of his rare trips away from Barbizon, on a visit to his home town of Gruchy in 1854. Over the next decade the artist executed at least six studies of this subject that culminated in a major canvas, exhibited at the Paris Salon of 1864, which is now in the Art Institute of Chicago (fig. 1).[3] This drawing is the most refined of all the studies and includes nearly all the elements of the finished painting. Thus, it would seem to have immediately preceded Millet's preparatory oil sketch, executed about 1860.[4]

This modest, accessible scene is typical of Millet and must have seemed striking in juxtaposition to the tradition of grand history painting from which it derived. Visitors to the Salon would have recognized that the artist found his models in the classicizing processions that appeared in the masterworks of Nicolas Poussin and Jacques-Louis David (no. 46). Although the image does not represent a heroic or literary tale, the sympathetic depiction of an important moment in the life of a peasant family evokes ideas of greater consequence. The farmers carry a sickly calf, recently born in the pasture, to the warmth of their home. Huddling low on the litter, ears drooping, the calf seems to shiver as it weakly raises its head to look out at the viewer. In the finished painting the animal is smaller and appears more vulnerable than in the drawing. While its direct gaze conveys a personality, the people who solemnly bear the animal remain anonymous. Looking down at the ground as they bear their load, the farmers themselves seem little more than beasts of burden. However, the woman's expression and her position alongside the cow, which reaches out to lick her offspring, imply care and tenderness. These instinctive reactions to the newborn emphasize the similarities between man and beast.

One significant feature missing from the drawing was added in the painting, where a pair of young girls wait in anticipation on the farmhouse doorstep. Their presence enhances both the cohesion of the peasant family and the importance of this event for them all. In the drawing the peasant men seem slightly more stooped. Moreover, the legs of the litter carriers and cow are slightly more apart, suggesting a procession that appears more urgent. When it was exhibited at the Salon of 1864, *The Newborn Calf* elicited disdain from the critics Jean Rousseau and Théodore Gautier, who found the procession needlessly melodramatic and solemn. In a letter to Alfred Sensier, Millet responded to this criticism by declaring that the bearers' attitudes were determined

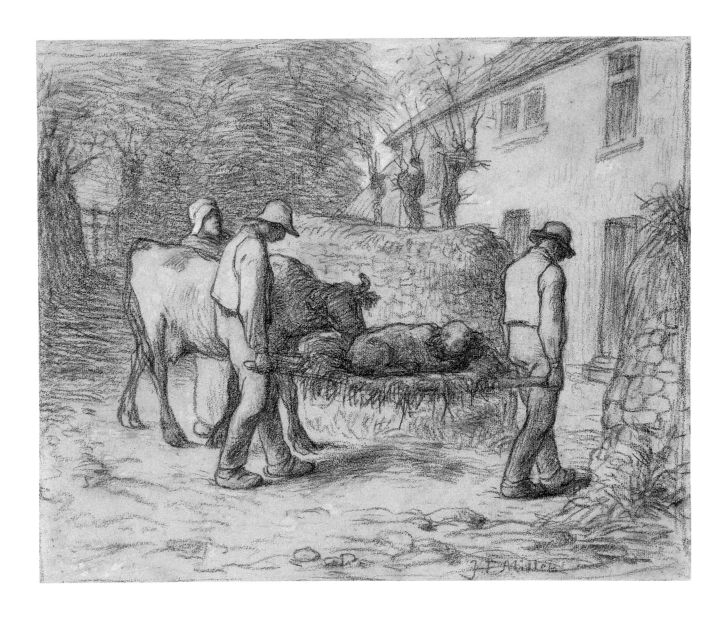

by their task and the weight of their burden. He felt that the physicality of the picture was true to life and successfully conveyed, writing: "If he admits that they carry it well, I ask no more."[5] When the painting was exhibited again at the Centennial Exposition in Paris in 1889 it drew widespread praise, including a comment from Vincent van Gogh (no. 71), who admired its honesty.[6]

Fig. 1. Jean-François Millet, *The Newborn Calf,* 1864, oil on canvas, 81.6 × 100.0 cm. Art Institute of Chicago, 1894.1063.

Edgar-Hilaire-Germain Degas

PARIS 1834–1917 PARIS

63. *Studies of Horses*, 1867–74

Black chalk on cream wove paper,
23.4 × 20.5 cm

PROVENANCE: Atelier Degas (Lugt
657); Galerie Georges Petit, Paris;
Galerie 18, Paris; Malcolm Rhodes
McBride, Fiesole.

EXHIBITION: *An Exhibition of Works
by Edgar Hilaire Germain Degas,
1834–1917*, Los Angeles County
Museum of Art, 1958.

REFERENCE: "La Chronique des
arts," *Gazette des Beaux-Arts*, vol. 115,
March 1990, p. 58.

Bequest of Malcolm Rhodes
McBride, 1989.46

The Impressionist painter Edgar Degas was the most renowned French draftsman of his age. His large oeuvre of surviving drawings provides the most intimate glimpse of his reserved personality. The son of a prosperous banker, Degas was born in Paris on 19 July 1834.[1] Although his parents were of French stock, his father had grown up in Naples and his Creole mother in New Orleans. After graduating from the Lycée Louis-le-Grand in 1853, he began law school, but soon abandoned his studies to pursue a career as a painter. At the Ecole des Beaux-Arts Degas studied briefly with Louis Lamothe and Hippolyte Flandrin, both followers of J.-A.-D. Ingres (no. 60).

In 1855 he traveled to Italy, where he spent the next three years. In Rome he copied the works of the Renaissance masters and executed his own history paintings. Notable among them is the painting *The Young Spartans* of 1860, now in the National Gallery in London. In Paris in 1861 Degas continued his history paintings as well as his practice of sketching, which he did in the Louvre galleries. It was there that he met Edouard Manet, who introduced him to Auguste Renoir, Claude Monet, and other young artists who influenced Degas to concentrate his attention on contemporary subjects.

Horses were a favorite subject of Degas, and they appear often in his drawings and paintings of the 1860s. They were central to daily life at this time, but the artist had a special admiration for their beauty. On his frequent visits to his friend Henri Valpinçon in Ménil-Hubert, in Normandy, Degas saw the well-bred horses at the nearby national stud farm, at Haras du Pin, and at the Argentan racecourse. The racecourse at Longchamp near Paris became a favorite haunt for the artist; most of his racing pictures were made there during the 1870s. In about 1867, when he began modeling small-scale clay and wax sculptures to be cast in bronze, his first experiments were models of gamboling horses.[2] Degas first exhibited his work in 1865 at the Paris Salon, the most prestigious annual exhibition of the day.

During the revolution of 1870 Degas served in the National Guard. He spent the years of the Commune in Normandy and on an extended visit to relatives in New Orleans. After returning to Paris, he helped organize the painting exhibition held in April 1874, the show for which disapproving critics invented the term *Impressionism*. Degas exhibited his work in seven of the eight Impressionist exhibitions. During the 1880s the artist favored more focused, intimate interior scenes, including milliners in their shops, laundresses at work, and ballet dancers at rehearsal and in performance. Deteriorating eyesight gradually led Degas to simplify his compositions and to strengthen his colors, as he came to prefer pastel

over oil. In 1892 the first and only solo exhibition of Degas's art was mounted at the Galerie Durand-Ruel in Paris. In 1908 he gave up his artistic activities altogether and lived in seclusion until his death at age eighty-three.

There are two drawings by Degas in the Worcester Art Museum. *Dancers Backstage* is a large and imprecise study for a more finished pastel, produced late in the artist's career, when faltering sight had affected his work (fig. 1).[3] By contrast, the present drawing is small and precise. It is probably a leaf from a notebook, one of many sheets sold individually among the contents of the artist's studio in 1919.[4] Thirty-eight volumes of Degas's notebooks are intact, now in the collection of the Bibliothèque Nationale in Paris.[5] Theodore Reff suggested that this drawing dates from 1867–74, a period when Degas created many of his racing and equestrian pictures.[6]

These studies of horses and horsemen attempt to capture the movements and mannerisms of the animals and men. At the bottom of the sheet a trainer exercises a horse tethered to a pylon, watching the animal's gait as he urges it forward. Wearing the bowler hat typical of many of Degas's horsemen, he crouches and concentrates on the horse, holding erect his long lunge whip. The horse lifts its forelegs together as it jumps two crossed rails on the ground. At first Degas sketched this animal with its head held higher; later he erased and redrew it in a lower position, with the neck more sharply foreshortened. In the middle of the sheet the artist sketched three other horses, two of which seem to be in full gallop. Lightly drawn at the right, the third horse has the docked tail and heavy proportions of a draft animal.

The vignette at the top of the notebook page captures many subtleties of a seemingly inconsequential moment. A hunter, in breeches and a bowler, with his rifle and game bag slung across his shoulders, has dismounted to lead his horse on foot. The man steps forward, but looks back while the horse follows haltingly, raising its feet high to step with caution. Its raised tail and the arch of its neck also imply its nervous hesitation, but the heavy stirrups sway slightly backward as the animal inclines forward. The hunter and his mount stand in deep grass, and the high, flat horizon behind them suggest that they are moving along the edge of a pond or marsh. As Degas knew well, horses are wary of tall foliage or mud, where the security of their footing may be uncertain. With a highly strung animal like this svelte, well-bred horse, it would not be unusual for a rider to climb down and lead his mount through a marshy area. The hunter and his horse look directly at one another as the man firmly urges the beast to follow, and it does so with prudence reflected in its posture. Degas

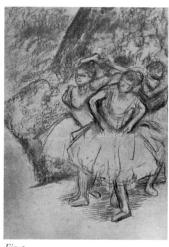

Fig. 1

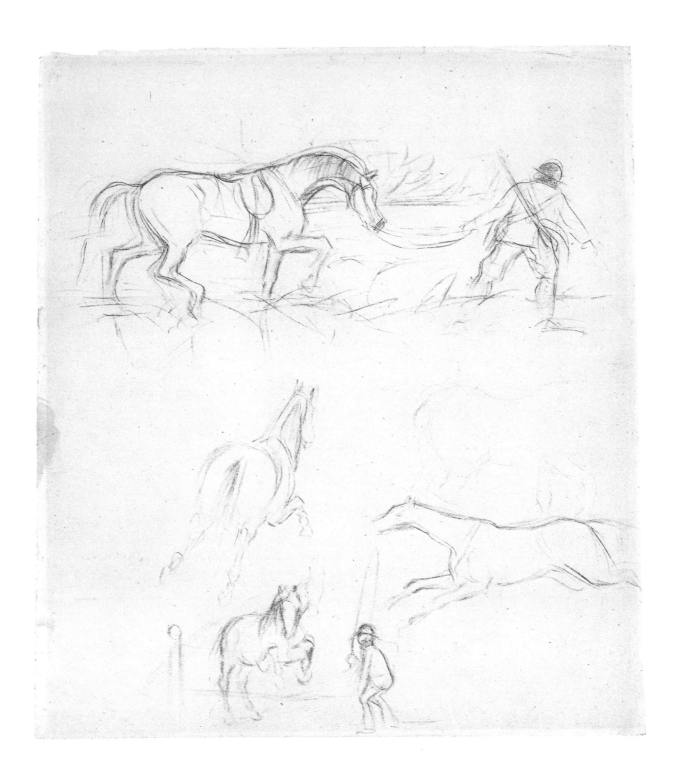

expressed the subtle psychology and dynamics of
this situation with uncanny sensitivity and skill.

Fig. 1. Edgar-Hilaire-Germain Degas, *Dancers Backstage,*
ca. 1904–6, pastel and charcoal on gray paperboard,
103.2 × 72.0 cm. Worcester Art Museum, Austin S. and Sarah
C. Garver Fund, 1956.76.

Adolph Menzel

BRESLAU 1815–1905 BERLIN

64. *Portrait of a Young Woman,* 1870–85

Graphite on white wove paper,
20.6 × 12.7 cm

INSCRIBED: In red chalk on verso,
upper left: *Z197*; in graphite on verso,
lower center: *48 × 32 N3558/4935*

PROVENANCE: Nationalgalerie, Berlin
(Lugt 1640); Professor Alfred Caspari,
Frankfurt; by descent in his family;
purchased from Thomas Le Claire,
Hamburg.

EXHIBITION: Berlin, Nationalgalerie,
1905.

Charlotte E. W. Buffington Fund,
1994.250

One of the most talented and prolific German drafts-men of the nineteenth century, Adolph Menzel drew constantly and compulsively. He made drawings in preparation for his illustration and painting projects and incessantly sketched the small and seemingly insignificant details of life around him. As he once wrote to encourage a young student, Menzel believed that an artist should study everyday surroundings most thoroughly.

As a teenager Menzel worked in his father's lithog-raphy shop, first in Breslau and then in Berlin, where the family moved in 1830.[1] After his father's death two years later, the youth supported himself and his family by maintaining the lithographic press and by designing certificates, letterheads, and other printed ephemera. He studied briefly at the Akademie der Künste in Berlin in 1833 and afterward continued his education on his own. He is said to have taught him-self how to paint and was probably ambidextrous, for he was able to draw with either hand. Soon Menzel was working as an illustrator, and his most important commission was for the designs for wood engravings illustrating Franz Kugler's *History of Frederick the Great,* published in 1842.[2] For this project and others like it Menzel diligently studied the styles, technol-ogy, and personalities of eighteenth-century Prussia so that his images could be as historically accurate as possible. Other publications followed concerning the life and times of Frederick II, employing Menzel for years to come. The most extensive of these was *The Army of Frederick the Great,* with over four hun-dred pen lithographs meticulously cataloguing the uniforms and accouterments of all the ranks of the eighteenth-century Prussian military. These images are remarkable in their historical accuracy, diversity, and inventiveness. In the mid-1840s the artist fre-quented the print cabinet of the Berlin Royal Museums to study the works of the old masters, and he produced several etchings of his own.

It was natural that Menzel should expand his efforts into history painting of eighteenth-century Prussia, but an ambitious series of canvases, begun in 1849, was poorly received.[3] In 1853 Menzel was elected to the Berlin Academy of Art, and his ascen-dancy in the official art establishment was affirmed in 1861 when he was commissioned to paint the coronation of King Wilhelm I at Königsberg. The Nationalgalerie in Berlin possesses over 170 prepara-tory drawings for this monumental canvas, which includes 132 portraits. During the 1860s and 1870s Menzel created paintings representing his own time. He traveled widely throughout Europe recording his journeys in drawings. He made the first of many trips to Paris in 1885. However, he took little notice of the French avant-garde, gravitating to the conven-tional—and very popular—art of Ernest Meissonier, whose influence appeared in his work. As time pro-gressed Menzel's handling of his materials became looser and more spontaneous; his canvases became more painterly and his drawings sketchier. In 1898 Menzel was awarded a title of nobility, and other accolades and honorary degrees followed. He lived until the age of ninety, continuing to work actively throughout his life. After the artist's death over four thousand drawings were found in his studio.[4]

Menzel's early drawings were executed in precise, gossamer pencil lines. The prolific artist also regularly worked in watercolor, gouache, and pastel. Then, during the 1860s he began to draw with thicker pieces of black chalk and the graphite of broad car-penter's pencils, which enabled him to create varied calligraphic lines. He also skillfully used a stump to smear and blend these soft media in increasingly sketchy and expressive works. Menzel habitually produced several drawn studies for a given motif, varying angles of perception, effects of light, or the manner of rendering. He also produced back and side views of figures that would be seen only from the front in a final painting.

This sheet represents an informal portrait of the sort that Menzel seems to have produced quickly and without premeditation. While he used careful control in delineating facial features and expression, he suggested the sitter's costume in rapid, abbrevi-ated strokes. An example of the draftsman's agility can be seen in the rapid, continuous line with which he depicted the placket and button on the front of the subject's dress. Subtle details of illumination— like the glint in the young woman's eye, or the shin-ing lock of hair curling away from her forehead— combined with carefully observed details such as her earring and eyelashes, give the portrait a feeling of life and verisimilitude. Menzel's skill as a designer is seen in the formal balance of the young woman's chignon with the shape of her shoulders and bust. The highlight of the flower in her hair is balanced by the jet black fabric of her collar, and her darkened pupil is emphasized by the highlighted brow and the bridge of her nose. Eckhard Schaar noted that the reliance on contour lines and the absence of heavy passages of dark shadow suggest that this drawing dates to about 1870–85, a period when the artist con-cerned himself with figure and portrait studies.[5]

This study of an alert, thoughtful young woman is similar to those of ladies' faces, costumes, and coiffures that Menzel made in preparation for his large group scenes, such as *King Wilhelm's Departure* (1871), or *The Ball Supper* (1878), paintings that both are now at the Nationalgalerie in Berlin.[6] This par-ticular woman does not seem to appear in those

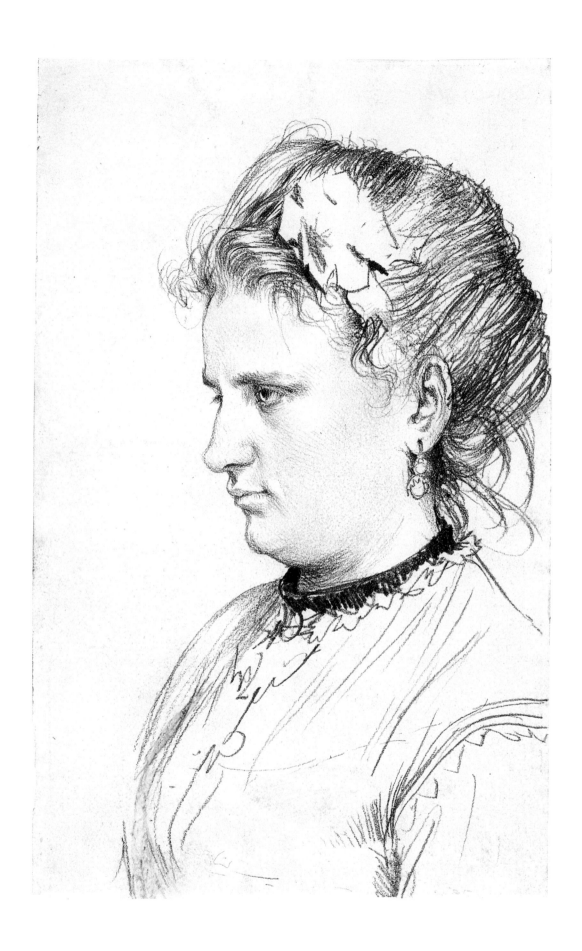

paintings, however. Since she wears a fashionable
dress for informal daily wear, she would thus seem
to have been a middle-class woman, whom the
artist closely observed and may have known.

Edward Lear

HOLLOWAY, ENGLAND 1812–1888 SAN REMO, ITALY

65. *View of Civitella di Subiaco,* 1870s

Pen and black ink with watercolor over black chalk on tan wove paper, 30.4 × 45.3 cm

INSCRIBED: In graphite, upper left: *32;* in graphite on verso, upper left: *5868/Lear*

PROVENANCE: Sir Osbert Sitwell, London; Sotheby's, London; Thomas Agnew and Sons, London; purchased from Mrs. Charlotte Frank, London.

EXHIBITIONS: *Edward Lear Illustrations to Tennyson's Poetry,* London, Thomas Agnew and Sons, 1967; *Edward Lear: Painter, Poet, and Draughtsman,* Worcester Art Museum, 1968.

REFERENCES: Sotheby's 1965, lot 680; Worcester Art Museum *Annual Report,* 1967, p. xv; Worcester Art Museum *News Bulletin and Calendar,* vol. 23, April 1968, p. 3; Dresser 1974, vol. 1, pp. 47–48.

Jerome A. Wheelock Fund, 1967.13

Fig. 1

Though best known today as the author of poems and caricatures for children, Edward Lear was a prominent scientific illustrator and landscape artist.[1] He was a prodigious child who began working as a draftsman at the London Zoological Gardens at age nineteen. During this period he also trained as a lithographer. In 1832 Lear produced *Illustrations of the Family of the Psittacidae, or Parrots,* one of the first collections of colored ornithological prints issued in England.[2] He also contributed lithographs to John Gould's monumental publication *Birds of Europe.*[3] Through his zoological illustrations Lear came to know Lord Stanley, the thirteenth Earl of Derby, who invited him to draw the animals in his private menagerie at Knowsley Hall; a selection of those images was published a decade later.[4]

In 1835 Lear journeyed to the Lake District of England and to Ireland, and gradually his artistic attention shifted to landscape. In 1837 he traveled to Rome for his health and spent weeks exploring the surrounding countryside and drawing views later transformed into lithographs, published in London in 1841 in a volume titled *Views in Rome and Its Environs.* Over the next three decades Lear voyaged around the world, documenting his travels in drawings, watercolors, and oil paintings that were sometimes transformed into the illustrations for his many travel books.

Aristocratic patrons helped to support Lear's work, and through them he attracted the attention of Queen Victoria, to whom he gave drawing lessons in 1846. In that year he published *Illustrated Travels in Italy,* as well as the first *Book of Nonsense by Derry Down Derry.*[5] Lear had written the silly verses and invented their satirical images to amuse the children of the Stanley family, who were his friends when he worked at Knowsley Hall in the 1830s. The little volume became an immediate success. Around 1850 Lear met Alfred, Lord Tennyson, England's poet laureate. The two men became intimate friends, and soon the artist was planning an edition of Tennyson's works to be illustrated by his own landscape lithographs. For years Lear planned the book, selecting landscape drawings made on his various trips and thematically matching them to suitable poems. Lear made new versions of each image, which may have been meant as models for the book illustrations and were roughly uniform in size, format, and technique. Executed in black and gray-brown wash, these drawings often have static compositions and sedate moods befitting the Romantic gravity of Tennyson's verse. At one point he even compiled a mock-up of the book with numbered miniature sketches coupled with the titles or first stanzas of their poems.

In 1871 Lear built a house at San Remo on the Italian Riviera, to which he would return between his continued travels. When he later moved into a larger villa at San Remo, the focus of his attention was perhaps reflected in the name he gave this house: Villa Tennyson. At that time he concentrated intently on the book of poems, now meant to include over two hundred subjects, including many drawings made in Southeast Asia. The project was left incomplete at his death in 1888. A year later a small volume finally appeared, with poems illustrated by twenty-two reduced facsimiles of Lear's drawings.[6]

Lear always associated Tennyson's line "Morn broaden'd on the borders of the Dark" with a sunrise he once witnessed over Civitella, a picturesque mountaintop hamlet in the Apennine mountains south of Rome, near the village of Subiaco. In the early nineteenth century the area was a favorite haunt of artists, most of whom were visitors from northern Europe and America. They came in search of the classical Arcadia described by Goethe and Byron and found this place where the magnificence of nature was accompanied by the evocative ruins left by ancient Romans and medieval Italians. Lear probably first visited Subiaco in May 1840. Over the next three decades he produced at least five different views of the site, in a variety of media and for different purposes. A lithograph representing a distant view of Civitella appeared in *Views in Rome and Its Environs.* Although that image represents the view in half-light, the valley beyond Civitella is visible with its meandering river. The artist balanced the village-crowned mountain on the right with a foreground rock surrounded by saplings and grape vines. The delicate effects of illumination in that print would characterize Lear's subsequent images of Civitella.

Apparently it was only the first line of this verse from Tennyson's "Dream of Fair Women" that captured Lear's imagination, for the image bears no connection to the rest of the poem. The image of Civitella was likely the first subject Lear associated with Tennyson that he interpreted in an oil painting. In 1855 the artist told Emily Tennyson, the poet's wife, that he had sold a painting that he called *Morn broaden'd on the borders of the Dark* to his friends Mr. and Mrs. William Neville.[7] That picture may well have been the canvas now in the collection of the Worcester Art Museum (fig. 1).[8] This image is quite different from Lear's 1840 lithograph, for its somber mood is heightened. The hour is so early that only the summits are illuminated by the rising sun. The point of perception has shifted and is now slightly closer and deeper in the valley before Civitella. A craggy dead tree emerges from the rock in the immediate right foreground before the mountain, leaving an unimpeded vista on the left into the valley be-

yond, still obscured by impenetrable darkness. A variant of this composition is reflected in the present sheet. In its size, format, media, and manner of execution, the drawing is comparable to many that Lear produced as preparatory designs for his projected Tennyson volume during the 1870s.[9]

Fig. 1. Edward Lear, *Civitella di Subiaco,* ca. 1855, oil on canvas, 93.7 × 149.9 cm. Worcester Art Museum, 1961.33.

Friedrich Preller the Elder

EISENACH 1804–1878 WEIMAR

66. *View of Olevano*, 1872

Black chalk and graphite on cream wove paper, 29.0 × 39.0 cm

INSCRIBED: In graphite, in image lower right: *18 F* (reversed) *P 72/ Weimar.*; in graphite, lower center: *Olevano.*

PROVENANCE: C. G. Boerner, Leipzig; purchased from Katrin Bellinger, Munich.

EXHIBITION: *German Drawings: A Selection of Recent Acquisitions,* London, Harari and Johns, 1992.

REFERENCES: Boerner 1931, lot 87; Bellinger 1992, p. 13.

Stoddard Acquisition Fund, 1993.58

The preeminent artist of Weimar in the era of Goethe and Wagner, Friedrich Preller was a noted draftsman whose manner combined influences from late neoclassicism and realism. Born in Eisenach in 1804, Preller moved with his family to Weimar in the same year.[1] There, at age fourteen, he began drawing lessons with Heinrich Meyer. In 1821 Preller met the author Johann Wolfgang von Goethe, who encouraged the young artist and described to him the glories of Italy. With a stipend from Grand Duke Carl August, Preller was able to attend the Academy in Antwerp for two years; then in 1826 he set off for Italy. After further studies at the Academy in Milan, Preller arrived in Rome in September 1828. He became an ever-present member of the circle of German artists gathered around Joseph Anton Koch.

Returning to Weimar in 1831, Preller embarked on a successful career as a decorative and history painter. The following year he won the handsome commission to decorate a room in the Roman House, the ancient-style residence of the Leipzig publisher Hermann Haertel. Preller's classicizing frescoes represented Homer's epic adventures of Odysseus. At this time the artist also began teaching drawing at the Weimar Academy. An even more important decorative painting project followed, when in 1835 Preller began painting murals in the Wieland room of the Munich ducal residence, a project that lasted six years.

Landscape was an important element of Preller's art, and he traveled extensively in search of material for his topographical views. In 1840, together with his students Carl Hummel, Sixt Thon, and Ferdinand Bellermann, Preller took a working journey to Holland, Denmark, and Norway. Other, shorter trips with students followed, including a trek in the Sudeten Mountains and to the Tyrol in 1849–50. A decade later he set off again for Italy, and during this two-year visit the artist became friends with the painter Peter Cornelius. Preller was also an accomplished portraitist, and among the subjects of his portrait drawings are Franz Liszt, Joseph Anton Koch, and Bertel Thorvaldsen, as well as Goethe on his deathbed.

In Weimar during the late 1850s and early 1860s Preller worked on drawings and cartoons for the Odyssey paintings in the Grandduchy Museum—a cycle that would be his masterpiece—in the chamber now known as the *Prellersaal,* or Preller room. In the late 1850s selections of these preparatory cartoons were exhibited in Dresden, Berlin, Düsseldorf, and Munich. Preller labored on the frescoes for almost four years, and they were unveiled at the museum's inauguration in the summer of 1869. The artist received many honors for his work,

including the key to the city of Weimar and the Knight's Cross of the Grand Ducal House. He also was named a member of the Academy of Fine Art in Vienna and elected to the prestigious post of director of the Weimar Drawing Academy, an office he held for five years. Preller's final journey south was in 1875 and 1876, two years before his death in Weimar.

The village of Olevano is perched on the remote hilltops of the Sabine Mountains, some fifty kilometers east of Rome. Its picturesque beauty was discovered by Joseph Anton Koch in 1804, and soon it became a haunt for many painters, including the German Nazarene group and such French artists as Camille Corot and Théodore d'Aligny. Flights of stairways punctuate the tall, close houses of the medieval village. Towering over the village on the slopes of Mount Celeste are the ruins of a thirteenth-century palazzo constructed by the Colonna family. Preller's dated drawings reveal that he first visited Olevano on a sketching trip in 1828.[2] He returned there regularly and represented the distinctive site in many works, including a painting now in the Museum of Leipzig.[3] Although he probably made many sketches on site in Olevano, the size, the academic finish of the present drawing, and its inscription show that Preller executed it in his Weimar studio. The dramatic moodiness of Romanticism is combined in this sheet with a vision of the Italian peasants and their life among the evocative ruins of an Arcadian past.

The drawing depicts storm clouds gathering over the mountain peaks and a bolt of lightning crackling through the summer sky. A strong wind whips through the trees, rustling leaves and bending stout trunks. A shifting darkness moves across the landscape. One can almost feel the cool, moist breeze and dropping temperature preceding the advancing storm. In this rapidly changing light the still brook seems eerily reflective and luminous. The storm has excited a group of goats that caper and playfully threaten one another in the foreground. Village women have left the stream where they were washing clothes, and with their laundry hoisted onto their heads, they hurry toward home. One laundress and a water carrier have stayed by the stream, along with the goatherd who stands confidently close to the shelter of his byre. The water carrier, sitting on the rocks almost at the center of the composition, is a timeless figure. His dress and posture, and the amphora beside him, evoke an ancient bucolic past and a meditation on the way of life that has continued in these mountains for centuries.

Preller used both linear and tonal means to achieve effects of texture and illumination. He drew crisp lines with sharpened chalks and smeared the dry pig-

Olevano.

ment over the paper surface with a stump, particularly in passages representing delicately modeled clouds. Though the artist often used scribbly lines, these appear to tighten and focus when the drawing is viewed from a distance. Preller's energetic technique evokes the Romantic theme of this drawing: the provocative contrast between transience and permanence, both in nature and in human affairs.

Samuel Worcester Rowse
BATH, MAINE 1822–1901 MORRISTOWN, NEW JERSEY

67. *Portrait of a Young Woman*, 1874

Crayon, charcoal, and white chalk on tan wove paper, 63.8 × 51.0 cm

INSCRIBED: In graphite, lower right: *S.W.R.*; across bottom: — *Entered according to Act of Congress in the year 1874 by Williams & Everett in the office of Librarian of Congress at Washington D.C.* —

PROVENANCE: Dudley Williams, Boston; by descent to his daughter Hetty Williams, Boston.

EXHIBITIONS: *Early New Jersey Artists, Eighteenth and Nineteenth Centuries,* Newark, New Jersey, Newark Museum, 1957; *Art in America, 1830–1950,* Worcester Art Museum, 1969; *Late Nineteenth-Century American Drawings and Watercolors,* Amherst, University Gallery, University of Massachusetts, 1977.

REFERENCES: Worcester 1969, p. 10; Hoppin 1977, pp. 47–50; Hills 1981, pp. 123, 125.

Gift of Miss Hetty Williams, 1924.62

A leading American portraitist of the late nineteenth century, Samuel Worcester Rowse was a prolific and talented professional who specialized in drawn rather than painted works. He achieved national fame for his likenesses of eminent American authors, poets, and educators. Born on the Maine coast, the son of immigrants, on 29 January 1822, Rowse moved with his large family to Augusta, Maine, when he was a young child.[1] There he began his artistic career as an apprentice to a banknote engraver. It was probably in 1841 that he moved to Boston and took a job at the printing firm of Tappan and Bradford.

Most of the artist's early designs were illustrative images reproduced in wood engraving, etching, or lithography. Published by Boston's most prominent printing shops, these accessible images were meant to be sold at popular prices. Rowse appears in the Boston Directory for the years 1843 through 1852 as a designer, and apparently he made a living as a freelance artist. His best-known print of the period was a large lithographic *View of the Water Celebration on Boston Common,* published by Tappan and Bradford in 1849.

In Boston Rowse became a close friend to the painter Eastman Johnson, who lived there briefly.[2] Two years younger than Rowse, Johnson also had grown up in Augusta, and in the early 1840s he too may have worked for Boston lithographers. By this time, however, he had lived in New York and had become the leading portraitist of the day. Johnson often drew studies for his portraits, using a combination of charcoal and hard crayons and a stump to smear the drawing medium on the paper to soften contours. Rowse used this technique for his portraits for over twenty years to come. The artist began to exhibit his portraits at the National Academy of Design in New York in 1857 and was elected to the membership two years later.[3] Rowse had a reserved, even saturnine personality. He never married but was a popular figure among a circle of friends that included notable artists, authors, and intellectuals.[4] James Russell Lowell once said, "Rowse may be silent, but he always says the best thing of the evening."[5] Around 1880 Rowse moved to New York where he resumed his acquaintance with Johnson, who portrayed his old friend in the painting *The Funding Bill,* now at the Metropolitan Museum of Art in New York.[6] After Rowse and Johnson visited London together in 1891, Rowse settled in Morristown, New Jersey, where he lived out his life.

Rowse maintained a consistent, almost formulaic style throughout his career as a portraitist. He favored the three-quarter profile bust and a technique of subtle, smoky modeling that he perfected early. These drawings never provide any setting,

but before about 1870 Rowse depicted his sitters' clothing in some detail. The present drawing probably represents an imaginary, somewhat idealized portrait of a young beauty who seems fresh and chaste. Like the subjects of all Rowse's portraits, she peers intently at something outside the frame, giving the image a momentary quality and the subject a lively alertness. This vitality contrasts with posed photographic portraits of the era, for which sitters set their features in unblinking stares for the camera's long exposure. The innocence and sympathy of this young woman are expressed by her large dark eyes. Like a make-up expert, Rowse highlighted her cheeks and forehead to make her gentle eyes the focal point of this characterization.

Rowse used delicate stipples of charcoal smeared over the toothy paper surface to model the face and to depict wisps of hair covered by a diaphanous cap or veil. He used a stump to smear and blend the pigment and sometimes even drew with the stump, pushing and smearing traces of charcoal lifted from other passages. This effect is evident in the gossamer curls on the right side of the woman's face. Rowse also used an eraser to remove charcoal from the sheet, creating highlights like those on the tip of the woman's nose and her lower lip. A tiny spot of white chalk in her left pupil is brighter even than the toned paper, adding a spark of life.

Rowse's continuing interest in commercial art and his business acumen are embodied in this unusual image, one of four crayon portraits by the artist in the Worcester Art Museum.[7] His role as a portraitist does not seem to have been threatened by the advent of photography. Nevertheless, he considered ways to exploit the new medium. The present drawing is one of a pair commissioned by the firm of Williams and Everett, a leading Boston art dealer in the latter half of the nineteenth century.[8] Sometime in the early 1870s Williams and Everett began to publish art photographs. Usually made by the economical albumen process, these photographic prints on paper often were portraits of statesmen, clergymen, and other celebrities. They represented famous masterpieces of painting, sentimental contemporary images of children in their mothers' arms, and idealized portraits of beautiful young women. Most art photographs were pocket-sized *cartes-de-visite* mounted on printed cards and measuring about two by four inches. Several Boston firms published them, including J. H. Bufford, Joseph Ward, J. P. Soule, and G. W. Tomlinson, companies that had grown out of printmaking shops or art galleries.

Rowse made the present drawing, and a pendant representing a *Young Girl with a Hat,* expressly to be photographed, reproduced, and sold inexpensively

−Entered according to Act of Congress in the year 1870 by Williams & Everett in the office of Librarian of Congress at Washington D.C.−

by Williams and Everett.[9] Because it was meant for publication, the artist inscribed his initials in the image and a copyright address along the bottom of the drawing, and an example was duly deposited in the Library of Congress in Washington. It seems that near the end of his career Rowse gave much attention to such appealing commercial images meant to be widely distributed as photographs. In the year after his death an entire exhibition of his imaginary portraits was mounted at Knoedler's Gallery in New York.[10]

Walter John Knewstub
COLCHESTER 1833–1906 LONDON

68. *Lily and Rose,* about 1875

Watercolor with gouache and gum arabic on cream wove paper, 43.0 × 33.0 cm

INSCRIBED: In watercolor, lower right: *WJK* in a circle (the artist's monogram)

PROVENANCE: Purchased from Peter Nahum Gallery, London.

EXHIBITIONS: *General Exhibition of Watercolours and Drawings,* London, Dudley Gallery, 1875; *Burne-Jones, the Pre-Raphaelites, and Their Century,* London, Peter Nahum Gallery, 1989.

REFERENCES: Dudley 1875, cat. no. 419; *Apollo,* vol. 128, November 1988, pp. 7–8; Morgan 1989, vol. 1, p. 135, vol. 2, pl. 99; Worcester Art Museum *Calendar,* January–April 1994, p. 3.

Theodore T. and Mary G. Ellis Fund, 1993.38

Fig. 1

This exquisite portrait exemplifies the style of the English Pre-Raphaelite brotherhood. In 1848 a group of young London-area artists who sought spirituality and romance in medieval art took this name to describe their distinctive new style. Among them were Dante Gabriel Rossetti, Ford Madox Brown, William Holman Hunt, and John Everett Millais.[1] Responding to the deep cultural introspection of the Industrial Revolution, they reacted against the artistic conventions of the eighteenth century. One of the most influential members of the group was Rossetti, who made paintings depicting a world of medieval romance and explored similar ideas and images in his own Dantesque poetry.

Walter John Knewstub was a close follower of Rossetti. Born the son of a painter, he was in his twenties and studying business when he discovered the writings of John Ruskin, which sparked an interest in art. Knewstub went to London and began attending evening art classes at the Working Men's College, where Ruskin was his drawing instructor.[2] He then enrolled in the Royal Academy Schools to study painting with Rossetti, who immediately and deeply impressed him.

Knewstub became close to Rossetti soon after the death of the master's wife, Elizabeth Siddal.[3] He lived in Rossetti's home at 16 Cheyne Walk in the London borough of Chelsea while working in his studio from 1862 to 1864. Although he probably began as a pupil, Knewstub was soon a paid assistant, and the two artists became close friends. During part of this time the authors William Rossetti, George Meredith, and Algernon Charles Swinburne also lived at Cheyne Walk. Knewstub painted portraits of Swinburne and other members of the Rossetti circle. He was charged with laying in the first stages of new paintings, working from Rossetti's drawings. Later he produced studio duplicates of Rossetti's oils and watercolors, which were sometimes signed by the master himself.[4] In 1865 Knewstub began to show his original work at the Dudley Gallery in London. He also exhibited at the Royal Academy, the Society of British Artists, Gambart's Gallery, and the New Gallery, and his works were included in the Pre-Raphaelite exhibitions at Birmingham and Whitechapel.

The model for this watercolor was a young woman named Emily Renshaw. This red-haired beauty had attracted the attention of Rossetti and Knewstub one day on a London street. They followed her home and asked for permission to call again and make portraits of her, which her father reluctantly granted.[5] Emily was acclaimed as one of the "stunners" whose unusual features appealed to the Pre-Raphaelites.[6]

She often sat for Rossetti and was the model for the oil painting *My Lady Greensleeves* (fig. 1), executed in early 1863.[7] Knewstub fell in love and married Emily Renshaw, against the objections of his family, who disinherited him. His sudden new role as breadwinner and apparently a protective attitude toward his wife drew Knewstub away from Rossetti. He now concentrated on his pictures for immediate sale and found the most important and supportive patron of his independent career in Lady Mount Temple. According to family tradition, the final rift began in 1864 when Knewstub took offense at Rossetti's use of Emily's head for the half-nude goddess in his painting *Venus Verticordia.*[8] After a row, another model was used in the final painting. The assistant's displeasure may also have come from Rossetti's procrastination in paying his salary, so Knewstub set out on his own.[9] In 1878 he joined Ford Madox Brown in work on the Manchester town hall frescoes, a major project that continued until 1893, to which Theodore Watts-Dunton and Rossetti also contributed.

In the present watercolor Emily Knewstub, seated in a rose bower, pauses from her book to daydream. She is surrounded by rosebuds and fluttering butterflies circling her head like a halo. The background trellis is reminiscent of the tapestry field settings of early Renaissance paintings by such artists as Benozzo Gozzoli and Fra Angelico. The Renaissance revival–style dress was the sort of garment popular during the 1870s. A golden locket dangles from a chain around her neck, and we imagine that it holds a keepsake or portrait of her lover, the focus of her musings. The taut chain, the restless twist of her fingers, and her sensuous countenance symbolize the mood of her reverie. So does the inescapable sensuality of the labial form suggested by the locket seen in profile. The blue satin gown and gilded red tresses provide an alluring counterpoint to the woman's pale, marmoreal complexion. To emphasize the softness and pallor of her skin, Knewstub painted over the rest of the watercolor with gum arabic, lending the sheet a rich, shiny surface, isolating and softening by juxtaposition the skin areas, rose blossoms, and butterflies.

The back of the original frame containing *Lily and Rose* bears a label with the title and date of this watercolor in the artist's hand. Although it was executed and exhibited during Knewstub's period of independent activity, the watercolor's style and imagery rely heavily on Rossetti. Knewstub may have found inspiration for his image of a passionate daydream and for its flower symbolism in the poetry of Alfred, Lord Tennyson, an author well loved by the Pre-Raphaelites.[10] In his 1855 monodrama

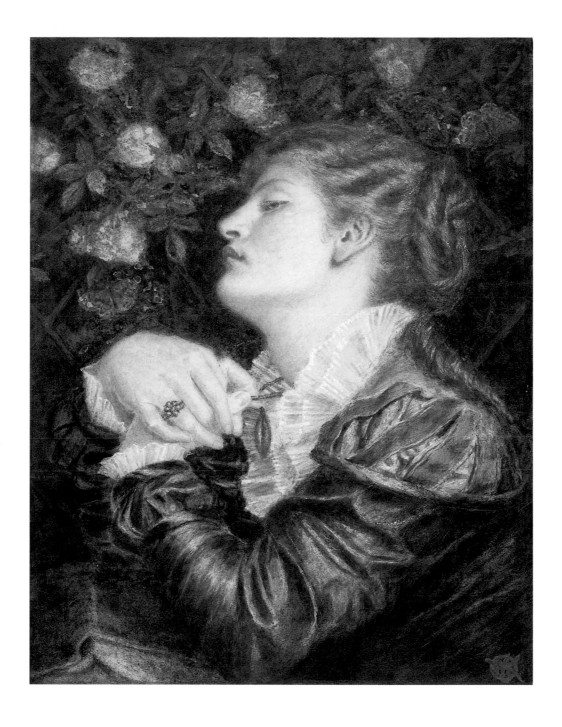

Maud, Tennyson wrote in the voice of a male narrator who meditated in a moonlit garden on the beauty of his beloved, speaking to the flowers:

> The lilies and roses were all awake,
> They sigh'd for the dawn and thee.
>
> Queen rose of the rosebud garden of girls,
> Come hither, the dances are done,
> In gloss of satin and glimmer of pearls,
> Queen lily and rose in one;
> Shine out, lithe head, sunning over with curls,
> To the flowers and to their sun.[11]

This sort of flower symbolism appears often in paintings and poems by the artists of the Pre-Raphaelite circle. It is ironic that these motifs are also prominent in Rossetti's *Venus Verticordia.*

Fig. 1. Dante Gabriel Rossetti, *My Lady Greensleeves,* 1863, oil on panel, 32.4 × 26.8 cm. Cambridge, Fogg Art Museum, Harvard University, 1943.203.

William Morris Hunt

BRATTLEBORO, VERMONT 1824–1879 APPLEDORE ISLAND, NEW HAMPSHIRE

69. *The Woodchopper*, 1877

Charcoal and pastel on tan wove
paper, 24.0 × 35.1 cm

PROVENANCE: Miss Harriet E. Clarke,
Worcester, Massachusetts.

EXHIBITION: *The Paintings and
Charcoal Drawings of the Late
William Hunt,* Boston, 1880.

REFERENCES: Worcester Art Museum
News Bulletin and Calendar, vol. 1,
December 1935, p. 3; Worcester Art
Museum *Annual Report,* 1936, pp. 10,
19.

Gift of Miss Harriet E. Clarke,
1935.197

The Boston painter William Morris Hunt brought the influence of French art to America in the mid–nineteenth century through his own painting, his work as a charismatic teacher, and his advice to collectors. Born into an affluent family in Brattleboro, Vermont, on 31 March 1824, he was the son of a banker who briefly served as a United States congressman.[1] In 1840 he entered Harvard, but Hunt lacked scholarly discipline and did not continue beyond his sophomore year. By this time he had decided to become a sculptor, and he began his artistic studies with John Crookshanks King.

The Hunt family moved to Europe in 1843, where William studied with the American sculptor Henry Kirke Brown in Rome. He briefly attended the Düsseldorf Academy in 1845, then returned to Paris, shifted his aspirations to painting, and entered the studio of Thomas Couture. Hunt's early works are genre pictures of contemporary subjects, often based on compositions borrowed from the old masters. He was much impressed by the work of Jean-François Millet (no. 62), which he saw at the Paris Salon in 1852. Soon Hunt moved to Barbizon to work alongside Millet. The master imparted to Hunt a sense of the moral purpose of art and its foundations in the beauty of nature and the daily struggles of life.

Soon after returning to the United States in 1855, Hunt married Louisa Dumaresq Perkins, who came from a wealthy, prominent Boston family. The artist was accepted by Brahmin society, as well as intellectual and literary circles, and made a successful career producing society portraits and Barbizon-influenced genre paintings. In 1866 the artist and his family journeyed to Europe to attend the Paris Exposition Universelle, where six of his paintings were shown. At that time he encountered the painting of Charles-François Daubigny and Camille Corot, which prompted Hunt occasionally to turn his attention to landscape. After returning to Boston in 1868, the artist opened his own art school. His aesthetic philosophy and teaching methods reflected his own intuitive approach to creativity, and these ideas were disseminated in his popular book *Talks on Art,* first published in 1875.[2]

The artist's life changed radically during the 1870s. His studio was destroyed in the fire that devastated central Boston in 1872, and much of his life's work was lost. Two years later he became estranged from his wife. His painting style reflected these changes, becoming freer in execution and more frequently depicting emotionally charged landscape. In 1878 Hunt won the commission to paint two monumental murals in the New York State Capitol at Albany.[3] The principal image was adapted from a design that Hunt had invented when he was a student in Paris

and depicted the mythical horses of night driven across the sky by the Persian goddess Anahita. To complement this allegory the artist created a conceptual vision of the landing of Columbus in the New World. The paintings were well received, but the demanding project exhausted Hunt, and he suffered a nervous breakdown. Unable to work, he traveled in New England to try to regain his health. While visiting friends on the Isles of Shoals, Hunt failed to return from an evening walk. On the morning of 8 September 1879 he was found dead in a pool, and it was never conclusively determined whether his drowning was the result of an accident or suicide.

The Worcester Art Museum owns several charcoal drawings by William Morris Hunt, as well as this pastel.[4] It depicts a solitary figure in a black suit and bowler hat chopping kindling. White and russet-colored chickens peck at the ground around him undistracted, suggesting that this is a familiar everyday activity. On the right the delicate branches of a sapling still hold a few of their dried brown leaves, and behind the figure on the left are a pump and a laden clothesline. The subdued palette of this pastel, with its occasional accents of pale green, sky blue, and yellow, well evokes a New England fall.

The anecdotal subject and the drawing's sketchy execution are typical of Hunt's late style. Sally Webster identified the location of this drawing as Magnolia, Massachusetts, where Hunt worked from July through October of 1877.[5] She noted that the pump, clothesline, and chickens appear in other works executed at that time, especially *Windy Day in Magnolia,* a painting presumed to depict the grounds surrounding Hunt's studio.[6] When the artist came to this village north of Boston it had already become a popular summer destination for artists. Hunt purchased a barn and adjoining carpenter's shop and converted them into a studio, with the help of his friend the architect William Ralph Emerson. They built an eccentric-looking structure with surrounding porches on both stories and an open, elevated pavilion that commanded splendid views of the sea and inland meadows. Hunt enjoyed a productive interlude there in the late summer of 1877. He created some of his best-known landscapes, including charcoal drawings and oil paintings of villages, tree-lined meadows, prospects of the coast, and seascapes, as well as picturesque views of nearby Gloucester Harbor. The present pastel, like *Windy Day in Magnolia,* is probably one of the works that Hunt executed while sitting on the studio porch in September or October.

This drawing still reflects the early influence of Millet, who always encouraged Hunt to find beauty in the seemingly inconsequential moments of every-

day life. The soft, evocative vision, with more atmosphere than anecdotal detail, also shows the influence of Daubigny and Corot. Indeed, the manner in which Hunt used long, tapering strokes of black to delineate the delicate saplings is specifically derived from Corot's technique. The present work is probably the pastel titled *The Woodchopper* that was included in Hunt's solo exhibition in Boston on 27 December 1878.[7] It may also be the drawing sold when the contents of Hunt's studio were auctioned in Boston after his death.[8]

Winslow Homer

BOSTON 1836–1910 PROUT'S NECK, MAINE

70. *Girl with Shell at Ear,* 1880

Graphite and charcoal with white gouache on blue-gray laid paper, 30.3 × 30.3 cm

WATERMARK: *Saint M[ars]*

INSCRIBED: In charcoal, lower right: *Homer/1880;* in graphite on detached mount, lower right: *To Granville* [sic] *H. Norcross/with compts of/Winslow Homer/Oct 12 1907.*

PROVENANCE: Grenville H. Norcross, Worcester.

EXHIBITIONS: Boston, Institute of Modern Art, 1941; New Britain, Connecticut, Art Museum of the New Britain Institute, 1941–42; *The Tile Club,* New London, Connecticut, Lyman Allyn Museum, 1945; Northampton, Massachusetts, Smith College Museum of Art, 1947; Amherst, Massachusetts, Amherst College, 1947; *The Practice of Drawing,* Worcester Art Museum, 1951–52; *Art in America, 1830–1950,* Worcester Art Museum, 1969; *Late Nineteenth-Century American Drawings and Watercolors,* Amherst, University of Massachusetts, 1977; *On the Beach,* Gloucester, Massachusetts, Cape Ann Historical Society, 1981; *American Traditions in Watercolor,* Worcester Art Museum, 1987.

REFERENCES: Worcester Art Museum *News Bulletin and Calendar,* vol. 3, November 1937, p. 1; Worcester Art Museum *Annual Report,* 1938, p. 14; Worcester Art Museum *News Bulletin and Calendar,* vol. 17, December 1951, pp. 4–5; Wilson 1969; Worcester 1969, p. 7; Strickler 1987, pp. 86–87.

Bequest of Grenville H. Norcross, 1937.14

Fig. 1

Although Winslow Homer is best known today as a painter and watercolorist, his artistic achievement was built on a foundation of academic drawing. His mother introduced him to the practices of drawing and watercolor when he was a boy.[1] At the age of eighteen Homer was apprenticed to the Boston lithographic firm of J. H. Bufford and Sons, where he learned the techniques of reproductive printmaking. On his twenty-first birthday he set himself up as a freelance illustrator in Boston and began saving to finance his move to New York two years later. There, he took night classes at the National Academy of Design with Thomas Seir Cummings and studied painting with Frédéric Rondel. Soon Homer found steady work designing illustrations for *Harper's Weekly* magazine, producing drawings that were translated into wood engravings.[2] In October 1861, early in the Civil War, the magazine sent Homer to Virginia as an artist-correspondent to report on General George McClellan's Army of the Potomac. He sent back illustrations that often represented the glory and heroism of the war but seldom its devastation. Homer capitalized on the popularity of these images in a series of seven lithographs titled *Campaign Sketches,* which he drew on the stones himself.[3] This successful enterprise was soon followed by two series of chromolithograph cards titled *Life in Camp,* representing a mildly satirical vision of the daily lives of Union campaigners off the battlefield.[4]

In 1863 the artist first exhibited his paintings at the National Academy of Design and two years later became an Academician. He spent ten months in France in 1867 when his painting *Prisoners from the Front* was shown at the Paris International Exposition. In the 1870s Homer's career thrived in New York. His paintings were exhibited regularly. His social circle included many prominent artists, such as John La Farge (no. 76). The artist spent his summers in the Adirondack Mountains or by the sea on Cape Ann in Massachusetts, and these experiences were reflected in his art.

In the summer of 1873, at Gloucester, Massachusetts, Homer worked seriously in watercolor for the first time. Throughout the decade he used this medium only during his summers in the country. In 1875 the artist submitted his final illustration to *Harper's* and began to concentrate instead on painting. He also gradually began to produce drawings and watercolors for sale, and his first solo exhibition of these works, at Doll and Richards Gallery in Boston in 1880, was well received. The following year the artist went to England, where he lived in the small fishing village and artists' colony of Cullercoats near Tynemouth, on the

Northumberland coast. There he produced many works, including *The Gale,* a painting now at the Worcester Art Museum.[5]

Returning to the United States in 1884, Homer settled at Prout's Neck, Maine. For the remainder of his career most of his pictures represented the power and majesty of the sea and its impact on man. The artist continued to travel, recording his adventures in drawings and watercolors. In 1884 he made his first trip to the Bahamas and in the following year visited Santiago de Cuba and Florida. In the mid-1880s Homer studied etching and began a series of prints reproducing his earlier oils and watercolors, such as *The Life Line, Eight Bells,* and *Saved,* most of which were published by Christian Klackner in New York. In 1909 Homer completed his final major oil painting.

The present drawing was made in 1880, during Homer's second summer at Gloucester, Massachusetts. That year he stayed as a guest in the lighthouse on Ten Pound Island, in the center of Gloucester harbor. His works seldom display the summertime narrative subjects he had previously favored. He concentrated instead on seascapes, boats and schooners, and especially images of elegant young women at the shore.[6] Several drawings at the Cooper-Hewitt Museum in New York, comparable in their imagery and technique, show that the artist seems to have developed this interest in about 1878 (fig. 1).[7] The drawings of wholesome beauties all were executed in graphite and charcoal and extensively overworked with white gouache. Depicted in couples or, more often, alone, these young women are surrounded by details of setting that place them in meadows, orchards, beaches, or dunes. Elegantly dressed, they often carry attributes of their femininity and occupation, hats, shawls, berrying pails, or seashells. They seem to be unwittingly observed in moments of private reverie or perhaps waiting for some unseen companion. Homer probably made all these drawings out of doors, for they have a spontaneity distinct from the artist's contemporaneous studio sketches.[8]

This sketchy quality is apparent in the present sheet, which Homer executed in layers. He drew on French laid paper that was originally a soft blue-gray in color but has discolored to its present tan. After executing most of the design in charcoal, the artist used a graphite pencil to superimpose modeling and details with progressively exacting precision. Then, with a brush and white wash he highlighted and further modeled forms, finally overpainting with thick Chinese white, probably directly from the tube.[9] In transmitted light, graphite lines can be seen behind the girl's right shoulder, where the artist originally

placed a straw hat hanging on a string around her neck. Homer decided that this element detracted from the girl's face, it seems, and covered it with white, placing a hat beside her instead. At the right edge of the image are the outlines of what seems to be a schooner on the horizon. The artist painted the dune over this, subtly to draw the viewer's eye up toward the girl's face. Lying in the sand at the young woman's left is a seashell, drawn over graphite shad-

ing and seemingly added as an afterthought. Homer probably introduced this clarifying detail to reaffirm that the girl holds a similar shell to her ear in which she hears the sound of the sea.

Fig. 1. Winslow Homer, *Young Woman with a Basket,* ca. 1880, black chalk and white gouache on gray wove paper, 40.3 × 25.9 cm. New York, Cooper-Hewitt Museum, Smithsonian Institution, 1912-12-79.

Vincent van Gogh

GROOT-ZUNDERT 1853–1890 AUVERS-SUR-OISE

71. *An Almshouse Man in a Top Hat,* 1882

Charcoal and crayon on cream wove paper, 40.0 × 24.5 cm

WATERMARK: *HALLINES 1877*

INSCRIBED: In graphite on verso, upper center: *6-26/20*

PROVENANCE: H. P. Bremmer, The Hague; E. J. van Wisselingh and Company, Amsterdam; Mr. and Mrs. Chapin Riley, Worcester, Massachusetts.

EXHIBITIONS: *European Drawings from the Museum Collection,* Worcester Art Museum, 1958; *Vincent van Gogh: The Influences of Nineteenth-Century Illustration,* Tallahassee, Florida State University, 1980; *The Genius of van Gogh,* Memphis, Tennessee, Dixon Gallery and Gardens, 1982; *Vincent van Gogh,* Tokyo, National Museum of Western Art/Nagoya, Nagoya-City Museum, 1985–86; *Van Gogh 1990,* Otterlo, Museum Kröller-Müller, 1990.

REFERENCES: American Federation of Arts, *Art Newsletter,* May 1958, p. 2; "Art Museum Given van Gogh Drawing," *Worcester Evening Gazette,* 2 April 1958, p. 32; *Art Quarterly,* vol. 21, Spring 1958, pp. 86, 95; "Van Gogh Drawing Given Museum as Memorial," *Boston Sunday Globe,* 6 April 1958, p. 28; Vey *Catalogue,* no. 29; Vey 1958, p. 42; Worcester Art Museum *Annual Report,* 1958, p. vii; Worcester Art Museum *News Bulletin and Calendar,* vol. 23, May 1958, p. 32; "La Chronique des arts," *Gazette des Beaux-Arts,* vol. 56, January 1960, p. 41, no. 140; Hennessey 1973, p. 183; Hulsker 1974, p. 29; Hulsker 1977, no. 287; van der Wolk 1990, p. 96, cat. no. 44; Worcester 1994, p. 147; Heenk 1995, pp. 69–70.

Gift of Mr. and Mrs. Chapin Riley in memory of Francis Henry Taylor, 1957.153

An artist whose ecstatic inspiration and stormy emotional life were reflected in his art, Vincent van Gogh has become for the twentieth-century the archetype of the troubled genius. He was born in a small village in northern Brabant, the son of a Protestant minister.[1] After working in an art gallery as a teenager, he decided to pursue a career in the ministry. In 1878 van Gogh became a lay preacher to the poor in the Belgian mining district of Borinage. Because of his extremes of personal asceticism and self-sacrifice, however, he lost this job and for several months afterward he was indigent, brooding over this personal failure.

It was in 1880, while living in his parents' house at Etten, that van Gogh resolved to become an artist. In 1885 he studied briefly with his cousin Anton Mauve, then attended the Antwerp Academy. At this time he painted in a style that combined the naturalism of the Hague School with a personal expressionism. His humanitarian concerns were conveyed in paintings of peasants and workers such as *The Potato Eaters,* now in Amsterdam. Early in 1886 van Gogh was in Paris, where he met Edgar Degas (no. 63), Camille Pissarro, Paul Gauguin (no. 74), and other artists. As he became fascinated by the symbolic and emotive values of color, his work changed radically. His palette became intense and expressive, and he began to apply paint in broad, vigorous, swirling strokes.

In February 1888 van Gogh moved to Arles. There, during the next fifteen months, he worked feverishly, despite recurrent psychological disturbances and the poverty that resulted from his inability to sell his work. Gauguin visited him toward the end of the year, but the two artists quarreled violently and van Gogh fell into deeper depression. He admitted himself to the asylum at Saint Rémy in May 1889, and there he executed some of his most remarkable paintings, including *The Yellow Cornfield,* now at the Tate Gallery in London, and *A Starry Night,* now in the Museum of Modern Art in New York. Van Gogh's sensitivity and his personal conflicts are documented in his correspondence with his brother, Theo.[2] He moved to Auvers-sur-Oise to be near his brother and there ensued another tremendous burst of activity, when in seventy days he painted as many canvases. These were his final works, for on 29 July 1890 he committed suicide.

Van Gogh was a prolific draftsman, and over the course of his brief career he produced more than eight hundred drawings.[3] In late 1882, when he executed the present drawing, much of his energy was focused on drawing from the model. Although he was poor, he found volunteer models in his neighborhood. "My ideal is gradually to work with more

and more models," he wrote to his brother, "a whole herd of poor people to whom the studio could be a kind of harbour or refuge on cold days, or when they are out of work or in need. Where they know that there is warmth, food and drink for them and a few cents earned."[4] Van Gogh also collected props and costumes, and to vary his exercises he often dressed his models in different jackets, hats, and overcoats. J.-B. de la Faille first recognized that this drawing was made in December 1882 and that it represented a pensioner who lived in a nearby almshouse.[5] Van Gogh was moved and inspired by the wisdom and experience he saw in this old man, and he tried to convey these qualities in his drawings. "I was interrupted in writing this letter by the arrival of my model," the artist wrote, "and I worked with him until dark. He wears a large old overcoat, which gives him a curious broad figure. . . . He has a curious bald head, large deaf ears, and white whiskers."[6]

On his shoulder the old man wears a badge displaying his almshouse registration number. By examining the archives of the Dutch Reformed Old Peoples' Home in The Hague, W. J. A. Visser used this number to determine that the sitter was the seventy-two-year-old Adrianus Jacobus Zuijderland, a pensioner who first registered at the almshouse on 6 July 1876.[7] A native of The Hague, he had fought in the Ten Days' Campaign of Holland against Belgium in 1830, a rebellion that led to the separation and independence of the two countries six years later. For his participation in that campaign Zuijderland was awarded the Metal Cross, a decoration that he proudly displayed on his lapel.[8] Van Gogh made several drawings of this old man, some that show him standing with a walking stick and others in which he is seated drinking a cup of tea. A few of these images were later transformed into lithographs. Representing a range of personalities and moods, these studies of Zuijderland illustrate the artist's interpretive skill. Some of the studies seem like candid glimpses of everyday life, and others even have a humorous quality. The present drawing stands out for its portrayal of the pensioner's dignity and the wisdom of his years, maintained despite his impoverished circumstances. Although Zuijderland's costume is shabby and his features are wizened, he holds his head high, and an undiminished intellect and a proud morality seem to shine in his sharply focused gaze.

Van Gogh drew with a broad-pointed pencil on a thick sheet of watercolor paper embossed with a pebblelike texture. He forcefully worked over the darkest areas of the drawing, indenting the paper and creating silvery reflective passages of thick graphite. His sketchy handling of the pencil gave a worn qual-

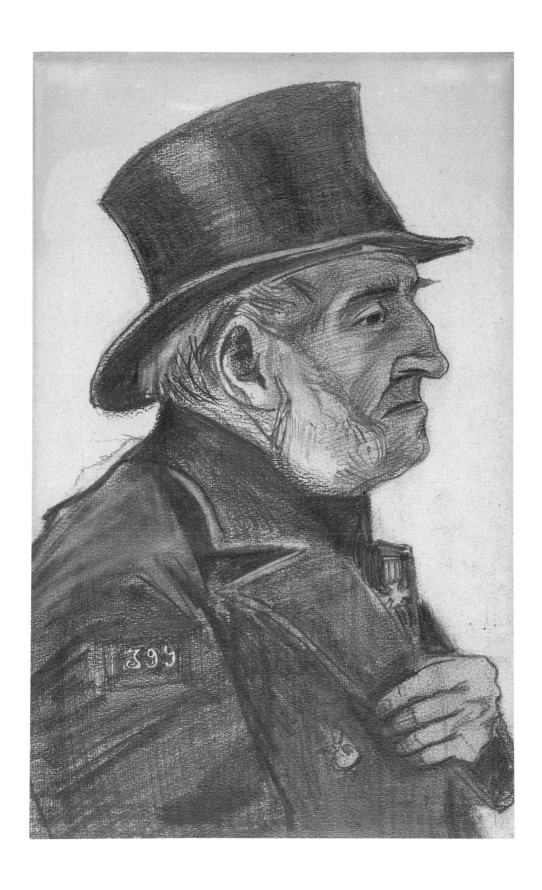

ity to the old man's features and his dress, composed
of a misshapen top hat and a wool overcoat with
brass buttons. Van Gogh seems to have delighted
in the exaggerated, cartilaginous features of this
model, and he emphasized the bushy eyebrows and
side whiskers to complement the large nose and ears
and protruding lip.

Mary Hallock Foote

MILTON, NEW YORK 1847–1938 BOSTON

72. *Spring Whistles,* before 1883

Graphite on cream wove paper,
15.2 × 10.5 cm

INSCRIBED: In graphite on verso,
upper center: *25*

PROVENANCE: Doll and Richards
Gallery, New York; Mrs. Penelope S.
Canfield, Worcester, Massachusetts.

EXHIBITIONS: Worcester,
Massachusetts, Alden Memorial,
Worcester Polytechnic Institute,
1964; *Late Nineteenth-Century
American Drawings and Watercolors,*
Amherst, University Gallery,
University of Massachusetts, 1977.

REFERENCES: Worcester Art Museum
Annual Report, 1900, p. 12; Henniker-
Heaton 1922, p. 176; Hoppin 1977,
cover and pp. 20–21.

Gift of Mrs. Penelope S. Canfield,
1899.11

Mary Hallock Foote was a celebrity in her day for her activities as an author and illustrator of the American West. She was born into a Quaker family in upstate New York and grew up in a community that valued education and enabled her to pursue her dream of becoming an artist.[1] After attending the Poughkeepsie Female Collegiate Seminary, Hallock continued her studies during the Civil War at the Cooper Union Institute of Design for Women, where she was the pupil of William Rimmer. In the 1870s she studied with the still-life and genre painter Frost Johnson at Fordham University. The noted artisan William Linton taught Hallock how to plan her designs for translation into wood engraving, which was then the principal method of printing illustrations in newspapers and magazines. Soon she was selling her illustration designs to the publisher Field, Osgood and Company and to *Harper's Weekly* magazine. Very few of Hallock's early drawings seem to have survived, possibly because she worked directly on the wood blocks, so that her drawings were destroyed in printing.

At Cooper Union, Hallock met Helena De Kay, a fellow student. An active professional artist, she was married to Richard Gilder, the editor of *Scribner's Monthly Magazine* (later *Century Magazine*), and together De Kay and Gilder profoundly influenced the style of American popular literature in the late nineteenth century. The two women remained close friends for many years, and through De Kay Hallock won commissions to design illustrations for *Scribner's.*

In 1867 Hallock married Arthur DeWint Foote, a mining engineer from Hanaford, Connecticut. Soon the young couple went west, and over the next nineteen years they moved from one mining town to another in Idaho, California, and Colorado. Mary Foote raised three children, while always maintaining her professional career. Her friends the Gilders supplied her with the latest books and articles, and in turn she sent back her drawings to be published. Her designs were used by the most expert wood engravers of the day, including Timothy Cole, Henry Marsh, and R. A. Müller. With encouragement from the Gilders, Foote produced magazine articles about her experiences and romantic novels set in Colorado, illustrated with her own drawings. Beginning in 1877 she produced regular illustrated articles for *Scribner's* about life in a California mining camp. Mrs. Foote had established a national reputation as both author and illustrator by the time her family moved to Leadville, Colorado, in 1879.

In 1881–82 the Footes went to Mexico, where their adventures were captured in a series of illustrated articles in *Century Magazine.* Arthur Foote became an engineer and business partner on an irrigation project in Boise, Idaho, from 1883 to 1893. When this project ended in humiliating failure, Mary had to support the family. This was the era of some of her best-known illustrations, eleven of which were published as an ongoing series in *Century Magazine* in 1888–89, under the title *Pictures of the Far West.*

When she exhibited drawings and watercolors at the World's Columbian Exposition in 1893, Foote was described as the nation's leading female illustrator.[2] Two years later, when her husband became chief engineer at the North Star Mine, the family moved to Grass Valley, California, where they would remain for thirty years. The continuing prominence of the artist is marked by the fact that her oil portrait *Old Lady* was exhibited in the New York Armory Show of 1913, the historic exhibition that introduced the work of the European modernists to American audiences.[3]

The illustrative images that Mary Hallock Foote produced in the West from the 1870s through the 1890s reflect the stylistic influences of both Winslow Homer and Frederic Remington. Foote was not afraid to confront the challenging hardships and rough adventures posed by the unsettled West. She did not shrink from recording these realistically in her writings, even though this tendency was apparently at odds with the period's expectations of a woman of status and gentility. However, in her illustrations she did not represent the myth of the rough and tumble Wild West; rather, her anecdotal vision showed the civilizing influence of the pioneers and how they imposed their refined Eastern lifestyles upon the wilderness.

This quality is apparent in the present sheet, for the artist has depicted well-dressed schoolboys, not farm laborers, miners, or Indian scouts. Together the three friends laze on a porch, playing with the hollow reed whistles they might have made. Their jackets and hats suggest that the weather is cool, and the leafless trees and vines on the background trellis affirm that it is early spring. Each boy seems lost in his own thoughts, piping on his reed or adjusting the whistle. The artist cleverly organized her composition to give the illusion of depth and dimension. The viewer's attention is initially drawn to the dark—almost silhouetted—figure seated before the central column, the prominent vertical of the composition. A strong receding diagonal, plotted by the edge of the porch and its stone step, draws the eye up to the piper standing behind. Then the focus is drawn to the reclining figure, whose flute points down to the boot scraper in the lower corner and back into the circular composition once again. The curving contours and soft treatment of the figures

stand out from the rectilinear geometry of their setting.

Although no illustration has been identified with this design, its scale and its seasonal subject indicate that it was made for a magazine illustration. Foote's drawing technique, with its assured, tight execution, suggests that the drawing was meant to be repro-duced by a wood engraving executed by another hand. However, the sheet is in good condition and shows no sign of having been traced or squared when the design was transferred to the wood block. For many years this drawing was preserved in its original frame, backed by a newspaper from 1882. At present this is the only clue we have to the drawing's date.

Truman Seymour

BURLINGTON, VERMONT 1824–1891 FLORENCE

73. *A Visitor in the Torre de las Infantas, the Alhambra,* 1884

Watercolor over graphite on cream wove paper, 33.2 × 23.0 cm

INSCRIBED: In graphite, lower right: *Torre de las Infantas / July 3ᵈ 1884.;* in graphite on verso, lower center: *July 3ᵈ p.m. / Torre de las Infantas*

PROVENANCE: By descent in the artist's family to the Reverend DeWolf Perry, Princeton, Massachusetts.

EXHIBITIONS: *Water Color and Drawings by Brevet Major General Truman Seymour, USMA 1846,* West Point, N.Y., United States Military Academy, 1974; *The Drawings and Watercolors by Truman Seymour (1824–1891),* Pittsfield, Massachusetts, Berkshire Museum / Newark, Delaware, University of Delaware Art Gallery / Scranton, Pennsylvania, Everhart Museum, 1986.

REFERENCES: Ahrens 1974, cat. no. 12; Ahrens 1986, p. 17, cat. no. 37, fig. 11.

Gift of the Reverend and Mrs. DeWolf Perry, 1986.143.

A career soldier for thirty years, Truman Seymour was also an artist and teacher in the circle of Robert Walter Weir. He was born on 24 September 1824 in Burlington, Vermont, the son of a Methodist minister who often moved with his family to a succession of parishes in small towns in New York, Massachusetts, and Vermont.[1] In 1840 the precocious youth stated in a letter to the United States Military Academy that by age sixteen he had already been an assistant geologist for the State of New York and an assistant chemistry professor at the Albany Medical College.[2] When his first application to the military academy was unsuccessful, he attended Norwich University until 1842, when he entered West Point.

All Academy cadets were taught to draw so that they could record topography and fortifications in the field. Thus Seymour received his first art instruction from Robert Weir, who was professor of drawing at West Point from 1834 to 1876.[3] He brought out the young man's talent as a draftsman and instilled in him a love of art that lasted a lifetime. After his graduation in 1846, Seymour saw his first active duty in the Mexican-American War, and for meritorious conduct at Cerro Gordo, Conteras, and Churbusco he was breveted captain. In 1850 he returned to West Point to become assistant professor of drawing. Thus Seymour continued his own artistic education alongside the professor's son John Ferguson Weir. He also met Weir's circle of friends who founded the Hudson River school of painting, including Asher B. Durand, Thomas Cole, and John Frederick Kensett.

In August 1852 Seymour married Weir's eldest daughter, Louisa. A portrait painted at about this time by his new father-in-law depicts a handsome, energetic young man.[4] In truth, however, his health was poor, and he probably suffered from tuberculosis. In April 1859 he took leave for a year's convalescent tour of Europe, where he and his wife spent much of their time viewing art. With these beneficial experiences, Seymour would have been well situated to inherit Weir's professorship, were it not for the Civil War.

In 1861, as a Union artillery captain, Seymour helped defend Fort Sumter, the battle that began the war. On active duty in the South during the entire war, he achieved a distinguished record.[5] For gallantry at the battles of South Mountain and Antietam, Seymour was breveted lieutenant colonel and colonel respectively. He was taken prisoner in 1864 at the Battle of the Wilderness and exchanged for a Confederate prisoner three months later. By 1865 Seymour held the rank of brevet major general in the Fifth Artillery, and he was present at the surrender of General Robert E. Lee at Appomattox.

After the war a variety of East Coast postings kept Seymour from fully returning to art, yet he continued to work and exhibit sporadically. Probably because of failing health he resigned from the army in November 1876, the year of Robert Weir's retirement. The following summer Seymour and his wife sailed to Europe. He began to keep sketchbooks that document his travels and the blossoming of a vital new artistic activity. It was probably in 1879 that the Seymours settled in Florence, in an apartment on the Via dei Bardi. They found a comfortable place in the English-speaking community of Tuscany. They became close friends of the painter Henry R. Newman, whose apartment on the Piazza dei Rossi was a favorite gathering place for artists and authors, including Robert Browning, Nathaniel Hawthorne, and Henry James.[6] The artist toured Europe, producing hundreds of landscape watercolors before 1885, when deteriorating health forced him to stay in Florence. There Seymour died on 30 October 1891.

The Worcester Art Museum owns extensive holdings of drawings and watercolors by Truman Seymour, most of which date from the period of his retirement in Italy. The present watercolor was made on the artist's last extended sketching tour in Spain, where from July through September of 1884 Seymour and his wife stayed in a rented apartment in Granada, where J. Ferguson Weir had painted in 1877.[7] This drawing is unusual among Seymour's works for its anecdotal quality and the prominence of the human figure. It represents a woman exploring a tower chamber of the Alhambra palace in Granada. Having set down her hat and parasol, the woman seems to bend forward, perhaps reaching into a niche in the wall or peeking around a pier, flirtatiously playing with a hidden companion. Quickly superimposed in graphite and black watercolor, the figure and her effects seem to have been added as an afterthought. These thinly sketched, unfocused elements remind us of an early photograph in which the human subject moved during the long exposure time to leave a transparent, ghostly aspect. Seymour sought to convey a sense of change, and his painterly technique and changing light reflect the influence of Impressionism, barely a decade old and still a topic of critical debate in 1884. The artist knew about this style of painting from his travels and through his younger brother-in-law, Julian Alden Weir, who studied in Paris during the 1870s and soon became a leading American Impressionist painter.

Although the underdrawing of this composition is quite precise, the overlayered brushstrokes and wash are sketchy and general. Richly varied sienna tones of the interior shadows contrast with bright sunshine

glimpsed through the window, a light that seems to diffuse and cool as it streams into the palace halls. Seymour used compositional effects to enhance the direction and radiance of the shifting light. By angling the diminishing archways off center, he created a sense of movement from left to right, the direction of the sun streaming into the room. The disequilibrium of the composition is balanced by the placement and pose of the figure, leaning just to the right of center.

Paul Gauguin

PARIS 1848–1903 DOMINIQUE, MARQUESAS ISLANDS

74. *Portrait of Mademoiselle Manthey,* 1884

Pastel on cream wove paper,
42.2 × 35.5 cm

INSCRIBED: In green pastel, lower left:
PG/84

PROVENANCE: Purchased from E. A.
Lewis, London.

EXHIBITIONS: *Exhibition of French
Paintings of the Nineteenth and
Twentieth Centuries,* Cambridge,
Fogg Art Museum, Harvard
University, 1929; *Paul Gauguin:
Exhibition of Paintings and Prints,*
San Francisco Museum of Art, 1936;
*Paul Gauguin: A Retrospective Loan
Exhibition,* New York, Wildenstein
and Company, 1936; *A Loan
Exhibition of Paul Gauguin,* New
York, Wildenstein and Company,
1946.

REFERENCES: Worcester Art Museum
Annual Report, 1921, p. 30; Worcester
Art Museum *Bulletin,* vol. 12, July
1921, pp. 22–23; Henniker-Heaton
1922, p. 178; Wentworth 1922, p. 327;
San Francisco 1936, p. 6; Rewald 1938,
pl. 48; Malingue 1943, pp. 12, 44;
Malingue 1948, pl. 89; Van Dovski
1948, p. 339, no. 41; Wildenstein 1964,
vol. 1, pp. 39–40; Bodelsen 1966;
Dresser 1974, vol. 1, pp. 250–51, 589.

Museum purchase, 1921.5

As much as any other figure in modern history, Paul Gauguin has come to exemplify the romantic, free-spirited artist. He renounced his family and his position in the bourgeois Parisian establishment to devote himself wholly to aesthetic and sensual experience. The son of a journalist, he was born in Paris on 7 June 1848.[1] After his father's death and an extended visit to Peru, the country of his mother's family, the Gauguins settled in Orléans. Following graduation in 1865, he joined the merchant marine and sailed the South Seas, later extending his time at sea by enlisting in the French navy in 1868. After his discharge in April 1871, Gauguin became a clerk in the Bertin exchange brokerage company in Paris. He established a successful career, married Mette-Sophie Gad, the daughter of a Danish minister, and began a family. His comfortable bourgeois life included painting as a weekend hobby. About 1873 he met the Impressionist painter Camille Pissarro, who became his mentor and introduced him to the studios of the Académie Colarossi. In the late 1870s he was able to buy works by the artists of his acquaintance, and he soon amassed a notable collection of Impressionist paintings. The artist exhibited his work at the Salon des Indépendants in 1880 and in the Impressionist exhibitions of the next three years.

Gauguin's family was dismayed when he left his job in 1883 to devote himself to painting full time. Little of his work sold, and he was forced to trade his art collection to support his family. In attempts to economize and to appease his wife, he tried to make fresh beginnings in Rouen and Copenhagen. He was unsuccessful, however, and by 1886 the artist had almost completely severed ties with his family. Seeking an affordable life in the country, he moved to the village of Pont-Aven in Brittany. He painted landscapes and genre scenes in a style that became broader and more expressive, enlivened by an intense palette. After an extended visit to Panama and Martinique in 1887, he returned to France in a destitute state and had to depend on the generosity of his friends. In October 1888 Gauguin went to live with Vincent van Gogh (no. 71) in Arles, but the two artists quarreled violently and ended their friendship.

In 1891 the artist sailed to Tahiti, where he settled in a village thirty miles from the port city of Papeete. During the next year he worked intensely. Some of Gauguin's finest works were his paintings of Polynesians, conceived in an expressive, decorative style for which he derived ornamental and compositional devices from Oceanic art, Japanese prints, and Indian sculpture.[2] Gauguin adopted the life of an islander in Tahiti and continued to work despite illness, poverty, and depression. In 1901 he moved to Atuana, a village on the island of Dominique in the Marquesas. Living there in destitution and emotional exile, he declined rapidly in health, and he died on 8 May 1903.

This drawing dates from early in Gauguin's career and reflects the influence of Impressionism on his style of that period. In the early 1880s many of the Impressionists had begun to work in pastel, and the present work reflects the influence of Camille Pissarro and Edgar Degas (no. 63). In this and other portraits of the time Gauguin sought to represent a mood and the personality of his subjects. He wished to create pleasing, harmonious images that balanced form and color.

In January 1884, to escape the high cost of living in Paris, and perhaps to be near his friend Pissarro, Gauguin moved his family to Rouen. Tension continued between the artist and his wife, who took their two younger children to her family in Denmark. Gauguin resolutely continued to paint, but desperately poor, he sold his life insurance policy at half price. After his wife returned the artist took a job as a sales representative for A. Dilles and Company, a canvas manufacturer in Roubaix. This portrait was made during Gauguin's brief residence in Rouen, before he moved his family to Copenhagen in November 1884.

The artist's son Pola later identified the subject of this portrait as Mademoiselle Manthey, a daughter of the consul representing Norway and Sweden in Rouen and Le Havre.[3] Gauguin seems to have known the entire Manthey family, who owned several of his paintings including a harbor view and painting of the same young woman.[4] In style and technique this pastel is similar to Gauguin's portraits of his own family, such as the pastel of his children *Clovis and Pola* of 1885.[5] At this time his use of pastel was similar to his painting technique, for he generally utilized short strokes of many different colors, laid side by side to be mixed in the viewer's eye and mind. Thus the artist methodically analyzed the light and color as reflected by a given form. The background, which seems at first glance to be quickly drawn in a solid, warm orange tone, was rendered in thick, vertical hatchings that periodically pause to suggest patterned wallpaper. This orange field is almost complementary to the deep green of the woman's jacket, and the juxtaposition of these hues makes the form appear to project, enhancing the illusion of intervening space between the figure and background. The simple composition is enlivened by the opposing diagonals of the woman's shoulders and the wedge-shaped brim of her hat. Gauguin seems to have captured the woman in a fleeting, unguarded moment, and her directed glance and half smile suggest a bright, vivacious personality.

Félix Bracquemond

PARIS 1833–1914 SÈVRES

75. *The Rainbow*, 1893

Charcoal with gray ink wash and white gouache on cream laid paper, 51.2 × 66.7 cm

INSCRIBED: In black crayon, lower right: *Bracquemond*

PROVENANCE: Mrs. Kingsmill Marrs, Boston.

REFERENCE: Vey *Catalogue*, no. 47.

Bequest of Mrs. Kingsmill Marrs, 1926.830

Fig. 1

Félix Bracquemond worked in a range of styles during a career that spanned more than fifty years. Almost as important as his own production was his role as catalyst of several stylistic and political movements during a turbulent period in nineteenth-century French art. He was born in Paris on 22 May 1833.[1] His father died when he was fifteen years old, and to help support the family he found work in a lithography shop. By learning the rudiments of etching from the Diderot Encyclopedia, and viewing old master prints at the Louvre study room, Bracquemond taught himself to make intaglio prints. After etching his first plate in 1849 he rapidly became an expert; he made several noteworthy prints over the next five years, including his first masterpiece, *Haut d'un battant de porte,* which was shown at the Paris World's Fair in 1855.

During the 1850s Bracquemond developed a successful career as a reproductive etcher.[2] He made prints for the Chalcographie du Louvre, the agency that published reproductions of the museum's collection in the days before economical photography. In 1856 he discovered a book of prints by Katsushika Hokusai, the Japanese master of color woodcut, and he was enchanted. He began to study Japanese art and to experiment with its style and imagery. He also ignited the interest of many of his artist friends, and japonisme quickly evolved into a stylistic phenomenon in French art.[3]

Independent, self-assured, and strong-willed, Bracquemond enjoyed the respect and companionship of many progressive Parisian artists, writers, and intellectuals.[4] He often welcomed friends to the Villa Brancas near St. Cloud, where he lived for more than fifty years. There he taught many of them to etch, including Edouard Manet, Théodore Rousseau, and Edgar Degas (no. 63). In 1862 Bracquemond helped to establish the Société des Aquafortistes. By publishing original prints and sponsoring exhibitions, this group helped transform etching from a dull reproductive technique into a vigorous creative medium.

Late in the 1860s the artist turned his attention to the decorative arts.[5] He learned the techniques of porcelain painting in the studio of Joseph-Théodore Deck and studied European and Asian ceramics in the Louvre. In 1867 Bracquemond executed a series of etchings depicting birds, animals, and flowers, images borrowed directly from Hokusai and conceived to decorate a table service of painted Creil faience made for the ceramic dealer Eugène Rousseau.[6] The artist also worked at the Sèvres Porcelain Factory and served for ten years as director of the Paris design studio of Haviland, a leading porcelain manufacturer headquartered in Limoges.

In 1869 the artist married Marie Quivoron-Pasquiou, a talented painter and designer who remained an active artist throughout their marriage.[7] In 1874 his friends Degas and the critic Philippe Burty convinced Bracquemond to contribute to the first Impressionist exhibition, and both he and his wife showed their work in the fourth and fifth Impressionist exhibitions.[8] His reputation reached its height in 1907 when the Société Nationale des Beaux-Arts honored him with a solo exhibition of his works in a variety of media at the Salon.[9] In the course of his long career Bracquemond created more than a thousand prints and also designed ceramics, book illustrations, textiles, jewelry, table silver, and embroidery patterns. He was an author as well and published poems, essays, and two technical manuals on printmaking.[10]

One of Bracquemond's best-known designs, the present drawing offers a distinctly fin de siècle vision of human coexistence with nature. The scene is a grassy riverbank along the Seine, downstream from Paris at Meudon. A sudden wind stirs the trees and tall grass in the meadows as a rainstorm passes through the countryside. Sitting at the river's edge, like an emerging bather, is a nude woman intent on her supernatural occupation. With both hands she elevates a long strip of gossamer fabric that billows out over the landscape as it changes into a rainbow. She is Iris, an ancient Greek deity who personifies the rainbow and who descended to earth as a messenger of the gods. Bracquemond derived the pose of this figure from Michelangelo's *Libyan Sibyl* on the ceiling of the Sistine Chapel in Rome. The way she controls her rainbow is also reminiscent of the demigoddess Fortuna in ancient and Renaissance art, whose unpredictable nature was suggested by a sail arching over her head, carrying her about haphazardly.

From the foreground sunshine the rainbow's arc passes through a dark cloudburst, across the river and over the distant city. Paris is identified by such landmarks as the Eiffel Tower and the towers of Notre Dame. Steam and smoke billow from tall factory chimneys, to evidence the handiwork of man and the ingenuity of modern industry; stretching to the heavens, these man-made structures create their own weatherlike effects, parallel to the rainbow and the cycles of nature. Previously the artist had represented this theme of the benevolent exploitation of nature by industry. In his ceramic mural of 1875 the personifications of fire and water appear in the foreground of a modern industrial landscape straddled by a rainbow; the wall carries a stanza that may be translated: "Wild water, and Fire from the lava-filled volcano, become the docile slaves of Progress."[11]

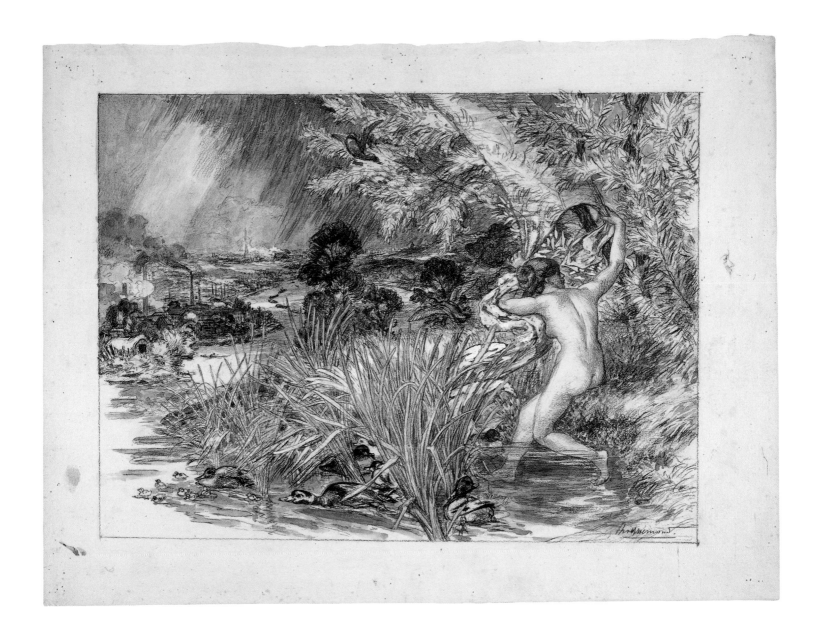

Bracquemond used this design for some of his most experimental prints. Indeed, since the sheet is precisely the same size as his etching of 1893, it may have served as a preparatory study for the print (fig. 1).[12] At the Zimmerli Art Museum at Rutgers University there is an impression of the etching that the artist tinted with watercolor.[13] In the margin of that print he wrote color notes and daubed swatches of each of the hues he used, apparently in prepara-

tion for either a color version of the intaglio, his color lithograph of the same composition, or a very experimental print that combined etching and lithography.[14]

Fig. 1. Félix Bracquemond, *The Rainbow,* 1893, etching and drypoint on cream wove paper, 41.1 × 54.0 cm (plate). Worcester Art Museum, bequest of Mrs. Kingsmill Marrs, 1926.829.

John La Farge

NEW YORK 1835–1910 PROVIDENCE

76. *The Pool at Bethesda: The Invalid,* 1896
The Pool at Bethesda: The Angel Troubling the Water, 1898

The Pool at Bethesda: The Invalid

Watercolor over graphite on cream Japanese vellum paper, 44.2 × 19.9 cm

INSCRIBED: In pen and brown ink in image, lower left: *JLF. 1896;* in graphite on mount: *THE POOL OF BETHESD.. LA FARGE;* in pen and black ink on mount: *Copyright by John La Farge. 1898*

The Pool at Bethesda: The Angel Troubling the Water

Watercolor over graphite on cream Japanese vellum paper, 45.1 × 20.9 cm

INSCRIBED: In pen and brown ink, lower right: *JLF. 98;* in graphite on mount: *The Pool of Bethesd . . . La Farge;* in pen and black ink on mount: *Copyright by John La Farge 1898*

PROVENANCE: Estate of the artist; George Breed Zug, Chicago and Hanover, New Hampshire; James W. Barney, New York; Parke-Bernet Galleries, New York; A. Loewy, New York; Kennedy Galleries, New York; E. Maurice Bloch, Los Angeles; purchased from Christie's, New York.

EXHIBITIONS: New York, Architectural League, 1899; New York, Montross Gallery, 1901; *Faces and Figures in American Drawings,* San Marino, California, Huntington Library and Art Gallery, 1989.

REFERENCES: Sturgis 1898; Weinberg 1977, pp. 423–24; Adams 1987, pp. 217, 219; Bloch 1989, pp. 48–50.

Stoddard Acquisition Fund, 1990.24.1, 1990.24.2

Fig. 1

John La Farge introduced new directions in aesthetic theory, style, and technique in American art of the late nineteenth century. He was the son of a French émigré from Santo Domingo who was a prosperous merchant.[1] La Farge attended Mount Saint Mary's College in Emmitsburg, Maryland, and Saint John's College in New York, from which he graduated in 1853; two years later he was awarded a law degree from Mount Saint Mary's College. By that time La Farge had become deeply interested in art. In 1856 he went to Paris to study with Thomas Couture. Three years later he continued his studies with William Morris Hunt (no. 69) in Newport, Rhode Island. Over the following decade he strove to establish a career as an artist, concentrating on plein air landscapes and painterly still lifes. The La Farge family spent their summers at Middletown, Rhode Island, and in 1863 John Chandler Bancroft became a neighbor there. Together La Farge and Bancroft enjoyed collecting Japanese prints and encouraged each other in the study of Asian art.[2] In 1864 the artist moved to the Boston area, where he studied anatomy with William Rimmer. His professional stature at that time was recognized in his election to the National Academy of Design in 1869. He won a commission from the architectural firm of Ware and Van Brunt to design and produce a stained-glass window for Harvard College in 1874. Two years later the architect H. H. Richardson engaged La Farge to decorate the interior of Trinity Church in Boston. Other major interior design projects followed, including the architectural decoration of several New York City churches, among them the Church of the Ascension in 1886.[3]

In 1879 La Farge opened his own studio in New York for the manufacture of glass and stained-glass windows. He and his assistants developed a new variety of opalescent glass, for which La Farge received a patent in 1880. The artist's success enabled him to travel widely; he journeyed to Japan in 1886 and the South Pacific in 1890–91.[4]

The present watercolors were made in preparation for a stained-glass diptych in the Mount Vernon Congregational Church in Boston.[5] In 1891 the construction of a new church building began at the corner of Beacon Street and Massachusetts Avenue. That year also was marked by the death of Dr. James Ayer, long a parishioner of Mount Vernon Congregational Church and physician to many neighborhood families. As a memorial his family commissioned stained-glass windows for the new church from La Farge. As the subject they chose a biblical story about a curative pool in Jerusalem

known as Bethesda. John the Evangelist called it "a place with five porches," so it was usually represented as a colonnaded spa.[6] Periodically an angel would descend to disturb the surface of the pool, and afterward the first one to touch the water was healed. Thus Bethesda had become a pilgrimage site for the disabled, who waited for the angel's appearance. One paralytic among them could never reach the water first, and when Christ visited Bethesda he sought out this unfortunate and cured him.

In the right panel of La Farge's design the angel bends forward to touch the water in the marble-lined pool. In the left panel a young man assists a lame woman to the water's edge. With faith and longing in her face, she gazes at the angel as her foot touches the water. The arched shape of the finished windows suggests the colonnade described in the Bible (fig. 1).[7] The composition of the watercolor was slightly expanded, and the two panels were drawn together by the continuous swath of hanging drapery above the figures and an illusion accentuated by the blue sky beyond.

In preparation for this design La Farge built a pool in his studio to enable him to study the reflections in water. He probably made study photographs of models posed before the pool, as he did in preparation for other glass projects at this time.[8] The artist also probably made many sketches for this project, but the present drawings are the only studies known. It is noteworthy that the watercolors are on two separate sheets and are dated two years apart. La Farge may have settled on the image of the invalid rather quickly, but resolved his design for the angel later. La Farge was a highly skilled watercolorist, and he brought a painter's sensibilities and color sense to stained glass. A contemporary critic wrote of the Ayer windows: "It is probable that there never was a window more deliberately made into a picture . . . an effect never before attempted in stained glass."[9] Some details were painted in black on the surface of the glass, but these were generally confined to features of hands and faces.

The hues of glass are carefully matched to the palette of the watercolor. As the critic said at the time: "The draperies are composed of glass just as it leaves the furnace, with all its glow, translucency, and subsequent richness of effect, every piece of the glass has within itself the most delicate and unexpected gradations of color, and the art of the designer is primarily to select these pieces out of his great store of thousands. . . . These bits of glass are his palette."[10] Perhaps the most technically innovative feature of these windows is the passage depicting

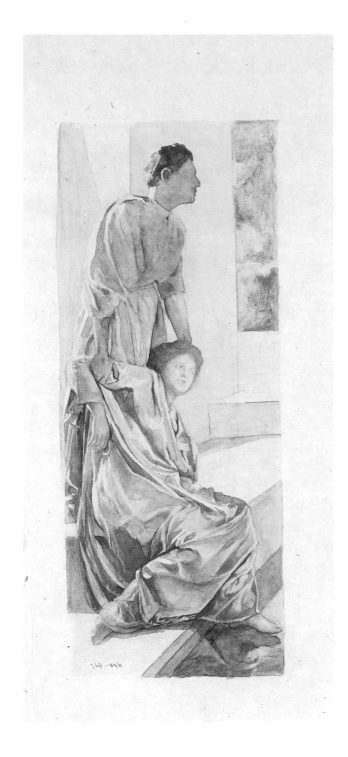

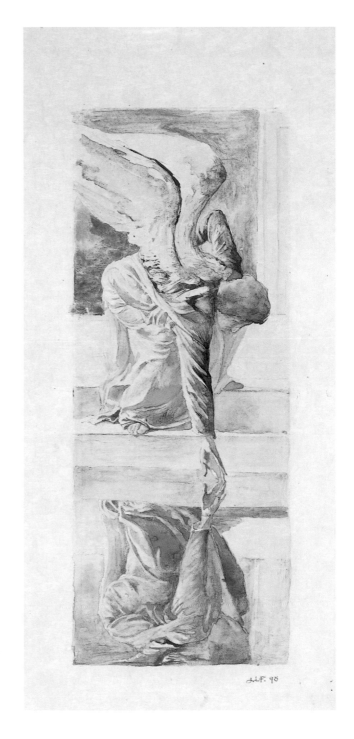

the reflections in the water. To achieve an illusionistic softening of line and form, the artist covered these passages with a sheet of lightly tinted gray glass that dulled the colors and diffused the focus.[11]

Construction of the new Mount Vernon Congregational Church was completed in 1897, and its interior decoration continued in the following year. The Ayer windows were unveiled and dedicated on 20 November 1898. Nearly a century later the Mount Vernon Congregational Church was desanctified and converted into residential buildings. At that time the Ayer windows were donated to the Worcester Art Museum.

Fig. 1. John La Farge and Studio, *The James Ayer Memorial Windows from Mount Vernon Congregational Church, Boston,* 1898, leaded stained glass, each 338.8 × 81.0 cm. Worcester Art Museum, gift of the Mount Vernon Congregational Church, 1975.100.

Ernst Ludwig Kirchner

ASCHAFFENBURG 1880–1938 FRAUENKIRCH

77. *Seated Woman,* 1909–10

Gouache on cream wove paper,
35.0 × 45.0 cm

INSCRIBED: In graphite on verso,
lower left: *Dre Bg 24;* stamped in black
ink on verso, lower left: *NACHLASS
E. L. KIRCHNER* enclosing, in pen
and black ink: *A Dre/Bg24*

PROVENANCE: Estate of the artist; Karl
Ströher, Darmstadt; Alan Frumkin
Gallery, Chicago; Mr. and Mrs. Hall
James Peterson, Minneapolis and
Petersham, Massachusetts.

EXHIBITIONS: *Kunst unserer
Zeit: Privatsammlung Karl
Ströher,* Darmstadt, Hessischen
Landesmuseum, 1954; *Aus der
Sammlung Ströher,* Wiesbaden,
Nassauischer Kunstverein, 1963; *Die
Sammlung Karl Ströher,* Darmstadt,
Hessischen Landesmuseum, 1965;
*Ernst Ludwig Kirchner: A Retrospective
Exhibition,* Seattle Art Museum/
Boston, Museum of Fine Arts/
Pasadena Art Museum, 1971;
*Drawings and Watercolors from
Minnesota Private Collections,*
Minneapolis Institute of Arts,
1971; *German Expressionist Prints,
Drawings, and Books,* Worcester
Art Museum, 1986.

REFERENCES: Darmstadt 1954, cat.
no. 91; Wiesbaden 1963, cat. no. 20;
Ragaller 1965, cat. no. 60; Gordon
1971, cat. no. 79; Pohl 1982, p. 290.

Promised gift of Kate Butler Peterson

The pioneer of German Expressionism, Ernst Ludwig Kirchner was the leading force behind the Dresden avant-garde artists' alliance Die Brücke. This small but enormously influential group reacted against the impersonal brutalities of modern civilization. They sought in their work to capture the fundamental creative spark that they perceived in ethnographic art.

Kirchner was born in Aschaffenburg on 6 May 1880, the son of a paper industry engineer.[1] His family moved in 1890 to Chemnitz, where his father taught at the Industrial Academy. After graduating from the Chemnitz Realgymnasium, Kirchner studied architecture at the Saxon Technical College in Dresden, where he won a preliminary degree in 1903. That fall he studied painting at the Munich Technical College and at the academy of Wilhelm von Debschitz and Hermann Obrist. Kirchner's early works were influenced by Post-Impressionist painters such as Georges Seurat and Paul Signac.

In 1905 Kirchner returned to Dresden to continue his architecture studies. There, along with three other students—Fritz Bleyl, Erich Heckel, and Karl Schmidt-Rottluff—he founded the artists' alliance called Die Brücke, or "the Bridge," to symbolize the strong bonds among them. Later the name reflected the artists' hopes for the future, toward which their work was meant to span. They worked closely together, sharing experiences and artistic influences. Building on the styles of Paul Gauguin (no. 74), Vincent van Gogh (no. 71), and Edvard Munch, they forged a simple and expressive style. They also found inspiration in late Gothic German woodcuts, as well as Oceanic, African, and other ethnographic art that they found in Dresden's Zwinger Museum. Their early work depicted images of imagined aboriginal lives and rituals, combining the artists' fantasies with their observations of their models. By organizing group publications and exhibitions, Die Brücke soon attracted critical attention and developed a cult following. Thus in 1906 Emil Nolde (no. 81) and Max Pechstein joined the group.

In October 1911 Kirchner moved to Berlin, where he painted scenes of urban life. He and Heckel collaborated on major commissions, and along with Pechstein he opened an art school. However, the artists found themselves in increasing disagreement, and in May 1913 Die Brücke was disbanded. Kirchner turned his attention to his first solo exhibitions, mounted at the Folkwang Museum in Hagen and at the Galerie Fritz Gurlitt in Berlin. He began to attract private commissions.

In the spring of 1915 Kirchner was drafted into the German army, and at Halle-an-der-Saale he was trained as a driver for the artillery. He was unsuited to military life, and soon its pressures caused an emotional and physical breakdown. In September Kirchner was furloughed, and he returned to Berlin and to his work. He made periodic visits to a sanatorium near Frankfurt, the first of several institutions in Germany and Switzerland where he sought treatment for emotional problems and the results of alcohol and barbiturate abuse. Nevertheless, he managed to produce and exhibit his work, supported by his friend the collector Carl Hagemann. In 1917 Kirchner moved to a sanatorium at Davos, Switzerland, and from there to a mountaineer's hut in the Sertig Valley near Frauenkirch, where he painted vivid alpine landscapes. In the late 1920s his style was considerably influenced by Pablo Picasso. Kirchner became a member of the Prussian Academy of Fine Arts in Berlin in 1931, and two years later a retrospective exhibition of his work was shown at the Kunsthalle in Bern. His first American show was mounted in 1937 at the Detroit Institute of Arts. However, in Germany he was censured by the Nazis. His works were confiscated from museums, and thirty-two of them were included in the notorious Munich exhibition meant to prove the decadence of German culture through its avant-garde art. In July the Prussian Academy demanded Kirchner's resignation. This disgrace, combined with unremitting ailments, prompted the artist to destroy many of his works and to commit suicide on 15 June 1938.

The present work was made during the heyday of Die Brücke and depicts Kirchner's favorite model of the period, Doris Grosse, known to her friends as "Dodo." They had an affair from 1906 through 1911, and later musings in Kirchner's diary reveal how important she was to him.[2] The chief inspiration of his art at this time, Dodo provided a sexual education to the artist. The artists of Die Brücke believed that sensual experiences, basic to all humankind, were among the chief forces that inspired primitive art.

Dodo's appearance in this drawing is comparable to Kirchner's many contemporaneous portraits of her, such as *Standing Nude with Hat,* a painting that represents her in the same setting, clad only in a broad hat and slippers, which emphasize her nudity and sensuality.[3] Here, Dodo sits in an interior with brightly colored walls, carpet, and curtains. These distinctive elements identify the setting as the storefront studios of Die Brücke at 65 Berlinerstrasse in Dresden.[4] In 1908–11 Kirchner and his friends decorated the three-room studio with wall paintings, woven and painted hangings, carved furnishings, and African and Oceanic sculpture. To divide the main space from a "relaxation room" *(Ruhe-Raum),* Kirchner made a pair of painted curtains out of old bed sheets; these appear in many studio scenes by

Die Brücke artists, including the present drawing.[5] They were painted a bright lemon yellow and decorated with green and dark blue roundels that contained the silhouettes of amorous couples, and, in the lower left, the figure of a crouching king, all painted in a style derived from the art of the Palau Islands.

These rooms were the center for the Bohemian life-style of the Die Brücke artists. Here, along with their models and friends, the artists often moved about undressed, without self-consciousness. In the present work, this comfortable confidence is reflected in Dodo's unashamed pose; she is free of the societal constraints that seek to control the appetites of the senses. In their sensual art, Kirchner and his colleagues reacted against the constraints of modern civilization, its materialism, strict social castes, and hidden lusts.

Lyonel Feininger
NEW YORK 1871–1956 NEW YORK

78. *The Viaduct, Meudon*, 1911

Pen and India ink on cream laid paper, 32.8 × 24.2 cm

INSCRIBED: In pen and black ink, lower margin: *Feininger/THE VIADUCT, MEUDON/Tuesday, August 1st, 1911.;* in graphite beneath: *Nur am den oberen Ecken anheften.*

PROVENANCE: Piroska and Karl Loewenstein, Amherst, Massachusetts.

REFERENCE: Worcester Art Museum *Journal*, vol. 3, 1979–80, pp. 66, 70.

Gift of Mr. and Mrs. Karl Loewenstein, 1979.51

Fig. 1

Lyonel Feininger synthesized a distinctive personal style, borrowing selectively from many different artistic movements and drawing upon experiences gained during his wide travels. He was born into a German-American family of concert musicians and learned to play the violin as a child.[1] At age sixteen Feininger went to Germany to pursue his music studies, but once in Europe he became even more enthralled by the visual arts, and he enrolled in the Kunstgewerbeschule in Hamburg. After further studies in Berlin, Liège, and Paris, Feininger found work in Berlin as a cartoonist and illustrator. He regularly sold his drawings to such periodicals as *Humoristiche Blätter, Narrenschif, Ulk,* and *Lüstige Blätter.* When his career became established, he married and began a family. In 1906 Feininger moved to Paris, where he produced cartoons for French, German, and American serials. Encountering the influences of Cubism and Futurism in France, he began to devote more of his attention to painting.

In 1908 Feininger returned with his family to Germany, and over the next five years he searched for a modernist vocabulary in his paintings and drawings. At first the imagery of the works grew out of his satirical illustrations, and Feininger called these his *Mummenschanz,* or "Masquerade," pictures. They were shown in the Berlin Secession exhibition in 1910 and at the Salon des Indépendants in Paris in 1911. Around that time the artist began to make etchings, signing some of the prints with the witty alias Einoel Leinfinger.[2] In 1912 Feininger began a friendship with the Austrian writer and illustrator Alfred Kubin, and through him he met and was influenced by several German Expressionist painters of the artists' alliance Die Brücke. Feininger also exhibited with the Blaue Reiter group at its first Berlin exhibition in 1913. In 1917 a solo exhibition of his oils and watercolors was mounted at Herwarth Walden's Sturm Gallery in Berlin.

In 1919 Feininger was invited to join the newly established Bauhaus in Weimar. At this progressive school modernist theories of aesthetic practicality were applied to a broad curriculum, including painting and sculpture as well as architecture and the decorative arts. Feininger became the instructor of graphic arts and was later charged with the design, production, and publication of the school newspaper. Along with Alexij Jawlensky, Wassily Kandinsky, and Paul Klee, Feininger participated in the Blauen Vier (the Blue Four), a group that organized international exhibitions of its work from 1925 to 1934. In 1926, when the Bauhaus moved into new quarters at Dessau, Feininger became artist-in-residence and remained there for seven years.

In 1936 Feininger visited Oakland, California, to teach a summer term at Mills College. In 1937, after his work was condemned by the Nazis, Feininger returned permanently to this country. His first major solo exhibition in the United States was mounted at the Museum of Modern Art in New York in 1944, to be followed by a retrospective at the Institute of Contemporary Arts, Boston, in 1949. After his death in 1956, major retrospectives of Feininger's work were organized by the San Francisco Museum of Art in 1959 and 1961 and by the Zurich Kunsthaus in 1973.

The Viaduct, Meudon dates from the period when Feininger moved away from his activities as an illustrator and established himself as a serious painter, producing images of a fantastic world of his own invention, which he described as his "city at the edge of the world." In the summer of 1911 he and his friend Richard Götz took several sketching trips to Meudon, a picturesque town six miles southwest of central Paris. On a postcard that Feininger sent to his wife, Julia, Götz jotted the note: "Leo experienced in Meudon the greatest sensation of his life, a viaduct with two locomotives."[3] To Feininger this industrial age spectacle of a flying viaduct bearing the chugging trains seemed otherworldly; it was as if his own masquerade world had come to life.

The present drawing represents the conflation of Feininger's observations of Meudon with his own fantasy world. In this topsy-turvy realm, the streets and buildings were built on vertiginous slopes apparently without heed to a plumb bob. Most of the townspeople are tall and lanky, like the artist himself. Their skinny limbs are obscured by layers of baggy clothes that billow and bunch and seem to take on lives of their own. Towering above is the viaduct, where a silhouetted locomotive, pulling only its coal car, belches black smoke into the sky.

At this time Feininger titled and dated his works precisely, a habit perhaps carried over from newspaper illustration. This makes it possible to collate several works based on his experiences that summer in Meudon that are comparable in their imagery but dissimilar in their mood. One of his first drawings of the town was probably executed on 16 July, a sketch in pen and ink with watercolor, now in the Museum of Modern Art in New York.[4] The title of that work, *The Disparagers* (fig. 1), seems to describe the mocking attitude of a group of Lilliputian townspeople toward the tall, debonair gentleman who stalks before them up the hill. The juxtaposition of several figures would seem to suggest that their size indicates their personalities, not their placement in depth. By comparison with the tension and bluster of *The Disparagers,* the present drawing seems quite calm and dignified.[5]

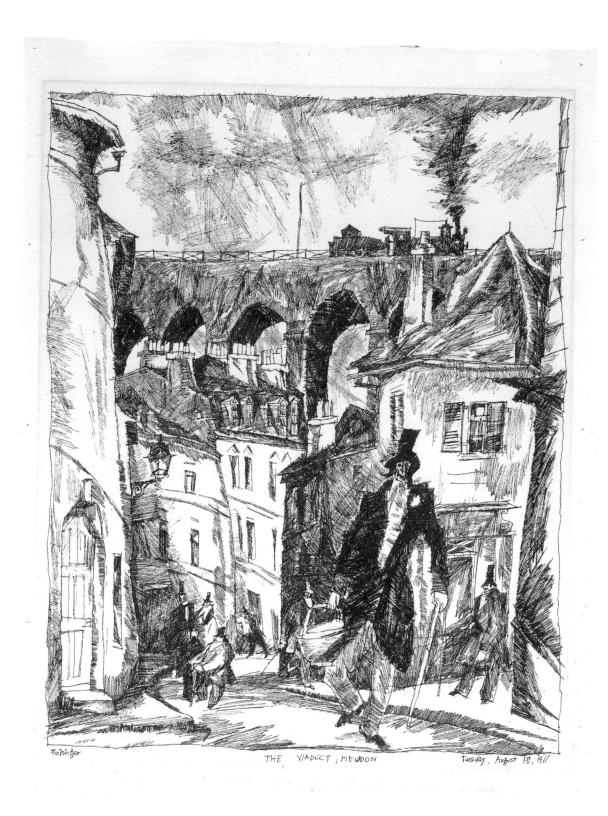

In this and most of his drawings Feininger used a steel pen and India ink, maintaining the familiar practice from his days as an illustrator. He used quick, short strokes, continuing to hatch with its sharp point after most of the ink had drained from the nib. Thus Feininger created pale, soft lines and scratched the paper, even abraded its surface. Applying even more fluid to the fractured, absorbent paper fibers, he created rich, velvety passages that stand in contrast to the soft, scratchy passages drawn with the draining nib.

Fig. 1. Lyonel Feininger, *The Disparagers*, 1911, pen and ink with watercolor, 24.1 × 31.4 cm. New York, Museum of Modern Art, 477.53.

Oskar Kokoschka

PÖCHLARN, AUSTRIA 1886–1980 VILLENEUVE, SWITZERLAND

79. *Portrait of a Savoyard Boy,* about 1912

Charcoal, wash, and chalk on tan wove paper, 40.2 × 27.5 cm

INSCRIBED: In charcoal, lower right: *OK;* in graphite on verso, upper right: *381;* lower center: *mar weiss gerahmt/5122;* lower left: *55 Knabe Moll;* lower right: *C.Moll;* left edge: *Moll 2805 as dis. 1/2 polar.*

PROVENANCE: Alma Mahler-Werfel, Vienna.

EXHIBITION: *Art Treasures for Worcester: The Legacy of Daniel Catton Rich,* Worcester Art Museum, 1970.

REFERENCES: Worcester Art Museum *Annual Report,* 1960, pp. ix, xiii; Worcester 1994, p. 157.

Gift of Alma Mahler-Werfel, 1959.112

Fig. 1

An artist who enjoyed a long and prolific career, Oskar Kokoschka developed a distinctive style in Berlin before World War I that distinguished him as an enduring leader of international Expressionism. He was born in a small village on the Danube in Lower Austria, and his family moved to Vienna when he was an infant.[1] With the support of a scholarship he attended the Kunstgewerbeschule, from 1904 to 1909, where Carl Otto Czeschka and Bernard Löffler instructed him in the fashionable *Jugendstil.* Kokoschka also worked for the Wiener Werkstätte, an association of workshops inspired by the English Arts and Crafts movement, for which he produced book illustrations and decorated fans and postcards that combined the Art Nouveau with late Symbolist styles.[2]

In 1910 Kokoschka met the architect Adolf Loos, who enthusiastically collected his work, arranged commissions for him, and introduced him to the intelligentsia of Berlin. His style evolved into Expressionism, and he became involved with the Berlin artists' group Der Sturm. Six months after the outbreak of World War I, Kokoschka enlisted in the cavalry of Austria-Hungary, and in July 1915 he was sent to the eastern front. A few weeks later, near Luck in the western Ukraine, his lung was pierced by a bayonet and his head struck by a bullet. He produced few works of art during his long recuperation. In 1917 the artist moved to Dresden, where he returned to painting and taught at the Academy from 1920 to 1924. He lived in Vienna from 1931 to 1934 and in Prague until 1938.

In 1937, after his work was condemned by the Nazis, Kokoschka moved to London, where he continued to work throughout World War II. Among his most important works of the succeeding decade are the *Prometheus* ceiling fresco of 1950 in the London home of Count Seilern, and the *Thermopylae* triptych of 1954, now at the University of Hamburg. The artist remained little affected by stylistic developments of the mid–twentieth century and continued to work in a manner that scarcely changed after the 1910s. In 1953 Kokoschka moved to Switzerland, settling at Villeneuve, near Geneva, where he died after another quarter century of prolific activity. The Tate Gallery in London organized retrospective exhibitions of Kokoschka's work in 1962 and 1986.[3]

The present drawing is one from a series done in late 1912 and early 1913, when Kokoschka taught drawing as an assistant to Professor Anton von Kenner at the Kunstgewerbeschule in Vienna. He would set intuitive figure drawing exercises for his students, known as "five-minute sketches." Instead of the school's professional models, Kokoschka used acrobats and circus performers and directed them to

move continually so that students came to understand not only the structure of anatomy, but also its function. The model represented in this sheet was a boy from Savoie, the region spanning southeastern France that borders Piedmont in northern Italy. The artist executed at least fifteen drawings of this youth.[4] In his slender physique and forlorn, troubling expression, the boy resembles the subjects depicted by George Minne, the Belgian sculptor who exhibited with the Vienna Secession and influenced Egon Schiele as well as Kokoschka.[5] In the months preceding his work with this model, the artist had made drawings of emaciated children, whose exaggerated ugliness contrasted with the artist's delicate, sensitive treatment of them.

Kokoschka executed this quick sketch with a stick of charcoal, using varied pressure to modulate the width and tone of his lines. A few abandoned contours show that he first considered placing the boy's head higher and angled downward. Lines defining the shape of the gaunt face sometimes continue around and beyond the form of the head, implying the skull-like structure beneath. The wide eyes, with their angled, upward glance, express a despondent submissiveness. After sketching the figure in charcoal, Kokoschka applied a pale blue watercolor wash over most of the face and selectively picked out folds of fabric in the boy's garment. Finally, to further emphasize the figure's wan complexion, the artist smeared the lower face with white chalk, which is apparent in the chin area.

This drawing is one of four given to the Worcester Art Museum by Alma Mahler-Werfel, daughter of the Austrian painter Emil Schindler. She was the widow of composer Gustav Mahler when Kokoschka painted her portrait in the spring of 1912, and a passionate love affair developed between them. The young artist became obsessed with this elegant sophisticate, and she became a dominant subject in his work.[6] In late August 1913 they traveled together to the Dolomite Mountains, where Kokoschka recorded the view from their hotel in a group of drawings. Three of these formed part of Alma Mahler-Werfel's gift to the Worcester Art Museum (fig. 1).[7] They are drawn on sheets of manila paper that are tattered along the short edge, indicating that they were originally bound together in a sketchbook. Kokoschka used graphite, charcoal, and colored pastels to sketch these simple, expressive views of the fir trees and mountains beneath a bright sun. The images reflect a cheerful, optimistic view of life and a passionate haste to capture these moments of joy.

In February 1915, after Kokoschka had joined the cavalry, Alma Mahler ended their affair. When Kokoschka was wounded just weeks later, the news-

papers in Vienna erroneously announced his death. Mahler then went to his studio to retrieve her letters to him, and she also carried away many works of art.[8] It seems likely that the present drawing and the three sheets representing alpine landscapes were among those she took.[9] Since they date from the period when their affair was flourishing, she may have had sentimental feelings about these works. Near the end of her life Mahler married the author

Franz Werfel and moved to the United States. In 1959, with the encouragement of Otto Kallir of the Galerie St. Etienne in New York, she presented the four drawings to the Worcester Art Museum.

Fig. 1. Oskar Kokoschka, *Alpine Landscape,* 1913, charcoal on tan wove paper, 26.2 × 34.9 cm. Worcester Art Museum, gift of Alma Mahler-Werfel, 1959.115.

Lovis Corinth

TAPIAU, EAST PRUSSIA 1858–1925 ZANDVOORT, NETHERLANDS

80. *The Archer*, 1913

Graphite on medium white wove
paper, 48.9 × 35.5 cm

WATERMARK: *1913 ENGLAND*

INSCRIBED: In graphite, lower right:
bogenschutze/Lovis Corinth/1913/X;
in graphite on verso, lower left: *12*

PROVENANCE: Fred L. Mayer, New
York.

EXHIBITIONS: Lexington,
Massachusetts, Cary Memorial
Library, 1963; Boston Center for
Adult Education, 1963.

REFERENCE: Worcester Art Museum
Annual Report, 1961, p. xiii.

Gift of Fred L. Mayer, 1961.11

Fig. 1

An influential painter and leading figure in the Berlin
Secession, Lovis Corinth's style was transformed by
the innovations of French Impressionism; later in
his career the artist moved on to new stylistic fron-
tiers. The son of a tannery owner, he was born on
21 October 1858 in a village near the provincial capi-
tal Königsberg in East Prussia.[1] In 1876 he entered
the Königsberg Art Academy and then attended the
Munich Academy, where he was the pupil of Franz
von Defregger and Ludwig von Löfftz. In search of
wider artistic experiences, Corinth went to Antwerp
in 1884 and then to Paris, where he studied with
Joseph Robert-Fleury and William Bouguereau at
the Académie Julian. Corinth returned to Germany,
finally settling in Berlin in 1887. It was not until 1895
that he sold his first picture, but soon his paintings
were in great demand, and his rise to fame was mete-
oric. In 1901 Corinth opened his own art school in
Berlin, where one of his first pupils was Charlotte
Berend. They married and raised a son and daughter.

The prolific Corinth completed sixty-one oil
paintings in 1911, the year in which he was elected
chairman of the Berlin Secession. Late in that year he
suffered a debilitating stroke. After his recovery new
facets of the artist's personality seem to have emerged
as a result of his illness. His style and technique
gradually became more spontaneous and emotional,
presaging the energy of German Expressionism.
Between February 1912 and his death in 1925 he
executed about half of his sizable oeuvre.[2] In 1915
Corinth succeeded Max Liebermann as president of
the Berlin Secession. In March 1921 he was awarded
an honorary doctorate from the University of
Königsberg. Corinth died in the Netherlands, where
he had journeyed to see the works of Frans Hals and
Rembrandt.

In 1913 Corinth began work on a suite of paintings
commissioned for the dining room of the home of
Dr. Ludwig Katzenellenbogen in Freienhagen. Two
years later he delivered six large canvases represent-
ing the authors Homer and Ludovico Ariosto and
their fictional heroes who struggled to rescue the
women they loved. These paintings are now in the
Berlinische Galerie, Martin Gropius-Bau. Two nar-
rative canvases depict the legend of Ruggiero and
Angelica from Ariosto's *Orlando Furioso,* and two
others represent events from the late chapters of
Homer's *Odyssey.*[3]

The ancient epic tells of the travels of Odysseus,
a Greek prince who fought heroically in the Trojan
War. It took him a decade to find his way home
to Ithaca, and Homer's tale recounts his many ad-
ventures on the way. Despite his long absence,
Odysseus's wife, Penelope, believed he was still
alive, and she rebuffed the advances of several

princes who sought her hand and domination
of the kingdom. Each suitor intended to protect
his own interest, and they took up residence in
Odysseus's palace, consuming the riches of the
court. When Odysseus finally reached Ithaca, the
goddess Athena advised him to enter the city in dis-
guise. He arrived to find Penelope hard pressed to
choose a new mate. She announced that she would
accept the man who could string and shoot the
mighty bow that her husband had left behind.
When the contest took place, only the disguised
Odysseus could meet the challenge. Then he shot
Antinous, the pretender who had insulted Penelope
most insolently, and when a skirmish ensued he
killed the other suitors. Later, Odysseus's knowledge
of the palace and of his own bedstead convinced
Penelope that her prince had returned.

In the first of Corinth's Odysseus paintings the
hero sits to draw the mighty bow, leaning his head to
sight the arrow (fig. 1).[4] Behind him stand Athena,
his protectress, and his companions. Siegfried Gohr
argued convincingly that Corinth modeled the
figure of Odysseus on the ancient Greek sculpture
of Paris from the gable of the Temple of Aegina,
which the artist could have seen in the Glyptothek
in Munich.[5] That marble figure of the classical era
represents a warrior, nude but for his helmet and
the greaves on his lower legs, kneeling as he draws
his bow to full stretch. The present drawing repre-
sents Corinth's early conception for the figure of
Odysseus, kneeling like the sculpture of Paris. The
artist also depicted a similar kneeling archer in a
preparatory oil sketch, now in the Kunsthalle at
Bremen.[6] In the completed painting, the figure of
Odysseus is shown seated, in an awkward, humble
position befitting his beggarly disguise.

The peculiar point of view in the drawing subor-
dinates the archer's personality while emphasizing
his deed. Corinth focused on the body, arms, and
hands of the figure, stressing its strength and the
physical feat of drawing the bow. He replaced the
stout figure of Paris with a wiry, elongated torso and
slender arms that characterize the figure of Odysseus
in the Freienhagen painting. In the canvas, however,
Corinth shifted the figure slightly in order to depict
the hero's face. Although the face is hidden in this
sketch, the archer's status is symbolized by his re-
markable helmet, with its winglike ear guards and
large plume. This exaggerated crest was an impor-
tant motif for Corinth, for it appears in all his ren-
ditions of the figure.

The artist also employed this design for a litho-
graph.[7] The lower limbs of the archer are suggested
more explicitly in the print, as are the head of the
figure and the extravagantly plumed helmet. Al-

though the original edition of twenty-five impressions presumably was published in 1913 or 1914, the image was published in the serial *Beilage zur Vossichen Zeitung* on 22 April 1917 and again in the *Almanach auf das Jahre* in 1919.

Fig. 1. Lovis Corinth, *Odysseus's Triumph over the Suitors of Penelope*, 1913, tempera on canvas, 213.0 × 227.0 cm. Berlinische Galerie, Martin Gropius-Bau.

Emil Nolde

NOLDE, GERMANY 1867–1956 SEEBÜLL

81. *A Woman of New Guinea*, 1914

Watercolor and black ink on cream
Japan paper, 45.1 × 33.5 cm

INSCRIBED: In graphite, lower right:
Nolde

PROVENANCE: Ada and Emil Nolde
Foundation, Seebüll; Marlborough
Gallery, New York; Manuel Berman,
Chestnut Hill, Massachusetts.

EXHIBITION: *Nolde Watercolors in
America,* Boston, Museum of Fine
Arts, 1995.

REFERENCE: Ackley 1995, n.p.

Promised gift of Mrs. Manuel
Berman and Laurence Berman

A passionate artist who combined the spirit of folk art and his own deeply felt emotions, Emil Nolde had a long and remarkably prolific career from the first decade of the century until after World War II. He was born Emil Hansen on his family's farm near the village of Nolde, close to the border of Germany and Denmark, land that had been in the family for nine generations.[1] He moved to Munich in 1888 to attend classes at the School of Arts and Crafts at Karlsruhe, while working as a designer and wood carver in various nearby furniture factories. Hansen began teaching industrial design at the Museum for Industrial Arts at Saint Gall, Switzerland, in 1892. He made his first oil paintings at that time and created fantastic drawings inspired by ancient Teutonic legends. Some of these images were reproduced as popular postcards, and the proceeds enabled him to leave teaching to devote himself to his art full time.

In the last years of the century Hansen concentrated on landscape painting, studying with Friedrich Fehr in Munich and Adolph Hözel in Dachau. At that time he also made his first etchings.[2] In 1899 he went to Paris, where he attended the Académie Julian. The artist then moved to Copenhagen, where he met Ada Vilstrup, a young actress who became his wife in 1902. At that time he changed his surname to that of his birthplace, Nolde. The artist had his first solo exhibition in 1905 at the Galerie Ernst Arnold in Dresden. Soon he began to exhibit with the new artists' alliance Die Brücke, and probably under the influence of Karl Schmidt-Rottluff and Edvard Munch, Nolde executed his first woodcuts. He also came under the influence of James Ensor and Vincent van Gogh (no. 71), and his paintings became larger, as he turned to ecstatic religious imagery. Nolde was intrigued by the traditional cultures of Africa and Oceania. He made drawings of ethnographic objects in the Völkerkunde-Museum in Dresden and assembled his own collection. Soon he began to explore wider aspects of tribal culture in his work, which depicted aboriginal figures, rituals, and celebrations. He even began to write an appreciative critical essay, "Artistic Expression of Primitive Peoples."[3] This interest also led Nolde and his wife to join an expedition to New Guinea, organized by the German Colonial Office in 1913.

In the succeeding decade the artist enjoyed a productive period and wide recognition throughout Europe. In 1926 he and his wife moved into a new house of his own design at Seebüll. To mark his sixtieth birthday, a major exhibition was mounted in Dresden in 1927, which was followed by a show at the Kunsthalle in Basel. In 1933 he became president of the Vereinigte Kunstschulen (United Art Schools). Four years later Nolde was prominent among the proscribed artists in the censorious Nazi exhibition of "Degenerate Art." More than a thousand of his works were confiscated from German museums, yet he ignored the admonitions of his friends and refused to leave Germany. Forbidden to engage in any artistic activity, he retired to his farmhouse at Seebüll and remained secluded there throughout the war. Despite the prohibition, Nolde produced more than a thousand small watercolors during the war, which he called *Ungemalte Bilder* (unpainted pictures).[4] In 1944, during the Allied bombing of Berlin, Nolde's studio was destroyed along with all his early work that had been stored there. The first postwar exhibition of Nolde's work was mounted in 1946, and at that time he was appointed professor by the government of Schleswig-Holstein. He returned to painting freely and spent his final years at Seebüll, where he continued working until weeks before his death.

The present drawing is one of many watercolors executed by Nolde during a trip to the South Seas during 1913–14.[5] Among the stated goals of this official expedition was the pursuit of medical and demographic research on the inhabitants of the German colonies. Apparently the artist's role was to record the racial characteristics of the population of German New Guinea by making drawings of the people he saw. He made sketches in colored pencils, pastel, and especially watercolors, representing the landscape and the tropical flora. Nolde also made quick, incidental sketches of life in the tribal villages. Perhaps the most coherent series of watercolors from the expedition, however, are the portrait studies of tribespeople. These studies often feature exotic hair styles adorned with flowers and the cosmetics and jewelry of the natives, and they nearly always capture the distinctive physiognomic character of these people. The most striking quality of these sketches is their personality, individuality, and vivacity. In these faces the artist sought to reflect the intangible, spiritual intimacy between the people and their still-natural environment. "These primitive people *within* their natural surroundings," Nolde wrote, "are one with it and part of the great unity of being. . . . I paint and sketch and seek to capture some sense of this primitive state of being."[6]

The New Guinea watercolor portraits are notable for their technical virtuosity. They were spontaneously executed, without preparatory sketches or underdrawing. This immediacy paralleled what to Nolde was one of the most important qualities in aboriginal art. "Primitive people," he commented, "begin making things with their fingers, with material in their hands. Their work expresses the pleasure of making. What we enjoy, probably, is the intense and often grotesque expression of energy, of life."[7]

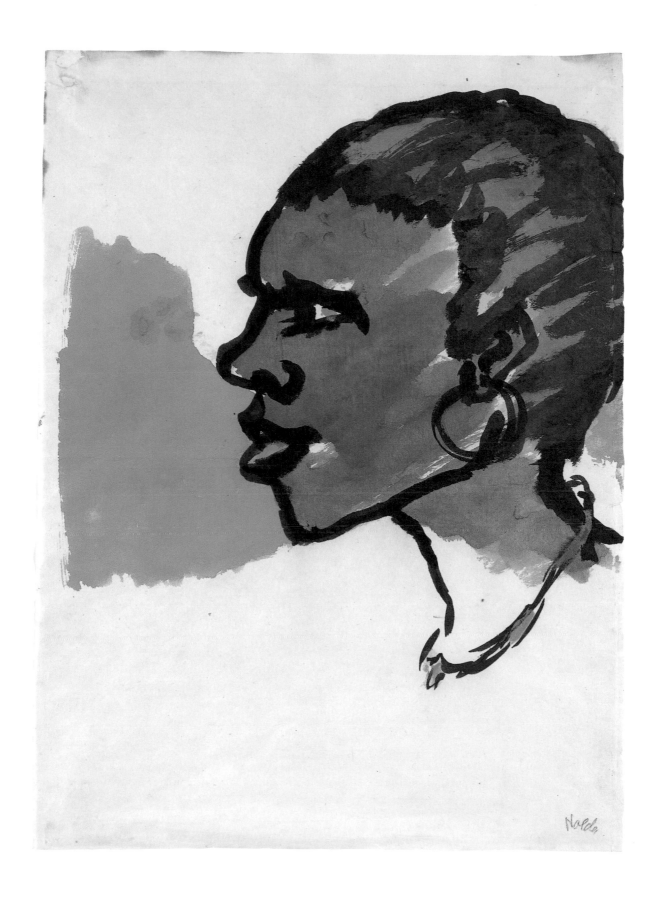

The artist used the full capabilities of the watercolor medium to suggest form and to capture the liveliness of his subjects. He began the watercolors with blocks of broadly applied wash that generally defined the shape of the head and its contours. The wash was allowed to soak into the paper, leeching thoroughly into its fibers. To achieve deep, saturated colors the artist often superimposed several layers of wash. The resultant juxtaposition of the soft, watery washes and the robust, overdrawn lines enhances the energy and vivacity of these sketches.

179

Amedeo Modigliani

LIVORNO 1884–1920 PARIS

82. *Head of a Woman,* about 1915

India ink, applied with pen and brush, with watercolor over graphite on cream wove paper, 42.8 × 32.5 cm

INSCRIBED: In graphite, lower right: *modigliani;* in graphite on verso, lower center: *31 1/1 42/16 17 1/2/ 475595;* lower right: *baguelle au vielle en 6h/On' 91.lec cremj/8 au et 9 1/2/ tariu stupuie/607;* sketched in graphite on verso: a female torso

PROVENANCE: Meyer, Zurich; Marlborough Fine Art, London; Mr. and Mrs. Chapin Riley, Worcester, Massachusetts.

EXHIBITIONS: London, Marlborough Fine Art, 1960; Baltimore Museum of Art Rental Auction, 1969; *Art Treasures for Worcester: The Legacy of Daniel Catton Rich,* Worcester Art Museum, 1970.

REFERENCE: Worcester Art Museum *Annual Report,* 1964, pp. x, xiii.

Gift of Mr. and Mrs. Chapin Riley, 1963.149

An eccentric and deeply devoted artist, Amedeo Modigliani was part of the turbulent life of Paris during the first two decades of the twentieth century. He was born in the Italian coastal town of Livorno, into a merchant family that had fallen on hard times.[1] As a teenager he suffered an attack of typhoid fever; later he was diagnosed as having tuberculosis. When he expressed his ambition to become an artist, his mother arranged for him to study with the local artist Guglielmo Micheli, a late plein air painter who had studied with Giovanni Fattori. Modigliani's serious study of art began in 1902 when he enrolled at the Scuola Libera di Nudo of the Accademia di Belle Arti in Florence, and in the following spring he continued his studies at the Istituto di Belle Arti in Venice.

Modigliani went to Paris in 1905 or 1906 and settled in the community of artists living and working in Montmartre. He became a member of the Société des Artistes Indépendants and made friends with Chaim Soutine and Moïse Kisling, whose Expressionist styles were early influences on him. In the following year he joined a group of artists living together in a house owned by the recently qualified doctor Paul Alexandre, who soon became the artist's primary patron and remained so for several years to come. The retrospective exhibition of Paul Cézanne's paintings in 1907 deeply impressed Modigliani, who responded to the master's painterly technique and to his planar fracturing of form. Most of his paintings at this time were portraits or stylized figural images. In 1908, while pursuing studies at the Académie Ranson, he exhibited six paintings at the Salon des Indépendants.

Alexandre introduced him to the sculptor Constantin Brancusi, who became a close and supportive friend. Under Brancusi's influence Modigliani began to work in sculpture. Although they had little interest in the principles of Cubism, both artists were fascinated with African art. Modigliani carved limestone figures that became progressively more attenuated and simplified. They had the smooth, simple contours of river boulders or roughened, weathered surfaces that evoked ideas of the passage of time. Modigliani's drawings at this time evolved into geometrized human figures that sought to imply sculptural form.[2] Many of them represented African, South Asian, and Greek Cycladic sculpture that the artist studied in Paris. When his Cézannesque painting *The Cellist* was exhibited at the Salon des Indépendants in 1910, Modigliani began to receive recognition. Several months later his sculptures were shown at the studio of his friend Amedeo de Souza Cardoso, and in 1912 he exhibited seven carvings at the Salon d'Automne in Paris. From

this point on the artist seldom showed his work. Modigliani continued to work in Paris during World War I. Alexandre and many of the artists who had made up Modigliani's group of friends were killed in the war. In 1914 the artist met Paul Guillaume, who commissioned a portrait and became one of his two major patrons. The other was the poet Leopold Zborowski, who became the artist's confidant and dealer; it was he who organized Modigliani's first solo exhibition, at the Berthe Weill Gallery in Paris in December 1917, from which none of the thirty-two paintings was sold.

In 1917 Modigliani met the nineteen-year-old art student Jeanne Hébuterne, and soon they were living together. Beginning in April 1918 she and the artist spent about a year living on the French Riviera, where Modigliani struggled to regain his health and Hébuterne gave birth to a daughter. The artist and his family then returned to Paris, where he continued to work despite his continuing ill health and financial troubles. On 24 January 1920 Modigliani died at the Hôpital de la Charité in Paris. Hébuterne committed suicide the following morning, leaving the artist's mother to raise their daughter in Livorno.

Modigliani was a diligent draftsman who made more drawings than paintings in the course of his career. The artist often executed drawings in series, experimenting and refining his images from one sheet to the next, sometimes working out his visual ideas in preparation for painting or sculpture. A drawing representing the head of a woman, presumed to have been made in 1915–16, and once in a private collection in Rome, is closely comparable to the present sheet in its imagery and technique.[3] That piece represents a similar woman with an ovoid head and darkly outlined almond eyes. She is turned slightly to the right so that her left ear is visible, and her nose is represented in profile; her hair is piled high on top of her head. In both drawings Modigliani rendered the simplified form of the face in single pencil lines, toned the flesh with watercolor wash, and surrounded the figure with vertical striations executed in India ink by dotting with a progressively drying brush. These drawings reflect the continuity of Modigliani's formal vocabulary. The faces were inspired by African woodcarving and the ancient sculpture of the Cycladic civilizations in Greece, as well as by the work of his friend Brancusi. The dry-brush technique that created the distinctive stuttered line seems to appear first in his drawings around 1914. The strangely pupil-less eyes are reminiscent of Modigliani's sculpture and ultimately the faces of Cycladic sculptures that lost their polychrome detailing centuries ago.[4] In his drawings and paintings, he usually depicted figures frontally,

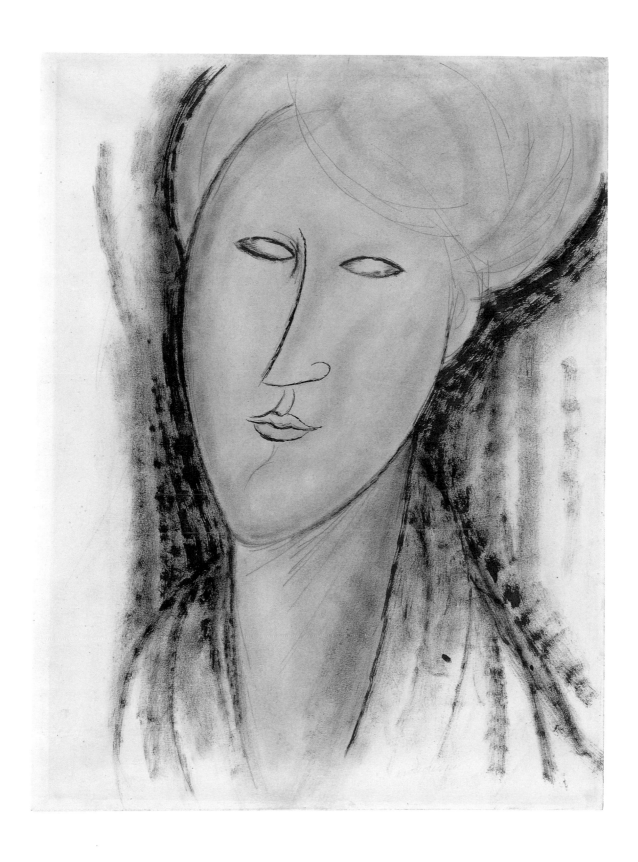

with schematic facial features. Even with this simplicity, however, the artist was able to endow his images with subtle inflections of personality and mood, a proclivity that was especially apparent in Modigliani's portraits.

John Singer Sargent

FLORENCE 1856–1925 LONDON

83. *Alligators*, 1917

Graphite on cream wove paper,
17.8 × 25.4 cm

INSCRIBED: In graphite, lower left:
J. S. 175

PROVENANCE: The artist's sisters,
Miss Emily Sargent and Mrs. Francis
Ormond, London.

EXHIBITIONS: *Art in America, 1830–
1950,* Worcester Art Museum, 1969;
*John Singer Sargent: Painter of the
Gilded Age,* Worcester Art Museum,
1995.

REFERENCE: Worcester 1969, p. 10.

Gift of Mrs. Francis Ormond and
Miss Emily Sargent, 1931.230

Fig. 1

A leading society portraitist of the Edwardian era, John Singer Sargent was an extraordinarily gifted draftsman and watercolorist.[1] Born in Florence on 12 January 1856, he was the son of wealthy Americans who enjoyed a comfortable life of leisure in Europe, seasonally moving their household to their favorite cities. Although his education was haphazard, Sargent became fluent in French and Italian and was an accomplished pianist. His mother encouraged him to draw when he was a child, and she probably taught him the fundamentals of watercolor.[2] As a boy he filled sketchbooks with images of the places and things he saw during his family's travels and with family portraits.

In the early 1870s Sargent attended classes at the Academy of Fine Arts in Florence. He became a pupil of the portraitist Emile-Auguste Carolus-Duran in Paris in 1874 and briefly studied at the Ecole des Beaux-Arts. Encouraged to copy paintings in the Louvre, the young artist was influenced by the work of Diego Velázquez and Frans Hals. Sargent first exhibited in the Paris Salon of 1877, and two years later he began a professional career and soon achieved international recognition as a society portraitist. He produced flattering likenesses of unrestrained elegance and delighted in his materials, applying paint thickly with confident strokes, emphasizing rather than concealing the brush marks. When Sargent's dramatic, revealing portrait of Madame Gautreau, enigmatically titled *Madame X,* was shown at the Paris Salon in 1884 it excited a public scandal. This notoriety did not tarnish his reputation in Edwardian England, however, where his painting *Carnation, Lily, Lily, Rose,* now in the Tate Gallery, was highly praised when it was shown at the Royal Academy in 1887. In that year Sargent first visited the United States to attend the Centennial Exposition in Philadelphia, to meet some of his American cousins, and to paint several portraits. In 1890 he was commissioned by the architectural firm of McKim, Mead and White to paint decorative murals in the new Boston Public Library building. In June of that year the artist visited Worcester, where he painted a handful of portraits.[3]

Sargent became an associate of the Royal Academy in 1895 and a full Academician two years later. After 1900 he shifted his focus from portraiture to mural decorations, landscapes, and genre paintings. After the death of their mother in 1905, Sargent and his sisters continued the family tradition of traveling on the Continent each summer, journeys documented in many drawings and watercolors. In 1918 Sargent traveled to France as an official war artist for the British government. His observations and sketches, often made near the front, were consolidated in two

major paintings, *Gassed,* now in the Imperial War Museum, London, and *Some Officers of the Great War,* now in the National Portrait Gallery, London. The artist died suddenly of heart failure at his London home on 15 April 1925. Memorial retrospective exhibitions of his work were mounted in Boston, New York, and London, and the first biography of the artist was published soon after his death.

Sargent drew constantly throughout his life, and when he died thousands of drawings and watercolors, ranging widely in their purpose and mood, were left in his studio. Aside from nine watercolors by Sargent, the Worcester Art Museum owns thirty-one drawings, including informal sketches of family and friends, studies of wildlife, copies of other artworks, and academic figure studies for his Boston mural projects.[4] The present drawing was made in Florida, where Sargent traveled in 1917 to paint a portrait of the elderly John D. Rockefeller at his estate at Ormond Beach. After about three weeks the artist proceeded to Miami, where he visited his old friend the Chicago industrialist Charles Deering. Together during the next two months they took a leisurely fishing trip and explored the waterways around Miami and the Florida Keys. They also visited Vizcaya, the Venetian-style palazzo that Charles's half-brother James Deering was then building on Biscayne Bay.

On 11 March 1917 Sargent wrote to a friend: "I have been sketching a good deal about here, but Palmettos and aligators [*sic*] don't make very interesting pictures."[5] Despite this comment, the artist made several drawings and watercolors of alligators, which suggests that the exotic creatures actually fascinated him. Perhaps the most famous of Sargent's Florida watercolors is *Muddy Alligators,* one of eleven purchased by the Worcester Art Museum not long after the artist returned from this trip (fig. 1). A masterful work that conveys the enormous size and weight of these reptiles and their potential energy and strength, it is also remarkable for its evocation of a warm, sunny lagoon. Two watercolor sketches are known that seem to have preceded *Muddy Alligators,* one in a private collection and another in the Metropolitan Museum of Art in New York.[6]

The present drawing is one among four pencil sketches in the Worcester Art Museum that were probably made in preparation for these watercolors, though no direct motifs were transferred to the finished works.[7] In these quick studies Sargent recorded his observations of the alligators, accurately describing their bodies, their habits, and their relations to one another. He tried several pictorial devices, including crosshatching and stippling, to suggest their scaly hide and pointed ridges along their backs and

tails. The alligators curl and twist across the page, some on land and others floating in the water. They are varied in scale and do not occupy a continuous space. Aside from recording the creatures' anatomies in the present drawing, Sargent tried to capture their behavior. At the bottom of the sheet one alligator dozes in the sunshine, while on the right another ambles deliberately away. Others are represented by their noses, foreheads, and backs protruding from the water as they float near the surface. One of these alligators appears to slumber with its eyes closed, while two others are quite alert, perhaps lying motionless waiting for their prey.

Fig. 1. John Singer Sargent, *Muddy Alligators,* 1917, watercolor over graphite on cream wove paper, 35.5 × 53.0 cm. Worcester Art Museum, Sustaining Membership Fund, 1917.86.

George Grosz

BERLIN 1893–1959 BERLIN

84. *Vorwärts,* 1919

Pen and brush with India ink on cream wove paper, 37.9 × 45.7 cm

INSCRIBED: In graphite, lower right: *GROSZ/1919;* lower left: *Ober links: Th. Däubler;* in graphite on verso, lower center: *Philipp Scheidemann (Vorwärts);* lower right: *#790-A*

PROVENANCE: Mrs. George Grosz, Berlin; purchased from Richard Feigen Gallery, Chicago.

EXHIBITIONS: *George Grosz (1915–1927),* Chicago, Richard Feigen Gallery, 1961; Boston Center for Adult Education, 1963; Lexington, Massachusetts, Cary Memorial Library, 1963; *Drawings 1916/1966: An Exhibition on the Occasion of the Fiftieth Anniversary of the Arts Club,* Arts Club of Chicago, 1966.

REFERENCES: *Art Quarterly,* vol. 23, 1960, p. 406; Joachim 1961, cat. no. 41; Worcester Art Museum *Annual Report,* 1961, pp. xiii–xiv.

Museum purchase, 1960.34

Fig. 1

George Grosz was one of the most important caricaturists of the twentieth century, and his art was inseparable from his principles and opinions. He studied art in Berlin and Dresden, where he embarked on a career as a caricaturist around 1910.[1] Through much of his career Grosz made visual notes and compositional experiments in sketchbooks that reflect the evolution of his style and the scope of his interests.[2]

At the beginning of World War I, Grosz enlisted in the Royal Prussian Grenadiers. Six months later he received a medical discharge for an illness perhaps as much emotional as physical. Returning to Berlin, Grosz frequented the Café des Westens on the Kurfürstendamm, a famous gathering spot for philosophers, writers, and artists. He associated with the painter Ludwig Meidner, the poets Johannes R. Becher and Theodor Däubler, and a set of left-wing intellectuals who were antiwar, antimilitary, and anticapitalist. Grosz adopted their sympathies, becoming so demonstrative that he anglicized his first name to protest German xenophobia. The artist embraced Dadaism, which arrived from Zurich in 1916.

In January 1917 Grosz was recalled to the army and became a psychiatric ward orderly at the military hospital at Görden. His sketches of patients, doctors, and bureaucrats there later appeared in scathing drawings and prints. The artist began to reproduce his satires in photolithographs that he published in such suites as *The Face of the Ruling Class* (1921) and *Ecce Homo* (1927). These widely distributed prints rapidly earned him an international reputation.

The artist's first solo exhibition was mounted at the Weyhe Gallery in New York in 1931. The following year the Art Students League invited Grosz to the United States as a visiting teacher, and two years later he settled in New York. Although his imagery continued to be satirical, Grosz's style began to soften. He produced genre subjects, still lifes, and landscapes, as well as caricatures of the life he observed around him. After over twenty-seven years of teaching, painting, and exhibiting in this country, Grosz returned to Berlin in 1959 where he died shortly after his arrival.

The present drawing is characteristic of Grosz's works that deprecated the politics and social ills of Weimar Germany. The composition is dominated by bold chevrons that suggest the perspective of receding city streets lined by tall buildings, similar to those of his sketchbook drawings of around 1911.[3] By 1919 the angles alone were enough to suggest an urban setting. These fractured compositions, with their overlapping images and telescoping space, reflect the influence of photomontage, a medium

used at this time by Grosz's friend John Heartfield.[4] The architectural nature of the setting is clarified by the tower motif at the upper left, where a prominent flag is displayed. A common motif in Grosz's art symbolizing nationalism and indoctrination, the flag here suggests an imaginary parade through the streets of Berlin. Diagonally through the center of the composition marches a ragtag column led by a pompous mustachioed general on a horse that looks like a stuffed toy. The passive bourgeoisie is represented by a conventionally dressed businessman who stands on the sidelines to watch the parade, symbolically ignoring society's problems.

Graphite inscriptions, in a hand other than the artist's, identify the main figures and provide a date. In the center of the parade is a well-dressed politician waving a pennant emblazoned with the word *Vorwärts* (Forward). He is Philipp Scheidemann, a leader of the Social Democratic Party (SPD), and his flag's slogan was also the name of the party's newspaper.[5] When Grosz made the drawing this politician was at the height of his influence in German politics. Since 1903 he had been a member of the Reichstag and had served as its vice president. Along with Friedrich Ebert, Scheidemann was joint president of the SPD in 1914, and during the war he spoke for the party's moderate faction. On 9 November 1918, without consent or the unanimous support of his party, it was Scheidemann who proclaimed the Weimar Republic in order to prevent the formation of a Soviet government in Germany. Although he formed the first Weimar cabinet, Scheidemann quickly resigned over his disagreement with the Treaty of Versailles. For the first issue of the dissident magazine *Die Pleite,* published in March 1919, Grosz caricatured Scheidemann in the character of Philip the Apostle proffering a loaf of bread to calm a hungry mob.[6] To solve Weimar Germany's problems, the artist taunted Scheidemann and the SPD to perform miracles of biblical proportions. The primary subject of this image is the problem of German demobilization after World War I. Scheidemann is shown welcoming returning soldiers and encouraging them to confront the difficult challenges of postwar reconstruction. Under a beaming sun in the background, a train races over a towered viaduct, perhaps symbolizing the bright, productive future for Germany touted by the SPD.

At the top of the drawing, just to the left of the center, sits a reader at a desk whose ovoid head, curly locks, and beard are repeated. This is Theodor Däubler, the Expressionist poet and art critic whom Grosz caricatured often.[7] Soon after he met the artist in 1916, Däubler wrote the first article about him in the *Weisse Blätter,* which brought overnight recogni-

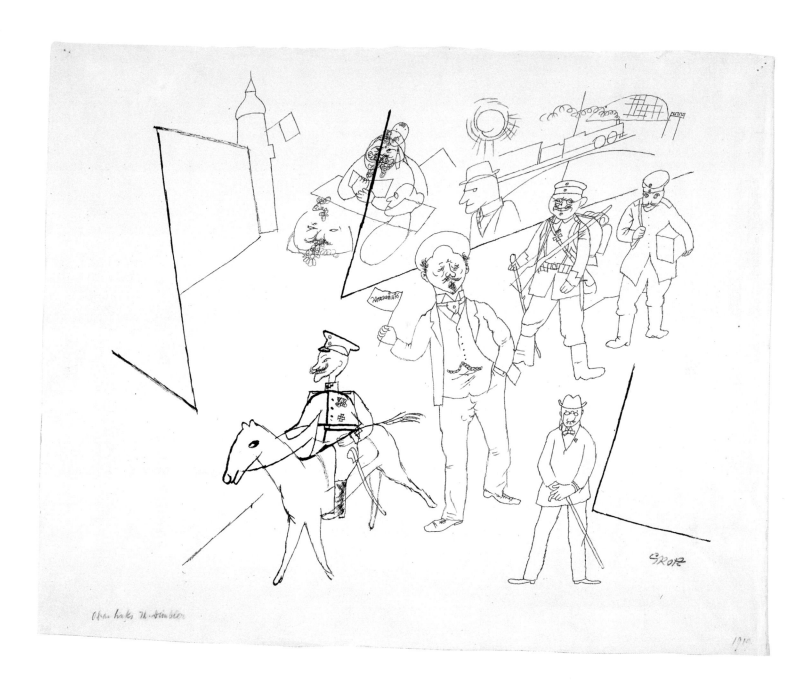

tion for Grosz. In this drawing the poet and the dissident leftists gathered around him are quietly creating, studying, and protesting, though their voices are barely heard under the tide of German politics.

Grosz's humor is revealed in a quick sketch on the verso, representing a figure on a bicycle (fig. 1). He wears Indian feathers, a common motif in Grosz's drawings, reflecting the popularity of the myth of

the American West and the power of the cinema in Germany during the 1910s.[8] His absurd grin and reckless posture would seem to express the pent-up frustration and the compulsion for puerile outburst caused by those painfully difficult times.

Fig. 1. George Grosz, *Vorwärts,* verso.

Joseph Stella

MURO LUCANO, ITALY 1877–1946 NEW YORK

85. *Pink Delphinium and Dogwood,* 1919

Silverpoint and colored pencils
on prepared cream wove paper,
35.8 × 25.4 cm

INSCRIBED: In graphite, lower right:
Joseph Stella

PROVENANCE: By descent to the
artist's nephew, Sergio Stella; pur-
chased from Richard York Gallery,
New York.

EXHIBITION: *Joseph Stella's Nature,*
New York, Richard York Gallery,
1994.

Richard A. Heald Fund, 1994.267

Although Joseph Stella is best known as one of
America's first Futurists and a painter of Surrealist
fantasy, first he was a virtuoso draftsman. In the
course of his career he produced thousands of draw-
ings in progressively evolving styles. He was born in
a small hillside town southeast of Naples, the fourth
of five sons.[1] In 1894 his eldest brother emigrated to
the United States and established a medical practice
in New York City. After his high school graduation,
Giuseppe—soon to be called Joseph—sailed from
Naples to join his brother. Although he studied med-
icine and pharmacology, he decided on a career in
art and in 1898 began a three-year course at William
Merritt Chase's New York School of Art. In the first
decade of the twentieth century Stella began a career
as an illustrator. In 1905 his drawings of Ellis Island
immigrants were published in *The Outlook,* and
thereafter he increasingly sold designs to illustrate
magazines and novels. In 1908 the artist was sent
to Pittsburgh to portray steelworkers for magazine
illustrations. This experience prompted an extended
series of industrial landscape drawings that gradually
evolved into tonalist abstractions.

In 1909 the Carnegie Institute in Pittsburgh
mounted a solo exhibition of Stella's drawings, which
traveled to Chicago and New York. However at that
time the artist had returned to Italy to study the
works of old masters. In February 1911, at the urging
of his friend the artist Walter Pach, Stella moved to
Paris. He was impressed by the Futurist exhibition at
the Galerie Bernheim-Jeune and may have met the
pioneers of this style, Umberto Boccioni and Gino
Severini. When Stella returned to New York in the
fall of 1911, he brought the influence of Futurism
with him.

Stella's work was featured in the International
Exhibition of Modern Art mounted at the New York
Armory in February 1913, the landmark show that
introduced modern art to a broad American audi-
ence. Gradually he became one of the country's most
prominent modernist painters. During the 1910s
Stella associated with Marcel Duchamp and other
Dada artists, and his work was influenced by their
ideas. In 1920 he became involved with the Société
Anonyme, a group founded by Duchamp, Katherine
Dreier, and Man Ray to promote the art of the avant-
garde in America. Stella participated in the society's
first shows and subsequent projects throughout the
decade. His experiments with Futurism coalesced
in his famous *New York Interpreted* polyptych of
1920–22, now in the Newark Museum in Newark,
New Jersey.[2] Although Stella became a citizen in
1923, he regularly traveled to Europe throughout the
1920s, providing a link for his American colleagues
to the European avant-garde. A retrospective exhibi-
tion of Stella's work was mounted at the Newark
Museum in April 1939. His artistic activity dimin-
ished in the early 1940s when he began to suffer
from heart disease, but he continued working inter-
mittently and even organized solo exhibitions of his
earlier work during his final years.

The present work is an early example from a pro-
tracted series of drawings in silverpoint with colored
pencils or wax crayons.[3] Stella based these images of
flora, fruits, and fauna on sketches made at the Bronx
botanical garden and on still lifes he had set up in his
studio. He was drawn to the medium because of its
links to the old masters. "In order to avoid careless
facility," Stella commented, "I dedicate my ardent
wish to draw with all the precision possible, using
the inflexible media of silverpoint and goldpoint
that reveal instantly the clearest graphic eloquence."[4]

Here the artist combined flowering sprigs from
two different plants, arranged as if they were held
invisibly, radiating like a bouquet in three dimen-
sions. Nearly all of Stella's botanical drawings depict
foliage, blooms, and fruits surrounded by spacious,
unmarked white margins, as if they were floating in
space suffused with light. These open compositions,
and the artist's precise, almost scientific accuracy,
recall European botanical illustrations of the eigh-
teenth and nineteenth centuries that were repro-
duced in etching and engraving and often tinted
by hand with watercolor wash.[5] These illustrations
often depict an entire plant, conflating its appear-
ance through the seasons to show flowers, seed pods,
and roots in a single image. They concentrate more
on a plant's taxonomy than on its appearance in na-
ture. Perhaps prompted by such models and by the
purposely incoherent combinations of Surrealism,
Stella also brought together unusual combinations
of fauna and fruit. The loving concentration on the
wondrous, often overlooked details of nature evokes
an ecstatic Franciscan appreciation of the world.[6]

Despite their precious cachet, Stella used fairly
simple means to produce his silverpoint drawings.
It seems that he mixed his own ground by thinning
commercial zinc oxide gouache with water and per-
haps adding chalk or powdered plaster to increase
its grittiness. He applied this mixture in layers onto
sheets of drawing paper. Then he drew with a simple
silver wire inserted into a wooden pencil casing. This
stylus produced fine lines, which were soft gray when
oxidized, with a tone similar to that of graphite. In
the present drawing, around the edges of the sheet
the white background contrasts with the surround-
ing cream color of the unpainted paper. The gleam-
ing white surface enhances the illusion of space
behind the plants, making them seem to float in the
air away from the surface of the sheet. Stella shaded

the flowers with scribbled diagonal hatching, then he tinted the drawing with colored pencils, applying soft pastel hues with precision and restraint. Atop the silverpoint, the colored pencils obscure the lines and soften the contrast. The radiating stems, punctuated by pink blossoms, form delicate, gently curving arcs that are emphasized by crayon strokes of orange and yellow. At the edges of the composition, the flowers in bud are colorless and delineated by outlines only. All of this splendor seems to burst from a nexus, marked by a starlike blue flower.

Alexander Archipenko

KIEV 1887–1964 NEW YORK

86. *Female Nude with Dividers,* about 1920–21

Charcoal on cream laid paper,
66.2 × 51.0 cm

INSCRIBED: In graphite, lower left: *X*

PROVENANCE: Yvonne Bedard
Corporon, New York (acquired
from the artist).

REFERENCE: Worcester Art Museum
Annual Report, 1971, p. xxi.

Bequest of Yvonne Bedard Corporon,
1970.163

A prolific sculptor and dynamic teacher, Alexander Archipenko changed the course of modernist sculpture in both Europe and the United States. By introducing new man-made materials in his works, he brought such unprecedented effects as color, transparency, projection, and reflection to sculpture. The artist was born in Russia on 30 May 1887, the son of an engineering professor at the University of Kiev.[1] From 1902 to 1905 Archipenko studied painting and sculpture at the Kiev Academy of Art; the foundations of his art were built on the influences of traditional Byzantine painting and the writings of the sculptor Nikolai Andreyev. After being expelled from the academy for criticizing his teachers, Archipenko went to Moscow, where he worked independently and exhibited in several group shows.

In Paris by 1908, Archipenko studied briefly at the Ecole des Beaux-Arts. He became involved with the Cubists in about 1910 and was a founding member of the Cubist group Section d'Or. In 1912 the artist opened his own art school in Montparnasse, where Amedeo Modigliani (no. 82) was among his students. One of the outstanding works of Archipenko's career was the Cubist-style *Medrano I* of 1912. Now destroyed, it was the first well-known sculpture to combine such modern materials as wood, glass, sheets of metal, and wire. The artist continued working during World War I, and afterward, in an ambitious attempt to rekindle interest in his art, he organized his own retrospective exhibition and arranged its tour to several European cities. In 1921 he opened an art school in Berlin, and in the same year his first solo exhibition in the United States was mounted at the Société Anonyme in New York.

In 1923 Archipenko moved to New York, where he reestablished his school. At that time he developed *Archipentura,* one of the first works of kinetic art.[2] The artist became an American citizen in 1928. He taught at Mills College and the Chouinard School in California and in 1937 joined László Moholy-Nagy (no. 93) as an instructor at the New Bauhaus in Chicago. He remained there, teaching at the Institute of Design, through World War II. During the 1940s Archipenko reopened his New York art school. Late in the decade he executed a series of sculptures illuminated by electric light from within, the first works in modern art to be so conceived. The artist continued to teach widely at this time, holding appointments in colleges and universities throughout the United States and in western Canada. Always striving to make his own voice heard above those of critics and commentators, he produced and published the monograph *Archipenko, Fifty Creative Years, 1908–1958.*[3] The artist remained active until his death on 25 February 1964.

Archipenko was a prolific draftsman who seems to have used drawing chiefly to record and refine ideas for works in other media. There are five drawings at the Worcester Art Museum attributed to Archipenko, all bequeathed to the institution by Yvonne Bedard Corporon, who was a student of the artist in New York around 1930.[4] They are all studies of female figures, executed in the naturalistic manner that Archipenko used from the end of his residence in Germany through his first several years in the United States. The present drawing, probably made about 1920 or 1921, is a simple study, very likely made from a model, perhaps as an exercise in Archipenko's school in Berlin.[5] Its elongated form and the twisted posture suggest the influence of the German sculptor Wilhelm Lehmbruck.[6] Several pentimenti and erasures show that Archipenko reconsidered the position of the woman's back, head, and hands. Contour lines circumscribing the passages of shade give the figure a lumpy quality, almost as if it were modeled in clay.

"I do not exclude naturalism from my conception of creative art," Archipenko wrote, "however, I do eliminate the photographic precision of details which contradicts the expression of some esthetic character which I intend to amplify. For instance, if muscles or bones interfere with the line, I eliminate them in order to obtain simplicity, purity and the expression of stylistic line and form. From such simplification further development evolves in symbolic form and becomes a creative suggestion liberating the object from its ordinary externality. Through such a transformation of naturalism, step by step, I approach the metaphysical and spiritual realm where creative expression has no limit. However, I prefer to stop on that frontier beyond which there begin the impoverishment of spirit and the deviation from metaphysics."[7]

In many ways this drawing is related to sculpture. The attenuated figure seems made up of component forms. Her pose, as she leans on her left elbow to twist her body over to draw with her right hand, seems unnatural and uncomfortable. She seems to lean on studio props: blocks or pedestals covered with drapery. The artist failed to suggest any support for the sheet of paper on which she draws, which seems almost to have been added as an afterthought. The model holds a pair of dividers, a device for measuring or transferring length or proportion. A traditional tool of sculptors, in the Renaissance this implement often appeared as a symbolic attribute of that art. In fact, Archipenko executed several figures of this style in the early 1920s, modeled in clay and cast in bronze.

George Wesley Bellows

COLUMBUS, OHIO 1882–1925 NEW YORK

87. *Reclining Nude,* 1923–24

Lithographic crayon over graphite on cream wove paper, 26.7 × 36.8 cm

INSCRIBED: In black crayon, upper right: *37;* in graphite, lower left: *Geo Bellows*

PROVENANCE: Mrs. Emma Bellows, New York.

EXHIBITIONS: *Art in America, 1830–1950,* Worcester Art Museum, 1969; *Art Treasures for Worcester: The Legacy of Daniel Catton Rich,* Worcester Art Museum, 1970; *Studies from the Model: Drawings and Prints of the Nude,* Worcester Art Museum, 1977.

REFERENCES: Worcester Art Museum *Annual Report,* 1928, pp. 23, 28; Worcester Art Museum *Bulletin,* vol. 21, October 1930, p. 86; Worcester 1969, p. 2.

Museum purchase, 1928.25

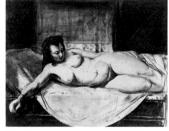

Fig. 1

A prominent figure among the second generation of American realist painters known as the Ashcan School, George Bellows enjoyed popularity and financial success during his lifetime. Born on 12 August 1882, in Columbus, Ohio, Bellows was the son of an architect and building contractor.[1] He attended Ohio State University but left in his junior year to study art in New York. Arriving in the city in 1904, he enrolled in William Merritt Chase's New York School of Art, where the chief instructor, Robert Henri, soon became his mentor. Later Bellows described Hardesty G. Maratta, Kenneth Hayes Miller, and Henri as his principal teachers.[2] His early style combined articulate drawing with an impressionistic application of paint. In 1907 the artist began a series of boxing paintings, and he sprang to fame with a dynamic painting of an illegal match in a smoky sporting club, *Stag at Sharkey's,* which is now in the Cleveland Museum of Art.

In April 1909 Bellows was elected an associate member of the National Academy of Design, and he became an instructor of life drawing at the Art Students League the following year. There were twenty-four paintings in Bellows's first solo exhibition, at the Madison Gallery in New York in 1910. He moved into a house on East Nineteenth Street and renovated its third floor for his studio. Soon afterward he married Emma Story and began a family. From 1912 to 1918 Bellows taught as a colleague of Henri at the Ferrer School. The artist also began producing magazine illustrations at that time, which significantly broadened his reputation.

The famous Armory Show of 1913 was important to Bellows; he assisted with its installation and attended the exhibition every day it was open. Afterward his work became less impressionistic and more dependent on formal and compositional balance. He studied the aesthetic theories of Maratta and Jay Hambidge and strove to incorporate their ideas into his work. In 1914, after his painting *Little Girl in White* won the Hallgarten Prize at the National Academy of Design annual exhibition, Bellows became a full Academician. He organized a show of twenty-seven of his paintings for the Worcester Art Museum in the fall of 1915.[3] Early in the following year the artist made his first lithographs, and for the rest of his career he worked consistently as a printmaker.[4] In the summer of 1920 Bellows took his family to Woodstock, New York, where he felt so comfortable that he later built a house and spent most summers there with his family. At Woodstock in 1922 he painted *The White Horse,* now at the Worcester Art Museum, which, despite its rural subject, reveals the artist's continuing interest in color theory and compositional structure.[5]

The early 1920s were extremely productive for Bellows. He was in demand as a portraitist and as a magazine illustrator. The *New York Evening Journal* engaged him to provide illustrations of the prize fight between Jack Dempsey and Luis Firpo in September 1923, and the artist developed his ringside sketches into a lithograph and a famous painting now at the Whitney Museum of American Art in New York. After suffering a ruptured appendix, Bellows died on 8 January 1925. A few weeks after his death an exhibition of sixteen of his paintings was shown at the Worcester Art Museum.[6]

Drawing was the foundation of Bellows's art and his primary means of expression. Early in his career he worked in a wide variety of graphic media, including pen and ink, graphite, and charcoal, which he often blended seamlessly. Sometime before 1910, years before his first print, Bellows discovered the lithographic crayon, and it became his favorite drawing medium. The flexibility of this soft, waxy material and its capability for producing rich, saturated lines appealed to him. Bellows periodically experimented with images of the female figure in flurries of studies that are sometimes disparate and incoherent and sometimes seem to represent one model in deliberate variants of a single pose. The lithographs of this type are unusual among his prints, for they are neither character studies nor narrative images.[7] The present drawing was executed during the winter of 1923–24 when Bellows produced several drawings and eight related lithographs of female nudes on each of which he inscribed the title *Study.*[8]

In this drawing Bellows first outlined the figure in simple contours and then sparingly modeled the forms to suggest depth and dimension. This style is shared by most of his nude studies of 1923–24, which isolate the figures with no suggestion of setting. The physique of the young woman and her pose—as she leans on one elbow, raising one knee and leaning it over her straightened leg—are comparable to those in Bellows's contemporaneous lithograph *Nude on a Classic Couch.* Both seem to derive ultimately from Michelangelo's sculpture *Dawn,* in the tomb of Lorenzo de' Medici in Florence.[9] The model's dark page-boy coiffure is also close to that depicted in a drawing that Bellows recorded in his workbook, and in a related print, *Nude Seated on a Flowered Cushion;* they may well have been made after the same model in a single sitting. It seems that these studies were intended as preparation for the painting of a contemporary figure, whose pose and presentation evoke the images of the old masters. In July 1924 Bellows painted *Nude on a Hexagonal Quilt,* now in the National Gallery of Art in Washington, which features a statuesque, half-reclining figure.[10] The

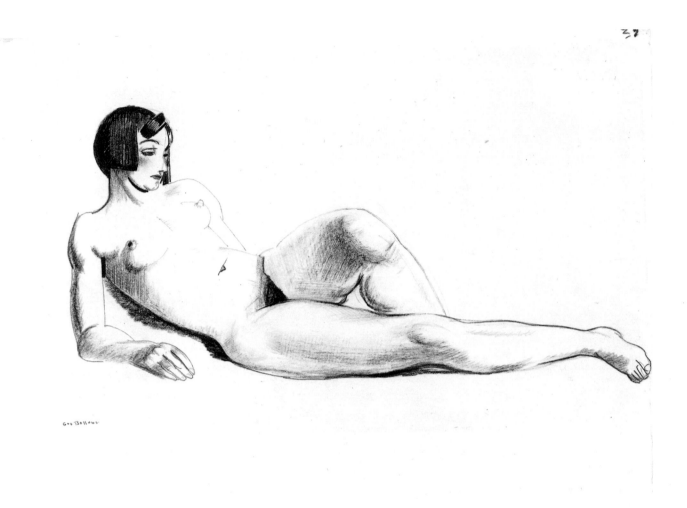

woman in that painting is similar to the figure in the present drawing in the plastic delineation of the figure, in her full proportions, and in the youthful, confident personality imparted by her fashionable coiffure and unabashed countenance. That canvas may have been the ultimate result of the present study and others like it. Another roughly contemporaneous crayon drawing, *Reclining Nude,* now at the

Worcester Art Museum (fig. 1), reflects the breadth of these explorations.

Fig. 1. George Wesley Bellows, *Reclining Nude,* ca. 1924, lithographic crayon and charcoal on cream wove paper, 28.1 × 35.7 cm. Worcester Art Museum, gift of Alden P. Johnson, 1962.169.

Gaston Lachaise

PARIS 1882–1935 NEW YORK

88. *Nude,* about 1924

Crayon on cream Japan paper,
30.3 × 14.2 cm

INSCRIBED: In graphite, lower right:
G Lachaise

PROVENANCE: Carus Gallery, New
York; Mrs. Helen Sagoff Slosberg,
Boston.

REFERENCE: Worcester Art Museum
Journal, vol. 2, 1978–79, p. 58.

Gift of Mrs. Helen Sagoff Slosberg,
1979.27

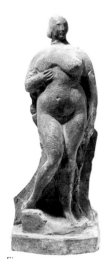

Fig. 1

An influential figure in the history of twentieth-century American sculpture, Gaston Lachaise was constantly inspired by the female form. His father was a noted cabinetmaker who passed a respect for craftsmanship on to his son.[1] In his teens Lachaise studied in Paris at the Ecole Bernard Palissy and the Académie Nationale des Beaux-Arts. In 1899 the rules of the Salon des Artistes were relaxed to allow the sixteen-year-old Lachaise to show his work, and he submitted annually to this exhibition through 1903.

By that time Lachaise had become acquainted with Isabel Dutaud Nagle, a Canadian-American living in Paris. Although she was married and ten years his senior, the couple soon became intimate. When she returned to Boston, Lachaise took a job with the decorative artisan René Lalique, for whom he designed and fabricated Art Nouveau–style jewelry and metalworks. In 1906, when he had earned enough money, Lachaise followed Nagle to Boston, where he became an assistant in the workshop of the academic sculptor Henry Hudson Kitson. In his own time he continued to produce his own sculpture in plaster and clay, with Nagle as his sole model and inspiration. After moving to New York with Kitson in 1912, Lachaise joined the workshop of the more progressive sculptor Paul Manship. Arthur B. Davies chose Lachaise's plaster sculpture *Nude with a Coat* for the International Exhibition of Modern Art—the famous Armory Show of 1913.

In 1917, when Nagle's son had reached adulthood, she finally consented to marry Lachaise. The artist became an American citizen, and a very productive period followed. His first solo exhibition was mounted at the Stephan Bourgeois Gallery in New York in 1918. His creative sculpture always represented the stylized female nude, often with a dance-like grace and sinuous contours, characteristics that have been compared to those in the sculpture of his contemporary Elie Nadelman. His stepson, Edward Nagle, introduced Lachaise to e. e. cummings, and through the young poet he became acquainted with a wide circle of authors, intellectuals, and artists. Lachaise also met the young intellectual Scofield Thayer, heir to a Worcester textile fortune. In January 1920, when Thayer and James Sibley Watson published the first issue of the arts and literary magazine *The Dial,* an illustration of a bronze plaque by Lachaise appeared as its frontispiece.[2] The continued support of this respected intellectual journal was important for the sculptor's career, and many of his later portraits depict members of *The Dial* staff.[3]

In 1921 Lachaise won the prestigious commission for a bronze frieze for the lobby of the AT&T Building in New York. Over the following decade he maintained a steady income by producing deco-

rative metalworks, like radiator caps and elevator doors. In the early 1930s he received several important public commissions, including reliefs for the RCA Building at Rockefeller Center in New York and for the Chicago World's Fair. He was the first living sculptor to have a retrospective exhibition at the Museum of Modern Art in New York, just four months before his death in New York on 17 October 1935.

Lachaise drew constantly throughout his career to prompt inspiration and explore new visual ideas. The artist's drawings always have a greater freedom than his sculpture. He favored simple, inexpensive drawing materials and sometimes mixed media. Lachaise worked swiftly, and most of his drawings represent single female figures, often with dramatic anatomical exaggeration. He preferred simple line drawings that were seldom modeled or colored. Yet he skillfully suggested dimension and animation with a firm, certain touch and a deft economy of line. By contrast with the rich textural surfaces that often appeared in his later sculptures cast from modeled and carved originals, Lachaise's drawings are reductive and precise. The artist often made several variants of a single image in almost identical compositions.

The present sketch is one of a pair in the Worcester Art Museum, each drawn in a single colored crayon on a thin sheet of long-fibered Asian paper.[4] They are closely similar in technique and style and could have been made in one sitting.[5] With just a few simple, spare lines, each drawing represents a single voluptuous female figure. Despite the economy of means, the figure's pose imparts both an illusion of dimension and depth and a sense of liveliness and movement. The woman's head and legs twist in opposite directions, and one hand is held behind the body while the other is drawn up to the shoulder. The figure fills the sheet and seems almost claustrophobically compressed, an effect further enhanced by the way the lower edge of the paper truncates her ankles and feet. Since this woman has no facial features, her persona is suggested wholly by her body. Her rotund forms, typical of Lachaise's figures, suggest fecundity. The graceful, tiny hands, head, and ankles emphasize the full curvilinear forms of the body.

Commentators have often discussed the relations between Lachaise's full-figured women and carved prehistoric fetishes like the *Venus of Willendorf.*[6] Those ancient statuettes represent rotund, faceless women whose exaggerated anatomical features were associated with childbearing. They were certainly familiar to Lachaise, who may have purposely adopted their form and meaning for the present

drawing. However, it is likely that the primary inspiration for this drawing was a living model. Similar figures appear in Lachaise's modeled and carved sculpture, the conception and style of which remained quite consistent throughout his career. A carved plaster statuette of a *Small Standing Nude* from the early 1920s, whose face shows that she was specifically inspired by Isabel Lachaise, reflects this stylistic similarity (fig. 1). The sculpture is comparable to the present drawing in the proportions and posture of the body, and in the sinuous outlines that circumscribe form and suggest the potential for elegant movement. The arms and hands of the carved figure are also similar to those in the drawing, in their positions and in their implications of sensuality and fecundity.

Fig. 1. Gaston Lachaise, *Small Standing Nude,* mid-1920s, plaster, 20.5 cm high. Courtesy the Lachaise Foundation.

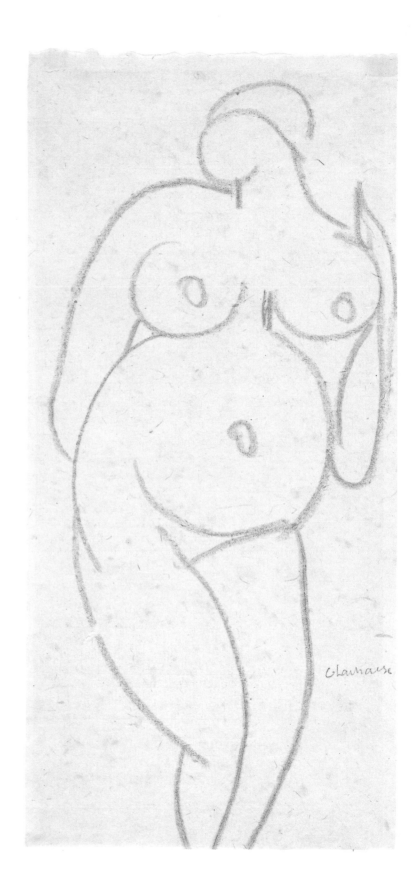

Marsden Hartley

LEWISTON, MAINE 1877–1943 ELLSWORTH, MAINE

89. *Trees #5,* 1927

Graphite on cream wove paper,
37.3 × 30.0 cm

INSCRIBED: In graphite, lower right:
Marsden Hartley/27

PROVENANCE: Charles Kunst (acquired from the artist); purchased from Mrs. Frances Malek, New York.

REFERENCES: Worcester Art Museum *Annual Report,* 1971, p. xxiii; *Art Quarterly,* vol. 34, winter 1971, p. 502.

Sarah C. Garver Fund, 1971.57

Fig. 1

One of the leading American abstract painters in the first half of the twentieth century, Marsden Hartley expressed his deep feelings about individuality and personal freedom in his poems and essays as well as his artwork. He was born and raised in rural Maine and left school at the age of fifteen to work in a shoe factory.[1] In 1896 he joined his siblings who lived in Cleveland, Ohio, and there he began taking weekly classes from a local painter, John Semon. Two years later Hartley won a scholarship to the Cleveland School of Art, and his promise also attracted another grant to support five years of study in New York. Thus, in the fall of 1899 he enrolled in William Merritt Chase's New York School of Art and the following year continued his studies at the National Academy of Design. His early works were Impressionist landscapes, often depicting his native woods.

In 1906 the artist moved back to Lewiston, Maine, where he hoped to teach painting. In his landscapes he gradually used brighter colors and applied paint more thickly. In the spring of 1909 the artist took these works to New York, where Alfred Stieglitz agreed to mount his first important solo exhibition at the 291 gallery. Hartley settled again in Manhattan, becoming a member of Stieglitz's circle, and he was introduced to European modernism and the work of Paul Cézanne, Henri Matisse, and Pablo Picasso. His art changed profoundly and began steadily evolving toward abstraction.

In the spring of 1912 Hartley went to Paris where he soon became part of the artistic community, and his work was influenced by the current styles of Fauvism and Cubism. He became a regular visitor to the salon of the American author and intellectual Gertrude Stein, who purchased some of his paintings and hung them in her apartment. When Hartley read Wassily Kandinsky's book *On the Spiritual in Art,* he was drawn to Germany. He moved to Berlin in the spring of 1913, and his work quickly became charged with emotion expressed through bold forms and saturated color. The following year he produced an outstanding series of abstract paintings based on still-life assemblages of German insignia: flags, uniform badges, buttons and ribbons symbolizing the militarism and nationalism that seized Germany at the beginning of World War I. These paintings were featured in the artist's only major solo exhibition in Europe, presented at the Münchener Graphik-Verlag in Berlin in October 1914.

After Hartley returned to the United States in 1916, his Cubist still lifes evolved into Constructivist abstractions. However, he soon changed course again, turning to dramatic pastels and small representational canvases of landscapes in Cape Cod,

New Mexico, and Bermuda. These gave rise to more formalized oils in the following decade. In 1920 Hartley was appointed first secretary of the Société Anonyme, a group founded by artists Marcel Duchamp, Man Ray, and Katherine Dreier to promote modern art and literature in the United States. He participated in many of the exhibitions and events sponsored by the organization. He also exhibited his work regularly at Stieglitz's new Intimate Gallery in New York. If his work was seen consistently in museums and galleries, the artist's life was otherwise unsettled, and through the 1930s he wandered constantly, spending time in France, Germany, Mexico, and Nova Scotia. Influenced by German Expressionism, his work became broader and more naïve in its manner. During the 1940s the artist divided his time chiefly between New York and Corea, Maine. Expressive and often childlike, his semiabstract paintings from the period represent subjects ranging from genre to religious images and Maine landscapes. After 1940 he devoted more of his time to writing poetry and essays.[2] Hartley died of heart failure during a visit to Ellsworth, Maine, on 2 September 1943.

The present drawing was made in 1927 when Hartley was living at Aix-en-Provence in southern France. He had left Paris because he felt the need to rest, reflect, and find a new direction. Hartley seems to have chosen Aix because Cézanne, an artist whom he idolized, had lived most of his life in the area and painted many landscapes in the nearby Château Noir forest.[3] In December 1927 Hartley moved into a house in the woods called Maison Maria, where Cézanne had kept a second studio and which was sometimes depicted in his paintings. To initiate and focus his work in a new direction, Hartley pointedly experimented with the style and techniques employed by Cézanne at Aix in about 1895–1900 (fig. 1). He sketched in the forests and meadows where his predecessor had wandered and created a series of canvases representing the painter's favorite subject, Mont Sainte-Victoire. Hartley's drawings and paintings are built on the architectonic, solid structure of Cézanne's compositions. He used colors that are meant to mix optically, applying them in broad, parallel brushstrokes ordered in distinct bands or registers. However, Hartley often used intense primary colors that were closer to those of the Fauves than to Cézanne's pastel hues.

The present drawing is one from an extensive series of landscape sketches in both graphite and silverpoint in the manner of Cézanne. Eight drawings of this sort are in the Marsden Hartley Memorial Collection in the Treat Art Gallery at Bates College in Lewiston, Maine.[4] They reveal how Hartley

attempted to revitalize his art by simplification. He tried to step back and analyze what he saw, selectively organizing and editing. Like many of these drawings, the present sheet seeks to interpolate the essential linear structure suggested by a landscape that Hartley observed. The framework of the composition is a series of simple contours, plotted by bundles of lines that approximate and soften the outlines. Modeling was added by means of scribbled passages of parallel hatching, which are analogous to Cézanne's hatched passages of watercolor wash or patches of a single color comprised of parallel brushstrokes.

Fig. 1. Paul Cézanne, *In the Park at Château Noir,* ca. 1898, oil on canvas, 92.0 × 73.0 cm. Paris, Musée du Louvre.

Diego Rivera
GUANAJUATO 1886–1957 MEXICO CITY

90. *Mother and Child,* 1927

Graphite on cream laid paper,
62.8 × 47.3 cm

WATERMARK: Rampant lion;
*Montgolfier St Marcel-Les Annonay
INGRES*

INSCRIBED: In graphite, lower right:
Diego Rivera. 27.; upper left: *no 10.;*
lower left: *DP.;* in graphite on verso,
upper left: *no 10 Caminante en
reporo woman resting;* upper right:
Worcester Mass. 1928.4

PROVENANCE: Purchased from Weyhe
Gallery, New York.

EXHIBITIONS: *Exhibition of Sketches
by the Mexican Artist Diego M. Rivera,*
Worcester Art Museum, 1927; *Diego
Rivera: 50 Años de su Labor Artistica,*
Mexico City, Museo Nacional des
Artes Plásticas, 1949; Worcester,
Massachusetts, Alden Memorial
Hall, Worcester Polytechnic Institute,
1964; *Mexican Prints and Drawings,*
Worcester Art Museum, 1974; *Diego
Rivera,* Mexico City, Museo Tamayo,
1983; *Diego Rivera: A Retrospective,*
Detroit Institute of Arts/Philadelphia
Museum of Art/Mexico City, Museo
del Palacio de Bellas Artes/Madrid,
Centro de Arte Reina Sofia/Berlin,
Staatliche Kunsthalle/London,
Hayward Art Gallery, 1986–87;
Imagen de México, Frankfurt, Schirn
Kunsthalle, 1987–88; *Una Vista de
México,* Worcester Art Museum, 1991.

REFERENCES: Eggers 1927, no. 18;
Worcester Art Museum *Annual
Report,* 1928, p. 23; Worcester Art
Museum *Bulletin,* vol. 19, April 1928,
p. 1; "Loaned to Mexico," *Worcester
Daily Telegram,* 24 August 1949;
Downs/Sharp 1986, p. 349, fig. 125;
Billeter 1987, cat. no. 244; Worcester
1994, p. 222.

Museum purchase, 1928.4

Fig. 1

The preeminent Mexican artist of the twentieth century, Diego Rivera was a charismatic figure who enjoyed great celebrity during his lifetime. He dreamed of forging a distinctly Mexican art, accessible to all and representing the ancient and noble culture of his homeland. The artist was born on 13 December 1886, a fraternal twin whose brother died at the age of two.[1] In 1892 Rivera's family moved to Mexico City; there his parents, both of whom were schoolteachers, provided him with a secure, middle-class upbringing. At the age of ten he enrolled at the Academia de San Carlos, where his teachers included Andrés Rios and José María Velasco. Dissatisfied with the uncompromising, realistic style taught there, Rivera left the academy in 1902, but he continued to work on his own. His first exhibition was in 1907, the year in which he won a grant to go to Spain.

After studying at the Academia de San Fernando in Madrid, the artist traveled through the Netherlands, England, and France. In Paris he exhibited his work at the Salon des Indépendants and was deeply impressed by the work of Paul Cézanne. Over the next few years Rivera was influenced by Pointillism and Cubism, and he actively participated in the experiments of the avant-garde. He also was sensitive to developments in literature and politics, becoming devoted to the ideals of the Russian Revolution. It was in Paris in 1919 that he and his countryman David Alfaro Siqueiros conceived the notion of a new school of Mexican art that might spark a national people's movement. The stylistic means for this crusade emerged in 1920 when Rivera visited Italy, where he was impressed by the frescoes of the early Renaissance. His work was influenced by the scale and narrative impact of mural painting and by the broad, almost sculptural style of such artists as Giotto and Piero della Francesca.

Rivera returned to Mexico in 1921, and in the following year he executed his first wall paintings at the Amphitheater Bolívar at the Escuela Nacional Preparatoria in Mexico City. This enormous project, featuring the work of twenty-two artists, including Siqueiros and José Clemente Orozco, gave impetus to the muralist movement. The 1920s were vital years for Rivera; notable among his many murals of the decade were those at the Escuela Nacional de Agricultura in Chapingo, painted in 1926–27. Through his involvement with the Mexican Communist Party he was cofounder of the associated Union of Revolutionary Painters, Sculptors, and Graphic Artists. In 1927 he visited the Soviet Union at the invitation of the Committee for Public Education. In 1929 Rivera married the painter Frida Kahlo, who shared his passionate dedication to art as

well as his political convictions. Although their relationship was often tempestuous, it was defining for both partners. Rivera became the director of the Academia de San Carlos in Mexico City in 1929. His international reputation was solidified in 1931 when a major exhibition of his work was mounted at the Museum of Modern Art in New York. In that year he began a fresco cycle at the Detroit Institute of Arts, commissioned by Edsel Ford, that depicts the role of heroic workers in great American factories. Then he began a controversial mural in Rockefeller Center in New York that represented the role of science and mass communications in modern life. Because this fresco contained a portrait of the Communist leader Vladimir Lenin, the painting was destroyed before its completion; later Rivera re-created its design in frescoes at the Palacio de Bellas Artes in Mexico City. A major exhibition at the Museo Nacional des Artes Plásticas in Mexico City in 1949 honored fifty years of Rivera's activity. After the death of Frida Kahlo in 1954, Rivera donated her house in Coyoacán to the Mexican people as a national museum of her art. Rivera died on 24 November 1957 in Mexico City.

In 1927 George W. Eggers, director of the Worcester Art Museum, organized an exhibition of Rivera's drawings in association with the Weyhe Gallery in New York. It was the artist's first show in an American museum.[2] The institution purchased six of the works exhibited, a diverse group including drawings made both in Paris and in Mexico City and representing the range of subject matter presented in the exhibition. The present drawing is perhaps the best known of the group.[3] It represents a peasant woman resting, perhaps on her way to a village. She holds a swaddled infant. In the basket sitting beside her and the cloth bundle balanced on her head, she may be carrying produce or other wares to market. By concealing the burden in the fabric parcel, Rivera does not dwell on its specifics but emphasizes its bulk and the physical demand of carrying it, a sensation further emphasized by the stripes that decorate the cloth. The figure is composed of broadly modeled, plastic forms that are almost geometric in their simplicity. The woman's body and that of the baby cradled tenderly at her breast are tightly wrapped in white fabric modeled to accentuate their three-dimensionality.

This sheet is one from a great many drawings that Rivera created in the 1920s depicting the landscapes, people, legends, and history of his homeland.[4] They were conceived as repertorial images for murals and other ambitious works depicting contemporary life and the social and political history of Mexico. Many of these sketches represent the difficult lives of peas-

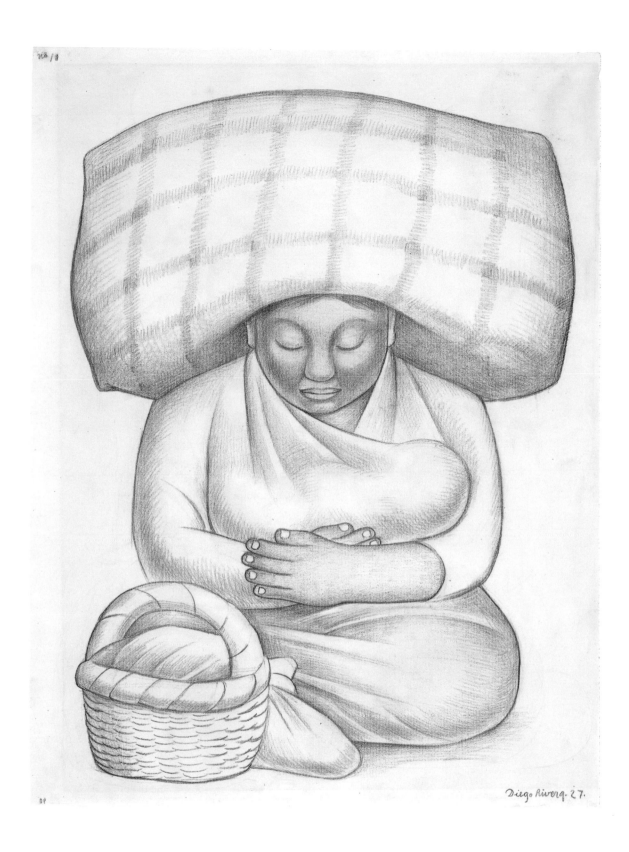

ants in Mexico's deserts and jungles, but they also convey the sincere human emotions and the dignity of these people. The sharp, symmetrical facial features of the peasant mother distinguish her as a descendant of ancient native cultures. Rivera consciously derived her image from sculptures carved in stone and modeled in terra cotta, artifacts of pre-Columbian civilizations that may be exemplified by a fifteenth-century Aztec carving of a fertility goddess (fig. 1).[5] Thus the artist expressed with extraordinary simplicity the ancient nobility behind this peasant woman's quiet dignity.

Fig. 1. Aztec, *Fertility Goddess,* 1450–1500, stone with traces of pigment, 34.0 × 16.9 × 11.8 cm. Worcester Art Museum, 1957.143.

Isamu Noguchi

LOS ANGELES 1904–1988 NEW YORK

91. *Seated Nude from the Back,* 1928

Charcoal on cream wove paper,
43.5 × 27.7 cm

INSCRIBED: In graphite, lower right:
Isamu Noguchi

PROVENANCE: Purchased from Marie
Sterner, New York.

EXHIBITION: *Art in America, 1830–
1950,* Worcester Art Museum, 1969.

REFERENCES: Worcester Art Museum
Annual Report, 1930, p. 30; Worcester
1969, p. 9.

Museum purchase, 1930.24

The son of the Japanese poet Yonejiro Noguchi and the American writer and teacher Leonie Gilmour, Isamu Noguchi spent much of his early childhood in the seaside town of Chigasaki, Japan, and at a French Jesuit elementary school in Yokohama.[1] In 1917 he was sent to northern Indiana, where he attended public schools in Rolling Prairie and later in LaPorte. His desire to become an artist led to an apprenticeship with the sculptor Gutzon Borglum. Noguchi entered Columbia University in New York in 1922. Two years later he took a studio in Greenwich Village and became a pupil of the sculptor Onoro Ruotolo at the Leonardo da Vinci School.

In 1926 Noguchi's artistic direction was completely transformed when he saw an exhibition of sculpture by Constantin Brancusi. The following year he won a John Simon Guggenheim Fellowship, meant to enable him to study for a year in Paris and then to travel widely, exploring the artistic traditions of Asia. In Paris he became an assistant to Brancusi, who taught him great respect for his materials and an aesthetic of purified abstract form. He also met other artists in Paris, including Jules Pascin and Alexander Calder. When funds ran out Noguchi returned to New York and produced sculptural portraits until, in 1930, he had saved enough to resume his travels. He studied brush drawing during an eight-month stay in China; then in Kyoto he was a pupil of the potter Uno Jinmatsu.

During the 1930s in New York the artist created works of extraordinary range, including naturalistic portraits, Surrealist sculptures, and the designs for his first landscape and garden projects. He also produced the set for Martha Graham's ballet *Frontier,* the first of many successful collaborations with the dancer and choreographer. In 1938 the artist executed a sculptural relief for the entrance of the Associated Press Building at Rockefeller Center. Three years later his sculpture *Capital* was purchased by the Museum of Modern Art in New York.

After World War II Noguchi concentrated more of his attention on functional objects, designing interiors and furniture. Surrealism dominated his sculptures of the 1940s, which were often made of slate or marble, fashioned into skeletal-like shapes and flat discs. The works became large and monolithic in the 1950s. Cast in concrete or carved in stone, they were often pierced and enclosed space as an integral element. The artist also continued his experiments with earthworks and gardens. His major commissions included the Peace Park bridges in Hiroshima and gardens for the UNESCO building in Paris.

In 1962, while artist-in-residence at the American Academy in Rome, Noguchi first visited the

Henraux marble quarries in Querceta. He often worked there over the next decade, producing works of laminated layers of multihued stone and sculptures that juxtapose crudely hewn and weathered passages with polished areas. In 1965 Noguchi completed the *Kodomo No Kuni* in Tokyo, the first of his playground designs. During the 1970s and 1980s Noguchi was one of the world's most renowned artists, producing scores of public monuments and gardens all over the world. Notable among them were the nine fountains for Expo '70 in Osaka and the Hart Plaza in Detroit. The artist continued to work until his death in New York on 30 December 1988.

Worcester was one of the first museums to recognize Noguchi's talent when in 1930 it purchased a group of six drawings.[2] These rare early sketches may have been shown in the artist's first solo exhibition at the Eugene Schoen Gallery in New York in 1929. Drawn in charcoal on inexpensive sketchbook leaves, they are studies of female nudes, probably made from models. Their style suggests that these drawings were made in Paris in 1928, at a time when the young Noguchi was searching for an understanding of abstraction and for his personal artistic voice. He spent his mornings in the workshop of Brancusi and his afternoons drawing from the model at the Académie de la Grande Chaumière and the Académie Colarossi. These were not studies for sculpture, but practice sketches to hone the artist's skill in representing form and space.[3]

The present drawing also reveals the influences of Noguchi's friends in Paris, combining Pascin's delicacy and sensuality with the spare, linear fluency of Calder. At that time Calder was at work on "dimensional drawings" made from a single strand of copper wire bent and twisted into the outlines of animals or circus figures.[4] The intermittent, discrete marks in this drawing exert their identity as two-dimensional lines, requiring the viewer's imagination to complete contours and define forms. Selective exclusion and reliance on the imagination are typical of traditional Japanese and Chinese art, and Noguchi used these effects emphatically here when he omitted the top of the woman's head. The artist sensitively complemented the contour lines with soft modeling, made with the edge of the charcoal stick. Noguchi explored simple ways to suggest form and the obscure boundaries between abstraction and representation, notions with which he was concerned daily in his experiences with Brancusi.[5]

The Worcester sketches anticipate figure studies that Noguchi made during his eight-month stay in Beijing in 1929. Those large figural drawings, made with "fantastic brushes and expressionist flourishes

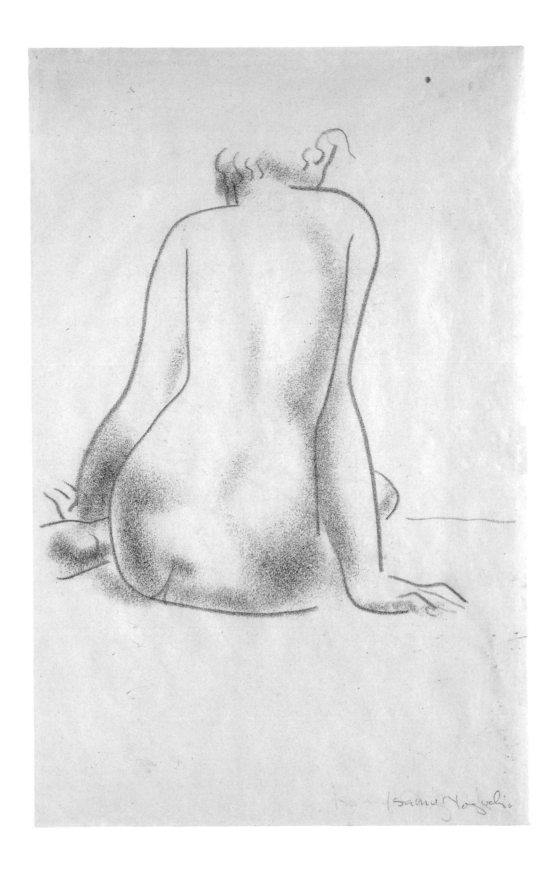

upon incredibly beautiful paper,"[6] were created under the tutelage of the master Ch'i Pai-Shih. In learning the techniques of Chinese ink painting, Noguchi did not copy unfamiliar calligraphy or traditional landscapes, but rendered the figures that he had come to know so well in Paris. Noguchi's brush drawings employ simply outlined figures, superimposed with heavy calligraphic flourishes in ink or wash that create a sense of dynamic connection or movement.[7] The figures in the Beijing drawings have balletic or yogic poses, which contrast with the earlier group and reveal the present drawing and its companions as interrogative studies of form and abstraction.

John Marin

RUTHERFORD, NEW JERSEY 1870–1953 CAPE SPLIT, MAINE

92. *The Brooklyn Bridge,* about 1930

Colored pencils on cream wove paper, 12.2 × 17.1 cm

INSCRIBED: In black pencil, lower right: *Marin;* in brown pencil on verso, upper right: *19 – 20*

PROVENANCE: Malcolm Rhodes McBride, Fiesole.

EXHIBITION: *Recent Acquisitions: Works on Paper,* Worcester Art Museum, 1989.

REFERENCE: Worcester Art Museum *Calendar,* Summer 1989, p. 2.

Bequest of Malcolm Rhodes McBride, 1989.62

Fig. 1

John Marin was one of a handful of artists who successfully popularized modernism in the United States during the first half of this century. A remarkably prolific artist, he also was a talented poet and essayist. He was born in Rutherford, New Jersey, on 23 December 1870 and grew up in the nearby communities of Weehawken and Union Hill.[1] After graduating from public school in 1881, he attended the Stevens Academy, where he developed an interest in architecture. He began the first of a succession of jobs in architects' offices in 1888 and became independent four years later. Yet Marin longed for a more personal mode of expression, and in 1899 he attended the Pennsylvania Academy of the Fine Arts in Philadelphia to study painting with Thomas P. Anshutz and Hugh Breckenridge. Afterward he continued his training in New York at the Art Students League as a pupil of Frank Vincent Du Mond.

In 1905 Marin sailed to Paris, where he briefly attended the Académie Delecluse and the Académie Julian. His works at this time were chiefly landscapes, painted in a Whistlerian manner influenced by Impressionism. He made small etchings of picturesque street scenes, the sale of which helped to finance his travels in Europe.[2] The artist began to exhibit his works at the Salon d'Automne and the Salon des Indépendants in Paris in 1907, and at that time the French government purchased his oil painting *Mills at Meaux.* In 1909 the photographer, connoisseur, and entrepreneur Alfred Stieglitz visited the artist at his Paris studio. He was enchanted by Marin's work and offered to exhibit it at his 291 gallery. Stieglitz became a tireless advocate and faithful friend to Marin, handling all of his professional affairs and supporting him in hard times. After returning to New York for his first solo exhibition at 291 early in 1910, Marin returned briefly to Europe, and the influence of Cubism and other stylistic advances in European painting began to appear in his work.

The artist married in 1912 and settled in New York City. The following year ten of his watercolors were included in the landmark Armory Show. Marin first visited Maine in 1914, and he was inspired by the place. He returned there each summer, spending most winters at work in Cliffside, New Jersey, where he bought a house in 1920. He also took painting expeditions to the mountains of New England and New Mexico. In 1933 Marin's work was featured in the first biennial exhibition at the Whitney Museum of American Art in New York. The Museum of Modern Art in New York presented a retrospective exhibition of Marin's work in 1936, at the height of his popularity. An approving pictorial feature in *Look* magazine in 1948 confirmed Marin's extraordi-

nary popularity. In 1950, three years before his death, the artist was awarded an honorary doctorate from Yale University, and he was a featured artist in the American pavilion at the Venice Biennale.

The present drawing is one of many modernist views of New York that Marin made during the 1910s and 1920s. Perhaps compelled by Parisian Cubist paintings of the Eiffel Tower, he often depicted the Brooklyn Bridge and the Woolworth Building, immediately recognizable New York landmarks.[3] The artist perceived these enormous structures as living organisms, invigorating their images with the animating spark that energized his landscapes. "Shall we consider the life of a great city as confined simply to the people and the animals on its streets and in its buildings?" the artist wrote in 1913. "Are the buildings themselves dead? You cannot create a great work of art unless the things you behold respond to something within you—the whole city is alive; buildings, people, all are alive; and the more they move me the more I feel them to be alive."[4]

In some of his images of the Brooklyn Bridge, Marin bent the architecture so that the span appears to dance rhythmically in the wind. In others he disassembled the edifice, abstracting and rearranging its structural elements as lines and planes of color. Marin's large watercolors of the bridge were probably painted on the portable, rotating easel that he carried around the city. He also made many little sketchbook drawings of the bridge, ranging from quick jottings to considered, deliberate designs.[5] The present drawing was made with five colored pencils on a sheet of paper that is tattered along its left side where it was torn from a sketchbook. A passage scribbled into the rough margin at the upper left proves that the paper had this irregular shape—and had been removed from the sketchbook—before Marin began to draw.

This sketch probably came immediately before Marin's watercolor *Brooklyn Bridge, On the Bridge,* painted in 1930 and now in the Terra Museum of American Art in Chicago (fig. 1).[6] Each represents a single bridge tower seen from the upper deck pedestrian walkway. Both images share the canted rectangular envelopes of space that contain the architecture and bracketing sets of parallel lines that make the structure appear to vibrate with energy. Marin used the Cubist practice of combining views of an object seen from different angles. While the curves and flickering hues of the watercolor express tensile elasticity, the drawing emphasizes the static, immovable aspect of the bridge. The structure possesses an energy that seems controlled and contained, providing mighty stability.

Parallel pencil strokes and scribbled blocks of color dissect the composition of the drawing into Cubist fragments. Marin accented rectilinear details like the bricks that articulate the tower and the parallel girders that flank the pedestrian walkway. The few curves stand out in this chiefly linear composition. The lancet arcs that trace the inside of the Gothic arches in the bridge tower emphasize an upward movement. Curves also bracket another prominent lozenge shape that appears to surmount the tower in the center of the design. This is a street-light, which casts its angular beams downward to merge with the bridge suspension cables, giving the whole composition a pyramidal shape. The lamp in the composition suggests that Marin made the drawing at night, and its prominence emphasizes the theme of modern man's challenge of nature.

Fig. 1. John Marin, *Brooklyn Bridge, On the Bridge,* 1930, watercolor and graphite, 55.3 × 68.0 cm. Chicago, Daniel J. Terra Museum of American Art, 11.1981.

László Moholy-Nagy

BORSOD, HUNGARY 1895–1946 CHICAGO

93. *Untitled,* 1938

Pen and black ink with pastel on
cream wove paper, 27.9 × 21.7 cm

INSCRIBED: In graphite, lower left:
for Katherine Kuh / L. Moholy = Nagy;
in pen and black ink, lower right:
Dec 11 / M = N 38

PROVENANCE: Katherine Kuh,
Chicago (acquired from the artist).

EXHIBITION: *Moholy-Nagy: A New
Vision for Chicago,* Springfield,
Illinois State Museum/Chicago, State
of Illinois Art Museum, 1990–91.

REFERENCE: Suhre 1991, cat. no. 58.

Gift of Mrs. Katherine Kuh in mem-
ory of Daniel Catton Rich, 1976.178

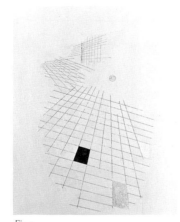

Fig. 1

One of the most versatile artists of the Constructivist
school, László Moholy-Nagy was committed to the
notion that fine art should be an ever present part of
everyday life. He was born on a wheat farm at Borsod
(Bácsborsod), near the village of Moholy in southern
Hungary on 20 July 1895.[1] He was drafted into the
Austro-Hungarian army at the beginning of World
War I, and his first work as a draftsman was the draw-
ing of military maps. Wounded in Italy in 1916, he
was confined to field hospitals for the rest of the war.
After his discharge in 1918, Moholy-Nagy devoted
himself to art. Although his early works were repre-
sentational, he soon fell under the influence of the
Russian Constructivist painters El Lissitzky and
Kasimir Malevich, as well as Lajos Kassák of the
Hungarian avant-garde group known as *MA,* or
"Today." In pursuit of his artistic interests, he moved
to Vienna late in 1919.

In January 1921 Moholy-Nagy married the artist
Lucia Schulz, who subsequently shared in his work.
He moved to Berlin, and his first solo exhibition
was mounted there at Herwarth Walden's gallery,
Der Sturm. At this time the artist was at work on
abstract constructions in metal, which reflected his
ongoing search for a styleless, pure art of the present.
He shared a Berlin studio with Kurt Schwitters,
under whose influence he made collages and photo-
montages. In 1923 Moholy-Nagy joined the faculty
of the Bauhaus, the progressive art school in Weimar,
headed by Walter Gropius. He became head of the
metal workshop and director of the preliminary
course. He was deeply involved in photography and
conducted darkroom experiments with multiple
exposures and negative printing.

In the spring of 1928, Gropius, Marcel Breuer,
Herbert Bayer, and Moholy-Nagy resigned from the
Bauhaus in protest against increased government
regulation. Returning to Berlin, Moholy-Nagy
opened a commercial design studio, and among his
projects were stage sets and lighting for the Kroll
Opera and the Piscator Theater. Moholy-Nagy con-
tinued to work in a wide variety of media, utilizing
such modern materials as enameled metals and
plastics. His reputation soared during the 1930s
as European museums began to acquire his work.
After Hitler's election in March 1933, Moholy-Nagy
moved to Amsterdam and then London, where he
worked as a commercial artist and photographer. He
published three books of his photography done in
England and produced several documentary films.

In 1937 Moholy-Nagy was appointed director of
the New Bauhaus, a privately funded school of fine
and applied arts in Chicago. His book *The New
Vision* surveyed the conceptual developments in
modern art and functioned both as stylistic mani-

festo and textbook for the New Bauhaus.[2] This
school closed after one year, but Moholy-Nagy
reorganized and reopened the Institute of Design,
which included many former Bauhaus teachers and
students on its faculty. Beginning in 1943 he worked
diligently on *Vision in Motion,* a book summarizing
the aesthetic theories he had developed during his
years in Chicago.[3] Before his death on 24 November
1946, Moholy-Nagy made arrangements for the
future administration of the successful Institute of
Design.

This drawing, made within months of the artist's
arrival in Chicago, shows how Moholy-Nagy con-
tinued to work in the style and imagery of Russian
Constructivism in his maturity. In this quick sketch,
using a simple, universal formal vocabulary, the
artist created powerful visual effects of space, illumi-
nation, energy, and movement. "The eyes react to
visual expression," wrote Moholy-Nagy, "because its
elements affect physiological and psychological per-
ception. It is never the object itself . . . which affect[s]
the spectator, but their direct and pure visual mean-
ing and their combination into a coherent visual
order. This visual order has a biological foundation.
It is more an unconscious than a conscious affair."[4]

For the present drawing Moholy-Nagy used a pen
with a steel nib, pressing firmly to draw wide, solid
lines. He sketched these lines quickly, without a
straightedge, recharging the pen with ink after each
stroke. The foreground grid suggests a plane tipped
away from the viewer, measured by parallel lines that
converge in the distance. Moholy-Nagy enhanced
the planar effect of this motif by filling in random
cells with pastel in primary colors. In the middle
ground two other linear networks that suggest planes
are placed at opposite angles. Where these grids
overlap the planes seem to intersect, suggesting not
only effects of expansive space, but also a sensation
of weightlessness. Moholy-Nagy enhanced the spa-
tial illusion further by clustering the imagery in the
bottom of the composition, so that the viewer sub-
consciously imposes an analogy with the terrestrial
landscape, with its horizon and expansive sky above.
To focus the viewer's attention the artist placed a
circle near the middle of the composition. By posi-
tioning this element slightly to the right of center,
Moholy-Nagy strengthened the impact of the fore-
ground grid and emphasized a sense of tension and
movement.

Moholy-Nagy transformed this composition
into a painting, which is now at the Art Institute of
Chicago (fig. 1).[5] The canvas is similar in style and
imagery to others that the artist created in 1939–40.[6]
Several subtle refinements of the design make the
painting rather different from the drawing in its

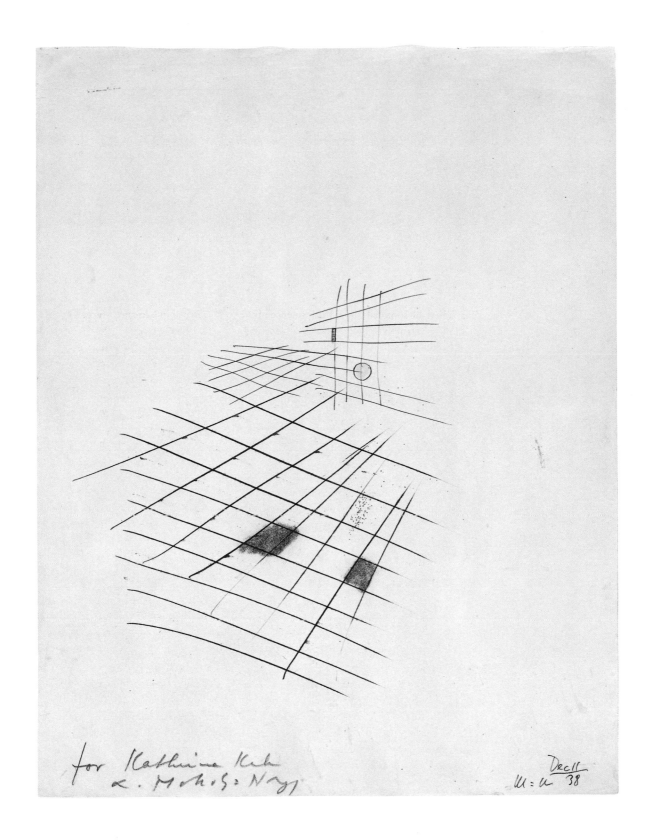

visual impact. The artist again used India ink to plot the lines on the canvas, but now he carefully measured the intervals of the grids, using a straightedge to rule precise lines. In the painting he used casein, or thick wax, to color selected cells as he had used pastel in the drawing. The casein was applied in thick, variegated impasto that insistently draws the attention to the surface, partially negating the illusion of depth. In the painting the artist increased

the angles of the middle grid to suggest a curving surface. He also separated the circular form from the grids, creating space around the circle that seems to glow like a halo.

Fig. 1. László Moholy-Nagy, *Untitled,* 1939, casein, oil, and India ink on canvas, 210.8 × 152.4 cm. Art Institute of Chicago, bequest of Lucile L. Keck in memory of George Fred Keck, 1983.262.

Jacques Lipchitz

DRUSKIENSKI, LITHUANIA 1891–1973 CAPRI

94. *Theseus and the Minotaur*, 1942

Charcoal, gouache, and pastel on gray wove paper, 65.1 × 49.2 cm

INSCRIBED: In pen and black ink, upper right: *Lipchitz*

PROVENANCE: Purchased from Bucholz Gallery, New York.

EXHIBITION: *Art in the Twentieth Century,* San Francisco Museum of Art, 1955.

REFERENCES: Valentin 1944, no. 15; Worcester Art Museum *News Bulletin and Calendar,* vol. 10, October 1944, p. 2; Pach 1946, p. 357; Strickler 1987, p. 211.

Director's Discretionary Fund, 1943.10

Fig. 1

One of the most influential sculptors of the twentieth century, Jacques Lipchitz continued to experiment and transform his style throughout his long career. The eldest son of a wealthy builder, he won praise for his drawings and models when he was at school in Bialystok.[1] He went to Paris in October 1909 to study briefly at the Ecole des Beaux-Arts, the Académie Julian, and the Académie Colarossi, and he was deeply influenced by the ancient Egyptian and Greek art that he saw in Paris museums. In about 1915 his friend the painter Diego Rivera (no. 90) introduced Lipchitz to Pablo Picasso and Juan Gris, and under their influence he embraced Cubism. In his carved and modeled sculpture Lipchitz adapted many of the style's concepts and devices, including overlapping and intersecting planes, multiple viewpoints, and severe reductions of depth. Throughout World War I the artist continued to work on Cubist figural sculptures, exempt from the French draft because of his Russian citizenship. In 1916 he created a sensation with his stone carving *Man with a Guitar,* the center of which was pierced by a hole. When Paris was threatened by the German bombardment, Lipchitz went to Gris's home at Beaulieu-près-Loches, where he created monumental sculptural reliefs. His first solo exhibition was at the Paris gallery of Léonce Rosenberg in 1920. The 1920s and 1930s were productive decades for Lipchitz, and he developed an international reputation. In 1924 he became a French citizen and married, and shortly thereafter he commissioned Le Corbusier to design his house and studio in Boulogne-sur-Seine.

In 1941, when the Germans invaded France during World War II, the artist embarked for the United States, eventually settling to work in a studio on Madison Square in New York. In the succeeding decade the artist continued to work in an exuberant, expressive figural style. In 1952 a fire in Lipchitz's Manhattan studio destroyed most of the works in his possession; however an aid committee sponsored by American museums helped him to build a new studio at Hastings-on-Hudson, New York. The artist became an American citizen in 1958. During the 1960s Lipchitz executed several large-scale bronzes for American cities. Major retrospective exhibitions of his work were mounted in Israel, Europe, and New York City in 1970–72. Lipchitz died on the island of Capri on 26 May 1973, and he was buried in Jerusalem.

The present drawing is one of many images, created in the middle of Lipchitz's career, that were inspired by ancient mythology. His motivation for this loosely connected series ultimately seems to have been sparked by the famous Hellenistic sculpture of the *Laocoön.*[2] Many of these works represent mortal man's heroic struggles against divinely empowered beasts. Beginning in the mid-1930s, they seem to reflect the political discord and ensuing war in Europe, as well as the inner conflicts that challenged mankind during that desperate period. "If you desire to continue freely in your creative work," the artist stated at the time, "it will be necessary for you to enter the struggle and conquer the forces of darkness that are about to invade the world."[3]

Lipchitz was captivated and inspired by the Greek myth of the Minotaur, the heroic tale of Theseus, the son of King Aegeus of the city-state of Athens.[4] The city was besieged once during a great war with King Minos of Crete, and for their deliverance the Athenians agreed to pay a horrible tribute. Every nine years fourteen children were sent to Crete, where they were imprisoned in the labyrinth, a maze that was an asylumlike home for the Minotaur, a fearsome monster who was half man and half bull. When the young Athenians found no escape through the confusing passages of the labyrinth, the Minotaur devoured them. One year Theseus arranged to be included in the tribute himself. When he arrived on Crete the prince met Ariadne, King Minos's daughter, who fell in love with him. She gave him a ball of string and told him to mark his way into the labyrinth so that he could find his escape. Theseus fought and killed the Minotaur, delivering Athens from its debt. The prince then fled with Ariadne to the island of Naxos, where he abandoned her and returned to Athens to succeed his father as king.

During World War II, when shortages curtailed Lipchitz's sculpture production and he concentrated more on drawing, he often depicted mythical tales. Soon after his arrival in New York in 1941, he executed several drawings of Theseus and the Minotaur as a standing, wrestling couple.[5] This is one of many drawings that Lipchitz made in a chiaroscuro manner using charcoal and a single colored pastel heightened with white on tinted paper.[6] These were intended as presentation drawings, executed for the New York market, perhaps even under the encouragement of his dealer, Curt Valentin. Lipchitz described form with straight, angular lines and used the side of his charcoal to shade in blocks of color that describe faceted surfaces.

The present drawing is related to Lipchitz's bronze statuette of *Theseus and the Minotaur,* executed in 1942 and reproduced in multiple castings (fig. 1).[7] The relationship between these combatants calls to mind the ancient sculptural type of the god Mithras, which surely provided a model for this image.[8] While the sculpture shows the bellowing monster falling to its bovine knees, the drawing represents the beast with human arms and hands, hanging limp

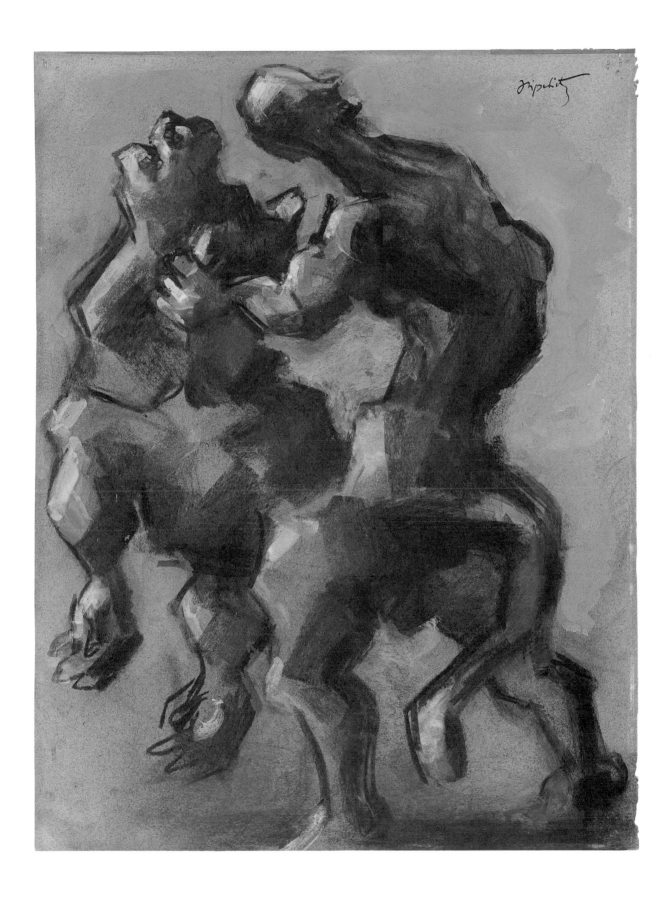

as he succumbs.[9] In the present drawing and related sculpture, the man and bull share their hind quarters, melding into one dynamic figure. Therefore these images evoke the universal theme of internal struggle.

Fig. 1. Jacques Lipchitz, *Theseus and the Minotaur*, 1942, bronze, 62.0 × 62.0 × 49.5 cm. Courtesy Estate of Jacques Lipchitz, Marlborough Gallery.

Alberto Giacometti

BORGONOVO, SWITZERLAND 1901–1966 GENEVA

95. *Still Life,* about 1955

Graphite on cream wove paper,
49.2 × 64.2 cm

WATERMARK: *CANSON & MONTGOLFIER*
☆ *VIDALON LES ANNONAY* ◊

INSCRIBED: In graphite, lower right:
1 in a circle; in graphite on verso,
lower right: *Alberto Giacometti*

PROVENANCE: Mr. and Mrs. James
Alsdorf, Chicago; Mr. and Mrs.
Daniel Catton Rich, Worcester,
Massachusetts.

EXHIBITIONS: *Twentieth-Century
Master Drawings,* Cambridge,
Harvard College, 1963/Boston
Center for Adult Education, 1963/
Lexington, Massachusetts, Cary
Memorial Library, 1963; *Twentieth-
Century Master Drawings,* New York,
Solomon R. Guggenheim Museum,
1964/Minneapolis, University
Gallery, University of Minnesota,
1964/Cambridge, Fogg Art Museum,
Harvard University, 1964; *Alberto
Giacometti: Retrospective Exhibition,*
New York, Solomon R. Guggenheim
Museum, 1974; *Henri Michaux,
Alberto Giacometti,* Framingham,
Massachusetts, Danforth Museum
of Art, 1986.

REFERENCES: *Art Quarterly,* vol. 26,
Spring 1963, p. 86; Worcester Art
Museum *Annual Report,* 1963, p. xii;
Hohl 1974, cat. no. 196; Antonsen/
Edison 1986, p. 12.

Gift of Mr. and Mrs. Daniel Catton
Rich, 1962.79

Fig. 1

One of the most famous sculptors of the twentieth century, Alberto Giacometti created distinctive, expressive works that seem to reflect the troubled spiritual atmosphere of his time. He was born on 10 October 1901 in a small mountain village in the Italian-speaking region of Switzerland.[1] His father was the noted Post-Impressionist painter Giovanni Giacometti, who encouraged both Alberto and his younger brother, Diego, to become skilled artists. Following his father's advice, at age eighteen he enrolled in the Ecole des Beaux-Arts in Geneva where he studied painting with David Estoppey, and the Ecole des Arts Industriels, where he studied sculpture under Maurice Sarkissoff. When Giovanni Giacometti served as Swiss commissioner for the Venice Biennale in 1920, Alberto accompanied his father to Italy. He was impressed by the sculpture of Alexander Archipenko (no. 86), which he saw there for the first time.

In January 1922 Giacometti moved to Paris, where he fell under the fashionable influence of Cubism, as well as African and other ethnographic sculpture. He was also influenced by the work of Henri Laurens and Jacques Lipchitz (no. 94), and for a time he produced Cubist-style sculptures. In the late 1920s Giacometti was working in plaster, producing smooth, almost embryonic sculptural forms. Some of his most individual Surrealist works, which he called "affective" sculptures, are cagelike structures on flat, slablike platforms, containing geometric forms or streamlined figures. Those sculptures prompted Salvador Dalí, Louis Aragon, and André Breton to invite Giacometti to join the Surrealist movement, and in the early 1930s he participated in the group's activities, publications, and shows throughout Europe. The artist's first exhibition in the United States was presented at the Julien Levy Gallery in New York in 1934. By that time, however, he had turned away from Surrealism to concentrate on expressive portrait heads modeled from life, works that reveal their own creation in agglomerated lumps of clay.

In 1940 the artist ceased working from models and concentrated instead on figures and heads created from memory, works that grew progressively slimmer and smaller. Giacometti moved to Geneva in 1942 where he met Annette Arm, who became his wife and favorite model. Over the next two decades he continued to produce small, attenuated, expressive sculptures representing heads and standing and walking figures, works that reestablished his international reputation. In the mid-1940s Giacometti returned to painting what he saw and produced landscapes, still lifes, and portraits. His popularity reached its zenith in the final years of his life. In 1965 the City of Paris awarded him the Grand Prix des Arts, and Bern University granted him an honorary degree. Large exhibitions of his work were presented at the Tate Gallery in London in that year, at the Museum of Modern Art in New York, and at the Louisiana Museum in Humlebaek, Denmark. The artist died several months later.

The present drawing was executed on a leaf from a sketch pad or block of artists' paper. The abandoned, partially erased sketches of two frontal figures can be seen just above the level of the tops of the boxes and jars, and the paper is indented where the artist pressed hard while drawing on the adjacent page in the pad. On the other side of the sheet is a rapid sketch of a walking man (fig. 1), which the artist signed, seemingly choosing it as the primary image. Traces of glue around the edges of this still life indicate that the sheet was mounted at one time, so that the present image was hidden from view. Thus this still life has been neglected. It is a powerful, expertly drawn image, which endows an ordinary kitchen corner with impressive scale and sculptural palpability. In the mid-1950s Giacometti made many oil paintings and drawings of his studio, its furnishings, and the still-life assemblages that he set up there.[2] The manner in which a few towering objects are gathered in this image is reminiscent of the compositions of the Bolognese painter and printmaker Giorgio Morandi.[3] While that artist endowed his objects with dimensional form by delicate coloration or systematic hatching, Giacometti sketched his subjects with flashing spontaneity.

In his paintings and sculpture, as well as his drawings, the artist's late style was characterized by a rough, unpolished quality in which his materials and process are apparent. Unrefined chunks of clay and the artist's fingerprints can be seen in his modeled sculptures and the castings from them, and underpainting, brushstrokes, and scumbles of paint are visible on his canvases. Similarly, in drawings like the present sheet, Giacometti did not erase. Rather than meticulously drafting and refining contour lines, he searched for the correct outlines in bundles of superimposed pencil lines. These scribbles become modeling and suggest the dimensional form of the objects; they also provide a vision of the artist's evolving conception of his image.

Giacometti's process is also revealed in this sketch in the shapes that loom behind the boxes and vessels on the table as seen from above. It seems that he began the drawing by viewing and plotting these objects straight on and slightly higher in the composition. When he decided to change the point of view, he did not bother to remove these outlines or their open, diagonal shading. Indeed, by leaving these

ghostly contours, he prompted the viewer to contemplate the change in points of perception over time, in the manner of Analytical Cubism. Although this intriguing experience is undeniable, it is impossible to know if it was Giacometti's intent. By drawing the table at a strongly receding diagonal to the picture plane, the artist enhanced the illusion of depth; but by inserting the arcs in opposite corners, and by circumscribing the composition with a square borderline, he denied that illusion. Although on first glance this sketch may seem ordinary, closer examination reveals it as the work of a skillful, puckish master.

Fig. 1. Alberto Giacometti, *Walking Man,* verso of *Still Life.*.

Philip Guston

MONTREAL 1913–1980 WOODSTOCK, NEW YORK

96. *Untitled*, 1963

Gouache on cream wove paper,
76.6 × 101.8 cm

WATERMARK: *Strathmore*

INSCRIBED: In gray gouache, lower
right: *Philip Guston*

PROVENANCE: Musa Guston, New
York.

Bequest of Musa Guston, 1992.99

The energy and immediacy of Abstract Expressionism are exemplified by this color sketch done by the painter Philip Guston in the early 1960s. The artist was born in Montreal on 23 June 1913, the youngest of seven children.[1] His father, Louis Goldstein, had emigrated from Odessa, Russia, to Canada; then after he moved his family to Los Angeles in 1919, he committed suicide. Artistically inclined, Philip attended the Los Angeles Manual Arts High School in 1927. He befriended Jackson Pollock, and together the two rebellious teenagers collaborated on a satirical broadside that resulted in their expulsion.

In 1930 Guston won a scholarship to the Otis Art Institute, but impatient with the structured classwork, he attended for just three months. Afterward, studying and painting independently, he became fascinated by the Italian Renaissance masters, particularly Piero della Francesca, and his early paintings reflect their influence. Guston's first solo exhibition was mounted in 1931 at Stanley Rose's bookshop in Los Angeles. His interests in art and philosophy led him to Mexico in the following year, where he met and was deeply influenced by Diego Rivera (no. 90) and David Alfaro Siqueiros. In 1935 Guston moved to New York City. Over the next few years he began to sell his paintings and achieve some recognition, and in 1937 he changed his name from Goldstein to Guston. From 1939 to 1942 the artist worked in the mural painting division of the Federal Arts Project, and his frescoes for the Works Progress Administration building at the New York World's Fair received wide critical acclaim. He also painted murals for the Queensbridge Housing Project in 1940 and for the Social Security building in Washington, D.C., in 1942. In 1941 Guston became an instructor at the State University of Iowa, beginning a distinguished teaching career that continued at Washington University in Saint Louis (1945–47), New York University (1951–59), and the Pratt Institute (1953–57).

During the 1940s Guston still worked in a figurative style that combined concepts from Surrealism and Magic Realism. However, his images gradually became more geometric and abstract and were superseded around 1950 by a calligraphic, gestural manner reflecting the influence of Abstract Expressionism. His large canvases had centralized passages of intense color floating in front of soft, nebulous backgrounds. Then, late in the 1960s Guston's style shifted dramatically to a bold, cartoonlike manner influenced by Pop art. He produced images of black humor and irony in which symbolic elements, like discarded shoes, robed Ku Klux Klansmen, or disembodied human heads, symbolized the plight of the individual in the modern world. Finally in 1975 the artist began a series of red paintings that returned to the free gesture and rich impasto of his gestural style. The artist died in Woodstock, New York, on 7 June 1980, several months after suffering a severe heart attack.

Beginning in the 1950s the boundaries between drawing and painting became indistinguishable in Guston's work. His visual thinking is revealed in intuitive sketches with brush and ink or gouache, which reflect the leading edge of his evolving and transforming style.[2] Guston drew to confront the essential problems of form and composition, and he became obsessively concerned with the intellectual and physical process of drawing.[3] The present work is one of a series of large studies that explore problems of perception and expression in drawings on paper of manageable, medium scale. It is similar to contemporaneous paintings the artist produced in the mid-1960s that represent freely brushed rectangles floating before active, gestural fields of steely gray that seem to pulse and move like the ocean's surface. In its composition and calligraphic forms the image also relates to a series of drawings that occupied Guston in the early 1960s, works that teased the differences between a nonobjective image and the associations it may conjure.

Most of these works were inspired by arranged still-life subjects, such as piled draperies or rows of jars arranged on shelves. As he drew, Guston did not record literal outlines of objects but picked out and melded together lines and forms from both figure and ground. The artist used vigorous, dark contour lines to locate forms precisely in compositions that could be read both in depth and as flat surface design. By sensitively choosing color, form, and line, the artist also evoked mood in these images. Inevitably these drawings also invite the viewer's own associations. Cold, stormy grays pierced by slashes of deep red evoke notions of a breach in the rocky earth that reveals molten lava flowing beneath the surface, or a gash in a body that exposes the gorged tissue and life's blood pulsing inside. Guston often executed these images in repetitive series in which the image evolved away from an original objective description and toward pure abstraction. As the artist's process and the physical behavior of his materials became more important, these forms lost their identities, and the image became less subjective. However, within these groups of similar drawings, in each successive rendition the creation of each piece was a unique event and the resulting drawing a fully independent work of art. These experiments sometimes developed into paintings, but the drawings were not so much preparatory studies as they were rehearsals for a performance.

Although this process seems highly intellectualized, it was largely intuitive and took place in an instant. As Guston began to draw, he sought to re-engage motifs that had been on his mind, and when he found his source of inspiration, his gesture was fluent and immediate. The depth and energy of this process was described by Irwin Hollander, a lithographer who collaborated with the artist in

1963. "Getting that image out from inside him," Hollander said, "it was an act of such a spiritual nature. It was also fast. With Guston that was magnificent because the squiggle, and the shape, and the richness was immediate. Then he would be spent, it would be like being with a boxer, and he had to leave, just to get out."[4]

Tom Wesselmann

BORN CINCINNATI, OHIO 1931

97. *Study for Great American Nude #59*, 1965

Graphite on cream wove paper,
31.5 × 28.9 cm

INSCRIBED: In graphite, lower right:
Wesselmann 65; in graphite on verso,
upper left: *06525*

PROVENANCE: Sidney Janis Gallery,
New York; Galerie Gian Enzo
Sperone, Turin; Mario Ravignon
Gallery, New York; Maxwell
Davidson Gallery, New York;
purchased from G. W. Einstein
Company, New York.

EXHIBITIONS: Maxwell Davidson
Gallery, New York, 1990; James
Goodman Gallery, New York, 1994;
Art Chicago, 1995; *Selected American
Drawings,* G. W. Einstein Company,
New York, 1995.

Stoddard Acquisition Fund, 1996.38

Fig. 1

A prominent figure in the American Pop art move-
ment, Tom Wesselmann focused his early imagery
on the fine line between commerce and desire, visual
experiences unique to the twentieth century. The
artist was born in Cincinnati, Ohio, on 23 February
1931.[1] There he attended Hiram College from 1949 to
1951 and then entered the University of Cincinnati.
The following year, at the height of the Korean War,
he was drafted into the army. To express his displea-
sure about army life Wesselmann drew satirical car-
toons. Because of his artistic proclivities he became
an interpreter of aerial photographs and an instruc-
tor of photograph analysis at Fort Bragg, North
Carolina.

After his discharge in 1954, Wesselmann returned
to the University of Cincinnati to complete a bache-
lor's degree in psychology, while also studying art at
the Cincinnati Art Academy. He sold humorous
drawings to national magazines and advertisers and
planned to be a professional cartoonist. In 1956,
intending to sharpen his drafting skills, Wesselmann
went to New York to study at the Cooper Union, and
a wealth of new experiences changed his aspirations.
He began to paint under the tutelage of Alex Katz
and Nicholas Marsicano, and he became excited by
the ideas and aesthetics of Abstract Expressionism.
His first serious paintings were in a gestural style
inspired by the work of Willem de Kooning. After
graduation from the Cooper Union in 1959, he
moved to Greenwich Village and pragmatically
became a public school art teacher. In his free time
he sketched the female nude and experimented with
collages of found materials like fabrics, linoleum,
and printed billboard scraps. In 1960 a dream in-
spired Wesselmann to begin his *Great American
Nude* series of collage paintings, featuring recum-
bent female figures in simplified interiors of red,
white, and blue. These paintings made up the artist's
first solo exhibition, mounted at Tanager Gallery in
New York in 1961.[2]

During the early 1960s Wesselmann also made
still-life collages of packaged products and electrical
appliances. The artist was hailed as a leader of the
Pop art movement in America, along with Roy
Lichtenstein, James Rosenquist, and Andy Warhol,
who all incorporated imagery from advertising and
comics in their paintings. Four of Wesselmann's
works were featured in the ground-breaking exhibi-
tion *The New American Realism* at Worcester in 1965,
the first show of Pop art in an American museum.[3]
At the same time his *Great American Nude #36* was
acquired for the museum's permanent collection.[4]

Generally during the 1970s Wesselmann's designs
became simpler, brighter, and more erotic. He grad-
ually ceased to use collage elements, but his paint-

ings retained an agglomerative effect in which the
nude is one of many assembled objects. Wesselmann
slowly progressed to shaped canvases, featuring
anatomical fragments and small still-life elements
enlarged to gargantuan scale and sometimes set
before schematic landscapes. In the 1980s the shaped
canvases gave way to assemblages of brightly painted
metal, welded in layers and conceived to hang on the
wall. Monumentalized versions of the artist's quick
line drawings, they depict nudes, still lifes, and land-
scapes, and over the years they have become denser
and more lush.

The present drawing exemplifies Wesselmann's
works of the mid-1960s. It includes all the compo-
nents of his *Great American Nude* paintings, simpli-
fied and schematized in order to tune and balance an
unresolved composition. The figure is pressed close
to the picture plane and cropped by the frame. A
single contour line delineates the unmodeled nude,
to flatten and abstract its form. Employing a preva-
lent advertising device, Wesselmann detailed the
hair, mouth, and nipples, motifs that emphasize the
sexuality of the model while denying any humanity
or personality.

The artist found that the bold geometry of stars,
stripes, and shields possesses the graphic strength
to balance the powerful eroticism of his early *Great
American Nude* paintings. The iconography of these
patriotic elements is just as subtle, intricate, and
equivocal as the sexual imagery. Thus Wesselmann
established a metaphor for American culture, point-
ing out that the commanding visual and cultural
experience of Western capitalist society is a constant
barrage of imagery conceived to influence our deci-
sions as consumers. It is an incessant onslaught,
employing every method of persuasion—including
sex—to urge the viewer to buy. Yet the captivating
imagery of the *Great American Nude* remains empty
and misleading, for the commended products cannot
deliver the fulfillment they promise. These images
remind us that advertising and many other sensual
experiences in our time are designed with manipula-
tive scientific detachment, to appeal viscerally to
the viewer and prompt subconscious conditioned
responses. Always in need of renewal and constantly
unfulfilling, these shallow, temporary experiences
are the real, tragic substance of the American culture
that has been exported throughout the world in
our century. Ironically, it is the very superficiality
of Wesselmann's art that engages the viewer to
thoughtful introspection; its soullessness possesses
an imploring poetry.

Wesselmann followed this drawing with another
pencil sketch of similar scale and a study in acrylic
on canvas (fig. 1), both of which are now in the

Hirshhorn Museum and Sculpture Garden in Washington, D.C.[5] In these images the figure is represented with yellow hair, and the composition is made more stable by rearrangement of the setting. Later in 1965 Wesselmann used the figure alone in the shaped *Great American Nude #74* and combined it with a variant setting in *Great American Nude #75,* both of which are made of vacuum-molded plastic, painted and illuminated from within by light bulbs.[6] The commercial aspect of these works is further emphasized by the use of the materials and technology of outdoor advertising. Like the vivid lighted plastic signs that glow above innumerable strip malls, these icons of desire and consumption exemplify the inescapable psychological complexity of life in the late twentieth century. Finally, Wesselmann used this figure for his canvas *Great American Nude #60,* which is now in the collection of Sydney and Frances Lewis.[7]

Fig. 1. Tom Wesselmann, *Study for First Illuminated Nude,* 1965, polymer acrylic and colored pencil on canvas, 116.8 × 109.2 cm. Washington, D.C., Hirshhorn Museum and Sculpture Garden, Smithsonian Institution, gift of Joseph H. Hirshhorn, 66.5527.

Sol LeWitt

BORN HARTFORD, CONNECTICUT 1928

98. *Documentation Drawing: 47 Three-Part Variations on a Cube,* 1967

Black felt-tip pen on tan wove paper,
21.7 × 28.0 cm

INSCRIBED: In black felt-tip pen,
lower right: *S. LeWitt 1967*

REFERENCES: Worcester Art Museum
Annual Report, 1974, p. 16; Legg 1978,
pp. 74–75.

Gift of the artist, 1974.96.3

Fig. 1

A pioneer of the international artistic style of
Minimalism, Sol LeWitt has been influential in
a wide variety of media, including painting, sculp-
ture, and printmaking. The son of Russian immi-
grants, he was born in Hartford, Connecticut, on
9 September 1928 and grew up in nearby New
Britain.[1] He studied art at Syracuse University
from 1945 to 1949. After serving in the army in
1951–52, LeWitt moved to New York to attend the
Cartoonists and Illustrators School and to begin a
career as a commercial artist and draftsman. He
worked briefly for *Seventeen* magazine and for the
architect I. M. Pei. On his own LeWitt became
interested in a more rarefied, more intellectual art,
and during the early 1960s he pursued that interest
by working as night receptionist at the Museum of
Modern Art. He came to know the artists Robert
Ryman, Robert Mangold, and Dan Flavin, who all
worked as museum guards and later became leading
proponents of Minimalism.[2] LeWitt began to show
his sculpture in 1963, and his first solo exhibition
was mounted at the Daniel Gallery in New York
in 1965. Three years later his work was featured in
the prestigious annual exhibition at the Whitney
Museum of American Art in New York. He taught
at the Museum of Modern Art School from 1964 to
1967 and the following year at the Cooper Union.

Generally LeWitt's sculptures of the 1960s com-
prised simple, rectilinear structures made of alu-
minum and finished with baked enamel. They were
often made by professional fabricators following the
artist's specifications. Like the contemporaneous
sculptors Donald Judd and Robert Morris, LeWitt
often deployed sets of identical or closely varied
objects. He strove to reduce and simplify his formal
vocabulary and organized his compositions in sys-
tematic, logical schemes.

LeWitt taught at the School of Visual Arts in
1969–70 and then at New York University. Over
the next decade he began to concentrate more of his
attention on "wall drawings," environmental murals
ranging from elementary linear compositions on
one surface to colored murals covering all the walls
of a room.[3] The artist often derived his wall drawing
designs from the architecture itself, directing and
manipulating the viewer's experience of a surface
or space, provoking contemplation, and evoking
distinctive moods. Like LeWitt's earlier works, the
wall drawings were executed by assistants from his
simple written instructions, thus removing the hand
of the artist. Rather than a physical object, the idea
and thought process leading to its realization had
become the work of art.

As LeWitt formulated and refined the plans for
his conceptual works, drawings remained funda-

mental to his creative process.[4] The present sheet is
one in a group of fifteen sketches in the Worcester
Art Museum's collection that document the con-
ception and planning of a sculptural installation.[5]
Other preparatory drawings for the project include
quick studies of sculptural forms, arithmetical com-
putations of their proportions, and charts of their
variation and propinquity. They are all done in ball-
point or felt-tip pen on thin sheets from a newsprint
sketch pad, materials that remove any pretense of
aesthetic cachet from his businesslike notations.
Together these drawings show how LeWitt based
his variations on a clear, logical, and systematic
scheme. In all of these drawings the artist planned
a complex, serial sculpture to consist of cubic mod-
ules. The cube has always been a primary element
of LeWitt's visual vocabulary, perhaps because of its
perfect dimensions and self-contained stability.

The present drawing represents the artist's nota-
tions for the shape and scale of a single three-part
cubic module and sketches of three variations. Be-
neath two of these forms LeWitt used his own code
to describe their form. Numbers refer to different
types of component forms: *1* stands for a solid cube,
2 signifies a cube with opposite sides removed, and
3 describes a cube with one side removed. Letters
refer to the absent sides of the solid cube: *F* stands
for a form with the front removed, *B* for a cube
without its back, and *R* for a cube without its right
side. With this code, which cogently and efficiently
describes the forms he has conceived, the artist could
succinctly plan, arrange, and convey his ideas for
these objects without ever having to construct the
sculpture. Befitting the intellectual and technologi-
cal nature of this work, the drawings seem more like
diagrams and planning computations than images
of formal beauty. In this regard LeWitt's drawings
resemble musical notations, abstract symbols for
other forms and ideas.

The artist's plans were given form in a sculpture
made of enameled aluminum by professional metal-
workers and exhibited at Dwan Gallery in New York
in February 1968 (fig. 1).[6] The installation consisted
of forty-seven of these variant three-part modules,
arranged five or six abreast on planar bases and
placed in equidistant rows. They were obvious prod-
ucts of high technology, flawless and impersonal,
and their calculated placement also conveyed system
and order. The repetitive forms evoked notions of
mass production and our culture of material con-
sumption. The immediate impact of these objects
in the gallery was architectural, and their open, pla-
nar structure made for fascinating shifting effects
of shade and reflection. This installation had great
presence and at first appeared complex and exten-

sive. The viewer was prompted to walk around and perceive the structures from different viewpoints, thereby to discover that the sculptures were flat and simple and that the rules of their construction could be readily learned. LeWitt purposely confined himself to a system of building blocks. As an intellectual game, he invented a set of rules for himself and puzzled out a viable solution, reducing his activity to elementary problem solving. The paradoxical sim-

plicity of these elements and the complexity of their combinations remind the viewer of the binary systems upon which our computers depend or the componential systems that make up DNA.

Fig. 1. Sol LeWitt, *47 Three-Part Variations on a Cube,* enameled aluminum. Installation at Dwan Gallery, New York, 1968.

David Hockney

BORN BRADFORD, ENGLAND 1937

99. *Portrait of Nick, Grand Hotel, Calvi*, 1972

Colored crayons on white wove paper, 43.2 × 35.4 cm

INSCRIBED: In black pencil, lower right: *Nick/Grand Hotel Calvi/July 1972/DH*

PROVENANCE: Kasmin Gallery, London; Mr. and Mrs. T. H. Gibson, London; Susan Gersh Gallery, Los Angeles; Mr. and Mrs. Chapin Riley, Los Angeles.

EXHIBITIONS: London, Kasmin Gallery, n.d.; *David Hockney: Tableaux et dessins,* Paris, Musée des Arts Décoratifs, 1974.

REFERENCES: Musée des Arts Décoratifs 1974, cat. no. 66; Stangos 1976, p. 246; Pillsbury 1978, n.p.; Stangos 1979, p. 87.

Promised gift of Chapin Riley and Mildred Jarrow Riley

A leading figure of the British Pop art movement of the 1960s, David Hockney has maintained great popularity as he has continued to pursue an evolving, transforming style and to explore new techniques. He studied at the Bradford College of Art from 1953 to 1957.[1] Then, after two years of hospital work to fulfill his National Service obligation as a conscientious objector, he continued his studies at the Royal College in London from 1959 to 1962. There, fellow student R. B. Kitaj drew him into the fashionable style of Pop art. Hockney received his first recognition in 1961 when he won the Royal College of Art Gold Medal and several other awards. In that year he also made his first visit to the United States. He began teaching at Maidstone College of Art in Kent in 1962 and subsequently has held American teaching posts at the University of Iowa, the University of Colorado, and the University of California, Los Angeles. The artist's first solo exhibition was mounted at the Kasmin Gallery in London in 1963. At Andy Warhol's Factory in lower Manhattan he met Henry Geldzahler, curator of twentieth-century art at the Metropolitan Museum of Art, who soon became a close friend. Advertising and the mass media were not a major theme in Hockney's early art, as they were for most Pop artists. His imagery was figural and based both on literature and on experiences of daily life in the twentieth century.

In 1964 Hockney moved to Los Angeles, where he painted the dreamlike suburban landscapes and life-styles of Southern California. In 1966 the artist ventured into theater design, creating decorations and costumes for a production of Alfred Jarry's *Ubu Roi* at the Royal Court Theatre in London; many other theater designs would follow. During the late 1960s Hockney's paintings, drawings, and prints developed in the direction of more realistic imagery, marking a break with Pop art and employing his great ability as a portraitist.

A knowledge and appreciation of the history of art has always been apparent in Hockney's work. Pablo Picasso has been an important influence on him, particularly during the 1970s, and Hockney diligently studied that master's stylistic evolution and explored its implications in his own work. In the next decade his manner gradually developed toward a bolder, more expressive, lyrical style influenced by Henri Matisse and Fauve painting. Style itself often became a thematic element of Hockney's images, and he deliberately avoided pictorial illusions of reality.

The present drawing was made at a time when Hockney used a realistic style to explore his own technical capabilities, the nature of life in the twen-

tieth century, and the emotions of his subjects.[2] Finding his inspiration in Picasso's realism of the first decade of the century, he drew many portraits in a naturalistic, virtuosic style. Hockney favored the fine lines of technical drafting pens or colored crayons, means that translated well to etched lines and lithographic crayons. When he first approached a new subject, the artist strove to produce an image that not only relayed physical likeness, but also captured his subject's mannerisms, attitude, and character. In several double portraits he tried to capture interpersonal relationships between his subjects. Hockney's quest for psychological insight and his compulsion to find the truth made it difficult for him to produce flattering commissioned portraits, so he often portrayed those close to him. This realistic phase culminated in such important paintings as *Portrait of Mr. and Mrs. Clark and Percy* of 1970–71 and *Portrait of My Parents* of 1977, both now in the Tate Gallery in London.

In the summer of 1972 Hockney and his friend Henry Geldzahler went to the island of Corsica for a month's holiday.[3] Geldzahler brought along Nick Rae from Glasgow, then a fashion student at the Royal College of Art, and Hockney also took a companion, a young Frenchman named Thierry. At the village of Calvi the four stayed in the Grand Hotel. Hockney brought along his new drawing case, a handled leather box that looked like a briefcase, made in London to his own specifications and outfitted to carry his drawing materials. He spent hours making drawings of vegetable still lifes and pen and crayon portraits of his companions, the present drawing among them.[4]

The portrait of Nick Rae projects a mood of sophisticated nonchalance. The sitter confronts the viewer directly, but with a look of confident disinterest. As in many of Hockney's portrait drawings of the period, there is no suggestion of setting. However, much of the subject's personality is expressed by the style of his clothing, certainly significant to the image of a fashion student. His hair is fashionably long, and he wears a conservative shirt and bow tie of the sort that come from the best shops in the West End of London. However, the youth eccentrically combined these sartorial elements, purposely mismatching a spotted brown tie with a shirt hatched with pink. He also wears a pair of blue denim coveralls, whose embroidered red, white, and blue label, with the brand name UFO, shows that these are not the work clothes of a farmer, but perhaps came from a trendy King's Road boutique. Rae's outfit seems to be a carefully considered mixture of expensive, well-made elements, combined to express an attitude of

aesthetic eccentricity. It is the sort of attire Hockney himself was known to wear during the 1970s.[5]

The artist commanded impressive technical skill in this sheet, combining exactingly drawn linear passages with scribbled delineation of form. This mixture gives a precise, realistic vision of the subject, as well as a glimpse of the artist's rapid, energetic process. Hockney skillfully uses a range of colors, placing lines and scribbles of seemingly incongruous hues together. These mix in the viewer's eye to achieve variegated, subtly tinted, and fittingly evocative effects of color and light.

Sam Francis

SAN MATEO, CALIFORNIA 1923–1994 SANTA MONICA, CALIFORNIA

100. *Untitled,* 1972

Acrylic paint and wash on white wove paper, 79.4 × 109.7 cm

WATERMARK: *Maso/BRESDIN JAPON*

INSCRIBED: In graphite on verso, lower right: *Sam Francis;* inscribed in graphite on verso, center: ↑ *TOP;* lower left: *Tokyo 1972/31¼ × 43¼/ SFT 72–104/X* (in a circle)

PROVENANCE: Private collection, Los Angeles; André Emmerich Gallery, New York; Salander-O'Reilly Galleries, New York; Susan Gersh Gallery, Los Angeles; Mr. and Mrs. Chapin Riley, Los Angeles.

Promised gift of Chapin Riley and Mildred Jarrow Riley

One of the most prominent and prolific California artists of the late twentieth century, Sam Francis worked in a wide variety of media, though his chief mode of expression was always painting. His style combined the energy and technical vocabulary of Abstract Expressionism with the vivid palette and scale of Color Field painting. The son of a mathematics professor and a piano teacher, Francis grew up in Southern California.[1] In 1941 he entered the University of California, Berkeley, as a botany major, later shifting to the study of psychology and medicine. He left college in 1943 to join the Army Air Corps and became a pilot. During a training flight near Tucson, Arizona, Francis suffered a back injury that developed into spinal tuberculosis. During his long convalescence he began painting. In 1947, shortly after his recovery, he executed his first abstract paintings. The following year he returned to Berkeley to study art.

Francis spent most of the 1950s in Paris. He briefly attended the Académie Fernand Léger and developed close friendships with several other émigré artists, including Jean-Paul Riopelle, Norman Bluhm, and Joan Mitchell. Like most of those painters, Francis was influenced by Tachisme, the French Surrealist–influenced manner that paralleled Abstract Expressionism in America. The artist's first solo exhibition was mounted at the Galerie du Dragon in Paris in 1952. Three years later the Museum of Modern Art in New York acquired one of his paintings.

While visiting Japan in 1957, Francis encountered the traditional *haboku* or "flung ink" style of painting, a manner that affirmed his active drip and splash technique. His ongoing fascination with Japanese art and culture was steadily nurtured and deepened by studies and frequent visits to Japan, where he often exhibited his work. During the 1960s the artist produced ever larger, more colorful paintings in his distinctive gestural manner. He was introduced to printmaking around 1960 by the publishers Tatyana Grosman on Long Island and Emil Matthieu in Zurich, who convinced him to begin making collaborative original lithographs. In 1976 he established the Litho Shop in Santa Monica, a private, fully outfitted workshop for the creation of his own lithographs and intaglio prints.[2]

In Kyoto in 1964 and 1965 Francis experimented with ceramic sculpture, producing both hanging and freestanding works. In Tokyo in 1966 he executed a "sky painting," providing choreographic plans for five helicopters trailing streams of colored smoke. A major retrospective of Francis's work was mounted at the Albright-Knox Art Gallery in Buffalo in 1972 and subsequently shown at the Corcoran Gallery of

Art in Washington, D.C., and the Whitney Museum of American Art in New York.[3]

Although his works often have a random, almost chaotic quality, they were actually thoughtfully made with care and precision. His process combined momentary inspiration and exacting visual editing. Francis often worked in stages, returning to a piece to add details, alter size, shape, or framing orientation, and sometimes to abandon and destroy unsatisfactory works. Throughout his career he always worked on paper, creating images in ink, watercolor, gouache, and acrylic; the present work was drawn directly with acrylic colors on the large, stout, bright white sheet. As with many of Francis's works, the nature of the materials and their physical behavior play an important part in the imagery.

For this piece the artist used a technique that he also employed in his monumental paintings on canvas and lithographs during the early 1970s. With the paper lying flat on the floor, Francis drew linear bars across the sheet in clear water with a wide, flat brush. When he dropped pigment into these pools of water, the colors dissolved, diluted, and bled into each other. The spreading colors were confined by the watery brushstrokes, beyond which the pristine white of the paper was preserved. The mottled washes dissipated in random, organic patterns that were to some extent determined by the rippling of the sheet as it responded to the application of water. This procedure was deliberate and partially controlled, for the artist selected and balanced hues and made decisions about their placement as the acrylic pigments dissolved, mixed, and created their own arrangement. Finally, after the washes were dry, Francis completed the drawing by dripping and spattering undiluted paint over the sheet, adding another layer of imagery.

Throughout his career Francis strove to explore fresh new imagery even though his formal vocabulary remained relatively consistent. The series of images with multicolored swaths of color grew naturally out of an earlier sequence of designs that placed imagery near the edges of the composition, leaving the center void. Although the density of image in these works varied widely, they usually shared a bright, saturated palette and the integral use of the white ground in the design, either the paper or the gessoed canvas. In all these images the stark intensity of the ground seems almost to give rise to the colors. The artist described his imagery as "a celebration of the fertility of white space."[4] Even more relevant than biological analogies of creation, however, are those concerning the physics of light, for spectral light is blindingly white. Despite the variations of imagery, the interplays between form and ground,

between the vivid and the colorless, remained constant in Francis's work. Those relationships evoke comparisons of potential with manifestation. By selecting and commanding colors with great care and authority, Francis achieved the mood and lyricism that are central to the immediate appeal of his art.

Notes

1. *The Martyrdom of Saint Lawrence, a Bifolium from a Gradual*

1. This group also includes *Bifolium from a Gradual with the Initial O and Saint Francis,* tempera and gold leaf on vellum, 55.7 × 38.5 cm (recto), 1989.170; *Bifolium from a Gradual with the Initial S and Two Women's Heads,* tempera and gold leaf on vellum, 55.6 × 38.6 cm (recto), 1989.171; *Folio from a Gradual with the Initial M and Two Foot Soldiers,* tempera on vellum, 56.3 × 37.8 cm, 1989.172; *Folio from a Gradual with the Initial S and the Conversion and Martyrdom of Saint Paul,* tempera and gold leaf on vellum, 55.6 × 38.8 cm (recto), 1989.173; *Bifolium from a Gradual with the Initial I with Saint Francis, and Saint Francis Preaching to the Birds,* tempera and gold leaf on vellum, 55.7 × 38.4 cm (recto), 1989.174; *Folio from a Gradual with the Initial O and Foliate Decoration,* tempera and gold leaf on vellum, 55.6 × 38.1 cm, 1989.176. All these were among a group of painted manuscripts purchased in Europe in the summer of 1921 by H. Stuart Michie, principal of the Worcester Art Museum School (see Worcester Art Museum *Bulletin,* vol. 12, October 1921, p. 54). They were formally transferred to the museum's collection in 1989.

2. Letter to Louisa Dresser, 25 August 1954.

3. See Wagstaff 1965, pp. 52–53, cat. no. 96.

4. Letter to the author, 2 March 1991.

5. Letter to the author, 4 May 1993. The Cleveland bifolium, which includes text for the celebration of the feast of All Saints, represents the initial *G* with Christ, the Virgin, and saints, ca. 1290–1310, black ink, tempera, and gold leaf on vellum, 56.2 × 38.7 cm, Cleveland Museum of Art, J. H. Wade Fund, 50.391.

6. The text comprises two verses selected from Psalm 95, with their order reversed so that verse 6 is followed by verse 1.

7. For the life of Saint Lawrence, see Voragine 1941, pp. 437–45.

8. See Marcucci 1958, cat. no. 20.

9. See Wagstaff 1965, pp. 10–11, cat. no. 2; Agnes and Elizabeth Mongan in Gould 1983, pp. 58–59.

10. See Boskovits 1987, pp. 122–24.

2. *Saint George*

1. See Winzinger 1980.

2. See Rubenstein-Bloch 1926, vol. 1, pl. 21.

3. See Voragine 1941, pp. 232–38.

4. See Thomas/Gamber 1954, pp. 15–20; Thomas 1974.

5. See Blair 1959, pp. 200–201, fig. 105.

6. Geisberg 1910, p. 109, pl. 61.

7. See Schmid 1977, pp. 111–16.

3. *The Prayer of King David, a Bifolium from an Antiphonary*

1. For biographical information on Caporali, see Scarpellino 1975.

2. The artist inscribed a miniature in the *Annali decemvirali,* now in the Archivo di Stato in Perugia (MS 108): "Non guardare a tal lavoro/Che Giapeco del Caporale magnifico Priore/El fe et no è costo denaio al notaro l'oro"; see Bombe 1910, p. 4.

3. On Bartolomeo Caporali, see Lothrop 1918.

4. The Latin text as shown here reads: "Servite d[omi]no. Evouae. *Tempore adventus antiphon.*/Veniet ecce rex. Evouae. *spr. pasc. li.x.*/Alleluia. Evouae. *Ps. David.*/BEAtus vir qui NON abüt in consilio i[m] pioru[m]" [Blessed is the man who walks not in the counsel of the wicked].

5. Letter to the author, 7 April 1993.

6. Letter to the author, 30 September 1993. Lunghi also noted that Pierantonio di Niccolò di Pocciolo worked in a similar style and contributed to the antiphonary of San Pietro. A missal now in the Capitulary Library in Perugia (MS 10), which contains illuminations by both Pierantonio and Giapeco, is also closely related in design and style to the present bifolium; see Caleca 1969, pp. 107–11.

7. On Caporali's contributions to the antiphonary of San Pietro, see Lunghi 1984, pp. 164–72; Lunghi 1992, pp. 259–61.

8. Ms Plimpton 41; see Alexander 1994, cat. no. 124. This codex, marked vol. K on its cover, was purchased in New York in 1911 by George A. Plimpton, who bequeathed it to Columbia University in 1936. It may be the volume that was stolen from the abbey in 1906 by Dr. Ruggiero Oddi, physician to the prior, padre Rossi; see *Bollettino d'Arte,* vol. 2, 1908, p. 279.

4. *Christ and the Woman of Samaria*

1. See Saint Florian 1965; Shestack/Talbot 1969.

2. John 4:1–30.

5. *The Supper at Emmaus*

1. See Friedländer 1974.

2. On de Beer, see Friedländer 1974, pp. 14–21; Ewing 1978.

3. Aert de Beer is best known as a designer of stained glass; see Van Mander 1906, vol. 1, pp. 62–65.

4. See Ewing 1984, pp. 98–99.

5. Hand 1986, p. 64.

6. See Hand 1986, pp. 64–65.

7. Mark 16:12; Luke 24:13–32.

8. See Boon 1978, p. 15, cat. no. 27.

9. As Vey *(Catalogue,* p. 20) recognized; see Ewing 1978, pp. 300–307.

10. Vey *Catalogue,* pp. 20–22.

6. *Three Old Men*

1. For biographical information on Parmigianino, see Vasari 1878–85, vol. 5,

pp. 217–41; for a monographic survey of his paintings, see Freedberg 1950.

2. See Popham 1971.

3. Pouncey 1976.

4. Inv. no. 510/24; Popham 1971, vol. 1, cat. no. 551.

5. Inv. no. 49-534; Popham 1971, vol. 1, cat. no. 3.

6. British Museum, London (inv. no. 1905-11-10-52; Popham 1971, vol. 1, cat. no. 242), Ashmolean Museum, Oxford (inv. no. 440; Popham 1971, vol. 1, cat. no. 334), and Chatsworth, Derbyshire (Popham 1971, vol. 1, cat. no. 719 verso).

7. See Popham 1971, vol. 1, pp. 25–28.

8. See Popham 1971, vol. 1, cat. no. 321.

7. *Allegorical Figures of Rivers and Mountains*

1. Vasari 1878–85; see Boase 1979.

2. On Aretino, see Putnam 1926; Larivalle 1980.

3. See Schulz 1961; McTavish 1981.

4. Frey 1923, vol. 1, pp. 104, 111–19; vol. 2, pp. 858–60. Other descriptions of the project are included in Vasari's biography of his associate Cristofano Gherardi (Vasari 1878–85, vol. 6, pp. 223–26) and in his autobiography (Vasari 1878–85, vol. 7, pp. 670–71).

5. See Bober/Rubenstein 1986, pp. 102–4.

6. On Michelangelo's Pauline Chapel, see De Tolnay 1960, vol. 4, pp. 138–42.

7. On the Vatican *Hercules Chiaramonti,* a Roman copy of a Greek sculptural type, see Bober/Rubenstein 1986, pp. 168–69.

8. There is a copy of this image in the Uffizi in Florence. Although its imagery and materials are analogous, that drawing is broader and less meticulous. A sheet in the Louvre (inv. no. 2168) related to this project represents the personification of the Adriatic Ocean. Since Vasari specifically mentioned this compartment in his description of the project and credited his assistant Cristofano Gherardi with the painting (Vasari 1878–85, vol. 6, p. 225), the drawing is attributed to that artist. Its style is not compatible with the Worcester drawing. See Barocchi 1964, pp. 54–55, fig. 33.

9. See Cecchi 1978, pp. 53–54.

8. *Susanna and the Elders*

1. For biographical information on Campi, see Godi/Cirillo 1978; Giulio Bora in Gregori 1985, pp. 127–31.

2. See Bober 1988.

3. For a discussion of this painting cycle, see Giulio Bora in Gregori 1985, pp. 136–37.

4. Daniel 13:1–64. Although it was part of the ancient Hebrew book of Daniel, the story of Susanna was not found there by Saint Jerome and thus was relegated to the Apocrypha.

5. Tietze-Conrat 1939; Vey *Catalogue,* p. 87; Vey 1958, p. 18.

6. Tietze-Conrat 1939, p. 160; Ostrow 1968, p. 20; Bora 1980, p. 38; Olszewski 1981, pp. 138–39.

7. See Giulio Bora in Gregori 1985, pp. 281–91.

8. See Bailey 1977, pp. 114–17.

9. See Bora 1971, p. 36; Weiner 1988, cat. no. 8.

9. *Constantinopolis*

1. The definitive study of Lombard is the monograph by Godelieve Denhaene (1990); see also Liège 1963; Liège 1966.

2. See Denhaene 1990, pp. 9–10 and pp. 317–21, for sixteenth-century documents relating to Lombard.

3. Van Mander 1906, vol. 1, pp. 164–67.

4. Lampsonius 1565.

5. On the Lombard Academy, see Denhaene (1990, pp. 217–21), who recorded seventy prints after Lombard (pp. 313–15) by many printmakers, including Balthazar van den Bos, Cornelis Bos, Hieronymus Cock, Hans Collaert, Dirck Volckhertsz. Coornhert, Cornelis Cort, Giorgio Ghisi, Pieter van der Heyden, Lambert Suavius, and Lombard himself.

6. It is difficult to reconcile Lampson's description of the workshop's output with extant prints. One identifiable plate was engraved there by Cornelis Bos around 1545, but many engravings described as having been reissued by Hieronymus Cock's Antwerp publishing house Aux Quatre Vents (At the Sign of the Four Winds) after 1550 still elude identification. Timothy Riggs (1977, cat. nos. 155–73) listed nineteen prints after the artist published by Cock. He also suggested that Lampsonius's description of Lombard's print shop may have recorded intention rather than actuality. It is possible, however, that the prints published by Cock were printed from a set of plates inherited from Lombard's teaching print shop.

7. On Constantinopolis in ancient and medieval art and Lombard's likely source, see Vickers 1986, p. 303.

10. *Two Men in Conversation*

1. For biographical information on Maso, see Cannon-Brookes 1968; Pace 1976.

2. Vasari 1878–85, vol. 7, p. 268.

3. On the Studiolo, see Vitzthum 1965; Bucci 1965.

4. The Turin drawing was attributed to Maso and connected with the Studiolo *Diamond Mining* panel by Janet Cox Rearick (1964, pp. 410–11, no. A361). Cannon-Brookes accepted this attribution (1968, p. 187); see also Bertini 1958, p. 48 n. 353.

5. See Monbeig-Goguel 1972, p. 53, cat. no. 49.

11. *The Madonna and Child with Saints and the Mystic Marriage of Saint Catherine*

1. For biographical information on Lanino, see Elena Ragusa in Romano 1986, pp. 220–38.

2. See Sadik 1956.

3. Vey *Catalogue*, no. 95; Vey 1958, pp. 14–15.

4. See Astrua/Romano 1985, pp. 33–34; Romano 1986, p. 257.

5. For example, the present drawing compares closely with the master's drawing of the enthroned *Madonna and Child with Saints and Donors,* now in the Biblioteca Reale in Turin, inv. no. 16153 DC; see Astrua/Romano 1985, p. 105.

6. For the legend of Saint Catherine of Alexandria, see Voragine 1941, pp. 708–16.

12. *David with the Head of Goliath*

1. On the Zuccaro brothers, see Gere 1969; Cleri 1993.

2. Zuccaro 1607.

3. Mundy 1989; Gere 1992.

4. 1 Samuel 17:38–51.

5. 1 Samuel 18:6–7.

6. See McTavish 1985, pp. 56–57.

7. See McTavish 1985, p. 56. James Mundy (1989, p. 298) disagreed with this hypothesis, believing that the present drawing is much later and should be dated to the end of Zuccaro's career.

13. *The Spies Returning from Canaan A Summer Fête in a Fantastic Town*

1. For biographical information on Bol, see Van Mander 1906, vol. 2, pp. 53–61; Franz 1965, p. 21.

2. On Bol's original etchings and the prints after his designs, see Hollstein, vol. 3, pp. 36–55.

3. Numbers 13:17–28.

4. Franz 1965, no. 133.

5. Vey 1959, p. 67.

6. Hans Bol, *A Tournament,* 1593, pen and wash, 15.0 × 21.7 cm, Brussels, Musées Royaux des Beaux-Arts; not in Franz. For the Hamburg drawing (our fig. 2), see Franz 1965, cat. no. 145.

7. Egbert Haverkamp-Begemann questioned whether this gouache was by Bol's hand (in Dresser 1974, vol. 1, p. 163). Although *The Spies Returning from Canaan* is indeed more precisely detailed and finely finished than *A Summer Fête in a Fantastic Town,* the style and technique of both miniatures are unmistakably Bol's and comparable to those of the drawings in Brussels and Frankfurt. It may be that this repetition of the master's design, produced late in his career, was painted or finished by one of Bol's assistants, who over the years included such skilled miniaturists as Jacques Savery, Joris Hoefnagel, and the artist's stepson, Frans Boels.

8. As Vey noted (1959, p. 69, n. 12).

9. See Vredeman de Vries 1581; Vredeman de Vries 1583.

10. Bramsen 1976.

11. See Koechlin 1924, vol. 1, pp. 373–90.

12. Bol's paintings prefigured the dalliances and celebrations of the fêtes that take place in the parks and canals of imaginary chateaux depicted by David Vinckboons in the early seventeenth century; see William Robinson in Hand 1986, pp. 301–2.

14. *Saint Ansano Baptizing the Sienese*

1. For biographical information on Vanni, see Riedl 1976.

2. "Sicondo il disegnio che n'ha lasciato di sua mano ne l'Opera"; see Riedl 1969, p. 163.

3. As Riedl (1960, p. 165) recognized.

4. See Riedl 1960, pp. 163–67; Ostrow 1968, p. 25; Riedl 1976, pp. 23–24. To this group may be added the black chalk drawing of *The Kneeling Man and Ansano's Hand,* formerly in the collection of Stefan von Licht; see Nissman/Abromson 1992, no. 10.

5. See Olsen 1962, pp. 163–69, pl. 45.

15. *Ruins of the Palace of Septimus Severus on the Palatine*

1. On Matham, see Strauss 1980; Widerkehr 1991.

2. See Reznicek 1961, vol. 1, pp. 110, 433. In these drawings the ground is often rendered in undulant parallel pen lines, which are similar to those in the drawings of Giulio Campagnola and to woodcuts produced in the circle of Titian. This manner probably provided the model for both Goltzius's and Matham's work.

3. Vey (1958, pp. 22–24) identified a copy of the drawing in the Rijksprentenkabinet in Amsterdam; see Boon 1978, vol. 1, pp. 33–34.

4. Stechow 1970, p. 55.

5. See D'Hulst 1972, pp. 12–13; Boon 1980, pp. 157–58.

6. Boon 1978, vol. 1, p. 33; Boon 1992, vol. 1, pp. 256–57.

7. See Widerkehr 1991, pp. 240–41.

16. *The Council of the Gods*

1. For biographical information on Rubens, see White 1987.

2. On Rubens as a draftsman, see Burchard/ D'Hulst 1963.

3. A story related by the ancient Roman author Apuleius in *The Golden Ass* (books 4–6).

4. Letter to the author, 8 July 1991. In an earlier conversation Egbert Haverkamp-Begemann concurred with this assessment of the drawing.

5. Letter to the author, 3 August 1993. Jaffé also suggested that the repairs along the left and right edges could have been made by the nineteenth-century collector P. H. Lankrink,

who mended other Rubens drawings in his possession.

6. See Jaffé 1977.

7. See Stampfle 1991, p. 138, no. 296; Goris/ Held 1947, p. 43, no. 100; Jaffé 1977, p. 100. Like the present drawing, the sheet in the Morgan Library was once owned by P. H. Lankrink.

17. *Prudence*

1. See Boerner 1987, no. 6.

2. For biographical information on Wägmann, see Thöne 1966.

3. Matthew 10:16.

4. Letter to the author, 19 September 1994.

5. Müller 1988, pp. 122–23.

6. Ganz 1950, pp. 271–72.

7. This correlation was recognized by Werner Schade (see Boerner 1987, no. 6). For Holbein's drawing *Young Woman Throwing a Stone* (ca. 1532–43, pen and black ink with gray wash and white heightening on red prepared paper, 20.3 × 12.2 cm, Basel, Kupferstichkabinett, 1662.160), see Müller 1988, pp. 247–49.

18. *Domestic Conflict*

1. For biographical information on Guercino, see Mahon 1992, pp. 311–12.

2. On Guercino's genre drawings, including those of theatrical subjects, see Turner/ Plazotta 1991, pp. 205–28; Mahon 1991, pp. 290–310.

3. As suggested by Horst Vey (*Catalogue,* p. 93), who observed that the flintlock pistol is not cocked.

4. Inv. no. 1937.10.8.1; see Mahon 1969, p. 204; Turner/Plazzotta 1991, p. 206.

5. Inv. no. 861; see Mahon 1969, p. 205; Turner/Plazzotta 1991, p. 206.

6. See Mahon 1969, p. 204. Nicholas Turner and Carol Plazzotta (1991, p. 206) describe this drawing as "A Woman Pulling out a Young Girl's Tooth," because they read the line running from the end of the distaff into the mouth of the kneeling figure as a thread. Guercino may have meant it as such, but another thread leads from the end of the distaff to a spindle dangling beneath. The line to the young girl's mouth may just be a misplaced pentimento, like the one below, where the artist experimented with the placement of her knee, or the line in the Worcester drawing leading from the woman's shoulder up to the man's elbow.

19. *Studies of Carriages and Carts*

1. For biographical information on Vrancx, see van den Branden 1883.

2. See Keersmaekers 1982, p. 168.

3. See Winkler 1964.

4. See Ruby 1990.

5. See Sotheby Mak van Waay 1984, lot 22.

6. See d'Hulst 1972, pp. 153–54.

20. *A Striding Philosopher*

1. For biographical information on the artist, see Pérez Sánchez/Spinosa 1992, pp. 51–55.

2. One of these canvases, representing an astronomer or philosopher, is now in the Worcester Art Museum, 1925.116; see Harold Wethey in Dresser 1974, vol. 1, pp. 509–11.

3. On Ribera as a draftsman, see Brown 1973, pp. 117–52; Pérez Sánchez/Spinosa 1992, pp. 193–230.

4. A similar bald old man pointing also appears as Saint Bernardino of Siena in an etching attributed to Ribera by Jonathan Brown (1973, p. 66), which exists in a unique impression at the Bibliothèque Nationale, Paris.

5. See Vitzthum 1970, no. 39; Brown 1973, pp. 164, 194; Manuel B. Mena Marqués in Pérez Sánchez/Spinosa 1992, p. 215.

6. Walter Vitzthum (1970, cat. no. 39) suggested that the subject of the Achenbach drawing might be related to Ribera's portraits of imaginary philosophers.

7. On the marble portrait of an old man from Otricoli, ca. 50 b.c., now in Rome, Museo Torlonia, see Kleiner 1992, p. 38.

8. On the life-size marble portrait of the emperor Augustus, from the Villa of Livia at Primaporta, 20–15 b.c., see Kleiner 1992, pp. 63–67.

9. In its composition and mood, the present work is similar to the other, roughly contemporary satirical drawings by Ribera that represent striding figures. One of these, now in the J. Paul Getty Museum in Malibu, California, is a large sheet representing a gaunt, hook-nosed man (see Pérez Sánchez/Spinosa 1992, p. 212). He wears similar seventeenth-century garb, with a long jerkin over a shirt with ample sleeves, leggings, and boots, as well as a feathered turban; following him is a homely pageboy carrying a halberd. The ugly, humorous faces of these two figures mark them as caricatures. In yet another of Ribera's drawings, now in a private collection in Madrid, a striding cavalier is dressed in an elaborate slashed and padded costume and wears a punchinello's mask (see Pérez Sánchez/Spinosa 1992, p. 213). Nude Lilliputian figures scale the cavalier, clambering over one another to hang on at the summit of his tall hat. The similarities among these three drawings show that Ribera had developed a satirical archetype in this striding figure, which became symbolic of pretense and pomposity.

21. *A Satyr Family among Animals*

1. For biographical information on Castiglione, see Timothy Standring in Dillon 1990, pp. 13–28.

2. Percy 1971, p. 27.

3. As suggested by Ann Percy in a letter to the author, 21 April 1993.

4. The painting may also contain more pointed references to the muses of lyric and amorous poetry; see Federica Lamera in Dillon 1990, p. 129.

5. As observed by Richard Bernheimer 1951, p. 47.

22. *The Beheading of Saint John the Baptist*

1. Otto Benesch (1954–57, vol. 3, no. 480a), who accepted the attribution to Rembrandt, first dated this drawing ca. 1640, comparing it to another *Beheading of John the Baptist,* then in the Von Hirsch collection, which he also dated ca. 1640 (no. 480).

2. Haverkamp-Begemann 1961.

3. Sumowski 1963, p. 207, no. 31.

4. Compare, for example, the drawings attributed to Bol and catalogued by Sumowski 1979, vol. 1, nos. 98, 183x.

5. In a letter to the author, 2 August 1994, Robinson compared the style of the present drawing to a sheet in Rotterdam that Sumowski attributed to Eeckhout (1979, vol. 3, no. 815xx).

6. Matthew 14:1–2; Mark 6:21–28; Luke 9:7–9.

7. See Benesch 1954–57, vol. 3, pp. 139–40, for several related drawings of decollation by Rembrandt and his workshop. There are notable similarities among the present sheet, the Von Hirsch drawing (see n. 1, above), and an etching, which is dated 1640 in the plate (Bartsch 92).

8. The setting for Rembrandt's drawing *The Beheading of John the Baptist* (Benesch 1954–57, vol. 3, no. 480) is also comparable.

23. *An Ostrich Hunt*

1. For biographical information on della Bella, see Massar 1971.

2. On della Bella as a printmaker, see DeVesme/Massar 1971; on della Bella as a draftsman, see Viatte 1974.

3. De Vesme/Massar 1971, vol. 1, cat. nos. 732–40.

4. See Bok-van Kammen 1980.

5. On Stradanus's suite of 132 hunting drawings, see Sotheby's 1987; on the series of 104 prints after them published by Philips Galle in Antwerp in 1579, see Hollstein, vol. 7, p. 81, nos. 424–527. Stradanus's design for the ostrich hunt is also reflected in an engraving by Harmen Jansz. Muller, published by Hieronymus Cock in Antwerp in 1570 (Hollstein, vol. 14, p. 104, no. 122; Worcester Art Museum, 1995.1). This plate represents a mounted chase with hunters using lances to subdue a bird that runs away from the viewer. It also incorporates the border from the tapestry, with swags of fruit interlacing the lion and ostrich heads with hunters, hounds, ibexes, and other game.

Stradanus's student Antonio Tempesta (1555–1630) also made nearly 200 different etchings of hunting subjects. Among them is a plate representing an ostrich hunt with horses and hounds, in which the hunters carry lances and specialized sticks to grasp the birds' huge necks (Bartsch 1126).

6. Vey 1958, p. 30.

24. *Christ and the Woman Taken in Adultery*

1. For biographical information on Giordano, see Ferrari/Scavizzi 1992, vol. 1, pp. 239–48.

2. In about 1674 Giordano painted an altarpiece for the church of Santa Maria del Pianto in Venice representing *The Deposition;* see Ferrari/Scavizzi 1966, vol. 1, p. 39, vol. 2, pp. 28–29. A reduced version of that painting is in the Worcester Art Museum (1969.1); see Dresser 1974, vol. 1, pp. 365–66. Soon afterward, it seems, Giordano depicted the myth of *The Triumph of Galatea* in a canvas first described in 1677; that painting is now in the Palazzo Pitti in Florence, and a smaller oil sketch is in Worcester (1961.32). On *The Triumph of Galatea,* see Ferrari/Scavizzi 1992, vol. 2, cat. no. A229; for the Worcester version, see Ferrari/Scavizzi 1992, vol. 2, cat. no. A230; Dresser 1974, vol. 1, pp. 366–67.

3. John 8:2–11.

4. Ferrari/Scavizzi 1992, vol. 1, cat. no. A72.

5. Ferrari/Scavizzi 1992, vol. 1, cat. no. A73.

6. It is puzzling that in the present drawing Christ writes with his left hand, a feature modified in all of Giordano's other versions of the composition. It may be that the artist ignored this fault in such a preliminary sketch where his main concerns were with formal and compositional matters. However, it also is possible that this sketch records his concept for an etching, in which the printing process would reverse the image. Giordano did execute the etching *Christ and the Woman Taken in Adultery* in 1653 (see Reed/Wallace 1987, pp. 286–87). However, the general composition of that image and the poses of Christ and several figures are quite different from those in the present drawing, which has much stronger ties to the Bremen painting and its antecedents.

7. See Ferrari/Scavizzi 1992, vol. 1, cat. nos. D23, A74.

8. A sketch by Giordano in the Uffizi in Florence (Ferrari/Scavizzi 1992, vol. 2, cat. no. D164, fig. 1040), representing *An Allegory of the Triumph of Wisdom,* has notes identifying the figures in both chalk and pen and ink. The style of these notations seems consistent with that of the inscriptions on the present sheet.

25. *A Riverside Landscape*

1. For biographical information on Grimaldi, see Batorska 1972, pp. 12–34.

2. On Grimaldi as a printmaker, see Bellini 1974; Reed/Wallace 1987, pp. 179–81.

3. See Lulofs 1992.

4. See Batorska 1982.

5. In 1666 the artist made a gift to Pope Alexander VII of drawings he had made in preparation for his decorations of a room in the Falconieri family Villa Rufina at Frascati; see Batorska 1972, p. 26.

26. *A Bathing Party*

1. For biographical information on Pace, see Erich Schleier in Kahn-Rossi 1989, pp. 82–85, 319–22; Cocke 1991.

2. Faldi 1966, p. 144.

3. Schleier in Kahn-Rossi 1989, pp. 319–22.

4. Cocke 1991, p. 361; some of Cocke's attributions have been questioned by Erich Schleier (1992).

5. Leach/Wallace 1982, p. 304.

6. Letter to the author, 14 December 1992.

7. Letter to the author, 12 July 1993.

8. See Cocke 1991, p. 374, no. 4, fig. 19.

27. *A Young Footman*

1. For biographical information on Palamedesz., see Bode 1883, pp. 126–33.

2. On Palamedesz. as a portraitist, see Burg 1911, pp. 293–95. The Worcester Art Museum also owns Palamedesz.'s *Portrait of a Man,* 1652, oil on canvas, 76.5 × 63.2 cm (1920.94); see Haverkamp-Begemann in Dresser 1974, vol. 1, pp. 125–26.

3. See Sutton 1984, pp. 292–93.

4. The border in pen and brown ink and the graphite on the verso, which traces the main contours of the figure, were added by later hands.

28. *The French Man-o-War "Royale Thérèse"*

1. On van de Velde, see Cannenburg 1950; Robinson 1958; Kaufmann 1981.

2. See Boymans-van Beuningen 1979; Kaufmann 1981.

3. Letter to the author, 7 January 1993.

4. Pierre Puget, *The Stern of the Ship "Paris,"* 1669, pen and black and brown inks heightened with white, 42.9 × 57.2 cm, Marseilles, Musée des Beaux-Arts, D.36.

5. Le Conte 1935.

6. Letter to the author, 7 January 1993. Yet another study, now in the Museum Boymans-van Beuningen in Rotterdam, has a legend that also alludes to the visit of King Charles II (inv. no. MB1866/T135). See Boymans-van Beuningen 1979, vol. 1, p. 65, pl. 255. The drawing is inscribed, *"frans schout bij nacht sweerls wonder."*

7. Robinson 1958, p. 175.

29. *View of Venice*

1. See Jatta 1992.

2. Walton 1981, p. 435 n. 5.

3. On Cruyl's activity in Rome, see Egger 1927; Francis 1943; Jatta/Connors 1989.

4. Hollstein, vol. 5, p. 99, nos. 11–26.

5. Two of these drawings, now in the Museum of the Chateau of Versailles, outside Paris, depict bird's-eye views of the entire palace complex, one from the east and one from the west. See Walton 1981, pp. 425–27.

6. Around 1689 he executed a topographical view of ancient Jerusalem with the battle of Judas Maccabeus and Antiochus, with a leg-

end on the verso comparing Louis XIV with Maccabeus. See Eisler 1988.

7. See Jatta 1992, nos. 87, 103, 104.

8. Sotheby's 1987, pp. 12, 60, lot 13.

9. The first (Jatta 104; 15.0 × 21.3 cm) is inscribed: *Prospectus Fori celeberrimi Sancti Marci Evang. / . . . Venetys a L. Cruyl delineatus.* The second (Jatta 103; 14.8 × 21.3 cm) is inscribed: *Prospectus celeberrimi Pontis Rialto / . . . Venetys a L. Cruyl delineatus.* Although the Worcester drawing bears no such legend, a note in the curatorial files describes an old mount, now lost, that was inscribed: *Prospectus Area S. Marci locorum adjacentium Venetys a Livino Cruyl delineatus 1676.* See Sotheby's 1987, pp. 12, 60, lot 13; Jatta 1992, no. 91.

10. Langedijk 1963, p. 86.

30. *Venus at the Forge of Vulcan*

1. For biographical information on Calandrucci, see Pascoli 1965, vol. 2, pp. 308–17; Graf 1986, vol. 1, pp. 17–28.

2. See Lione Pascoli's biography of Giuseppe Passeri (1965, vol. 1, p. 217).

3. Pascoli 1965, vol. 2, p. 311; reprinted in Graf 1986, vol. 1, p. 203.

4. As Matizia Maroni Lumbroso shows (1962, pp. 544–45). Today, in place of the painted ceiling in the Salone Rosso, destroyed in 1882, there is a coffered ceiling with painted rinceaux ornament. Only portions of the figural friezes remain at the top of the walls. The fictive architecture that provides the compositional structure in those paintings gives some suggestion of Calandrucci's painted ceilings (see Graf 1986, vol. 2, pp. 496–500).

5. On the basis of Calandrucci's drawings, Dieter Graf (1986, vol. 1, p. 50) speculated that the artist also designed similar oval narrative compositions representing Juno Bidding Aeolus to Release the Winds and perhaps Acis and Galatea.

6. Virgil *Aeneid* 8.370–85.

31. *The Crucifixion*

1. For biographical information on Boitard, see Hans Vollmer in Thieme/Becker, vol. 4, p. 223.

2. On Lafage, see Whitman 1963.

3. Houbraken 1718–21, vol. 1, p. 170.

4. Von Heusinger 1986, pp. 194–95.

5. Guiffrey/Marcel 1907–28, vol. 1, pp. 72, 74–75.

6. Pushkin 1977, nos. 6, 7.

7. Bjurström 1976, nos. 160–63.

8. Whitman (1963, p. 83 n. 47) describes a suite of erotic drawings by Boitard.

9. Bjurström 1976, cat. no. 159.

32. *The Judgment of Solomon*

1. For biographical information on van Mieris, see Sluijter/Enklaar/Nieuwenhuizen

1988, p. 152. On Frans van Mieris the Elder, see Naumann 1981.

2. See Hollstein, vol. 14, 1956, p. 49.

3. Fock 1973.

4. 1 Kings 3:16–28.

5. Welu 1977, pp. 15–17.

33. *Studies of a Soldier*

1. For biographical information on Parrocel, see Charles-Nicholas Cochin in Dussieux 1854, vol. 2, pp. 405–27; Parrocel 1861, pp. 47–70; Schuman 1979, pp. 2–36.

2. See Robichon de la Guérinière 1733. A second edition of Robichon's treatise, published in 1736, includes eighteen plates etched by Parrocel himself.

3. On Parrocel as a printmaker, see Robert-Dumesnil 1835–50, vol. 2, pp. 207–20.

4. Matthiesen 1950, p. 20, cat. no. 60.

5. See Cochin in Dussieux 1854, vol. 2, p. 414; Schuman 1979, p. 105.

6. See Niemeijer 1967; Guy Grieten in D'Hulst 1983, pp. 182–83.

7. Bjurström 1982, cat. nos. 1097, 1102; Bauereisen/Stuffmann 1986–87, p. 80.

8. Bauereisen/Stuffmann 1986–87, p. 81, cat. no. 61.

9. Charles Parrocel, *Head of a Soldier,* ca. 1740, red chalk on cream laid paper, Montpellier, Musée Atger, Doucet 2894; see Schuman 1979, pp. 132–33, cat. no. D35.

10. Schuman 1979, pp. 133, 135.

34. *Portrait of Charlotte Philippine de Châtre de Cangé, Marquise de Lamure*

1. Dresser 1974, vol. 1, p. 234.

2. A contemporary biographical sketch of the artist was written by Bernard Lepicie (1752, vol. 2, pp. 1–41); the most comprehensive study of the artist is the monograph by Thierry Lefrançois (1994).

3. The inscription may be translated: "Charlotte Philippine de Châtre de Cangé, widowed in her first marriage to M. de Boze, [married] widowed in the second to the Marquis de Lamure. Died 1 April 1789. First cousin of Madame du Can, née Charlotte Rosalie de Châtre. This label affixed on 24 April 1846" (the word *mariée* is effaced).

4. Dresser 1974, vol. 1, pp. 234–35.

5. For biographical information on the sitter and her two husbands, see Lefrançois 1994, pp. 266–68.

6. Lefrançois 1994, p. 268.

7. Another example of Coypel's use of this device is his pastel portrait *Madame de Mouchy in a Ball Gown,* engraved by L. Surugne in 1746.

8. Madelyn Gutwirth (1992, pp. 87–88) suggests that the marquise is seated in a theater loge and describes her as a typical society beauty of the Rococo.

9. I am grateful to Deborah A. Kraak of the Winterthur Museum for her assistance in the study and description of the costume.

10. Millia Davenport (1948, vol. 2, p. 678) mentions the fashion for wearing the cap lappets pinned up in this way in her brief discussion of Charles Coypel's painted portrait assumed to be that of Madame de Mouchy of 1748. That lady was so concerned with the correct details of costume and deportment that Marie Antoinette nicknamed her "Madame Etiquette."

35. *The Miracle of Intercession*

1. For biographical information on Tiepolo, see Levey 1986.

2. Letter to Daniel Catton Rich, director of the Worcester Art Museum, 26 September 1964. Knox suggested that the drawing may have come from the famous Orloff Album (see Knox 1961), but nothing is known of its early provenance. On the verso are framing measurements in French written in a loopy hand that has a nineteenth-century appearance.

3. Addis/Arnold 1951, pp. 721–23.

4. 2 Kings 2:8.

5. 2 Kings 2:9–15.

6. This painting is now in the Brera Gallery in Milan; see Gemin/Padrocco 1993, pp. 240–41.

7. Barcham 1989, p. 144.

8. On the *gran salone* of the Scuola dei Carmini, see Levey 1986, pp. 106–9; Gemin/Pedrocco 1993, pp. 352–55.

9. See Niero 1976–77.

36. *The Two Goats*

1. For biographical information on Oudry, see Opperman 1977 and the catalogue of the definitive exhibition in Paris (Opperman/Rosenberg 1983).

2. See Opperman 1977, vol. 2, cat. nos. D170–220, E56–65; Carlson/Ittmann 1984, pp. 70–71.

3. La Fontaine 1755–59; see also Opperman 1977, vol. 2, pp. 682–85; David P. Becker in Carlson/Ittmann 1984, pp. 139–41.

4. The drawings remained together until the 1960s, when they both appeared on the art market at the Schaeffer Gallery in New York. Its pendant was offered in an auction at Sotheby's, London, in March 1990 (see Opperman 1977, vol. 2, p. 712).

5. Rosenberg further suggested that the drawing was made in the nineteenth century; see Opperman 1977, vol. 2, p. 712.

6. Letter to the author, 25 August 1991.

37. *Study for the Figure of Chronos*

1. For biographical information on Batoni, see Clark 1985.

2. Clark 1985, p. 239.

3. On Duquesnoy's *Saint Susanna,* see Wittkower 1958, pp. 178–79, figs. 95B, 100.

4. Marcantonio Raimondi, after Raphael, *The Judgment of Paris,* ca. 1517–20, engraving, 29.8 × 44.2 cm; see Shoemaker 1981, pp. 146–47.

5. Inv. no. 1958.88; see Clark 1985, p. 378, no. D5.

38. *A Children's Bacchanal*

1. For biographical information on de Wit, see Staring 1958.

2. For an illustrated discussion of a room decorated with paintings by de Wit and others, with ornamental carved woodwork, see Fock 1980.

3. Purchased by the museum from Lucien Goldschmidt in New York, this drawing is accompanied by a counterproof on a paper similarly prepared with tan-colored wash (1964.83.2). Signatures on both sheets, in pen and black ink, inscribed as if the sheets were horizontal, do not seem to be in de Wit's hand; see *Art Quarterly,* vol. 28, 1965, p. 109.

4. De Wit's extensive and accurate drawings of Rubens's ceiling decorations in the Jesuit church in Antwerp, made about 1711–12, became the best record of this painting cycle after the destruction of the church in 1718.

5. On Boreel (1684–1738), see Elias 1903, vol. 1, pp. 537–38.

6. I am grateful to Eric Domela Nieuwenhuis of the Rijks Universiteit, Leiden, for determining this fact and for information on Jan Jeronimus Boreel.

7. See Staring 1958, pp. 155, 194, fig. 101. A pair of panels by de Wit recently on the art market also shares figures, situations, and motifs with the present sheet; see *Apollo,* vol. 141, March 1995, suppl., p. 34. Painted in colors, one of these oils on a small panel (38.0 × 25.5 cm) is dated 1747.

39. *Revelers in a Park before a Fountain of Neptune*

1. Much of what we know about Baumgartner's life comes from a treatise by Paul von Stetten the Younger on the history of Augsburg (Stetten 1765, pp. 216–19), published a few years after the artist's death. A more comprehensive biography is Alois Hämmerle's account (Hämmerle 1906; Hämmerle 1907), included in his articles about the monastic church in Bergen decorated by the artist, based on Stetten's account of the artist's life as well as on handwritten notes of the Augsburg engraver and publisher Georg Christoph Kilian, a friend of Baumgartner, and on eighteenth-century letters and documents from Augsburg, Nuremberg, and Bergenau. For additional information on Baumgartner's career, see Bushart 1981, pp. 69–70; Geissler-Petermann 1993.

2. On Baumgartner's reverse paintings on glass, see Ryser 1989.

3. Geissler-Petermann 1993, p. 615.

4. Bushart 1981.

5. See Billesberger 1995, pp. 22, 47.

6. Billesberger 1995, pp. 24–30.

40. *Fame and Putti in the Clouds*

1. The authoritative monograph on Domenico Tiepolo as a painter is Mariuz 1971; on his activity as a draftsman, see Shaw 1962.

2. For information on Tiepolo's activity as a printmaker, see Rizzi 1971.

3. For the oil sketch, see Mariuz 1971, p. 150. For the etching, see Rizzi 1971, no. 147. Although the fluttering pose of Fame in the etching is quite close to that in our drawing, she does not carry a laurel wreath in her left hand. In the etching Fame proclaims the virtue of Hercules, who rides across the sky in a chariot drawn by a centaur. A banner fastened to her trumpet bears the inscription "*VIRTVTE.*"

4. Another version of the composition, in a painting in the Thyssen-Bornemisza collection at Lugano (Andrade/Guerrero 1992, p. 372), lacks the figure of Fame.

5. See Christie's 1965, lot 58.

6. An inscription in the Worcester Art Museum copy of the Christie's sale catalogue notes that the present lot (58) was purchased by "Barrett."

41. *The Bodies of Saints Peter and Paul in the Catacombs*

1. On Subleyras, see Rosenberg/Michel 1987.

2. For example, Subleyras's *Charon Ferrying the Dead*, executed about 1735, now in the Louvre, and his *Saint Camille de Lellis Ministering to the Sick* of 1746, now in the Museo di Roma. Rosenberg (1972, p. 229) observed that in the painting *Tobias Burying the Dead* in the Museum at Saintes, Charente-Maritime in France, traditionally attributed to La Traverse, one of the corpses lying on the stair is quite similar to the uppermost, highlighted figure in the present drawing.

3. Rosenberg 1972, p. 229, cat. no. 157.

4. On La Traverse in Spain, see Ceán Bermúdez 1800, vol. 5, pp. 74–77.

5. See Cornillot 1957, cat. nos. 99–108. Drawings by La Traverse in Rouen and at the National Library of Madrid also have affinities with the present sheet.

6. Cornillot 1957, cat. no. 107.

42. *Portrait of a Young Woman*

1. For biographical information on Frye, see Wynne 1972; Wynne 1982.

2. On Frye as a printmaker, see Chaloner Smith 1878–82, vol. 2, pp. 516–22; Wax 1990, pp. 43–44.

3. See Alexander 1973.

4. See Tait 1959; Lane 1961, pp. 85–95; Hugh Tait in Charleston 1965, pp. 42–52.

5. Chaloner Smith 1878–82, vol. 2, p. 516.

6. Chaloner Smith 1878–82, vol. 2, p. 516.

7. The distinctive striped fabric appears in others of Frye's drawings and prints. For example, the material is similar in its pattern to the fabric wound into the headpiece worn by the young man in a drawing that depicts a *Young Man in a Turban*, ca. 1760 (42.5 × 31.5 cm, New Haven, Yale Center for British Art, B1979.31.1), which was made in preparation for the mezzotints of the first series (Chaloner Smith 1878–82, vol. 2, cat. no. 14).

8. Chaloner Smith 1878–82, vol. 2, cat. no. 10.

9. Thomas Frye, *A Man in a Turban*, ca. 1760, charcoal and white chalk on cream laid paper, 42.5 × 31.5 cm, Seattle Art Museum, gift of Mr. and Mrs. Charles M. Clark, 53.91. See Chaloner Smith 1878–82, vol. 2, p. 520, cat. no. 16; Wynne 1972, p. 84, cat. no. 37, fig. 25.

10. Chaloner Smith 1878–82, vol. 2, cat. no. 16.

11. Chaloner Smith 1878–82, vol. 2, cat. no. 1.

43. *The Annunciation*

1. For a recent survey of Boucher's life and art, see Laing 1987.

2. For surveys of Boucher's activities as a draftsman and designer, see Ananoff 1966; Jacoby 1986.

3. See Heim 1977, no. 12.

4. As suggested by Alastair Laing in a letter to the author, 26 January 1993. Having exhaustively studied the documents relating to Boucher's career and the eighteenth-century sale catalogues, Laing was not able to find any drawing of this subject by Boucher that was sold or mentioned in the eighteenth century.

44. *Portrait of Joseph Barrell*

1. For biographical information on Copley, see Amory 1882; Prown 1966.

2. A drawing by Copley, now in the Worcester Art Museum, is a study for an early conception for this project, representing *Queen Charlotte and Princess Amelia*, ca. 1784, black chalk heightened with white on cream wove paper prepared with gray wash, 43.8 × 31.9 cm, gift of Mr. and Mrs. Arthur L. Williston in memory of Clarence H. Denny, 1952.29.

3. These works include *Portrait of Deborah Scollay Melville*, ca. 1762, watercolor on ivory, 3.2 × 2.5 cm, 1917.184; *Portrait of Mrs. John Murray*, 1763, oil on canvas, 126.7 × 101.6 cm, 1969.37; *Portrait of John Bours*, ca. 1763, oil on canvas, 127.6 × 101.9 cm, 1908.7; *Portrait of Mrs. Samuel Phillips Savage*, ca. 1762, oil on canvas, 127.0 × 101.6 cm, 1916.51.

4. Joseph was a descendant of George Barrell, who emigrated to America from Saint Michaels, Suffolk, in 1637. See Joseph Barrell's obituary in the Boston *Monthly Anthology*, 1804, p. 571; see also the broadside published in Boston after Barrell's death: *Died at his seat Pleasant Hill. Saturday morning last. Joseph Barrell, Esq.*, American

Antiquarian Society, Worcester, microform, Shaw-Shoemaker no. 6166.

5. After Pleasant Hill was sold by Barrell's heirs, it became the McLean Asylum; see Little 1968; Kirker 1969, pp. 45–55; Thornton 1989, pp. 39–43.

6. See Schofield 1993, pp. 36–51 passim. To celebrate what they knew would be a historic voyage, Barrell and his partners even produced a commemorative medallion, the die for which might have been engraved by Paul Revere. The medal carried the names of the ships, their captains, and the expedition financiers, surrounding an obverse image of the ships. Several hundred were struck in copper, pewter, and silver, and they were sent with the ships. See Schofield 1993, p. 45.

7. See Bayley 1915, p. 19. Later Copley painted the merchant's second wife, Hannah Fitch Barrell; see Rebora 1995, pp. 268–89, cat. no. 58.

8. Prown 1966, vol. 1, p. 66.

9. Now in the Museum of Fine Arts, Boston, 1987.295; see Rebora 1995, pp. 245–46, cat. no. 45.

45. *Study of Drapery*

1. For biographical information on Prud'hon, see Quarré 1959.

2. See Guiffrey 1924, pp. 466–67.

3. As noted by Horst Vey (*Catalogue*, p. 39).

4. Letter to the author, 9 August 1994.

5. The inscription reads: "*esquisse d'une draperie de fond de tableau éxécuté en miniature à huile en 1778.*"

6. Vey *Catalogue*, pp. 39–40.

7. Clément 1870, p. 37.

8. Clément 1870, pp. 302, 416.

46. *Apollo with a Cithara*

1. For biographical information on David, see Schnapper 1989, pp. 558–637.

2. On David as a draftsman, see Arlette Sérullaz in Schnapper 1989, pp. 22–29; Sérullaz 1991.

3. See Stewart 1990, vol. 1, pp. 289–93.

4. See Sérullaz 1983, pp. 45–46, cat. no. 14; Schnapper 1989, cat. no. 50.

47. *Nymph and Satyr*

1. For biographical information on Rowlandson, see Grego 1880; Falk 1949.

2. The drawing is now in the Victoria and Albert Museum, London (P.13-1967); see Hayes 1990, pp. 66–69.

3. Rowlandson's *Three Judges: Cognovit, Fiere Facias, and Clausem Friget*, now in the Worcester Art Museum (n.d., pen and brown ink with watercolor on cream wove paper, 25.9 × 27.4 cm, museum purchase, 1919.314), is an example of a popular image reproduced by counterproofing (see Sir Robert Gore in Dresser 1974, vol. 1, pp. 60–61). The original of this famous

caricature of judges Sir Vicary Gibbs, Lord Ellenborough, and Sir Alexander Thompson is in the Laing Art Gallery in Newcastle-upon-Tyne, titled *We Three Logger-Heads Be* (ca. 1815, pen and ink with watercolor over graphite, 28.5 × 26.0 cm). There is one other drawing by Thomas Rowlandson in the Worcester Art Museum (*A Covered Cart*, n.d., watercolor over graphite on cream wove paper, 10.8 × 17.8 cm, museum purchase, 1951.15).

4. See Hayes 1990, pp. 196–97.

5. Antiope was a beautiful nymph admired by Jupiter, king of the gods. To hide his liaison with her, he transformed himself into a satyr and surprised her as she slept (see Ovid *Metamorphoses* 6.110–11). In another ancient myth, the princess Amyone was sent in search of water for holy ablutions, and she searched until she became exhausted. A salacious faun interrupted her sleep and was driven off when Amyone invoked the aid of the god Neptune (Hyginus, *Fabulae* 69).

6. On the ancient sculptural type of the sleeping Ariadne, see Bober/Rubenstein 1986, pp. 113–14; see also Meiss 1966.

7. See Rosand/Muraro 1976, pp. 280–81.

48. *Herod Desecrating the Tombs of the Kings*

1. For biographical information on Giani, see Acquaviva/Vitali 1979, pp. 197–223.

2. Acquaviva/Vitali 1979, pp. 62 n. 62, 211.

3. On Giani as a draftsman, see Massar 1976.

4. As recognized by Vey 1958, p. 37; see Josephus *Antiquitates Judaicae* 715. 3.

5. Vey 1958, p. 37.

6. See Pressley 1979, pp. 107–9; Cavina 1985, pp. 279–85. The Worcester Art Museum also owns drawings by other members of this circle of artists in Rome, including William Young Ottley (no. 52), John Flaxman (1993.21), Henry Singleton (1971.125), and James Jeffreys (1972.94).

49. *Portrait of Charles Brockden Brown*

1. For a recent biography of Brown, including a survey of his writings, see Axelrod 1983.

2. See Dunlap 1930, vol. 1, p. 305.

3. The pastel now at Independence Hall was given to the city of Philadelphia by a descendant of Brown in 1874. Knox (1930, p. 100) listed a third portrait of Brown in the collection given by the artist's wife in 1849 to the Royal West of England Academy, which has come down to the City Art Gallery in Bristol. However, this portrait represents a different, older sitter. The author is grateful to Karie Diethorn of the Independence National Historical Park and Francis Greenacre of the Bristol Museums and Art Gallery for generously sharing their research and information on Sharples.

4. *The Diary of Ellen Sharples*, Bristol, Royal West of England Academy, on deposit at the National Portrait Gallery, London, p. 120.

5. The Worcester Art Museum also owns another pair of pastel portraits by James

Sharples or his wife, Ellen, both executed ca. 1800: *General William Hull*, 24.3 × 18.9 cm, and his wife, *Sarah Fuller Hull*, 23.8 × 18.8 cm, Alexander and Caroline Murdock DeWitt Fund, 1969.64–65; see Knox 1930, p. 96; Jareckie 1976, pp. 32–33. Hull (1753–1825) distinguished himself in the Revolution and rose to the rank of lieutenant colonel. In 1781 he married Sarah Fuller and settled in Newton, Massachusetts, to practice law. In 1805 Hull became governor of Michigan Territory, commanding territory forces in an invasion of Canada in the War of 1812. After embarrassing losses Hull was forced to surrender Detroit to the British. Condemned to death by court-martial for negligence, Hull was spared by President James Madison.

50. *Portrait of Thomas Jefferson*

1. On Chrétien's *physiognotrace*, see Hennequin 1932.

2. For biographical information on Saint-Mémin, see Dexter 1862; Ramsay 1962; Dijon 1965.

3. See Dexter 1862, who edited a catalogue of 762 of the engraved portraits. The Worcester Art Museum owns 34 of the engravings and, aside from the present sheet, one other drawing attributed to Saint-Mémin, *Portrait of Simeon Baldwin*, ca. 1810, charcoal and black, white, and gray chalks on pink prepared cream laid paper, 55.9 × 43.8 cm, gift of Bradley B. Gilman, 1967.11.

4. Kimball 1944, p. 524.

5. Kimball 1944, p. 524.

51. *Self-Portrait*

1. For biographical information on Cosway, see Williamson 1897; Lloyd 1995.

2. Sir Philip Currie in Daniell 1890, p. iv.

3. On the life and work of the German philosopher Jacob Boehme, see Hartmann 1977.

4. Richard Cosway, *Self-Portrait as Esau*, 1806, graphite and watercolor on cream wove paper, 25.7 × 21.5 cm, Florence, Galeria degli Uffizi, 1890 n. 3257; see Lloyd 1995, p. 127, cat. no. 161.

5. No catalogue seems to have been produced, though there were a number of notices in the press, one of which is reproduced in Daniell 1890, p. xi.

6. 1–2 June 1896. The Worcester miniature was lot 79 in that sale. It was purchased for the sum of 12 guineas by the great dealer in works by Cosway, E. M. Hodgkins, who sold in London and Paris.

52. *Rhea Delivering the Infant Zeus to Her Parents*

1. For biographical information on Ottley, see Ottley 1866; Gere 1958.

2. In one of Flaxman's sketchbooks, now in the Victoria and Albert Museum, London, several pages representing sculpture at Orvieto cathedral were drawn by Ottley; see Pressly 1979, pp. 141–44.

3. Ottley accompanied Humbert on a tour of Umbria in 1793; see Previtali 1962.

4. See Gere 1958; Scheller 1973.

5. Gere 1958, pp. 51–52.

6. See Pressly 1979, pp. 141–44.

7. Ottley's personal admiration for Fuseli is reflected in his essay on the artist that was included in Knowles's biography published in 1831 (vol. 1, pp. 421–27).

8. Binyon 1898–1907, vol. 3, p. 150.

9. Hesiod *Theogony*, 123–40.

10. Letter to the author, 1 March 1993.

11. Constable 1927, p. 100.

12. See Powney 1976, cat. no. 22; Bindman 1979, p. 129.

13. On Cambiaso, see Manning/Suida 1958.

53. *The Folksinger*

1. For biographical information and the most comprehensive treatment of Norblin's drawings, see Westfehling/Clercx-Léonard-Etienne 1989.

2. On Norblin as a printmaker, see Hillemacher 1948.

3. See Batowski 1911, pp. 176–95.

4. Batowski 1911, pp. 122–26.

5. Examples of this print series are in the collection of the Worcester Art Museum, 1926.224–31.

6. See Batowski 1911, pp. 50–51.

54. *An Iron Forge*

1. The authoritative biography of Cruikshank is the anecdotal account by Blanchard Jerrold (1882); see also Patten 1992.

2. George Cruikshank, *The Eclipse of the Sun*, 1809, graphite with gray wash on cream wove paper, 39.4 × 28.4 cm, 1934.235. Both these works are from the collection of Dr. Samuel B. Woodward, who bequeathed his collection of some 1,600 prints and 642 books illustrated by Cruikshank to the Worcester Art Museum in 1934; see Hamilton 1934.

3. Cruikshank's widow donated a large body of his work to the Victoria and Albert Museum in 1884, and she gave nearly 4,000 of Cruikshank's drawings to the British Museum in 1891.

4. The English-born Gough (1817–1886) was the son of a war veteran, raised on heroic tales that instilled a fertile imagination and a storyteller's flair. He emigrated to America at the age of twelve, settling in New York to train as a bookbinder and later work as an actor. When performing in Boston in the late 1830s, Gough married and began a family. He was an alcoholic, and this affliction caused the loss of his wife and child and reduced him to a life of poverty on the streets of Boston and Worcester. However, in 1842 Gough gained control of his drinking, found a new career in lecturing and writing about the horrors of alcoholism, and became a champion of the temperance movement. He remarried and settled in West Boylston,

north of Worcester, where his estate Hillside remained his home throughout an ensuing career, marked by notoriety and success. Gough formed a large collection of Cruikshank's works, and between his visits to Britain in 1853, 1857, and 1878 he tried unsuccessfully to promote the artist's reputation in the United States (see Gough 1871; Gough 1890; Martyn 1893).

5. See Gough 1871, pp. 440–41; Jerrold 1882, pp. 133–35.

6. Although this drawing was listed in the sale catalogue for Gough's collection in 1892, it apparently did not sell. Later Gough's widow gave it to Mary G. Whitcomb, from whom it descended to Esther Forbes Hoskins. The noted author of *Johnny Tremain* and other novels about the American Revolution, Mrs. Hoskins was a corporator of the Worcester Art Museum and made a gift of the drawing to the museum in 1962.

7. See Gilpin 1786.

55. *Study of a Male Nude*

1. For biographical information on Wicar, see Beaucamp 1939; Oursel 1984, pp. 5–18.

2. On Wicar as a collector, see Beaucamp 1939, vol. 2, pp. 555–68; Oursel 1984, pp. 80–81. The first of Wicar's drawing collections was stolen in Florence in 1799 (see Gere 1958; Scheller 1973). The artist then compiled another group, which was sold in 1823 to Samuel Woodburn. He then formed yet another collection, including some of the stolen drawings that he had bought back, which was bequeathed to the Musée Wicar at Lille.

3. In 1826 Wicar wrote to his friend the Chevalier Alexis-François Artaud de Montar, secretary of the French embassy in Rome, discussing the Duke de Laval's picture; see Beaucamp 1939, vol. 1, pp. 539–40.

4. Beaucamp (1939, vol. 2, p. 664, no. 6) incorrectly identified the image as *Iphigenia Carrying the Ashes of Orestes*.

5. Beaucamp 1939, vol. 2, p. 639, no. 63; for a related drawing, see Oursel 1984, p. 45.

6. Beaucamp 1939, vol. 2, p. 639, no. 66.

7. Sophocles *Electra* 1095–1325.

8. See Quarré-Reybourbon 1961, pp. 26, 33; Beaucamp 1939, vol. 2, p. 640, no. 81.

9. A pencil drawing now in the Accademia di Belle Arte in Perugia shows that the artist's initial conception for the picture was quite different from his final solution. Another study preserved in the Musée des Beaux-Arts in Lille is inscribed to the Duke de Montmorency-Laval. Three other drawings representing the figures of Electra, Orestes, and Pylades—the first two in the final poses that appear in the painting—are in the collection of Pierre Rosenberg in Paris.

10. See Betti 1936, p. 485. Among the other works of art left to Bianchi in Wicar's will were other figure studies of Electra ("e quadro di Elettre che abbraccia l'Urna fatta in Gioventu") that may have been related to the Worcester painting.

Two other sketches in the collection of the Worcester Art Museum also seem to be related to this figure. They are *Study of a Sandaled Foot*, ca. 1826, black chalk on cream laid paper, 16.0 × 16.3 cm; and *Study of an Antique Sandal*, ca. 1826, black crayon on cream laid paper, 12.1 × 8.6 cm; both were the gift of Margot Gordon, 1994.237.1, 1994.237.2.

56. *Portrait of Timothy Pickering*

1. For biographical information on Peale, see Miller 1992.

2. On the Peale family, see Elam 1967.

3. An impression of the print is in the Worcester Art Museum (1910.48.3546); see Worcester 1994, p. 193.

4. On Timothy Pickering, see Pickering/Upham 1862–73.

5. In a letter of 27 June 1790, Charles Willson Peale applied to George Washington for the job of postmaster general, the position given to Pickering; see Miller 1983, vol. 1, p. 589.

6. See Sellers 1952, pp. 171–72. Pickering was also portrayed by James Sharples (no. 49) in a pastel now at the Massachusetts Historical Society (ca. 1800; see Oliver/Huff/Hanson 1988, pp. 75–76), and by Charles Févret de Saint-Mémin (no. 50) in a drawing at the Museum of Fine Arts, Boston (1806; 33.578), and engraved copies.

7. Letter to the author, 17 January 1996.

8. A drawing of Pickering is mentioned in Peale's letter to Dreer of 1860, which is now among the Peale Family Papers at the Smithsonian Institution (no. 003317).

57. *Sketch of Contadini*

1. For biographical information on Morse, see Prime 1875; Kloss 1988; Staiti 1989.

2. See Staiti 1989, p. 176. Louisa Dresser (1941, p. 71 n. 1) noted that Morse and Salisbury were distantly related, by the marriage of the painter's aunt to Salisbury's cousin.

3. Prime 1875, p. 199.

4. Quoted in Dresser 1941, p. 66.

5. Morse made a number of sketches at this site, among them a study of peasant women carrying their children in their arms, with their costumes carefully observed and with handwritten color notations. This sheet is now among the Morse papers in the Library of Congress. See Staiti 1989, pp. 181, 183, fig. 97.

6. Apparently Morse kept this drawing for many years. Its inscription indicates that nearly thirty years after its execution he gave the sketch to his friend John R. Chapin. An illustrator and painter who specialized in battle scenes, Chapin may have come to know the artist while he was a student and Morse a professor at New York University. See Bloch 1989, p. 52; Chapin 1895.

7. Samuel F. B. Morse, *The Chapel of the Virgin at Subiaco*, 1830, oil on canvas, 22.2 × 27.4 cm, Worcester Art Museum, museum purchase, 1941.16. See Dresser 1941,

p. 69; Kloss 1988, p. 121; Staiti 1989, p. 184, fig. 99.

The artist's sketches from this site yielded another finished canvas, representing an enlarged detail of the *Contadina Kneeling at the Shrine of the Virgin* (oil on canvas, 54.6 × 43.8 cm). Morse sold this small painting to an American, Charles Carvill, for one hundred dollars; it is now in the Virginia Museum of Fine Arts in Richmond; see Kloss 1988, p. 122.

8. Quoted in Dresser 1941, p. 68.

58. *Portrait of Mary Davis Denny Portrait of Joseph Addison Denny*

1. William Henshaw fought in the French and Indian Wars. During the Revolution he advocated for local militia before the Continental Congress, and he mobilized the Minute Men of Worcester County. Further information on Bascom's family and the military career of her father is given by Avigad 1987, p. 35.

2. Ruth Henshaw Bascom's diary descended through the Henshaw-Denny family and was donated to the American Antiquarian Society in Worcester by her great-nieces Mary Denny Thurston and Caroline L. Thurston. Eight years of the journal are missing, and two incomplete years, 1804 and 1805, were supplemented by the diarist's sister Clara. For biographical information on Bascom, see Fouratt 1986.

3. After a Mr. Taylor called on her one evening, she wrote, "he took his painting, and gave me a dollar." She wrote on 31 December 1828, "(since I have commenced drawing) my time is much more valuable."

4. Ruth Henshaw Bascom, *Portrait of Mary Smith Davis*, 1839, pastel over graphite with collage on cream wove paper, 48.7 × 35.7 cm, 1965.405; *Portrait of Charles Addison Denny*, 1837, pastel over graphite on cream wove paper, 40.1 × 30.3 cm, 1965.409. The children's portraits were drawings in graphite and pastel, not cut-paper silhouettes. They were executed first, in early July 1837. Bascom's other works at the Worcester Art Museum include *Portrait of Jacob Puffer*, 1829, pastel, graphite, and gouache with collage on blue wove paper, 50.4 × 37.7 cm; and *Portrait of Mrs. Jacob Puffer*, 1829, pastel, charcoal, and gouache with collage on blue wove paper, 50.3 × 36.9 cm. Both were the gift of Hazen Wheeler, 1979.19, 1979.20.

5. Bascom Diary, American Antiquarian Society, Worcester, 12 July 1839.

6. Bascom Diary, 19 July 1839.

59. *Study of a Young Woman*

1. For biographical information on Greenough, see Wright 1963.

2. See Greenough 1852.

3. Greenough 1887.

4. The drawing came to the museum bound into an extra-illustrated edition of Tuckerman's collection of artists' biographies (1867, vol. 3, pp. 246–75), where it is accompanied by three other sheets: an autograph letter from Greenough, *A Letter to Samuel Whitwel, with Sketches for a Monument for Mr. Buckminster*, 1833, pen and brown ink over graphite on cream wove paper, 24.8 × 20.7 cm, 1916.128.184; a two-sided study, *Castor and Pollux Exchanging Life and Death*, n.d., charcoal and white chalk over graphite on gray wove paper, 26.9 × 22.3 cm, 1916.128.187; and *Studies of the Head of a Child and the Head of a Woman*, n.d., graphite and white chalk on gray prepared off-white laid paper, 22.5 × 20.7 cm, 1916.128.188.

5. Tuckerman 1853.

60. *Study for the Portrait of Madame Moitessier*

1. See Naef 1977–80.

2. Davies 1936.

3. J.-A.-D. Ingres, *Portrait of Madame Moitessier Standing*, 1851, oil on canvas, 148.0 × 105.0 cm, Washington, D.C., National Gallery of Art.

4. Five other related sheets at the Musée Ingres at Montauban represent details of pose, costume, and the sitter's reflection recording the progress of the artist's work; see Ternois 1959, nos. 124–28. In the Fogg Art Museum at Harvard University there is another sketchy study of the pose of head and shoulders. This drawing, like the Worcester sheet, is marked with the Ingres estate stamp; see Cohn/Siegfried 1980, p. 58.

5. Mongan 1965a, p. 2.

61. *View of Rocca di Papa*

1. For biographical information on Brown, see Leavitt 1973.

2. On Brown's prints, see Bruhn 1992, pp. 62–63, 75.

3. Baedecker 1907, pp. 416–17.

62. *Bringing Home the Newborn Calf*

1. For biographical information on Millet, see Herbert 1976, pp. 21–31.

2. The Worcester Art Museum owns five other drawings by Millet: *The Milkmaid*, n.d., pastel on blue-gray laid paper, 19.0 × 30.7 cm, 1935.40; *The Vigil (Women Sewing)*, charcoal on cream wove paper, 32.7 × 26.5 cm, 1962.38; *A Sheet of Studies with Sketches of Phoebus and Boreas*, ca. 1854, graphite on cream laid paper, 27.2 × 20.9 cm, 1964.109; *Study for the Woodcutter and His Wife in the Forest*, n.d., charcoal on cream wove paper, 31.6 × 20.3 cm, 1964.110; and *Studies for La Maternité*, ca. 1870, graphite with oil paint on cream wove paper, 20.2 × 31.5 cm, 1971.121.

3. See Herbert 1966, pp. 42, 52–53, 60–61; Herbert 1976, pp. 143–45.

4. Robert Herbert (1976, p. 144) noted that the oil sketch is best known through an engraving after it by Maxime Lalanne, which was made for the catalogue of the Saucède sale of 1879.

5. In a letter dated 3 May 1864; see Cartwright 1902, pp. 264–65.

6. In a letter to his brother, Theo, written in early December 1889; see van Gogh 1958, vol. 2, p. 521.

63. *Studies of Horses*

1. For biographical information on Degas, see Boggs 1988.

2. See Boggs 1988, pp. 137–40.

3. For the Worcester study, see Dresser 1974, vol. 1, pp. 236–37.

4. As indicated by the estate stamp (Lugt 657) printed in red ink on the verso of the drawing. Although the right and bottom edges of the sheet seem to be cleanly trimmed, the left edge and top appear to have been torn against a straightedge.

5. See Reff 1976.

6. Letter to the author, 3 September 1993.

64. *Portrait of a Young Woman*

1. For a biographical chronology of Menzel's career, see Betthausen 1990, pp. 222–32.

2. On Menzel as an illustrator, see Ebertshäuser 1976; Griesebach 1984.

3. On Menzel as a painter, see Jensen 1982; Hochhuth 1991.

4. The *Portrait of a Young Woman* was once among the vast holdings of works by Menzel in the collection of the Nationalgalerie in Berlin after the artist's death. It was deaccessioned by the museum in 1924, as part of a group exchanged for rare drawings by Hans von Marées.

5. Letter to the author, 27 July 1994.

6. As such it may be compared with the sheet discussed in Hopp/Schaar 1982, p. 196.

65. *View of Civitella di Subiaco*

1. For biographical information on Lear and detailed discussions of his work, see Noakes 1985.

2. Lear 1832.

3. Gould 1832–37. Lear executed 68 of the 449 plates in this omnibus; see Noakes 1985, p. 208.

4. Lear 1846b.

5. Lear 1846a. This was followed by his children's books *Nonsense Verse* and *The Owl and the Pussycat*, which combine clever verse with purposely naïve illustrations.

6. Alfred, Lord Tennyson, *Poems*, with illustrations by Edward Lear and George Frederick Watts's photograph of the artist (London: Boussod, Valadon and Co.; New York: Scribner and Welford, 1889). See also Pitman 1985.

7. Pitman 1985, p. 100.

8. See St. John Gore in Dresser 1974, vol. 1, pp. 46–48. The Worcester Art Museum owns one other landscape drawing by Lear, representing a view in Argyllshire, 1875, watercolor over graphite heightened with white gouache on cream wove paper, 22.8 × 28.8

cm, bequest of Malcolm Rhodes McBride, 1989.60.

9. Yet another drawing of this composition is among Lear's works associated with the Tennyson project, now at the Houghton Library, Harvard University; see Garvey/ Hofer 1967, p. 37.

66. *View of Olevano*

1. For biographical information on Preller, see Krauss 1978.

2. Roquette 1883, p. 58.

3. See Gensel 1904, p. 122, fig. 127.

67. *Portrait of a Young Woman*

1. For biographical information on Rowse, see Emerson 1918, pp. 388–91; Bolton 1923, pp. 58–62; Hills 1981.

2. On Eastman Johnson, see Hills 1977.

3. Waters/Hutton 1894, p. 227.

4. New-York Historical Society 1943, vol. 2, p. 106.

5. Bolton 1923, p. 60.

6. Eastman Johnson, *The Funding Bill*, 1881, oil on canvas, 153.7 × 198.8 cm, New York, Metropolitan Museum of Art, 98.14. This painting depicts Rowse in conversation with Johnson's brother-in-law, Robert W. Rutherford. See Spassky 1985, vol. 2, pp. 233–36.

7. The other three are the family portraits of Susan Ridley Sedgwick Norton (1948.8), Catherine Jane Norton (1948.9), and Grace Norton (1948.10), which were bequeathed to the museum in 1948 by Miss Margot Norton of Cambridge, Massachusetts.

8. Research by Sally Pierce of the Boston Athenaeum has shown that this prominent gallery evolved from a shop selling home furnishings. Dudley Williams first appears in the 1846 Boston Directory as a retailer of looking glasses at 234 Washington Street. Soon he expanded his business into the sales of carpets and other deluxe home furnishings. He seems to have been a successor to John Doggett and Company, who sold art in their shop in the 1820s alongside carpets and mirrors. In 1856 William Everett advertised as a dealer of similar products at the same Washington Street premises, in addition to his activities as a frame maker, gilder, and importer of plate glass. Three years later advertisements for the partnership of Williams and Everett first appeared. By 1859 their Boston Directory ad shows that Williams and Everett sold fine engravings and other works of art. By 1874, the year of Rowse's drawing, the manufacture of mirrors and frames at Williams and Everett had become secondary to their activities as "Importers of dealers in paintings, engravings and other works of art." In the mid-1880s the company moved to a more fashionable address on Boylston Street. Before 1887 Henry Dudley Williams, presumably the proprietor's son, came into the business, and the firm continued to flourish as art dealers through 1907.

9. According to a note in the curatorial files from the donor, Miss Hetty Williams, the pendant drawing was purchased by a Dr. Weld of Boston. Since the museum corresponded with Miss Williams through Mrs. Kingsmill Marrs, a prominent Bostonian and supporter of the institution, the latter might have been instrumental in securing the gift of this drawing for the Worcester Art Museum.

10. See Knoedler 1902. Hills (1981, pp. 125–26 n. 4) notes that the author of this four-page catalogue was the artist Charles Akers (1835–1906), a Maine-born crayon portraitist whose likeness of Rowse was included in the exhibition.

68. *Lily and Rose*

1. The other initial members of the secret brotherhood were the sculptor Thomas Woolner and critics William H. Rossetti and F. G. Stephens. On the Pre-Raphaelite movement, see Hunt 1905.

2. For biographical information on Knewstub, see W. M. James in Thieme/Becker, vol. 20, 1927, p. 581; John Rothenstein (1930) observed that Knewstub was a direct descendant of the famous Puritan theologian of the Elizabethan period, John Knewstub (1544–1624).

3. In 1860 Rossetti married Elizabeth Eleanor Siddal, whom he had known for nearly a decade and who was his chief model. The daughter of a Sheffield cutler, she was a talented watercolorist and poet in her own right. Her unusual beauty was an inspiration to Rossetti and other Pre-Raphaelite artists. However, Siddal suffered from tuberculosis and depression, and she died early in 1862 from an overdose of laudanum. A measure of how Rossetti's romantic life was manifested in his art is reflected in the fact that his manuscript poems were entombed in his wife's coffin. See Garrett 1921–22.

4. According to the artist's son-in-law, William Rothenstein (1931, p. 229).

5. Rothenstein 1965, pp. 10–11.

6. See Hunt 1930, esp. pp. 78, 80–81.

7. See Surtees 1971, no. 161.

8. See Surtees 1971, pp. 91–100, nos. 173, 173F.

9. Two of Knewstub's three daughters were married to artists: Alice Mary to Professor William Rothenstein (see Rothenstein 1931, p. 229) and Grace to Sir William Orpen (see Rothenstein 1930).

10. During the mid-1850s Rossetti—along with John Everett Millais (no. 62), William Holman Hunt, and other artists—made illustrations for Tennyson's poems, which were reproduced in wood engravings and published by Edward Moxon in 1857.

11. *Maud: A Monodrama,* part 1, chap. 22, stanzas 8–9; see *The Works of Alfred Lord Tennyson* (Boston and New York, 1902), vol. 3, p. 34.

69. *The Woodchopper*

1. For biographical information on Hunt, see Knowlton 1899; Webster 1991.

2. Hunt 1875.

3. Webster 1991, pp. 151–90.

4. These works are *An Owl,* ca. 1865, charcoal on tan laid paper, 43.3 × 28.4 cm, gift of Mrs. Edward K. Hill, 1921.82; *Landscape with Bathers,* ca. 1870, charcoal on cream wove paper, 9.8 × 34.3 cm, gift of Miss Harriet E. Clarke, 1935.198; *Landscape with Roadside Cedars,* ca. 1875, charcoal on gray laid paper, 21.0 × 13.4 cm, gift of Mrs. Enneking Long, 1990.116; and *Standing Bather,* 1877, charcoal on cream laid paper, 40.0 × 48.2 cm, gift of Mr. Robert Woods Bliss, 1942.44.

5. Letter to the author, 29 July 1993.

6. For this painting, now in a private collection, see Landgren/McGurn 1976, pp. 34–35, 93, cat. no. 16.

7. Hunt 1878, lot 27. It is impossible to confirm this identification since this pamphlet—found by Martha Hoppin in the Boston Public Library and dated by her—does not provide dimensions.

8. See Bartlett 1880, lot 71.

70. *Girl with Shell at Ear*

1. For biographical information on Homer, see Goodrich 1944.

2. See Goodrich 1968; Beam 1979.

3. See Goodrich 1968, pp. 10, 28, figs. 13–20.

4. See Goodrich 1968, pp. 10, 28–29, figs. 21–24.

5. Winslow Homer, *The Gale,* 1881, oil on canvas, 76.8 × 122.7 cm, Worcester Art Museum, museum purchase, 1916.48. This painting was awarded a gold medal at the World's Columbian Exposition in Chicago in 1893; see Pyne 1983, pp. 231–32.

6. See Atkinson 1990, pp. 49–50.

7. See Wilmerding/Dee 1972, nos. 36–45.

8. As noted by Helen Cooper in Strickler 1987, p. 86. There are at least fourteen such drawings of young women, all of which seem to date from 1878–80. They are executed in graphite, charcoal, and white gouache. Although two seem to be carbon tracings from earlier drawings that have been retouched and refined (Cooper-Hewitt Museum, 1912-12-71, 1912-12-72), only one seems to be a preparatory drawing for another work (Cooper-Hewitt Museum, 1912-12-79; for the 1878 oil painting *Peach Blossoms*).

9. According to Judith Walsh of the National Gallery of Art, Washington, D.C., objects left in Homer's studio at his death, now in the collection of Bowdoin College in Brunswick, Maine, include such a tube of Winsor and Newton Chinese white.

71. *An Almshouse Man in a Top Hat*

1. For biographical information on van Gogh, see Sweetman 1990.

2. See van Gogh 1958.

3. On van Gogh as a draftsman, see Wadley 1969; van der Wolk 1990.

4. See van Gogh 1958, vol. 2, p. 21, no. 278.

5. In his catalogue raisonné, first published in 1928; see 3d ed., Faille 1970, p. 356, no. 954.

6. Van Gogh 1958, vol. 1, p. 465, no. 235.

7. See Visser 1973, pp. 58–65; van der Wolk 1990, pp. 64–65. Elizabeth Heenk (1995, p. 70) questioned Visser's reading of the number on this badge and, consequently, his identification of Zuijderland. However, examination of the pensioner's entry in the Almshouse *Stamboek*—kindly provided to me by Michiel van der Mast of the Haags Historisch Museum—shows that the orthography of this very stylized "199" matches that on the old man's badge. Moreover, the register of pensioners does not number as high as 399.

8. See *Stamboek Oude Liedengesticht,* vol. 133, 1877–90, inv. no. 1652, Archief van de Diaconie der Nederlands Her vormde Gemeente 's-Gravenhage [Municipal Archives, The Hague].

72. *Spring Whistles*

1. For information on the artist's life, see her autobiography, Foote 1972, and Johnson 1980.

2. Rubinstein 1982, p. 174.

3. Mary Hallock Foote, *An Old Lady,* ca. 1900–1912, oil on canvas, 91.5 × 63.5 cm, Art Institute of Chicago, 1913.520.

73. *A Visitor in the Torre de las Infantas, the Alhambra*

1. For biographical information on Seymour, see *Dictionary of American Biography* 1935, vol. 9, p. 12; Ahrens 1986, pp. 9–21; see also Hemenway 1867–91, vol. 3, pp. 985–86.

2. Ahrens 1986, p. 9.

3. On Robert W. Weir, see Gerdts/Callow 1976.

4. See Gerdts/Callow 1976, pp. 25, 47.

5. For details of Seymour's military experiences, see *Dictionary of American Biography* 1935, vol. 9, p. 12.

6. Seven of Seymour's watercolors at the Worcester Art Museum, made between 23 March and 6 April 1882 (1986.118–24), represent views of housetops from the window of Newman's flat depicted at different times of day in varied illumination.

7. A photograph, from the collection of DeWolf Perry, shows J. Alden Weir and several of his friends with their sketch pads in the Court of the Lions at the Alhambra. It is dated 3 August 1877. In about 1901 John Ferguson Weir painted the Alhambra in a canvas that is now in the Metropolitan Museum of Art, New York (92.1 × 118.1 cm, gift of David T. Owsley, 64.119).

74. *Portrait of Mademoiselle Manthey*

1. For biographical information on Gauguin, see Brettell 1988.

2. One of Gauguin's most important paintings executed during his first visit to Tahiti

was the *Brooding Woman,* once owned by Degas and now in the Worcester Art Museum (1921.186); see Dresser 1974, vol. 1, pp. 250–53; Worcester 1994, p. 149.

3. Bodelsen 1966.

4. Wildenstein 1964, vol. 1, p. 39, no. 97.

5. For Gauguin's *Clovis and Pola Gauguin* (pastel, 72.0 × 53.5 cm, now in a private collection), see Brettell 1988, p. 38.

75. *The Rainbow*

1. For biographical information on Bracquemond, see Lostalot 1884.

2. On Bracquemond as a printmaker, see Béraldi 1885–92, vol. 3; Béraldi 1889.

3. See Ives 1974, p. 12, passim.

4. This remarkable network of alliances is reflected in Bracquemond's prolific correspondence; see Bouillon 1973.

5. For an overview of Bracquemond's work in the decorative arts, see Mortagne 1972.

6. Bouillon/Shimizu/Thiebault 1988.

7. On Marie Bracquemond, see Bouillon/Kane 1984.

8. See Jean-Paul Bouillon in Isaacson 1979, pp. 50–57.

9. For the exhibition's catalogue, see Vailliat 1907.

10. Bracquemond 1885; Bracquemond 1897.

11. This comparison was made by Bonnie Grad and Timothy Riggs (1982, p. 257).

12. See Vailliat 1907, p. 9, cat. no. 121.

13. Félix Bracquemond, *The Rainbow,* 1873, etching and drypoint with watercolor on cream wove paper, New Brunswick, New Jersey, Jane Voorhees Zimmerli Art Museum, Rutgers University, gift of the Friends, 77.034.003; see Grad/Riggs 1982, fig. 151. The Zimmerli also owns several single-color and progressive proofs of this print (77.034.6–20).

14. At the Worcester Art Museum there is a set of color proofs from the six stones of Bracquemond's lithograph (1926.831–36) and an impression of the final print (1926.837). Yet another, later version of *The Rainbow,* in which the artist combined etching and lithography, is at the Zimmerli Art Museum (77.034.5).

76. *The Pool at Bethesda: The Invalid The Pool at Bethesda: The Angel Troubling the Water*

1. For biographical information on La Farge, see Yarnall 1990.

2. Bancroft was a wealthy Bostonian whose grandfather had been a Unitarian minister in Worcester. In 1901 Bancroft bequeathed his collection of Japanese prints to the Worcester Art Museum, establishing the institution's collection of works on paper. See Weinberg 1977, pp. 423–25; Swinton 1982–83. La Farge's pencil portrait of Bancroft is now in the Worcester Art Museum (1950.276).

3. In 1889 La Farge's workshop executed another stained-glass window for the

Church of the Ascension, *The Three Marys*. A preparatory watercolor for this window is also in the Worcester Art Museum (gift of Felix A. Gendrot, 1935.113); see Strickler 1987, pp. 78–79.

4. La Farge recorded these travels in drawings and watercolors and later published written accounts of his experiences; see La Farge 1897; La Farge 1912. Two of La Farge's watercolors painted in Japan are now in the Worcester Art Museum (1939.48 and 1939.49); see Strickler 1987, pp. 74–77.

5. See Holmes 1942, pp. 29–30.

6. John 5:2–8.

7. John La Farge and Studio, *The Invalid*, 1898, leaded stained glass, 338.8 × 81.0 cm, inscribed below image: WHOSOEVER THEN FIRST THE TROUBLING OF THE WATER STEPPED IN WAS MADE WHOLE/JAMES AYER, M.D./1891/JULIA HANSON/THOMAS WRIGHT/ASSISTANTS, Worcester Art Museum, gift of the Mount Vernon Congregational Church, 1975.100.B.
 John La Farge and Studio, *The Angel Stirring the Pool*, 1898, leaded stained glass, 333.8 × 81.0 cm, inscribed below image: FOR AN ANGEL WENT DOWN AT A CERTAIN SEASON INTO THE POOL AND TROUBLED THE WATER/IN MEMORY OF/1815, Worcester Art Museum, gift of the Mount Vernon Congregational Church, 1975.100A.

8. See Sloan/Yarnall 1992, pp. 25–26.

9. Sturgis 1898.

10. Sturgis 1898.

11. See Holmes 1942, p. 30.

77. *Seated Woman*

1. For biographical information on Kirchner, see Hans Bolliger and Georg Reinhardt in Griesebach/Meyer zu Eissen 1979, pp. 46–105.

2. See the entry in Kirchner's diary from 5 July 1919; Griesebach 1968, p. 43.

3. Ernst Ludwig Kirchner, *Standing Nude with Hat*, 1910, oil on canvas, Frankfurt-am-Main, Städtische Galerie; see Griesebach/Meyer zu Eissen 1979, p. 11, fig. 1. In 1911–12 Kirchner reproduced this design in a large woodcut; see Dube 1967, vol. 1, cat. no. 207.

4. Many of Kirchner's works of the period, including his photographs, represent this space and its furnishings, and confirm this fact for the Worcester drawing. For further discussion, and several of these photographs, see Erika Billeter, "Ernst Ludwig Kirchner: Kunst als Lebensentwurf," in Griesebach/Meyer zu Eissen 1979, pp. 16–25; see also Lohberg 1994, vol. 2, cat. no. 3.

5. Griesebach/Meyer zu Eissen 1979, pp. 54–55.

78. *The Viaduct, Meudon*

1. For biographical information on Feininger, see Hess 1961.

2. On Feininger as a printmaker, see Prasse 1972.

3. Hess 1961, p. 52 n. 9.

4. See Marlborough-Gerson 1969, pp. 14, 103; this drawing was the model for an etching; see Prasse 1972.

5. The pencil inscription beneath, in German, may be translated, "Tack only in upper corners" *(Nur am den oberen Ecken anheften)*, and would seem to be a later instructive note for a framer or dealer.

79. *Portrait of a Savoyard Boy*

1. For biographical information on the artist, see Kokoschka 1973.

2. See Schweiger 1983.

3. See Tate Gallery 1986.

4. See Strobl/Weidinger 1994, cat. nos. 127–31, for a series of nude studies of this model, and Gunther Thiem's Stuttgart catalogue (Thiem 1966, cat. no. 23) for another portrait of the youth.

5. See Hooze 1982, pp. 198–200.

6. Mahler later wrote of this affair in her autobiography: "I was the stable thing in his ever-changing life . . . [for me] the following three years were a constant, powerful struggle of love, never in my life did I experience such paroxysms of hell and paradise" (Mahler 1960, p. 58).

7. The three landscape drawings given to the Worcester Art Museum by Alma Mahler-Werfel are *Sunny Landscape*, 1913, graphite on tan wove paper, 26.1 × 35.0 cm, 1959.113; *Landscape with Blue Tree*, 1913, charcoal and pastel on tan wove paper, 26.1 × 35.0 cm, 1959.114; and *Alpine Landscape*, 1913, charcoal on tan wove paper, 26.2 × 34.9 cm, 1959.115.

8. "[When she heard of my death] Alma Mahler went immediately to my studio," Kokoschka later wrote in his autobiography (Kokoschka 1973, p. 130), "with her own key, and took away sacks full of letters. War hardens people; her behavior seemed very cold to me, and quite different from the passionate woman I knew. I remember the time when every morning I would wait with beating heart for the mailman to deliver her much anticipated love letter. Less important to me were the sketches and finished drawings that she also took away, works that I had left in my studio in the naive hope that the war would be short. Later I heard that, after her remarriage in 1915, she gave away those works to young painters who ruined them by completing the drawings in order to make them marketable. Perhaps she hoped to calm her guilty conscience."

9. The inscriptions on the present drawing, which seem to be framing notations, include the name C. Moll and prompt the question of whether the sheet might have been in the possession of the painter Carl Moll, Alma Mahler's stepfather and a colleague of Kokoschka's.

80. *The Archer*

1. For biographical information on the artist, see Corinth 1926; Berend-Corinth 1959.

2. On Corinth as a draftsman, see Uhr 1975; and as a printmaker, Schwarz 1917–22; Müller 1960. The Worcester Art Museum

owns one other drawing by Corinth, *A Sheet of Studies with the Portrait of Charlotte Berend-Corinth*, ca. 1913, graphite and purple pencil on cream wove paper, 37.2 × 50.2 cm, gift of George Hecker, 1996.108.

3. The Odysseus pictures were shown at the Berlin Secession exhibition in 1916; see Röthel 1958, p. 128, no. 573.

4. See Röthel 1958, p. 128, no. 573.

5. Siegfried Gohr, "Das Figurenbild im Werke Corinths," in Keller/Gohr/Hässlin 1976, pp. 30–31.

6. Lovis Corinth, *Antique Scene*, 1913, oil on paperboard, 71.5 × 50.0 cm, Bremen Kunsthalle, 559-1949/3; see Kreul 1994, p. 20, cat. no. 224.

7. Lovis Corinth, *The Archer*, 1913, lithograph, 23.8 × 18.1 cm; see Schwarz 1917–22, vol. 1, cat. no. 181.

81. *A Woman of New Guinea*

1. For a detailed chronology of Nolde's life, see Urban 1987, vol. 1, pp. 13–31.

2. On Nolde's graphic art, see Schiefler/Mosel 1966–67; Ackley/Benson/Carlson 1995.

3. On Nolde's "Kunstäusserungen der Naturvölker," see Bradley 1986, p. 81.

4. See Urban 1970.

5. The artist's own account of this journey is given in the third volume of his autobiography, *Welt und Heimat*, written in 1936 and published posthumously in 1965; see esp. pp. 55–107.

6. "Die Urmenschen leben in ihrer Natur, sind eins mit ihr und ein Teil vom ganzen All. . . . Ich male und zeiche und suche einiges vom Urwesen festzuhalten"; letter of 1914 to Hans Fehr; see Nolde 1965, p. 88.

7. In Nolde's uncompleted manuscript for "Kunstäusserungen der Naturvölker"; quoted in Bradley 1986, p. 81.

82. *Head of a Woman*

1. For biographical information on the artist, see Modigliani 1959.

2. For Modigliani's drawings of this period and their relation to sculpture, see Alexandre 1993.

3. Amedeo Modigliani, *Head of a Woman*, 1915–16, graphite and India ink with watercolor, 30.0 × 19.0 cm, formerly private collection, Rome; see Patani 1991, vol. 3, no. 133.

4. For Modigliani's carved heads of 1911–12, see Ceroni 1965, pls. 41–101.

83. *Alligators*

1. For biographical information on Sargent, see Ormond 1970.

2. On Sargent as a watercolorist, see Strickler 1987, pp. 59–60; Reed/Troyen 1993, pp. 151–76.

3. See Strickler 1982–83.

4. Most of these were given to the Worcester Art Museum in 1930 and 1932 by Sargent's sisters, Miss Emily Sargent and Mrs. Francis Ormond, who distributed the quantities of drawings among many museums. The first group includes anatomical studies made in preparation for Sargent's Boston mural projects (1930.1–10); the second group is more diverse in its subjects and in the dates of the drawings (1932.29–39). Several small portrait sketches were given by the widow of Francis Henry Taylor, director of the Worcester Art Museum from 1931 to 1939 and 1955 to 1957 (1958.18–21). In addition, the *Portrait of George Marston Whitin* was donated by a descendant of the sitter in 1987 (1987.139).

5. Letter to Thomas Fox in Boston, 11 March 1917, which is now in the Boston Athenaeum.

6. John Singer Sargent, *Alligators*, 1917, watercolor, New York, Metropolitan Museum of Art, gift of Mrs. Francis Ormond, 50.130.63.

7. The other three drawings are *Two Alligators*, 1917, graphite on cream wove paper, 17.8 × 25.4 cm, 1931.227; *Three Alligators*, 1917, graphite on cream wove paper, 17.8 × 25.4 cm, 1931.228; and *Two Alligators*, 1917, graphite on cream wove paper, 17.8 × 25.4 cm, 1931.229. They were all given to the museum by the artist's sisters.

84. *Vorwärts*

1. For biographical information on the artist, see Grosz 1955.

2. See Nisbet 1993.

3. See Nisbet 1993, pp. 25–26, 31, 151.

4. On the personal and artistic relations between Grosz and Heartfield, see Lewis/Simon 1980.

5. On Scheidemann, see Grebing 1988.

6. The print is captioned: *Apostel Philipp verspricht seit dem 9. November andauernd das tägliche Brot* [The Apostle Philip who on 9 November promised everlasting daily bread]. I am grateful to Professor Sherwin Simmons for bringing this illustration to my attention in a letter of 8 May 1994.

7. On Däubler, see Rietzschel 1988; Grosz 1955, pp. 81–84. A drawing in one of Grosz's sketchbooks executed around 1918 has a caricature of Däubler's moon face developed from sketches of buttocks; see Nisbet 1993, p. 158, no. 39. The artist would continue to represent Däubler in this manner for some years to come.

8. This figure can be compared to the leering warrior reproduced in Grosz 1955, p. 55.

85. *Pink Delphinium and Dogwood*

1. For biographical information on Stella, see Moser 1990, pp. 155–58; Haskell 1994, pp. 225–28.

2. The artist described this project in a magazine essay (Stella 1929), which he later reprinted as a brochure.

3. For further discussion of Stella's silver-point botanical drawings, see Moser 1990, pp. 107–26. Between 1920 and 1924 the artist

also used silverpoint for a series of portrait studies of friends, which, in their precision and strict profile, recall drawings of the Florentine Renaissance.

4. From a brief, undated manuscript by the artist, now among his papers in the Archives of American Art, Smithsonian Institution, Washington, D.C.; reprinted in Haskell 1994, p. 220.

5. See Blunt 1950.

6. As suggested by Haskell 1994, p. 122.

86. *Female Nude with Dividers*

1. For biographical information on the artist, see Archipenko 1960; Karshan 1974.

2. See Archipenko 1960, pp. 65–67.

3. The title page reads "By Alexander Archipenko and Fifty Art Historians." This 346-page book includes a 52-page manifesto on creativity by Archipenko, an extensive bibliography, quotations from critics, and 292 plates of his works.

4. In addition to the present drawing, these include *Standing Female Nude Reading*, ca. 1920, charcoal and gray wash on cream wove paper, 66.2 × 51.0 cm, 1970.100; *Study of Two Figures*, ca. 1920, charcoal on cream wove paper, 51.0 × 33.1 cm, 1970.161; *Seated Female Figure*, ca. 1920, oil on prepared tan wove paper, 58.0 × 46.0 cm, 1970.164; and *Studies of Two Female Nudes*, ca. 1920, graphite on cream wove paper, 66.1 × 51.0 cm, 1970.162.

5. For a group of similar drawings, see Michaelsen 1977, pp. 215–16, cat. nos. D23–35.

6. Compare this figure with Lehmbruck's sculptures of 1913–14, such as *Seated Woman* or *Bending Female Torso*, both in Stuttgart; see Schubert 1990, figs. 143–45.

7. Archipenko 1960, p. 48.

87. *Reclining Nude*

1. For biographical information on Bellows, see Morgan 1965.

2. In the artist's handwritten curriculum vitae in the Worcester Art Museum archives.

3. *Exhibition of Paintings by George Bellows*, exhibition checklist, Worcester Art Museum, 5–26 September 1915.

4. On Bellows as a printmaker, see Mason 1992.

5. George Bellows, *The White Horse*, 1922, oil on canvas, 86.7 × 111.9 cm, Worcester Art Museum, museum purchase, 1929.109; see Quick/Myers 1992, p. 86; Worcester 1994, p. 220.

6. *Exhibition of Paintings by George Bellows*, with introduction by Forbes Watson, exhibition catalogue, Worcester Art Museum, 22 February–8 March 1925. In the following years the museum's director, George W. Eggers, became intimately acquainted with Bellows's art during his preparation of a monograph on the artist (Eggers 1931), and it was he who purchased the present drawing from the artist's widow. On 12 March 1928 Emma Bellows noted the sale of the piece in

the artist's account book, which she continued after her husband's death.

7. The artist made four lithographs representing female nudes in 1917 (Mason 1992, nos. 38–41); five more in 1921 (Mason 74–78); and eight in the winter of 1923–24, when he executed the present drawing (Mason 170–77).

8. The artist's records describe several drawings of female nudes produced at this time: *Female Nude Stretched on Bed*, drawing for the lithograph, Mason 1992, no. 176, see Boswell 1942, p. 56 (present location unknown); *Female Nude Seated on a Flowered Cushion*, drawing for the lithograph, Mason 172 (present location unknown); *Reclining Female Nude*, see Morgan 1973, p. 41 (present location unknown); *Female Nude Lying on a Pillow*, lithographic crayon, 25.7 × 31.0 cm, drawing for the lithograph, Mason 177, New Haven, Yale University Art Gallery, 1916.18.10; and *Female Nude Bending Over*, lithographic crayon, 32.0 × 25.7 cm, Art Institute of Chicago, 1947.54. For a discussion of these drawings and prints, see Myers/Ayres 1988, pp. 122–27.

9. See Seiberling 1948, p. 157.

10. George Bellows, *Nude on a Hexagonal Quilt*, 1924, oil on canvas, 129.6 × 157.7 cm, Washington, D.C., National Gallery of Art; see Quick/Myers 1992, p. 87.

88. *Nude*

1. For biographical information on Lachaise, see Nordland 1974.

2. On *The Dial*, see Brown 1981.

3. On Lachaise as a portraitist, see Carr/Christman 1985.

4. The other drawing (*Nude with Drapery*, ca. 1924, crayon and graphite on cream Japan paper, 29.0 × 14.6 cm, gift of Mrs. Helen Sagoff Slosberg, 1979.28) represents a standing female figure seen from the back, who seems to stand on her tiptoes on stairs or a stepped plinth, leaning forward and away from the viewer. Although the outline of the figure in this sheet is rendered with a purple crayon, Lachaise used a pencil to add a curly mass of hair, feet, and drapery, one end of which seems to fall over a parapet before the woman for her to lean on, while the other end trails behind her and below the level of her feet.

5. Two drawings in the Fogg Art Museum, Cambridge (49.1969a; 50.1969), which are similar in their style and media and roughly comparable in their size, would seem to be contemporaneous with the Worcester drawings; see Wasserman 1980, p. 43, cat. nos. 17, 18.

6. On the relation between Lachaise's sculpture and fertility figures from several prehistoric cultures, see Nordland 1974, pp. 65–68.

7. I am grateful to Marie P. Charles of the Lachaise Foundation in Boston for information on the artist and for the photograph of this sculpture.

89. *Trees #5*

1. For biographical information on Hartley, see Haskell 1977, pp. 185–93.

2. On Hartley as a poet, see Henry W. Wells in Hartley 1945.

3. On Cézanne's activities in this neighborhood, see Rewald 1986, pp. 239–50; for his landscape drawings that inspired Hartley, see Chappuis 1977, cat. nos. 1177–86.

4. See Mitchell 1970.

90. *Mother and Child*

1. For biographical information on the artist, see Rivera 1960; Laurance P. Hurlburt in Downs/Sharp 1986, pp. 23–115.

2. See Eggers 1927.

3. The other works in this group are *Bowl of Fruit*, 1918, graphite on dark cream laid paper, 23.7 × 31.5 cm, 1928.1; *Mexican Landscape*, ca. 1927, charcoal on cream laid paper, 23.7 × 31.3 cm, 1928.2; *Mexican House*, ca. 1927, graphite on cream laid paper, 31.6 × 47.1 cm, 1928.3; *Still Life with Water Pitcher*, 1918, graphite on cream laid paper, 35.9 × 24.8 cm, 1928.5; and *Portrait of Chirokof*, 1917, graphite on white wove paper, 30.7 × 24.0 cm, 1928.6.

4. For another contemporary drawing by Rivera of a Mexican mother and child, now in the De Young Museum in San Francisco, see Berggruen 1940, cat. no. 22.

5. See Worcester 1994, p. 176.

91. *Seated Nude from the Back*

1. For biographical information on the artist, see Noguchi 1968; Ashton 1992.

2. The other drawings are *Two Seated Nudes*, 1928, charcoal on cream wove paper, 43.6 × 27.4 cm, 1930.20; *Nude Leaning on Right Knee*, 1928, charcoal on cream wove paper, 44.0 × 27.1 cm, 1930.21; *Two Standing Nudes*, 1928, charcoal on cream wove paper, 43.6 × 27.1 cm, 1930.22; *Kneeling Nude with Arms Outstretched*, 1928, charcoal on cream wove paper, 27.2 × 42.9 cm, 1930.23; and *Seated Nude*, 1928, charcoal on cream wove paper, 39.7 × 30.9 cm, 1930.25.

3. An important group of forty-six similar figure studies by Noguchi, executed in 1929–30, is now at the University of Michigan Museum of Art in Ann Arbor, 1948/1.287–1.332).

4. See Marter 1991, pp. 19, 49–63. These works evolved from Calder's manner of drawing with a single continuous line, a practice he had developed in his years at the Art Students League in New York, and very likely prompted by his friend and fellow student John Graham.

5. For the contemporaneous geometric abstractions in gouache, see Hunter 1978, pp. 197–98; Grove 1987, pp. 121–22. Ten of them were shown in Noguchi's exhibition at the Albright Art Gallery in Buffalo in 1930.

6. Noguchi 1968, p. 20.

7. Three of Noguchi's Beijing drawings are reproduced in Hunter 1978, pp. 41–42.

92. *The Brooklyn Bridge*

1. For biographical information on Marin, see Fine 1990, pp. 289–98.

2. On Marin as a printmaker, see Fleischman 1982; Fine 1990, pp. 31–73.

3. Reich 1970, vol. 1, pp. 58–59; see Fine 1990, pp. 129–36, for a discussion of Marin's continuing fascination with the Brooklyn Bridge.

4. Written on the occasion of the artist's fourth exhibition at Stieglitz's 291 gallery; see Norman 1949, p. 4.

5. For several of these drawings of the Brooklyn Bridge, ranging in date from the 1910s to the 1950s, see Reich 1969, pp. 42–46, 70–71, passim.

6. See Reich 1970, vol. 2, cat. no. 30.51.

93. *Untitled*

1. For biographical information on Moholy-Nagy, see David 1991, pp. 298–309.

2. Moholy-Nagy 1938.

3. Moholy-Nagy 1947.

4. Moholy-Nagy 1947, p. 123. The artist gave the Worcester drawing to his friend the noted art historian Katherine Kuh, who presented it to the museum in memory of Daniel Catton Rich, the late Worcester Art Museum director.

5. Moholy-Nagy gave the painting to his colleague at the Institute of Design, George Fred Keck, whose widow bequeathed the canvas to the Art Institute of Chicago.

6. Compare, for example, with the Lissitzky-like paintings reproduced by David 1991, pls. 74, 76.

94. *Theseus and the Minotaur*

1. For biographical information on the artist, see Lipchitz 1972; Hammacher 1975, pp. 214–15, passim.

2. On the *Laocoön*, see Bober/Rubenstein 1986, pp. 151–55, fig. 122.

3. Quoted in Jenkins/Pullen 1986, p. 70.

4. There are many different versions of this tale; see the ancient mythographers Plutarch (*Lives* 19.19) and Ovid (*Metamorphoses* 8.169–73).

5. See Valentin 1944, nos. 15–18.

6. Soon after his arrival in New York, the artist also experimented briefly with printmaking. He worked at Atelier 17, an experimental workshop run by Stanley William Hayter that operated in New York, exiled from its home in Paris. Sometime in 1942–44 Lipchitz etched two plates representing *Theseus Wrestling with the Minotaur*. A painterly soft-ground etching with aquatint seems to have been the first of them. In another, smaller version of this subject, he used aquatint and drypoint: Jacques Lipchitz, *Theseus and the Minotaur*, ca. 1942–43, etching, engraving, and liquid-ground aquatint, 35.1 × 28.4 cm (plate); see Moser 1977, pp. 29, 66; and Jacques Lipchitz, *Theseus and the Minotaur*, 1943, etching and aquatint with drypoint, 22.8 × 17.4 cm (plate).

7. See Pach 1946, p. 356; Stedelijk 1958, no. 85; Marlborough 1973, no. 30.

8. On the ancient Mithras sculptural type, see Bober/Rubenstein 1986, pp. 45–46, fig. 46.

9. In another drawing, also executed in 1942, the artist was less certain about the beast's anatomy, for the Minotaur seems to have a bull's forelegs with human hands. Prominent genitalia in that drawing give a heightened masculinity to the figure of Theseus and a sexual connotation to this struggle. See Marlborough 1973, no. 30.

95. *Still Life*

1. For biographical information on Giacometti, see Lord 1983.

2. Note, for example, the paintings reproduced in Dupin 1962, pp. 124, 141, 151.

3. On Morandi, see Vitali 1970.

96. *Untitled*

1. For biographical information on Guston, see Arnason 1986.

2. See Dabrowski 1988, p. 27.

3. See Ashton 1976, pp. 132–33.

4. Quoted by Ruth E. Fine in Gilmour 1988, p. 270.

97. *Study for Great American Nude #59*

1. For biographical information on Wesselman, see Stealingworth 1980, pp. 11–80.

2. From the first, their provocative imagery made some viewers uncomfortable (see Raynor 1962). When one of his early paintings in this series was excluded from an exhibition at the Gallery of Modern Art in Washington, D.C., the artist charged censorship in a letter to the editor of *Arts* magazine; see Wesselmann 1963.

3. See Rich/Carey 1965, n.p.

4. Tom Wesselmann, *Great American Nude #36*, 1962, enamel and acrylic polymer with collage on composition board, 121.9 × 152.4 cm, Worcester Art Museum, 1965.393; see Worcester 1994, p. 231.

5. Tom Wesselmann, *Study for First Illuminated Nude*, 1965, graphite on cream wove paper, 33.1 × 30.8 cm, Washington, D.C., Hirshhorn Museum and Sculpture Garden, Smithsonian Institution, gift of Joseph H. Hirshhorn, 66.5528. See Adams 1978, p. 77, pl. 62.

6. On Wesselmann's works made from dye-cut and vacuum-formed plastic, later painted or printed, see Stealingworth 1980, pp. 47–52.

7. Tom Wesselmann, *Great American Nude #60*, 1965, acrylic on canvas, 119.4 × 127.0 cm, Richmond, Virginia, Sydney and Frances Lewis.

98. *Documentation Drawing: 47 Three-Part Variations on a Cube*

1. For biographical information on LeWitt, see Legg 1978, pp. 12–14.

2. He also met Lucy R. Lippard, who worked in the museum library and became an influential critic and the artist's wife.

3. See Haenlein 1988.

4. See Singer 1992.

5. See Kraus 1968; Siegel 1968. Along with the drawings at the Worcester Art Museum are two photographs of that installation.

6. Sol LeWitt, *Documentation Drawings for 47 Three-Part Variations on a Cube*, 1967, 15 sheets, black ballpoint pen, red ballpoint pen, or black felt-tip pen on tan wove paper, each about 21.7 × 28.0 cm, Worcester Art Museum, gift of the artist, 1974.96.1–15. Also in the museum's collection is LeWitt's monochromatic watercolor *Form Derived from a Cube* of 1982 (1984.134); see Strickler 1987, pp. 210–11.

99. *Portrait of Nick, Grand Hotel, Calvi*

1. Biographies of Hockney include Stangos 1976; Webb 1988.

2. See Pillsbury 1978, passim.

3. See Webb 1988, pp. 126–27; Geldzahler 1980, pp. 47–48.

4. Hockney's color crayon portrait of Geldzahler in a Hawaiian shirt, made in Calvi, is reproduced in Pillsbury 1978, n.p. For other drawings created on this trip, see Stangos 1976, pp. 156–57, 237.

5. Hockney made another portrait drawing of Rae in 1975, a three-quarter view of the young man seated. In that drawing the subject's costume does not seem as important as his high cheekbones and long fingers; see Stangos 1976, p. 281.

100. *Untitled*

1. For biographical information on Francis, see Selz 1982, pp. 284–87.

2. On Francis as a printmaker, see Lembark 1992.

3. Buck 1972.

4. See Yves Michaud, "Conversations with Sam Francis, Santa Monica, California, 14, 15, 16, 17 May 1988," in Fournier 1988, p. 49.

Master Drawings

CHECKLIST OF FURTHER DRAWINGS

Checklist of Further Drawings

This list of American and European drawings in the collection of the Worcester Art Museum is organized alphabetically by nationality, and therein by accession number, which reflects the date of the museum's acquisition of each work of art. Many of the attributions are those traditional to the museum. Dimensions are in centimeters, height before width.

American

Lewin Alcopley (born 1910), *Untitled,* 1957, watercolor on off-white laid paper, 52.2 × 42.0 cm. Gift of the Betty Parsons Foundation, 1985.267.

Francis Alexander (1800–1881), *Portrait of Henry Wadsworth Longfellow,* n.d., graphite and pastel with white gouache on cream wove paper, 14.4 × 9.7 cm. Museum purchase, 1925.48.

Washington Allston (1779–1843), *A Log House of the First Order,* n.d., pen and black ink with wash on cream wove paper, 21.4 × 25.8 cm. Museum purchase, 1916.127.110.

Stuart P. Anderson (1924–1979), *Charles Correcting Papers,* 1970s, black crayon on cream wove paper, 61.1 × 45.8 cm. Gift of Charles B. Cohn in memory of Stuart P. Anderson, 1985.231.

Stuart P. Anderson (1924–1979), *A Market Building, Guanojato* [sic], *Mexico,* n.d., black crayon on cream wove paper, 35.3 × 42.9 cm. Bequest of Charles B. Cohn in memory of Stuart P. Anderson, 1985.235.

Anonymous (19th century), *To the Memory of Mrs. Mary Grosvenor,* ca. 1820, brush and gray ink with watercolor on cream silk, 29.8 × 25.2 cm. Bequest of Stephen Salisbury, 1907.17.

Anonymous (19th century), *The Goddess Diana,* n.d., graphite on cream wove paper, 13.3 × 20.8 cm. William Grimm Fund, 1982.80.

Anonymous, Native American (20th century), *Supai Dancer,* early 1930s, watercolor and gouache over graphite on off-white wove paper, 36.0 × 23.7 cm. Museum purchase, 1935.95.

Anonymous, Native American (20th century), *War Dance,* early 1930s, watercolor over graphite on cream wove paper, 20.0 × 33.7 cm. Museum purchase, 1935.96.

William Graham Anthony (born 1934), *Sausalito, February 19, 1963,* 1963, black crayon on cream wove paper, 33.3 × 28.9 cm. Gift of Mr. and Mrs. Edward V. Randel, 1970.151.

Alexander Archipenko (1887–1964), attributed to, *Standing Female Nude Reading,* ca. 1920, charcoal and gray wash on cream wove paper, 66.2 × 51.0 cm. Bequest of Yvonne Bedard Corporon, 1970.100.

Alexander Archipenko (1887–1964), attributed to, *Study of Two Figures,* ca. 1920, charcoal on cream wove paper, 51.0 × 33.1 cm. Bequest of Yvonne Bedard Corporon, 1970.161.

Alexander Archipenko (1887–1964), attributed to, *Studies of Two Female Nudes,* ca. 1920, graphite on cream wove paper, 66.1 × 51.0 cm. Bequest of Yvonne Bedard Corporon, 1970.162.

Alexander Archipenko (1887–1964), *Seated Female Figure,* ca. 1920, oil on prepared tan wove paper, 58.0 × 46.0 cm. Bequest of Yvonne Bedard Corporon, 1970.164.

John Taylor Arms (1887–1953), *Cavendish Church, Suffolk,* 1936, graphite on cream ragboard, 45.7 × 31.0 cm. Gift of Mr. Edward A. Bigelow, 1949.4.

John Taylor Arms (1887–1953), *Stokesay Castle,* 1941, graphite on off-white wove paper, 14.0 × 20.2 cm. Edward A. Bigelow Collection, gift of Mrs. Robert M. Heberton, 1981.63.

David Aronson (born 1923), *Abraham Abulafia,* 1962, pen and brown ink with watercolor over graphite on white laid paper, 28.3 × 22.0 cm. Director's Discretionary Fund, 1963.60.

Richard Artschwager (born 1924), *Untitled,* 1973, charcoal on cream laid paper, 48.4 × 64.3 cm. Gift of the artist, 1974.94.

Alice Baber (1928–1982), *Green Dervish Turns to Blue,* 1973, watercolor on off-white wove paper, 75.7 × 105.4 cm. Gift of Mr. Adin Baber, 1974.269.

Henry Bacon (1839–1912), *An Egyptian Mother,* 1911, watercolor over graphite on cream wove paper, 47.5 × 93.2 cm. Gift of Mrs. Frederick L. Eldridge in memory of Henry Bacon, 1943.16.

Henry Bacon (1839–1912), *Bedouins on Pilgrimage to Abu Shreer,* 1911, watercolor over graphite on cream wove paper, 47.5 × 92.9 cm. Gift of Mrs. Frederick L. Eldridge in memory of Henry Bacon, 1943.17.

Henry Bacon (1839–1912), *Bedouin Campfires,* ca. 1911, watercolor over graphite on cream wove paper, 42.8 × 66.2 cm. Gift of Mrs. Frederick L. Eldridge in memory of Henry Bacon, 1943.18.

Henry Bacon (1839–1912), *The Last of the Krio Sphinxes between Karnak and Luxor,* 1911, watercolor over graphite on cream wove paper, 43.1 × 65.9 cm. Gift of Mrs. Frederick L. Eldridge in memory of Henry Bacon, 1943.19.

Henry Bacon (1839–1912), *An Appeal to the Great Abel Hone,* 1910, watercolor over graphite on cream wove paper, 52.0 × 34.6 cm. Gift of Mrs. Frederick L. Eldridge in memory of Henry Bacon, 1943.20.

Henry Bacon (1839–1912), *Where Afric's Sunny Fountains Roll Down Their Golden Sand,* 1902, watercolor over graphite on cream wove paper, 56.8 × 39.0 cm. Gift of Mrs. Frederick L. Eldridge in memory of Henry Bacon, 1943.21.

Henry Bacon (1839–1912), *Temple of the Abou Simbel,* 1902, watercolor over graphite on cream wove paper, 60.7 × 48.0 cm. Gift of Mrs. Frederick L. Eldridge in memory of Henry Bacon, 1943.22.

Henry Bacon (1839–1912), *The Great Sphinx,* 1910, watercolor over graphite on cream wove paper, 60.7 × 48.0 cm. Gift of Mrs. Frederick L. Eldridge in memory of Henry Bacon, 1943.23.

Henry Bacon (1839–1912), *The Nile,* ca. 1911, watercolor over graphite on cream wove paper, 40.8 × 58.3 cm. Gift of Mrs. Frederick L. Eldridge in memory of Henry Bacon, 1943.24.

Henry Bacon (1839–1912), *Sunset on the Theban Hills,* 1907, watercolor over graphite on cream wove paper, 33.6 × 51.2 cm. Gift of Mrs. Frederick L. Eldridge in memory of Henry Bacon, 1943.25.

Henry Bacon (1839–1912), *Queen Arsinoe and King Ptolemy, Temple of Isis, Philae,* ca. 1900, watercolor over graphite on

cream wove paper, 50.5 × 34.3 cm. Gift of Mrs. Frederick L. Eldridge in memory of Henry Bacon, 1943.26.

Henry Bacon (1839–1912), *Provisions for Sakkarah,* 1903, watercolor over graphite on cream wove paper, 35.3 × 53.3 cm. Gift of Mrs. Frederick L. Eldridge in memory of Henry Bacon, 1943.27.

Henry Bacon (1839–1912), *A Sacred Lake, Karnnak,* 1905, watercolor over graphite on cream wove paper, 40.6 × 58.5 cm. Gift of Mrs. Frederick L. Eldridge in memory of Henry Bacon, 1943.28.

Henry Bacon (1839–1912), *The Step Pyramid at Sakkarah at Noon,* ca. 1903, watercolor over graphite on cream wove paper, 35.7 × 53.6 cm. Gift of Mrs. Frederick L. Eldridge in memory of Henry Bacon, 1943.29.

Henry Bacon (1839–1912), *Women Fetching Water at Dawn on the Plain of Thebes,* ca. 1907, watercolor over graphite on cream wove paper, 34.4 × 51.2 cm. Gift of Mrs. Frederick L. Eldridge in memory of Henry Bacon, 1943.30.

Henry Bacon (1839–1912), *A Street in Cairo,* 1905, watercolor over graphite on cream wove paper, 34.4 × 50.8 cm. Gift of Mrs. Frederick L. Eldridge in memory of Henry Bacon, 1943.31.

Henry Bacon (1839–1912), *Caught in the Sandstorm,* 1908, watercolor over graphite on cream wove paper, 35.6 × 52.1 cm. Gift of Mrs. Frederick L. Eldridge in memory of Henry Bacon, 1943.32.

Henry Bacon (1839–1912), *The Nile and Golden Sand of Upper Egypt,* 1906, watercolor over graphite on cream wove paper, 45.1 × 60.2 cm. Gift of Mrs. Frederick L. Eldridge in memory of Henry Bacon, 1943.33.

Henry Bacon (1839–1912), *Travelers Near Sakkarah,* 1905, watercolor over graphite on cream wove paper, 44.9 × 59.6 cm. Gift of Mrs. Frederick L. Eldridge in memory of Henry Bacon, 1943.34.

Henry Bacon (1839–1912), *Shepherds at a Bedouin Tent,* 1906, pastel on gray laid paper, 44.9 × 59.7 cm. Gift of Mrs. Frederick L. Eldridge in memory of Henry Bacon, 1943.35.

Henry Bacon (1839–1912), *Bridal Procession Crossing the Desert,* 1906, pastel on gray-green laid paper, 45.5 × 61.6 cm. Gift of Mrs. Frederick L. Eldridge in memory of Henry Bacon, 1943.36.1.

Henry Bacon (1839–1912), *The Pharaoh's Boat Landing Place,* ca. 1907, watercolor over graphite on cream wove paper, 33.4 × 50.9 cm. Gift of Mrs. Frederick L. Eldridge in memory of Henry Bacon, 1943.36.2.

Henry Bacon (1839–1912), *The Colossi of Thebes,* 1904, watercolor over graphite on cream wove paper, 39.3 × 54.9 cm. Gift of Mrs. Frederick L. Eldridge in memory of Henry Bacon, 1943.36.3.

Henry Bacon (1839–1912), *The Forecourt of the Temple of Abydos,* 1902, watercolor over graphite on cream wove paper, 54.6 × 39.5 cm. Gift of Mrs. Frederick L. Eldridge in memory of Henry Bacon, 1943.36.4.

Henry Bacon (1839–1912), *The Sheik's Tomb in the Desert,* ca. 1905, watercolor over graphite on cream wove paper,

34.5 × 50.8 cm. Gift of Mrs. Frederick L. Eldridge in memory of Henry Bacon, 1943.36.5.

Henry Bacon (1839–1912), *Along a Canal in the Fayoum,* ca. 1905, watercolor over graphite on cream wove paper, 34.2 × 51.0 cm. Gift of Mrs. Frederick L. Eldridge in memory of Henry Bacon, 1943.36.6.

Henry Bacon (1839–1912), *The Nile,* 1905, watercolor over graphite on cream wove paper, 40.7 × 58.1 cm. Gift of Mrs. Frederick L. Eldridge in memory of Henry Bacon, 1943.36.7.

William Bailey (born 1930), *Female,* 1975, graphite on cream wove paper, 37.8 × 28.8 cm. Gift of Sidney Rose in memory of his parents, Mary D. and Philip Rose, 1983.59.

Herbert Barnett (1910–1972), *Portrait of Hermann P. Riccius,* n.d., blue crayon and gray wash on cream wove paper, 42.0 × 29.7 cm. Gift of Mrs. George E. King and Walter H. Riccius, 1965.54.

Domingo Barreres (born 1941), *Untitled,* 1975, oil paint, polymer acrylic, and wax on off-white wove paper, 57.0 × 57.1 cm. Sarah C. Garver Fund, 1975.129.

Ruth Henshaw Bascom (1772–1848), *Portrait of Mary Smith Davis,* 1839, pastel over graphite with collage on cream wove paper, 48.7 × 35.7 cm. Gift of Miss Mary Davis Thurston, 1965.405.

Ruth Henshaw Bascom (1772–1848), *Portrait of Mary Elizabeth Denny,* 1837, pastel over graphite on cream wove paper, 40.1 × 30.7 cm. Gift of Miss Mary Davis Thurston, 1965.408.

Ruth Henshaw Bascom (1772–1848), *Portrait of Charles Addison Denny,* 1837, pastel over graphite on cream wove paper, 40.1 × 30.3 cm. Gift of Miss Mary Davis Thurston, 1965.409.

Ruth Henshaw Bascom (1772–1848), *Portrait of Mrs. Jacob Puffer,* 1829, pastel, charcoal, and gouache with collage on blue wove paper, 50.3 × 36.9 cm. Gift of Hazen Wheeler, 1979.19.

Ruth Henshaw Bascom (1772–1848), *Portrait of Jacob Puffer,* 1829, pastel, charcoal, and gouache with collage on blue wove paper, 50.4 × 37.7 cm. Gift of Hazen Wheeler, 1979.20.

Leonard Baskin (born 1922), *Weeping Man,* 1956, pen and India ink with wash on off-white wove paper, 57.0 × 79.4 cm. Museum purchase, 1957.18.

Leonard Baskin (born 1922), *Study for Cross-Eyed Jew II,* 1956, pen and India ink on cream laid paper, 46.6 × 58.3 cm. Anonymous gift, 1963.137.

Romare Bearden (1914–1988), *Two Trojan Soldiers,* early 1960s, pen and India ink on cream wove paper, 65.2 × 50.1 cm. Gift of Mr. Ben Goldstein, 1974.91.

Albert Fitch Bellows (1829–1883), *A Cavalry Marching before a Castle,* n.d., graphite with white gouache on green wove paper, 9.0 × 12.0 cm. Museum purchase, 1916.128.296.

George Wesley Bellows (1882–1925), *Reclining Nude,* ca. 1924, lithographic crayon and charcoal on cream wove paper, 28.1 × 35.7 cm. Gift of Alden P. Johnson, 1962.169.

Richard Peter Benoit (1888–1989), *Portrait of a Woman,* 1909, graphite with white gouache on blue laid paper, 32.0 × 23.6 cm. Gift of Richard S. Benoit, 1990.120.

Richard Peter Benoit (1888–1989), *Kathy Dixon Reading,* 1909, graphite on cream wove paper, 35.9 × 25.3 cm. Gift of Richard S. Benoit, 1990.121.

Frank W. Benson (1862–1951), *Eider Ducks Flying,* ca. 1913, watercolor over graphite on cream wove paper, 55.0 × 76.3 cm. Museum purchase, 1913.60.

Frank W. Benson (1862–1951), *Eider Ducks in Winter,* ca. 1913, watercolor over graphite on cream wove paper, 50.4 × 68.0 cm. Museum purchase, 1913.61.

Jake Berthot (born 1939), *Untitled,* 1991, rabbit skin glue, polymer acrylic, and India ink on white wove paper, 74.2 × 54.0 cm. Gift of the American Academy of Arts and Letters, Hassam, Speicher, Betts, and Symons Funds, 1993.10.

Natvar Bhavsar (born 1934), *Untitled (for Janet),* 1972, sand and dry pigment with acrylic polymer medium on off-white paperboard, 102.0 × 81.4 cm. Gift of Ms. Janet Brosoius, 1974.105.

A. Robert Birmelin (1933–1988), *Two Hands with a Cup,* 1962, watercolor on cream wove paper, 99.4 × 70.1 cm. Director's Discretionary Fund, 1964.10.

Isabel Bishop (1902–1988), *Two Women and a Man on a Park Bench,* 1930s, pen and black ink with graphite on cream wove paper, 20.3 × 22.2 cm. Bequest of Charles B. Cohn in memory of Stuart P. Anderson, 1985.217.

Sally Bishop (1936–1994), *Cantabrian Traces #24,* 1991, polymer acrylic, oil pastel, crayon, and graphite on white wove paper, 74.8 × 73.7 cm. Eliza S. Paine Fund, 1994.276.

Oscar Bluemner (1867–1938), *Landscape, Port Washington,* 1911, black crayon on cream wove paper, 14.3 × 18.2 cm. Alexander and Caroline DeWitt Fund, 1996.25.

Oscar Bluemner (1867–1938), *Landscape, Cold Spring,* 1910, graphite on cream wove paper, 14.3 × 18.2 cm. Alexander and Caroline DeWitt Fund, 1996.26.

Varujan Boghosian (born 1926), *The River,* mid-1950s, pen and black ink on white illustration board, 38.1 × 51.0 cm. Director's Discretionary Fund, 1959.70.

Richard Boyce (born 1920), *Orpheus and Eurydice,* 1959, pastel on off-white wove paper, 107.0 × 84.8 cm. Director's Discretionary Fund, 1959.69.

William Bradford (1827–1892), *Seascape,* n.d., pen and black ink with wash on cream wove paper, 8.1 × 18.8 cm. Museum purchase, 1916.129.348.

Carolyn Brady (born 1937), *Last Red Tulips (Baltimore Spring 84),* 1984, watercolor over graphite on white wove paper, 97.0 × 141.3 cm. National Endowment for the Arts Museum Purchase Plan, 1984.132.

George Loring Brown (1814–1889), *Dead Sparrow,* 1833, watercolor over graphite on cream wove paper, 17.1 × 10.5 cm. Museum purchase, 1916.128.228.

George Loring Brown (1814–1889), *Still Life with Bird and Apple,* 1835, watercolor over graphite on cream wove paper, 9.1 × 17.7 cm. Museum purchase, 1916.128.230.

Byron Browne (1907–1961), *Transmutations,* 1950, gouache over graphite on off-white wove paper, 50.9 × 66.4 cm. Anonymous fund, 1986.96.

Charles Burchfield (1893–1967), *June Wind,* 1937, watercolor and gouache on off-white wove paper, 58.3 × 81.1 cm. Gift of Chapin and Mary Alexander Riley, 1986.45.

Bryson Burroughs (1869–1934), *Study for Samson and Delilah,* ca. 1931, pastel with watercolor on off-white laid paper, 36.6 × 45.1 cm. Gift of the artist's grandson, 1991.220.

Bryson Burroughs (1869–1934), *First Autumn,* 1898, pastel and graphite on gray wove paper, 38.5 × 24.0 cm. Gift of the artist's grandson, 1991.221.

Kenneth Callahan (1906–1986), *Summer Bug,* early 1960s, pen and black ink with wash on white wove paper, 58.8 × 89.9 cm. Museum purchase, 1964.26.

Richard Callner (born 1927), *Constellation,* 1965, graphite and black felt-tip pen on off-white wove paper, 66.0 × 100.5 cm. Gift under the Museum Donor Program of the American Federation of Arts, 1966.53.

Martin Carey (born 1938), *Black Panther Diptych,* 1970, India ink on white wove paper, 58.3 × 45.5 cm. Gift of the artist, 1971.71.1–2.

Charles Milton Carter (1853–1929), *Portrait of Stephen Salisbury II,* 1878, charcoal and black, gray, and white chalks on cream wove paper, 76.4 × 63.4 cm. Bequest of Stephen Salisbury, 1916.111.

Bernard Chaet (born 1924), *Valley,* mid-1950s, brush and black ink with wash on off-white wove paper, 66.0 × 101.6 cm. Director's Discretionary Fund, 1961.2.

Susan Christian (20th century), *Mohave,* 1972, acrylic polymer paint on off-white laid paper, 86.8 × 58.8 cm. Museum purchase, 1990.164.

Carmen Cicero (born 1926), *New Friends,* 1961, black felt-tip pen on off-white wove paper, 57.5 × 72.7 cm. Director's Discretionary Fund, 1961.8.

Walter Appleton Clark (1876–1907), *King Is He, Of Thee Begot, Queen Both Fair and Good!* 1899, watercolor and gouache over graphite on cream wove paper, 42.2 × 50.7 cm. Museum purchase, 1907.85.

H. George Cohen (born 1913), *Dybbuk,* 1961, black ink applied with sponge and collage on illustration board, 50.7 × 38.1 cm. Gift of the artist in honor of O. Victor Humann, 1966.56.

Bruce Conner (born 1933), *Portrait No. 18,* ca. 1962, brown and black felt-tip pens on off-white wove paper, 66.4 × 51.0 cm. Director's Discretionary Fund, 1964.102.

John Singleton Copley (1738–1815), *Queen Charlotte and Princess Amelia: Study for the Daughters of George III,* ca. 1784, black chalk heightened with white on cream wove paper prepared with gray wash, 43.8 × 31.9 cm. Gift of Mr. and Mrs. Arthur L. Williston in memory of Clarence H. Denny, 1952.29.

Dorothy Coulter (born 1903), *Bust of a Young Man,* 1963, charcoal on light green laid paper, 27.7 × 24.8 cm. Gift of the artist, 1972.21.

Dorothy Coulter (born 1903), *Sleep,* 1963, graphite on gray laid paper, 36.5 × 48.4 cm. Gift of the artist, 1972.22.

Jasper Francis Cropsey (1823–1900), *On the Susquehanna River,* 1889, watercolor over graphite on cream wove paper, 34.5 × 52.0 cm. Gift of Mrs. John C. Newington, 1985.304.

Charles Culver (1908–1967), *Three Deer Resting,* 1948, pen and black ink with watercolor over graphite on cream laid paper, 57.3 × 78.9 cm. Museum purchase, 1948.32.

Charles Culver (1908–1967), *Elk Resting,* 1948, graphite on cream wove paper, 21.5 × 33.0 cm. Gift of the artist, 1950.280.

Felix O. C. Darley (1822–1888), *The Appearance of a Ghost,* n.d., pen and black and brown inks over graphite with gray wash on cream wove paper, 11.8 × 16.0 cm. Museum purchase, 1916.128.287.

Arthur B. Davies (1862–1928), *Castello, Edge of the Alps,* ca. 1928, watercolor on cream wove paper, 19.4 × 28.1 cm. Gift of Mrs. Cornelius N. Bliss, 1941.3.

Arthur B. Davies (1862–1928), *Castello, Italian Coast Port,* ca. 1928, watercolor over graphite on cream wove paper, 19.3 × 28.1 cm. Gift of Mrs. Cornelius N. Bliss, 1941.4.

Arthur B. Davies (1862–1928), *Standing Female Nude,* 1920s, watercolor over graphite on cream wove paper, 46.5 × 33.7 cm. Gift of Mr. and Mrs. Karl L. Briel, 1974.225.

Alice Preble Tucker de Haas (?–1920), *York Bay, Maine,* n.d., watercolor on groundwood board, 23.0 × 53.5 cm. Bequest of Stephen Salisbury, 1916.62.

Charles Demuth (1883–1935), *A Man Lying on the Beach,* 1934, graphite on cream wove paper, 21.0 × 27.8 cm. Charlotte E. W. Buffington Fund, 1994.272.

Burt Morgan Dennis (1892–1960), *A Begging Dog,* 1934, red chalk over graphite on cream laid paper, 40.8 × 31.3 cm. Edward A. Bigelow Collection, gift of Mrs. Robert M. Heberton, 1981.237.

Koren Der Harootian (born 1909), *Patience,* 1931, watercolor over graphite on off-white wove paper, 56.3 × 41.4 cm. Museum purchase, 1932.16.

Koren Der Harootian (born 1909), *Cockerels,* 1962, graphite on cream wove paper, 60.7 × 45.0 cm. Gift of the artist, 1965.494.

Preston Dickinson (1891–1930), *Roof Tops,* ca. 1923, oil pastel and graphite on gray laid paper, 54.7 × 45.8 cm. Gift of Mrs. Saundra L. Lane, 1996.61.

Toni Dove (born 1946), *Land Bird,* 1974, watercolor over graphite on off-white wove paper, 83.8 × 63.4 cm. Alexander and Caroline M. DeWitt Fund, 1974.117.

Seymour Drumlevitch (born 1923), *Jacob's Ladder,* 1957, pen and India ink on off-white wove paper, 90.9 × 58.6 cm. Gift of Dr. and Mrs. Elton Yasuna, 1964.1.

Alfred Duca (born 1920), *Child with Doll,* n.d., metalpoint with graphite on white wove paper, 28.2 × 22.2 cm. Museum purchase, 1948.29.

Kerr Eby (1888–1946), *In the Open,* n.d., pen and India ink over graphite on cream illustration board, 31.0 × 40.9 cm. Edward A. Bigelow Collection, gift of Mrs. Robert M. Heberton, 1981.98.

Kerr Eby (1888–1946), *The Night March,* n.d., brown pencil and charcoal on cream wove paper, 50.8 × 61.4 cm. Edward A. Bigelow Collection, gift of Mrs. Robert M. Heberton, 1981.100.

Kerr Eby (1888–1946), *Refugees,* n.d., charcoal on cream paperboard, 34.5 × 47.2 cm. Edward A. Bigelow Collection, gift of Mrs. Robert M. Heberton, 1981.101.

Kerr Eby (1888–1946), *The St. Miheil Drive,* 1935, charcoal on cream paperboard, 34.9 × 49.0 cm. Edward A. Bigelow Collection, gift of Mrs. Robert M. Heberton, 1981.104.

Louis M. Eilshemius (1864–1941), *Rice Paddy,* ca. 1908, watercolor over graphite on cream wove paper, 30.5 × 45.9 cm. Bequest of Dorothy K. Hartwell, 1978.53.

Charles Eldred (born 1938), *Traps,* 1968, pen and black ink on cream wove paper, 76.7 × 57.0 cm. Museum purchase, 1968.12.

Lester Elliot (born 1921), *Night into Morning,* 1967, pen and black ink on off-white wove paper, 98.0 × 74.8 cm. Director's Discretionary Fund, 1967.40.

John J. Enneking (1841–1916), *Ships at Harbor,* n.d., graphite on gray-green wove paper, 20.6 × 27.2 cm. Gift of Mrs. Enneking Long, 1990.117.

John J. Enneking (1841–1916), *Cattle Drinking from a Brook,* n.d., graphite on cream wove paper, 14.4 × 18.2 cm. Gift of Mrs. Enneking Long, 1990.118.

John J. Enneking (1841–1916), *Evening Landscape,* n.d., watercolor on cream wove paper, 17.7 × 25.4 cm. Alexander and Caroline DeWitt Fund, 1996.24.

Manny Farber (born 1917), *Untitled,* 1970, polymer acrylic on white wove paper with collage, 227.6 × 291.8 cm. Gift of Sidney Rose in memory of his parents, Mary D. and Philip Rose, 1983.61.

Dean Fausett (born 1913), *Vermont Landscape,* 1940, watercolor on cream wove paper, 55.7 × 76.2 cm. Gift of the Friends of Southern Vermont Artists, 1940.25.

Paul Feeley (1913–1966), *Venice,* 1966, watercolor over graphite on cream wove paper, 38.0 × 50.1 cm. Gift of the Betty Parsons Foundation, 1985.279.

Lyonel Feininger (1871–1956), *The River,* 1940, pen and India ink with watercolor over graphite on cream laid paper, 29.2 × 46.6 cm. Museum purchase, 1942.48.

Lyonel Feininger (1871–1956), *Dead End,* 1942, pen and India ink with wash and watercolor over charcoal on cream laid paper, 48.1 × 41.5 cm. Museum purchase, 1943.15.

Lyonel Feininger (1871–1956), *Gelmeroda VIII,* 1916, charcoal on gray laid paper, 43.3 × 27.8 cm. Gift of William H. and Saundra B. Lane, 1975.676.

Lyonel Feininger (1871–1956), *Weimar Park,* 1913, black crayon on cream wove paper, 20.1 × 15.7 cm. Bequest of Malcolm Rhodes McBride, 1989.49.

Jackie Ferrara (born 1929), *Drawing for Trannik,* 1980, black felt-tip pen over graphite on white wove paper, 55.9 × 128.3 cm. Charlotte E. W. Buffington Fund, 1993.9.

Edwin Wallace Fillmore (1859–1920), *Standing Male Nude,* 1886, charcoal on cream laid paper, 61.2 × 47.0 cm. Mary G. Ellis Fund, 1973.6.

R. Fistique (19th century), *Competition Drawing for the Seal of the Worcester Art Museum,* 1899, graphite on cream paperboard, 14.1 × 16.5 cm. Gift of the artist; transferred from the Worcester Art Museum library, 1988.273.

Leonard Flettrich (born 1916), *Torso of a Woman,* n.d., brush and India ink over charcoal on off-white wove paper, 86.3 × 58.8 cm. Museum purchase, 1968.37.

David Fredenthal (1914–1958), *Morning Meal-Cave-Volmen Tone,* n.d., colored inks applied with pen and brush on cream wove paper, 21.8 × 28.8 cm. Museum purchase, 1948.30.

A. Galvin (20th century), *Two Horses,* 1924, watercolor over graphite on cream wove paper, 30.2 × 45.5 cm. Museum purchase, 1935.2.

Madeleine Gekiere (born 1919), *Space Ride,* n.d., graphite with watercolor on cream wove paper, 31.8 × 48.2 cm. Director's Discretionary Fund, 1961.15.

Robert Swain Gifford (1840–1905), *Trees by a Stream,* n.d., graphite on tan wove paper, 12.8 × 20.1 cm. Bequest of Mabel E. Greenwood, 1965.841.

Robert Swain Gifford (1840–1905), *In the Middle of the Forest,* n.d., graphite on cream wove paper, 8.8 × 11.6 cm. Bequest of Mabel E. Greenwood, 1965.842.

Robert Swain Gifford (1840–1905), *Faggot Gatherers,* n.d., graphite on cream wove paper, 10.5 × 15.2 cm. Bequest of Mabel E. Greenwood, 1965.843.

Robert Swain Gifford (1840–1905), *Faggot Gatherer Near a Forest Clearing,* n.d., graphite on cream wove paper, 9.3 × 15.0 cm. Bequest of Mabel E. Greenwood, 1965.844.

Robert Swain Gifford (1840–1905), *Peasant in a Forest,* n.d., graphite on cream wove paper, 9.5 × 15.3 cm. Bequest of Mabel E. Greenwood, 1965.845.

Louis Gonzales (20th century), *Hunter and Slain Buffalo,* early 1930s, watercolor over graphite on cream illustration board, 36.9 × 22.5 cm. Museum purchase, 1935.97.

Eliza Goodridge (1798–1882), *View of Round Hill, Northampton, Massachusetts,* 1824, watercolor over graphite on cream laid paper, 22.9 × 27.3 cm. Eliza S. Paine Fund, 1994.286.

Lev Vladimir Goriansky (1897–1967), *Figure Shading His Eyes,* n.d., charcoal with watercolor on cream wove paper, 35.7 × 43.2 cm. Gift of Buchanan Charles, 1953.58.

Philip Grausman (born 1935), *Reclining Figure,* 1974, graphite on off-white wove paper, 37.5 × 56.0 cm. Anonymous gift, 1975.648.

Morris Graves (born 1910), *Ibis Feeding on Its Own Breast,* 1947, gouache and ink wash on cream Japan paper, 63.4 × 78.0 cm. Museum purchase, 1948.31.

Morris Graves (born 1910), *Crane Dancing with a Pebble,* 1945, watercolor and gouache on laminated cream Japan paper, 108.7 × 63.6 cm. Gift of Mr. Robert G. Reed, 1967.43.

Morris Graves (born 1910), *Bird Calling Down a Hole,* 1945, brush and black ink with gouache on cream laid paper, 47.9 × 27.0 cm. Gift of Mr. and Mrs. Daniel Catton Rich, 1973.91.

Morris Graves (born 1910), *Moon Rising,* 1944, watercolor and gouache on tan laid paper, 78.4 × 68.3 cm. Gift of William H. and Saundra B. Lane, 1976.179.

Nancy Graves (1940–1995), *Pussy Willow,* ca. 1980, graphite on white laid paper, 26.8 × 18.4 cm. Gift of Leslie and Tom Freudenheim, 1984.170.

Sante Graziani (born 1920), *After Ingres,* 1966, graphite on off-white paperboard, 56.0 × 71.2 cm. Gift under the Museum Donor Program of the American Federation of Arts, 1966.42.

Sante Graziani (born 1920), *Annunciation to a Shepherd in a Gothic Style,* 1970s, pen and black ink over graphite on cream wove paper, 38.0 × 50.6 cm. Gift of the artist, 1988.280.

Sante Graziani (born 1920), *Gothic Madonna,* 1970s, pen and India ink on cream ragboard, 30.4 × 15.8 cm. Gift of the artist, 1989.190.

Sante Graziani (born 1920), *Madonna and Child,* 1970s, pen and India ink over graphite on off-white paperboard, 40.8 × 30.0 cm. Gift of the artist, 1989.191.

Sante Graziani (born 1920), *Madonna and Child,* 1970s, pen and India ink over graphite on cream wove paper, 28.1 × 21.6 cm. Gift of the artist, 1989.192.

Sante Graziani (born 1920), *The Infant Christ Blessing,* 1970s, pen and India ink over graphite on off-white paperboard, 59.2 × 50.8 cm. Gift of the artist, 1990.158.

Sante Graziani (born 1920), *Nativity,* 1970s, pen and India ink over graphite on white wove paper, 32.8 × 43.0 cm. Gift of the artist, 1990.162.

Edward D. E. Greene (1823–1879), attributed to, *A Sleeping Child,* n.d., graphite on cream wove paper, 13.5 × 8.2 cm. Bequest of Philip J. Gentner, 1942.66.

Gertrude Greene (1904–1956), *Study for Progression,* 1944, graphite on cream wove paper, 34.6 × 28.8 cm. Gift of Dr. and Mrs. Elton Yasuna, 1991.236.

Horatio Greenough (1805–1852), *A Letter to Samuel Whitwel, with Sketches for a Monument for Mr. Buckminster,* 1833, pen and brown ink over graphite on cream wove paper, 24.8 × 20.7 cm. Museum purchase, 1916.128.184.

Horatio Greenough (1805–1852), *Castor and Pollux Exchanging Life and Death,* n.d., charcoal and white chalk over graphite on gray wove paper, 26.9 × 22.3 cm. Museum purchase, 1916.128.187.

Horatio Greenough (1805–1852), *Studies of the Head of a Child and the Head of a Woman*, n.d., graphite and white chalk on gray prepared off-white laid paper, 22.5 × 20.7 cm. Museum purchase, 1916.128.188.

Joseph Greenwood (1857–1927), 306 sketches, chiefly landscape studies in graphite on cream wove paper. Gift of the estate of Mabel E. Greenwood, 1965.492.001–306.

William Gropper (1897–1977), *The Führer*, ca. 1938, India ink applied with pen and brush with white gouache on cream wove paper, 49.5 × 31.9 cm. Museum purchase, 1941.46.

Chaim Gross (1904–1991), *Sketch for a Sculpture*, 1967, watercolor over graphite on off-white wove paper, 55.9 × 78.0 cm. Gift of the artist, 1974.334.

Dan Gustin (born 1947), *Reclining Nude*, 1976, charcoal on cream wove paper, 127.2 × 96.7 cm. Jerome A. Wheelock Fund, 1978.43.

Robert Gwathmey (1903–1988), *Old Woman*, 1940s, graphite on off-white wove paper, 57.8 × 39.7 cm. Gift of Mrs. Helen Sagoff Slosberg, 1972.1.

Michael Hachey (born 1948), *Phi Fugue*, 1984, graphite on off-white wove paper, 56.4 × 46.1 cm. Bradley C. Higgins Fund, 1985.247.

George C. Halcott (1839–1913), *The Worcester Art Museum*, 1896, watercolor over graphite on cream wove paper, 43.0 × 63.8 cm. Bequest of Stephen Salisbury, 1907.86.

Philip Leslie Hale (1865–1931), *Studies of Boxers*, ca. 1895, graphite and white chalk on brown wove paper. Gift of Anne M. and Paul S. Morgan, 1996.70.

Lee Hall (born 1934), *Betty's View/Connecticut Horizon*, 1981, watercolor on cream Japan paper, 18.6 × 14.2 cm. Gift of the Betty Parsons Foundation, 1985.268.

Lee Hall (born 1934), *Shore Distance/Betty's Ledge*, 1981, watercolor on cream Japan paper, 18.7 × 14.3 cm. Gift of the Betty Parsons Foundation, 1985.269.

Robert Hallowell (1886–1939), *Gloire Passée*, 1931, watercolor over graphite on cream wove paper, 60.8 × 48.5 cm. Gift of Lee Simonson, 1942.46.

DeWitt Hardy (born 1940), *View of Dover, New Hampshire*, 1976, watercolor over graphite on off-white wove paper, 56.8 × 75.6 cm. Gift of Dr. and Mrs. Robert A. Johnson, 1985.4.

Herbert Harrington (1945–1975), *18 Mile Road*, 1970, graphite on off-white wove paper, 57.0 × 76.0 cm. Jerome Wheelock Fund, 1970.120.

William Stanley Haseltine (1835–1900), *The Delaware River*, ca. 1860, pen and black ink over graphite with gray wash on cream wove paper, 38.0 × 55.9 cm. Gift of Helen Haseltine Plowden, 1952.20.

Burton Hasen (born 1921), *Head*, 1958, graphite, pastel, and crayon on off-white wove paper, 85.3 × 59.0 cm. Director's Discretionary Fund, 1961.5.

Childe Hassam (1859–1935), *Yonkers from the Palisades*, 1916, watercolor over graphite on cream wove paper, 35.5 × 50.9 cm. Museum purchase, 1917.40.

Childe Hassam (1859–1935), *Lyman's Pool*, 1912, watercolor on off-white wove paper, 30.6 × 46.1 cm. Bequest of Mrs. Charlotte E. W. Buffington, 1935.52.

Childe Hassam (1859–1935), *Looking into Beryl Pool*, 1912, watercolor on cream wove paper, 27.8 × 38.8 cm. Bequest of Mrs. Charlotte E. W. Buffington, 1935.53.

Childe Hassam (1859–1935), *Still Life with Fruit*, 1886, watercolor on off-white wove paper, 24.9 × 35.6 cm. Anonymous gift, 1941.41.

Childe Hassam (1859–1935), *Road by the Pond, Cos Cob*, 1902, pastel on sandpaper, 45.8 × 56.1 cm. Gift of Frank L. and Louise C. Harrington, 1991.2.

James Dexter Havens (1900–1960), *Wind and Snow*, ca. 1938, graphite and colored pencils on cream paperboard, 8.1 × 12.6 cm. Gift of Bettina Havens Letcher, 1989.129.

Martin Johnson Heade (1819–1904), *Fryeburg*, 1861, graphite on cream wove paper, 22.2 × 29.5 cm. Charlotte E. W. Buffington Fund, 1994.238.

Charles Emile Heil (1870–after 1940), *Blackburnian Warbler and Apple Blossoms*, n.d., watercolor over graphite on cream wove paper, 18.3 × 19.1 cm. Gift of Grace M. Neill, 1985.355.

John Heliker (born 1909), *The Cafe Manager*, n.d., pen and India ink on white wove paper, 30.6 × 22.9 cm. Gift of Nelson Goodman, 1984.14.

Velino Herrera [Ma-pe-wi] (1902–1973), *The Three Tribes: Pueblo, Sioux, Navajo*, 1930s, gouache over graphite on off-white wove paper, 50.9 × 61.3 cm. Museum purchase, 1940.1.

Velino Herrera [Ma-pe-wi], Native American (1902–1973), *The Buffalo Hunt*, 1930s, gouache over graphite on off-white paperboard, 53.1 × 68.7 cm. Museum purchase, 1940.2.

John William Hill (1812–1879), *Mountain River*, 1868, watercolor over graphite on cream wove paper, 40.6 × 35.2 cm. Loring Holmes Dodd Fund, 1985.303.

Jack Hokeah, Native American (1902–after 1967), *Kiowa Warrior Celebrating a Ritual*, early 1930s, gouache over graphite on blue wove paper, 27.3 × 19.1 cm. Museum purchase, 1935.98.

Chuck Holtzman (born 1950), *Untitled #356*, 1993, charcoal and graphite on white wove paper, 73.4 × 58.5 cm. Helen Sagoff Slosberg Fund, 1996.27.

Chuck Holtzman (born 1950), *Untitled #407*, 1994, charcoal and graphite on white wove paper, 26.0 × 18.0 cm. Helen Sagoff Slosberg Fund, 1996.28.

Winslow Homer (1836–1910), *Old Friends*, 1894, watercolor over graphite on off-white wove paper, 54.8 × 38.6 cm. Museum purchase, 1908.3.

Winslow Homer (1836–1910), *Boys and Kitten*, 1873, watercolor and gouache over graphite on cream wove paper, 24.4 × 34.6 cm. Sustaining Membership Fund, 1911.1.

Winslow Homer (1836–1910), *Bermuda Settlers,* 1901, watercolor over graphite on off-white wove paper, 35.8 × 53.5 cm. Museum purchase, 1911.12.

Winslow Homer (1836–1910), *Sunset, Prout's Neck,* 1895, watercolor over graphite on off-white wove paper, 35.5 × 51.0 cm. Museum purchase, 1911.13.

Winslow Homer (1836–1910), *The Lighthouse, Nassau,* 1899, watercolor over graphite on off-white wove paper, 37.0 × 53.8 cm. Museum purchase, 1911.14.

Winslow Homer (1836–1910), *Coral Formation,* 1901, watercolor over graphite on off-white wove paper, 35.7 × 53.8 cm. Museum purchase, 1911.15.

Winslow Homer (1836–1910), *Prout's Neck, Rocky Shore,* 1883, watercolor over graphite on off-white wove paper, 29.5 × 50.5 cm. Museum purchase, 1911.16.

Winslow Homer (1836–1910), *Rum Cay,* ca. 1898, watercolor over graphite on off-white wove paper, 38.2 × 54.8 cm. Museum purchase, 1911.17.

Winslow Homer (1836–1910), *Grand Discharge, Lake Saint John,* ca. 1897, watercolor over graphite on off-white wove paper, 35.6 × 55.6 cm. Museum purchase, 1911.18.

Winslow Homer (1836–1910), *In a Florida Jungle,* ca. 1885, watercolor over graphite on off-white wove paper, 35.8 × 51.0 cm. Museum purchase, 1911.19.

Winslow Homer (1836–1910), *Prout's Neck, Surf on Rocks,* 1895, watercolor over graphite on off-white wove paper, 38.8 × 54.8 cm. Museum purchase, 1911.20.

Winslow Homer (1836–1910), *Saguenay River, Lower Rapids,* 1897, watercolor over graphite on off-white wove paper, 35.7 × 53.5 cm. Museum purchase, 1911.21.

Winslow Homer (1836–1910), *Fishing Boats, Key West,* 1904, watercolor over graphite on off-white wove paper, 35.6 × 55.6 cm. Museum purchase, 1911.22.

Winslow Homer (1836–1910), *The Turkey Buzzard,* 1904, watercolor over graphite on cream wove paper, 35.4 × 50.1 cm. Museum purchase, 1917.6.

Winslow Homer (1836–1910), *Crab Fishing,* 1883, watercolor over graphite on off-white wove paper, 37.3 × 55.6 cm. Bequest of Grenville H. Norcross, 1937.13.

Winslow Homer (1836–1910), *The Swing,* ca. 1879, watercolor over graphite on cream wove paper, 18.4 × 24.6 cm. Gift of Mrs. Howard W. Preston in memory of Dr. and Mrs. Loring Holms Dodd, 1969.128.

Winslow Homer (1836–1910), *The Garden Gate, Bahamas,* 1885, watercolor over graphite on off-white wove paper, 53.3 × 37.0 cm. Bequest of Miss Miriam Shaw, 1983.26.

Dorothy Hood (born 1919), *Flower,* n.d., pen and black ink over graphite on gray wove paper, 66.2 × 50.9 cm. Gift of Mrs. Eugene H. Wagner, 1968.4.

Charles Sydney Hopkinson (1869–1962), *Wind in Bermuda,* 1940, watercolor over graphite on off-white wove paper, 38.0 × 55.8 cm. Museum purchase, 1942.49.

Edward Hopper (1882–1967), *Yawl Riding a Swell,* 1935, watercolor over graphite on cream wove paper, 51.4 × 71.7 cm. Museum purchase, 1935.145.

Edward Hopper (1882–1967), *Cobb House,* 1942, watercolor over graphite on off-white wove paper, 55.2 × 75.9 cm. Gift of Mr. Stephen C. Clark, 1943.9.

Augustus Hoppin (1828–1896), *A Beauty and Her Admirers,* 1863, pen and black ink over graphite on cream wove paper, 27.2 × 26.6 cm. Museum purchase, 1916.129.300.

Earl Horter (1881–1940), *Storage Tanks,* 1931, pen and black ink with gouache over graphite on cream wove paper, 44.9 × 44.2 cm. Gift of David and Selma Medoff, 1982.86.

Leon Hovsepian (born 1915), *The Flight of a Song,* 1968, pen and India ink with gouache on cream wove paper, 70.6 × 55.8 cm. Museum purchase, 1968.40.

Charles Howard (1899–1978), *Drawing #22,* 1957, black ink applied with pen and brush with gouache, charcoal, black crayon, and graphite on off-white wove paper, 54.4 × 75.3 cm. Director's Discretionary Fund, 1959.1.

O. Victor Humann (1874–1951), *Vatican Gardens,* n.d., watercolor over graphite on white wove paper, 27.8 × 38.3 cm. Gift of Mr. and Mrs. O. Victor Humann in memory of Francis Henry Taylor, 1959.75.

William Morris Hunt (1824–1879), *An Owl,* ca. 1865, charcoal on tan laid paper, 43.3 × 28.4 cm. Gift of Mrs. Edward K. Hill, 1921.82.

William Morris Hunt (1824–1879), *Landscape with Bathers,* ca. 1875, charcoal on cream wove paper, 9.8 × 34.3 cm. Gift of Miss Harriet E. Clarke, 1935.198.

William Morris Hunt (1824–1879), *Standing Bather,* 1877, charcoal on cream laid paper, 40.0 × 48.2 cm. Gift of Mr. Robert Woods Bliss, 1942.44.

William Morris Hunt (1824–1879), *Landscape with Roadside Cedars,* ca. 1875, charcoal on gray laid paper, 21.0 × 13.4 cm. Gift of Mrs. Enneking Long, 1990.116.

Henry Inman (1801–1846), *Head of a Child,* 1827, pen and black ink over graphite on cream wove paper, 19.5 × 12.8 cm. Museum purchase, 1916.128.171.

Henry Inman (1801–1846), *A Soldier at a Cenotaph,* n.d., pen and black ink on cream wove paper, 19.8 × 14.2 cm. Museum purchase, 1916.128.172.

Joel Janowitz (born 1945), *Quiet Water,* 1975, watercolor on white laid paper, 42.3 × 70.7 cm. Gift of Ralph Rose in memory of his parents, Mary D. and Philip Rose, 1983.73.

Joel Janowitz (born 1945), *Wrapped Apples,* 1974, watercolor over graphite on white wove paper, 18.0 × 26.0 cm. Gift of B. A. King, 1989.153.

Andrew Jansons (born 1944), *Untitled,* 1973, acrylic polymer paint on white wove paper, 29.6 × 38.1 cm. Gift of Dr. Raymond Ashare, 1974.98.

David Claypool Johnston (1799–1865), *Benevolence,* n.d., graphite on cream wove paper, 7.6 × 8.0 cm. Museum purchase, 1916.129.307.

John Bernard Johnston (1847–1886), *Grazing Cattle,* n.d., charcoal on cream laid paper, 23.5 × 32.0 cm. Bequest of J. Eastman Chase, 1924.41.

Zubel Kachadoorian (born 1924), *Portrait of Robert Warren,* 1957, charcoal on cream wove paper, 69.2 × 59.2 cm. Museum purchase, 1959.104.

Alex Katz (born 1927), *Ada with Hand,* 1972, graphite on cream wove paper, 50.6 × 75.5 cm. Gift of Sidney Rose in memory of his parents, Mary D. and Philip Rose, 1983.63.

Jane Kaufman (born 1938), *Untitled,* 1973, acrylic polymer paint and colored glitters over graphite on white wove paper, 31.0 × 33.3 cm. Gift of the artist, 1974.97.

Mark Keahbone, Native American (20th century), *Kiowa Brave on Horseback,* late 1940s, pen and black ink with watercolor and gouache over graphite on cream wove paper, 26.8 × 27.6 cm. Museum purchase, 1990.160.

John Frederick Kensett (1816–1872), *View of Niagara Falls,* ca. 1852, graphite on cream wove paper, 29.3 × 45.8 cm. Gift of Michael Saint Clair, 1985.321.

Rockwell Kent (1882–1971), *Man Seated,* ca. 1926, watercolor over graphite on off-white wove paper, 24.8 × 35.0 cm. Museum purchase, 1927.12.

Rockwell Kent (1882–1971), *Landscape with Sheep,* ca. 1926, watercolor over graphite on off-white wove paper, 24.8 × 35.0 cm. Museum purchase, 1927.13.

Rockwell Kent (1882–1971), *Boy on a Cliff,* ca. 1926, watercolor over graphite on white wove paper, 35.0 × 24.8 cm. Museum purchase, 1927.14.

Rockwell Kent (1882–1971), *Cottage in Landscape,* ca. 1926, watercolor over graphite on off-white wove paper, 24.9 × 35.1 cm. Museum purchase, 1927.15.

Rockwell Kent (1882–1971), *Woman Reaping,* ca. 1926, watercolor over graphite on off-white wove paper, 24.7 × 35.0 cm. Museum purchase, 1927.16.

Earl Kerkam (1891–1965), *Elbow Rest,* 1953, brush and India ink over pastel on cream wove paper, 51.2 × 33.6 cm. Alexander and Caroline Murdock DeWitt Fund, 1966.123.

Franz Kline (1910–1962), *Untitled,* ca. 1952, watercolor and oil paint on white wove paper, 27.8 × 21.5 cm. Gift of Mrs. Helen Sagoff Slosberg. 1980.3.

Lois Jean Knobler (born 1929), *Drawing 2,* n.d., brush and India ink with wash on white illustration board, 25.4 × 38.3 cm. Director's Discretionary Fund, 1963.97.

Helen Mary Knowlton (1832–1918), *Antonio,* n.d., pastel on sandpaper, 32.6 × 24.8 cm. Museum purchase, 1908.23.

Helen Mary Knowlton (1832–1918), *The Market Place at Dives, France,* n.d., charcoal on cream laid paper, 41.3 × 28.2 cm. Gift of Mrs. Isaac Fenno-Gendrot in memory of Helen M. Knowlton, 1918.180.

Helen Mary Knowlton (1832–1918), *Portrait of a Young Girl,* n.d., charcoal on tan laid paper, 28.2 × 22.5 cm. Anonymous gift, 1978.83.

Florence Koehler (1861–1944), *Portrait of Marguerite Matisse Du Thuit,* n.d., black chalk on gray laid paper, 45.4 × 34.3 cm. Gift of Mrs. Henry D. Sharpe, 1951.35.

Florence Koehler (1861–1944), *Fruit No. 2,* n.d., gouache on gray wove paper, 42.5 × 38.8 cm. Gift of Mrs. Henry D. Sharpe, 1951.36.

Vaino Kola (born 1937), *June Light,* 1979, graphite on white wove paper, 18.2 × 24.8 cm. Gift of the artist, 1979.33.

Auguste Koopman (1869–1914), *Standing Male Nude,* n.d., charcoal on cream laid paper, 62.2 × 41.2 cm. Gift of Paul Prouté, 1982.62.

Leon Kroll (1884–1974), *Study of the Figure of Education for a Mural in the Worcester Memorial Auditorium,* 1940, charcoal on prepared gray paperboard, 68.6 × 50.9 cm. Museum purchase, 1941.51.

Leon Kroll (1884–1974), *The Reader,* ca. 1940, charcoal on prepared cream paperboard, 56.1 × 71.4 cm. Gift of Mrs. Francis Henry Taylor, 1958.23.

Walt Kuhn (1877–1949), *Agnes,* 1926, brush and black ink on gray wove paper, 43.0 × 22.3 cm. Gift of Dr. and Mrs. Robert Johnson, 1993.103.

Yayoi Kusama (born 1929), *Pacific Ocean (No. 1),* 1959, watercolor, charcoal, and pastel on cream Japan paper, 60.3 × 71.4 cm. Gift of Mrs. Helen Sagoff Slosberg, 1973.1.

Gaston Lachaise (1882–1935), *Nude with Drapery,* ca. 1924, purple crayon and graphite on cream Japan paper, 29.0 × 14.6 cm. Gift of Mrs. Helen Sagoff Slosberg, 1979.28.

John La Farge (1835–1910), *The Three Marys: A Study for the Southworth Window, Church of the Ascension, New York,* 1889, watercolor over graphite with gouache on cream wove paper, 38.4 × 18.4 cm. Gift of Felix A. Gendrot, 1935.113.

John La Farge (1835–1910), *The Sacred Font, Iyemitsu Temple, Nikko,* 1886, watercolor over graphite on cream wove paper, 22.0 × 28.3 cm. Gift of Dr. Samuel B. Woodward, 1939.48.

John La Farge (1835–1910), *Musicians in Ceremonial Costume,* 1887, watercolor over graphite with gouache on cream wove paper, 26.6 × 23.8 cm. Gift of Dr. Samuel B. Woodward, 1939.49.

John La Farge (1835–1910), *The Last Sight of Tahiti: Trade Winds,* 1893, watercolor over graphite on cream Japanese vellum paper, 30.5 × 45.6 cm. Gift of Dr. Samuel B. Woodward, 1939.52.

John La Farge (1835–1910), *Portrait of John Chandler Bancroft,* ca. 1863, charcoal on white wove paper, 15.2 × 8.7 cm. Museum purchase, 1950.276.

John La Farge (1835–1910), *Wild Roses,* ca. 1895, watercolor on cream wove paper, 31.6 × 23.6 cm. Gift of Mildred Rothwell in memory of Ruth E. Dodd, 1988.47.

Paul Landacre (1893–1963), *Preparatory Drawing for "Yesterday,"* ca. 1940, graphite on off-white wove paper, 35.7 × 24.9 cm. Anonymous gift, 1987.55.

Paul Landacre (1893–1963), *Preparatory Drawing for "Yesterday,"* ca. 1940, graphite on off-white wove paper, 35.9 × 25.4 cm. Anonymous gift, 1987.56.

Robert Laurent (1890–1969), *Head in Profile,* n.d., black crayon on cream wove paper, 31.8 × 23.7 cm. Sarah C. Garver Fund, 1981.310.

Jacob Lawrence (born 1917), *They Live in Fire Traps,* 1943, gouache over graphite on off-white wove paper, 57.7 × 39.4 cm. Museum purchase, 1943.14.

Dwight B. Lawton (19th century), *Seascape,* n.d., watercolor on paper, 22.9 × 15.2 cm. Bequest of Stephen Salisbury, 1916.60.

Elizabeth Lee [McKissock] (born 1906), *Russian Ballet Dancers,* n.d., watercolor on off-white wove paper, 38.6 × 47.8 cm. Museum purchase, 1934.41.

Claire Leighton (1901–1989), 67 studies and preparatory drawings for the artist's cycle of stained-glass windows in the Cathedral of Saint Paul, Worcester, 1957, the Saint John Lutheran Church, Waterbury, Connecticut, 1957, and the Methodist Church, Wellfleet, Massachusetts, 1966; chiefly in graphite, pen and India ink, and gouache on cream laid paper. Bequest of the artist, 1990.38–104.

Jack Levine (born 1915), *Man with a Cigarette,* 1960s, brush and black ink on off-white wove paper, 30.4 × 22.9 cm. Gift of the Reverend Thaddeus Clapp, 1966.127.

Edmond Darch Lewis (1837–1910), *Harbor Scene,* 1881, watercolor over graphite on pale green wove paper, 25.1 × 51.0 cm. Gift of Mr. and Mrs. Hall James Peterson, 1982.106.

Sol LeWitt (born 1928), *Documentation Drawings for 47 Three-Part Variations on a Cube,* 1967, 15 sheets, black ballpoint pen, red ballpoint pen, or black felt-tip pen on tan wove paper, each about 21.7 × 28.0 cm. Gift of the artist, 1974.96.1–15.

Sol LeWitt (born 1928), *Form Derived from a Cube,* 1982, watercolor over graphite on off-white wove paper, 56.0 × 56.0 cm. National Endowment for the Arts Museum Purchase Plan, 1984.134.

Thomas Liesegang (born 1955), *Strassenbild,* 1984, acrylic polymer paint, sand, and charcoal on white wove paper, 56.9 × 76.1 cm. Gift of Mark G. Kelleher, 1985.19.

Charles H. Lincoln (1861–1943), *Design for the Seal of the Worcester Art Museum,* 1899, watercolor over graphite over printed tone on cream wove paper, 10.8 × 10.8 cm. Gift of the artist, 1899.27.

Charles H. Lincoln (1861–1943), *Design for the Seal of the Worcester Art Museum,* 1899, watercolor on cream paperboard, 8.9 × 8.9 cm. Gift of the artist, 1899.28.

Seymour Lipton (born 1903), *Untitled,* 1956, black crayon on off-white wove paper, 27.9 × 21.6 cm. Gift of the Betty Parsons Foundation, 1985.265.

Louis James Lucas (born 1938), *The Dragon Plant,* 1962, pen and India ink on off-white wove paper, 43.2 × 34.2 cm. Director's Discretionary Fund, 1963.98.

Carol N. Luick (born 1946), *Untitled,* 1973, pen and black ink on white wove paper, 48.4 × 48.4 cm. Sarah C. Garver Fund, 1973.67.

Dodge Macknight (1860–1950), *French Canadian Wash,* ca. 1918, watercolor over graphite on cream wove paper, 38.9 × 55.0 cm. Museum purchase, 1918.16.

Dodge Macknight (1860–1950), *Meadow in Snow,* ca. 1918, watercolor over graphite on cream wove paper, 39.2 × 56.5 cm. Museum purchase, 1918.186.

Dodge Macknight (1860–1950), *Grand Canyon of the Colorado,* ca. 1915, watercolor over graphite on off-white wove paper, 45.2 × 57.0 cm. Gift of Henry H. and Zoe Oliver Sherman, 1922.199.

Dodge Macknight (1860–1950), *Pool in Autumn,* n.d., watercolor over graphite on off-white wove paper, 43.7 × 60.2 cm. Gift of Gertrude W. and David J. Tucker, 1986.61.

Ronald Markman (born 1931), *Clowns on Bicycles,* 1958, pen and black ink on cream wove paper, 25.8 × 33.8 cm. Director's Discretionary Fund, 1959.23.

Reginald Marsh (1898–1954), *New York from Weehawken,* 1940, watercolor over graphite on white wove paper, 38.7 × 57.5 cm. Gift of the Friends of Southern Vermont Artists, 1940.24.

Reginald Marsh (1898–1954), *Tessie's Bridal Shop,* 1946, watercolor over graphite with gray wash on off-white wove paper, 69.4 × 102.7 cm. Bequest of Felicia Meyer Marsh, 1979.24.

Reginald Marsh (1898–1954), *View of Manhattan,* 1929, watercolor over graphite on off-white wove paper, 35.5 × 51.0 cm. Bequest of Felicia Meyer Marsh, 1979.25.

Reginald Marsh (1898–1954), *Monument on the Shore,* n.d., watercolor over graphite on off-white wove paper, 35.6 × 50.9 cm. Bequest of Felicia Meyer Marsh, 1979.26.

Reginald Marsh (1898–1954), *Street Scene,* 1944, pen and black ink and gray wash over graphite on cream wove paper, 35.4 × 50.8 cm. Gift of Mr. and Mrs. Robert Warner, 1984.56.

Julian Martinez, Native American (1879–1943), *Deer Dance, San Ildefonso Pueblo,* early 1930s, gouache over graphite on off-white illustration board, 52.9 × 76.0 cm. Museum purchase, 1935.94.

Julian Martinez, Native American (1879–1943), *Pueblo Corn Dancer,* early 1930s, gouache over graphite on cream wove paper, 37.3 × 26.4 cm. Museum purchase, 1935.100.

Richard Martinez, Native American (20th century), *An Antelope in a Downpour,* early 1930s, gouache over graphite on tan wove paper, 33.3 × 50.3 cm. Museum purchase, 1935.89.

Richard Martinez, Native American (20th century), *Rain Man,* early 1930s, gouache over graphite on tan wove paper, 57.7 × 75.8 cm. Museum purchase, 1935.93.

Richard Martinez, Native American (20th century), *Warrior Slaying a Buffalo,* early 1930s, gouache over graphite on gray illustration board, 45.6 × 55.6 cm. Museum purchase, 1935.103.

Richard Martinez, Native American (20th century), *Arrow Dance,* early 1930s, gouache over graphite on cream illustration board, 45.8 × 55.8 cm. Museum purchase, 1935.104.

Richard Martinez, Native American (20th century), *Eagle Dance,* early 1930s, gouache over graphite on gray illustration board, 48.2 × 48.2 cm. Museum purchase, 1935.106.

Jan Matulka (1890–1972), *An Autogiro,* 1930s, graphite on cream wove paper, 21.5 × 13.9 cm. Gift of Lewis A. Shepard and Ellen R. Berezin, 1983.31.

Alfred H. Maurer (1868–1932), *Vineyards,* n.d., oil paint over graphite on cream wove paper, 25.4 × 35.9 cm. Gift of Mr. and Mrs. O. Victor Humann, 1959.76.

Michael Mazur (born 1935), *Texas Tree #13,* 1991, black crayon and charcoal on plywood, 67.0 × 60.6 cm. Gift of Richard A. Heald Fund and the artist, 1992.75.13.

Michael Mazur (born 1935), *Texas Tree #16,* 1991, graphite on white wove paper, 60.8 × 56.5 cm. Gift of Richard A. Heald Fund and the artist, 1992.75.16.

Todd McKie (born 1944), *European Visitor,* 1977, watercolor and ink over graphite on off-white wove paper, 70.9 × 56.6 cm. Gift of Mr. and Mrs. B. A. King in honor of Richard Stuart Teitz, 1981.346.

Todd McKie (born 1944), *Slide Show,* 1978, watercolor over graphite on off-white wove paper, 66.3 × 57.0 cm. Gift of Sidney Rose in memory of his parents, Mary D. and Philip Rose, 1983.64.

Todd McKie (born 1944), *Slightly South of France,* 1979, watercolor over graphite on off-white wove paper, 65.4 × 83.8 cm. Gift of Sidney Rose in memory of his parents, Mary D. and Philip Rose, 1983.65.

Todd McKie (born 1944), *Woman with Pipe,* 1980, watercolor over graphite on white wove paper, 126.9 × 106.0 cm. Gift of Sidney Rose in memory of his parents, Mary D. and Philip Rose, 1983.66.

Todd McKie (born 1944), *Simplicity Rears Its Ugly Head,* 1981, watercolor over graphite on white wove paper, 111.8 × 139.7 cm. Gift of Sidney Rose in memory of his parents, Mary D. and Philip Rose, 1983.67.

Mary Melikian (born 1927), *Roses,* 1968, watercolor on white Japan paper, 28.0 × 22.2 cm. Gift of the artist, 1969.41.

Ludwig Mestler (1891–1959), *The Village of Lauffen on the Traun, Upper Austria,* 1932, watercolor over graphite on off-white wove paper, 24.9 × 34.0 cm. Museum purchase, 1939.44.

William Meyerowitz (1887–1981), *Two Men Dancing,* 1940s, red ballpoint pen on off-white wove paper, 21.4 × 14.0 cm. Gift of Mrs. Helen Sagoff Slosberg, 1979.29.

Leo Mielziner (1869–1935), *Arabesque,* 1916, metalpoint on prepared cream wove paper, 38.8 × 26.6 cm. Gift of Mr. and Mrs. Benjamin B. Snow, 1927.17.

Edward Moran (1829–1901), *Seascape,* 1869, watercolor on cream wove paper, 11.6 × 24.7 cm. Museum purchase, 1916.129.375.

Thomas Moran (1837–1926), *Sketch of Rocky Coast,* n.d., graphite with white chalk on gray wove paper, 25.3 × 35.7 cm. Gift of Dr. and Mrs. Elton Yasuna, 1973.4.

Samuel F. B. Morse (1791–1872), *Mare and Colt,* n.d., pen and black ink with wash on cream wove paper, 10.1 × 14.4 cm. Museum purchase, 1916.127.131.

Barry Moser (born 1940), *Study for "Landscape of Eternal Youth,"* 1976, pen and black ink with white heightening on gray laid paper, 12.9 × 18.1 cm. Gift of the artist, 1977.19.

Robert Motherwell (1915–1991), *Cartoon for a Mural,* 1951, graphite over watercolor on cream paperboard, 36.6 × 73.6 cm. Sarah C. Garver Fund, 1973.94.

William Sidney Mount (1807–1868), *A Man Standing before a Shed,* n.d., pen and brown ink on cream wove paper, 4.8 × 8.6 cm. Museum purchase, 1916.128.251.

Antonia Munroe (born 1952), *Still Life with Pink Onions and Blue Bottle,* n.d., acrylic polymer paint on off-white wove paper, 52.8 × 54.1 cm. Gift of Sidney Rose in memory of his parents, Mary D. and Philip Rose, 1984.156.

Thomas Nast (1840–1902), *Caricature of the Artist,* 1882, pen and black ink over graphite on cream wove paper, 7.4 × 11.9 cm. Museum purchase, 1916.129.301.

Carl Gustaf Nelson (born 1898), *Maine Shore,* 1946, gouache and pen and black ink on off-white wove paper, 50.4 × 69.3 cm. Museum purchase, 1947.15.

Carl Gustaf Nelson (born 1898), *Angel,* 1962, black ballpoint pen on off-white wove paper, 99.1 × 84.2 cm. Museum purchase, 1963.99.

Lowell Nesbitt (1933–1993), *Variations: Hands and Rose,* 1964, pen and black ink with graphite on cream wove paper, 141.8 × 92.0 cm. Gift of the artist, 1974.104.

Gilbert Stuart Newton (1794–1835), *Putto on a Wine Cask,* n.d., pen and black ink on cream wove paper, 18.2 × 12.0 cm. Museum purchase, 1916.125.45.

Isamu Noguchi (1904–1988), *Two Seated Nudes,* 1928, charcoal on cream wove paper, 43.6 × 27.4 cm. Museum purchase, 1930.20.

Isamu Noguchi (1904–1988), *Nude Leaning on Right Knee,* 1928, charcoal on cream wove paper, 44.0 × 27.1 cm. Museum purchase, 1930.21.

Isamu Noguchi (1904–1988), *Two Standing Nudes,* 1928, charcoal on cream wove paper, 43.6 × 27.1 cm. Museum purchase, 1930.22.

Isamu Noguchi (1904–1988), *Kneeling Nude with Arms Outstretched,* 1928, charcoal on cream wove paper, 27.2 × 42.9 cm. Museum purchase, 1930.23.

Isamu Noguchi (1904–1988), *Seated Nude,* 1928, charcoal on cream wove paper, 39.7 × 30.9 cm. Museum purchase, 1930.25.

Dennis Oppenheim (born 1938), *And Then the Winds Came,* 1983, pastel, charcoal, and oil paint over graphite on off-white wove paper, 97.4 × 127.8 cm. National Endowment for the Arts Museum Purchase Plan, 1984.32.

Palmer, Native American (20th century), *Apache Brave Leaving His Family for the Hunt,* 1930s, pen and black ink with gouache on blue wove paper, 45.4 × 65.2 cm. Museum purchase, 1940.345.

Margaret Jordan Patterson (1867–1950), *View in the Italian Alps,* ca. 1914, watercolor and gouache over graphite on cream wove paper, 25.4 × 35.5 cm. Eliza S. Paine Fund, 1991.23.

Encarnacion Peña (20th century), *Arrow Dance, Santa Clara Pueblo,* early 1930s, gouache over graphite on off-white illustration board, 30.5 × 46.0 cm. Museum purchase, 1935.102.

Joseph Pennell (1860–1926), *Street Scene in New York,* 1908, pastel and black chalk over graphite on gray wove paper, 30.3 × 22.8 cm. Museum purchase, 1988.282.

Charles Hovey Pepper (1864–1950), *Attean Lake, New Hampshire,* ca. 1939, watercolor and gouache on off-white wove paper, 38.8 × 28.8 cm. Museum purchase, 1939.40.

Charles Hovey Pepper (1864–1950), *View of Eze, France,* 1939, watercolor and gouache on cream wove paper, 54.9 × 37.8 cm. Museum purchase, 1939.41.

Charles Hovey Pepper (1864–1950), *View of Skowhegan, Maine,* ca. 1941, watercolor and gouache on white wove paper, 38.5 × 56.5 cm. Gift of the artist, 1941.52.

Bernard Perlin (born 1918), *Willow Tree,* 1947, silverpoint on prepared off-white wove paper, 59.0 × 51.4 cm. Museum purchase, 1948.28.

Charles O. Perry (born 1929), *Star Moebus [sic],* 1966, pen and black ink over graphite on off-white wove paper, 20.5 × 26.4 cm. Gift of the Betty Parsons Foundation, 1985.284.

Gabor Peterdi (born 1915), *The Temptation of Saint Anthony II,* 1963, pen and black ink, black felt-tip pen, and gray wash on off-white wove paper, 107.4 × 76.2 cm. Director's Discretionary Fund, 1963.100.

Bernard Pfriem (born 1914), *Ingres's Model: Four Views,* n.d., graphite and pastel on off-white wove paper, two panels, each 243.2 × 121.8 cm. Gift of Emily B. Staempfli, 1974.304.1–2.

Panche Pin, Native American (20th century), *Eagle Dance, Tesuque Pueblo,* early 1930s, gouache over graphite on cream wove paper, 31.5 × 50.2 cm. Museum purchase, 1935.91.

Enrico Vittorio Pinardi (born 1934), *Study for Sculpture No. 1,* 1965, pen and black ink over graphite with acrylic polymer paint on cream wove paper, 33.2 × 27.1 cm. Alexander and Caroline Murdock DeWitt Fund, 1966.125.

Ogden Pleissner (1905–1983), *The Ramparts, Saint Malo,* 1950, watercolor over graphite on off-white wove paper, 51.9 × 72.2 cm. Museum purchase, 1951.4.

Reginald Pollack (born 1924), *Nude in Landscape,* 1957, charcoal on off-white wove paper, 49.0 × 63.9 cm. Director's Discretionary Fund, 1961.9.

Fairfield Porter (1907–1975), *Study for Jimmy with Lamp,* 1971, pen and blue ink on off-white wove paper, 27.2 × 35.5 cm. Gift of the artist, 1974.99.

Maurice Brazil Prendergast (1859–1924), *Low Tide, Beachmont,* ca. 1902, watercolor over graphite and charcoal on off-white wove paper, 48.8 × 56.2 cm. Museum purchase, 1941.34.

Maurice Brazil Prendergast (1859–1924), *Across the Harbor, Salem,* ca. 1906, watercolor and gouache over graphite on cream wove paper, 26.7 × 36.4 cm. Museum purchase, 1941.35.

Maurice Brazil Prendergast (1859–1924), *Notre Dame,* 1907, watercolor and gouache over graphite on cream wove paper, 34.8 × 50.5 cm. Museum purchase, 1941.36.

Maurice Brazil Prendergast (1859–1924), *Venice,* ca. 1911, watercolor over graphite on cream wove paper, 38.5 × 55.7 cm. Museum purchase, 1941.37.

Maurice Brazil Prendergast (1859–1924), *Gloucester Park,* ca. 1916, watercolor over graphite on cream wove paper, 36.5 × 57.7 cm. Museum purchase, 1941.38.

Gregorio Prestopino (born 1907), *Sharecropper's Cabin,* n.d., pen and India ink on off-white wove paper, 51.2 × 66.3 cm. Gift of Helen Sagoff Slosberg, 1969.15.

Terri Priest (born 1928), *Three Blues-Green,* 1974, colored pencils on off-white wove paper, 56.2 × 71.4 cm. Gift of the artist, 1976.26.

George Ratkai (born 1907), *Men of Brass,* 1960, pen and India ink with gouache on off-white wove paper, 69.2 × 85.5 cm. Director's Discretionary Fund, 1961.13.

Charles Stanley Reinhart (1844–1896), *Waiter,* n.d., pen and black ink with black crayon on cream paperboard, 23.8 × 25.2 cm. Source unknown, 1988.278.

William Trost Richards (1833–1905), *Sea and Rocks,* late 1870s, watercolor over graphite on gray wove paper, 19.7 × 35.2 cm. Gift of the National Academy of Design from the bequest of Mrs. William T. Brewster, 1954.17.

William Trost Richards (1833–1905), *Slievemore, Achill Island, Ireland,* 1893, watercolor over graphite on cream wove paper, 13.2 × 18.8 cm. Gift of the National Academy of Design from the bequest of Mrs. William T. Brewster, 1954.18.

Chris Ritter (1908–ca. 1971), *The Crow and a Picture of Matisse,* 1942, pen and black ink with watercolor, gouache, monoprint, and collage on off-white wove paper, 50.2 × 63.0 cm. Museum purchase, 1947.14.

Ellen Robbins (1828–1905), *Carnations and Poppies,* 1888, watercolor and gouache over graphite on off-white wove paper, 48.2 × 65.8 cm. Gift of Mrs. Gertrude Thaxter, 1911.23.

Thomas Arthur Robertson (1911–1976), *The Orange Point,* ca. 1941, watercolor on cream wove paper, squared in graphite, 17.0 × 11.4 cm. Thomas Hovey Gage Fund, 1994.229.

Robert Rohm (born 1934), *Untitled,* 1973, graphite and colored pencils on off-white wove paper, 21.0 × 31.3 cm. Gift of the artist, 1974.274.

Victoria Romand (born 1939), *Scene from Alexander Nevski,* ca. 1963, graphite on white wove paper, 57.8 × 73.0 cm. Director's Discretionary Fund, 1963.101.

Joseph [James] Ropes (1812–1885), *Winter,* n.d., charcoal and white chalk on tan wove paper, 15.2 × 13.2 cm. Museum purchase, 1916.129.371.

Theodore Roszak (1907–1981), *Study for "A Thorn Flower,"* 1951, pen and black ink on off-white wove paper, 104.0 × 58.0 cm. Gift of Daniel Catton Rich, 1972.110.

Theodore Roszak (1907–1981), *Self-Portrait,* 1929, graphite on cream wove paper, 27.9 × 20.2 cm. Gift of the artist's estate, 1985.11.

Theodore Roszak (1907–1981), *Studies of Sculptural Constructions,* 1935, graphite on cream wove paper, 34.5 × 21.5 cm. Gift of the artist's estate, 1985.12.

Theodore Roszak (1907–1981), *Notes for the Sculpture "Whaler of Nantucket,"* 1949, India ink applied with pen and brush with colored wash on white wove paper, 35.4 × 25.5 cm. Gift of the artist's estate, 1985.13.

Theodore Roszak (1907–1981), *Sketches for the Sculpture "Whaler of Nantucket,"* 1950, black ink applied with pen and brush on off-white wove paper, 27.9 × 21.6 cm. Gift of the artist's estate, 1985.14.

Theodore Roszak (1907–1981), *Studies for Sculpture,* 1950, black ink applied with pen and brush with wash on off-white wove paper, 21.8 × 28.0 cm. Gift of the artist's estate, 1985.15.

Theodore Roszak (1907–1981), *Sketch for the Sculpture "Fledgling,"* 1956, pen and brown ink with colored wash on cream wove paper, 45.6 × 30.2 cm. Gift of the artist's estate, 1985.16.

Theodore Roszak (1907–1981), *Sea Animals,* 1960, pen and India ink with colored wash on off-white wove paper, 48.4 × 31.9 cm. Gift of the artist's estate, 1985.17.

Theodore Roszak (1907–1981), *Satellites,* 1975, graphite on white wove paper, 73.1 × 58.8 cm. Gift of the artist's estate, 1985.18.

Samuel Worcester Rowse (1822–1901), *Portrait of Susan Ridley Sedgwick Norton,* 1870s, charcoal on brown prepared cream wove paper, 61.2 × 49.0 cm. Bequest of Miss Margaret Norton, 1948.8.

Samuel Worcester Rowse (1822–1901), *Portrait of Catherine Jane Norton,* 1870s, charcoal and white chalk on cream wove paper, 58.8 × 44.0 cm. Bequest of Miss Margaret Norton, 1948.9.

Samuel Worcester Rowse (1822–1901), *Portrait of Grace Norton,* 1870s, black chalk and charcoal on cream wove paper, 70.9 × 52.8 cm. Bequest of Miss Margaret Norton, 1948.10.

John Roy (born 1930), *Untitled,* 1966, charcoal and wash over graphite on cream wove paper, 29.2 × 60.8 cm. Gift of the American Federation of Arts, 1966.124.

Richards Ruben (born 1925), *Y-1,* 1963, charcoal, graphite, black ink, and bronze powder on Japan paper, 52.3 × 67.0 cm. Director's Discretionary Fund, 1964.25.

Olive Rush (1873–1966), *Edge of the Forest,* ca. 1928, watercolor over graphite on cream wove paper, 24.1 × 18.3 cm. Museum purchase, 1928.28.

Olive Rush (1873–1966), *Fallow Deer,* ca. 1928, watercolor over graphite on cream wove paper, 29.9 × 45.8 cm. Museum purchase, 1928.29.

Fred Sandback (born 1943), *Untitled (Study for Sculpture for the Kestner-Gesellschaft, Hannover),* 1987, colored pencils on cream wove paper, 40.8 × 73.6 cm. Eliza S. Paine Fund, 1992.98.

John Singer Sargent (1856–1925), *Muddy Alligators,* 1917, watercolor over graphite on cream wove paper, 35.5 × 53.0 cm. Sustaining Membership Fund, 1917.86.

John Singer Sargent (1856–1925), *Derelicts,* 1917, watercolor over graphite on off-white wove paper, 34.7 × 53.4 cm. Sustaining Membership Fund, 1917.87.

John Singer Sargent (1856–1925), *Shady Paths, Vizcaya,* 1917, watercolor over graphite on off-white wove paper, 39.9 × 53.5 cm. Sustaining Membership Fund, 1917.88.

John Singer Sargent (1856–1925), *Palms,* 1917, watercolor over graphite on off-white wove paper, 40.1 × 53.2 cm. Sustaining Membership Fund, 1917.89.

John Singer Sargent (1856–1925), *Boats at Anchor,* 1917, watercolor over graphite on off-white wove paper, 40.1 × 53.2 cm. Sustaining Membership Fund, 1917.90.

John Singer Sargent (1856–1925), *The Bathers,* 1917, watercolor over graphite on off-white wove paper, 40.1 × 53.3 cm. Sustaining Membership Fund, 1917.91.

John Singer Sargent (1856–1925), *The Pool,* 1917, watercolor over graphite on off-white wove paper, 34.7 × 53.3 cm. Sustaining Membership Fund, 1917.93.

John Singer Sargent (1856–1925), *Sketch of a Seated Male Nude,* n.d., charcoal on cream laid paper, 47.5 × 62.2 cm. Gift of Miss Emily Sargent and Mrs. Francis Ormond, 1930.1.

John Singer Sargent (1856–1925), *Sketch of Kneeling Male Nude,* n.d., charcoal on cream laid paper, 48.1 × 63.7 cm. Gift of Miss Emily Sargent and Mrs. Francis Ormond, 1930.2.

John Singer Sargent (1856–1925), *Sketch of Two Male Nudes,* n.d., charcoal on cream laid paper, 47.7 × 62.5 cm. Gift of Miss Emily Sargent and Mrs. Francis Ormond, 1930.3.

John Singer Sargent (1856–1925), *Sketch of Draped Kneeling Figure,* n.d., charcoal on cream laid paper, 61.8 × 47.4 cm. Gift of Miss Emily Sargent and Mrs. Francis Ormond, 1930.4.

John Singer Sargent (1856–1925), *Studies of Hands,* n.d., charcoal on green wove paper, 63.3 × 48.4 cm. Gift of Miss Emily Sargent and Mrs. Francis Ormond, 1930.5.

John Singer Sargent (1856–1925), *Sketch of Draped Legs,* n.d., charcoal on cream laid paper, 63.3 × 48.0 cm. Gift of Miss Emily Sargent and Mrs. Francis Ormond, 1930.6.

John Singer Sargent (1856–1925), *Sketch of a Male Nude and Baluster,* n.d., graphite on tan laid paper, 54.6 × 23.5 cm. Gift of Miss Emily Sargent and Mrs. Francis Ormond, 1930.7.

John Singer Sargent (1856–1925), *Standing Male Nude,* n.d., charcoal on cream laid paper, 63.3 × 48.5 cm. Gift of Miss Emily Sargent and Mrs. Francis Ormond, 1930.8.

John Singer Sargent (1856–1925), *Sketch of a Seated Female Nude,* n.d., charcoal on cream laid paper, 62.4 × 47.6 cm.

Gift of Miss Emily Sargent and Mrs. Francis Ormond, 1930.9.

John Singer Sargent (1856–1925), *Sketch of a Hovering Angel,* n.d., charcoal on cream laid paper, 48.2 × 63.7 cm. Gift of Miss Emily Sargent and Mrs. Francis Ormond, 1930.10.

John Singer Sargent (1856–1925), *Two Alligators,* 1917, graphite on cream laid paper, 17.8 × 25.4 cm. Gift of Miss Emily Sargent and Mrs. Francis Ormond, 1931.227.

John Singer Sargent (1856–1925), *Three Alligators,* 1917, graphite on cream laid paper, 17.8 × 25.4 cm. Gift of Miss Emily Sargent and Mrs. Francis Ormond, 1931.228.

John Singer Sargent (1856–1925), *Two Alligators,* 1917, graphite on cream laid paper, 17.8 × 25.4 cm. Gift of Miss Emily Sargent and Mrs. Francis Ormond, 1931.229.

John Singer Sargent (1856–1925), *Bullfight,* n.d., pen and black and brown inks over graphite on cream laid paper, 20.2 × 32.8 cm. Gift of Miss Emily Sargent and Mrs. Francis Ormond, 1932.29.

John Singer Sargent (1856–1925), *Eagle,* 1880s, charcoal on tan laid paper, 26.9 × 41.0 cm. Gift of Miss Emily Sargent and Mrs. Francis Ormond, 1932.30.

John Singer Sargent (1856–1925), *Two Eagles,* n.d., charcoal on tan laid paper, 26.8 × 41.1 cm. Gift of Miss Emily Sargent and Mrs. Francis Ormond, 1932.31.

John Singer Sargent (1856–1925), *Sketch of Gothic Sculpture: A Wise Virgin,* n.d., graphite on cream wove paper, 15.0 × 9.1 cm. Gift of Miss Emily Sargent and Mrs. Francis Ormond, 1932.32.

John Singer Sargent (1856–1925), *Sketch of Gothic Sculpture: Saint Euphraisie,* n.d., graphite on cream wove paper, 14.9 × 8.9 cm. Gift of Miss Emily Sargent and Mrs. Francis Ormond, 1932.33.

John Singer Sargent (1856–1925), *Sketch of Gothic Sculpture: Saint Euphraisie,* n.d., graphite on cream wove paper, 14.9 × 8.9 cm. Gift of Miss Emily Sargent and Mrs. Francis Ormond, 1932.34.

John Singer Sargent (1856–1925), *Museum Sketches: "Portrait of Eleanor Lopez de Villanueva," after Antonio Moro,* n.d., graphite on cream wove paper, 12.5 × 7.6 cm. Gift of Miss Emily Sargent and Mrs. Francis Ormond, 1932.35.

John Singer Sargent (1856–1925), *Museum Sketches: "Ballerina," after Edgar Degas,* n.d., graphite on cream wove paper, 15.2 × 8.9 cm. Gift of Miss Emily Sargent and Mrs. Francis Ormond, 1932.36.

John Singer Sargent (1856–1925), *A Doe,* early 1880s, graphite on cream wove paper, 29.0 × 38.7 cm. Gift of Miss Emily Sargent and Mrs. Francis Ormond, 1932.37.

John Singer Sargent (1856–1925), *Mountain Landscape,* n.d., graphite on cream wove paper, 19.2 × 27.5 cm. Gift of Miss Emily Sargent and Mrs. Francis Ormond, 1932.38.

John Singer Sargent (1856–1925), *Portrait of a Young Girl,* ca. 1871, graphite on cream wove paper, 14.5 × 9.5 cm. Gift of Miss Emily Sargent and Mrs. Francis Ormond, 1932.39.

John Singer Sargent (1856–1925), *Portrait of a Woman,* n.d., graphite on cream wove paper, 12.3 × 9.9 cm. Gift of Mrs. Francis Henry Taylor, 1958.18.

John Singer Sargent (1856–1925), *Portrait of a Woman,* n.d., graphite on cream wove paper, 16.0 × 12.3 cm. Gift of Mrs. Francis Henry Taylor, 1958.19.

John Singer Sargent (1856–1925), *Portrait of a Woman Reading,* ca. 1880, graphite on off-white wove paper, 10.1 × 11.7 cm. Gift of Mrs. Francis Henry Taylor, 1958.20.

John Singer Sargent (1856–1925), *Portrait of a Woman,* ca. 1880, graphite on off-white laid paper, 10.0 × 9.1 cm. Gift of Mrs. Francis Henry Taylor, 1958.21.

John Singer Sargent (1856–1925), *Portrait of a Young Man,* ca. 1880, graphite on white laid paper, 11.5 × 11.3 cm. Gift of Mrs. Francis Henry Taylor, 1958.22.

John Singer Sargent (1856–1925), *Venice,* ca. 1902, watercolor over graphite on cream wove paper, 25.4 × 35.6 cm. Gift of Mr. and Mrs. Stuart Riley, 1974.332.

John Singer Sargent (1856–1925), *Fish Weirs,* 1922, watercolor over graphite on cream wove paper, 35.2 × 53.5 cm. Gift of Mr. and Mrs. Richard C. Storey in memory of Richard C. Storey, Jr., 1975.674.

John Singer Sargent (1856–1925), *Portrait of George Marston Whitin,* 1917, charcoal on cream laid paper, 62.9 × 48.3 cm. Gift of Mrs. Marston W. Keeler, 1987.139.

Edward Savage (1761–1817), *Falls of the Passaic at Patterson,* 1806, gray wash over graphite on cream wove paper, 25.0 × 41.5 cm. Museum purchase, 1943.42.

Edward Savage (1761–1817), *Jefferson's Rock,* ca. 1807, gray wash over graphite on pale green wove paper, 20.7 × 24.9 cm. Museum purchase, 1943.43.

Edward Savage (1761–1817), *A View on Jackson River, Virginia,* 1809, gray wash over graphite on pale green wove paper, 20.7 × 24.9 cm. Anonymous fund, 1986.9.

Edward Savage (1761–1817), *Falls of the Principio Creek, Chesapeake Bay,* 1807, gray wash over graphite on pale green wove paper, 25.0 × 41.3 cm. Anonymous fund, 1986.10.

Edward Savage (1761–1817), *Part of the Falls at Little River, Norwich, Connecticut,* 1807, gray wash over graphite on pale green wove paper, 41.5 × 24.9 cm. Anonymous fund, 1986.11.

Edward Savage (1761–1817), *Little River Falls, Norwich, Connecticut,* 1807, gray wash over graphite on pale green wove paper, 24.8 × 41.1 cm. Anonymous fund, 1986.12.

Edward Savage (1761–1817), *Pawtucket Falls,* 1807, gray wash over graphite on pale green wove paper, 24.9 × 41.6 cm. Anonymous fund, 1986.13.

Edward Savage (1761–1817), *The Nashua River at Groton, and Townsend Point,* 1807, gray wash over graphite on cream wove paper, 42.0 × 25.5 cm. Anonymous fund, 1986.14.

Edward Savage (1761–1817), *Bellows Falls,* 1807, gray wash over graphite on cream wove paper, 27.0 × 42.0 cm. Anonymous fund, 1986.15.

Edward Savage (1761–1817), *Cascade at Brattleboro, Vermont,* 1807, gray wash over graphite on pale green wove paper, 20.6 × 24.9 cm. Anonymous fund, 1986.16.

Edward Savage (1761–1817), *Cohoes Falls, Mohawk River,* 1807, gray wash over graphite on pale green wove paper, 25.1 × 42.1 cm. Anonymous fund, 1986.17.

Edward Savage (1761–1817), *Falls of Wapping Creek,* 1807, gray wash over graphite on pale blue-green wove paper, 20.6 × 24.9 cm. Anonymous fund, 1986.18.

Edward Savage (1761–1817), *The Middle Falls of Kenderhook,* 1807, gray wash over graphite on cream wove paper, 26.5 × 42.0 cm. Anonymous fund, 1986.19.

Edward Savage (1761–1817), *The Upper Falls of Kenderhook,* 1807, gray wash over graphite on cream wove paper, 25.4 × 41.9 cm. Anonymous fund, 1986.20.

Edward Savage (1761–1817), *Bridge on the Delaware at Trenton,* 1807, gray wash over graphite on cream wove paper, 26.3 × 42.1 cm. Anonymous fund, 1986.21.

Edward Savage (1761–1817), *Bridge on the Schuylkill at Philadelphia,* 1807, gray wash over graphite on cream wove paper, 26.4 × 42.1 cm. Anonymous fund, 1986.22.

Edward Savage (1761–1817), *The Falls of the Ohiopyle on the Youghiogheny River,* 1807, gray wash over graphite on cream wove paper, 25.4 × 42.0 cm. Anonymous fund, 1986.23.

Edward Savage (1761–1817), *The Narrows of the Great Meadow Run,* 1807, gray wash over graphite on cream wove paper, 26.7 × 42.1 cm. Anonymous fund, 1986.24.

Edward Savage (1761–1817), *Cucumber Falls,* 1807, gray wash over graphite on cream wove paper, 30.9 × 42.1 cm. Anonymous fund, 1986.25.

Edward Savage (1761–1817), *Harper's Ferry,* 1807, gray wash over graphite on cream wove paper, 25.5 × 41.9 cm. Anonymous fund, 1986.26.

Edward Savage (1761–1817), *The Kittle Falls on the River Shodere (Chaudière),* 1807, gray wash over graphite over pen and black ink on cream wove paper, 20.3 × 33.4 cm. Anonymous fund, 1986.27.

Edward Savage (1761–1817), *The Falls, Mills and Village of Indian South,* 1807, pen and gray ink over graphite on cream wove paper, 28.0 × 43.0 cm. Anonymous fund, 1986.28.

Edward Savage (1761–1817), *Falls on Choudie (Chaudière),* 1807, graphite over pen and black ink on cream laid paper, 20.5 × 33.4 cm. Anonymous fund, 1986.29.

Edward Savage (1761–1817), *Gorge with a Bridge,* 1807, graphite on cream laid paper, 20.2 × 33.3 cm. Anonymous fund, 1986.30.

Edward Savage (1761–1817), *The Three Sisters,* 1807, graphite on cream laid paper, 20.3 × 33.4 cm. Anonymous fund, 1986.31.

Edward Savage (1761–1817), *The Three Sisters,* 1807, graphite on cream laid paper, 20.3 × 33.4 cm. Anonymous fund, 1986.32.

Edward Savage (1761–1817), *View of Chawgraw, Black River,* 1809, pen and black ink over graphite on cream laid paper, 20.2 × 33.4 cm. Anonymous fund, 1986.33.

Edward Savage (1761–1817), *Middlebery (Middlebury, Vermont),* 1809, pen and black ink over graphite on cream laid paper, 20.1 × 33.4 cm. Anonymous fund, 1986.34.

Miriam Schapiro (born 1923), *Curtain of Childhood,* 1973, enamel and stencil over fabric collage on illustration board, 71.1 × 55.6 cm. Gift of the artist, 1974.100.

Alexander Schilling (1859–1939), *Trees and Rooftops,* 1912–15, charcoal and colored pencils on brown illustration board, 51.0 × 38.6 cm. Gift of Mrs. Frances D. Beebe, Dr. James M. Dunning, and Mrs. Lloyd B. Scheer, 1987.127.

Alexander Schilling (1859–1939), *Two Pollard Willows,* 1901, colored pencils on gray-brown wove paper, 39.3 × 28.5 cm. Gift of Mrs. Frances D. Beebe, Dr. James M. Dunning, and Mrs. Lloyd B. Scheer, 1987.128.

Alexander Schilling (1859–1939), *Dunes and Marshes,* 1900, charcoal and colored pencils on brown wove paper, 27.2 × 50.4 cm. Gift of Mrs. Frances D. Beebe, Dr. James M. Dunning, and Mrs. Lloyd B. Scheer, 1987.129.

Alexander Schilling (1859–1939), *Pond in a Field,* 1905, colored pencils on brown wove paper, 31.5 × 47.9 cm. Gift of Mrs. Frances D. Beebe, Dr. James M. Dunning, and Mrs. Lloyd B. Scheer, 1987.130.

Alexander Schilling (1859–1939), *Thatched Cottages,* 1913, charcoal and colored pencils on brown illustration board, 38.1 × 50.7 cm. Gift of Mrs. Frances D. Beebe, Dr. James M. Dunning, and Mrs. Lloyd B. Scheer, 1987.131.

Alexander Schilling (1859–1939), *The Edge of the Field,* 1904, colored pencils on gray-brown wove paper, 28.6 × 28.8 cm. Gift of Mrs. Frances D. Beebe, Dr. James M. Dunning, and Mrs. Lloyd B. Scheer, 1987.132.

Georges Schreiber (1904–1977), *Seepage Lake,* 1944, watercolor over graphite on cream wove paper, 54.7 × 74.1 cm. Gift of Esso Standard Oil Company, 1951.100.

Truman Seymour (1824–1891), *A Courtyard of the Casa de Pilatos, Seville,* ca. 1884, watercolor over graphite on dark cream wove paper, 27.8 × 18.7 cm. Gift of the Reverend DeWolf Perry, 1986.41.

Truman Seymour (1824–1891), *A View of the Casa de Pilatos, Seville,* ca. 1884, watercolor over graphite on dark cream wove paper, 28.0 × 18.9 cm. Gift of the Reverend DeWolf Perry, 1986.42.

Truman Seymour (1824–1891), *Patio de la Mezquita, Cordova,* 1884, watercolor over graphite on cream wove paper, 33.4 × 23.2 cm. Gift of the Reverend DeWolf Perry, 1986.43.

Truman Seymour (1824–1891), *Landscape with Cottages,* 1844, graphite on cream wove paper, 28.8 × 39.3 cm. Gift of the Reverend and Mrs. DeWolf Perry, 1986.107.

Truman Seymour (1824–1891), *View of San Juan at Teotihuacan,* 1848, pen and brown ink over graphite on cream wove paper, 20.1 × 29.1 cm. Gift of the Reverend and Mrs. DeWolf Perry, 1986.108.

Truman Seymour (1824–1891), *Stone Head*, 1847–48, graphite on white wove paper, 15.2 × 20.9 cm. Gift of the Reverend and Mrs. DeWolf Perry, 1986.109.

Truman Seymour (1824–1891), *View at Jalapa*, 1848, graphite on cream wove paper, 14.9 × 21.6 cm. Gift of the Reverend and Mrs. DeWolf Perry, 1986.110.

Truman Seymour (1824–1891), *Camp Scene near Poplar Spring, Maryland*, 1862, pen and brown ink on cream laid paper, 12.7 × 20.9 cm. Gift of the Reverend and Mrs. DeWolf Perry, 1986.111.

Truman Seymour (1824–1891), *The Pazzi Chapel, Santa Croce, Florence*, 1881, graphite on tan wove paper, 27.8 × 18.2 cm. Gift of the Reverend and Mrs. DeWolf Perry, 1986.112.

Truman Seymour (1824–1891), *"Sur le toit," View from the Roof of My Quarters, Jalapa, Mexico*, 1847, watercolor over graphite on cream wove paper, 14.7 × 23.9 cm. Gift of the Reverend and Mrs. DeWolf Perry, 1986.113.

Truman Seymour (1824–1891), *View of the Mountain Iztaccihuatl, Mexico* (recto), *View of a Mountain across a Lake* (verso), 1848, watercolor over graphite on cream laid paper, 20.2 × 30.1 cm. Gift of the Reverend and Mrs. DeWolf Perry, 1986.114.

Truman Seymour (1824–1891), *Interior of a Transept of a French Gothic Cathedral* (recto), *View of a Mountain Village by a Lake* (verso), 1885, watercolor over graphite on cream laid paper, 21.5 × 15.4 cm. Gift of the Reverend and Mrs. DeWolf Perry, 1986.116.

Truman Seymour (1824–1891), *Interior of a Transept of a French Gothic Cathedral* (recto), *View of a Mountain Village by a Lake* (verso), 1885, watercolor over graphite on cream wove paper, 21.4 × 15.4 cm. Gift of the Reverend and Mrs. DeWolf Perry, 1986.117.

Truman Seymour (1824–1891), *View from Newman's Window, 1 Piazza dei Rossi, Florence, No. 1*, 1882, watercolor over graphite on off-white wove paper, 30.2 × 21.9 cm. Gift of the Reverend and Mrs. DeWolf Perry, 1986.118.

Truman Seymour (1824–1891), *View from Newman's Window, 1 Piazza dei Rossi, Florence, No. 3*, 1882, watercolor over graphite on off-white wove paper, 23.8 × 29.7 cm. Gift of the Reverend and Mrs. DeWolf Perry, 1986.119.

Truman Seymour (1824–1891), *View from Newman's Window, 1 Piazza dei Rossi, Florence, No. 5*, 1882, watercolor over graphite on off-white wove paper, 45.6 × 30.7 cm. Gift of the Reverend and Mrs. DeWolf Perry, 1986.120.

Truman Seymour (1824–1891), *View from Newman's Window, 1 Piazza dei Rossi, Florence, No. 6*, 1882, watercolor over graphite on off-white wove paper, 30.8 × 22.3 cm. Gift of the Reverend and Mrs. DeWolf Perry, 1986.121.

Truman Seymour (1824–1891), *View from Newman's Window, 1 Piazza dei Rossi, Florence, No. 8*, 1882, watercolor over graphite on dark cream wove paper, 30.5 × 22.4 cm. Gift of the Reverend and Mrs. DeWolf Perry, 1986.122.

Truman Seymour (1824–1891), *View from Newman's Window, 1 Piazza dei Rossi, Florence, No. 9*, 1882, watercolor over graphite on cream wove paper, 30.1 × 21.2 cm. Gift of the Reverend and Mrs. DeWolf Perry, 1986.123.

Truman Seymour (1824–1891), *View from Newman's Window, 1 Piazza dei Rossi, Florence, No. 10*, 1882, watercolor over graphite on cream wove paper, 25.0 × 34.2 cm. Gift of the Reverend and Mrs. DeWolf Perry, 1986.124.

Truman Seymour (1824–1891), *Isola dei Pescatori, Lake Maggiore*, 1882, watercolor over graphite on off-white wove paper, 18.8 × 27.5 cm. Gift of the Reverend and Mrs. DeWolf Perry, 1986.125.

Truman Seymour (1824–1891), *Street Scene with the Bell Tower of San Giacomo, Pallanza*, 1882, watercolor over graphite on off-white wove paper, 27.7 × 18.9 cm. Gift of the Reverend and Mrs. DeWolf Perry, 1986.126.

Truman Seymour (1824–1891), *A Siena Courtyard*, 1882, watercolor over graphite on off-white wove paper, 27.0 × 19.0 cm. Gift of the Reverend and Mrs. DeWolf Perry, 1986.127.

Truman Seymour (1824–1891), *No. 229, a Sienese House*, 1882, watercolor over graphite on off-white wove paper, 14.4 × 23.4 cm. Gift of the Reverend and Mrs. DeWolf Perry, 1986.128.

Truman Seymour (1824–1891), *The Palazzo Vecchio, Florence*, 1882, watercolor over graphite on off-white wove paper, 27.2 × 37.8 cm. Gift of the Reverend and Mrs. DeWolf Perry, 1986.129.

Truman Seymour (1824–1891), *A Street Scene in Florence with the Palazzo Vecchio*, 1882, watercolor over graphite on off-white wove paper, 38.2 × 26.8 cm. Gift of the Reverend and Mrs. DeWolf Perry, 1986.130.

Truman Seymour (1824–1891), *A View in Florence with the Palazzo Vecchio*, 1882, watercolor over graphite on cream wove paper, 21.0 × 13.9 cm. Gift of the Reverend and Mrs. DeWolf Perry, 1986.131.

Truman Seymour (1824–1891), *The 90th Regiment Returning from Drill to the Fortezza San Giorgio, Florence*, 1882, watercolor over graphite on off-white wove paper, 18.5 × 21.9 cm. Gift of the Reverend and Mrs. DeWolf Perry, 1986.132.

Truman Seymour (1824–1891), *A View of Florence across the Arno*, 1882, watercolor on off-white wove paper, 17.5 × 27.2 cm. Gift of the Reverend and Mrs. DeWolf Perry, 1986.133.

Truman Seymour (1824–1891), *A View of the Cathedral, Florence*, 1882, watercolor over graphite on cream wove paper, 18.9 × 27.8 cm. Gift of the Reverend and Mrs. DeWolf Perry, 1986.134.

Truman Seymour (1824–1891), *An Unfinished View of Venice*, 1882, watercolor over graphite on off-white wove paper, 22.3 × 30.6 cm. Gift of the Reverend and Mrs. DeWolf Perry, 1986.135.

Truman Seymour (1824–1891), *A House with French Windows*, 1882, watercolor over graphite on off-white wove paper, 21.7 × 15.4 cm. Gift of the Reverend and Mrs. DeWolf Perry, 1986.136.

Truman Seymour (1824–1891), *Italian Houses with a Donkey Cart*, n.d., watercolor over graphite on off-white

wove paper, 17.8 × 23.4 cm. Gift of the Reverend and Mrs. DeWolf Perry, 1986.137.

Truman Seymour (1824–1891), *An Italian Street,* n.d., watercolor over graphite on off-white wove paper, 19.1 × 27.5 cm. Gift of the Reverend and Mrs. DeWolf Perry, 1986.138.

Truman Seymour (1824–1891), *Italian Buildings with Three Flower Pots,* n.d., watercolor over graphite on off-white wove paper, 22.1 × 31.0 cm. Gift of the Reverend and Mrs. DeWolf Perry, 1986.139.

Truman Seymour (1824–1891), *A View through an Archway, Seville,* 1884, watercolor over graphite on off-white laid paper, 13.4 × 19.8 cm. Gift of the Reverend and Mrs. DeWolf Perry, 1986.140.

Truman Seymour (1824–1891), *The Almeda of the Alhambra,* 1884, watercolor over graphite on off-white wove paper, 23.1 × 33.4 cm. Gift of the Reverend and Mrs. DeWolf Perry, 1986.141.

Truman Seymour (1824–1891), *The Torre de las Infantas, the Alhambra,* 1884, watercolor over graphite on off-white wove paper, 25.0 × 16.2 cm. Gift of the Reverend and Mrs. DeWolf Perry, 1986.142.

Truman Seymour (1824–1891), *The Garden of the Lindaraja Seen through an Archway,* 1884, watercolor over graphite on off-white wove paper, 25.1 × 16.2 cm. Gift of the Reverend and Mrs. DeWolf Perry, 1986.144.

Truman Seymour (1824–1891), *Interior of San Francisco, the Alhambra,* 1884, watercolor over graphite on cream wove paper, 23.5 × 33.0 cm. Gift of the Reverend and Mrs. DeWolf Perry, 1986.145.

Truman Seymour (1824–1891), *Interior of the Alhambra,* 1884, watercolor over graphite on off-white wove paper, 29.0 × 21.2 cm. Gift of the Reverend and Mrs. DeWolf Perry, 1986.146.

Truman Seymour (1824–1891), *Interior of the Mosque, the Alhambra,* 1884, watercolor over graphite on cream wove paper, 23.0 × 33.3 cm. Gift of the Reverend and Mrs. DeWolf Perry, 1986.147.

Truman Seymour (1824–1891), *Interior of the Alhambra,* 1884, watercolor over graphite on off-white wove paper, 29.5 × 22.1 cm. Gift of the Reverend and Mrs. DeWolf Perry, 1986.148.

Truman Seymour (1824–1891), *The Balcony of the Hall of the Ambassadors, the Alhambra,* 1884, watercolor over graphite on off-white wove paper, 23.4 × 16.7 cm. Gift of the Reverend and Mrs. DeWolf Perry, 1986.149.

Truman Seymour (1824–1891), *Towers over the Sala de las dos Hermanos, the Alhambra,* 1884, watercolor over graphite on off-white wove paper, 23.0 × 30.3 cm. Gift of the Reverend and Mrs. DeWolf Perry, 1986.150.

Truman Seymour (1824–1891), *Towers over the Sala de las dos Hermanos, the Alhambra,* 1884, watercolor over graphite on off-white wove paper, 16.4 × 23.4 cm. Gift of the Reverend and Mrs. DeWolf Perry, 1986.151.

Truman Seymour (1824–1891), *The Gate of Justice, the Alhambra,* 1884, watercolor over graphite on off-white

wove paper, 33.1 × 23.2 cm. Gift of the Reverend and Mrs. DeWolf Perry, 1986.152.

Truman Seymour (1824–1891), *An Architectural View with a Moorish Arch,* n.d., watercolor over graphite on off-white wove paper, 23.3 × 16.1 cm. Gift of the Reverend and Mrs. DeWolf Perry, 1986.153.

Truman Seymour (1824–1891), *A Street Scene, Seville,* 1884, watercolor over graphite on off-white wove paper, 14.8 × 22.1 cm. Gift of the Reverend and Mrs. DeWolf Perry, 1986.154.

Truman Seymour (1824–1891), *Calle de Genova 89, Seville,* 1884, watercolor over graphite on cream wove paper, 14.6 × 21.5 cm. Gift of the Reverend and Mrs. DeWolf Perry, 1986.155.

Truman Seymour (1824–1891), *The Giralda from the Convent of Santa Paula,* 1884, watercolor over graphite on cream wove paper, 24.7 × 16.0 cm. Gift of the Reverend and Mrs. DeWolf Perry, 1986.156.

Truman Seymour (1824–1891), *A Street Scene in Seville with the Giralda,* 1884, watercolor over graphite on off-white wove paper, 55.7 × 38.0 cm. Gift of the Reverend and Mrs. DeWolf Perry, 1986.157.

Truman Seymour (1824–1891), *The Convent of Santa Clara,* 1884, watercolor over graphite on off-white wove paper, 21.0 × 29.2 cm. Gift of the Reverend and Mrs. DeWolf Perry, 1986.158.

Truman Seymour (1824–1891), *The Convent of Santa Clara,* 1884, watercolor over graphite on off-white wove paper, 22.1 × 29.6 cm. Gift of the Reverend and Mrs. DeWolf Perry, 1986.159.

Truman Seymour (1824–1891), *Square by the Giralda,* 1884, watercolor over graphite on cream wove paper, 18.7 × 27.9 cm. Gift of the Reverend and Mrs. DeWolf Perry, 1986.160.

Truman Seymour (1824–1891), *View of Granada in the Albaicin,* 1884, watercolor over graphite on off-white wove paper, 13.4 × 19.6 cm. Gift of the Reverend and Mrs. DeWolf Perry, 1986.163.

Truman Seymour (1824–1891), *Plaza de los "Zattadores,"* 1884, watercolor over graphite on off-white wove paper, 20.6 × 14.4 cm. Gift of the Reverend and Mrs. DeWolf Perry, 1986.164.

Truman Seymour (1824–1891), *A Street Scene with a Donkey,* 1884, watercolor over graphite on off-white wove paper, 19.7 × 13.2 cm. Gift of the Reverend and Mrs. DeWolf Perry, 1986.165.

Truman Seymour (1824–1891), *A Portal of Santa Clara,* 1884, watercolor over graphite on off-white wove paper, 27.6 × 18.6 cm. Gift of the Reverend and Mrs. DeWolf Perry, 1986.166.

Truman Seymour (1824–1891), *San Pablo, Seville,* 1885, watercolor over graphite on cream wove paper, 27.7 × 18.8 cm. Gift of the Reverend and Mrs. DeWolf Perry, 1986.167.

Truman Seymour (1824–1891), *The Principal Entrance of the Mosque at Cordova,* 1885, watercolor over graphite on

off-white wove paper, 25.4 × 27.6 cm. Gift of the Reverend and Mrs. DeWolf Perry, 1986.168.

Truman Seymour (1824–1891), *The View from My Window, Hotel Suiza, Cordova,* 1885, watercolor over graphite on off-white wove paper, 18.8 × 27.5 cm. Gift of the Reverend and Mrs. DeWolf Perry, 1986.169.

Truman Seymour (1824–1891), *A Street Scene in Tangier,* 1884, watercolor over graphite on dark cream wove paper, 22.8 × 15.0 cm. Gift of the Reverend and Mrs. DeWolf Perry, 1986.170.

Truman Seymour (1824–1891), *The Remains of a Roman Aqueduct Near Tangier,* 1884, watercolor on off-white wove paper, 6.8 × 12.2 cm. Gift of the Reverend and Mrs. DeWolf Perry, 1986.171.

Truman Seymour (1824–1891), *A Street Scene in Tangier with a Minaret,* 1884, watercolor over graphite on off-white wove paper, 28.2 × 19.5 cm. Gift of the Reverend and Mrs. DeWolf Perry, 1986.172.

Truman Seymour (1824–1891), *View from a Terrace, Tangier,* 1884, watercolor over graphite on white wove paper, 14.2 × 30.6 cm. Gift of the Reverend and Mrs. DeWolf Perry, 1986.173.

Truman Seymour (1824–1891), *View across a Crenellated Hall, Tangier,* 1884, watercolor over graphite on white wove paper, 20.7 × 30.2 cm. Gift of the Reverend and Mrs. DeWolf Perry, 1986.174.

Truman Seymour (1824–1891), *Clarens,* 1885, watercolor over graphite on off-white laid paper, 22.5 × 26.4 cm. Gift of the Reverend and Mrs. DeWolf Perry, 1986.175.

Truman Seymour (1824–1891), *Cafe Vaudois, Clarens,* 1885, watercolor over graphite on off-white wove paper, 18.3 × 23.7 cm. Gift of the Reverend and Mrs. DeWolf Perry, 1986.176.

Truman Seymour (1824–1891), *The Dents du Midi from Clarens, Morning,* 1885, watercolor over graphite on off-white laid paper, 25.6 × 22.8 cm. Gift of the Reverend and Mrs. DeWolf Perry, 1986.177.

Truman Seymour (1824–1891), *A View of Lake Geneva from Clarens,* 1885, watercolor on off-white laid paper, 17.6 × 25.8 cm. Gift of the Reverend and Mrs. DeWolf Perry, 1986.178.

Truman Seymour (1824–1891), *Lake Como, Bellagio,* 1885, watercolor over graphite on off-white wove paper, 15.2 × 23.5 cm. Gift of the Reverend and Mrs. DeWolf Perry, 1986.179.

Truman Seymour (1824–1891), *A Street Scene in Clarens,* 1885, watercolor over graphite on cream wove paper, 18.7 × 27.6 cm. Gift of the Reverend and Mrs. DeWolf Perry, 1986.180.

Truman Seymour (1824–1891), *Landscape with Sun on the Horizon,* 1885, watercolor on paperboard, 8.1 × 12.2 cm. Gift of the Reverend and Mrs. DeWolf Perry, 1986.181.

Truman Seymour (1824–1891), *Sun on the Horizon,* 1885, watercolor on off-white wove paper, 13.3 × 15.4 cm. Gift of the Reverend and Mrs. DeWolf Perry, 1986.182.

Truman Seymour (1824–1891), *Fishing Boats at Sunset, Lake Geneva,* 1891, watercolor on cream wove paper, 13.0 × 22.7 cm. Gift of the Reverend and Mrs. DeWolf Perry, 1986.183.

James Sharples (1761–1811), *Portrait of General William Hull,* ca. 1800, pastel and charcoal over graphite on cream laid paper, 24.3 × 18.9 cm. Alexander and Caroline Murdock DeWitt Fund, 1969.64.

James Sharples (1761–1811), *Portrait of Sarah Fuller Hull,* ca. 1800, pastel and charcoal over graphite on cream laid paper, 23.8 × 18.8 cm. Alexander and Caroline Murdock DeWitt Fund, 1969.65.

Charles Sheeler (1883–1965), *City Interior No. 2,* 1935, tempera over graphite on cream wove paper, 19.6 × 26.1 cm. Gift of William H. and Saundra B. Lane, 1977.143.

Everett Shinn (1876–1953), *Rue Notre Dame des Champs,* 1903, pastel and charcoal on blue wove paper mounted on illustration board, 55.9 × 71.0 cm. Charlotte E. W. Buffington Fund, 1967.4.

Roswell Morse Shurtleff (1838–1915), *Chapel Brook,* n.d., watercolor over graphite on cream wove paper, 35.5 × 25.9 cm. Gift of Jeanie Lea Southwick in memory of Sarah Golger Earle, 1922.136.

Oli Sihvonen (born 1921), *Untitled,* 1961, pen and black ink on off-white paperboard, 32.7 × 55.5 cm. Director's Discretionary Fund, 1962.2.

Mitchell Siporin (1910–1976), *Glass,* from the series *Porta Portese, Rome,* 1967, watercolor on white wove paper, 70.0 × 100.4 cm. Gift of Mrs. Helen Sagoff Slosberg, 1969.58.

Moses Soyer (1899–1974), *Reclining Nude,* 1940s, black chalk on cream Japanese vellum paper, 37.9 × 54.9 cm. Gift of Dr. and Mrs. Elton Yasuna, 1973.3.

Alice Springer (20th century), *Spaniel with Quail,* n.d., graphite on cream wove paper, 37.0 × 32.0 cm. Edward A. Bigelow Collection, gift of Mrs. Robert M. Heberton, 1981.238.

James Louis Steg (born 1922), *The Temptation of Saint Anthony,* 1960, pen and black ink on off-white wove paper, 100.0 × 67.8 cm. Director's Discretionary Fund, 1961.3.

Hedda Sterne (born 1916), *Drawing 1270,* n.d., black crayon on cream wove paper, 40.8 × 32.4 cm. Gift of the Betty Parsons Foundation, 1985.270.

Ary Stillman (1891–1967), *Enchantment,* 1962, gouache on off-white wove paper, 51.0 × 33.3 cm. Gift of Stillman-Lack Foundation, 1984.37.

James Sullivan (born 1939), *Otsego,* 1974, acrylic polymer on off-white wove paper, 55.6 × 70.6 cm. Gift of the artist, 1974.271.

James Sullivan (born 1939), *Study for Ecmelic,* n.d., graphite on white wove paper, 20.6 × 26.9 cm. Source unknown, 1988.276.

Thomas Sully (1783–1872), *Head of a Young Woman in a Fur Cap,* n.d., watercolor on cream wove paper, 11.5 × 7.7 cm. Museum purchase, 1916.127.121.

Seymour Swetzoff (born 1918), *Job,* n.d., graphite and pen and black ink on paperboard, 31.9 × 20.8 cm. Gift of Mrs. Helen Sagoff Slosberg, 1966.86.

Quincy Tahoma, Native American (20th century), *Navajo Warriors Preparaing to Raid a Village,* 1940, gouache over graphite on cream illustration board, 55.7 × 55.8 cm. Museum purchase, 1940.167.

Cephas G. Thompson (1809–1888), *Head of a Man,* n.d., red crayon with white heightening on green wove paper, 8.8 × 7.3 cm. Museum purchase, 1916.129.305.

Nellie Louise Thompson (19th century), *Pink Waterlilies,* n.d., watercolor on cream wove paper, 78.1 × 55.9 cm. Gift of Mrs. Kingsmill Marrs, 1925.480.

Dorothy Maria Thurn (born 1907), *A Tree,* ca. 1931, watercolor and gouache on cream wove paper, 38.9 × 56.8 cm. Museum purchase, 1932.17.

Mark Tobey (1890–1976), *The Cycle of the Prophet,* 1945, gouache and watercolor on gray chipboard, 40.6 × 50.4 cm. Gift of William H. and Saundra B. Lane, 1976.180.

Harold Tovish (born 1921), *Study for Man with Sword II,* 1959, pen and black ink on off-white wove paper, 28.0 × 35.6 cm. Museum purchase, 1960.30.

Edmond Tracey, Native American (20th century), *Buffalo Dance,* early 1930s, gouache over graphite on cream wove paper, 35.2 × 55.7 cm. Museum purchase, 1935.88.

Edmond Tracey, Native American (20th century), *Father Sky and Mother Earth,* early 1930s, gouache over graphite on prepared laminated paperboard, 33.0 × 45.4 cm. Museum purchase, 1935.90.

Steven Trefonides (born 1926), *Desire,* n.d., charcoal and pastel on off-white laid paper, 50.8 × 66.0 cm. Gift of Dr. and Mrs. Elton Yasuna, 1964.3.

Ernest Trova (born 1927), *Untitled,* 1955, casein and acrylic polymer paint on illustration board, 91.8 × 71.3 cm. Gift of the artist, 1974.103.

John Trumbull (1756–1843), attributed to, *George Washington with His Generals,* n.d., pen and brown and black inks with watercolor on cream wove paper, 28.0 × 32.2 cm. Museum purchase, 1915.97.

John Trumbull (1756–1843), attributed to, *A Mounted General,* n.d., pen and brown and black inks with watercolor on cream wove paper, 23.3 × 14.9 cm. Museum purchase, 1916.125.63.

Monroe Le Tsatoke, Native American (1904–1937), *Kiowa Warriors Celebrating a Ritual,* early 1930s, gouache over graphite on gray wove paper, 19.5 × 27.3 cm. Museum purchase, 1935.99.

Awa Tsireh, Native American (20th century), *Koshare Dance, Rio Grande Pueblo,* early 1930s, pen and black ink with watercolor over graphite on gray-green laid paper, 35.6 × 60.3 cm. Museum purchase, 1935.86.

Awa Tsireh, Native American (20th century), *Initiate Ceremony, San Ildefonso Pueblo,* early 1930s, pen and black ink with gouache over graphite on green laid paper, 30.6 × 47.6 cm. Museum purchase, 1935.87.

Awa Tsireh, Native American (20th century), *A Turkey,* early 1930s, pen and black ink with watercolor over graphite on cream wove paper, 27.8 × 35.6 cm. Museum purchase, 1935.101.

Awa Tsireh, Native American (20th century), *Clan Symbols,* early 1930s, pen and black ink with watercolor over graphite on gray-green wove paper, 45.6 × 60.2 cm. Museum purchase, 1935.105.

Che-Chille Tsoise, Native American (20th century), *Helene Katchina,* early 1930s, pen and brown ink with gouache over graphite on cream wove paper, 56.0 × 76.4 cm. Museum purchase, 1940.344.

Michael Tulysewski (born 1925), *Head of a Prophet,* n.d., pen and black ink with gray wash and charcoal on cream wove paper, 61.1 × 46.1 cm. Gift of Mrs. Helen Sagoff Slosberg, 1969.14.

Ross Sterling Turner (1846–1915), *East Gloucester,* 1884, watercolor over graphite on cream wove paper, 41.9 × 62.9 cm. Gift of Mrs. Kingsmill Marrs, 1925.476.

Ross Sterling Turner (1846–1915), *Village Street in Spring,* 1893, watercolor and gouache over graphite on cream wove paper, 55.8 × 71.6 cm. Bequest of Mrs. Charlotte E. W. Buffington, 1935.51.

John Vanderlyn (1775–1852), *Mother and Child,* n.d., watercolor on cream wove paper, 9.7 × 15.7 cm. Museum purchase, 1916.127.98.

Pablita Velarde, Native American (20th century), *Sun Basket Dance,* early 1930s, gouache and pastel on cream illustration board, 50.7 × 61.0 cm. Museum purchase, 1940.343.

Anthony Velonis (born 1911), *6:30 P.M.,* 1939, gouache over graphite on cream paperboard, 23.5 × 18.2 cm. Eliza S. Paine Fund, 1991.60.

Romando Vigil, Native American (20th century), attributed to, *Festive Dance,* early 1930s, gouache over graphite on cream wove paper, 30.6 × 50.0 cm. Museum purchase, 1945.2.

Ruth Vollmer (1903–1982), *Untitled,* 1979, graphite on cream wove paper, 21.7 × 28.2 cm. Gift of the Betty Parsons Foundation, 1985.280.

Ruth Vollmer (1903–1982), *Untitled,* 1978, graphite on cream wove paper, 21.7 × 28.2 cm. Gift of the Betty Parsons Foundation, 1985.281.

Ruth Vollmer (1903–1982), *Untitled,* 1978, graphite on cream wove paper, 21.7 × 28.2 cm. Gift of the Betty Parsons Foundation, 1985.282.

Ruth Vollmer (1903–1982), *Untitled,* 1978, graphite on cream wove paper, 29.7 × 42.1 cm. Gift of the Betty Parsons Foundation, 1985.283.

David von Schlegell (1920–1992), *Untitled (Landscape),* 1964, gouache and watercolor on cream wove paper, 45.2 × 57.2 cm. Gift of Robert Flynn Johnson in honor of his parents, 1982.94.

Herman Armour Webster (1878–1970), *San Pietro di Castello, Venice,* 1955, graphite on cream wove paper, 20.2 × 27.3 cm. Thomas Hovey Gage Fund, 1984.128.

Herman Armour Webster (1878–1970), *San Pietro di Castello, Venice,* 1955, pen and brown ink with watercolor on cream laid paper, 17.2 × 25.0 cm. Thomas Hovey Gage Fund, 1984.129.

Elbert Weinberg (born 1928), *Study for Sculpture: The Bride,* 1959, pen and black ink on cream Japan paper, 50.3 × 38.0 cm. Director's Discretionary Fund, 1960.29.

John Ferguson Weir (1841–1926), *Sketch for the Portrait of Mary French,* n.d., pen and black ink over graphite on cream wove paper, 25.7 × 20.2 cm. Gift of the Reverend DeWolf Perry, 1972.137.

John Ferguson Weir (1841–1926), *The Itchen Near the College, Winchester, England,* 1913, watercolor and gouache over charcoal on illustration board, 26.9 × 36.7 cm. Gift of the Reverend DeWolf Perry, 1986.44.

Cady Wells (1904–1954), *Ground Swell,* 1950, brush and India ink with watercolor on white wove paper, 29.0 × 39.0 cm. Gift of Mason B. Wells, 1983.25.

Cady Wells (1904–1954), *Darkness and Noon,* 1950, brush and black ink on white wove paper, 12.5 × 17.7 cm. Gift of John W. Curtis in honor of Timothy A. Riggs, 1983.50.

Susan Chrysler White (born 1954), *We All Scream,* 1981, oil pastel over graphite on prepared cream wove paper, 171.6 × 107.5 cm. Alexander and Caroline M. DeWitt Fund, 1982.1.

Edwin Whitefield (1816–1892), *View of Worcester from Union Hill,* 1876, pen and black ink over graphite with watercolor on off-white wove paper, 64.9 × 100.3 cm. Anonymous gift, 1955.9.

John Wilde (born 1919), *Design for a Defense Mechanism,* 1944, graphite with pen and red and black inks on cream Japanese vellum paper, 51.0 × 46.5 cm. Director's Discretionary Fund, 1959.4.

John Wilde (born 1919), *Portrait of HDPRAW,* 1949, graphite on cream wove paper, 71.4 × 47.2 cm. Director's Discretionary Fund, 1959.5.

William T. Wiley (born 1937), *Construct a Vista,* 1981, black felt-tip pen and watercolor over graphite on off-white wove paper, 57.0 × 76.4 cm. National Endowment for the Arts Museum Purchase Plan, 1984.133.

William Willard (1819–1904), *Portrait of Abraham Lincoln,* 1896, charcoal and white chalk on gray wove paper, 66.9 × 49.8 cm. Gift of Stephen Salisbury III, 1905.129.

Douglas Fenn Wilson (born 1953), *Entangled Banyan,* 1975, watercolor over graphite on off-white wove paper, 37.8 × 57.1 cm. Charlotte E. W. Buffington Fund, 1976.124.

Jack Wolfe (born 1925), *DC 2,* 1963, oil paint, charcoal, crayon, and graphite on off-white wove paper, 72.6 × 57.6 cm. Director's Discretionary Fund, 1963.102.

Charles H. Woodbury (1864–1940), *Seascape with Rainbow,* 1924, watercolor on cream illustration board, 45.9 × 60.6 cm. Gift of Edward Kenway, 1956.4.

Andrew Wyeth (born 1917), *The Rope,* 1957, watercolor and gouache over graphite on illustration board, 53.2 × 33.4 cm. Gift of Mrs. Robert W. Stoddard, 1988.39.

Mahonri Mackintosh Young (1877–1957), *View of Salt Lake City,* 1940, pen and gray ink with wash on cream wove paper, 22.8 × 30.4 cm. Museum purchase, 1941.11.

Mahonri Mackintosh Young (1877–1957), *Pony and Rider,* ca. 1940, pen and brown ink with watercolor on cream wove paper, 14.9 × 21.7 cm. Museum purchase, 1941.12.

Jack Youngerman (born 1926), *August 6, 1965, No. 2,* 1965, brush and India ink on off-white paperboard, 73.8 × 58.6 cm. Museum purchase, 1968.10.

Mario Yrisarry (born 1933) *Untitled,* 1972, graphite and black crayon on off-white wove paper, 58.5 × 73.6 cm. Gift of the artist, 1974.102.

Adja Yunkers (1900–1983), *Untitled,* 1970, acrylic polymer paint medium on cream wove paper, 105.8 × 75.5 cm. Gift of the artist, 1974.93.

Zeke Ziner (20th century), *Mother and Children,* n.d., brush and black and brown inks on cream Japanese vellum paper, 109.4 × 66.0 cm. Gift of Daniel Catton Rich, 1970.107.

William Zorach (1887–1966), *Autumn, Robinhood, Maine,* 1960, watercolor over graphite on off-white wove paper, 39.3 × 56.7 cm. Gift of the Zorach children in memory of Miriam Pulde, 1981.16.

Australian

Charles Blackman (born 1928), *A Game,* 1962, charcoal on white wove paper, 50.9 × 38.2 cm. Director's Discretionary Fund, 1963.109.

Donald Friend (born 1915), *Expedition Headquarters,* n.d., black ink and colored inks with watercolor on off-white wove paper, 51.4 × 71.1 cm. Director's Discretionary Fund, 1963.108.

Daryl Hill (born 1930), *Mirage of a Salt Lake,* 1960, watercolor and gouache on off-white wove paper, 58.1 × 77.9 cm. Director's Discretionary Fund, 1963.107.

Austrian

Oskar Kokoschka (1886–1980), *Sunny Landscape,* 1913, graphite on tan wove paper, 26.1 × 35.0 cm. Gift of Alma Mahler-Werfel, 1959.113

Oskar Kokoschka (1886–1980), *Landscape with Blue Tree,* 1913, charcoal and pastel on tan wove paper, 26.1 × 35.0 cm. Gift of Alma Mahler-Werfel, 1959.114.

Oskar Kokoschka (1886–1980), *Alpine Landscape,* 1913, charcoal on tan wove paper, 26.2 × 34.9 cm. Gift of Alma Mahler-Werfel, 1959.115.

Belgian

Henri-Edmond Cross (1856–1910), *Tartanes at St. Tropez,* n.d., pastel on cream wove paper, 21.3 × 26.8 cm. Bequest of Malcolm Rhodes McBride, 1989.43.

British

Pamela Bianco (born 1906), *Mother and Child,* 1924, graphite on off-white wove paper, 20.6 × 16.5 cm. Museum purchase, 1928.8.

Muirhead Bone (1876–1953), *Gateway of the Alhambra,* n.d., black crayon and brown wash on white wove paper, 18.7 × 9.5 cm. Edward A. Bigelow Collection, gift of Mrs. Robert M. Heberton, 1981.192.

Frank Brangwyn (1867–1956), *Boat Building,* n.d., graphite and gouache on blue wove paper, 55.5 × 67.1 cm. Gift of Robert G. Reed, 1967.66.

Gerald Brockhurst (1890–1943), *Reverie,* 1913, pen and black ink with wash on cream wove paper, 38.8 × 28.5 cm. Edward A. Bigelow Collection, gift of Mrs. Robert M. Heberton, 1981.202.

Hablot Knight Brown, called Phiz (1815–1882), *Two Fox Hunters Leaping a Wall,* ca. 1910, graphite, pastel, and wash on brown wove paper, 26.5 × 37.0 cm. Bequest of John Curtis, 1994.234.1.

Edward Burne-Jones (1833–1898), *Head of a Woman,* 1885, graphite on cream wove paper, 20.2 × 14.2 cm. Museum purchase, 1969.26.

Howard Carter (1873–1939), *Profiles of a Prince and Princess,* 1909, watercolor over graphite on off-white paper, 38.2 × 49.4 cm. Gift of Mrs. Kingsmill Marrs, 1925.140.

Howard Carter (1873–1939), *A Prince Costumed as the Priest Imunuteff,* 1909, watercolor over graphite on off-white paper, 53.5 × 47.7 cm. Gift of Mrs. Kingsmill Marrs, 1925.141.

Howard Carter (1873–1939), *Queen Aahmes,* 1908, watercolor over graphite on off-white paper, 57.7 × 40.4 cm. Gift of Mrs. Kingsmill Marrs, 1925.142.

Howard Carter (1873–1939), *The Daughter of Men-na,* 1907, watercolor over graphite on off-white paper, 56.4 × 39.7 cm. Gift of Mrs. Kingsmill Marrs, 1925.143.

Howard Carter (1873–1939), *A Relief Sculpture of Queen Nefertari,* 1908, watercolor over graphite on off-white paper, 70.6 × 46.8 cm. Gift of Mrs. Kingsmill Marrs, 1925.144.

Howard Carter (1873–1939), *View of the Temple of Medmet Nabon,* 1909, watercolor over graphite on off-white paper, 59.8 × 42.7 cm. Gift of Mrs. Kingsmill Marrs, 1925.145.

Howard Carter (1873–1939), *A Little Temperance Member,* 1902, watercolor over graphite on off-white paper, 42.2 × 28.6 cm. Gift of Mrs. Kingsmill Marrs, 1925.465.

Thomas Carwitham (active ca. 1725), *Figure Studies,* n.d., pen and brown ink with wash on cream laid paper, 22.8 × 31.8 cm. Austin S. Garver Fund, 1972.95.

Thomas Carwitham (active ca. 1725), *Figure Studies,* n.d., pen and brown ink with wash on cream laid paper, 23.4 × 30.5 cm. Austin S. Garver Fund, 1972.96.

Edward Clifford (1844–1907), *Portrait of Esther Elizabeth Brown Beebe,* 1885, watercolor over graphite on cream wove paper, 97.1 × 72.8 cm. Gift of Elizabeth Mifflin Hammond, 1962.27.

Charles John Collings (1848–1931), *After the Storm,* n.d., watercolor on cream laid paper, 12.9 × 18.0 cm. Museum purchase, 1924.5.

Charles John Collings (1848–1931), *Moonlight in the Mountains,* n.d., watercolor on cream laid paper, 19.8 × 28.8 cm. Museum purchase, 1924.6.

Charles John Collings (1848–1931), *Early Winter in the Selkirks,* n.d., watercolor on cream laid paper, 13.2 × 18.3 cm. Museum purchase, 1924.7.

Charles John Collings (1848–1931), *In Marble Halls,* n.d., watercolor on cream laid paper, 19.0 × 13.6 cm. Museum purchase, 1924.8.

Charles John Collings (1848–1931), *The Break-up,* n.d., watercolor on cream laid paper, 27.9 × 38.8 cm. Museum purchase, 1925.4.

Walter Crane (1845–1915), *The Great Lord Sol,* an illustration for *Mrs. Mundi at Home,* 1875, pen and brown ink over graphite on cream paperboard, 19.1 × 30.3 cm. Gift of the Paine Charitable Trust, 1965.705.

George Cruikshank (1792–1878), *The Death of Boney,* ca. 1805, graphite with pen and brown ink on cream wove paper, 27.5 × 34.4 cm. Samuel B. Woodward Collection, 1934.245.

George Cruikshank (1792–1878), *The Eclipse of the Sun,* 1809, graphite with gray wash on cream wove paper, 39.4 × 28.4 cm. Samuel B. Woodward Collection, 1934.235.

George Dance the Younger (1741–1825), *Portrait of George Kinock,* ca. 1799, graphite on cream wove paper, 25.4 × 19.0 cm. Alexander and Caroline DeWitt Fund, 1996.23.

William Derby (1786–1847), *The Black Amputee,* ca. 1825, watercolor over graphite with white gouache on cream wove paper, 28.8 × 20.0 cm. Gift of David Richardson, 1992.46.

Gainsborough Dupont (1754–1797), after Thomas Gainsborough (1727–1788), *Portrait of Francis Rawdon Hastings, First Marquis of Hastings, Second Earl of Moira,* n.d., charcoal and black, white, and gray chalks on tan laid paper, 62.1 × 41.1 cm. Museum purchase, 1941.24.

John Flaxman (1755–1826), *The Infant Orestes Taken from His Native Land,* ca. 1790, black chalk, brush and gray ink with wash on cream laid paper, 16.2 × 15.4 cm. Austin S. Garver Fund, 1993.21.

George Frost (1754–1821), *The Road into the Wood,* n.d., charcoal and gray wash on cream laid paper, 39.6 × 29.7 cm. Bequest of Theodore T. Ellis, 1940.137.

William Gilpin (1724–1804), *Raglan Castle,* n.d., brush and black ink with watercolor and wash on cream laid paper, 27.6 × 21.9 cm. Museum purchase, 1951.10.

Philip Gilbert Hamerton (1834–1894), *Overlooking the Seine at St. Germain,* n.d., graphite on green wove paper, 11.7 × 21.9 cm. Gift of Mrs. Kingsmill Marrs, 1914.54.

Samuel William Howitt (1765–1822), attributed to, *Sheep Resting,* n.d., watercolor over graphite on cream wove paper, 12.8 × 17.8 cm. Gift of Wallace T. Montague, 1952.6.

William Henry Hunt (1790–1864), *A Boy Wiping His Brow,* ca. 1850, watercolor over graphite on cream wove paper, 27.5 × 19.4 cm. Gift of David Richardson, 1992.48.

James Jefferys (1757–1784), attributed to, *An Entombment,* n.d., pen and black ink with gray wash on cream laid paper, 38.6 × 56.7 cm. Museum purchase, 1972.94.

Augustus John (1878–1961), *Sketches of a Female Nude,* n.d., charcoal and brown pastel on gray laid paper, 62.5 × 47.2 cm. Gift of Scott and Fowles, 1922.193.

William Joy (1803–1857), *Two Brigantines under Sail,* 1830s, watercolor with pen and black ink on cream wove paper, 24.0 × 33.2 cm. Gift of David Richardson, 1992.47.

Charles Samuel Keene (1823–1891), *Extremes Meet!* n.d., pen and brown ink with white heightening on cream laid paper, 33.3 × 26.8 cm. Gift of the Paine Charitable Trust, 1965.704.

Samuel Laurence (1812–1884), *Portrait of the Honorable George Bancroft,* 1854, charcoal and white chalk on prepared brown wove paper, 60.0 × 44.7 cm. Museum purchase, 1954.83.

Edward Lear (1812–1888), *Argyllshire Landscape,* 1875, watercolor over graphite heightened with white gouache on cream wove paper, 22.8 × 28.8 cm. Bequest of Malcolm Rhodes McBride, 1989.60.

John Frederick Lewis (1805–1876), *A Kneeling Pilgrim,* 1835, watercolor over graphite on cream wove paper, 33.0 × 24.1 cm. Gift of Dr. and Mrs. Robert A. Johnson, 1985.306.

James McBey (1883–1959), *The Quay at Veere,* 1922, pen and black ink with watercolor on cream laid paper, 26.0 × 43.9 cm. Edward A. Bigelow Collection, gift of Mrs. Robert M. Heberton, 1981.216.

James McBey (1883–1959), *Hastings Fishing Smacks, Evening,* 1925, pen and black ink with watercolor on cream laid paper, 22.3 × 40.5 cm. Bequest of Malcolm Rhodes McBride, 1989.64.

George Morland (1763–1804), *A Peddlar Boy,* n.d., black chalk on cream wove paper, 14.5 × 9.8 cm. Museum purchase, 1951.12.

William James Muller (1812–1845), *A Country Cottage,* n.d., watercolor on gray wove paper, 17.8 × 36.9 cm. Museum purchase, 1951.13.

Noel Paton (1821–1901), attributed to, *Clusters of Angels Greeting the Light,* n.d., pen and black ink with brown wash and white heightening on brown wove paper, 29.0 × 30.7 cm. Sarah C. Garver Fund, 1972.7.

John Piper (born 1903), *The Green Sheepfold at Tryfan, North Wales,* 1948, pen and black ink with watercolor and gray wash on cream wove paper, 53.5 × 68.5 cm. Gift of Dr. Allan Roos and Mrs. B. Mathieu Roos, 1971.123.

John Piper (born 1903), *Coventry Cathedral,* n.d., brush and black ink with gouache on off-white wove paper, 122.0 × 49.5 cm. Gift of Malcolm Rhodes McBride, 1983.56.

David Roberts (1796–1864), *The Castle of Burresheim,* 1841, graphite and gray wash on cream wove paper, 18.0 × 24.2 cm. Museum purchase, 1951.14.

George Romney (1734–1802), *The Wounded Tancred Supported by Erminia and Vafrino,* 1780s, pen and brown ink on cream laid paper, 19.6 × 16.0 cm. William Grimm Fund and Binney Foundation Fund, 1981.1.

George Romney (1734–1802), *Studies for Sin, Satan, and Death,* 1780s, graphite on cream wove paper, 14.0 × 23.4 cm. William Grimm Fund and Binney Foundation Fund, 1981.2.

George Romney (1734–1802), attributed to, *Two Figures,* ca. 1760, pen and brown ink with wash on cream laid paper, 12.6 × 13.2 cm. Gift of David Richardson, 1992.45.

Thomas Rowlandson (1756–1827), *Three Judges: Cognovit, Fiere Facias, and Clausem Friget,* n.d., pen and brown ink with watercolor on cream wove paper, 25.9 × 27.4 cm. Museum purchase, 1919.314.

Thomas Rowlandson (1756–1827), *A Covered Cart,* n.d., watercolor over graphite on cream wove paper, 10.8 × 17.8 cm. Museum purchase, 1951.15.

John Ruskin (1819–1900), *Sketch for an Illustration of Lombardic Domestic Architecture,* n.d., watercolor over graphite on off-white wove paper, 34.2 × 27.0 cm. Museum purchase, 1951.16.

John Ruskin (1819–1900), *Munster,* n.d., graphite, pen and black and brown inks with wash and white heightening on cream wove paper, 30.8 × 44.8 cm. Gift of Mrs. Howard W. Preston, 1974.328.

Charles H. Shannon (1865–1937), *Two Draped Women,* ca. 1880, black and white chalks on gray laid paper, 35.8 × 25.7 cm. Gift of David Richardson, 1992.49.

Henry Singleton (1766–1839), *The News of the Defeat and Death of the Earl of Warwick Brought to Margaret of Anjou,* n.d., black chalk and gray wash on cream laid paper, 20.7 × 31.3 cm. Museum purchase, 1971.125.

Robert Streatfield (1786–1852), *View of Brussels,* ca. 1850, watercolor on cream wove paper, 15.6 × 18.6. Gift of Dr. and Mrs. Robert A. Johnson, 1992.85.

Walter Tyndale (1835–1943), *The Temple of Seti I at Gurnah, Thebes,* n.d., watercolor on cream wove paper, 26.5 × 36.9 cm. Gift of Mrs. Kingsmill Marrs, 1925.462.

Richard Westall (1765–1836), *Two Children Lost in the Woods,* ca. 1810, pen and brown ink with watercolor on cream laid paper, 17.4 × 20.6 cm. Gift of Joan Peterson Klimann, 1994.211.

Charles Whymper (1853–1941), *Looking into the Tombs of the Kings,* 1908, watercolor over graphite, 53.0 × 41.9 cm. Gift of Mrs. Kingsmill Marrs, 1925.139.

Charles Whymper (1853–1941), *Pelicans,* 1908, watercolor over graphite, 27.0 × 37.2 cm. Gift of Mrs. Kingsmill Marrs, 1925.472.

Charles Whymper (1853–1941), *Shoebills,* 1908, watercolor over graphite, 53.3 × 39.4 cm. Gift of Mrs. Kingsmill Marrs, 1925.479.

Austin Wright (born 1911), *Tenement,* 1955, charcoal, pen and black ink, and watercolor over graphite on cream wove paper, 76.4 × 55.8 cm. Director's Discretionary Fund, 1957.21.

William Wyld (1806–1889), *View of Amsterdam,* n.d., watercolor and gouache over graphite on off-white wove paper, 10.7 × 22.3 cm. Gift of Mrs. Kingsmill Marrs, 1914.46.

Canadian

Leonard Brooks (born 1911), *Fiesta Procession,* 1949, black ink over charcoal with gouache and washes on white wove paper, 22.8 × 17.0 cm. Gift of Edward Kenway, 1950.248.

Chilean

Roberto Matta Echaurren (born 1912), *The Monster,* ca. 1960, charcoal on cream wove paper, 75.3 × 53.5 cm. Director's Discretionary Fund, 1961.35.

Ludwig Zeller (born 1927), *Converted into a Mare, I Sat to Think about Schopenhauer's Ideas,* 1971, collage of printed elements on white wove paper, 35.5 × 48.4 cm. Sarah C. Garver Fund, 1972.18.

Cuban

Augustin Fernandez (born 1928), *No. 8,* 1967, graphite on off-white wove paper, 53.9 × 36.2 cm. Director's Discretionary Fund, 1967.46.

Danish

Carl Henning-Pedersen (born 1913), *Kelden Og Kippen,* 1947, blue crayon on off-white wove paper, 28.4 × 40.6 cm. Gift of the Betty Parsons Foundation, 1985.266.

Dutch

Anonymous (16th century), *Two Male Nudes,* ca. 1600, pen and brown ink over black chalk with wash on cream laid paper, 29.0 × 22.7 cm. Gift of David Richardson, 1992.57.

Anonymous (17th century), *A Man Reading a Book,* n.d., black and white chalks on blue wove paper, 25.1 × 17.9 cm. Museum purchase, 1951.18.

Anonymous (18th century), *Seascape,* n.d., watercolor and wash with pen and brown ink on cream laid paper, 23.6 × 36.1 cm. Gift of David Richardson, 1992.51.

Karel Appel (born 1921), *Paris Series No. 5,* n.d., black felt-tip pen and gray wash on off-white wove paper, 55.3 × 50.2 cm. Director's Discretionary Fund, 1963.63.

Jan de Bisschop (1628–1671), atttributed to, *The Penitence of a Female Saint,* n.d, red chalk and pen and brown ink with wash on tan laid paper, 24.3 × 29.1 cm. Sarah C. Garver Fund, 1971.117.

Anthonis Blocklandt (ca. 1532–1583), *Nymphs,* 1570s, pen and black ink with wash on cream laid paper, 20.3 × 31.8 cm. Eliza S. Paine Fund, 1997.8.

Abraham Bloemaert (1564–1651), copy after, *Pan and Syrinx,* ca. 1600, pen and black ink with brown wash on cream laid paper, 17.5 × 17.9 cm. Museum purchase, 1956.24.

Bernardus Johannes Blommers (1845–1914), *Young Girl with a Baby on the Dunes,* n.d., watercolor, pastel, and wash on cream wove paper, 32.3 × 46.4 cm. Bequest of Miss Mabel Buffington, 1941.10.

Karel Frederick Bombled (1822–1902), *The Carriage,* ca. 1887, watercolor and gouache over graphite on cream laid paper, 20.5 × 30.8 cm. Bequest of Malcolm Rhodes McBride, 1989.35.

Jan Both (ca. 1618–1652), school of, *Landscape with Peasants,* n.d., pen and brown ink on cream laid paper, 25.5 × 18.1 cm. Museum purchase, 1919.272.

Maerten van Heemskerck (1498–1574), *King David,* ca. 1565, pen and brown ink on cream laid paper, 21.0 × 14.1 cm. Sarah C. Garver Fund, 1997.1.

Jan van Kessel (1626–1679), school of, *Insects, Reptiles, Flowers, and Shells,* n.d., gouache over charcoal on vellum, 21.5 × 30.6 cm. Eliza S. Paine Fund in memory of William R. and Frances T. C. Paine, 1956.85.

Anton Mauve (1838–1888), *The Return of the Flock,* n.d., watercolor on cream wove paper, 37.0 × 51.7 cm. Bequest of Mrs. Charlotte E. W. Buffington, 1935.37.

Adriaen van Ostade (1610–1684), school of, *Man with a Jug,* n.d., black and white chalks on blue wove paper, 12.4 × 13.0 cm. Gift of Mrs. Mordecai A. Fisherman, 1952.19.

Rembrandt Harmensz. van Rijn (1606–1669), copy after, *Beggars,* n.d., pen and brown ink on cream wove paper, 12.7 × 9.3 cm. Museum purchase, 1919.215.

Johannes Rutten (1809–1884), *View of a Riverside Village,* 1850s, watercolor over graphite on cream laid paper, 24.5 × 33.6 cm. Sarah C. Garver Fund, 1995.17.

Hermann Saftleven (1609–1685), *Landscape with a Traveler,* n.d., black chalk with brown and gray washes on cream laid paper, 18.0 × 23.9 cm. Eliza S. Paine Fund, 1977.131.

Jacob de Wit (1695–1754), *Studies of Hands,* ca. 1715, red chalk with white heightening on cream laid paper, 19.9 × 15.4 cm. Museum purchase, 1964.83.1.

Flemish and Belgian

Pieter van Bloemen (1657–1720), *Pastoral Scene,* n.d., black chalk and gray wash on cream wove paper, 13.0 × 19.4 cm. Museum purchase, 1951.24.

Roel d'Haese (born 1921), *The Beadle Dreams of Setting a Fire,* 1962, black felt-tip pen on cream wove paper, 37.9 × 28.4 cm. Alexander and Caroline Murdock DeWitt Fund, 1966.54.

Anthony van Dyck (1599–1641), copy after, *Portrait of Cornelius Saftleven,* n.d., black chalk with brown wash on

cream laid paper, 21.9 × 17.4 cm. Bequest of Mrs. Susan Chapman Dexter, 1917.77.

Peter Paul Rubens (1577–1640), copy after, *A Man in Armor,* n.d., black and red chalks with brown and black washes on cream laid paper, 17.9 × 12.0 cm. Bequest of Mrs. Susan Chapman Dexter, 1917.76.

Peter Paul Rubens (1577–1640), copy after, *Portrait of Isabella Brant,* n.d., pen and black ink with brown and gray washes heightened with white on cream laid paper, 11.4 × 9.2 cm. Bequest of Mrs. Susan Chapman Dexter, 1917.78.

Frans Snyders (1579–1657), school of, *Dogs Attacking a Boar,* n.d., pen and brown ink with wash on cream laid paper, 12.5 × 19.9 cm. Museum purchase, 1951.17.

French

Anonymous (19th century), *Group Portrait,* n.d., graphite on cream paperboard, 28.9 × 26.7 cm. Sarah C. Garver Fund, 1982.6.

Adolphe Appian (1818–1898), *Landscape with Fisherman on a Riverbank,* 1865, charcoal on brown wove paper, 20.8 × 23.7 cm. Austin S. Garver Fund, 1978.47.

Paul Albert Besnard (1849–1934), *Reflection,* ca. 1900, graphite, charcoal, and gouache on cream wove paper, 48.9 × 40.8 cm. Bequest of Malcolm Rhodes McBride, 1989.34.

Jacques Blanchard (1600–1638), attributed to, *A Putto Carrying a Helmet, Shield, Trumpet, and Quiver,* n.d., graphite and red chalk with red wash on cream laid paper, 18.2 × 14.4 cm. William Grimm Fund, 1982.81.

Guillaume Bodinier (1795–1872), *Head of Bacchus, Study of a Sculptural Fragment,* n.d., charcoal and white chalk on cream wove paper, 42.4 × 36.4 cm. William Grimm Fund, 1982.76.

Edmé Bouchardon (1698–1762), copy after, *Study for Neptune,* ca. 1725, red and white chalks on tan laid paper, 41.9 × 26.3 cm. Gift of David Richardson, 1992.54.

William-Adolphe Bouguereau (1825–1905), *A Sheet of Studies,* n.d., graphite on cream wove paper, 17.5 × 31.2 cm. William Grimm Fund, 1981.14.

Hedwig Calmelet (1814–after 1870), *A Picnic in the Country,* n.d., watercolor on off-white wove paper, 14.3 × 21.9 cm. Purchased with funds given by William H. Sawyer, Sr., 1950.282.

Hedwig Calmelet (1814–after 1870), *The Road to the Village,* n.d., watercolor on off-white wove paper, 14.3 × 21.9 cm. Purchased with funds given by William H. Sawyer, Sr., 1950.283.

Eugène Carrière (1849–1906), *Studies of a Reclining Woman,* n.d., charcoal on cream wove paper, 20.0 × 21.1 cm. Gift of Mr. and Mrs. Hall James Peterson, 1982.31.

Michel Corneille (1602–1664), after Nicolas Poussin (1594–1665), *Faustulus Delivering Romulus and Remus,* n.d., graphite, black chalk, and pen and brown ink on cream laid paper, 28.5 × 43.0 cm. Museum purchase, 1951.23.

Jean-Baptiste Camille Corot (1796–1875), *A Norman Cart,* ca. 1823, graphite on off-white wove paper, 9.5 × 15.0 cm. Bequest of Malcolm Rhodes McBride, 1989.42.

Thomas Couture (1815–1879), *Portrait of Monsieur Egle,* n.d., charcoal and white chalk on blue wove paper, 44.4 × 33.5 cm. Gift of Henri Baderou, 1951.42.

Edgar-Hilaire-Germain Degas (1834–1917), *Dancers Backstage,* ca. 1904–6, pastel and charcoal on gray paperboard, 103.2 × 72.0 cm. Austin S. and Sarah C. Garver Fund, 1956.76.

Louis Jean Desprez (1743–1804), *A Renaissance Feast in a Grotto at Polignano,* n.d., pen and black ink with watercolor on cream wove paper, 23.0 × 35.8 cm. Gift of Stephen C. Earle, 1913.53.

Louis Jean Desprez (1743–1804), *Landscape with Ruined Tower,* n.d., pen and black ink with watercolor on cream wove paper, 26.0 × 38.3 cm. Gift of Stephen C. Earle, 1913.58.

Louis Jean Desprez (1743–1804), *Feast in the Atrium of a Pompeiian House,* n.d., pen and black ink with watercolor on cream laid paper, 21.5 × 36.4 cm. Bequest of Mrs. Kingsmill Marrs, 1926.158.

Gustave Doré (1832–1883), *A Man in Overalls,* n.d., pen and brown ink over graphite on cream wove paper, 12.9 × 9.0 cm. Bequest of Malcolm Rhodes McBride, 1989.48.

School of Fontainebleau (16th century), *Mars and Venus,* ca. 1550, pen and black ink with gray wash and white heightening on gray prepared paper, 19.6 × 28.8 cm. Museum purchase, 1956.21.

School of Fontainebleau (16th century), *Venus and Adonis Meeting in a Forest,* ca. 1560, pen and brown ink with gray wash on cream laid paper, 27.1 × 21.9 cm. Museum purchase, 1956.27.

Jean Louis Forain (1852–1931), *An English School Teacher with War Orphans,* n.d., black crayon on cream wove paper, 28.6 × 41.4 cm. Anonymous gift, 1963.136.

Jean-Honoré Fragonard (1732–1806), copy after, *The Tax Collectors,* ca. 1780, pen and brown ink wash on cream laid paper, 34.5 × 25.5 cm. Museum purchase, 1952.5.

Paul Gavarni (1804–1866), *The Masked Ball,* n.d., watercolor and gouache over black chalk on tan wove paper, 53.1 × 72.7 cm. Museum purchase, 1932.14.

Claude Gellée, called Claude Lorrain (1600–1682), school of, *Fête champêtre,* n.d., pen and brown ink and gray wash on cream laid paper, 19.1 × 14.5 cm. Museum purchase, 1956.23.

Jean-Louis-André-Théodore Géricault (1791–1824), *Artillery Fire in the Plain of Grenelle,* n.d., graphite on cream wove paper, 29.4 × 42.5 cm. Museum purchase, 1981.352.

Claude Gillot (1673–1722), attributed to, *Characters from the Commedia dell'Arte,* n.d., black chalk on cream laid paper, 29.4 × 18.7 cm. Museum purchase, 1956.30.

François Marius Granet (1775–1849), *Taking the Oath of the Knights Templar,* 1843, pen and brown ink over graphite

with colored washes on cream laid paper, 24.2 × 36.5 cm. Alexander and Caroline Murdock DeWitt Fund, 1966.57.

Jean-Baptiste Greuze (1725–1805), copy after, *Head of a Girl,* n.d., red chalk on cream laid paper, 40.7 × 30.3 cm. Museum purchase, 1962.8.

Alfred Grévin (1827–1892), *Two Dancers Costumed as Hens,* 1864, graphite with watercolor on cream wove paper, 25.5 × 20.7 cm. Gift of Mrs. Harry Goodspeed, 1974.270.

Constantine Guys (1805–1892), *A Lady in an Evening Gown,* ca. 1860, pen and brown ink over graphite with black crayon and wash on illustration board, 28.1 × 19.2 cm. Museum purchase, 1930.27.

Henri-Joseph Harpignies (1819–1916), *A Wooded Landscape,* 1911, watercolor on cream paperboard, 9.9 × 15.3 cm. Bequest of Malcolm Rhodes McBride, 1989.55.

Jacques Hayet (died 1916), *Passengers in the Third Class Coach,* ca. 1885, charcoal on cream wove paper, 18.1 × 23.2 cm. Bequest of Malcolm Rhodes McBride, 1989.56.

Jean Hélion (born 1904), *An Evening Festival at Belle Ile,* 1966, pen and India ink, black felt-tip pen, and watercolor on blue wove paper, 32.3 × 50.0 cm. Gift of Katharine Kuh in memory of Daniel Catton Rich, 1976.177.

Paul-César Helleu (1859–1927), *A Lady Kneeling to View a Picture,* n.d., black, red, and white chalks over graphite on cream wove paper, 44.1 × 58.9 cm. Sarah C. Garver Fund, 1973.93.

Charles Huard (1874–1965), *Don Quixote,* ca. 1935, brown ink applied with pen and brush, with washes on cream laid paper, 21.1 × 17.4 cm. Gift of Mme Charles Huard, 1966.95.

Charles Huard (1874–1965), *Sketches of People in Trafalgar Square,* 1901, graphite on cream wove paper, 25.0 × 17.7 cm. Gift of Mme Charles Huard, 1966.96.

Charles Huard (1874–1965), *Sketches of People in Trafalgar Square,* 1901, graphite on cream wove paper, 25.3 × 17.5 cm. Gift of Mme Charles Huard, 1966.97.

Charles Huard (1874–1965), *City Dwellers in a Close,* ca. 1925, pen and brown ink with wash on cream laid paper, 30.2 × 19.9 cm. Gift of Mme Charles Huard, 1966.98.

Charles Huard (1874–1965), *Frances Wilson Huard at the Piano,* 1910, red chalk on cream laid paper, 22.8 × 17.5 cm. Gift of Mme Charles Huard, 1966.99.

Charles Huard (1874–1965), *A Storm in England,* ca. 1927, brush and brown ink with wash on cream laid paper, 14.6 × 20.0 cm. Gift of Mme Charles Huard, 1966.100.

Charles Huard (1874–1965), *View of a Village in Normandy,* ca. 1935, brush and brown ink and wash on cream laid paper, 26.6 × 16.1 cm. Gift of Mme Charles Huard, 1966.101.

Charles Huard (1874–1965), *Figures in a Gothic Courtyard,* ca. 1935, brush and brown ink with wash on cream laid paper, 27.0 × 18.4 cm. Gift of Mme Charles Huard, 1966.102.

Charles Huard (1874–1965), *A Carriage before a Gothic Church,* ca. 1935, brush and brown ink with wash on cream

laid paper, 24.9 × 16.9 cm. Gift of Mme Charles Huard, 1966.103.

Charles Huard (1874–1965), *Portrait of a Man in a Turban,* ca. 1935, charcoal with white gouache on blue laid paper, 29.4 × 24.1 cm. Gift of Mme Charles Huard, 1966.104.

Marie Laurencin (1885–1956), *Self-Portrait,* n.d., watercolor over graphite on off-white wove paper, 20.3 × 13.2 cm. Anonymous gift, 1964.111.

Henri Lebasque (1865–1937), *Looking Out to Sea,* n.d., black crayon and watercolor on cream wove paper, 31.7 × 26.9 cm. Bequest of Malcolm Rhodes McBride, 1989.59.

Alphonse Legros (1837–1911), *A Man in a Cape,* n.d., charcoal on blue laid paper, 42.9 × 30.6 cm. Sarah C. Garver Fund, 1973.92.

Alphonse Legros (1837–1911), *Study for a Tomb,* n.d., watercolor over graphite on cream wove paper, 33.4 × 34.4 cm. William Grimm Fund, 1982.63.

Léon-Augustin Lhermitte (1844–1925), *The Spinner,* n.d., charcoal on cream laid paper, 51.5 × 42.4 cm. Museum purchase, 1965.65.

Léon-Augustin Lhermitte (1844–1925), *The Soup Seller,* n.d., charcoal and brown pastel on cream laid paper, 49.5 × 32.2 cm. Mary G. Ellis Fund, 1972.133.

Claude-Antoine Littret de Montigny (ca. 1735–1775), *Two Seated Female Figures,* 1773, red chalk on cream laid paper, 17.5 × 30.0 cm. Gift of Stephen C. Earle, 1913.56.

Carle van Loo (1705–1765), copy after, *A Boy Holding a Knife on a Tray,* n.d., red chalk on cream laid paper, 46.3 × 31.5 cm. Gift of Henri Baderou, 1951.43.

Carle van Loo (1705–1765), copy after, *A Soldier Asking a Sailor for Directions,* n.d., red chalk on cream laid paper, 32.1 × 28.3 cm. Sarah C. Garver Fund, 1972.39.

Georges Mathieu (born 1921), *Abstract Brown,* 1958, pen and black ink with brown wash on off-white laid paper, 69.6 × 50.4 cm. Gift of Dr. and Mrs. Elton Yasuna, 1964.2.

Jean-François Millet (1814–1875), *The Milkmaid,* n.d., pastel on blue-gray laid paper, 19.0 × 30.7 cm. Bequest of Mrs. Charlotte E. W. Buffington, 1935.40.

Jean-François Millet (1814–1875), *The Vigil (Women Sewing),* n.d., charcoal on cream wove paper, 32.7 × 26.5 cm. Museum purchase, 1962.38.

Jean-François Millet (1814–1875), *A Sheet of Studies with Sketches of Phoebus and Boreas,* ca. 1854, graphite on cream laid paper, 27.2 × 20.9 cm. Gift of Mr. and Mrs. Daniel Catton Rich, 1964.109.

Jean-François Millet (1814–1875), *Study for the Woodcutter and His Wife in the Forest,* n.d., charcoal on cream wove paper, 31.6 × 20.3 cm. Gift of Mr. and Mrs. Daniel Catton Rich, 1964.110.

Jean-François Millet (1814–1875), *Study for Motherhood,* ca. 1870, graphite with oil paint on cream wove paper, 20.2 × 31.5 cm. Gift of Mr. and Mrs. Daniel Catton Rich, 1971.121.

Antonin Marie Moine (1796–1849), *Two Monks,* n.d., graphite, black chalk, and pen and brown ink on cream laid paper, 21.2 × 10.3 cm. Sarah C. Garver Fund, 1982.7.

Auguste Pegurier (1856–1936), *September Morning, St. Tropez,* 1920, pastel on sandpaper, 13.1 × 18.9 cm. Bequest of Malcolm Rhodes McBride, 1989.68.

Jean Pillement (1728–1808), attributed to, *Two Women in a Landscape,* n.d., graphite and black and red chalks with watercolor on off-white wove paper, 18.5 × 24.5 cm. Bequest of Theodore T. Ellis, 1940.48.

Camille Pissarro (1830–1903), *Along the Riviera,* n.d., graphite on white wove paper, 11.0 × 16.7 cm. Bequest of Malcolm Rhodes McBride, 1989.69.

Pierre Puvis de Chavannes (1824–1898), *A Crowned Allegorical Figure,* n.d., black crayon over graphite on cream laid paper, 31.1 × 23.9 cm. Eliza S. Paine Fund, 1977.110.

Auguste Raffet (1804–1860), *A Mob Carrying a Man on a Stretcher,* n.d., pen and brown ink over graphite on cream wove paper, 30.9 × 50.6 cm. William Grimm Fund, 1981.3.

Henri Alexandre Georges Regnault (1843–1871), *A Day of Mourning,* 1863, graphite on cream wove paper, 14.2 × 22.3 cm. Gift of Henri Baderou, 1951.44.

Hubert Robert (1733–1808), school of, *An Italian Garden,* n.d., black chalk on off-white laid paper, 21.9 × 33.1 cm. Sarah C. Garver Fund, 1982.4.

Theodore Rousseau (1812–1867), *A Woman Walking in a Country Lane,* n.d., graphite on cream wove paper, 8.1 × 12.6 cm. Gift of Malcolm Rhodes McBride, 1981.303.

Louis-Félix de la Rue (1720–1765), *A Cavalry Battle,* n.d., graphite and pen and gray ink with watercolor on cream laid paper, 3.2 × 43.5 cm. Anonymous fund, 1986.95.

Charles Fevret de Saint-Mémin (1770–1852), attributed to, *Portrait of Simeon Baldwin,* ca. 1810, charcoal and black, white, and gray chalks on pink-prepared cream laid paper, 55.9 × 43.8 cm. Gift of Bradley B. Gilman, 1967.11.

Jacques-François-Joseph Saly (1717–1776), attributed to, *Design for a Torchère,* n.d., pen and black ink with wash on cream laid paper, 59.0 × 28.1 cm. Jerome A. Wheelock Fund, 1979.1.

Frederic Henri Schopin (1804–1880), *Head of a Muse with Eyes Raised,* n.d., charcoal and pastel on blue laid paper, 25.4 × 27.4 cm. Jerome A. Wheelock Fund, 1980.11.

Emile Schuffenecker (1851–1934), *Portrait of Madame Félicien Champsaur,* 1890, pastel and charcoal on cream laid paper, 55.0 × 37.7 cm. Museum purchase, 1963.150.

Alfred Sisley (1839–1899), *A Work Horse in Harness,* n.d., graphite and colored crayon on cream wove paper, 8.9 × 11.9 cm. Bequest of Malcolm Rhodes McBride, 1989.73.

Marcel Spranck (1890–1978), *Bathers,* n.d., pen and brown ink on tan wove paper, 8.4 × 13.0 cm. William Grimm Fund, 1982.77.

Jacques Villon (1875–1963), *Portrait of Charles de Livry,* 1897, pen and black ink and watercolor over graphite on

brown Kraft paper, 15.2 × 12.5 cm. Bequest of Malcolm Rhodes McBride, 1989.79.

Jean-Antoine Watteau (1684–1721), school of, *A Youth Offering a Basket of Flowers,* n.d., red chalk on cream laid paper, 18.8 × 11.4 cm. Museum purchase, 1951.27.

Jean-Baptiste Joseph Wicar (1762–1834), *Study of a Sandaled Foot,* ca. 1826, black chalk on cream laid paper, 16.0 × 16.3 cm. Gift of Margot Gordon, 1994.237.1.

Jean-Baptiste Joseph Wicar (1762–1834), *Study of an Antique Sandal,* ca. 1826, black crayon on cream laid paper, 12.1 × 8.6 cm. Gift of Margot Gordon, 1994.237.2.

German

Anonymous (19th century), *Tree Trunks and Foliage,* n.d., pen and black ink with brown wash on cream laid paper, 32.6 × 36.6 cm. Director's Discretionary Fund, 1970.75.

Lovis Corinth (1858–1925), *A Sheet of Studies with the Portrait of Charlotte Berend-Corinth,* ca. 1913, graphite and purple pencil on cream wove paper, 37.2 × 50.2 cm. Gift of George Hecker, 1996.108.

Wendel Dietterlin the Younger (active ca. 1600–1625), attributed to, *Roman Soldiers at the Foot of the Cross,* 1602, pen and brown ink with wash on cream laid paper, 18.0 × 32.1 cm. Museum purchase, 1956.28.

George Grosz (1893–1959), *Bathers,* ca. 1925, pen and black ink with watercolor on cream laid paper, 48.7 × 63.0 cm. Gift of Leo Lionni, 1960.59.

George Grosz (1893–1959), *The Muzzle,* ca. 1922, pen and India ink on cream wove paper, 65.3 × 52.3 cm. Director's Discretionary Fund, 1969.40.

Eduard Hildebrandt (1818–1869), *View of Buffalo,* 1844, watercolor over graphite on cream paperboard, 25.0 × 36.2 cm. Gift of Mr. and Mrs. Karl Loewenstein, 1979.53.

Eduard Hildebrandt (1818–1869), *View of Albany,* 1844, watercolor over graphite on cream paperboard, 25.5 × 36.2 cm. Gift of Mr. and Mrs. Karl Loewenstein, 1979.54.

Heinrich Kley (1863–1910), *A Galloping Horse,* n.d., graphite on cream wove paper, 9.0 × 18.6 cm. Gift of Mr. and Mrs. Hall James Peterson, 1982.33.

Georg Kolbe (1877–1947), *Reclining Female Nude,* n.d., watercolor over graphite on cream wove paper, 37.5 × 49.7 cm. Museum purchase, 1968.9.

Karl Anton Heinrich Mücke (1806–1891), *Female Head,* n.d., black chalk, charcoal, and white chalk on tan wove paper, 33.2 × 32.2 cm. Jerome A. Wheelock Fund, 1980.12.

Ernst Ferdinand Oehme (1797–1855), *Mountain Landscape,* n.d., watercolor on cream wove paper, 23.8 × 35.4 cm. Bequest of Mrs. Kingsmill Marrs, 1926.161.

Ernst Ferdinand Oehme (1797–1855), *Chapel in the Mountains,* n.d., watercolor on cream wove paper, 23.8 × 35.4 cm. Bequest of Mrs. Kingsmill Marrs, 1926.162.

Max Pechstein (1881–1955), *Dancing Couple,* 1910, brush and black ink over graphite with pastel on cream wove paper, 12.5 × 20.5 cm. Gift of Louis W. Black, 1955.16.

Franz von Stuck (1863–1928), *Portrait of a Boy,* n.d., pen and black ink with pastel and white gouache on gray chipboard, 52.5 × 46.5 cm. Gift of Joan Petersen Klimann, 1994.282.

Januarius Zick (1730–1797), attributed to, *Design for a Banner with a Bishop Anointing a King,* n.d., pen and black ink with wash and white heightening on blue laid paper, 22.2 × 13.7 cm. Jerome A. Wheelock Fund, 1979.31.

Israeli

Pinchas Cohen-Gan (born 1942), *Square within a Square,* 1973, brush and black ink on white wove paper, and collage, 63.3 × 78.5 cm. Sarah C. Garver Fund, 1975.1.

Italian

Filippo Abbiati (1640–ca. 1715), *Two Men Harnessing a Horse,* n.d., pen and brown ink over black chalk on tan laid paper, 21.8 × 26.8 cm. Sarah C. Garver Fund, 1972.38.

Francesco Allegrini (1587–1663), *Studies of Two Standing Figures,* n.d., pen and brown ink on cream laid paper, 10.8 × 12.8 cm. Jerome A. Wheelock Fund, 1979.2.

Anonymous, Tuscan (14th century), *Bifolium from a Gradual with the Initial O and Saint Francis,* ca. 1325, tempera and gold leaf on vellum, 55.7 × 38.5 cm. Museum purchase, 1989.170.

Anonymous, Tuscan (14th century), *Bifolium from a Gradual with the Initial S and Two Women's Heads,* ca. 1325, tempera and gold leaf on vellum, 55.6 × 38.6 cm. Museum purchase, 1989.171

Anonymous, Tuscan (14th century), *Folio from a Gradual with the Initial M and Two Foot Soldiers,* ca. 1325, tempera on vellum, 56.3 × 37.8 cm. Museum purchase, 1989.172

Anonymous, Tuscan (14th century), *Folio from a Gradual with the Initial S and the Conversion and Martyrdom of Saint Paul,* ca. 1325, tempera and gold leaf on vellum, 55.6 × 38.8 cm. Museum purchase, 1989.173.

Anonymous, Tuscan (14th century), *Bifolium from a Gradual with the Initial I with Saint Francis, and Saint Francis Preaching to the Birds,* ca. 1325, tempera and gold leaf on vellum, 55.7 × 38.4 cm. Museum purchase, 1989.174.

Anonymous, Tuscan (14th century), *Folio from a Gradual with the Initial O and Foliate Decoration,* ca. 1325, tempera and gold leaf on vellum, 55.6 × 38.1 cm. Museum purchase, 1989.176.

Anonymous (15th century), *The Baptism of Christ,* n.d., pen and brown and black inks with wash on cream laid paper, 23.3 × 15.1 cm. Museum purchase, 1951.28.

Anonymous (16th century), *Design for an Altarpiece with Virgin and Child in an Elaborate Frame,* n.d., pen and brown ink with blue wash on cream laid paper, 15.1 × 11.7 cm. Museum purchase, 1919.212.

Anonymous (16th century), *Grotesque Mask,* n.d., pen and brown ink over black chalk with brown wash and white heightening on cream laid paper, 12.3 × 9.6 cm. Museum purchase, 1951.53.

Anonymous, Florentine (16th century), *The Last Supper,* n.d., red chalk on cream laid paper, 16.2 × 33.8 cm. Museum purchase, 1956.35.

Anonymous, Mantuan (ca. 1525–1575), *Studies of Dragon Heads,* n.d., pen and brown ink over black chalk on cream laid paper, 21.0 × 25.1 cm. Museum purchase, 1950.285.

Anonymous (16th century), *A Bacchanal,* ca. 1600, pen and gray ink with colored washes on off-white laid paper, 13.1 × 30.7 cm. Museum purchase, 1951.26.

Anonymous (1575–1625), *Two Classical Heads,* n.d., metalpoint, black and red chalks with wash on cream laid paper, 13.7 × 18.1 cm. Museum purchase, 1919.207.

Anonymous, Tuscan (1550–1625), *Design for Torchère Supported by Atlas,* n.d., pen and brown ink over black chalk on cream laid paper, 29.7 × 12.0 cm. Museum purchase, 1919.213.

Anonymous, Tuscan? (16th–17th century), *Study of Half-Length Male Figure,* n.d., red chalk on cream laid paper, 14.9 × 11.3 cm. Gift of David Richardson, 1992.56.

Anonymous (17th century), *Study for the Facade of the Palazzo Granucci-Cancelleri, Pistoia,* n.d., pen and brown ink with gouache and wash on cream laid paper, 41.3 × 35.3 cm. Museum purchase, 1919.273.

Anonymous (17th century), *Christ and the Dove of the Holy Spirit with the Archangel Michael in the Clouds,* n.d., pen and brown wash over black chalk heightened with white on cream laid paper, 41.7 × 21.4 cm. Museum purchase, 1971.118.

Anonymous (17th or 18th century), *A Female Allegorical Figure in Classical Armor,* n.d., black and red chalks over graphite with white heightening on cream wove paper, 33.3 × 25.1 cm. Director's Discretionary Fund, 1973.95.

Anonymous (18th century), *Design for a Wall Decoration with Rococo Ornament,* n.d., pen and brown ink with wash on off-white laid paper, 19.1 × 23.8 cm. Museum purchase, 1919.211.

Anonymous (18th century), *An Album of Architectural Sketches,* n.d., 161 sketches in various media mounted in a small album, 23.4 × 15.8 × 0.7 cm. Gift of the Reverend Arthur L. Washburn, 1964.73.

Anonymous, Venetian (18th century), *Head of a Woman,* n.d., pastel and charcoal on blue laid paper, 45.5 × 33.5 cm. Museum purchase, 1919.81.

Anonymous, Venetian? (18th century), *Head of a Man in a Blue Cap,* n.d., pastel and charcoal on blue laid paper, 41.0 × 31.8 cm. Museum purchase, 1919.82.

Anonymous, Venetian (18th century), *Head of Girl,* n.d., pastel over black chalk on cream laid paper, 24.3 × 18.7 cm. Museum purchase, 1919.83.

Anonymous, Venetian (18th century), *Head of Girl,* n.d., pastel over black chalk on blue laid paper, 24.4 × 19.3 cm. Museum purchase, 1919.84.

Anonymous, Venetian (18th century), *Three Peasants Fishing,* n.d., pen and brown ink with gray wash on cream laid paper, 21.4 × 16.9 cm. Source unknown, 1972.51.

Anonymous, Genoese (18th century), *The Virgin on a Crescent and a Monk with Loaves,* n.d., brush and black ink and wash with white heightening on cream laid paper, 20.2 × 18.3 cm. Director's Discretionary Fund, 1973.96.

Anonymous (19th century), *Head of a Young Woman,* n.d., pastel on cream laid paper, 29.0 × 20.6 cm. Museum purchase, 1919.332.

Anonymous (19th century), *Putti Celebrating at a Bacchanal,* n.d., red chalk on cream laid paper, 19.4 × 32.7 cm. Bequest of Theodore T. Ellis, 1940.49.

Anonymous (19th century), *The Assumption of the Virgin, a Design for a Plaquette,* n.d., brush and brown ink with brown and gray washes and white heightening on cream laid paper, 21.8 × 21.9 cm. Eliza S. Paine Fund, 1977.150.

Giovanni Francesco Barbieri, called Il Guercino (1591–1666), school of, *Landscape with a Ferry on a River,* n.d., pen and brown ink with brown and gray washes on cream laid paper, 23.6 × 36.5 cm. Museum purchase, 1919.209.

Francesco Bartolozzi (1725–1815), after Thomas Stothard (British, 1755–1835), *Satan Arousing His Legions,* ca. 1793, red chalk on cream wove paper, 34.0 × 27.5 cm. Bequest of Mrs. Kingsmill Marrs, 1926.908.

Jacopo Bassano (ca. 1515–1592), attributed to, *Bust of Man in a Hat,* n.d., red chalk on cream laid paper, 9.9 × 11.3 cm. Museum purchase, 1919.270.

Jacopo Bassano (ca. 1515–1592), workshop of, *Saint Eleutherius Blessing the Faithful,* n.d., brown ink applied with brush and pen on cream laid paper, 53.2 × 39.0 cm. Museum purchase, 1956.37.

Giuseppe-Bernardino Bison (1762–1844), *Two Garlanded Male Heads,* ca. 1750, pen and brown ink with wash over charcoal on cream laid paper, 20.0 × 26.1 cm. Gift of David Richardson, 1992.65.

Michele Bracci (active ca. 1791), *Trompe l'Oeil Still Life,* 1791, pen and black ink with washes, watercolor, chalks, and gold on off-white laid paper, 38.9 × 53.7 cm. Mary G. Ellis Fund, 1971.60.

Luca Cambiaso (1527–1585), *The Rape of Io,* ca. 1560, pen and brown ink on cream laid paper, 27.4 × 28.6 cm. Gift of David Richardson, 1992.61.

Luca Cambiaso (1527–1585), *Three Putti Reading from a Scroll,* ca. 1570, pen and brown ink and wash on dark laid paper, 25.5 × 39.0 cm. Gift of David Richardson, 1992.63.

Luca Cambiaso (1527–1585), school of, *The Ascension of Mary Magdalen,* ca. 1560, pen and brown ink with wash on cream laid paper, 40.9 × 28.4 cm. Gift of David Richardson, 1992.60.

Luca Cambiaso (1527–1585), copy after, *The Resurrection,* ca. 1560, pen and brown ink and wash over gray chalk on cream laid paper, 21.3 × 31.4 cm. Gift of David Richardson, 1992.62.

Annibale Carracci (1560–1609), school of, *Study of a Half-Length Male Figure,* n.d., red chalk on cream laid paper, 14.9 × 11.3 cm. Gift of David Richardson, 1992.56.

Rosalba Carriera (1675–1757), copy after, *Berenice,* 1740s, pastel on blue laid paper, 43.8 × 34.5 cm. Museum purchase, 1918.140.

Giovanni Battista Cipriani (1766–1839), *The Arrival of Venus Anadyomene,* n.d., pen and brown ink with gray and brown washes on cream laid paper, 18.2 × 23.1 cm. Sarah C. Garver Fund, 1996.18.

Pietro Consagra (born 1920), *Composition for Sculpture,* 1955, black crayon on cream wove paper, 35.1 × 50.0 cm. Anonymous gift, 1965.525.

Gaspare Diziani (1689–1767), *Perseus and Andromeda,* n.d., pen and brown ink and red chalk over metalpoint with brown wash on cream laid paper, 28.2 × 20.5 cm. Mary G. Ellis Fund, 1969.35.

Giovanni Fattori (1825–1908), *Two Children,* n.d., graphite on cream laid paper, 14.8 × 10.5 cm. Gift of Mrs. Minnie Levenson, 1986.188.

Ciro Ferri (1634–1689), copy after, *Calliope and Melpomene,* n.d., black chalk heightened with white on cream laid paper prepared with blue wash, 28.0 × 28.2 cm. Jerome A. Wheelock Fund, 1978.45.

Anton Domenico Gabbiani (1652–1726), *Christ Crowned with Thorns,* n.d., brush and brown ink and wash over black chalk with white heightening on cream laid paper, 23.1 × 17.5 cm. Museum purchase, 1919.208.

Pier Leone Ghezzi (1674–1755), *Caricature of Charles Howard, Third Earl of Carlisle,* ca. 1725, pen and brown ink on white laid paper, 27.2 × 18.2 cm. Gift of Janos Scholz, 1957.136.

Giovanni di San Giovanni, called Manozzi (1592–1636), *A Young Apostle,* n.d., black chalk on cream laid paper, 42.3 × 22.3 cm. Museum purchase, 1951.25.

Renzo Grazzini (born 1912), *The Resistance,* 1943, India ink applied with pen and brush with wash and white gouache on cream wove paper, 32.8 × 48.6 cm. Gift of Dr. and Mrs. Oscar Hechter, 1960.41.

Emilio Greco (born 1913), *Seated Woman,* 1957, pen and India ink on off-white wove paper, 50.2 × 35.3 cm. Director's Discretionary Fund, 1959.111.

Giovanni Antonio Guardi (1698–1760), attributed to, *Holy Family,* n.d., pen and brown ink on cream wove paper, 17.0 × 22.3 cm. Museum purchase, 1919.206.

Luciano Guarnieri (born 1930), *Mexico,* 1959, black felt-tip pen on cream wove paper, 20.8 × 26.8 cm. Bequest of Malcolm Rhodes McBride, 1989.52.

Pietro Longhi (1702–1785), copy after, *A Young Woman,* n.d., pen and black ink on off-white laid paper, 21.7 × 16.9 cm. Museum purchase, 1919.210.

Alessandro Magnasco (1681–1747), copy after, *The Temptation of Saint Anthony,* n.d., pen and brown ink with wash and white heightening on cream laid paper, 26.5 × 40.7 cm. Museum purchase, 1919.335.

Antonio Mancini (1852–1930), *Portrait of a Man,* n.d., charcoal and pastel on gray chipboard, 57.7 × 43.7 cm. Museum purchase, 1929.24.

Antonio Mancini (1852–1930), *Portrait of a Young Man,* n.d., pastel on gray wove paper, 52.8 × 36.9 cm. Museum purchase, 1929.25.

Luciano Miori (born 1922), *Head of a Young Man,* ca. 1953, red chalk on cream wove paper, 70.0 × 48.0 cm. Gift of Mr. and Mrs. Leo Laskoff in memory of Aaron Laskoff, 1957.152.

Pier Francesca Mola (1612–1666), school of, *Caricature of an Astronomer,* n.d., pen and brown ink with wash on cream laid paper, 26.2 × 17.0 cm. Museum purchase, 1956.26.

Giovanni Paolo Pannini (1691–1765), school of, *Architectural Caprice,* n.d., pen and black ink with wash on cream laid paper, 20.1 × 12.7 cm. Museum purchase, 1951.20.

Perino del Vaga (1500–1547), school of, *Zeuxis Selecting a Model for His Painting of Helen,* n.d., pen and brown ink on cream laid paper, 10.4 × 14.5 cm. Museum purchase, 1951.50.

Perino del Vaga (1500–1547), manner of, *Vertumnus and Pomona,* n.d., pen and brown ink over black chalk on cream laid paper, 20.1 × 32.5 cm. Museum purchase, 1956.31.

Arnaldo Pomodoro (born 1926), *Untitled,* 1958, brush and India ink with scraper on cream wove paper, 48.6 × 66.3 cm. Gift of Katharine Kuh in memory of Daniel Catton Rich, 1976.176.

Arnaldo Pomodoro (born 1926), *Landscape with Sculptures,* 1960, pen and India ink with watercolor on cream wove paper, 24.0 × 32.8 cm. Gift of the Betty Parsons Foundation, 1985.323.

Francesco Primaticcio (1504–1570), school of, *Flora with a Putto,* n.d., red chalk on cream laid paper, 14.5 × 17.9 cm. Museum purchase, 1919.271.

Giulio Cesare Procaccini (1574–1625), copy after, *The Christ Child Lying on the Cross,* n.d., red chalk on cream laid paper, 17.0 × 25.0 cm. Museum purchase, 1913.55.

Biagio Pupini (active ca. 1530–50), *Adoration of the Shepherds,* ca. 1550, brown wash with white gouache and black chalk on dark cream laid paper, 18.1 × 41.5 cm. Gift of David Richardson, 1992.58.

Raphael Sanzio (1483–1520), copy after, *Lot and His Daughters Leaving Sodom,* n.d., pen and brown ink with brown and gray washes on cream laid paper, 14.8 × 17.9 cm. Source unknown, 1972.52.

Marco Ricci (1676–1730), school of, *In the Ruins of an Ancient Cemetery,* n.d., pen and brown ink with wash over black chalk on cream laid paper, 38.8 × 27.4 cm. Mary G. Ellis Fund, 1969.36.

Daniele Ricciarelli da Volterra (1509–1566), attributed to, *Study of Sculptural Fragments,* ca. 1550, red chalk on cream laid paper, 25.3 × 17.9 cm. Gift of David Richardson, 1992.59.

A. de Rosa (20th century), *The Flower Sellers at the Spanish Steps,* 1940s, watercolor over graphite on cream laid paper, 32.2 × 22.5 cm. Source unknown, 1988.274.

Luigi Spazzapan (1899–1958), *Geometric Composition with Figure,* n.d., India ink applied with pen and brush on cream wove paper, 36.4 × 49.1 cm. Director's Discretionary Fund, 1960.1.

Giovanni Battista Tagliasacchi (1697–1737), *Studies of Hands and Arms,* n.d., black chalk on cream laid paper, 32.0 × 23.0 cm. Source unknown, 1968.8.

Giovanni Battista Tiepolo (1696–1770), *Man in a Turban,* n.d., red chalk with white heightening on blue laid paper, 20.0 × 15.1 cm. Museum purchase, 1950.284.

Giovanni Battista Tiepolo (1696–1770), school of, *Caricature of Old Man in a Smock,* n.d., pen and brown ink on off-white laid paper, 20.2 × 14.0 cm. Museum purchase, 1951.52.

Mario Toppi (born 1899), *The Nativity,* n.d., pastel and charcoal over graphite on cream wove paper, 52.5 × 70.4 cm. Museum purchase, 1923.23.

Giovanni Battista Trotti (1555–1619), *Design for Architectural Decoration,* n.d., pen and brown ink on cream laid paper, 27.8 × 19.9 cm. Museum purchase, 1913.57.

Emilio Vedova (born 1919), *Agitated Space,* 1956, brush and India ink and gouache over charcoal with graphite on off-white wove paper, 34.7 × 50.5 cm. Director's Discretionary Fund, 1960.2.

Francesco Zuccarelli (1702–1788), school of, *Peasants Working Near a Village,* n.d., pen and black ink over black chalk with gray wash and white heightening on cream laid paper, 30.9 × 45.8 cm. Museum purchase, 1919.333.

Federico Zuccaro (1543–1609), attributed to, after Andrea del Sarto (1486–1530), *Saints Michael and Giovanni Gualberto,* n.d., black and red chalks on cream laid paper, 25.5 × 13.1 cm. Bequest of Mrs. Susan Chapman Dexter, 1917.75.

Mexican

Leonora Carrington (born 1917), *The Egyptian Mary Summoning the Spirits to Aid Her in Alchemy,* 1965, pen and white ink with white pencil on black illustration board, 111.2 × 70.2 cm. Director's Discretionary Fund, 1965.384.

Miguel Covarrubias (1904–1957), *Mussolini,* 1932, gouache over graphite on cream wove paper, 43.7 × 34.4 cm. Bequest of Charles B. Cohn in memory of Stuart P. Anderson, 1985.177.

Miguel Covarrubias (1904–1957), *Sketch for Caricature of Georges Braque with Canvas,* n.d., brush and India ink over graphite on cream wove paper, 23.8 × 21.6 cm. Bequest of Charles B. Cohn in memory of Stuart P. Anderson, 1985.178.

Miguel Covarrubias (1904–1957), *Strut,* n.d., brush and black ink with wash on white wove paper, 38.3 × 28.2 cm. Bequest of Charles B. Cohn in memory of Stuart P. Anderson, 1985.179.

Miguel Covarrubias (1904–1957), *Cake Walk,* n.d., brush and black ink with wash over graphite on white wove paper, 38.3 × 28.2 cm. Bequest of Charles B. Cohn in memory of Stuart P. Anderson, 1985.180.

Miguel Covarrubias (1904–1957), *Preparatory Sketch for a Mural,* n.d., pen and India ink on cream wove paper, 27.8 × 21.5 cm. Bequest of Charles B. Cohn in memory of Stuart P. Anderson, 1985.181.

Miguel Covarrubias (1904–1957), *Woman in Serape,* n.d., graphite on cream wove paper, 27.7 × 21.2 cm. Bequest of Charles B. Cohn in memory of Stuart P. Anderson, 1985.182.

Miguel Covarrubias (1904–1957), *Woman Grinding Corn and Beating Chocolate,* ca. 1945, pen and India ink on cream wove paper, 27.9 × 21.5 cm. Bequest of Charles B. Cohn in memory of Stuart P. Anderson, 1985.183.

Miguel Covarrubias (1904–1957), *Stela 5 from Cerro de las Mesas,* ca. 1945, pen and India ink over graphite on cream wove paper, 28.1 × 21.6 cm. Bequest of Charles B. Cohn in memory of Stuart P. Anderson, 1985.186.

Miguel Covarrubias (1904–1957), *Caricature of Georges Braque,* n.d., India ink applied with pen and brush over graphite on off-white wove paper, 15.2 × 25.2 cm. Bequest of Charles B. Cohn in memory of Stuart P. Anderson, 1985.188.

Miguel Covarrubias (1904–1957), *Caricature for "Vanity Fair,"* 1930, pen and India ink over graphite on cream wove paper, 37.8 × 25.2 cm. Bequest of Charles B. Cohn in memory of Stuart P. Anderson, 1985.189.

Miguel Covarrubias (1904–1957), *Editorial on Franco,* 1950, gouache over graphite on white wove paper, 28.0 × 22.6 cm. Bequest of Charles B. Cohn in memory of Stuart P. Anderson, 1985.190.

Miguel Covarrubias (1904–1957), *Caricature Self-Portrait,* n.d., pen and India ink on cream wove paper, 13.5 × 13.3 cm. Bequest of Charles B. Cohn in memory of Stuart P. Anderson, 1985.191.

Miguel Covarrubias (1904–1957), *Sketch of Caricature of Georges Braque with Palette,* n.d., graphite on cream wove paper, 34.2 × 25.1 cm. Bequest of Charles B. Cohn in memory of Stuart P. Anderson, 1985.192.

Miguel Covarrubias (1904–1957), *Sketch for Caricature of Georges Braque,* n.d., brush and India ink on cream wove paper, 28.0 × 21.7 cm. Bequest of Charles B. Cohn in memory of Stuart P. Anderson, 1985.193.

Miguel Covarrubias (1904–1957), *Two Women Carrying Bundles,* n.d., graphite on cream wove paper, 28.0 × 21.6 cm. Bequest of Charles B. Cohn in memory of Stuart P. Anderson, 1985.194.

Miguel Covarrubias (1904–1957), *Woman in a Flowered Skirt,* 1945, pen and black ink with watercolor over graphite on off-white paper, 27.8 × 21.5 cm. Bequest of Charles B. Cohn in memory of Stuart P. Anderson, 1985.195.

Miguel Covarrubias (1904–1957), *Sketch for Caricature of Georges Braque,* n.d., brush and India ink over graphite on cream wove paper, 28.0 × 21.6 cm. Bequest of Charles B. Cohn in memory of Stuart P. Anderson, 1985.196.

Miguel Covarrubias (1904–1957), *Zocalo, Vera Cruz,* n.d., pen and India ink on off-white paper, 26.2 × 21.5 cm. Bequest of Charles B. Cohn in memory of Stuart P. Anderson, 1985.197.

Miguel Covarrubias (1904–1957), *Sketches for Caricature of Georges Braque with Motifs from His Paintings,* n.d., India ink applied with pen and brush over graphite on cream wove paper, 28.1 × 21.8 cm. Bequest of Charles B. Cohn in memory of Stuart P. Anderson, 1985.221.

Miguel Covarrubias (1904–1957), *Sketch for Caricature of Georges Braque with Palette,* n.d., India ink applied with pen and brush over graphite on off-white wove paper, 34.5 × 25.7 cm. Bequest of Charles B. Cohn in memory of Stuart P. Anderson, 1985.222.

Miguel Covarrubias (1904–1957), *Jaguar,* n.d., pen and black ink on off-white wove paper, 7.5 × 10.3 cm. Bequest of Charles B. Cohn in memory of Stuart P. Anderson, 1985.224.

José Luis Cuevas (born 1933), *The Charity Sister,* n.d., gray ink with watercolor on off-white wove paper, 70.5 × 104.3 cm. Director's Discretionary Fund, 1965.395.

Jorge Flores (20th century), *Untitled,* n.d., black ink applied with pen and brush on cream wove paper, 35.6 × 43.3 cm. Museum purchase, 1968.36.

Jesus Guerrero Galvan (born 1912), *Sleeping Girl,* 1939, graphite on cream wove paper, 32.0 × 45.8 cm. Gift of Mrs. Helen Sagoff Slosberg, 1969.16.

Carlos Merida (1895–1984), *The Peaches of San Miguel,* 1939, gouache and black ink over graphite on primed cotton canvas, 33.7 × 48.9 cm. Gift of Katharine Kuh, 1966.122.

Guillermo Meza (born 1917), *Plantation Workers (Los Canaverales),* 1953, colored pencils on cream wove paper, 56.0 × 101.9 cm. Director's Discretionary Fund, 1963.62.

Guillermo Meza (born 1917), *The Bride,* 1944, charcoal and graphite on cream wove paper, 65.1 × 50.3 cm. Gift of Daniel Catton Rich, 1972.111.

Jose Clemente Orozco (1883–1949), attributed to, *Sketches of Face and Hands,* n.d., pen and black ink with charcoal on cream wove paper, 33.1 × 50.3 cm. Bequest of Charles B. Cohn in memory of Stuart P. Anderson, 1985.207.

Diego Rivera (1886–1957), *Bowl of Fruit,* 1918, graphite on dark cream laid paper, 23.7 × 31.5 cm. Museum purchase, 1928.1.

Diego Rivera (1886–1957), *Mexican Landscape,* ca. 1927, charcoal on cream laid paper, 23.7 × 31.3 cm. Museum purchase, 1928.2.

Diego Rivera (1886–1957), *Mexican House,* ca. 1927, graphite on cream laid paper, 31.6 × 47.1 cm. Museum purchase, 1928.3.

Diego Rivera (1886–1957), *Still Life with Water Pitcher,* 1918, graphite on cream laid paper, 35.9 × 24.8 cm. Museum purchase, 1928.5.

Diego Rivera (1886–1957), *Portrait of Chirokof,* 1917, graphite on white wove paper, 30.7 × 24.0 cm. Museum purchase, 1928.6.

Diego Rivera (1886–1957), *Woman and Donkey,* n.d., brush and India ink on gray-green laid paper, 29.2 × 39.4 cm. Bequest of Charles B. Cohn in memory of Stuart P. Anderson, 1985.226.

Russian

David Burliuk (1882–1967), *Portrait of Ms. Fitsgerald,* 1946, blue chalk on cream wove paper, 35.2 × 25.1 cm. Gift of Mrs. Florence Gerstein and Mrs. Edna Kalman in memory of their mother, Helen Sagoff Slosberg, 1985.322.

Alexei von Jawlensky (1867–1941), *Head of a Woman (Portrait of Frau H. Kirchoff),* 1926, blue wash on cream wove paper, 13.0 × 9.7 cm. Gift of Louis W. Black, 1955.15.

Ossip Zadkine (1890–1967), *Napping Peasants,* 1934, gouache over graphite on cream wove paper, 51.7 × 76.4 cm. Gift of Mr. and Mrs. Francis Henry Taylor, 1953.91.

Spanish

Juan Genovés (born 1930), *Advance and Retreat,* 1966, brush and black ink and gouache over graphite on white wove paper, 76.8 × 57.8 cm. Director's Discretionary Fund, 1966.49.

Constantino Gomez y Salvador (born 1864), *A Religious Procession by Candlelight,* n.d., gouache and oil paint over graphite with pastel on cream wove paper, 85.4 × 54.8 cm. Source unknown, 1990.163.

Francisco Goya (1746–1828), manner of, *Four Hunchbacks,* n.d., red and brown washes over red chalk on medium cream laid paper, 18.3 × 23.5 cm. Museum purchase, 1951.51.

Eugenio Lucas y Padilla (1824–1870), attributed to, *Kneeling Man Receiving Satanic Mass,* n.d., pen and brown ink with wash on cream laid paper, 14.7 × 16.0 cm. Sarah C. Garver Fund, 1971.116.

Swiss

Walter Bodmer (born 1903), *Perpetual Motion,* 1956, colored pencils on cream wove paper, 41.7 × 56.3 cm. Anonymous gift, 1965.526.

Paul Klee (1879–1940), *Lummox Bitten by a Snake,* 1923, pen and purple ink on prepared canvas, 12.7 × 22.6 cm. Gift of Mr. and Mrs. Hall James Peterson, 1974.333.

Théophile-Alexandre Steinlen (1859–1923), *Study of a Young Woman Holding a Spoon,* 1890s, charcoal on tan wove paper, 65.2 × 51.0 cm. Mary G. Ellis Fund, 1973.11.

Théophile-Alexandre Steinlen (1859–1923), *Morals: The Police Are Vigilant—Sleep, Parisians,* n.d., pen and black ink with colored crayons on cream wove paper, 52.6 × 40.3 cm. Sarah C. Garver Fund, 1974.340.

Wolfgang-Adam Töpffer (1766–1847), *Portrait of Anton Boecklin, Legionnaire,* n.d., graphite on white wove paper, 17.1 × 13.5 cm. Museum purchase, 1966.132.

Turkish

Burhan Dogançay (born 1925), *Untitled,* 1960s, watercolor and gouache over graphite on off-white wove paper, 54.1 × 45.6 cm. Gift of Mrs. Fahire Hammond, 1970.1.

Glossary

ballpoint pen

A popular twentieth-century writing tool often used by artists. It consists of an ink-filled, open-ended capillary tube attached to a tiny, very hard ball bearing that rolls the ink onto the paper. Although the smooth, flowing action of this pen makes it ideal for drawing, its inexpensive spirit- or oil-soluble dyes often fade quickly.

bistre

A brown, particulate drawing ink used in the seventeenth and eighteenth centuries. It was made of the soluble tars of greasy wood soot collected from the walls of the hearth, then boiled in water and filtered to intensify the saturation of the pigment.

blind stamp (chop)

A colorless identifying mark embossed into the paper and used by artists, papermakers, collectors, and print publishers. Blind stamps are stamped dry into the pliable paper fibers by interlocking metal dies usually held in a pliers-like tool or small mechanical press.

body color

See **gouache**.

brush

The most common drawing instrument from ancient times. In the West, drawing and calligraphy brushes generally were made of squirrel hair fixed into the tapered ends of quills. These are less refined than oil painters' brushes, which used the finer winter fur of rabbit or lutrine mammals. The familiar brushes used today have a metal collar that holds the hairs on the end of a wooden shaft.

carbon ink

A common drawing and writing ink made from lampblack, collected as the soot from burning wax or oil. This fine pigment is mixed with a weak glue binder and water to make an ink that retains its black color.

casein

A gelatinous protein, derived from curdled milk, that is used as a binding medium for paint. In use it can be thinned with water, but it cannot be rewetted after it dries to an opaque mat finish.

chalk

Natural, powdery mineral clays mined for use as a drawing medium. White chalk is either calcite or soapstone, while black chalk is usually carbonaceous shale. Naturally colored gray and red chalks were also commonly used from the sixteenth through the nineteenth centuries. After excavation they were chipped or carved into small cylindrical flakes and inserted into wood or metal holders before the drawing end was shaved to a point. These materials were the models for **pastels**.

charcoal

A common and affordable dry drawing medium made by burning wood at high temperature in a kiln from which the oxygen is extracted to prevent combustion. Charcoal drawings often are covered with a **fixative** to protect the surface from smudging. Oil charcoal, which came into use in the mid–sixteenth century, was made by soaking natural charcoal in linseed oil. It had to be used before the oil oxidized and hardened, but it did not smudge, and over time it hardened like oil paint.

China paper (chine)

A thin, soft, translucent paper traditionally made in China from bamboo fibers. In Europe it has been used since the seventeenth century chiefly for printmaking, including lithographic transfer and *chine appliqué*. Since the eighteenth century the generic terms "China" and "India proof" paper also have been used for European imitations made of linen or cotton.

chine appliqué

A layered, compound paper support used most often for prints. It is comprised of a relatively thick sheet of Western wove paper backing a smaller, very thin leaf of China or India paper. These are fixed together with a thin film of glue secured under the pressure of a printing press.

Chinese white

See **zinc oxide**.

coated paper

An inexpensive production paper covered with a thin layer of inert pigment to create an even, uniform opaque surface for printing or drawing. Clay, precipitated chalk, and titanium dioxide are the pigments most frequently used, and their adhesive binders can be glue, casein, starch, polyvinyl alcohol, or synthetic resins.

collage (papier découpé)

A French term, meaning gluing or pasting, generally used to describe artwork composed of multiple pieces affixed to a single surface. Although chiefly made up of paper, any found or fabricated materials can be collage elements.

collector's mark

A small identifying mark added to a work of art to indicate possession. These can be written, stamped in ink, or **blind stamped.** They usually take the form of a stylized name, initial, or monogram, but often a crest or symbol is used. Similarly, studio stamps are applied to the contents of an artist's workshop, often by the executors when an estate is dispersed after the artist's death. Collectors' marks can be used to compile the **provenance** of a work, and although they do not denote authenticity, the marks add cachet to a work of art. The standard encyclopedia of collector's marks is that of Frits Lugt (1921/supplement 1956).

colored pencil

A drawing pencil made from chromatic pigments usually mixed with clay and wax binders rather than graphite, and often encased in wood. Colored pencils have been in common use since they became commercially available in the early nineteenth century.

Conté crayon

Originally a medium made of powdered graphite and other pigments combined with clay in a recipe similar to that of **fabricated chalk.** The Conté crayon was developed as a writing medium during the Napoleonic wars, when graphite for writing was in short supply, by the Frenchman Nicholas-Jacques Conté. Today Conté crayons are made with a variety of fabricated chalks, quite different from the nineteenth-century medium.

counterproof

A reversed copy of an image made by passing a drawing through a printing press against a damp sheet of paper. The moisture adheres to particles of ink, chalk, or graphite, pulling away enough to create a ghostly image on the receiving sheet. Counterproofs are made to record designs or to be used as the starting point for a variant image.

crayon

A term, derived from the French *craie,* meaning chalk, used in the seventeenth and eighteenth centuries to describe colored, dry drawing materials. Early in the nineteenth century the German Alois Senefelder, the inventor of lithography, made soft crayons for his printmaking process from beeswax, tallow, shellac, and spermaceti—the waxy discharge from the sperm whale. Artists found this medium ideal for drawing, and modern stick crayons may well have evolved from the nineteenth-century version. Their colors are carried in a waxy or greasy medium, usually made from a combination of water-soluble and fatty components.

deckle

See **laid paper.**

fabricated chalk

See **pastel.**

false plate mark

To achieve a precious or bookish effect, artists sometimes create margins for their drawings by pressing **plate marks** into the sheets, sometimes in combination with *chine appliqué.*

felt-tip pen

A twentieth-century writing instrument in which ink flows through a tiny point of porous synthetic felt. Usually these are disposable pens made of polymer acrylics. They use thin ink suspended in solvent, which often fades quickly.

fixative

A liquid chemical applied to a drawing made with a dry medium such as **charcoal** or **pastel** to consolidate and protect the surface. In the sixteenth century natural adhesive binders derived from skimmed milk, egg white, fig juice, rice water, gums, or shellac were brushed over the drawing. In the eighteenth century pastels were often laid face down on a bath of thin fixative. Modern fixatives are made from synthetic resins and are usually atomized over the surface of the drawing. Fixatives can affect both paper and drawing media, changing colors and softening the edges of lines and forms.

gold leaf (gilding)

Pure gold is traditionally used for the decoration of illuminated manuscripts, in bookbinding, and in the mounting of drawings. Having been beaten into extremely thin sheets, the metal is applied to a prepared surface with an adhesive such as glair, or egg white. The gold is affixed by rubbing, and its surface is then burnished. It can also be decorated with the incised line of a stylus or with debossing punchwork. See also **metal leaf.**

gouache (body color)

Any opaque water-soluble pigment, and the technique of its use. The term, first used in France in the eighteenth century, was adopted in England only in 1882 and originally described the process of making watercolors opaque during painting by adding white chalk in a medium of gum and honey.

graphite (black lead, plumbago)

A naturally occurring crystalline allotropic form of carbon which is the essential ingredient of the modern pencil. Beginning in the sixteenth century

graphite was mined for use as a drawing medium. Since the nineteenth century natural graphite has been powdered and mixed with clay before being pressed into slender sticks, which are usually encased in wood to make pencils.

gray chipboard

The most common type of cardboard, made from recycled newspapers that have been ground into powder, mixed in a watery slurry, and reformed into sheets. The wood pulp **newsprint** combined with printing ink give this material its characteristic color. Illustration board, or poster board, is made by laminating a thin sheet of opaque, clay-coated paper to a piece of gray chipboard.

groundwood board

Inexpensive pulp cardboard made from peeled or barked logs that have been roughly ground and cast into sheets. Impurities often remain in this thick material, which is often used as packing material.

heightening

Opaque white chalk or paint used to add visual highlights to drawings. The pigment most commonly used is white lead suspended in water; however, **zinc oxide** and titanium are also used. Sometimes a similar effect is achieved by scraping away drawn or painted areas to reveal the white of the paper.

illustration board

See **gray chipboard.**

India ink

A common **carbon ink** made from lampblack mixed with resin and gum arabic, which is concentrated and hardened by baking. When dry, India ink becomes waterproof, and its resin gives a sheen to its drawn line.

India paper

A thin, strong wove paper of cotton or linen content, made in imitation of paper from eastern Asia. India paper provides an even, uniform, opaque surface for printing and is also suitable for drawing. Developed in England in the eighteenth century for Oxford University Press, to be used for printing Bibles and prayer books, the material is also called Oxford India or Bible paper.

ink

Any fluid or viscous substance used for writing, drawing, or printing, composed of pigment suspended in a liquid vehicle. For drawing the old masters used four different kinds of ink: **bistre, carbon ink, iron gall ink,** and **sepia,** and infinite mixtures thereof. Commercially prepared inks for writing and drawing have been widely available since the seventeenth century.

iron gall ink

A common black ink used by artists from the thirteenth to the nineteenth centuries made from gallotannic acid derived from oak tree galls, plant excrescences caused by disease. After the gall nuts were crushed they were soaked or boiled in water or wine. Then the solution was clarified and ferrous sulfate and gum arabic were added. Although it was almost black when applied, this ink often faded and turned brown. Over time its acidic content can literally eat away paper, causing sheets to thin, fracture, or perforate.

Japan paper

A distinctive handmade paper made throughout eastern Asia from the bast fibers found in the inner bark of a family of mulberry trees. Because of its tradition of manufacture in Japan and its export from that country, it has been called Japan paper since the eighteenth century. Its long fibers are strong and supple, and they have a natural cream color.

Japanese vellum paper (vegetable parchment)

A deluxe paper for printing and bookbinding, used especially in the late nineteenth century. Usually thick and fairly stiff, it often has a swirly surface pattern from long multidirectional fibers, giving it an appearance similar to **Japan paper.** This material was generally machine-made in the West, partly in response to the fashion for japonisme. The final step of its commercial manufacture was ironing in a hot press to create a uniform, polished surface sheen comparable to **vellum.**

laid paper

A qualitative term describing the manufacture of paper by the oldest traditional method in Europe. Laid papers were originally made of cotton or linen taken from old rags that were shredded, soaked, and macerated until the fibers were reduced to their shortest length. Suspended in a watery slurry, the paper pulp was placed in a vat. Sheets were formed when a flat, sievelike mold of wire mesh was stretched on a wooden frame. The papermaker would dip the mold into the vat of pulp and allow the water to drain away. The pulp was contained on top of the mold by a separate frame called a **deckle.** Excess moisture was squeezed from the newly formed sheets in a mechanical press, and they were hung over a cord to dry. Laid papers are recognizable by their overall watermarks. The pattern of "laid lines" from the individual wires and "chain lines"

where these filaments are sewn to supporting slats in the mold gives laid paper its distinctive gridded pattern in transmitted light.

metal leaf (Dutch metal)

Imitation gold used for decoration, made from extremely thin sheets of metal, usually brass with low zinc content. It is applied in the same manner as gold leaf; however, its surface is sealed with lacquer or varnish to prevent it from tarnishing. Because its color is less rich and lustrous than that of gold leaf, metal leaf is more often used in mounts or frames rather than in works of art.

metalpoint

A technique in which the artist draws with a sharpened metal instrument on prepared **vellum** or paper. Traditionally the ground was composed of powdered lime, chalk, or seashells, mixed with size or gum water and often with colored pigments, and applied to the support in several coats. The metal reacted chemically with the ground on the paper to produce a line. One of the earliest methods used to create drawings that were independent works of art, metalpoint developed from the practice of manuscript illumination.

natural chalk (whiting)

The white pigment most commonly used by artists. It is derived from calcium carbonate, which occurs naturally in mineral form, and is traditionally mined from the ground. By contrast, precipitated chalk is produced as a by-product of chemical manufacturing. This inert synthesized material is usually whiter, finer, and more uniform than mined chalk and is commonly used to make gesso and **pastels.**

newsprint

An inexpensive paper made of powdered wood cellulose, so named because it is the material on which newspapers are printed. Although it is supplied to printing plants in enormous continuous rolls, artists buy newsprint in economical drawing pads.

nib

See **steel pen.**

oil charcoal

See **charcoal.**

oil paint

The principal technique for easel painting, which is also used for works on paper. Oil paints are comprised of powdered pigments usually suspended in linseed oil. Other oils from seeds or vegetables with similar drying characteristics are sometimes used. The paint can be extended by addition of more medium or a thinning solvent such as turpentine. When a pigment retards the drying properties of the binding medium, other chemicals may be added. To give all the colors the same pasty consistency, stabilizers such as wax or aluminum stearate are added.

parchment

See **vellum.**

paperboard

A paper cast or laminated into a thick card. Paperboard has had a wide variety of uses since the late eighteenth century, such as mounting, framing, and packing. This generic term describes high quality materials such as **rag board**, as well as inexpensive **groundwood board** or **strawboard.**

pastel

Pastels, or fabricated chalks, are made from dry, powdered pigments combined with nongreasy binders into a paste, and then formed into cylinders. When dry, the soft, smooth sticks are similar in density and workability to **natural chalk.** Pastels originated in Italy in the sixteenth century. Since the nineteenth century they have been manufactured and commercially available in a wide spectrum of colors. Since the eighteenth century specially prepared papers, often tinted and with an embossed surface, have been made for pastel drawing. Modern pastels often use acrylic, vinyl, or polymer emulsions as binding media.

pencil

A writing or drawing tool in which a stick of dry pigment, usually **graphite,** is encased in wood. Usually the casing is progressively carved away in a conical tip to expose the medium. Originally this old French term described a finely pointed artist's brush.

pentimento

An Italian noun meaning repentance or regret, used to describe changes of design that remain visible in a work of art. In works on paper pentimenti may include erasures or scraped or overpainted areas.

plate mark

The embossment left in paper by a metal intaglio plate during printing.

precipitated chalk

See **natural chalk.**

provenance

The source or origin of a work of art, or a chronological list of its former ownership. Since **collectors' marks** are often placed on a drawing, it is sometimes

possible to document an extended history of its ownership, increasing the cachet of an object.

quill pen

A tool for writing in ink made from the shaft of a feather. The capillary pressure of this pliable tube naturally holds a small amount of ink, which runs down inside the shaft to be spread in a line when the quill is dragged across paper. Quills were the foremost drawing tools from the fifteenth century to the end of the nineteenth. To prepare a quill pen, an angled cut was made through the tubular feather shaft and trimmed into a sharp, V-shaped point. A final slice bifurcating the point allowed the nib to spread under the downward pressure of the artist's hand, and thus the width of the line could be adjusted.

rag board

A modern laminated, acid-free paperboard made from cotton fibers. Developed as an inert, safe material for mounting and storing artworks, the high quality of this material makes it favorable for artists.

recto

The front side of a sheet, as distinguished from the back side or **verso.** In a codex or bound volume the right-hand page is called a recto.

reed pen

A tool for writing in ink made from fine canes or bamboolike grasses. It was used for writing in ancient times, but not employed as a drawing implement until the Renaissance. Reeds were prepared and used in much the same way as **quill pens,** which superseded their use.

sepia

A liquid pigment found naturally in the cuttlefish. It came into use as a drawing medium at the end of the eighteenth century when it became possible chemically to extract and concentrate the natural colorant.

squaring

A technique for transferring or enlarging a design. A grid, usually comprised of equilateral squares, is ruled onto the surface of a drawing while a larger proportional network is plotted on the surface to receive the enlarged image. Using the multiple points of reference, the design can then be transferred square by square.

steel pen (nib)

A stylus to hold and dispense ink made from thin sheets of metal, curved and split in a form that copies the shape of the traditional sharpened quill. In the nineteenth century the steel pen succeeded the **quill pen** and natural **reed** as a writing and drawing instrument, because it is stronger and can be formed in larger, broader, and more efficient shapes. The stiffer splines also tend to produce fewer blots.

strawboard

An inexpensive paper or cardboard made from straw or inexpensive plant fibers that are ground and cast into sheets, often along with recycled paper and **groundwood.**

stump (tortillon)

A soft, cylindrical tool used for rubbing and blending dry pigments such as chalk or charcoal on the surface of a drawing. Stumps are usually made by rolling a triangular piece of leather, felt, or paper into a coil with points at both ends. Although artists can easily make them, stumps of various sizes have been commercially available since the mid–nineteenth century.

stylus

A drawing instrument usually made of cast metal, pointed at either end, and used by artists in the initial stages of a composition only to impress lines into paper, thus avoiding the need to erase. Artists also use the stylus to trace images onto another sheet beneath, or to transfer them to a printing plate. The term traditionally describes any drawing pen.

tempera

Common water-soluble paint made by mixing dry pigments with a glutinous binder such as egg yolk. The medium was often used on a ground of chalk or plaster. Although gradually supplanted by oil painting, the tempera technique was revived in the late nineteenth century.

vellum

Animal skin treated for use as a writing or drawing support. Although the terms *vellum* and *parchment* are used interchangeably, the former is more properly a finer material made from the skins of newborn or stillborn animals. The skin of calves, lambs, or kids is scraped thin and stretched to dry without tanning, and its surface is rubbed smooth with pumice, chalk, or ground bone. Generally vellum was superseded when paper became widely available in the fourteenth century; however, artists have been drawn to the material for its translucent color, its nonabsorbent surface, and for its archaic association.

verso

The back side of a sheet, as distinguished from the front side, or **recto.** In a codex or bound volume the left-hand page is called a verso.

wash

Any diluted ink or paint, usually applied with a brush. Translucent ink washes are customarily used to add tonal values to drawings executed in pen and ink in the same or complementary inks.

watercolor

A painting medium in which pigment, and usually a binder, are carried in dilute washes of water. The microscopic particles of color flow across the paper and distribute themselves evenly in **washes** so thin that the tone of the paper shines through and affects the appearance of the watercolor. Watercolor papers are usually absorbent and often have reticulated surfaces, with minute projections to hold pigment. Watercolors are usually available in dry cakes. A wetted brush is used to pick up the color, which may be remixed in a small metal or ceramic tray, then applied to the paper in a thin wash. Mixing watercolors with a white pigment makes them more opaque.

watermark

A mark molded into the fabric of a sheet of paper, visible when the sheet is held up to the light. An image of thick, twisted wire is sewn onto the mold in which sheets of paper are made. When the sheets are formed, the wire makes the paper thinner and hence more translucent. Beginning in Italy in the thirteenth century, manufacturers commonly used these marks to identify their products. Scholars have compiled watermark dictionaries, based on makers' records and the datable images drawn or printed onto marked papers. Thus, the origin and date of a paper can sometimes be determined from its watermark.

whiting

See **natural chalk.**

wove paper

A qualitative term describing a method of paper manufacture. When mechanically woven wire mesh was developed in the late eighteenth century, this metal cloth was used to cover papermaking molds. Sheets of paper made with these molds are referred to as wove. They are uniform in thickness and texture and lack the overall watermark pattern of **laid paper.** Most modern wove papers are machine-made and not formed by hand. However, they are still the product of the basic process of pouring a watery slurry or macerated fibers through a sievelike mold to capture a thin layer of this material, thus forming a sheet.

zinc oxide

A white pigment used primarily as a **heightening** medium. Zinc oxide was occasionally used for drawing in France in the late eighteenth century. Then in 1834 the English firm of Winsor and Newton patented a "Chinese white" watercolor, a refined medium that provided uniform coverage and could be evenly diluted in washes. This improvement, and the new commercial availability of the pigment, established white as a hue in the watercolor palette.

Selected Bibliography: Cohn 1977; Hunter 1947; Lugt 1921/1956; Mayer 1969; Meder 1978; Watrous 1967.

References

Aaron 1985
Aaron, Olivier. *Dessins insolites du XVIIIe siècle*. Paris, 1985.

Ackley 1995
Ackley, Clifford S. *Nolde Watercolors in America*. Exhibition catalogue. Boston, Museum of Fine Arts, 1995.

Ackley/Benson/Carlson 1995
Ackley, Clifford S., Timothy O. Benson, and Victor Carlson. *Nolde: The Painter's Prints*. Exhibition catalogue. Boston, Museum of Fine Arts, 1995.

Acquaviva/Vitali 1979
Acquaviva, Stefano, and Marcella Vitali. *Felice Giani: Un maestro nella civiltà figurativa faenza*. Faenza, 1979.

Adams 1976a
Adams, William Howard, ed. *The Eye of Thomas Jefferson*. Exhibition catalogue. Washington, D.C., National Gallery of Art, 1976.

Adams 1976b
Adams, William Howard, ed. *Jefferson and the Arts: An Extended View*. Washington, D.C., 1976.

Adams 1978
Adams, Hugh. *Art of the Sixties*. Oxford, 1978.

Adams 1987
Adams, Henry, et al. *John La Farge*. Exhibition catalogue. Pittsburgh, Carnegie Museum of Art, 1987.

Addis/Arnold 1951
Addis, William E., and Thomas Arnold. *A Catholic Dictionary*. 15th ed. Saint Louis, Mo., 1951.

Adlow 1958
Adlow, Dorothy. "The Home Forum." *Christian Science Monitor*, 10 October 1958, p. 8.

Ahrens 1974
Ahrens, Kent. *Water Colors and Drawings by Brevet Major General Truman Seymour, USMA 1846*. Exhibition catalogue. West Point, N.Y., United States Military Academy, 1974.

Ahrens 1986
Ahrens, Kent. *The Drawings and Watercolors by Truman Seymour (1824–1891)*. Exhibition catalogue. Scranton, Pa., Everhart Museum, 1986.

Alexander 1973
Alexander, David. "The Dublin Group: Irish Mezzotint Engravers in London 1750–1775." *Quarterly Bulletin of the Irish Georgian Society*, vol. 16, July–September 1973, pp. 73–92.

Alexander 1994
Alexander, Jonathan J. G., ed. *The Painted Page: Italian Renaissance Book Illumination, 1450–1550*. Exhibition catalogue. London, Royal Academy of Arts, 1994.

Alexandre 1993
Alexandre, Noël. *The Unknown Modigliani*. Exhibition catalogue. London, Royal Academy of Arts, 1993.

Amory 1882
Amory, Martha B. G. *The Domestic and Artistic Life of John Singleton Copley, R.A.* Boston, 1882.

Ananoff 1966
Ananoff, Alexandre. *L'Oeuvre dessiné de François Boucher (1703–1770): Catalogue raisonné*. Paris, 1966.

Andersson/Talbot 1983
Andersson, Christiane, and Charles Talbot. *From a Mighty Fortress: Prints, Drawings, and Books in the Age of Luther, 1483–1546*. Exhibition catalogue. Detroit Institute of Arts, 1983.

Andrade/Guerrero 1992
Andrade, José Manuel Pita, and Maria del Mar Borobia Guerrero. *Old Masters: Thyssen-Bornemisza Museum*. Barcelona/Madrid, 1992.

Antonsen/Edison 1986
Antonsen, Lasse, and Laurie Edison. *Henri Michaux, Alberto Giacometti*. Exhibition catalogue. Framingham, Mass., Danforth Museum of Art, 1986.

Archipenko 1960
Archipenko, Alexander. *Archipenko: Fifty Creative Years, 1908–1958*. New York, 1960

Arnason 1986
Arnason, H. Harvard. *Philip Guston*. New York, 1986.

Ashton 1976
Ashton, Dore. *A Critical Study of Philip Guston*. Berkeley/Los Angeles, 1976.

Ashton 1992
Ashton, Dore. *Noguchi East and West*. New York, 1992.

Astrua/Romano 1985
Astrua, Paola, and Giovanni Romano. *Bernardino Lanino*. Milan, 1985.

Atkinson 1990
Atkinson, D. Scott. *Homer in Gloucester*. Exhibition catalogue. Chicago, Terra Museum of American Art, 1990.

Avigad 1987
Avigad, Lois S. "Ruth Henshaw Bascom: A Youthful Viewpoint." *Clarion: Museum of American Folk Art*, vol. 12, fall 1987, pp. 35–41.

Axelrod 1983
Axelrod, Alan. *Charles Brockden Brown: An American Tale*. Austin, Tex., 1983.

Ayers 1985
Ayers, James. *The Artist's Craft: A History of Tools, Techniques, and Materials*. Oxford, 1985.

Baedecker 1907
Baedecker, Karl. *Italy, Handbook for Travelers: Central Italy and Rome*. 14th ed. Leipzig, 1907.

Bailey 1977
Bailey, Stephen. "Metamorphoses of the Grimani 'Vitellius.'" *J. Paul Getty Museum Journal*, vol. 5, 1977, pp. 105–22.

Baker 1985
Baker, Cathleen. "A Comparison of Drawing Inks Using Ultraviolet and Infrared Light Examination Techniques." In *The Application of Science in the Examination of Works of Art*, pp. 159–63. Boston, 1985.

Bank 1979
Bank, Mirra. *Anonymous Press*. New York, 1979.

Barcham 1989
Barcham, William L. *The Religious Paintings of Giambattista Tiepolo: Piety and Tradition in Eighteenth-Century Venice*. Oxford, 1989.

Barocchi 1964
Barocchi, Paola, et al. *Mostra di disegni del Vasari e della sua cerchia*. Exhibition catalogue. Florence, Galleria degli Uffizi, 1964.

Bartlett 1880
Bartlett, Truman H. *Exhibition Catalogue of the Paintings and Charcoal Drawings of the Late William Morris Hunt*. Exhibition catalogue. Boston, Museum of Fine Arts, 1880.

Batorska 1972
Batorska, Danuta. "Giovanni Battista Grimaldi." Ph.D. dissertation, Los Angeles, University of California, 1972.

Batorska 1982
Batorska, Danuta. "Grimaldi's Frescoes in the Palazzo del Quirinale." *Paragone*, vol. 33, May 1982, pp. 3–12.

Batorska 1991
Batorska, Danuta. "Grimaldi as Collaborator of Agostino Tassi." *Paragone,* vol. 42, September 1991, pp. 67–69.

Batorska 1994
Batorska, Danuta. "Grimaldi's Designs for the Sets of 'Il Trionfo della Pietà ovvero La Vita Humanità.'" *Master Drawings,* vol. 32, 1994, pp. 40–49.

Batowski 1911
Batowski, Zygmut. *Norblin.* Lemberg, 1911.

Bauereisen/Stuffmann 1986–87
Bauereisen, Hildegarde, and Margaret Stuffmann. *Französische Zeichnungen im Städelschen Kunstinstitut, 1500 bis 1800.* Frankfurt-am-Main, 1986–87.

Bayley 1915
Bayley, Frank W. *The Life and Works of John Singleton Copley.* Boston, 1915.

Bayley 1929
Bayley, Frank W. *Five Colonial Artists of New England.* Boston, 1929.

Beam 1979
Beam, Philip C. *Winslow Homer's Magazine Illustrations.* New York, 1979.

Beaucamp 1939
Beaucamp, Fernand. *Le Peintre lillois Jean-Baptiste Wicar (1762–1834): Son oeuvre et son temps.* 2 vols. Lille, 1939.

Bellinger 1992
Deutsche Zeichnungen, eine Auswahl von Neuerwerbungen. Exhibition catalogue. Munich, Kunsthandel Katrin Bellinger, 1992.

Bellini 1974
Bellini, Paolo. "Giovanni Francesco Grimaldi: A Complete Catalogue of His Graphic Work." *Print Collector (I quaderni del conoscitore di stampe),* no. 22, 1974, pp. 6–27.

Benedictis 1978
Benedictis, Cristina de. "Miniatura senesi del primo Trecento." *Prospettiva,* vol. 14, 1978, pp. 58–65.

Bénédite 1906
Bénédite, Léonce. *Les Dessins de J.-F. Millet.* Paris, 1906.

Benesch 1954–57
Benesch, Otto. *The Drawings of Rembrandt.* 6 vols. London, 1954–57.

Béraldi 1885–92
Béraldi, Henri. *Les Graveurs du XIXe siècle.* 12 vols. Paris, 1885–92.

Béraldi 1889
Béraldi, Henri. *L'oeuvre de Bracquemond: Supplément.* Paris, 1889.

Berend-Corinth 1959
Berend-Corinth, Charlotte. *Lovis.* 2nd ed. Munich, 1959.

Berggruen 1940
Berggruen, Heinz. *Diego Rivera: Drawings and Watercolors.* Exhibition catalogue. San Francisco Museum of Art, 1940.

Bernheimer 1951
Bernheimer, Richard. "Some Drawings by Benedetto Castiglione." *Art Bulletin,* vol. 33, 1951, pp. 47–51.

Bertini 1958
Bertini, A. *I disegni italiani della Biblioteca reale di Torino.* Rome, 1958.

Betthausen 1990
Betthausen, Peter, et al. *Adolph Menzel, 1815–1905: Master Drawings from East Berlin.* Exhibition catalogue. Alexandria, Va., Art Services International, 1990.

Betti 1936
Betti, Salvatore. *Documenti inediti per una biografia di G. B. Wicar, Rome.* Rome, 1936.

Betts/Bear 1966
Betts, Edwin Morris, and James Adam Bear, Jr., eds. *The Family Letters of Thomas Jefferson.* Columbia, Mo., 1966.

Billesberger 1995
Johann Wolfgang Baumgartner, Zeichnungen. Exhibition catalogue. Munich, Galerie Siegfried Billesberger, 1995.

Billeter 1987
Billeter, Erika, ed. *Imagen de Mexico.* Exhibition catalogue. Frankfurt, Schirn Kunsthalle, 1987.

Bindman 1979
Bindman, David, ed. *John Flaxman.* Exhibition catalogue. London, Royal Academy, 1979.

Binyon 1898–1907
Binyon, Laurence. *Catalogue of Drawings by British Artists and Artists of Foreign Origin Working in Great Britain . . . in the British Museum.* 4 vols. London, 1898–1907.

Bjurström 1976
Bjurström, Per. *French Drawings: Sixteenth and Seventeenth Centuries.* Nationalmuseum, Stockholm, 1976.

Bjurström 1982
Bjurström, Per. *French Drawings: Eighteenth Century.* Nationalmuseum, Stockholm, 1982.

Blair 1959
Blair, Claude. *European Armour.* New York, 1959.

Blankert 1982
Blankert, Albert. *Ferdinand Bol (1616–1680): Rembrandt's Pupil.* Doornsprijk, 1982.

Bloch 1989
Bloch, E. Maurice. *Faces and Figures in American Drawings.* Exhibition catalogue. San Marino, Calif., Huntington Library and Art Gallery, 1989.

Blunt 1950
Blunt, Wilfrid. *The Art of Botanical Illustration.* London, 1950.

Boase 1979
Boase, Thomas S. R. *Giorgio Vasari: The Man and the Book.* Princeton, N.J., 1979.

Bober 1988
Bober, Jonathan. "Cremonese Drawings for the Entry of Charles V: New Attributions and an Interpretation." *Master Drawings,* vol. 26, 1988, pp. 219–32.

Bober/Rubenstein 1986
Bober, Phyllis Bray, and Ruth Rubenstein. *Renaissance Artists and Antique Sculpture.* London, 1986.

Bock/Rosenberg 1931
Bock, Elfried, and Jakob Rosenberg. *Die Zeichnungen alter Meister in Kupferstichkabinett* (Berlin): *Die Niederländischen Meister.* 2 vols. Frankfurt am Main, 1931.

Bode 1883
Bode, Wilhelm. *Studien zur Geschichte der holländischen Malerei.* Brunswick, 1883.

Bodelsen 1966
Bodelsen, Merete. "The Gauguin Catalogue." *Burlington Magazine,* vol. 108, January 1966, p. 35.

Boerner 1931
C. G. Boerner and Company. *Original-handzeichnungen: Versteigerungskatalog CLXXII.* Leipzig, 1931.

Boerner 1987
C. G. Boerner and Company. *Neue Lagerliste 86.* Düsseldorf, 1987.

Boggs 1988
Boggs, Jean Sutherland, et al. *Degas.* Exhibition catalogue. New York, Metropolitan Museum of Art, 1988.

Bok-van Kammen 1980
Bok-van Kammen, H. "Stradanus and the Hunt." Ph.D. dissertation, Baltimore, Johns Hopkins University, 1980.

Bolton 1923
Bolton, Theodore. *Early American Portrait Draftsmen in Crayons.* New York, 1923.

Bombe 1910
Bombe, Walter. "Dokumente und Regesten zur Geschichte der Peruginer Miniaturmalerei." *Repertorium für Kunstwissenschaft,* vol. 33, 1910, pp. 1–21.

Boon 1978
Boon, Karel G. *Netherlandish Drawings of the Fifteenth and Sixteenth Centuries in the Rijksmuseum.* 2 vols. The Hague, 1978.

Boon 1980
Boon, Karel G. *L'Epoque de Lucas de Leyde et Pierre Bruegel: Dessins des anciens Pays-Bas, collection Frits Lugt.* Exhibition catalogue. Paris, Institut Néerlandais, 1980.

Boon 1992
Boon, Karel G. *The Netherlandish and German Drawings of the Fifteenth and Sixteenth Centuries of the Frits Lugt Collection.* 2 vols. Paris, 1992.

Bora 1971
Bora, Giulio. *Disegni di manieristi Lombardi.* Milan, 1971.

Bora 1980
Bora, Giulio. *I disegni lombardi e genovesi del cinquecento.* Treviso, 1980.

Boskovits 1987
Boskovits, Miklos. *Berlin, Gemäldegalerie, Katalog der Gemälde: Frühe italienische Malerei.* Berlin, 1987.

Boswell 1942
Boswell, Peyton. *George Bellows.* New York, 1942.

Bouillon 1973
Bouillon, Jean-Paul. "La Correspondance de Félix Bracqemond." *Gazette des Beaux-Arts,* vol. 82, 1973, pp. 351–86.

Bouillon/Kane 1984
Bouillon, Jean-Paul, and Elizabeth Kane. "Marie Bracquemond." *Woman's*

Art Journal, vol. 5, no. 2, 1984, pp. 21–27.

Bouillon/Shimizu/Thiebault 1988
Bouillon, Jean-Paul, Christine Shimizu, and Philippe Thiebault. *Art, industrie, et japonisme, le service "Rousseau."* Exhibition catalogue. Paris, Musée d'Orsay, 1988.

Bowen 1892
Bowen, Clarence W., ed. *The History of the Centennial Celebration of the Inauguration of George Washington.* New York, 1892.

Boymans-van Beuningen 1979
Museum Boymans-van Beuningen. *The Willem van de Velde Drawings in the Boymans-van Beuningen.* 3 vols. Rotterdam, 1979.

Bracquemond 1885
Bracquemond, Félix. *Du Dessin et de la couleur.* Paris, 1885.

Bracquemond 1897
Bracquemond, Félix. *Etude sur la gravure sur bois et la lithographie.* Paris, 1897.

Bradley 1986
Bradley, William S. *Emil Nolde and German Expressionism: A Prophet in His Own Land.* Ann Arbor, Mich., 1986.

Bramsen 1976
Bramsen, Henrik. "Le Château d'Amour." In *Hafnia: Copenhagen Papers in the History of Art,* pp. 91–95. Copenhagen, 1976.

Brettell 1988
Brettell, Richard, et al. *The Art of Paul Gauguin.* Exhibition catalogue. Washington, D.C., National Gallery of Art, 1988.

Brown 1973
Brown, Jonathan. *Jusepe de Ribera: Prints and Drawings.* Exhibition catalogue. Princeton, N.J., Art Museum, Princeton University, 1973.

Brown 1977
Brown, Charles Brockden. *Weiland, or the Transformation; An American Tale; and Memoirs of Carvini.* Kent, Ohio, 1977.

Brown 1981
Brown, Gaye L. *The Dial: Arts and Letters in the 1920s.* Exhibition catalogue. Worcester Art Museum, 1981.

Bruhn 1992
Bruhn, Thomas P. *The American Print: Originality and Experimentation, 1790–1890.* Exhibition catalogue. Storrs,

William Benton Museum of Art, University of Connecticut, 1992.

Bucci 1965
Bucci, M. *Lo Studiolo di Francesco I.* Florence, 1965.

Buck 1972
Buck, Robert T., et al. *Sam Francis.* Exhibition catalogue. Buffalo, N.Y., Albright-Knox Art Gallery, 1972.

Burandt 1994
Burandt, Jan. "An Investigation toward the Identification of Traditional Drawing Inks." *[American Institute for Conservation] Book and Paper Group Annual,* vol. 13, 1994, pp. 9–16.

Burchard/D'Hulst 1963
Burchard, Ludwig, and Roger Adolf D'Hulst. *Rubens Drawings.* 4 vols. Brussels, 1963.

Burg 1911
Burg, Hermann. "Uber einige Porträt des Antonius Palmedesz." *Monatshefte für Kunstwissenschaft,* vol. 4, 1911, pp. 293–95.

Bush 1962
Bush, Alfred L. *The Life Portraits of Thomas Jefferson.* Exhibition catalogue. Charlottesville, University of Virginia Museum of Fine Arts, 1962.

Bushart 1981
Bushart, Bruno. "Das malerische Werk des Augsburger 'Kunst- und Historienmalers' Johann Wolfgang Baumgartner und seine Fresken in Bergen." In *Kloster Bergen bei Neuberg an der Donau und seine Fresken von Johann Wolfgang Baumgartner,* pp. 61–77. Weissenhorn, 1981.

Caleca 1969
Caleca, Antonio. *Miniatura in Umbria.* Vol. 1, *La Biblioteca Capitolare di Perugia.* Florence, 1969.

Calmann 1953
Hans M. Calmann, Dealer in Old Master Drawings. Exhibition catalogue. London, H. M. Calmann, 1953.

Cannenburg 1950
Cannenburg, W. Voorbeytel. "The van de Veldes." *Mariner's Mirror,* vol. 36, July 1950, pp. 186–204.

Cannon-Brookes 1968
Cannon-Brookes, Peter. "Maso da San Friano." Ph.D. dissertation, Courtauld Institute of Art, University of London, 1968.

Carlson/Ittmann 1984
Carlson, Victor I., and John W. Ittmann, eds. *Regency to Empire: French Printmaking, 1715–1814.* Exhibition catalogue. Baltimore Museum of Art, 1984.

Carr/Christman 1985
Carr, Carolyn Kinder, and Margaret C. S. Christman. *Gaston Lachaise Portrait Sculpture.* Exhibition catalogue. Washington, D.C., National Portrait Gallery, Smithsonian Institution, 1985.

Cartwright 1902
Cartwright, Julia Ady. *Jean François Millet.* Exhibition catalogue. New York, Metropolitan Museum of Art, 1902.

Carvalho 1904
Carvalho, David N. *Forty Centuries of Ink: A Chronological Narrative Concerning Ink and Its Backgrounds.* New York, 1904.

Cavina 1985
Cavina, Anna Ottani. "Giani e la cerchia di Füssli a Roma." *Paragone,* vol. 36, January/March/May 1985, pp. 279–85.

Ceán Bermúdez 1800
Ceán Bermúdez, Djuan Agustin. *Diccionario historia de las bellas Artes en España.* 6 vols. 1800. Reprint, Madrid, 1965.

Cecchi 1978
Cecchi, Alessandro. "Nuove acquisitioni per un catalogo dei disegni de Giorgio Vasari." *Antichità Viva,* vol. 17, no. 1, 1978, pp. 52–61.

Cennini 1960
Cennini, Cennino. *The Craftsman's Handbook: Il libro dell'arte.* Rev. ed. Edited by Daniel V. Thompson. New Haven, Conn., 1960.

Ceroni 1965
Ceroni, Ambrogio. *Amedeo Modigliani: Dessins et sculptures.* Milan, 1965.

Chaloner Smith 1878–82
Chaloner Smith, John. *British Mezzotint Portraits.* 6 vols. London, 1878–82.

Chapin 1895
Chapin, John R. "Random Recollections of a Veteran Illustrator." *Quarterly Illustrator,* vol. 3, January–March 1895, pp. 3–17.

Chappuis 1977
Chappuis, Adrien. *The Drawings of Paul Cézanne.* 2 vols. Greenwich, Conn., 1977.

Charleston 1965
Charleston, Robert J., ed. *English Porcelain, 1745–1850.* London, 1965.

Christie's 1949
Christie's. *Old Master Drawings.* London, 1949.

Christie's 1965
Christie's. *Catalogue of Drawings of Giovanni Domenico Tiepolo: The Property of the Rt. Hon. Earl of Beauchamp.* London, 1965.

Christie's 1990
Christie's. *American and European Works on Paper from the Estate of E. Maurice Bloch.* Part I. New York, 1990.

Christie's 1991
Christie's. *Old Master Drawings from the Woodner Collection.* London, 1991.

Clark 1985
Clark, Anthony M. *Pompeo Batoni.* Oxford, 1985.

Clément 1870
Clément, Charles. *Prud'hon: Sa vie, ses oeuvres, et sa correspondence.* Paris, 1870.

Cleri 1993
Cleri, Bonita. *Per Taddeo e Federico Zuccari nelle Marche.* Exhibition catalogue. Sant'Angelo in Vado, Palazzo Fagnani, 1993.

Coburn 1915
Coburn, Frank W. "A Copley Portrait." *Boston Herald,* 22 August 1915.

Cocke 1991
Cocke, Richard. "The Drawings of Michele and Giovanni Battista Pace." *Master Drawings,* vol. 29, 1991, pp. 347–84.

Cohn 1970
Cohn, Marjorie B. "A Note on Media and Methods." In George Knox, *Tiepolo: A Bicentenary Exhibition, 1770–1970,* pp. 211–21. Exhibition catalogue. Cambridge, Fogg Art Museum, Harvard University, 1970.

Cohn 1977
Cohn, Marjorie B. *Wash and Gouache: A Study of the Development of the Materials of Watercolor.* Exhibition catalogue. Cambridge, Fogg Art Museum, Harvard University, 1977.

Cohn/Siegfried 1980
Cohn, Marjorie B., and Susan L. Siegfried. *Works by J.-A.-D. Ingres in the Collection of the Fogg Art Museum.* Exhibition catalogue. Cambridge, Fogg Art Museum, Harvard University, 1980.

Comstock 1957
Comstock, Helen. "The Connoisseur in America." *Connoisseur*, vol. 139, March 1957, p. 134.

Constable 1927
Constable, William G. *John Flaxman, 1755–1826*. London, 1927.

Corinth 1926
Corinth, Lovis. *Selbstbiographie*. Leipzig, 1926.

Cornillot 1957
Cornillot, Marie Lucie. *Inventaire général des dessins des musées de Provence, Collection Pierre-Adrien Paris*. Besançon, 1957.

Courtright 1990
Courtright, Nicola. *Northern Travelers to Sixteenth-Century Italy: Drawings from New England Collections*. Exhibition catalogue. Amherst, Mass., Mead Art Museum, Amherst College, 1990.

Crane 1914
Crane, Walter. *Line and Form*. London, 1914.

Cummings 1965
Cummings, Frederick. *Art in Italy, 1600–1700*. Exhibition catalogue. Detroit Institute of Arts, 1965.

Cunningham 1981
Cunningham, Noble E., Jr. *The Image of Thomas Jefferson in the Public Eye: Portraits for the People, 1800–1899*. Charlottesville, Va., 1981.

Dabrowski 1988
Dabrowski, Magdalena. *The Drawings of Philip Guston*. Exhibition catalogue. New York, Museum of Modern Art, 1988.

Daniell 1890
Daniell, Frederick B. *A Catalogue Raisonné of the Works of Richard Cosway, R.A.* London, 1890.

Darmstadt 1954
Kunst unserer Zeit: Privatsammlung Karl Ströher. Exhibition catalogue. Darmstadt, Hessischen Landesmuseum, 1954.

Davenport 1948
Davenport, Millia. *The Book of Costume*. 2 vols. New York, 1948.

David 1991
David, Catherine. *László Moholy-Nagy*. Exhibition catalogue. Kassel, Museum Fridericianum, 1991.

Davies 1936
Davies, Martin. "A Portrait by the Aged Ingres." *Burlington Magazine*, vol. 68, June 1936, pp. 257–68.

De Boer 1956
Kunsthandel P. de Boer. *Catalogue of Old Pictures*. Amsterdam, 1956.

Delteil 1897
Delteil, Loys. "Bracquemond." *L'Artiste*, n.s., vol. 13, 1897, pp. 424–32.

Denhaene 1990
Denhaene, Godelieve. *Lambert Lombard: Renaissance et humanisme à Liège*. Antwerp, 1990.

De Pas/Flieder 1976
De Pas, Monique, and Françoise Flieder. "History and Prospects for Analysis of Black Manuscript Inks." In Norman Bromelle and Perry Smith, eds., *Conservation and Restoration of Pictorial Art*, pp. 193–201. London/Boston, 1976.

De Tolnay 1960
De Tolnay, Charles. *Michelangelo*. 4 vols. Princeton, N.J., 1960.

De Vesme/Massar 1971
De Vesme, Alexandre, and Phyllis Dearborn Massar. *Stefano della Bella: Catalogue Raisonné*. 2 vols. New York, 1971.

Dexter 1862
Dexter, Elias, ed. *The St.-Mémin Collection of Portraits*. New York, 1862.

D'Hulst 1972
D'Hulst, Roger-Adolf. *Flemish Drawings of the Seventeenth Century from the Collection of Frits Lugt, Institut Néerlandais, Paris*. Exhibition catalogue. Paris, Institut Néerlandais, 1972.

D'Hulst 1983
D'Hulst, Roger-Adolf, et al. *Dessins du XVe au XVIIIe siècle dans les collections privées de Belgique*. Exhibition catalogue. Brussels, Société Générale de Banque, 1983.

Dijon 1965
Charles-Balthazar-Julien Févret de Saint-Mémin, un descendant d'une grande famille de parlementaires bourguignons. Exhibition catalogue. Musée de Dijon, Palais des Etats de Bourgogne, 1965.

Dillon 1990
Dillon, Gianvittorio, et al. *Il genio di G. B. Castiglione, il Grechetto*. Exhibition catalogue. Genoa, Accademia Linguistica di Belle Arti, 1990.

Dossie 1764
Dossie, Robert. *The Handmaid to the Arts*. 2nd ed. London, 1764.

Downs/Sharp 1986
Downs, Linda, and Ellen Sharp. *Diego Rivera: A Retrospective*. Exhibition catalogue. Detroit Institute of Arts, 1986.

Dresser 1941
Dresser, Louisa. *"The Chapel of the Virgin at Subiaco* by Samuel F. B. Morse: Two Versions Owned by the Worcester Art Museum." Worcester Art Museum *Annual*, vol. 4, 1941, pp. 64–71.

Dresser 1951
Dresser, Louisa. "A Life Portrait of Thomas Jefferson." Worcester Art Museum *News Bulletin and Calendar*, vol. 17, December 1951, pp. 1–2.

Dresser 1974
Dresser, Louisa, ed. *European Paintings in the Collection of the Worcester Art Museum*. 2 vols. Worcester, 1974.

Dube 1967
Dube, Annemarie, and Wolf-Dieter Dube. *E. L. Kirchner: Das graphische Werke*. 2 vols. Munich, 1967.

Dudley 1875
General Exhibition of Watercolours and Drawings. Exhibition catalogue. London, Dudley Gallery, 1875.

Dunlap 1930
Dunlap, William. *The Diary of William Dunlap (1766–1839)*. 3 vols. New York, 1930.

Dupin 1962
Dupin, Jacques. *Alberto Giacometti*. Paris, 1962.

Dussieux 1854
Dussieux, Louis, ed. *Mémoires inédites sur la vie et les ouvrages des membres de l'Académie royale de peinture et de sculpture*. 2 vols. Paris, 1854.

Ebertshäuser 1976
Ebertshäuser, Heidi. *Adolph von Menzel: Das graphische Werk*. 2 vols. Munich, 1976.

Egerton 1990
Egerton, Judy. *Wright of Derby*. Exhibition catalogue. London, Tate Gallery, 1990.

Egger 1927
Egger, Hermann. "Liévin Cruyls römische Veduten." *Mededeelingen van het Nederlandsch Historisch Institute te Rome*, 2nd ser., vol. 7, 1927, pp. 183–96.

Eggers 1927
Eggers, George W. *Exhibition of Sketches by the Mexican Artist Diego M. Rivera*. Exhibition catalogue. Worcester Art Museum, 1927.

Eggers 1931
Eggers, George W. *George Bellows*. New York, 1931.

Eisler 1988
Eisler, Colin. "Power to Europe's Chosen Peoples: A New Maccabean Page for Louis XIV by Liévin Cruyl," *Artibus et Historiae*, vol. 17, 1988, pp. 31–38.

Elam 1967
Elam, C. H. *The Peale Family: Three Generations of American Artists*. Exhibition catalogue. Detroit Institute of Arts, 1967.

Elias 1903
Elias, J. E. *De Vroedscap van Amsterdam, 1578–1795*. 2 vols. Haarlem, 1903.

Emerson 1918
Emerson, Edward Waldo. *The Early Years of the Saturday Club, 1855–1870*. Boston, 1918.

Evelyn 1688
Evelyn, John. *The Excellency of Pen and Pencil*, London, 1688.

Ewing 1978
Ewing, Dan. "The Paintings and Drawings of Jan de Beer." Ph.D. dissertation, Ann Arbor, University of Michigan, 1978.

Ewing 1984
Ewing, Dan. "Some Documentary Additions to the Biography of Jan de Beer." *Jaarboek der Koninklijk Museum voor Schone Kunsten–Antwerpen*, 1984, pp. 85–100.

Faggin 1968
Faggin, Giorgio T. *La pittura ad Anversa nel cinquecento*. Florence, 1968.

Faille 1970
Faille, Jacob-Baast de la. *The Works of Vincent van Gogh: His Paintings and Drawings*. 3rd ed. Amsterdam, 1970.

Faldi 1966
Faldi, Italo. "I dipinti chigiani di Michele e Giovan Battista Pace." *Arte antica e moderna*, vols. 34–36, 1966, pp. 144–50.

Falk 1949
Falk, Bernard. *Thomas Rowlandson: His Life and Art*. London, 1949.

Ferrari/Scavizzi 1966
Ferrari, Oreste, and Giuseppe Scavizzi. *Luca Giordano.* 3 vols. Naples, 1966.

Ferrari/Scavizzi 1992
Ferrari, Oreste, and Giuseppe Scavizzi. *L'opera completa di Luca Giordano.* 2 vols. Naples, 1992.

Fine 1990
Fine, Ruth E. *The Watercolors of John Marin.* Exhibition catalogue. Washington, D.C., National Gallery of Art, 1990.

Fleischman 1982
Fleischman, Lawrence A. *John Marin Prints: A Retrospective.* Exhibition catalogue. New York, Kennedy Galleries, 1982.

Fletcher 1984
Fletcher, Shelley. "A Preliminary Study of the Use of Infrared Reflectography in the Examination of Works of Art on Paper." In *Preprints: ICOM Committee for Conservation, 7th Triennial Meeting, Copenhagen, 10–14 September 1984,* pp. 24–28. Paris, 1984.

Fock 1973
Fock, Willemijn C. "Willem van Mieris als ontwerper en boetseerder van tuin-vazen." *Oud Holland,* vol. 87, 1973, pp. 27–47.

Fock 1980
Fock, Willemijn C. "Een Kamer van Jacob de Wit thuisgebracht." *Nederlands Kunsthistorisch Jaarboek,* vol. 31, 1980, pp. 375–86.

Foley 1875
Foley, John. *History of the Invention and Illustrated Process of Making Foley's Diamond Pointed Gold Pens.* New York, 1875.

Foley/Rice 1979
Foley, William E., and Charles David Rice. "Visiting the President: An Exercise in Jeffersonian Indian Diplomacy." *American West: The Magazine of Western History,* vol. 16, November–December 1979, pp. 4–15.

Foote 1972
Foote, Mary Hallock. *A Victorian Gentlewoman in the Far West.* Edited by Rodman W. Paul. San Marino, Calif., 1972.

Fouratt 1986
Fouratt, Mary Eileen. "Ruth Henshaw Bascom, Itinerant Portraitist." In Peter Benes, ed., *Itinerancy in New England and New York,* pp. 190–211. Dublin Seminar for New England Folklife Annual Proceedings, 1984. Boston, 1986.

Fournier 1988
Sam Francis: Works on Paper, 1947–1988. Exhibition catalogue. Paris, Galeries Jean Fournier, 1988.

Fox 1980
Fox, Frank L. *Great Ships: The Battlefleet of King Charles II of England, 1660–1685.* Annapolis, Md., 1980.

Francis 1943
Francis, Henry S. "Drawings by Liévin Cruyl in Rome." *Bulletin of the Cleveland Museum of Art,* vol. 30, 1943, pp. 152–59.

Franz 1965
Franz, Heinrich Gerhard. "Hans Bol als Landschaftszeichner." *Jahrbuch des Kunsthistorischen Instituts Graz,* vol. 1, 1965, pp. 19–67.

Freedberg 1950
Freedberg, Sydney. *Parmigianino: His Works in Painting.* Cambridge, Mass., 1950.

Frey 1923
Frey, Karl, ed. *Der literarische Nachlass Giorgio Vasaris.* 2 vols. Munich, 1923.

Friedländer 1915
Friedländer, Max J. "Die Antwerpener Manieristen von 1520." *Jahrbuch der königlich preussischen Kunstsammlungen,* vol. 36, 1915, pp. 65–91.

Friedländer 1974
Friedländer, Max J. "The Antwerp Mannerists, Adriaen Ysenbrandt." In *Early Netherlandish Painting,* vol. 11, pp. 17–21, 68–69. Translated by Heinz Norden, comments and notes by Henri Pauwels and Anne-Marie Hess. New York, 1974.

Ganz 1950
Ganz, Paul L. *The Paintings of Hans Holbein.* New York, 1950.

Garrett 1921–22
Garrett, Richard. "Dante Gabriel Rossetti." In *Dictionary of National Biography,* vol. 17, pp. 284–89. 2d ed. Oxford, 1921–22.

Garvey/Hofer 1967
Garvey, Eleanor, and Philip Hofer. *Edward Lear: Painter, Poet, and Draughtsman.* Exhibition catalogue. Worcester Art Museum, 1967.

Geisberg 1910
Geisberg, Max. *Die Anfänge des Deutschen Kupferstiches und der Meister E.S.* Leipzig, 1910.

Geissler-Petermann 1993
Geissler-Petermann, Annette. "Johann Wolfgang Baumgartner." In K. G. Saur, *Allgemeines Künstlerlexikon: Die Bildenden Künstler aller Zeiten und Völker,* vol. 7, pp. 614–16. Munich/Leipzig, 1993.

Geldzahler 1980
Geldzahler, Henry. "David Hockney: An Intimate View." *Print Review,* no. 12, 1980, pp. 37–50.

Gemin/Pedrocco 1993
Gemin, Massimo, and Filippo Pedrocco. *Giambattista Tiepolo: I dipinti, opera completa.* Venice, 1993.

Gensel 1904
Gensel, Julius. *Friedrich Preller d. Ä.* Bielefeld/Leipzig, 1904.

Gerdts/Callow 1976
Gerdts, William, and James T. Callow. *Robert Weir: Artist and Teacher of West Point.* Exhibition catalogue. West Point, N.Y., Cadet Fine Arts Forum, United States Corps of Cadets, 1976.

Gere 1958
Gere, John. "William Young Ottley as a Collector of Drawings." *British Museum Quarterly,* vol. 27, June 1958, pp. 44–53.

Gere 1969
Gere, John. *Taddeo Zuccaro: His Development Studied in His Drawings.* Chicago, 1969.

Gere 1992
Gere, John. *Taddeo Zuccari nei gabinetto delle stampe e disegni della galleria degli Uffizi.* Exhibition catalogue. San Severino Marche, Fondazione Salimbeni per le Arti Figurative, 1992.

Gettens/Stout 1947
Gettens, Rutherford, and George Stout. *Painting Materials: A Short Encyclopedia.* 4th ed. New York, 1947.

Gilmour 1988
Gilmour, Pat, ed. *Lasting Impressions: Lithography as Fine Art.* London, 1988.

Gilpin 1786
Gilpin, William. *Observations, Relative Chiefly to Picturesque Beauty.* London, 1786.

Girardin 1913
Girardin, Marquis de. "L'Edition des fables de La Fontaine dite d'Oudry." *Bulletin du bibliophile,* 1913, pp. 217–36, 277–92, 330–47, 386–98.

Godi/Cirillo 1978
Godi, Giovanni, and Giuseppe Cirillo. *Studi su Giulio Campi.* Milan, 1978.

Goodrich 1944
Goodrich, Lloyd. *Winslow Homer.* New York, 1944.

Goodrich 1968
Goodrich, Lloyd. *The Graphic Art of Winslow Homer.* Exhibition catalogue. New York, Museum of Graphic Art, 1968.

Göpel 1956
Göpel, Erhard. "Die Situation des Kunstmarktes im Spiegel der Herbst-Auktionen." *Weltkunst,* vol. 26, December 1956, p. 12.

Gordon 1968
Gordon, Donald E. *Ernst Ludwig Kirchner.* Cambridge, Mass., 1968.

Gordon 1971
Gordon, Donald E. *Ernst Ludwig Kirchner: A Retrospective Exhibition.* Exhibition catalogue. Seattle Art Museum, 1971.

Goris/Held 1947
Goris, Jan-Albert, and Julius S. Held. *Rubens in America.* New York, 1947.

Gough 1871
Gough, John B. *Autobiography and Personal Recollections . . . with Twenty-six Years Experience as a Public Speaker.* 2nd ed. Springfield, Mass., 1871.

Gough 1890
Gough, John B. *The Works of George Cruikshank . . . Collected by John B. Gough.* Exhibition catalogue. Boston, Club of Odd Volumes, 1890.

Gould 1832–37
Gould, John. *The Birds of Europe.* 5 vols. London, 1832–37.

Gould 1983
Gould, Cecil, ed. *European and American Works in the Putnam Foundation Collection.* 2nd ed. San Diego, Calif., Timken Art Gallery, 1983.

Grad/Riggs 1982
Grad, Bonnie L., and Timothy A. Riggs. *Visions of City and Country: Prints and Photographs of Nineteenth-Century France.* Exhibition catalogue. Worcester Art Museum, 1982.

Graf 1986
Graf, Dieter. *Die Handzeichnungen von Giacinto Calandrucci.* 2 vols. Düsseldorf, 1986.

Grappe 1958
Grappe, Georges. *Pierre-Paul Prud'hon.* Paris, 1958.

Grebing 1988
Grebing, Helga. "Scheidemann." In *Biographisches Lexikon zur Weimar Republik,* pp. 286–87. Munich, 1988.

Greenough 1852
Greenough, Horatio. *The Travels, Observations, and Experiences of a Yankee Stonecutter.* 1852. Reprint, Gainesville, Fla., 1958.

Greenough 1887
Greenough, Horatio. *Letters from Horatio Greenough to His Brother, Henry Greenough.* Boston, 1887.

Grego 1880
Grego, Joseph. *Rowlandson the Caricaturist.* 2 vols. London, 1880.

Gregori 1985
Gregori, Mina, ed. *I Campi e la cultura artistica cremonese del cinquecento.* Exhibition catalogue. Milan, Museo Civico, 1985.

Griesebach 1968
Griesebach, Lothar, ed. *E. L. Kirchners Davoser Tagebuch.* Cologne, 1968.

Griesebach 1984
Griesebach, Lucius, et al. *Adolph Menzel Zeichnungen: Druckgraphik und illustrierte Bücher, Ein Bestandskatalog der Nationalgalerie, des Kupferstichkabinetts und der Kunstbibliothek Staatliche Museen Preussischer Kulturbesitz.* Berlin, 1984.

Griesebach/Meyer zu Eissen 1979
Griesebach, Lucius, and Annette Meyer zu Eissen. *Ernst Ludwig Kirchner, 1880–1938.* Exhibition catalogue. Berlin, Nationalgalerie, 1979.

Grosz 1955
Grosz, George. *A Small Yes and a Big No.* London/New York, 1955.

Grove 1987
Grove, Nancy. "Noguchi and Drawing." *Drawing,* vol. 8, March–April 1987, pp. 121–24.

Guiffrey 1924
Guiffrey, Jean. *L'oeuvre de Pierre-Paul Prud'hon.* Paris, 1924.

Guiffrey/Marcel 1907–28
Guiffrey, Jean, and Pierre Marcel. *Inventaire général des dessins du Musée du Louvre et du Musée de Versailles.* 10 vols. Paris, 1907–28.

Gutekunst and Klipstein 1956
Gutekunst and Klipstein. *Aquarelle und Handzeichnungen Alter und Moderner Meister.* Bern, 1956.

Gutwirth 1992
Gutwirth, Madelyn. *The Twilight of the Goddesses: Women and Representation in the French Revolutionary Era.* New Brunswick, N.J., 1992.

Haenlein 1988
Haenlein, Carl. *Sol LeWitt: Walldrawings.* Exhibition catalogue. Hanover, Kestner-Gesellschaft, 1988.

Hamilton 1812
Hamilton, George. *The Elements of Drawing in Its Various Branches for the Use of Students.* London, 1812.

Hamilton 1934
Hamilton, Mary. "The Samuel B. Woodward Collection of Cruikshankiana." Worcester Art Museum *Bulletin,* vol. 25, autumn 1934, pp. 69–83.

Hammacher 1975
Hammacher, A. M. *Jacques Lipchitz.* New York, 1975.

Hämmerle 1906
Hämmerle, Alois. "Die ehem. Kloster- und Wallfahrtskirche zu Bergen bei Neuberg a.D., ihre Geschichte und Beschreibung." *Sammelblatt des Historischen Vereins Eichstätt,* vol. 21, 1906, pp. 3–103.

Hämmerle 1907
Hämmerle, Alois. "Nachtrag zur Geschichte der Kirche in Bergen bei Neuberg a.D." *Sammelblatt des Historischen Vereins Eichstätt,* vol. 22, 1907, pp. 77–81.

Hand 1986
Hand, John Oliver, et al. *The Age of Bruegel: Netherlandish Drawings in the Sixteenth Century.* Exhibition catalogue. Washington, D.C., National Gallery of Art, 1986.

Hart 1898
Hart, Charles Henry. "The Life Portraits of Thomas Jefferson." *McClure's Magazine,* vol. 2, May 1898, pp. 47–55.

Hartley 1945
Hartley, Marsden. *Selected Poems.* New York, 1945.

Hartmann 1977
Hartmann, Franz. *Jacob Boehme: Life and Work.* New York, 1977.

Haskell 1977
Haskell, Barbara. *Marsden Hartley.* Exhibition catalogue. New York, Whitney Museum of American Art, 1977.

Haskell 1994
Haskell, Barbara. *Joseph Stella.* Exhibition catalogue. New York, Whitney Museum of American Art, 1994.

Haverkamp-Begemann 1961
Haverkamp-Begemann, Egbert. Review of Otto Benesch, "The Drawings of Rembrandt." *Kunstchronik,* vol. 14, February 1961, p. 51.

Hayes 1990
Hayes, John. *The Art of Thomas Rowlandson.* Exhibition catalogue. Alexandria, Va., Art Services International, 1990.

Heckscher 1951
Heckscher, William S. *Six Centuries of Master Drawings.* Exhibition catalogue. Iowa City, State University of Iowa, 1951.

Heenk 1995
Heenk, Elizabeth Nicoline. "Vincent van Gogh's Drawings: An Analysis of Their Production and Uses." Ph.D. dissertation, Courtauld Institute of Art, University of London, 1995.

Heim 1977
The Finest Drawings from the Museums of Angers. Exhibition catalogue. London, Heim Gallery, 1977.

Hemenway 1867–91
Hemenway, Abby Maria. *The Vermont Historical Gazetteer.* 5 vols. Claremont, N.H., 1867–91.

Hennequin 1932
Hennequin, René. *Les Portraits au phsyiognotrace, gravés de 1788 à 1830.* Troyes, 1932.

Hennessey 1973
Hennessey, William J. *A Handbook to the Worcester Art Museum.* Worcester, 1973.

Henniker-Heaton 1922
Henniker-Heaton, Raymond. *Worcester Art Museum: Catalogue of Paintings and Drawings.* Worcester, 1922.

Herbert 1966
Herbert, Robert. "Millet Reconsidered." *[Art Institute of Chicago] Museum Studies,* vol. 1, 1966, pp. 28–65.

Herbert 1975
Herbert, Robert, ed. *Jean-François Millet.* Exhibition catalogue. Paris, Grand Palais, 1975.

Herbert 1976
Herbert, Robert, ed. *Jean-François Millet.* Exhibition catalogue. London, Hayward Gallery, 1976.

Herding 1966
Herding, Klaus. "Schiffszeichnungen im Werk von Pierre Puget." *Zeitschrift für Kunstgeschichte,* vol. 29, 1966, p. 145.

Herron 1954
Pontormo to Greco: The Age of Mannerism. Exhibition catalogue. Indianapolis, Ind., John Herron Art Institute, 1954.

Hess 1961
Hess, Hans. *Lyonel Feininger.* New York, 1961.

Hillemacher 1948
Hillemacher, Fredine. *Catalogue des estampes qui composent l'oeuvre de Jean Pierre Norblin.* Paris, 1948.

Hills 1977
Hills, Patricia. *The Genre Painting of Eastman Johnson: The Sources and Development of His Style and Themes.* New York, 1977.

Hills 1981
Hills, Patricia. "Gentle Portraits of the Longfellow Era: The Drawings of Samuel Worcester Rowse." *Drawing,* vol. 2, March–April 1981, pp. 121–26.

Historical Records Survey 1939
Historical Records Survey. *American Portraits, 1620–1825, Found in Massachusetts.* 2 vols. Boston, 1939.

Hochhuth 1991
Hochhuth, Rolf. *Menzel: Maler des Lichts.* Frankfurt-am-Main, 1991.

Hoffmeister/Kreul 1995
Hoffmeister, Angelica, and Andreas Kreul. *Luca Giordano, Christus und die Ehebrecherin.* Exhibition catalogue. Bremen, Kunsthalle, 1995.

Hohl 1974
Hohl, Reinhold. *Alberto Giacometti: A Retrospective Exhibition.* Exhibition catalogue. New York, Solomon R. Guggenheim Museum, 1974.

Hollstein
Hollstein, F. W. H. *Dutch and Flemish Etchings, Engravings, and Woodcuts: ca.1450–1700.* 36 vols. Amsterdam, 1949–.

Holmes 1942
Holmes, Pauline. *One Hundred Years of Mount Vernon Church, 1842–1942.* Boston, 1942.

Hooze 1982
Hooze, Robert. *George Minne, en de Kunst rond 1900.* Exhibition catalogue. Ghent, Museum voor Schone Kunsten, 1982.

Hopp/Schaar 1982
Hopp, Gisela, and Eckhart Schaar. *Menzel: Der Beobachter.* Exhibition catalogue. Hamburg, Kunsthalle, 1982.

Hoppin 1977
Hoppin, Martha J., ed. *Late Nineteenth-Century American Drawings and Watercolors.* Exhibition catalogue. Amherst, University Gallery, University of Massachusetts, 1977.

Houbraken 1718–21
Houbraken, Arnold. *De groote schouburgh der Nederlantsche Kinstschilders en schilderessen.* 3 vols. Amsterdam, 1718–21.

Howard 1985
Howard, Seymour. "The Steel Pen and the Modern Line of Beauty." *Technology and Culture,* vol. 26, no. 4, October 1985, pp. 785–99.

Hulsker 1974
Hulsker, Jan. "A New Extensive Study of van Gogh's Stay in The Hague." *Vincent,* vol. 3, 1974, pp. 29–32.

Hulsker 1977
Hulsker, Jan. *The Complete van Gogh: Paintings, Drawings, Sketches.* New York, 1977.

Hunt 1875
Hunt, William Morris. *Talks on Art.* Boston, 1875.

Hunt 1878
Pastels and Drawings by William Morris Hunt. Exhibition catalogue. Boston, 1878.

Hunt 1905
Hunt, William Holman. *Pre-Raphaelitism and the Pre-Raphaelite Brotherhood.* 2 vols. London/New York, 1905.

Hunt 1930
Hunt, Violet. "Stunners." *Artwork,* vol. 6, 1930, pp. 77–87.

Hunter 1947
Hunter, Dard. *Papermaking: The History and Technique of an Ancient Craft.* New York, 1947.

Hunter 1978
Hunter, Sam. *Isamu Noguchi.* New York, 1978.

Isaacson 1979
Isaacson, Joel. *The Crisis of Impressionism, 1878–1882.* Exhibition catalogue. Ann Arbor, University of Michigan Museum of Art, 1979.

Ives 1974
Ives, Colta Feller. *The Great Wave: The Influence of Japanese Woodcuts on French Prints.* Exhibition catalogue. New York, Metropolitan Museum of Art, 1974.

Jacoby 1986
Jacoby, Beverly Schreiber. *François Boucher's Early Development as a Draughtsman.* New York, 1986.

Jaffé 1977
Jaffé, Michael. "Rubens and Raphael." In *Studies in Renaissance and Baroque Art Presented to Anthony Blunt on His 60th Birthday,* pp. 98–107. London, 1977.

Jareckie 1976
Jareckie, Stephen B. *The Early Republic: Consolidation of Revolutionary Goals.* Exhibition catalogue. Worcester Art Museum, 1976.

Jatta 1992
Jatta, Barbara. *Liévin Cruyl.* Rome/Brussels, 1992.

Jatta/Connors 1989
Jatta, Barbara, and Joseph Connors. *Vedute romane di Liévin Cruyl: Paesaggio urbano sotto Alessandro VII.* Rome, 1989.

Jenkins/Pullen 1986
Jenkins, David Fraser, and Derek Pullen. *The Lipchitz Gift: Models for Sculpture.* Exhibition catalogue. London, Tate Gallery, 1986.

Jensen 1982
Jensen, Jens Christian. *Adolph Menzel.* Cologne, 1982.

Jerrold 1882
Jerrold, Blanchard. *The Life of George Cruikshank in Two Epochs.* 2 vols. London, 1882.

Joachim 1961
Joachim, Harold. *George Grosz (1915–1927).* Exhibition catalogue. Chicago, Richard Feigen Gallery, 1961.

Johnson 1980
Johnson, Lee Ann. *Mary Hallock Foote.* Boston, 1980.

Kahn-Rossi 1989
Kahn-Rossi, Manuela, ed. *Pier Francesco Mola.* Exhibition catalogue. Lugano, Museo Cantonale d'Arte, 1989.

Karshan 1974
Karshan, Donald H. *Archipenko: The Sculpture and Graphic Art.* Tübingen, 1974.

Kaufmann 1981
Kaufmann, Gerhard. *Zeichner der Admiralität, Marine Zeichnungen und Gemälde von Willem van de Velde dem Älteren und dem Jüngeren.* Exhibition catalogue. Greenwich, Eng., National Maritime Museum, 1981.

Keersmaekers 1982
Keersmaekers, A. "De Schilder Sebastiaen Vrancx (1573–1647) als Rederijker." *Jaarboek van het Koninklijk Museum voor Schone Kunsten Antwerpen,* 1982, pp. 165–86.

Keller/Gohr/Hässlin 1976
Keller, Horst, Siegfried Gohr, and Johann Jakob Hässlin. *Lovis Corinth: Gemälde, Aquarelle, Zeichnungen, und druckgraphische Zyklen.* Exhibition catalogue. Museums of the City of Cologne, 1976.

Kimball 1944
Kimball, Fiske. "The Life Portraits of Thomas Jefferson." *Proceedings of the American Philosophical Society,* vol. 88, 1944, pp. 497–534.

King/Haden 1972
King, Frank L., and Edward Byron Haden. "Ball-Point Pens." In *Encyclopaedia Brittanica,* vol. 17, p. 548. Chicago/London, 1972.

Kirker 1969
Kirker, Harold. *The Architecture of Charles Bulfinch.* Cambridge, Mass., 1969.

Kleiner 1992
Kleiner, Diana E. E. *Roman Sculpture.* New Haven, Conn., 1992.

Kloss 1988
Kloss, William. *Samuel F. B. Morse.* New York, 1988.

Knoedler 1902
Ideal Children's Heads in Crayon and Oil by S. W. Rowse. Exhibition catalogue. New York, M. Knoedler and Company, 1902.

Knowles 1831
Knowles, John. *The Life and Writings of Henry Fuseli.* 3 vols. London, 1831.

Knowlton 1899
Knowlton, Helen Mary. *Art–Life of William Morris Hunt.* Boston, 1899.

Knox 1930
Knox, Katherine McCook. *The Sharples.* New Haven, Conn., 1930.

Knox 1961
Knox, George. "The Orloff Album of Tiepolo Drawings." *Burlington Magazine,* vol. 103, June 1961, pp. 269–75.

Knox 1968
Knox, George. "G. B. Tiepolo and the Ceiling of the Scalzi." *Burlington Magazine,* vol. 110, July 1968, pp. 394–400.

Knox 1980
Knox, George. *Giambattista and Domenico Tiepolo: A Study and Catalogue Raisonné of the Chalk Drawings.* 2 vols. Oxford, 1980.

Koechlin 1924
Koechlin, Raymond. *Les Ivoires gothiques français.* 3 vols. Paris, 1924.

Kokoschka 1973
Kokoschka, Oskar. *Mein Leben.* Munich, 1973.

Kraus 1968
Kraus, Rosalind. "Sol LeWitt, Dwan Gallery." *Artforum,* vol. 6, April 1968, pp. 57–58.

Krauss 1978
Krauss, Rainer. *Friederich Preller: Ausstellung anlässlich seines 100. Todestages.* Exhibition catalogue. Weimar, Kunsthalle, 1978.

Kreul 1994
Kreul, Andreas. *Kunsthalle Bremen: Verzeichnis Sämtlicher Gemälde.* Wiesbaden, 1994.

La Farge 1897
La Farge, John. *An Artist's Letters from Japan.* New York, 1897.

La Farge 1912
La Farge, John. *Reminiscences of the South Seas.* New York, 1912.

La Fontaine 1755–59
La Fontaine, Jean de. *Fables choisies, mises en vers.* 4 vols. Paris, 1755–59.

Laing 1987
Laing, Alastair. *François Boucher, 1703–1770.* Exhibition catalogue. New York, Metropolitan Museum of Art, 1987.

Lampsonius 1565
Lampsonius, Domenicus. *Lamberti Lombardi apud Eburones pictoris celeberrima vis, pictoribus, sculptoribus, architectis, aliisque id genus artificibus utilis et necessaria.* Bruges, 1565.

Landgren/McGurn 1976
Landgren, Marchal E., and Sharman Wallace McGurn. *The Late Landscapes of William Morris Hunt.* Exhibition catalogue. College Park, University of Maryland Department of Art, 1976.

Lane 1961
Lane, Arthur. *English Porcelain Figures of the Eighteenth Century.* London, 1961.

Langedijk 1963
Langedijk, Karla. "Eine unbekannte Zeichnungsfolge von Liéven Cruyl in Florenz." *Mitteilungen des Kunsthistorischen Institutes in Florenz,* vol. 10, 1963, pp. 67–94.

Larivalle 1980
Larivalle, Paul. *Pietro Aretino fra rinascimento e manierismo.* Rome, 1980.

Leach/Wallace 1982
Leach, M. C., and Richard Wallace. "Salvatore Rosa." *The Illustrated Bartsch,* vol. 45. New York, 1982.

Lear 1832
Lear, Edward. *Illustrations of the Family of the Psittacidae, or Parrots.* London, 1832.

Lear 1841
Lear, Edward. *Views in Rome and Its Environs.* London, 1841.

Lear 1846a
Lear, Edward. *The Book of Nonsense.* London, 1846.

Lear 1846b
Lear, Edward. *Gleanings from the Menagerie and Aviary at Knowsley Hall.* London, 1846.

Leavitt 1973
Leavitt, Thomas W. *George Loring Brown: Landscapes of Europe and America, 1834–1880.* Exhibition catalogue. Burlington, Vt., Robert Hull Fleming Museum, University of Vermont, 1973.

Le Conte 1935
Le Conte, Pierre. *List of Men-of-War: Part II, French Ships, 1648–1700.* London, 1935.

Lee 1929
Lee, Cuthbert. *Early American Portrait Painters.* New Haven, Conn., 1929.

Lefrançois 1994
Lefrançois, Thierry. *Charles Coypel, peintre du roi (1694–1752).* Paris, 1994.

Legg 1978
Legg, Alicia, ed. *Sol LeWitt.* Exhibition catalogue. New York, Museum of Modern Art, 1978.

Lehrer 1892
Lehrer, Sigmund. *The Manufacture of Ink.* Philadelphia, 1892.

Lembark 1992
Lembark, Connie W. *The Prints of Sam Francis: A Catalogue Raisonné, 1960–1990.* 2 vols. New York, 1992.

Lenormand/Dayen 1987
Lenormand, Jacques, and Patrick Dayen. *Importants Tableaux, dessins et sculptures, anciens et modernes.* Exhibition catalogue. Paris, Hôtel Drouot, 1987.

Lepicie 1752
Lepicie, Bernard. *Vies des premiers peintres du roi depuis M. Le Brun jusqu'à présent.* 2 vols. Paris, 1752.

Levey 1986
Levey, Michael. *Giambattista Tiepolo: His Life and Art.* New Haven, Conn./ London, 1986.

Lewis/Simon 1980
Lewis, Beth Irwin, and Sidney Simon. *Grosz–Heartfield: The Artist as Social Critic.* Exhibition catalogue. Minneapolis, University of Minnesota Gallery, 1980.

Libbie 1892
C. F. Libbie and Company. *Catalog of the Private Library of the late John B. Gough, Esq., of Worcester, Mass., Consisting of Cruikshankiana.* Boston, 1892.

Liège 1963
Dessins de Lambert Lombard, ex-collection d'Arenberg. Exhibition catalogue. Liège, Musée de l'Art Wallon, 1963.

Liège 1966
Lambert Lombard et son temps. Exhibition catalogue. Liège, Musée de l'Art Wallon, 1966.

Lipchitz 1972
Lipchitz, Jacques. *My Life in Sculpture.* New York, 1972.

Little 1968
Little, Nina Fletcher. "Early Buildings of the Asylum at Charlestown." *Old Time New England,* vol. 59, October– December 1968, pp. 29–30.

Lloyd 1995
Lloyd, Stephen. *Richard and Maria Cosway, Regency Artists of Taste and Fashion.* Exhibition catalogue. Edinburgh, Scottish National Portrait Gallery, 1995.

Lohberg 1994
Lohberg, Gabriele. *Ernst Ludwig Kirchner.* 2 vols. Exhibition catalogue. Davos, Kirchner Museum, 1994.

Lord 1983
Lord, James. *Giacometti: A Biography.* New York, 1983.

Lostalot 1884
Lostalot, Alfred de. "Les Artistes contemporains: M. Félix Bracquemond— Peintre, graveur." *Gazette des Beaux- Arts,* 2nd ser., vol. 29, 1884, pp. 420–26, 517–24; vol. 30, 1884, pp. 155–61.

Lothrop 1918
Lothrop, Stanley B. *Bartolomeo Caporali.* Rome, 1918.

Louvre 1967
Le Cabinet d'un grand amateur, P. J. Mariette, 1694–1774: Dessins du XVe siècle au XVIIIe siècle. Exhibition catalogue. Paris, Cabinet des Estampes, Musée du Louvre, 1967.

Lugt 1921/1956
Lugt, Frits. *Les Marques de collections de dessins et d'estampes.* Amsterdam, 1921. Supplement, Amsterdam, 1956.

Lulofs 1992
Lulofs, Hiske. "A Design by Grimaldi for the Forty Hours of Devotion." *Master Drawings,* vol. 30, 1992, pp. 320–25.

Lumbroso 1962
Lumbroso, Matizia Maroni. "Palazzo Strozzi Besso alle Stimmate." *Capitolium,* August–September 1962, pp. 542–47.

Lunghi 1984
Lunghi, Elvio. "Per la miniatura umbra del quattrocento." *Atti Accademia Prosperziana del Subiaso,* vol. 8, 1984, pp. 151–97.

Lunghi 1992
Lunghi, Elvio. "Le miniature nei manoscritti italiani della Biblioteca Capitolare di Perugia (Secoli XIII, XIV e XV)." In *Una città e la sua cattedrale: Il Duomo di Perugia,* pp. 249–76. Perugia, 1992.

Mahler 1960
Mahler, Alma. *Mein Leben.* Frankfurt, 1960.

Mahon 1969
Mahon, Denis. *Il Guercino (Giovanni Francesco Barbieri, 1591–1666): Catalogo critico dei disegni.* Exhibition catalogue. Bologna, Palazzo dell'Archiginnasio, 1969.

Mahon 1991
Mahon, Denis. *Giovanni Francesco Barbieri, Il Guercino, 1591–1666, disegni.* Exhibition catalogue. Bologna, Museo Civico Archeologico, 1991.

Mahon 1992
Mahon, Denis, et al. *Guercino: Master Painter of the Baroque.* Exhibition catalogue. Washington, D.C., National Gallery of Art, 1992.

Malingue 1943
Malingue, Maurice. *Gauguin.* Paris, 1943.

Malingue 1948
Malingue, Maurice. *Gauguin: Le peintre et son oeuvre.* Paris, 1948.

Manning/Suida 1958
Manning, Bertina Suida, and William Suida. *Luca Cambiaso.* Florence, 1958.

Marcucci 1958
Marcucci, Luisa. *Dipinti toscani del secolo XIII.* Florence, Accademia, 1958.

Mariuz 1971
Mariuz, Adriano. *Giandomenico Tiepolo.* Venice, 1971.

Marlborough 1973
Jacques Lipchitz: Sculptures and Drawings. Exhibition catalogue. London/Zurich, Marlborough Gallery, 1973.

Marlborough-Gerson 1969
Lyonel Feininger. Exhibition catalogue. New York, Marlborough-Gerson Gallery, 1969.

Marter 1991
Marter, Joan M. *Alexander Calder.* Cambridge, 1991.

Martyn 1893
Martyn, Carlos. *John B. Gough: The Apostle of Cold Water.* London, 1893.

Mason 1992
Mason, Lauris. *The Lithographs of George Bellows.* Rev. ed. San Francisco, 1992.

Massar 1971
Massar, Phyllis Dearborn. *Presenting Stefano della Bella: Seventeenth-Century Printmaker.* New York, 1971.

Massar 1976
Massar, Phyllis Dearborn. "Felice Giani Drawings at the Cooper-Hewitt Museum." *Master Drawings,* vol. 14, 1976, pp. 396–420.

Matthiesen 1950
Matthiesen Gallery. *French Master Drawings of the Eighteenth Century.* London, 1950.

Mayer 1969
Mayer, Ralph. *A Dictionary of Art Terms and Techniques.* New York, 1969.

McTavish 1981
McTavish, David. "Apparato dei Sempertini, Venezia, per la commedia de Pietro Aretino." In *Giorgio Vasari, principi letterati e artistici . . . ,* pp. 108–16. Florence, 1981.

McTavish 1985
McTavish, David, et al. *Italian Drawings from the Collection of Duke Roberto Feretti.* Exhibition catalogue. Toronto, Art Gallery of Ontario, 1985.

Meder 1978
Meder, Joseph. *The Mastery of Drawing.* Translated and revised by Winslow Ames. 2 vols. New York, 1978.

Meiss 1966
Meiss, Millard. "Sleep in Venice: Ancient Myths and Renaissance Proclivities." *Proceedings of the American Philosophical Society,* vol. 110, 1966, pp. 348–69.

Merkel 1958
Merkel, Walter. "Art and Artists." *Worcester Sunday Telegram,* 2 March 1958, p. C7.

Michaelsen 1977
Michaelsen, Katherine Jánszky. *Archipenko: A Study of the Early Works, 1908–1920.* New York, 1977.

Michaelsen/Guralnik 1986
Michaelsen, Katherine Jánszky, and Nehama Guralnik. *Alexander Archipenko: A Centennial Tribute.* Exhibition catalogue. Washington, D.C., National Gallery of Art, 1986.

Mielke 1988
Mielke, Hans. *Albrecht Altdorfer.* Berlin, 1988.

Miles 1994
Miles, Ellen G. *Saint-Mémin and the Neoclassical Profile Portrait in America.* Washington, D.C., 1994.

Miller 1983
Miller, Lillian B. *The Selected Papers of Charles Willson Peale and His Family.*

2 vols. New Haven, Conn./London, 1983.

Miller 1992
Miller, Lillian B. *In Pursuit of Fame: Rembrandt Peale, 1778–1860.* Exhibition catalogue. Washington, D.C., National Portrait Gallery, Smithsonian Institution, 1992.

Milwaukee 1954
Of Music and Art. Exhibition catalogue. Milwaukee Art Institute, 1954.

Mireur 1911
Mireur, Hippolyte. *Dictionnaire des ventes d'art faites en France.* 7 vols. Paris, 1911.

Mitchell 1937
Mitchell, C. Ainsworth. *Inks: Their Composition and Manufacture.* London, 1937.

Mitchell 1970
Mitchell, William J. *Ninety-nine Drawings by Marsden Hartley.* Exhibition catalogue. Lewiston, Maine, Treat Art Gallery, Bates College, 1970.

Modigliani 1959
Modigliani, Jeanne. *Modigliani: Man and Myth.* London, 1959.

Moholy-Nagy 1938
Moholy-Nagy, László. *The New Vision: Fundamentals of Design, Painting, Sculpture, Architecture.* New York, 1938.

Moholy-Nagy 1947
Moholy-Nagy, László. *Vision in Motion.* Chicago, 1947.

Monbeig-Goguel 1972
Monbeig-Goguel, Catherine. *Vasari et son temps: Maîtres toscans nés après 1500, morts avant 1600, inventaire général des dessins Italiens.* Paris, Louvre, 1972.

Mongan 1965a
Mongan, Agnes. "A Portrait Drawing by Ingres." Worcester Art Museum *News Bulletin and Calendar,* vol. 30, March 1965, pp. 1–3.

Mongan 1965b
Mongan, Agnes. "Un portrait dessiné d'Ingres." *Bulletin de Musée Ingres,* no. 17, July 1965, pp. 3–8.

Mongan 1967
Mongan, Agnes. *Ingres: Centennial Exhibition, 1867–1967.* Exhibition catalogue. Cambridge, Fogg Art Museum, Harvard University, 1967.

Morgan 1965
Morgan, Charles H. *George Bellows: Painter of America.* New York, 1965.

Morgan 1973
Morgan, Charles H. *The Drawings of George Bellows.* Alhambra, Calif., 1973.

Morgan 1989
Morgan, Hilary. *Burne-Jones, the Pre-Raphaelites, and Their Century.* Exhibition catalogue. London, Peter Nahum Gallery, 1989.

Morse 1914
Morse, Edward Lind, ed. *Samuel F. B. Morse: His Letters and Journals.* 2 vols. Boston, 1914.

Mortagne 1972
Félix et Marie Bracquemond. Exhibition catalogue. Mortagne-au-Perche, Musée Alain, 1972.

Moser 1977
Moser, Joann. *Atelier 17: A Fiftieth Anniversary Retrospective Exhibition.* Exhibition catalogue. Madison, Wis., Elvehjem Art Center, 1977.

Moser 1990
Moser, Joann. *Visual Poetry: The Drawings of Joseph Stella.* Exhibition catalogue. Washington, D.C., National Museum of American Art, Smithsonian Institution, 1990.

Moskowitz 1962
Moskowitz, Ira. *Great Drawings of All Time.* New York, 1962.

Mount 1955
Mount, Charles Merrill. *John Singer Sargent: A Biography.* New York, 1955.

Müller 1960
Müller, Heinrich. *Die späte Graphik von Lovis Corinth.* Hamburg, 1960.

Müller 1988
Müller, Christian. *Hans Holbein d. J. Zeichnungen aus dem Kupferstichkabinett Basel.* Exhibition catalogue. Basel, Kupferstichkabinett, 1988.

Mundy 1989
Mundy, James. *Renaissance into Baroque: Italian Master Drawings by the Zuccari, 1500–1600.* Exhibition catalogue. Milwaukee Art Museum, 1989.

Musée des Arts Décoratifs 1974
David Hockney: Tableaux et dessins. Exhibition catalogue. Paris, Musée des Arts Décoratifs, 1974.

Myers/Ayres 1988
Myers, Jane, and Linda Ayres. *George Bellows: The Artist and His Lithographs.* Exhibition catalogue. Fort Worth, Tex., Amon Carter Museum, 1988.

Naef 1977–80
Naef, Hans. *Die Bildniszeichnungen von J.- A.- D. Ingres.* 5 vols. Bern, 1977–80.

Naumann 1981
Naumann, Otto. *Frans van Mieris, the Elder (1635–1681).* 2 vols. Doornsprijk, 1981.

New-York Historical Society 1943
New-York Historical Society. *National Academy of Design Exhibition Record, 1826–1860.* 2 vols. New York, 1943.

Nicolson 1968
Nicolson, Benedict. *Joseph Wright of Derby.* 2 vols. London, 1968.

Niemeijer 1967
Niemeijer, J. W. "Een studiekop van Charles Parrocel, Notities bij een recente aanwinst." *Bulletin van het Rijksmuseum,* vol. 15, 1967, pp. 135–38.

Niero 1976–77
Niero, Antonio. "Giambattista Tiepolo alla Scuola dei Camini: Precisazioni d'archivio." *Atti dell'Istituto Veneto di Scienze, Lettere, ed Arti,* vol. 135, 1976–77, pp. 373–91.

Nisbet 1993
Nisbet, Peter, ed. *The Sketchbook of Georg Grosz.* Exhibition catalogue. Cambridge, Busch-Reisinger Museum, Harvard University, 1993.

Nissman/Abromson 1992
Nissman, Abromson and Company. *Master Drawings, 1500–1900.* Exhibition catalogue. New York/Brookline, Mass., 1992.

Noakes 1985
Noakes, Vivien. *Edward Lear, 1812–1888.* Exhibition catalogue. London, Royal Academy of Arts, 1985.

Noguchi 1968
Noguchi, Isamu. *A Sculptor's World.* New York/Evanston, Ill., 1968.

Nolde 1965
Nolde, Emil. *Welt und Heimat.* Cologne, 1965.

Nordland 1974
Nordland, Gerald. *Gaston Lachaise: The Man and His Work.* New York, 1974.

Norfleet 1942
Norfleet, Fillmore. *Saint-Mémin in Virginia: Portraits and Biographies.* Richmond, Va., 1942.

Norman 1949
Norman, Dorothy, ed. *The Selected Writings of John Marin.* New York, 1949.

Oliver/Huff/Hanson 1988
Oliver, Andrew, Ann Millspaugh Huff, and Edward W. Hanson. *Portraits in the Massachusetts Historical Society Collection.* Boston, 1988.

Olsen 1962
Olsen, Harald. *Federico Barocci.* Copenhagen, 1962.

Olszewski 1981
Olszewski, Edward J. *The Draftsman's Eye: Late Italian Renaissance Schools and Styles.* Exhibition catalogue. Cleveland Museum of Art, 1981.

Opperman 1977
Opperman, Hal. *Jean-Baptiste Oudry.* 2 vols. New York, 1977.

Opperman 1983
Opperman, Hal. *J.-B. Oudry, 1686–1755.* Exhibition catalogue. Fort Worth, Tex., Kimbell Art Museum, 1983.

Opperman/Rosenberg 1983
Opperman, Hal, and Pierre Rosenberg. *J.-B. Oudry, 1686–1755.* Exhibition catalogue. Paris, Grand Palais, 1983.

Ormond 1970
Ormond, Richard. *John Singer Sargent: Paintings, Drawings, Watercolors.* London/New York, 1970.

Ostell 1807
Ostell, Thomas. *The Artist's Assistant, or School of Science.* Birmingham, 1807.

Ostrow 1968
Ostrow, Stephen E. *Visions and Revisions.* Exhibition catalogue. Providence, Rhode Island School of Design Museum of Art, 1968.

Ottley 1866
Ottley, Henry. *Biographical and Critical Dictionary of Recent and Living Painters.* London, 1866.

Oursel 1984
Oursel, Hervé, ed. *Le chevalier Wicar: Peintre dessinateur et collectionneur lillois.* Exhibition catalogue. Lille, Musée des Beaux-Arts, 1984.

Pace 1976
Pace, Valentino. "Maso da San Friano." *Bollettino d'arte,* ser. 5, vol. 61, 1976, pp. 74–99.

Pach 1946
Pach, Walter. "Jacques Lipchitz and the Modern Movement." *Magazine of Art,* vol. 39, December 1946, pp. 355–69.

Parker/Wheeler 1938
Parker, Barbara Neville, and Anne Bolling Wheeler. *John Singleton Copley: American Portraits in Oil, Pastel, and Miniature, with Biographical Sketches.* Boston, 1938.

Parrocel 1861
Parrocel, Etienne. *Monographie des Parrocel.* Marseilles, 1861.

Pascoli 1965
Pascoli, Lione. *Vite de' pittori, scultori ed architetti moderni.* 2 vols. Rome, 1730–36. Facsimile, Amsterdam, 1965.

Pasko 1894
Pasko, Wesley Washington, ed. *American Dictionary of Printing and Bookmaking.* New York, 1894.

Patani 1991
Patani, Osvaldo. *Amedeo Modigliani: Catalogo generale.* 3 vols. Rome, 1991.

Patten 1992
Patten, Robert L. *George Cruikshank's Life, Times, and Art.* 2 vols. New Brunswick, N.J., 1992.

Peirce 1953
Peirce, Josephine H. "Obscure Leicester Artist's Crayon Portraits of the 1830's Now Sought by Collectors." *Worcester Sunday Telegram,* 10 May 1953, "Parade" section, pp. 7–8.

Peirce 1970
Peirce, Josephine H. "From the Diary of Ruth Henshaw Bascom." *Yankee Magazine,* vol. 34, March 1970, pp. 90–93, 108–11.

Percy 1971
Percy, Ann. *Giovanni Benedetto Castiglione, Master Draughtsman of the Italian Baroque.* Exhibition catalogue. Philadelphia Museum of Art, 1971.

Pérez Sánchez/Spinosa 1992
Pérez Sánchez, Alfonso E., and Nicola Spinosa. *Jusepe de Ribera, 1591–1652.* Exhibition catalogue. New York, Metropolitan Museum of Art, 1992.

Pickering/Upham 1862–73
Pickering, Octavius, and Charles W. Upham. *The Life of Timothy Pickering.* 4 vols. Boston, 1862–73.

Pillsbury 1978
Pillsbury, Edmund. *David Hockney: Travels with Pen, Pencil, and Ink.* New York, 1978.

Pitman 1985
Pitman, Ruth. *Edward Lear's Tennyson.* Manchester/New York, 1985.

Pohl 1982
Pohl, Erika, et al. *Karl Ströher: Sammler und Sammlung.* Darmstadt, 1982.

Popham 1932
Popham, Arthur Ewart. *Catalogue of Drawings by Dutch and Flemish Artists . . . in the British Museum.* 5 vols. London, 1932.

Popham 1971
Popham, Arthur Ewart. *The Drawings of Parmigianino.* 3 vols. London/New York, 1971.

Pouncey 1976
Pouncey, Philip. "Popham's Parmigianino Corpus." *Master Drawings,* vol. 14, 1976, pp. 172–76.

Powney 1976
Powney, Christopher. *John Flaxman.* Exhibition catalogue. London, Heim Gallery, 1976.

Prasse 1972
Prasse, Leona E. *Lyonel Feininger: A Definitive Catalogue of His Graphic Work, Etchings, Lithographs, Woodcuts.* Berlin/Cleveland, 1972.

Pressley 1979
Pressley, Nancy L. *The Fuseli Circle in Rome: Early Romantic Art of the 1770s.* Exhibition catalogue. New Haven, Conn., Yale Center for British Art, 1979.

Previtali 1962
Previtali, Giovanni. "Alle origini del primitivismo romantico: Il viaggio umbro-toscano di William Young Ottley e Humbert De Superville." *Paragone,* vol. 13, May 1962, pp. 32–51.

Prime 1875
Prime, Samuel Irenaeus. *The Life of Samuel F. B. Morse, L.L.D.: Inventor of the Electro-Magnetic Recording Telegraph.* New York, 1875.

Prouté 1993
Prouté, Paul. *Dessins, estampes anciennes du XVIe au XVIIIe siècle.* Paris, 1993.

Prown 1966
Prown, Jules. *John Singleton Copley.* 2 vols. Washington, D.C., 1966.

Pushkin 1977
Pushkin Museum. *Le Dessin français des XVIe–XVIIIe siècles.* Moscow, 1977.

Putnam 1926
Putnam, Samuel. *The Works of Aretino, Translated into English . . . with a Critical and Biographical Essay.* Chicago, 1926.

Pyne 1983
Pyne, Kathleen, ed. *The Quest for Unity: American Art between World's Fairs, 1876–1893.* Exhibition catalogue. Detroit Institute of Arts, 1983.

Quarré 1959
Quarré, Pierre. *P.-P. Prud'hon, 1758–1823: Les Premières Etapes de sa carrière.* Exhibition catalogue. Dijon, Musée des Beaux-Arts, 1959.

Quarré-Reybourbon 1961
Quarré-Reybourbon, Louis. *La Vie, l'oeuvre et les collections du peintre Wicar.* Paris, 1961.

Quick/Myers 1992
Quick, Michael, Jane Myers, et al. *The Paintings of George Bellows.* Exhibition catalogue. Fort Worth, Tex., Amon Carter Museum, 1992.

Ragaller 1965
Ragaller, Heinrich. *Die Sammlung Karl Ströher.* Exhibition catalogue. Darmstadt, Hessischen Landesmuseum, 1965.

Ramsay 1962
Ramsay, Oliver. "C. B. J. Févret de Saint-Mémin (1770–1852): Profilist, Crayon and Watercolor Portraitist, Engraver." *Essay-Proof Journal,* vol. 19, winter 1962, pp. 11–17.

Rapp 1832
Rapp, Adam William. *Penmanship.* Philadelphia, 1832.

Raynor 1962
Raynor, Vivien. "Tom Wesselmann." *Arts,* vol. 36, February 1962, p. 47.

Rearick 1964
Rearick, Janet Cox. *The Drawings of Pontormo.* Cambridge, Mass., 1964.

Rebora 1995
Rebora, Carrie, et al. *John Singleton Copley in America.* Exhibition catalogue. New York, Metropolitan Museum of Art, 1995.

Reed/Troyen 1993
Reed, Sue Welsh, and Carol Troyen. *Awash in Color: Homer, Sargent, and the Great American Watercolor.* Exhibition catalogue. Boston, Museum of Fine Arts, 1993.

Reed/Wallace 1987
Reed, Sue Welsh, and Richard Wallace. *Italian Etchers of the Renaissance and Baroque.* Exhibition catalogue. Boston, Museum of Fine Arts, 1987.

Reff 1976
Reff, Theodore. *The Notebooks of Edgar Degas.* 2 vols. Oxford, 1976.

Reich 1969
Reich, Sheldon. *John Marin Drawings, 1886–1951.* Exhibition catalogue. Salt

Lake City, University of Utah Museum of Fine Arts, 1969.

Reich 1970
Reich, Sheldon. *John Marin: A Stylistic Analysis and Catalogue Raisonné.* 2 vols. Tucson, Ariz., 1970.

Rewald 1938
Rewald, John. *Gauguin.* New York/Paris, 1938.

Rewald 1986
Rewald, John. *Cézanne: A Biography.* New York, 1986.

Reznicek 1961
Reznicek, Emil K. J. *Die Zeichnungen von Hendrick Goltzius.* 2 vols. Utrecht, 1961.

Ribeiro 1983
Ribeiro, Aileen. *European Dress in the Eighteenth Century.* London, 1983.

Rice 1959
Rice, Howard C., Jr. "Saint-Mémin's Portrait of Jefferson." *Princeton University Library Chronicle,* vol. 20, summer 1959, pp. 182–92.

Rich/Carey 1965
Rich, Daniel Catton, and Martin Carey. *The New American Realism.* Exhibition catalogue. Worcester Art Museum, 1965.

Rich/Dresser 1966
Rich, Daniel Catton, and Louisa Dresser. "The Worcester Art Museum." *Antiques,* vol. 90, November 1966, pp. 647–54.

Riedl 1960
Riedl, Peter Anselm. "A Few Drawings by Francesco Vanni." *Connoisseur,* vol. 146, 1960, pp. 163–67.

Riedl 1976
Riedl, Peter Anselm. *Disegni dei barocceschi Senesi, Francesco Vanni e Ventura Salimbeni.* Exhibition catalogue. Gabinetto disegni e stampe degli Uffizi, Florence, 1976.

Rietzschel 1988
Rietzschel, Thomas. *Theodor Däubler: Eine Collage seiner Biographie.* Leipzig, 1988.

Riggs 1976
Riggs, Timothy. *The Second Fifty Years: American Art, 1826–1876.* Exhibition catalogue. Worcester Art Museum, 1976.

Riggs 1977
Riggs, Timothy. *Hieronymous Cock, Printmaker and Publisher.* New York, 1977.

Rivera 1960
Rivera, Diego. *My Art, My Life.* New York, 1960.

Rizzi 1971
Rizzi, Aldo. *The Etchings of the Tiepolos.* New York, 1971.

Robert-Dumesnil 1835–50
Robert-Dumesnil, A. P. F. *Le Peintre-graveur français.* 8 vols. Paris, 1835–50.

Robichon de la Guérinière 1733
Robichon de la Guérinière, François. *Ecole de cavalerie, contenant la connaissance, l'instruction, et la conservation du cheval.* Paris, 1733.

Robinson 1958
Robinson, Michael Strang. *Van de Velde Drawings: A Catalogue of Drawings in the National Maritime Museum Made by the Elder and the Younger Willem van de Velde.* 2 vols. Cambridge, 1958.

Romano 1970
Romano, Giovanni. *Casalesi del cinquecento: L'avvento del manierismo in una città padana.* Turin, 1970.

Romano 1986
Romano, Giovanni. *Bernardino Lanino e il cinquecento a Vercelli.* Turin, 1986.

Roquette 1883
Roquette, Otto. *Friederich Preller: Ein Lebensbild.* Frankfurt-am-Main, 1883.

Rosand/Muraro 1976
Rosand, David, and Michaelangelo Muraro. *Titian and the Venetian Woodcut.* Exhibition catalogue. Washington, D.C., International Exhibitions Foundation, 1976.

Rosenberg 1972
Rosenberg, Pierre. *French Master Drawings of the Seventeenth and Eighteenth Centuries in North American Collections.* Exhibition catalogue. Ottawa, National Gallery of Canada, 1972.

Rosenberg/Michel 1987
Rosenberg, Pierre, and Oliver Michel. *Subleyras: 1699–1749.* Exhibition catalogue. Paris, Palais de Luxembourg, 1987.

Röthel 1958
Röthel, Hans Konrad. *Die Gemälde von Lovis Corinth: Werkkatalog.* Munich, 1958.

Rothenstein 1930
Rothenstein, John. "Walter John Knewstub." *Artwork,* vol. 6, 1930, p. 87.

Rothenstein 1931
Rothenstein, William R. *Men and Memories: Recollections of William Rothenstein, 1872–1900.* New York, 1931.

Rothenstein 1965
Rothenstein, John. *Summer's Lease: An Autobiography, 1901–1938.* London, 1965.

Rox 1950
Rox, Henry. *The Eye Listens: Music in the Visual Arts.* Exhibition catalogue. South Hadley, Mass., Dwight Memorial Art Gallery, Mount Holyoke College, 1950.

Rubenstein-Bloch 1926
Rubenstein-Bloch, Stella. *Catalogue of the George and Florence Blumenfeld Collection.* 2 vols. New York, 1926.

Rubinstein 1982
Rubinstein, Charlotte Streifer. *American Women Artists.* Boston, 1982.

Ruby 1990
Ruby, Louisa Wood. "Sebastian Vrancx as Illustrator of Virgil's *Aeneid.*" *Master Drawings,* vol. 28, 1990, pp. 54–73.

Ryser 1989
Ryser, Frieder. "Veduten hinter Glas: Johann Wolfgang Baumgartner als Hinterglasmaler." *Kunst und Antiquitäten,* vol. 2, 1989, pp. 36–43.

Sadik 1956
Sadik, Marvin S. "A North Italian Drawing of the Sixteenth Century," Worcester Art Museum *News Bulletin and Calendar,* vol. 22, December 1956, pp. 10–11.

Saint Florian 1965
Die Kunst der Donauschule, 1490–1540. Exhibition catalogue. Stift Saint Florian und Linz, Schlossmuseum, 1965.

Salmon 1685
Salmon, William. *Polygraphice; or, The Art of Engraving.* 2 vols. 5th ed. London, 1685.

San Francisco 1936
Paul Gauguin: Exhibition of Paintings and Prints. Exhibition catalogue. San Francisco Museum of Art, 1936.

Scarpellino 1975
Scarpellino, P. "Giapeco Caporali." In *Dizionario biografico degli Italiani,* vol. 18, pp. 682–83. Rome, 1975.

Scarron 1726
Scarron, Paul. *Le Roman comique.* Paris, 1726.

Scheller 1973
Scheller, Robert W. "The Case of the Stolen Raphael Drawings." *Master Drawings,* vol. 11, 1973, pp. 119–36.

Schiefler/Mosel 1966–67
Schiefler, Gustav, and Christel Mosel, eds. *Emil Nolde: Das graphische Werk.* 2 vols. Cologne, 1966–67.

Schleier 1992
Schleier, Erich. "Pier Giovanni Battista Pace e Pier Francesco Mola." *Antichità Viva,* vol. 31, nos. 5/6, 1992, pp. 13–18.

Schmid 1977
Schmid, Elmar. *Nördlingen—die Georges Kirche.* Stuttgart, 1977.

Schnapper 1989
Schnapper, Antoine, et al. *Jacques-Louis David, 1748–1825.* Exhibition catalogue. Paris, Louvre, and Versailles, Musée National du Château, 1989.

Schofield 1993
Schofield, John. *Hail Columbia! Robert Gray, John Kendrick, and the Pacific Fur Trade.* Portland, Ore., 1993.

Schubert 1990
Schubert, Dietrich. *Die Kunst Lehmbrucks.* 2nd ed. Dresden, 1990.

Schulz 1961
Schulz, Juergen. "Vasari at Venice." *Burlington Magazine,* vol. 103, December 1961, pp. 500–511.

Schuman 1979
Schuman, Jack Crosby. "Charles Parrocel (1688–1752)." Ph.D. dissertation, Seattle, University of Washington, 1979.

Schwarz 1917–22
Schwarz, Karl. *Das graphische Werk von Lovis Corinth.* 2 vols. Berlin, 1917–22.

Schweiger 1982
Schweiger, Werner J. *Wiener Werkstätte: Kunst und Handwerk, 1903–1932.* Vienna, 1982.

Schweiger 1983
Schweiger, Werner J. *Der junge Kokoschka: Leben und Werk, 1904–1914.* Vienna, 1983.

Seiberling 1948
Seiberling, Frank, Jr. "George Bellows, 1882–1925: His Life and Development as an Artist." Ph.D. dissertation, University of Chicago, 1948.

Sellers 1952
Sellers, Charles Coleman. *Portraits and Miniatures by Charles Willson Peale.* Philadelphia, 1952.

Selz 1982
Selz, Peter, et al. *Sam Francis.* Rev. ed. New York, 1982.

Sérullaz 1983
Sérullaz, Arlette. *Autour de David: Dessins néoclassiques du Musées des Beaux-Arts de Lille.* Exhibition catalogue. Lille, Musées des Beaux-Arts, 1983.

Sérullaz 1991
Sérullaz, Arlette. *Dessins de Jacques-Louis David: Inventaire général des dessins, école française.* Paris, 1991.

Shaw 1962
Shaw, James Byam. *The Drawings of Domenico Tiepolo.* London, 1962.

Sherrill 1975
Sherrill, Sarah B. "Current and Coming: Colonial Art at Worcester." *Antiques,* vol. 108, July 1975, pp. 28, 32.

Shestack 1967
Shestack, Alan. *Master E.S.* Exhibition catalogue. Philadelphia Museum of Art, 1967.

Shestack/Talbot 1969
Shestack, Alan, and Charles Talbot, eds. *Prints and Drawings of the Danube School.* Exhibition catalogue. New Haven, Conn., Yale University Art Gallery, 1969.

Shoemaker 1981
Shoemaker, Innis H. *The Engravings of Marcantonio Raimondi.* Exhibition catalogue. Lawrence, Kans., Spencer Museum of Art, 1981.

Siegel 1968
Siegel, Jeanne. "Sol LeWitt: 46 Variations Using 3 Different Kinds of Cubes." *Arts,* vol. 42, February 1968, p. 57.

Singer 1992
Singer, Susanna, ed. *Sol LeWitt Drawings, 1952–1992.* Exhibition catalogue. The Hague, Haags Gemeentemuseum, 1992.

Sistach/Espadaler 1993
Sistach, Maria Carme, and Ignasi Espadaler. "Organic and Inorganic Components in Iron Gall Inks." *Preprints: ICOM Committee for Conservation, 10th Triennial Meeting, Washington, D.C., 22–27 August 1993,* pp. 485–90. Paris, 1993.

Sloan/Yarnall 1992
Sloan, Julie L., and James L. Yarnall. "Art of an Opaline Mind: The Stained Glass of John La Farge." *American Art Journal,* vol. 24, 1992, pp. 5–43.

Sluijter/Enklaar/Nieuwenhuizen 1988
Sluijter, Eric Jan, Marlies Enklaar, and Paul Nieuwenhuizen. *Leids Fijnschilders: Van Gerrit Dou tot Frans van Mieris de Jonge, 1630–1760.* Exhibition catalogue. Leiden, Stedelijk Museum de Lakenthal, 1988.

Snow 1960
Snow, Nicholas. *Master Drawings of the Italian Renaissance.* Exhibition catalogue. Detroit Institute of Arts, 1960.

Sotheby Mak van Waay 1984
Dutch and Flemish Drawings. Sale catalogue. Amsterdam, Sotheby Mak van Waay, 1984.

Sotheby Parke Bernet 1979
The Benjamin Sonnenberg Collection. 2 vols. Sale catalogue. New York, Sotheby Parke Bernet, 1979.

Sotheby's 1965
Valuable Printed Books, Autograph Letters and Historical Documents, the Property of Sir Osbert Sitwell, Bt., Edward Martin, Esq., and Others. Sale catalogue. London, Sotheby's, 1965.

Sotheby's 1975
Fine Old Master Drawings. Sale catalogue. London, Sotheby's, 1975.

Sotheby's 1987
Old Master Drawings. Sale catalogue. London, Sotheby's, 1987.

Sotheby's Monaco 1987
Dessins de Stradanus, extraits du catalogue de la bibliothèque Marcel Jeanson, première partie: chasse. Sale catalogue. Monte Carlo, Sotheby's Monaco, 1987.

Spassky 1985
Spassky, Natalie, et al. *American Paintings in the Metropolitan Museum of Art.* 2 vols. New York, 1985.

Staiti 1989
Staiti, Paul J. *Samuel F. B. Morse.* Cambridge, Mass., 1989.

Staiti/Reynolds 1982
Staiti, Paul J., and Gary A. Reynolds. *Samuel F. B. Morse.* Exhibition catalogue. Grey Art Gallery and Study Center, New York University, 1982.

Stampfle 1991
Stampfle, Felice. *Netherlandish Drawings of the Fifteenth and Sixteenth Centuries and Flemish Drawings of the Seventeenth and Eighteenth Centuries in the Pierpont Morgan Library.* New York, 1991.

Stangos 1976
Stangos, Nikos, ed. *David Hockney by David Hockney.* London, 1976.

Stangos 1979
Stangos, Nikos, ed. *Pictures by David Hockney.* New York, 1979.

Staring 1958
Staring, Adolph. *Jacob de Wit.* Amsterdam, 1958.

Stealingworth 1980
Stealingworth, Slim. *Tom Wesselmann.* New York, 1980.

Stebbins 1992
Stebbins, Theodore E., Jr. *The Lure of Italy: American Artists and the Italian Experience, 1760–1914.* Exhibition catalogue. Boston, Museum of Fine Arts, 1992.

Stechow 1970
Stechow, Wolfgang. *Dutch Mannerism: Apogee and Epilogue.* Exhibition catalogue. Poughkeepsie, N.Y., Vassar College Art Gallery, 1970.

Stedelijk 1958
Jacques Lipchitz. Exhibition catalogue. Amsterdam, Stedelijk Museum, 1958.

Stein 1993
Stein, Susan R. *The Worlds of Thomas Jefferson at Monticello.* New York, 1993.

Steinberg 1987
Steinberg, Norma S. *Monstrosities and Inconveniences: Works by George Cruikshank from the Worcester Art Museum.* Exhibition catalogue. Worcester Art Museum, 1987.

Stella 1929
Stella, Joseph. "The Brooklyn Bridge (A Page of My Life)." *Transition,* vols. 16–17, June 1929, pp. 86–88.

Stetten 1765
Stetten, Paul von, the Younger. *Erläuterungen der in Kupfer gestochen Vorstellungen aus der Geschichte der Reichstadt Augsburg: Historische Briefe an ein Frauenzimmer.* Augsburg, 1765.

Stewart 1990
Stewart, Andrew. *Greek Sculpture: An Exploration.* 2 vols. New Haven, Conn./London, 1990.

Stone 1991
Stone, David. *Guercino, Master Draftsman: Works from North American Collections.* Exhibition catalogue.

Cambridge, Arthur M. Sackler Museum, Harvard University, 1991.

Stout 1951
Stout, George. "The Practice of Drawing." *Art News,* vol. 50, December 1951, p. 24.

Strauss 1980
Strauss, Walter L., ed. "Netherlandish Artists: Matham, Saenredam, Muller." *The Illustrated Bartsch,* vol. 4. New York, 1980.

Strickler 1981–82
Strickler, Susan E. "A Paris Connection: John Vanderlyn's Portrait of Sampson V. S. Wilder." *Worcester Art Museum Journal,* vol. 5, 1981–82, pp. 33–47.

Strickler 1982–83
Strickler, Susan E. "John Singer Sargent and Worcester." *Worcester Art Museum Journal,* vol. 6, 1982–83, pp. 18–39.

Strickler 1987
Strickler, Susan E., ed. *American Traditions in Watercolor: The Worcester Art Museum Collection.* Exhibition catalogue. Worcester Art Museum, 1987.

Strobl/Weidinger 1994
Strobl, Alice, and Alfred Weidinger. *Oskar Kokoschka: Das Frühwerk (1897/8–1917): Zeichnungen und Aquarelle.* Exhibition catalogue. Vienna, Graphischen Sammlung Albertina, 1994.

Sturgis 1898
Sturgis, Russell. "A Pictorial Window." *New York Evening Post,* 7 November 1898, p. 4.

Suhre 1991
Suhre, Terry. *Moholy-Nagy: A New Vision for Chicago.* Exhibition catalogue. Chicago, Illinois State Museum, 1991.

Sumowski 1963
Sumowski, Werner. *Das Leben Jesu in Bildern, Handzeichnungen, Radierungen von Rembrandt.* Berlin, 1963.

Sumowski 1979
Sumowski, Werner. *Drawings of the Rembrandt School.* 10 vols. New York, 1979.

Surtees 1971
Surtees, Virginia. *The Paintings and Drawings of Dante Gabriel Rossetti (1828–1882): A Catalogue Raisonné.* 2 vols. Oxford, 1971.

Sutton 1984
Sutton, Peter C. *Masters of Seventeenth-Century Dutch Genre Painting.*

Exhibition catalogue. Philadelphia Museum of Art, 1984.

Sweetman 1990
Sweetman, David. *Van Gogh: His Life and Art*. New York, 1990.

Swinton 1982–83
Swinton, Elizabeth de Sabato. "John Chandler Bancroft: Portrait of a Collector." *Worcester Art Museum Journal*, vol. 6, 1982–83, pp. 53–63.

Tait 1959
Tait, Hugh. *Bow Porcelain, 1744–76*. Exhibition catalogue. London, British Museum, 1959.

Tate Gallery 1986
Oskar Kokoschka, 1886–1980. Exhibition catalogue. London, Tate Gallery, 1986.

Taylor 1933
Taylor, Francis Henry. *A Guide to the Collections of the Worcester Art Museum*. Worcester, 1933.

Taylor 1948
Taylor, Francis Henry. *Art through Fifty Centuries*. Worcester, 1948.

Teitz 1979
Teitz, Richard Stuart. *American Art from the Collection of the Worcester Art Museum*. Exhibition catalogue. Fort Worth, Tex., Amon Carter Museum, 1979.

Ternois 1959
Ternois, Daniel. *Les Dessins d'Ingres au Musée de Montauban: Les Portraits*. Montauban, 1959.

Thiem 1966
Thiem, Gunther. *Oskar Kokoschka: Aquarelle und Zeichnungen, Ausstellung zum 80. Geburtstag*. Exhibition catalogue. Stuttgart, Staatsgalerie, 1966.

Thieme/Becker
Thieme, Ulrich, and Felix Becker. *Allgemeines Lexikon der bildenden Künstler*. 37 vols. Leipzig, 1915–50.

Thomas 1974
Thomas, Bruno. "Die Innsbrucker Plattnerkunst, ein Nachtrag." *Jahrbuch der Kunsthistorischen Sammlungen in Wien*, vol. 70, 1974, pp. 179–220.

Thomas/Gamber 1954
Thomas, Bruno, and Ortwin Gamber. *Die Innsbrucker Plattnerkunst*. Exhibition catalogue. Innsbruck, Tiroler Landesmuseum Ferdinandeum, 1954.

Thöne 1966
Thöne, Friedrich. "Hans Heinrich Wägmann als Zeichner: Ein Beitrag zur Luzerner Zeichenkunst und Malerei von Wägmann bis Storer." *Schweizerisches Institut für Kunstwissenschaft Jahresbericht*, 1966, pp. 108–53.

Thöne 1972
Thöne, Friedrich. *Die Zeichnungen des 16. und 17. Jahrhunderts*. Schaffhausen, 1972.

Thornton 1989
Thornton, Tamara P. *Cultivating Gentlemen: The Meaning of Country Life among the Boston Elite, 1785–1860*. New Haven, Conn., 1989.

Tietze-Conrat 1939
Tietze-Conrat, Erika. "A Master Drawing by Antonio Campi." *Art in America*, vol. 27, October 1939, pp. 160–63.

Tuckerman 1853
Tuckerman, Henry T. *A Memorial of Horatio Greenough*. New York, 1853.

Tuckerman 1867
Tuckerman, Henry T. *Book of the Artists: American Artist Life*. 3 vols. New York/London, 1867.

Turner/Plazotta 1991
Turner, Nicholas, and Carol Plazzotta. *Drawings by Guercino from British Collections*. London, 1991.

Uhr 1975
Uhr, Horst. "The Drawings of Lovis Corinth." Ph.D. dissertation, New York, Columbia University, 1975.

Urban 1970
Urban, Martin. *Nolde, Forbidden Pictures: Watercolors, 1939–1945*. Exhibition catalogue. London, Marlborough Fine Arts, 1970.

Urban 1987
Urban, Martin. *Emil Nolde: Catalogue Raisonné of the Oil-Paintings*. 2 vols. London/New York, 1987.

Vailliat 1907
Vailliat, Leandre. *Oeuvres de Bracquemond, exposées à la Société Nationale des Beaux-Arts*. Exhibition catalogue. Salon de Paris, 1907.

Valentin 1944
Valentin, Curt. *The Drawings of Jacques Lipchitz*. New York, 1944.

van den Branden 1883
van den Branden, F. J. *Geschiedenis der Antwerpsche Schilderschool*. Antwerp, 1883.

van der Wolk 1990
van der Wolk, Johannes, et al. *Vincent van Gogh: Drawings*. Exhibition catalogue. Otterlo, Museum Kröller-Müller, 1990.

Van Dovski 1948
Van Dovski, Lee. *Paul Gauguin*. Bern 1948.

van Gogh 1958
van Gogh, Vincent. *The Complete Letters of Vincent van Gogh*. 2 vols. London/New York, 1958.

Van Mander 1906
Van Mander, Carel. *Das Leben der niederländischen und deutschen Maler*. Edited by Hans Floerke. 2 vols. Munich/Leipzig, 1906.

Vasari 1878–85
Vasari, Giorgio. *Le vite de' piu eccellenti pittori, scultori ed architetti. . . .* Edited by Gaetano Milanesi. 9 vols. Florence, 1878–85.

Vey *Catalogue*
Vey, Horst. *Catalogue of the Drawings by European Masters in the Worcester Art Museum*. Worcester, 1958.

Vey 1958
Vey, Horst. "Some European Drawings at Worcester." *Worcester Art Museum Annual Report*, vol. 6, 1958, pp. 8–42.

Vey 1959
Vey, Horst. "Two Unpublished Miniature Paintings by Hans Bol." *Art Quarterly*, vol. 22, spring 1959, pp. 63–70.

Viatte 1974
Viatte, Françoise. *Dessins de Stefano della Bella, 1610–1664*. Paris, 1974.

Vickers 1986
Vickers, Michael. "Constantinopolis." In *Iconographicum Mythologiae Classicae*, vol. 3/1, pp. 301–4. Zurich/Munich, 1986.

Visser 1973
Visser, W. J. A. "Vincent van Gogh en 'sGravenhage." *Jaarboek die Haghe*, 1973, pp. 1–125.

Vitali 1970
Vitali, Lamberto. *Giorgio Morandi, pittore*. 3rd ed. Milan, 1970.

Vitzthum 1965
Vitzthum, Walter. *Lo Studiolo di Francesco I a Firenze*. Milan, 1965.

Vitzthum 1970
Vitzthum, Walter. *A Selection of Italian Drawings from North American Collections*. Exhibition catalogue. Toronto, Mackenzie Art Gallery, 1970.

von Heusinger 1986
von Heusinger, Christian. "Duke Anton Ulrich as a Collector of Prints and Drawings." *Apollo*, vol. 123, March 1986, pp. 190–95.

Voragine 1941
Voragine, Jacobus de. *The Golden Legend*. Translated by Granger Ryan and Helmut Ripperger. New York/London, 1941.

Vredeman de Vries 1581
Vredeman de Vries, Jan. *Architectura*. Antwerp, 1581.

Vredeman de Vries 1583
Vredeman de Vries, Jan. *Hortorum viridariorumque, elegantes et multiplicis formae*. Antwerp, 1583.

Wadley 1969
Wadley, Nicholas. *The Drawings of van Gogh*. London, 1969.

Wagstaff 1965
Wagstaff, Samuel J. *An Exhibition of Italian Panels and Manuscripts from the Thirteenth and Fourteenth Centuries in Honor of Richard Offner*. Exhibition catalogue. Hartford, Conn., Wadsworth Atheneum, 1965.

Walton 1981
Walton, Guy. "Liévin Cruyl: The Works for Versailles." In *Art, the Ape of Nature: Studies in Honor of H. W. Janson*, pp. 425–37. Edited by Moshe Barasch and Lucy Freeman Sandler. New York, 1981.

Washington 1943
The Thomas Jefferson Bicentennial Exhibition, 1743–1943. Exhibition catalogue. Washington, D.C., National Gallery of Art, 1943.

Wasserman 1980
Wasserman, Jeanne A. *Three American Sculptors and the Female Nude: Lachaise, Nadelman, Archipenko*. Exhibition catalogue. Cambridge, Fogg Art Museum, Harvard University, 1980.

Waters 1940
Waters, C. E. *Inks*. U.S. National Bureau of Standards Circular C426. Washington, D.C., 1940.

Waters/Hutton 1894
Waters, Clara Erksine Clement, and Laurence Hutton. *Artists of the Nineteenth Century and Their Works*. New York, 1894.

Watrous 1967
Watrous, James. *The Craft of Old-Master Drawings.* Madison/Milwaukee, Wis., 1967.

Wax 1990
Wax, Carol. *The Mezzotint: History and Technique.* New York, 1990.

Webb 1988
Webb, Peter. *Portrait of David Hockney.* London, 1988.

Webster 1991
Webster, Sally. *William Morris Hunt, 1824–1879.* New York, 1991.

Wehelte 1975
Wehelte, Kurt. *The Materials and Techniques of Painting.* New York, 1975.

Weinberg 1977
Weinberg, H. Barbara. *The Decorative Work of John La Farge.* New York/London, 1977.

Weiner 1988
Old Master Drawings: Fall Exhibition. Exhibition catalogue. New York, Mia N. Weiner and Company, 1988.

Welu 1977
Welu, James A. "Willem van Mieris: Judgement of Solomon." Worcester Art Museum *Journal,* vol. 1, 1977, pp. 15–17.

Wentworth 1922
Wentworth, Robert. "Actualités: La Vie dans les musées d'Amérique." *Revue de l'Art,* vol. 41, April 1922, p. 327.

Wesselmann 1963
Wesselmann, Tom. "Editor's Letters." *Art News,* vol. 62, summer 1963, p. 6.

Westfehling/Clercx-Léonard-Etienne 1989
Westfehling, Uwe, and Françoise Clercx-Léonard-Etienne. *Jean Pierre Norblin, Ein Künstler des Revolutionszeitalters in Paris und Warschau: Zeichnungen und Druckgraphik.* Exhibition catalogue. Cologne, Wallraf-Richartz Museum, 1989.

White 1987
White, Christopher. *Peter Paul Rubens: Man and Artist.* New Haven, Conn., 1987.

Whitman 1963
Whitman, Nathan T. *The Drawings of Raymond Lafage.* The Hague, 1963.

Widerkehr 1991
Widerkehr, Léna. "*Jacob Matham Goltzij Privignus:* Jacob Matham graveur et ses rapports avec Hendrick Goltzius." *Nederlands Kunsthistorisch Jaarboek,* vols. 42–43, 1991, pp. 219–60.

Wiesbaden 1963
Aus der Sammlung Ströher. Exhibition catalogue. Wiesbaden, Nassauischer Kunstverein, 1963.

Wildenstein 1964
Wildenstein, Georges. *Gauguin.* 2 vols. Edited by Raymond Cogniat and Daniel Wildenstein. Paris, 1964.

Williamson 1897
Williamson, George C. *Richard Cosway, R.A., and His Wife and Pupils.* London, 1897.

Wilmerding/Dee 1972
Wilmerding, John, and Elaine Evans Dee. *Winslow Homer, 1836–1910: A Selection from the Cooper-Hewitt Collection.* Exhibition catalogue. Cooper-Hewitt Museum of Decorative Arts and Design, Smithsonian Institution, New York, 1972.

Wilson 1969
Wilson, Patricia Boyd. "Home Forum." *Christian Science Monitor,* 7 February 1969, p. 10.

Winkler 1964
Winkler, Friedrich. "Der unbekannte Sebastian Vrancx." *Pantheon,* vol. 22, 1964, pp. 322–34.

Winzinger 1980
Winzinger, Franz. "An Unknown Drawing of the Gothic Period." *Master Drawings,* vol. 18, 1980, pp. 27–29.

Wittkower 1958
Wittkower, Rudolf. *Art and Architecture in Italy, 1600 to 1750.* Baltimore, 1958.

Worcester 1921–22
English and American Paintings: Eighteenth and Nineteenth Centuries. Exhibition catalogue. Worcester Art Museum, 1921–22.

Worcester 1969
Art in America, 1830–1950: Paintings, Drawings, Prints, and Sculpture from the Collection of the Worcester Art Museum. Exhibition catalogue. Worcester, 1969.

Worcester 1994
Worcester Art Museum: Selected Works. Worcester, 1994.

Worcester Daily Telegram 1951
"Museum Lends 3 Drawings for Iowa Show." *Worcester Daily Telegram,* 6 July 1951, p. 2.

Wright 1963
Wright, Nathalia. *Horatio Greenough: The First American Sculptor.* Philadelphia, 1963.

Wynne 1972
Wynne, Michael. "Thomas Frye (1710–1762)." *Burlington Magazine,* vol. 114, February 1972, pp. 79–84.

Wynne 1982
Wynne, Michael. "Thomas Frye (1710–1762) Reviewed." *Burlington Magazine,* vol. 124, October 1982, pp. 624–28.

Yarnall 1987
Yarnall, James L. *John La Farge.* Exhibition catalogue. Washington, D.C., National Museum of American Art, Smithsonian Institution, 1987.

Yarnall 1990
Yarnall, James L. *John La Farge: Watercolors and Drawings.* Exhibition catalogue. Yonkers, N.Y., Hudson River Museum of Westchester, 1990.

York Civic Trust 1989
The Language of the Fan. Exhibition catalogue. York, York Civic Trust, 1989.

Zuccaro 1607
Zuccaro, Federico. *L'idea de' pittori, scultori ed architetti.* Turin, 1607.

Index

Page numbers in *italics* refer to illustrations. Checklist of Further Drawings begins on page 230. Checklist references are not included in this index.